ISABEL LÓPEZ-QUESADA

TOWN & COUNTRY

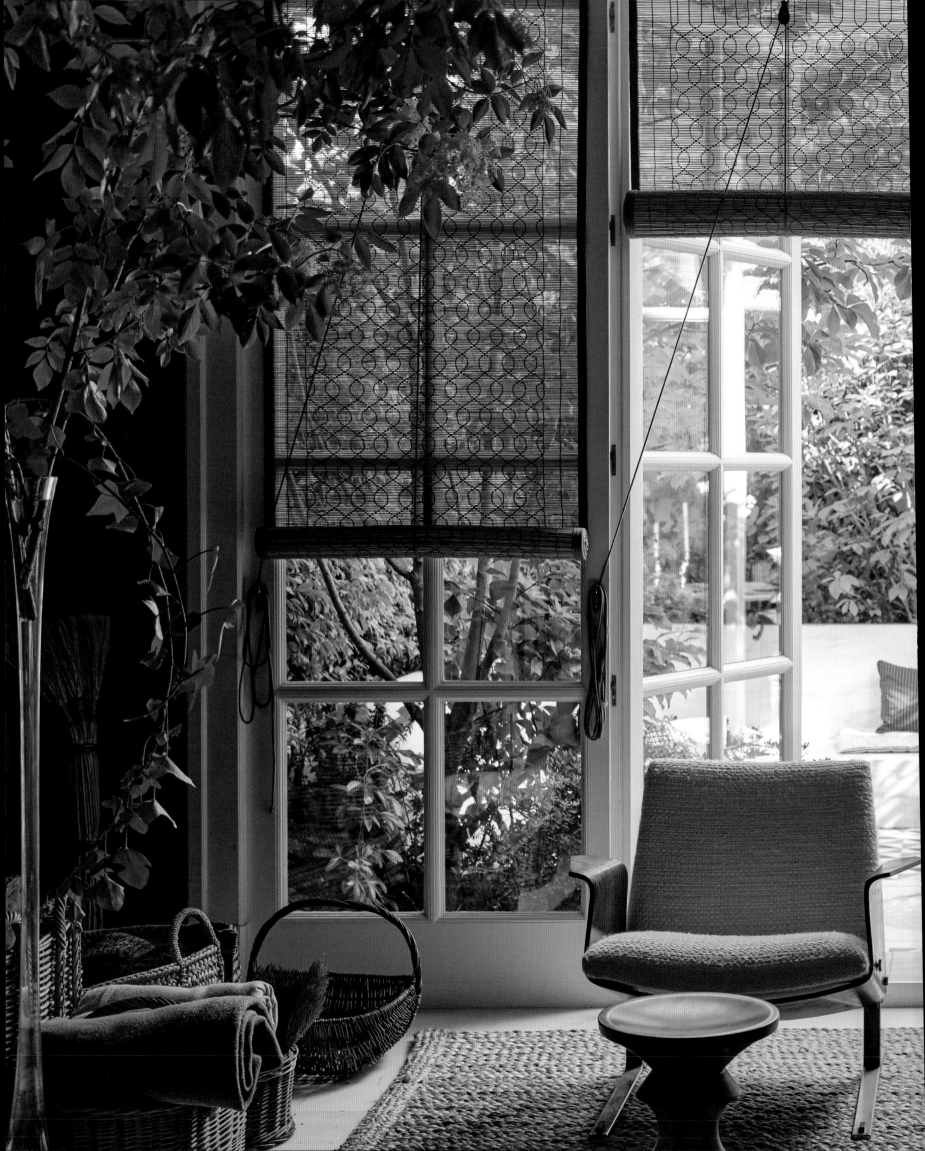

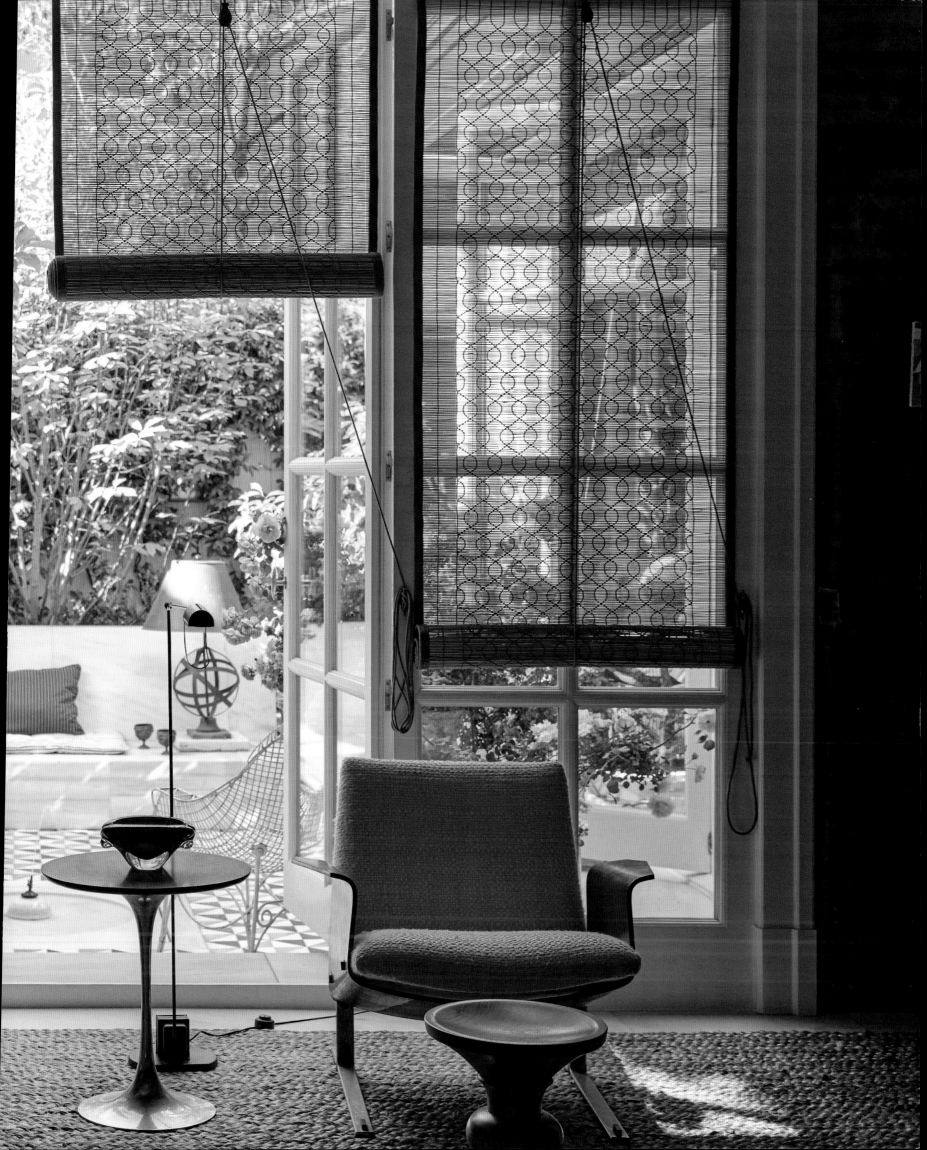

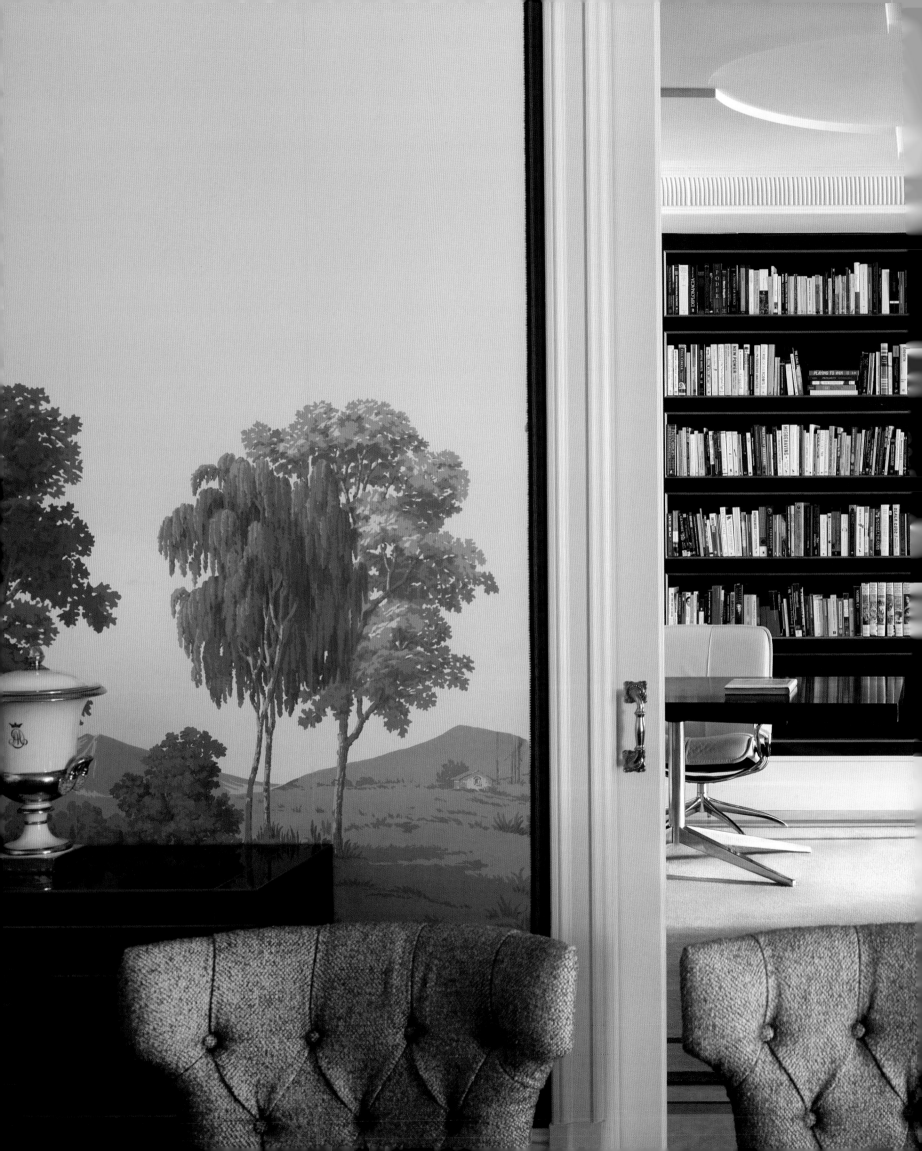

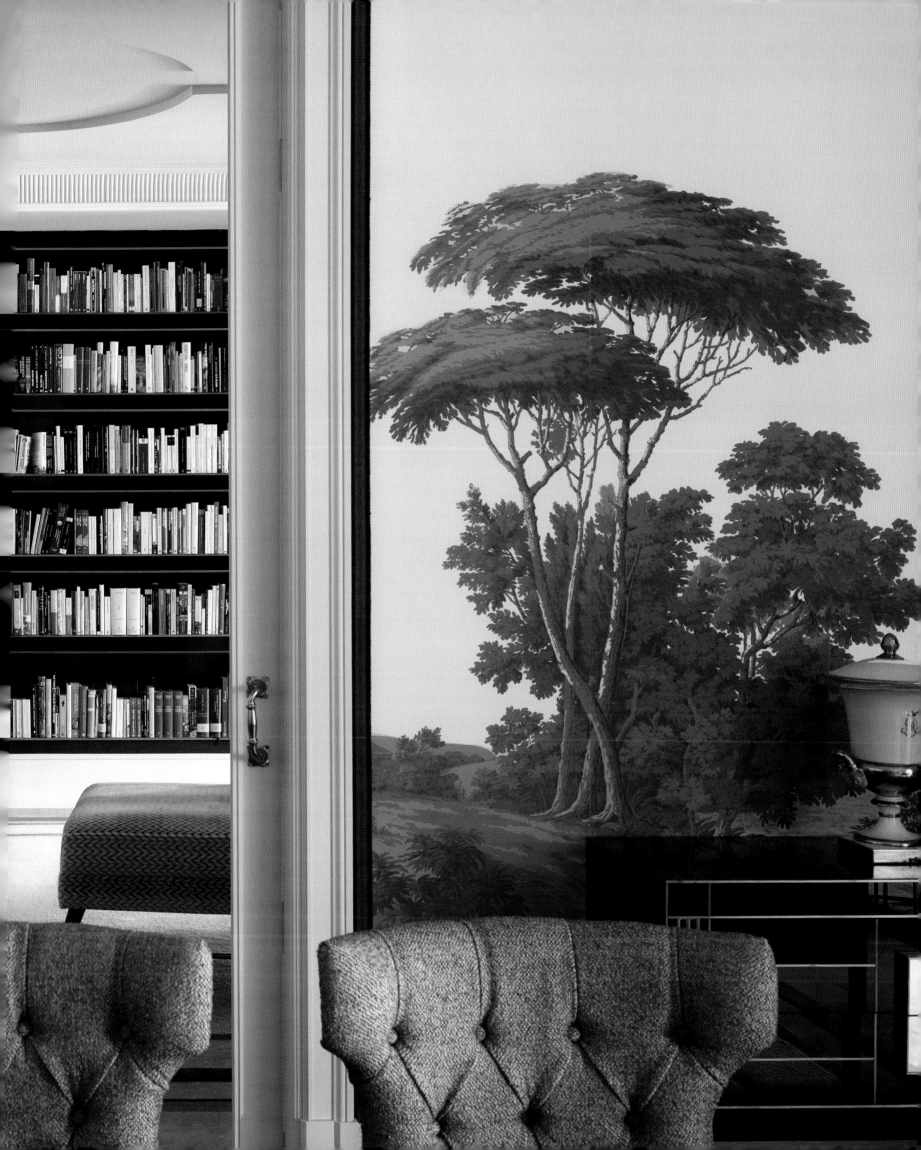

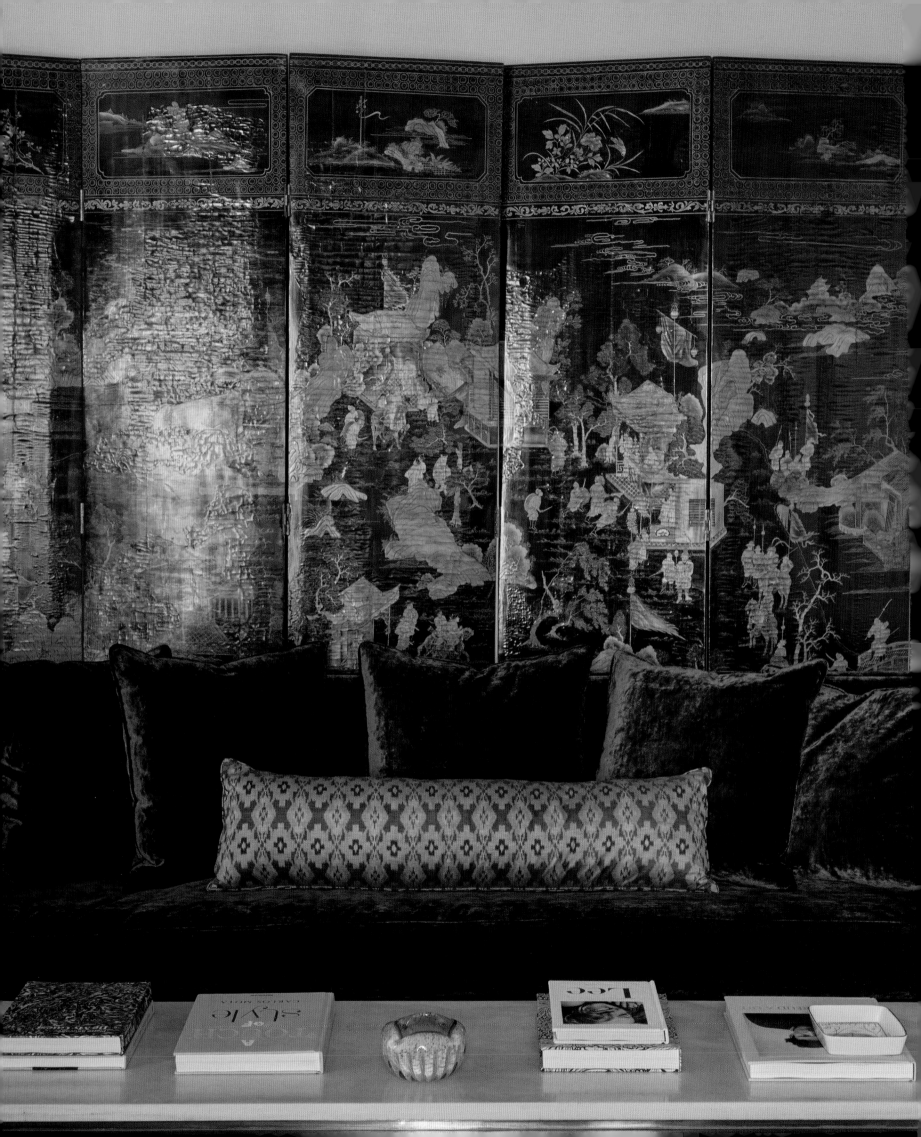

ISABEL LÓPEZ-QUESADA

TOWN & COUNTRY

PHOTOGRAPHY BY
MIGUEL FLORES-VIANNA

VENDOME

CONTENTS

INTRODUCTION

It's been six years since the publication of *At Home*, my previous book, which told the story of my home and studio in Madrid, Spain, and the farm in Biarritz, in southern France, where I go to escape. Its pages contained all the things that enrich my life and work, and that are considered characteristic of my style: my family, simple pleasures, flowers and plants, treasured books and objects, special furniture discovered trawling antique shops on my travels, and my obsession with natural fabrics and fibers. Every inch of my houses—from the laundry rooms that celebrate that old Spanish tradition so closely related to a love of fabric, to luminous spaces with wooden and antique stone surfaces that improve with age—demonstrates my love for my profession, which remains as strong as ever and continues to allow me to pursue new directions. Six years on, I would not have thought it possible to further deepen my appreciation of homes that exist in harmony with our lives.

It's time to turn the page, change focus, and celebrate forty years of work by starting a new journey. This book features projects I've completed for others, my clients and friends and the people who accompany me day to day in this wonderful profession. *Town & Country* throws open the doors of some of the houses I've designed along with my studio in recent years. The book mostly features projects from the last twenty years: eight town houses and seven country houses that would not exist without their owners' collaboration and trust. Miguel Flores-Vianna once again traveled with me on this adventure and captured the homes with his exquisite eye.

The fact that a Madrid-based studio has worked on international projects—from the United States to the Caribbean to Japan, and throughout Europe—is both a professional challenge and a matter of personal pride. The first response to each challenge is architectural, the search for a logical and elegant layout that alters spaces from the ground up. There's the connection to the landscape to consider too—so fundamental to reinventing a place. To fully understand my work requires an understanding of my love of art, other cultures, and other landscapes. To travel is to learn: imagining an empty place demands an understanding of everything that's possible in terms of different ways of living. I always say that designing a house is like staring at a blank page, and my first step to dealing with this unwritten story is to bombard my clients with thousands of questions. I need to know everything about them, their lives, and their wishes. That's how I write the first paragraph of every great tale.

OPPOSITE Isabel López-Quesada at her home in Segovia.

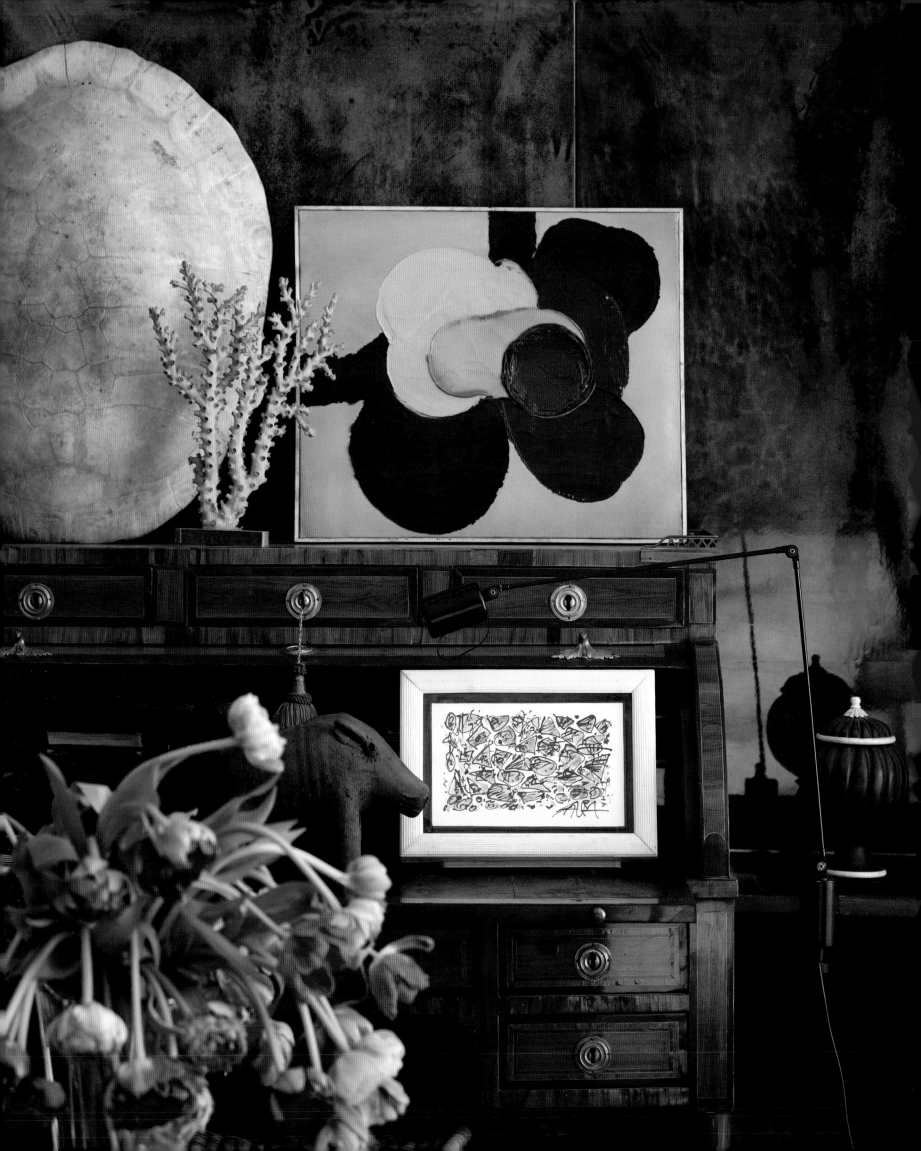

OPPOSITE In the lounge room of Isabel López-Quesada's home in Madrid, artworks by Luis Feito and Antonio Saura and an albino tortoise shell sit on an eighteenth-century French desk, with Aldo Tura goatskin panels in the background.

Finding the spirit of a location, understanding it, and making it your own is no easy task. Neither is communicating my ideas to all the trades involved to create a house that embodies my vision. I take nothing for granted and treat each of my designs as carefully as if it were my first. I love my work and I believe my enthusiasm is contagious, so I never feel fearful of working on projects far from Spain. After four decades, I trust my instinct and experience.

Each house in this book can be seen as a discovery—of a place, a family, a couple, a certain climate, a new craft. Obviously, all my houses feature common elements, invisible threads I weave that capture my taste and my idea of what makes a home special. I advocate for what I call "tranquil décor" or silent luxury, an expression that rejects the obvious and expresses my belief that beauty and comfort are entwined. Houses are for using and enjoying, to be lived in with others, to experience joy and happiness and—when we need it—calm and seclusion. This is why I believe more in harmonious elegance than in attention-seeking excess.

To look through this book is to enter a world of dreams and an endeavor to make different ideals into a reality. You'll find them on a tropical estate and in the tale of two barns—one from the end of the nineteenth century and the other from the beginning of the twentieth; in a Mediterranean house filled with blue accents, nestled within olive groves on the island of Spetses; in a duplex that belonged to Ava Gardner when that actress lived in Madrid; in a homely apartment in downtown Manhattan with spectacular views over New York; and in another exquisite Madrid apartment opposite the Botanical Gardens and the Prado Museum that enjoys spectacular sunsets. You'll discover bookshelves where a whole lifetime is hiding, fabulous furniture and works of art, reused objects and materials given a new life, and trees that offer shade and coolness in beautiful gardens—like the albizias found on the estate in the middle of the Extremaduran *dehesa* and the ombú trees in the wonderful colonial style house on Menorca. The houses gathered in this book are all special and unique in their own way, like the Segovian estate that helped to secure my international career, attracting—among others—the owners of another farm, this time in Pennsylvania, which was completely transformed and whose wooden structure was restored with the help of local Amish artisans.

I've been my own client, too, over the last six years. I left my old house and moved to a new one, this time thinking more about myself and my husband and less about family life. The inspiration for my new home relates to the concept of stripping back, returning to what's essential—you'll find some of these secrets in the book. I'll just say that it has a lot to do with chocolate-colored panels by Aldo Tura and one of my obsessions, tortoise shells. I finally paid homage to my grandmother Isabel by decorating my dressing room with the Isola Bella Zuber wallpaper that she had in her own house and that so helped train my eye. Forty years have passed since I opened my first Madrid studio as a young woman. Today, from my new house, surrounded by my books and objects and all the things that I truly love, I continue to dream of new spaces, materials, shapes, and colors. I feel like an explorer on a quest for beauty.

TOWN

Towns and cities are undergoing extraordinary change—something that Isabel López-Quesada understands firsthand. This book features eight urban houses, most of which are found in Madrid, Spain's capital, with others in Santo Domingo—the capital of the Dominican Republic—New York, and Lisbon. They're all exceptional homes. Some have a fascinating past, others are found in extraordinary neighborhoods, all are recreated with Isabel López-Quesada's characteristic mixture of beauty, boldness, and pragmatism. Isabel often reminds us that houses are meant to be lived in, and much of her work focuses on discovering ever more solid, sophisticated materials that improve with time. Single-family homes, a terraced duplex, and nineteenth-century apartments—all are reimagined for the future with one eye on tradition.

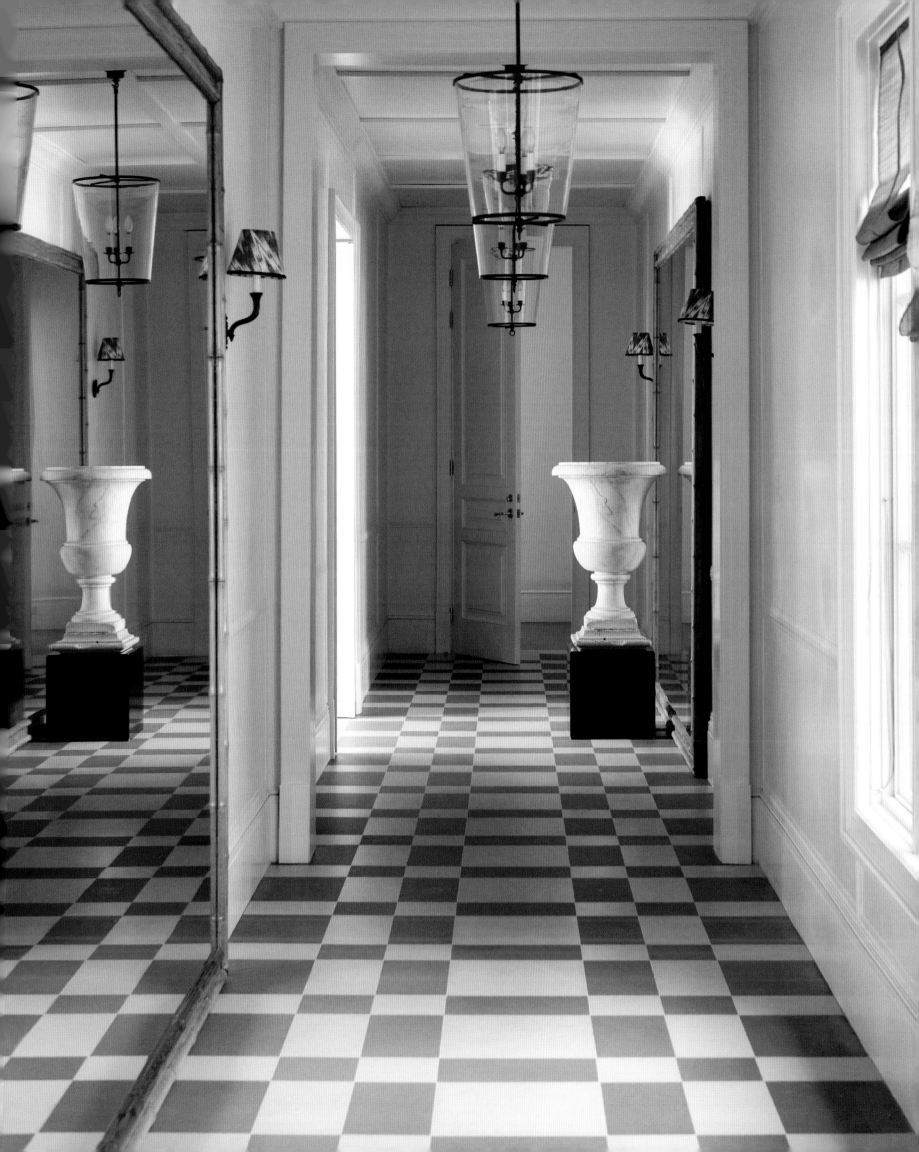

THE SELFISH HOUSE

At Home, López-Quesada's first book, which featured her home studio in Madrid and her Biarritz farm and hen house, marked the end of an era in some ways—at least that of her home in Madrid's El Viso district. With her three children now grown up, the family home felt too large. Isabel found what she'd been searching for in a nearby neighborhood with a London vibe she'd always loved, a little like a Spanish Notting Hill. At its center is a cluster of wonderfully cheerful, colorful houses that were designed in the thirties. Their modest charm combines with the neighborhood's colors to bring a sense of joy to an urban setting. This project, completed at the beginning of 2020, involved joining two small residences together, completely rebuilding them in the process, to create a new home for Isabel and her husband. The core premise was, in Isabel's own words, to meet a few "selfish" needs. Now that she was designing for a couple rather than a family, her aim was to create a practical, pared-back home.

The south-facing property features two courtyards designed by Fernando Caruncho, one by the entrance and another set within the ground floor. This interior courtyard leads into the dining room/sunroom, the lounge, and the adjoining kitchen, which can be opened up to become part of the space. The sash windows have a London townhouse feel tempered by French and Italian touches, with oriental details in the lounge and courtyard. The hall stairs lead upstairs to the primary bedroom with a terrace and two bathrooms with dressing rooms. Isabel's dressing room is her refuge, a fantasy of mirrored closets that endlessly multiply the Isola Bella colored wallpaper by Zuber that so reminds her of her grandmother's house. The uppermost floor keeps things in order with a large laundry room and is also home to a guest bedroom and bathroom.

The property's true character and inspiration is revealed in the striking lounge walls, the result of following a hunch, coupled with a touch of fate. The sophisticated 1960s chocolate-colored lacquered goatskin panels by Italian designer Aldo Tura were bought from a Parisian antiques dealer for another project that never came to fruition. These fabulous panels now encompass the lounge, creating spectacular plays of light with a color and finish reminiscent of one of Isabel's obsessions—tortoise shells. The black-painted bookcase, the curved white sofa, the mid-century furniture, the artworks, and the pink and red of the pictures and flowers—everything has been curated to form an exceptional space that's ready to be enjoyed in this new chapter of Isabel's life.

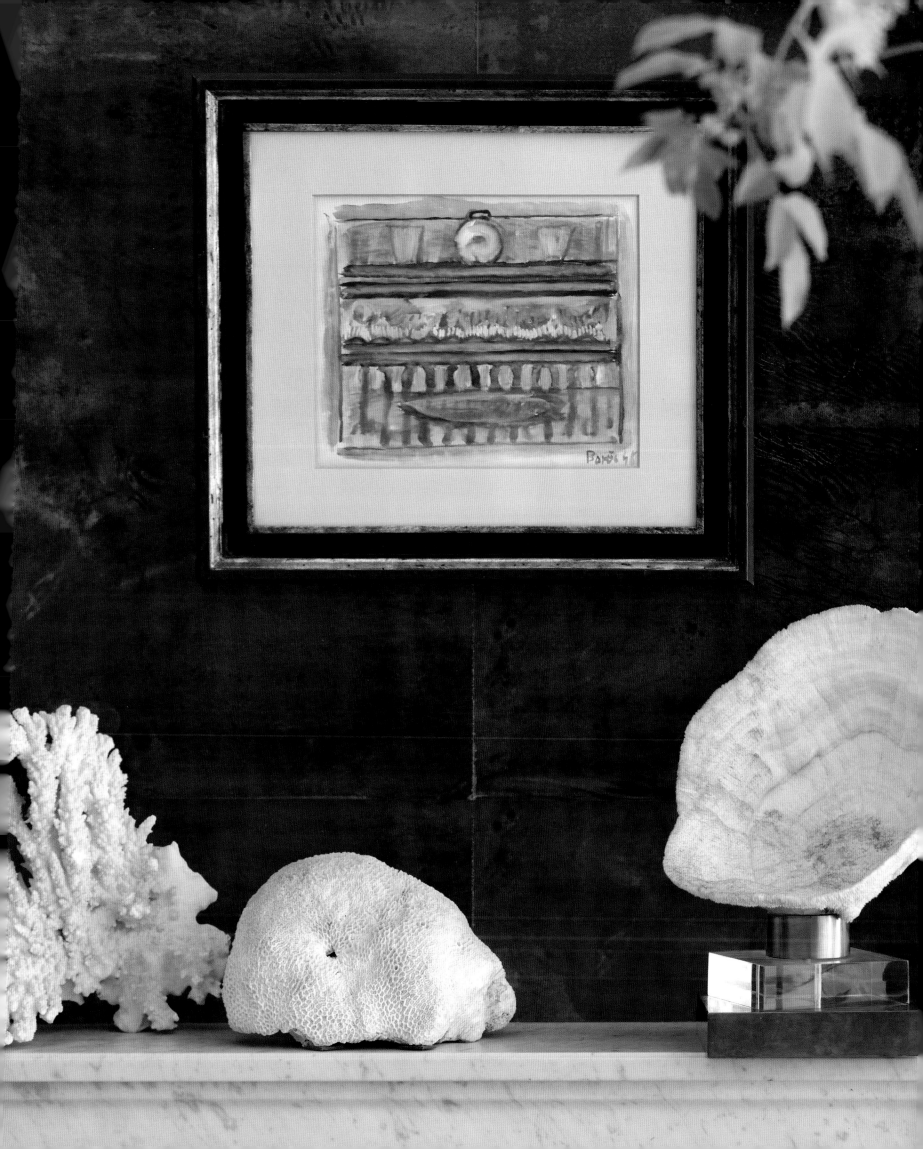

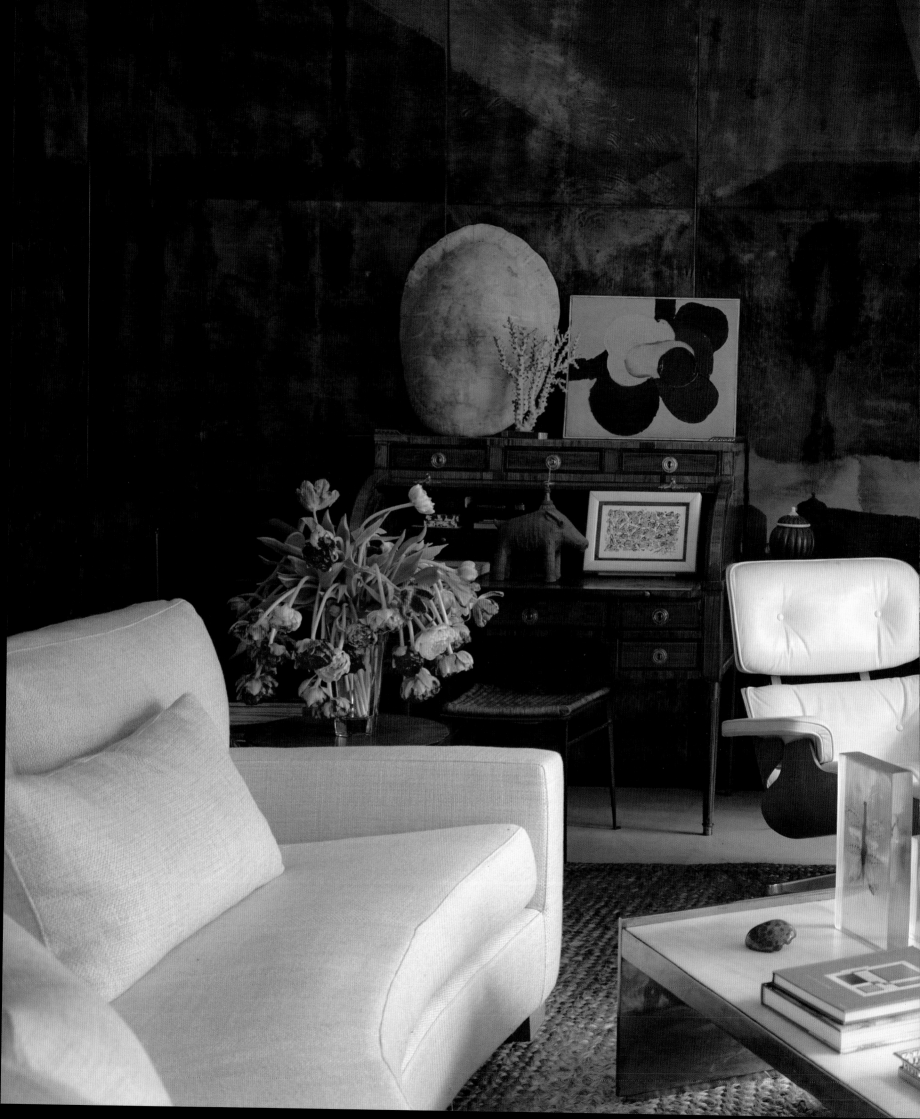

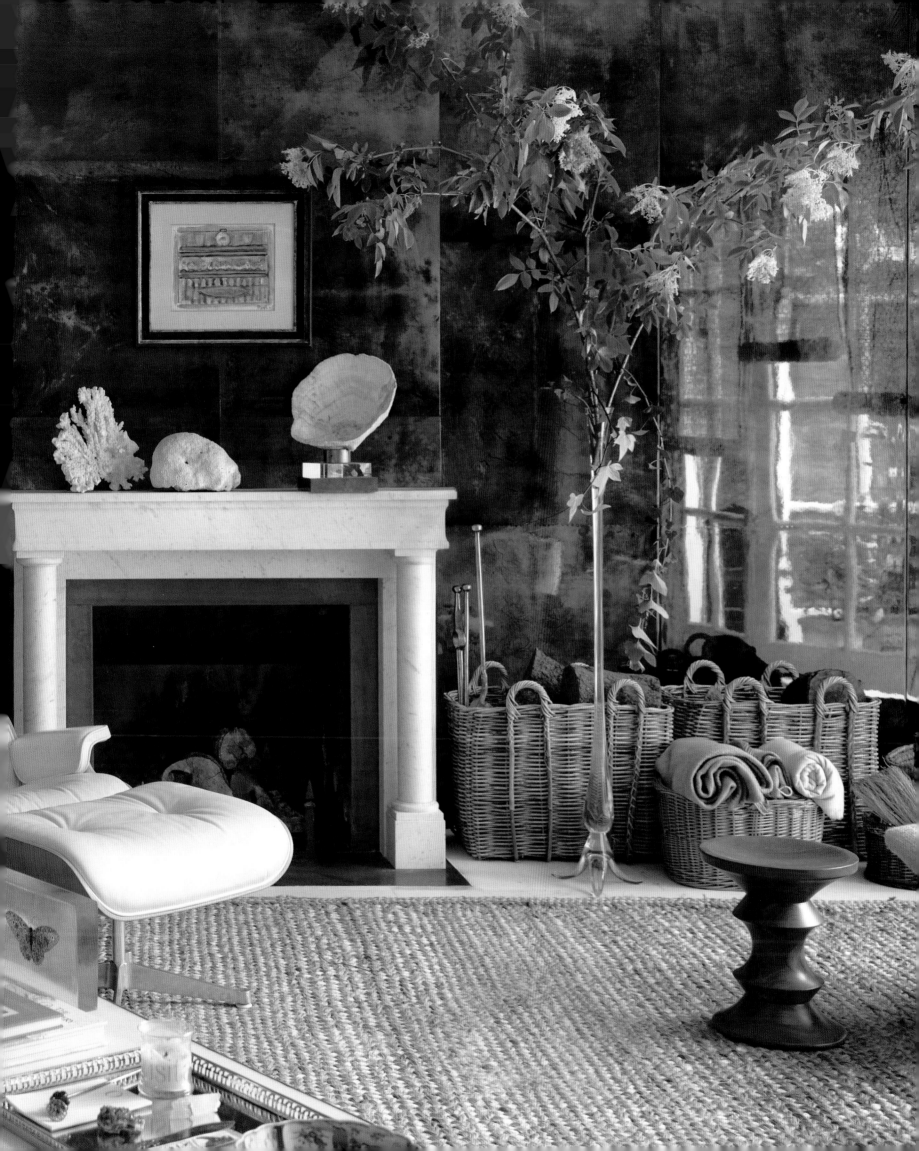

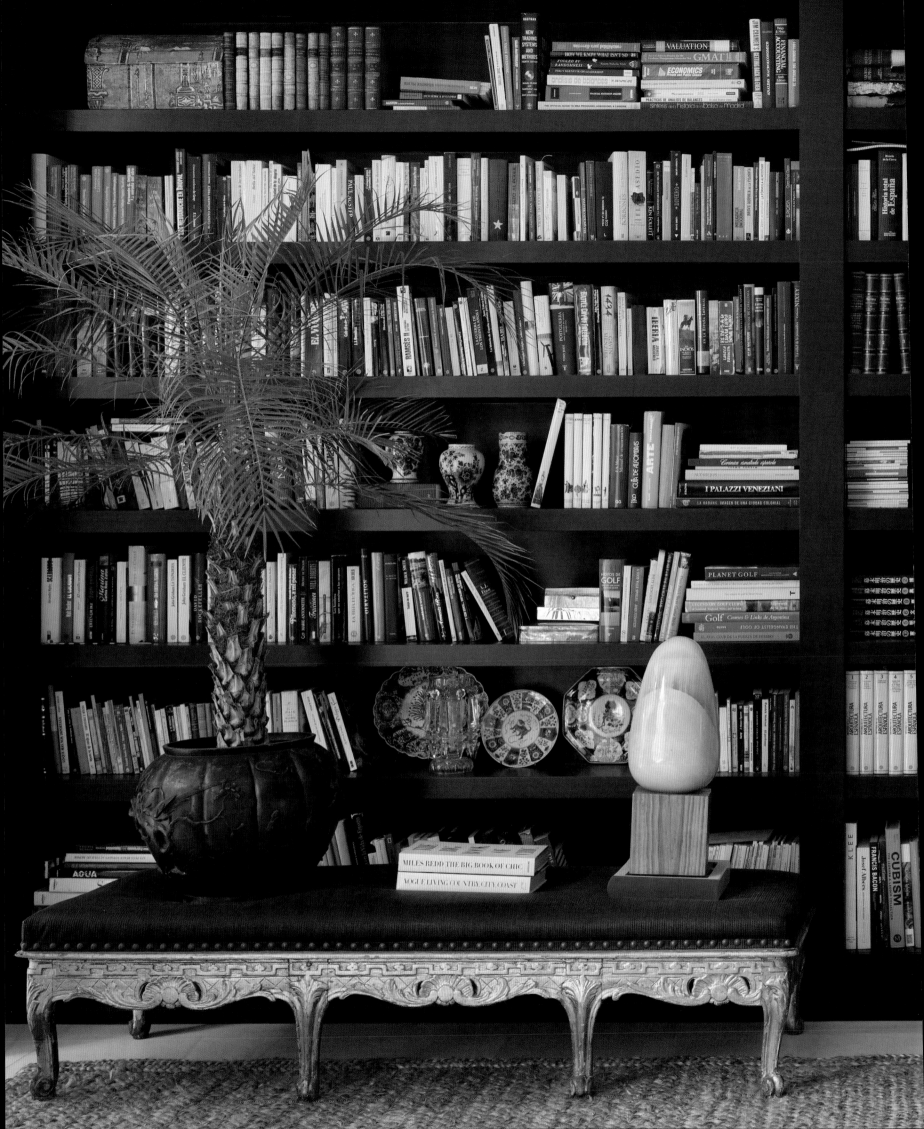

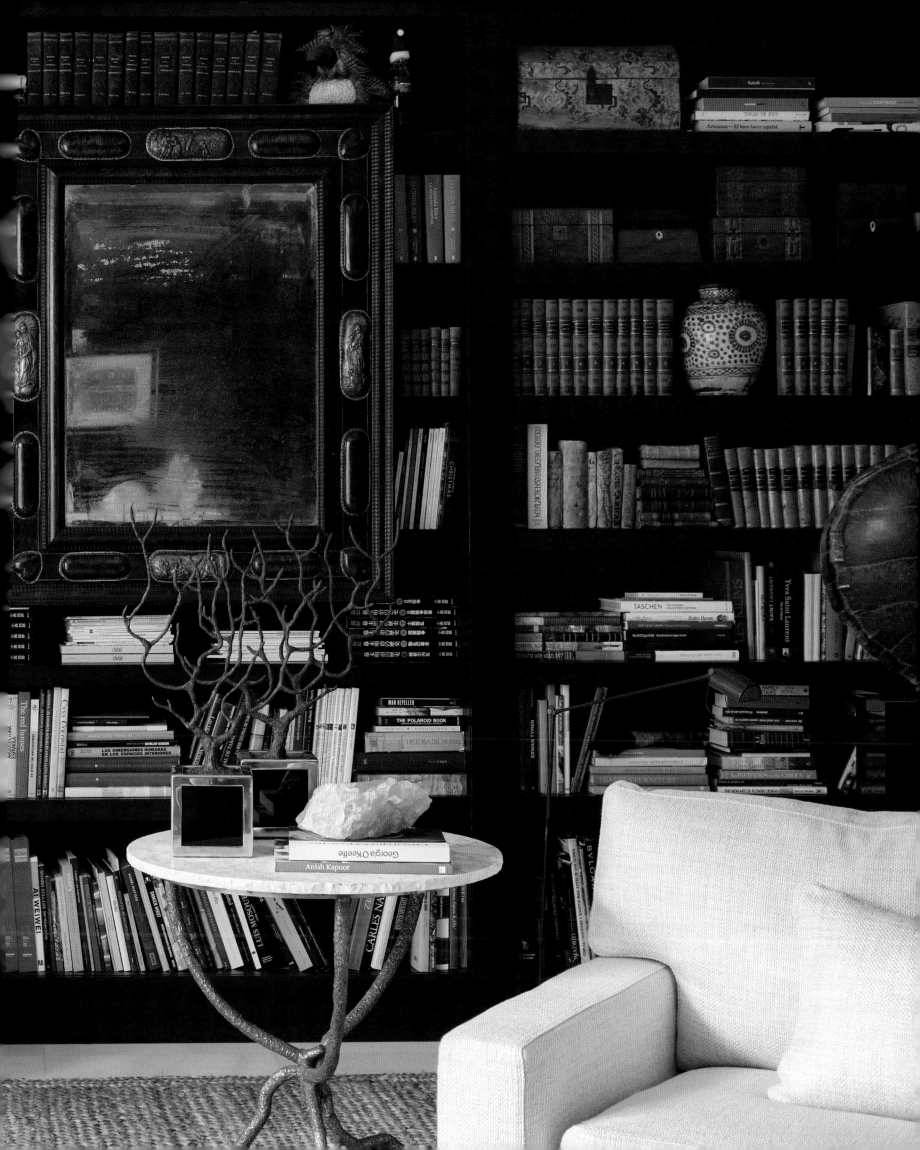

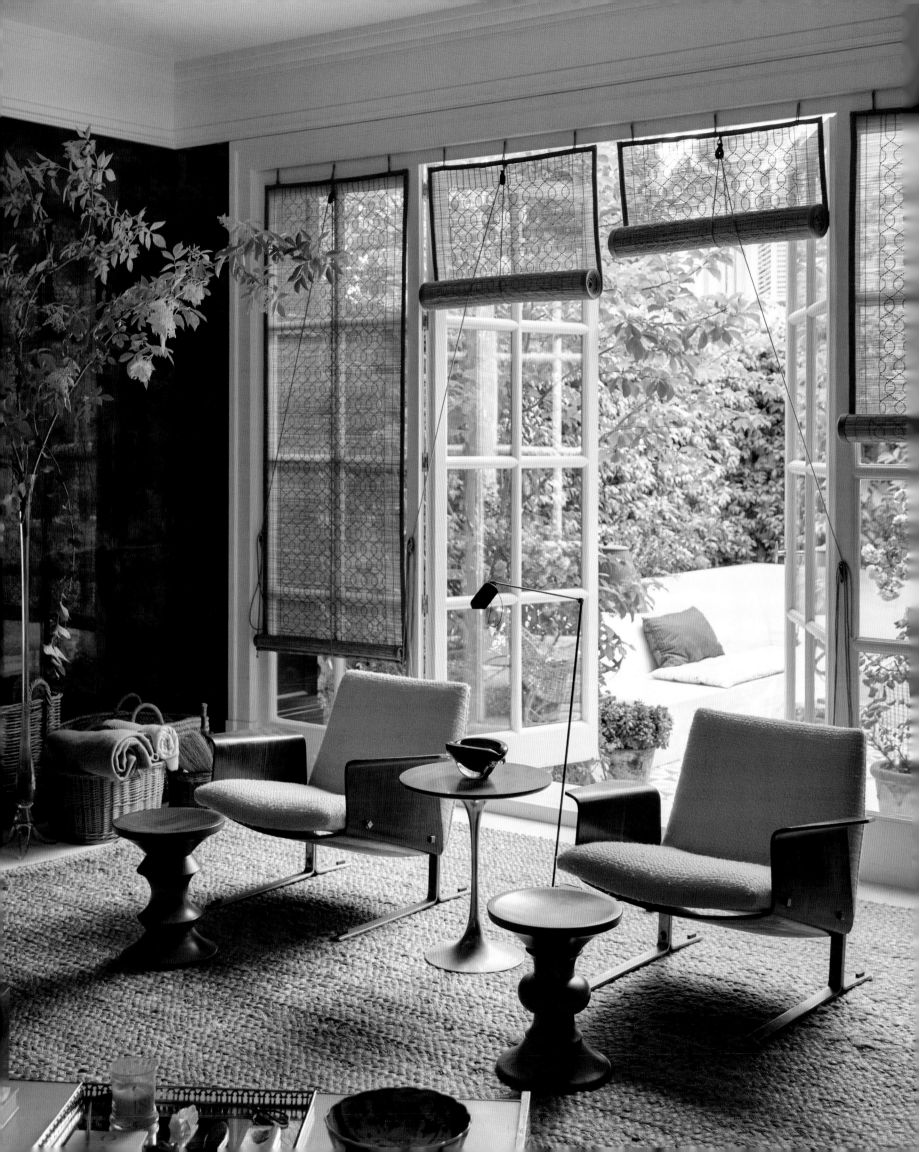

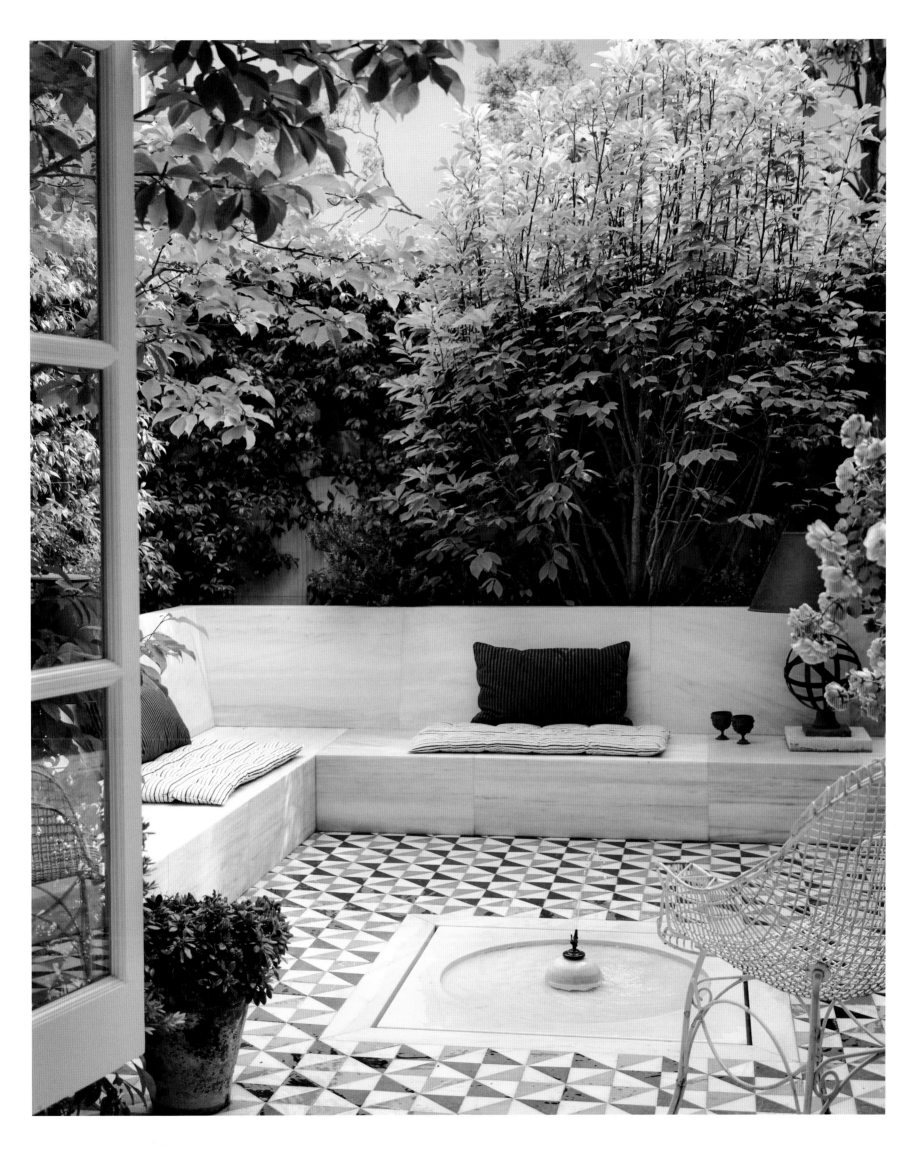

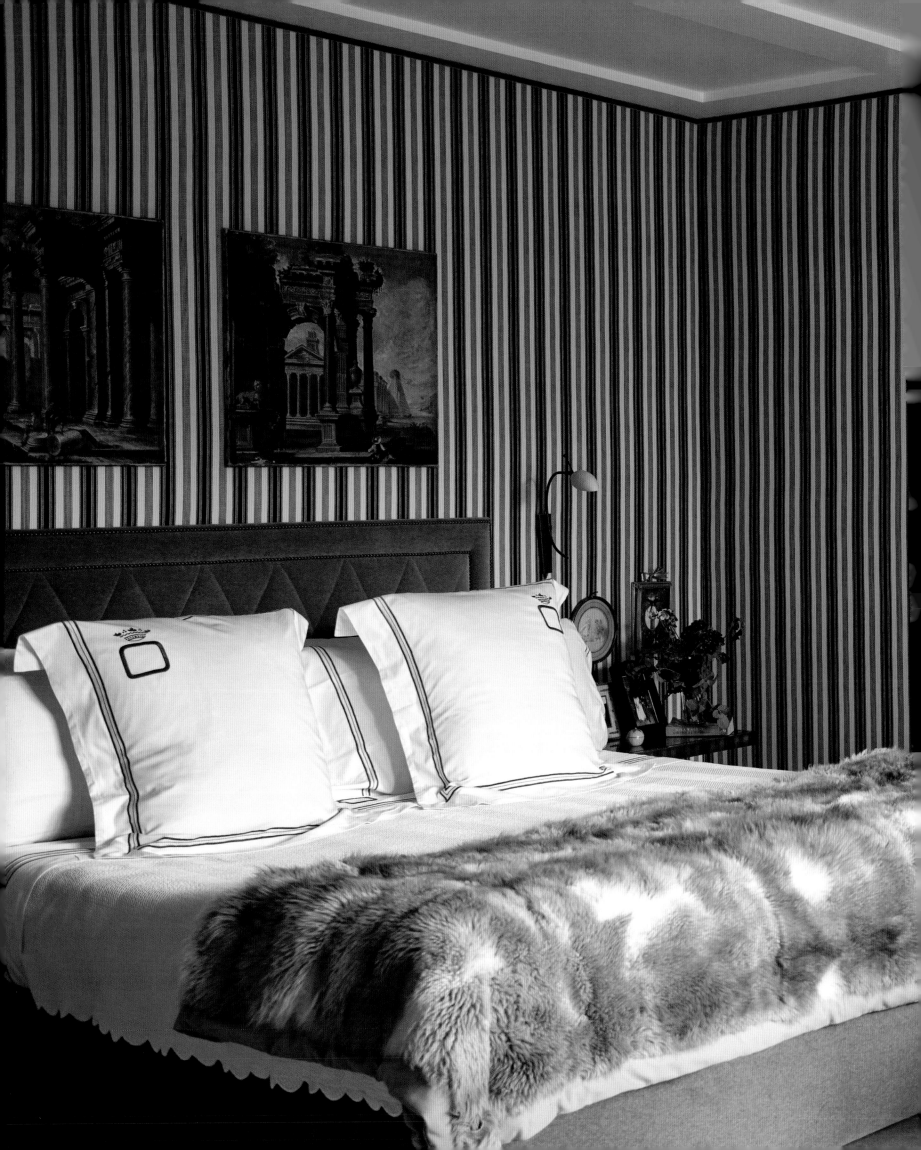

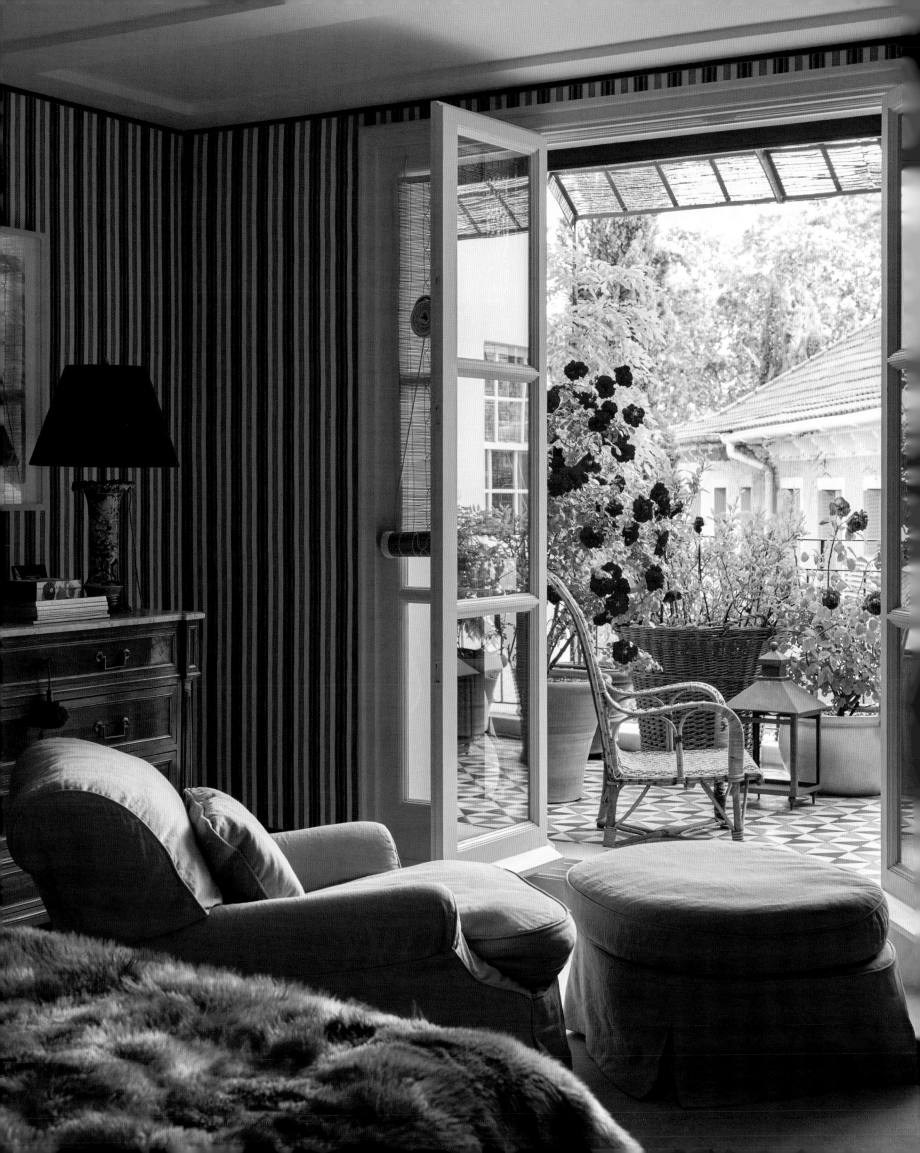

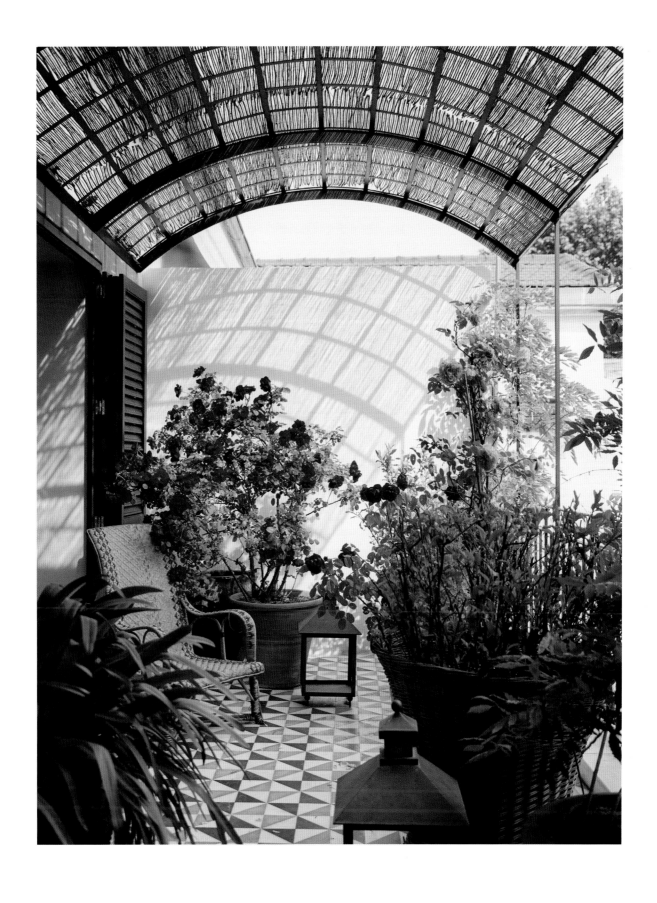

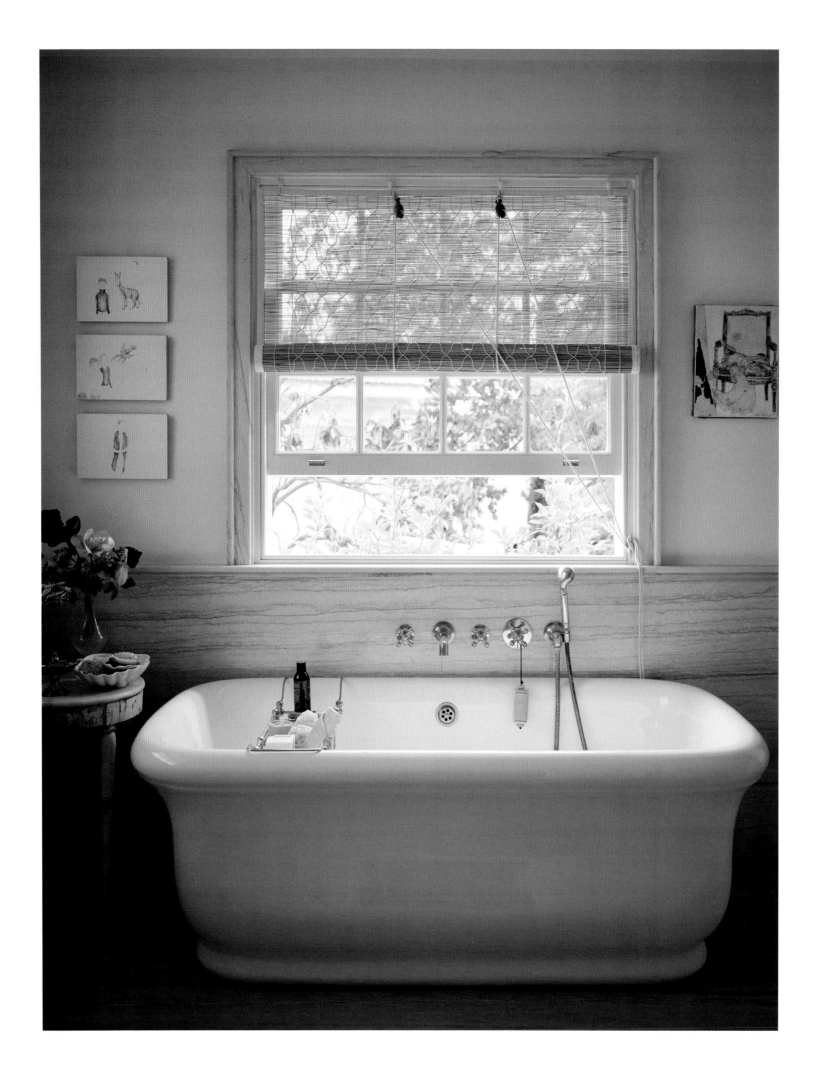

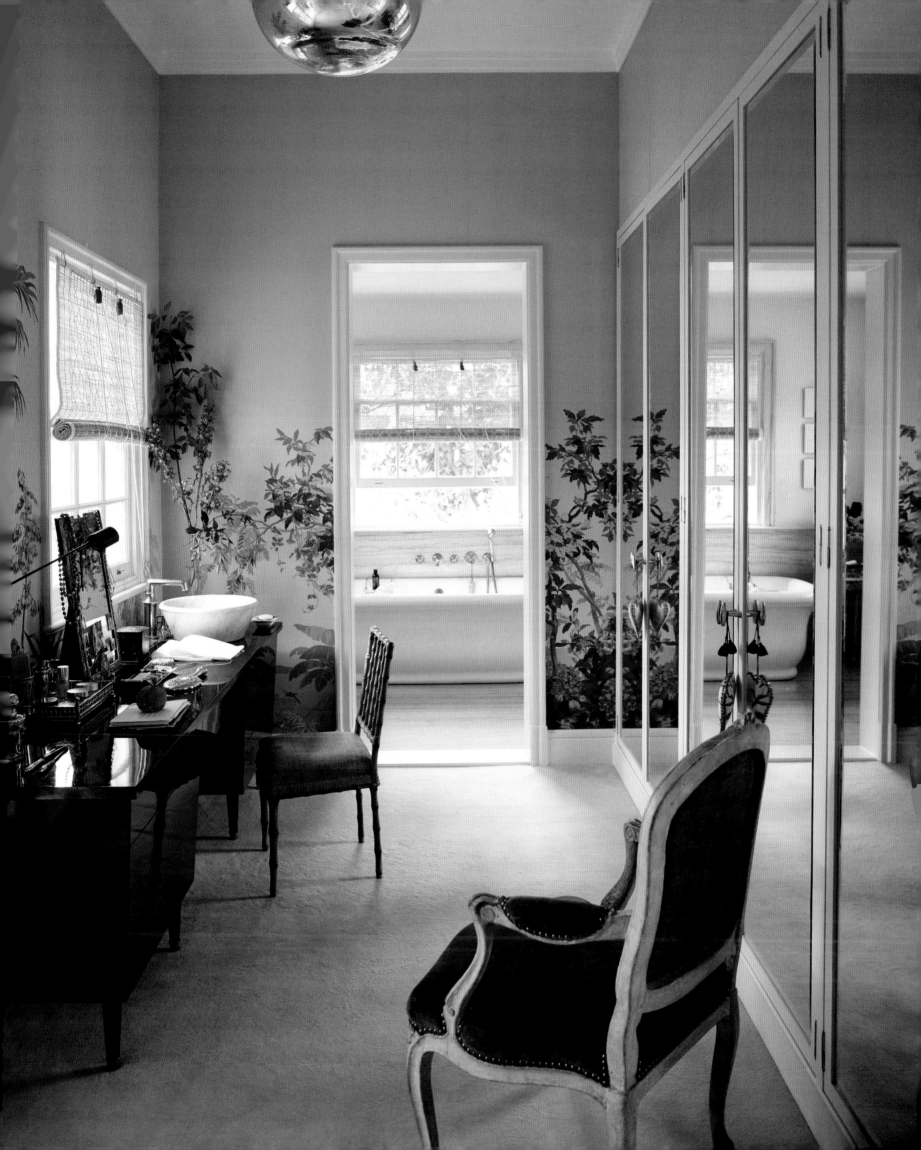

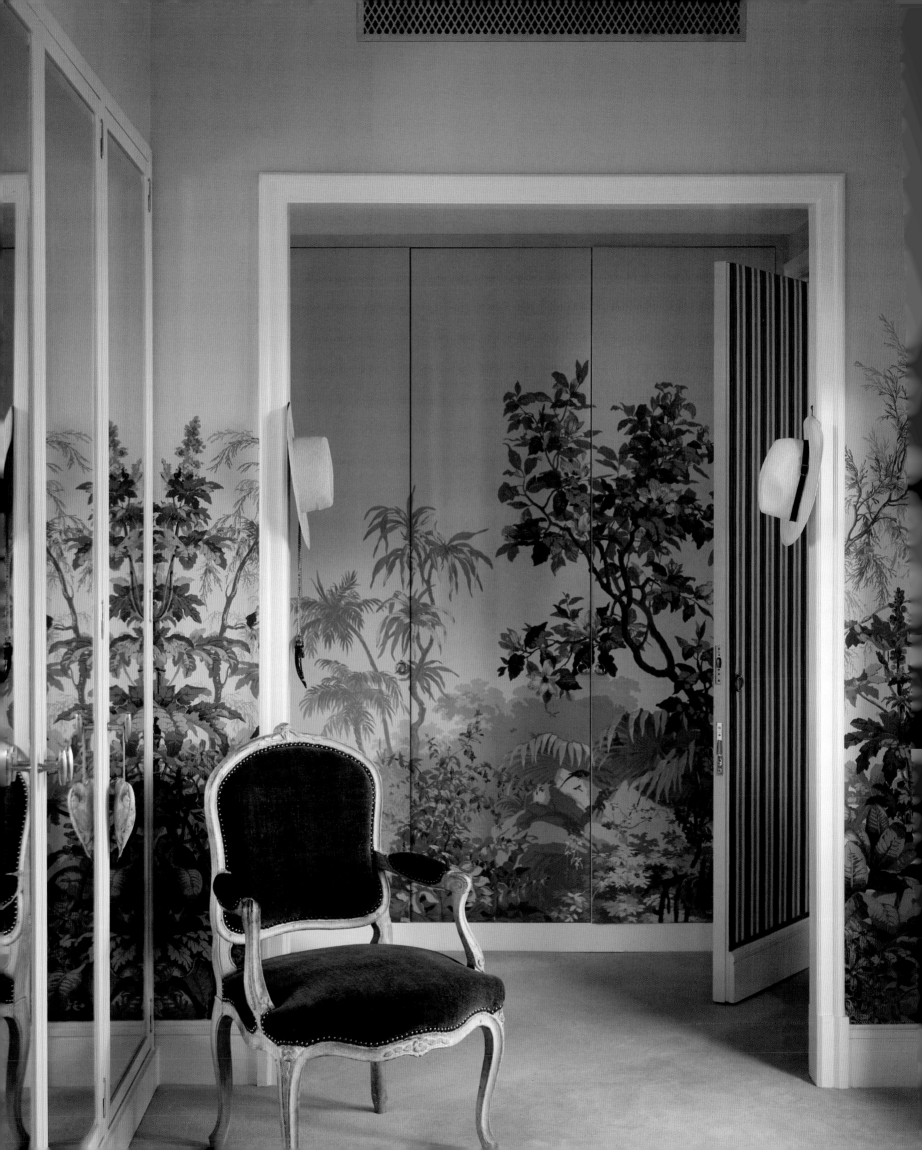

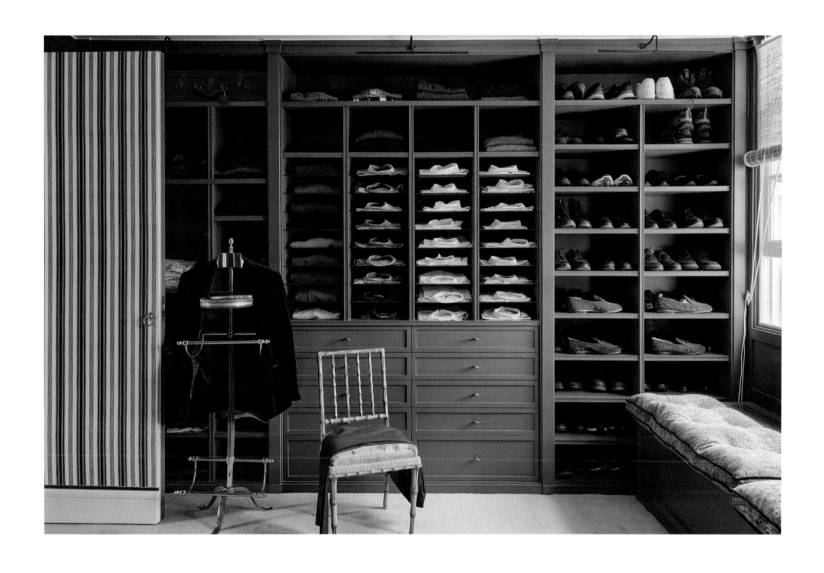

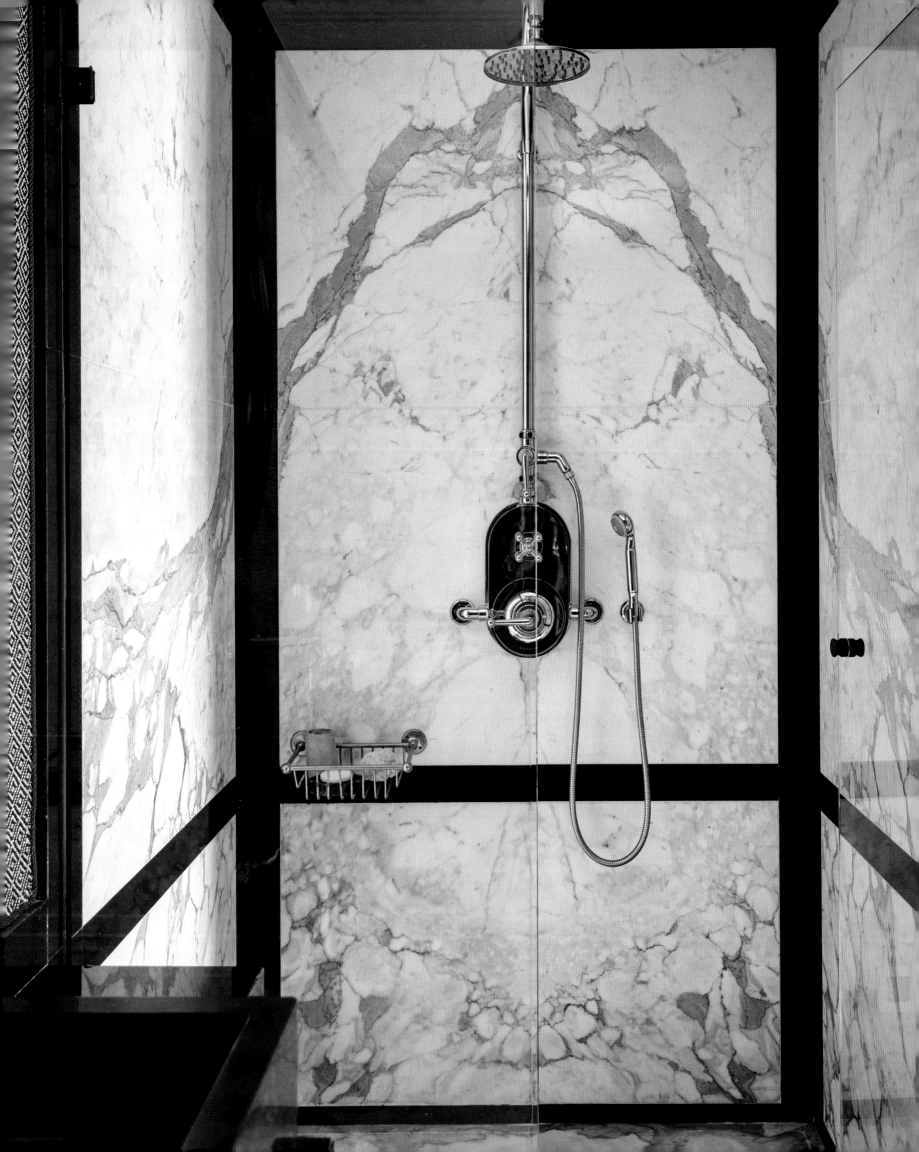

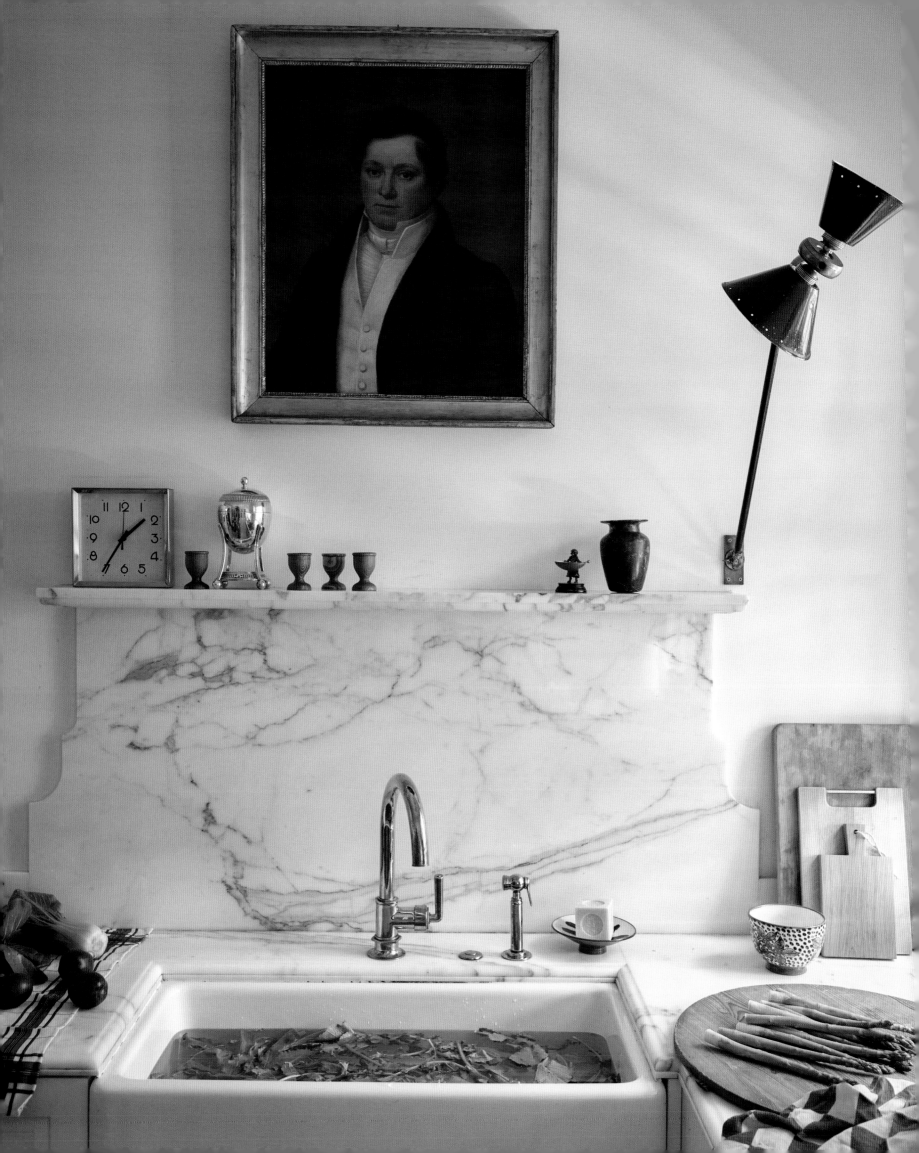

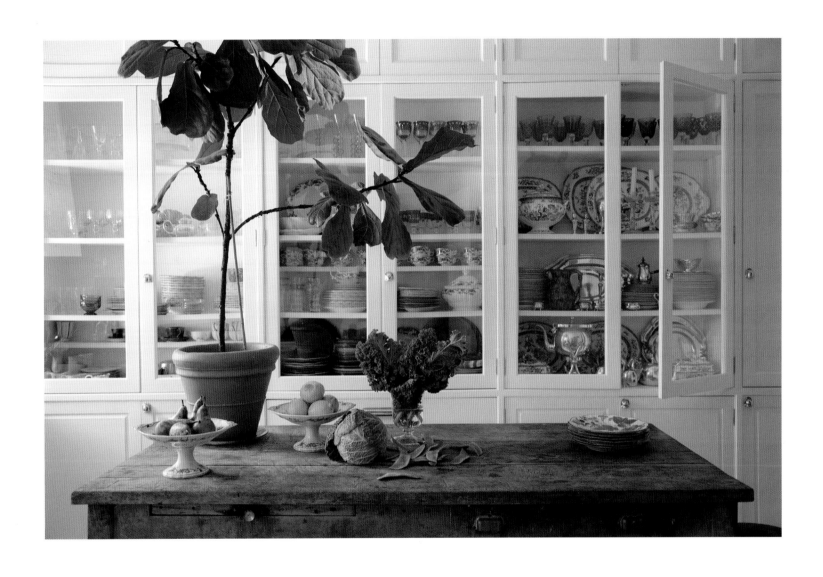

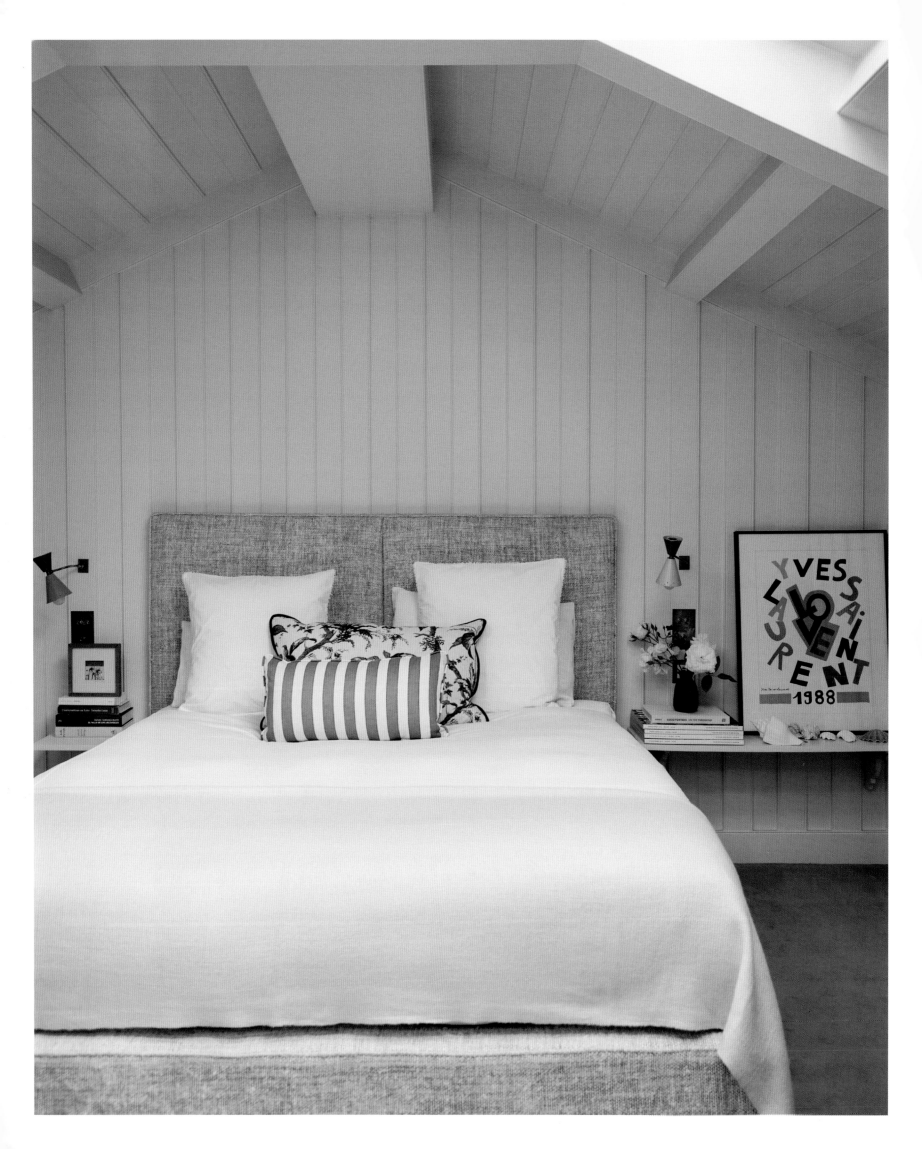

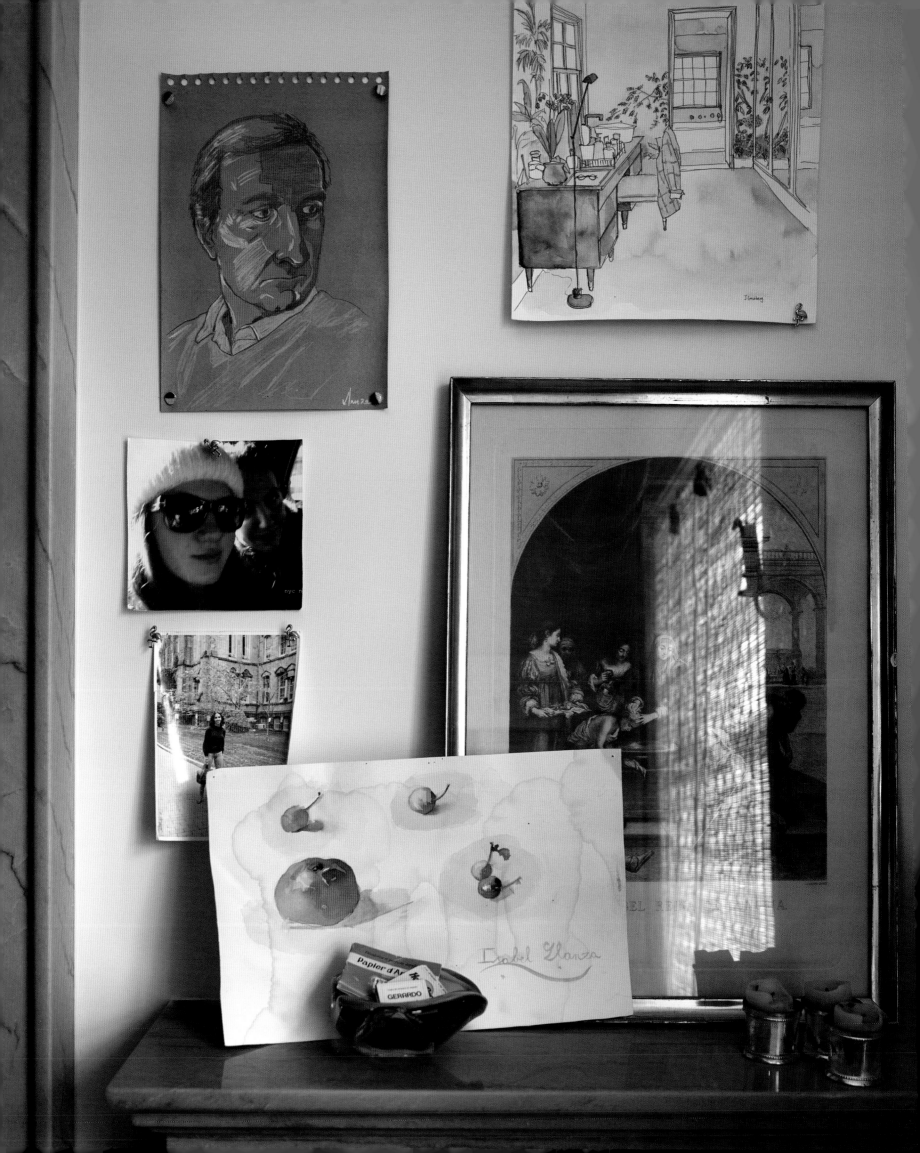

PAGE 21 A collection of vintage coral atop a white marble mantelpiece—the right-hand piece was mounted onto a brass and acrylic stand in the 1970s. A small painting by Francisco Bores hangs above on the Aldo Tura panels that cover the walls.

PAGE 22 In the entrance hall, next to a Gonzalo Lebrija painting, is a 1950s lacquered walnut table for holding keys and mail. A turquoise Manises lamp with a chocolate shade stands out against the off-white wall.

PAGE 23 With large French doors to the west and a sash window to the south, the dining room feels like a sunroom. The walls are covered with raffia, and the windows with straw blinds. The corner sofa, upholstered in striped English fabric, mirrors the shape of the courtyard bench. A painting by Günther Förg fills the wall space, and four eighteenth-century polychrome French Louis XVI chairs ensure there is seating for ten.

PAGES 24–25 View of the central fireplace in the lounge. The room is lined with incredible panels. A French Louis XVI desk sits to the left of the fireplace, and baskets of firewood to the right. A large English rug covers the marble floor. The curved sofa, Eames chair and ottoman, and Italian lounge chairs are all upholstered in white and—along with the white marble central table and fireplace—stand out against the wall panels.

PAGES 26–27 A black floor-to-ceiling bookcase runs the length of the wall opposite the fireplace. The central section holds a seventeenth-century tortoiseshell mirror that has been passed down through the family. On the left is an eighteenth-century horsehair bench from Sweden.

PAGE 28 Lacquered goatskin panels reflect the light and the flowers like a mirror and create a stunning contrast with the white French doors, rugs, and garden bench. The 1960s Italian chairs and Vitra footstools frame the socializing area around the fireplace.

PAGE 29 The courtyard, designed by Fernando Caruncho, features a large corner bench in solid Macael marble. A small fountain set in the tricolor floor is a focal point among magnolias, jasmine, and roses. The reflections and play of light in the water are transporting.

PAGES 30–31 In the primary bedroom, lined with striped English fabric, the bed sits opposite the French doors to the terrace. A Blaze Lamper drawing hangs above a nineteenth-century French chest of drawers.

PAGE 32 A pink armchair and footrest by the French doors opening onto the terrace add a softer touch to the gray and black decor of this bedroom. The Imari lamp with a navy shade has been in the family for years.

PAGE 33 This beautiful terrace, reached from the dressing room and bedroom, has the same three-stone flooring as the courtyard below. Wisteria, roses, agapanthus, and plumbago grow here. A wicker chair nestles among the plant pots, next to Fernando Caruncho copper lanterns.

PAGE 34 Isabel's bathroom at the back of the dressing room benefits from southern and eastern light. Brazilian gray-striped quartzite lines the area around the freestanding bath, shower, and toilet. An English bathtub sits between the window and the door and is adorned with gold American-style taps.

PAGE 35 Isabel's dressing room is lined with Zuber Isola Bella wallpaper with wall-to-wall mirrored closets along one side. The black dressing table includes a sink and doubles as a dresser.

PAGE 36 The entrance to the dressing room is illuminated with light from the terrace. A French Louis XVI chair, upholstered in deep blue velvet, creates a break in the Isola Bella wallpaper.

PAGE 37 Isabel's husband's dressing room features dark gray wood with a bench under the windows for packing suitcases. A beige carpet covers the floor.

PAGE 38 The dressing room leads to a bathroom. A solid basin carved from a single piece of stone sits atop a black Zimbabwe granite shelf.

PAGE 39 The shower is lined with Italian Arabescato marble edged in black, with nickel-colored American fittings.

PAGE 40 In the kitchen, an English porcelain sink is set in Italian marble, with a splash back carved in a vintage 1920s shape. Above the sink, a 1960s lamp is positioned next to a portrait of Uncle Patito inherited by Isabel.

PAGE 41 Opposite the sink, a painted wooden cabinet holds dinnerware, glassware, and silverware, with table linens stored in the bottom section. The kitchen table is solid French oak.

PAGE 42 The guest room, located in the attic, is paneled in painted wood. Four skylights flood the room with daylight and 1960s wall lamps in different colors add an original touch.

PAGE 43 The laundry room is also in the attic and has the same wood-paneled walls. An Italian marble basin is set on a cabinet, and white cupboards hide the washing machine, tumble dryer, and cleaning products. Four more skylights let in the light from above.

PAGE 44 A drawing of Isabel's dressing room by Julia Grunberg; a portrait of her husband drawn by their son Álvaro; a photo of Isabel and her eldest daughter Claudia, aged twenty, and another photo of Isabel at the University of Pennsylvania; a watercolor by younger daughter Isabel; and a print of Saint Isabel of Hungary inherited from Isabel's grandmother, also named Isabel.

STARTING OVER IN THE ATTIC

The huge transformation of northern Madrid began in the 1950s, after the Spanish Civil War and the post-war period. Santiago Bernabéu, Real Madrid's football stadium, is a gateway to this area, which is full of modern buildings on one side of the Paseo de la Castellana, and prestige apartments in spacious, leafy areas and the center of the El Viso district on the other. The project was in a 1950s attic apartment with a garden, typical of this area that's so beloved by the people of Madrid.

The clients were a couple with grown-up children who wanted to adapt their home to their new and future needs. The idea was to completely remodel the apartment, although existing pieces were reused where possible. These included an antique gilded and marbled bookcase, which moved to the dining room after being stripped to reveal the original wood. The kitchen furniture was inspired by pieces found in the old apartment.

The relocation of the bedrooms was the most drastic change. The rooms originally led out onto the large terrace, but in the new layout—completed in the summer of 2020—the lounge, dining room, and living room moved to this part of the property. The new location provided access to the outdoors from these rooms, creating a large communal inside–outside area perfect for eating or enjoying the outdoors almost all year round. The terrace features a pergola, teak and iron furniture, two tables holding potted plants, and a basin water feature that little ones can take a dip in; it also serves to drown out traffic noise from the street. The terrace continues around the house, narrowing somewhat, so all the bedrooms enjoy plenty of light and have access to an outside space filled with flowers and plants. The living room was opened up into a large sunroom. The original brick was left intact, maintaining the character of the space.

A photograph from the *Danza Cubana* series by Spanish photographer Isabel Muñoz commands the hallway, while a beautiful sculpture of the goddess Diana Cazadora (Diana the Huntress) presides over the lounge. The dialogue between two velvet sofas—one curved and pink, the other black—along with 1960s armchairs and a balanced selection of classical and contemporary art creates a beautiful ambience. The combination of colors, the light from outside, the plant life, and the antiques—many relocated by López-Quesada to give them a new lease on life— create a serene atmosphere, enveloping the space and transforming this attic into a sophisticated and timeless abode in northern Madrid.

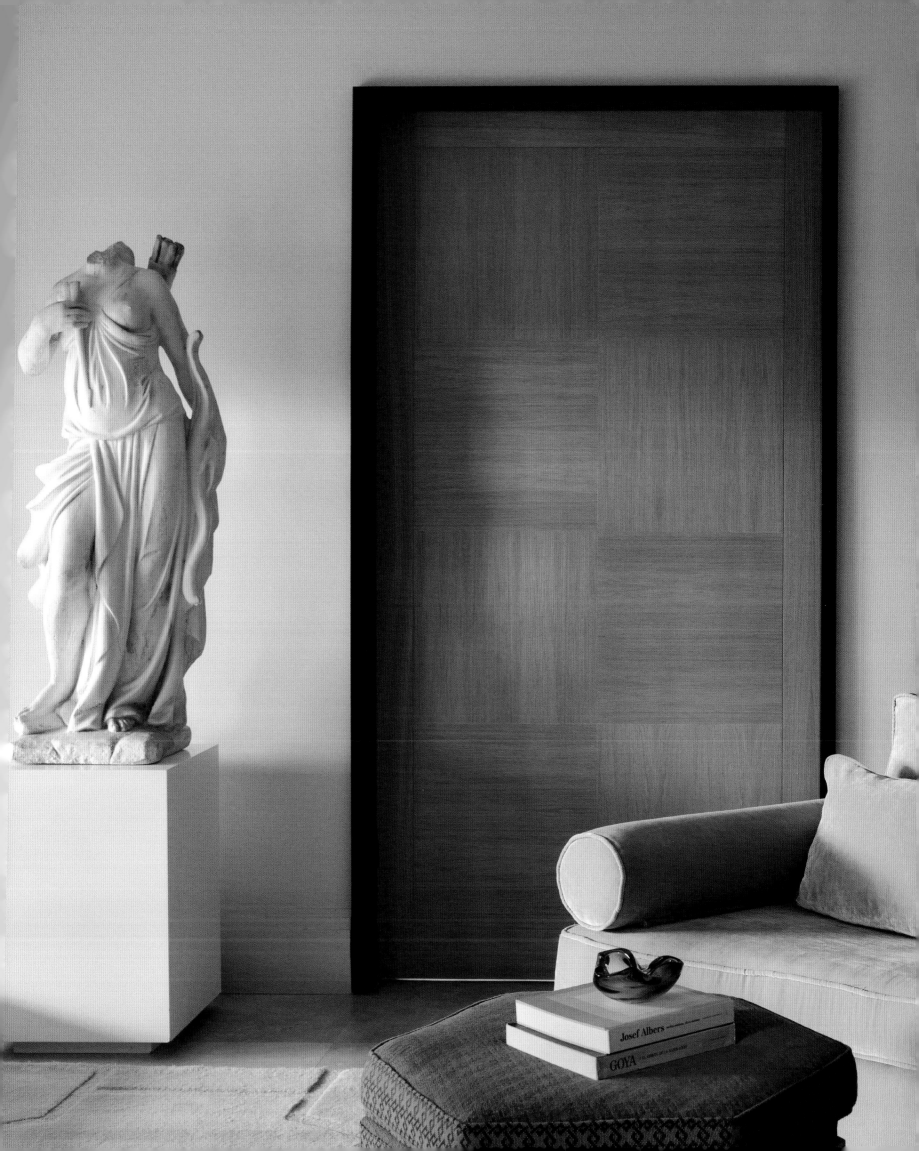

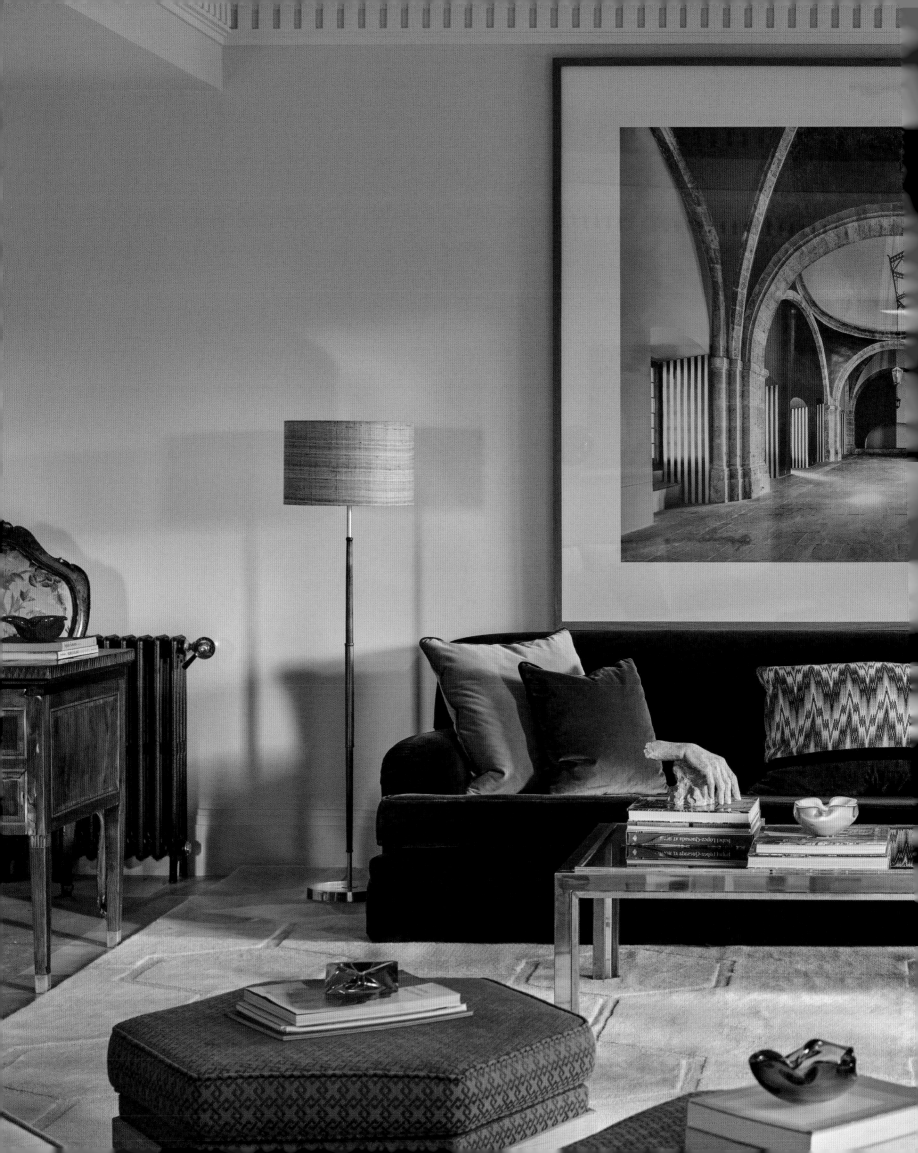

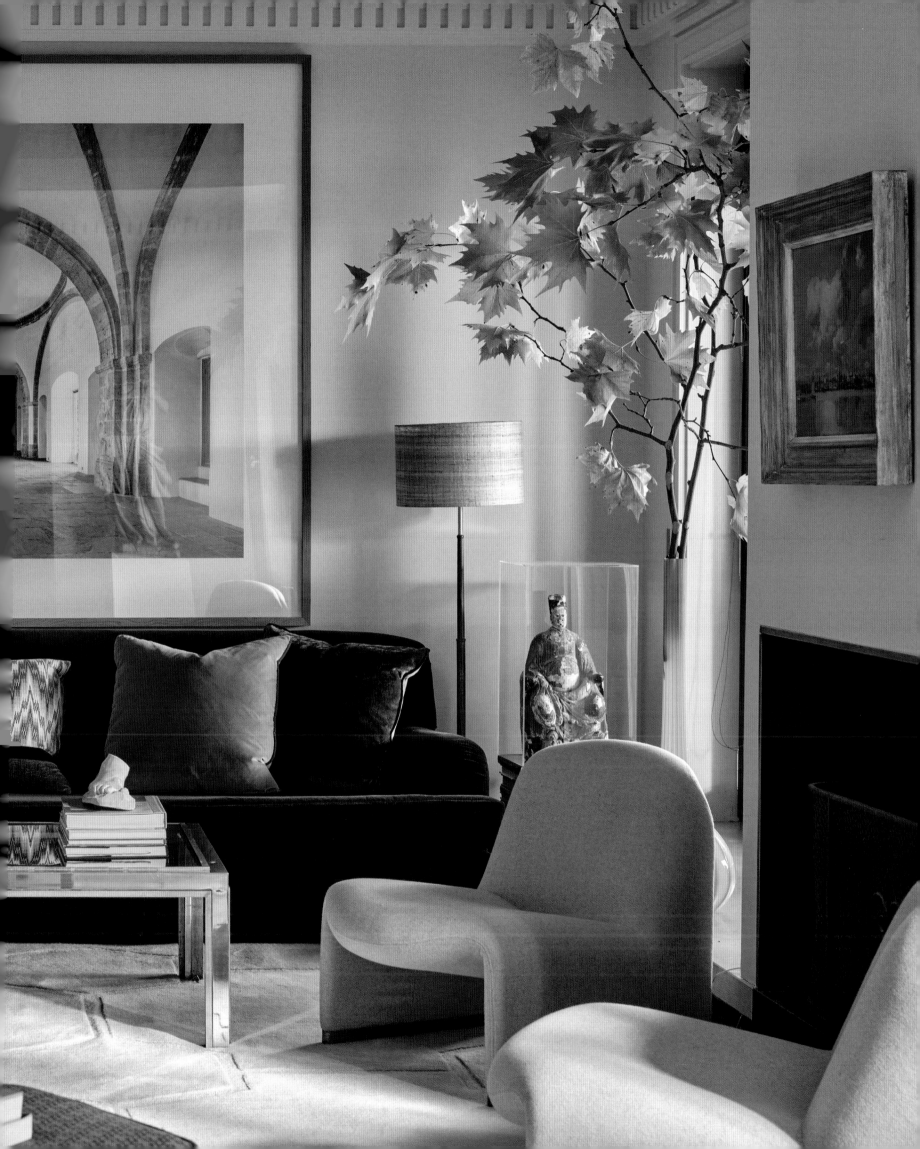

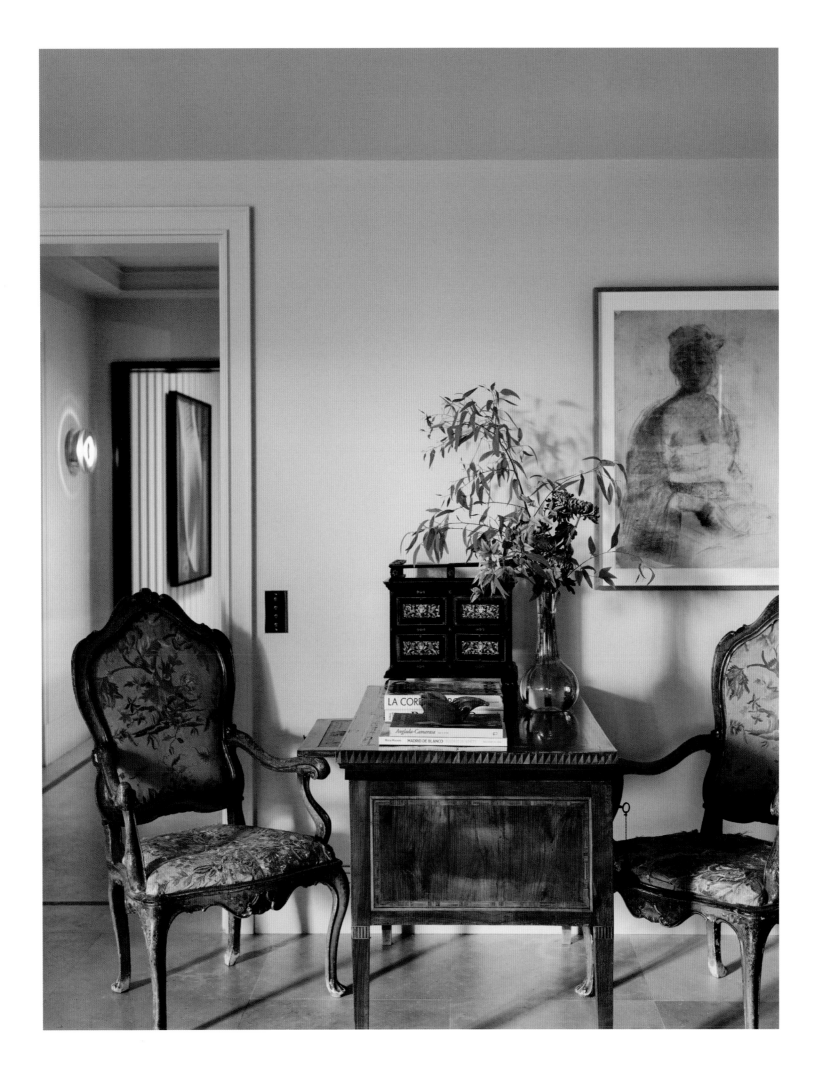

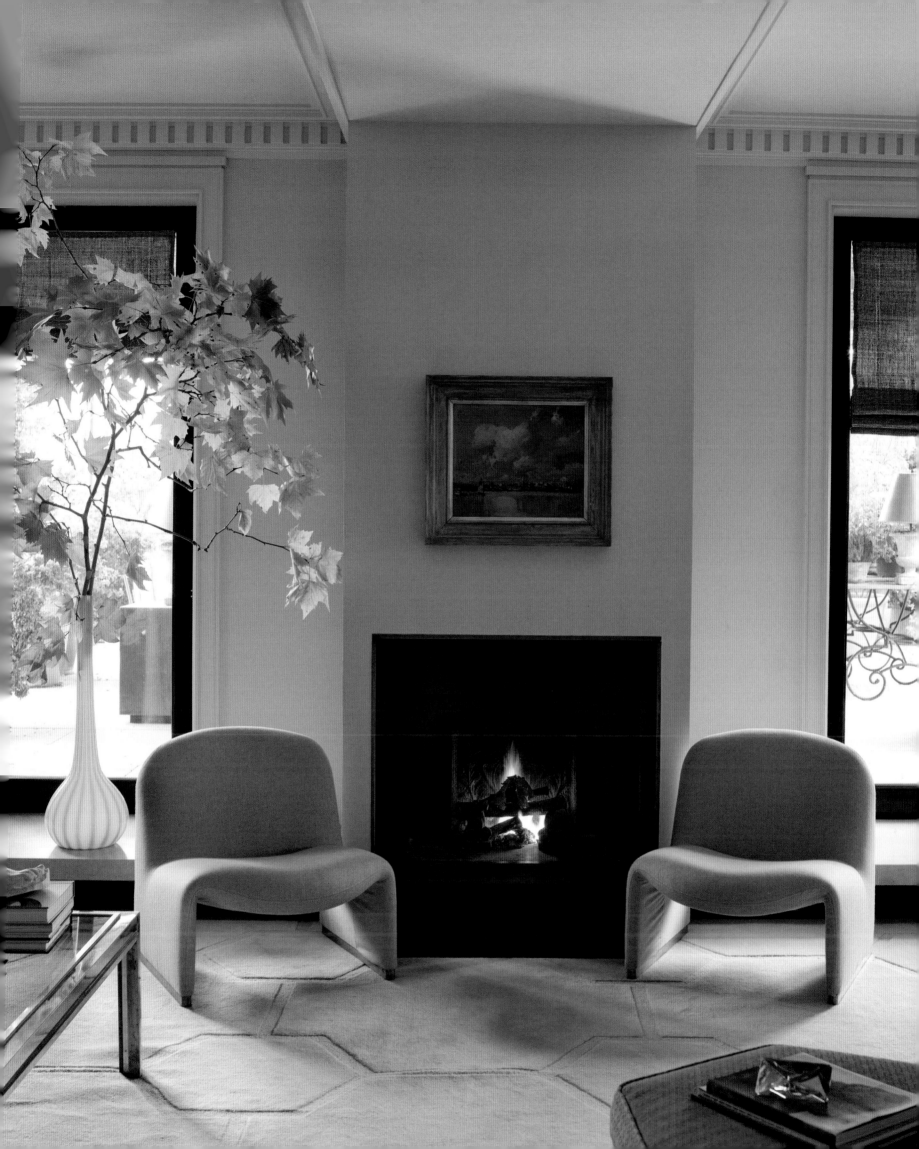

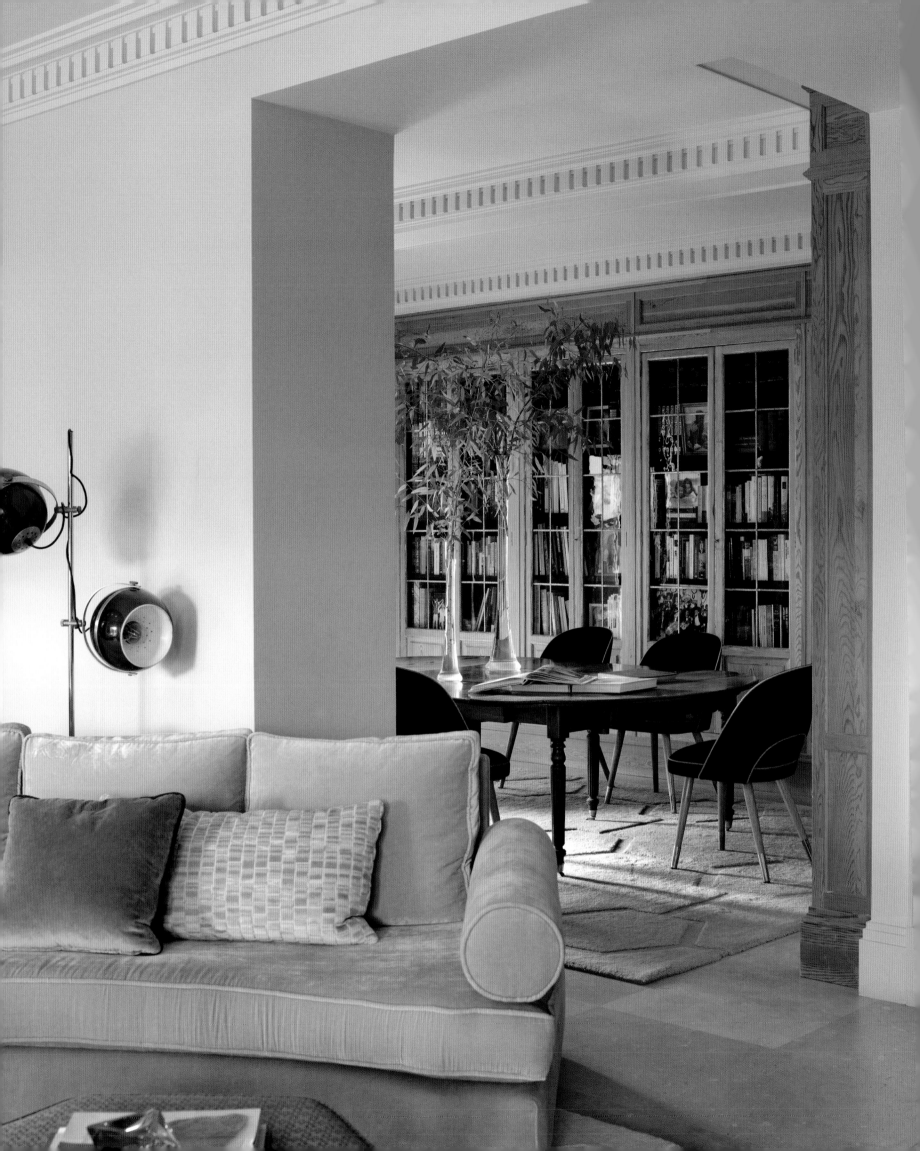

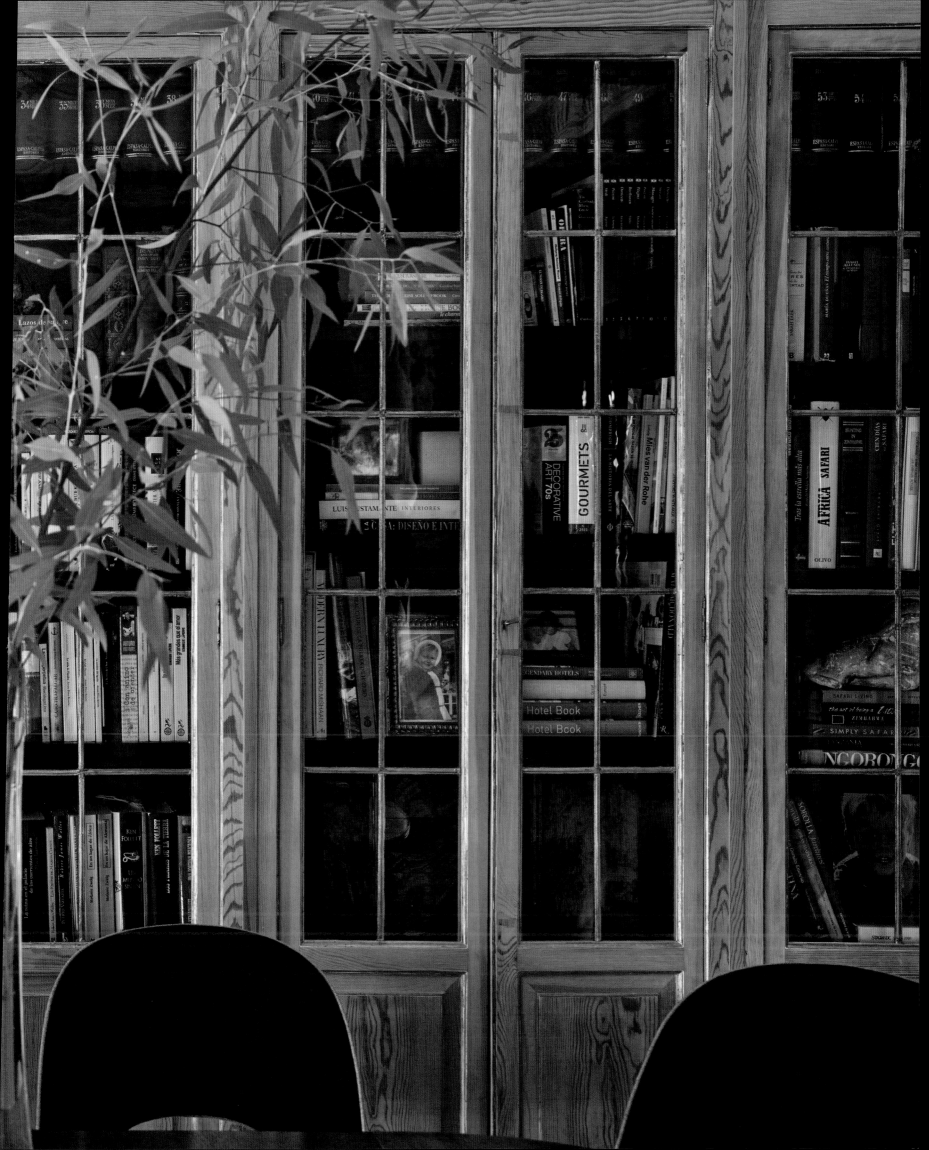

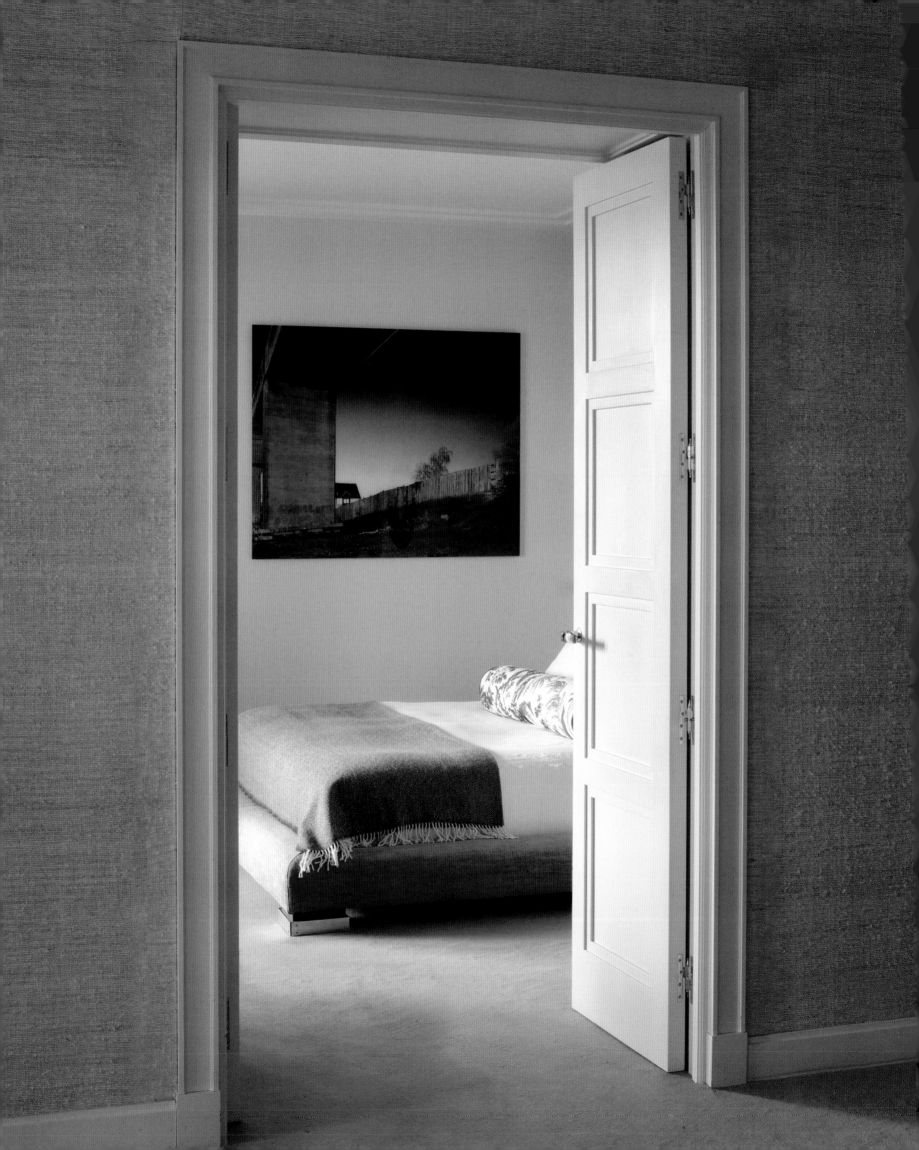

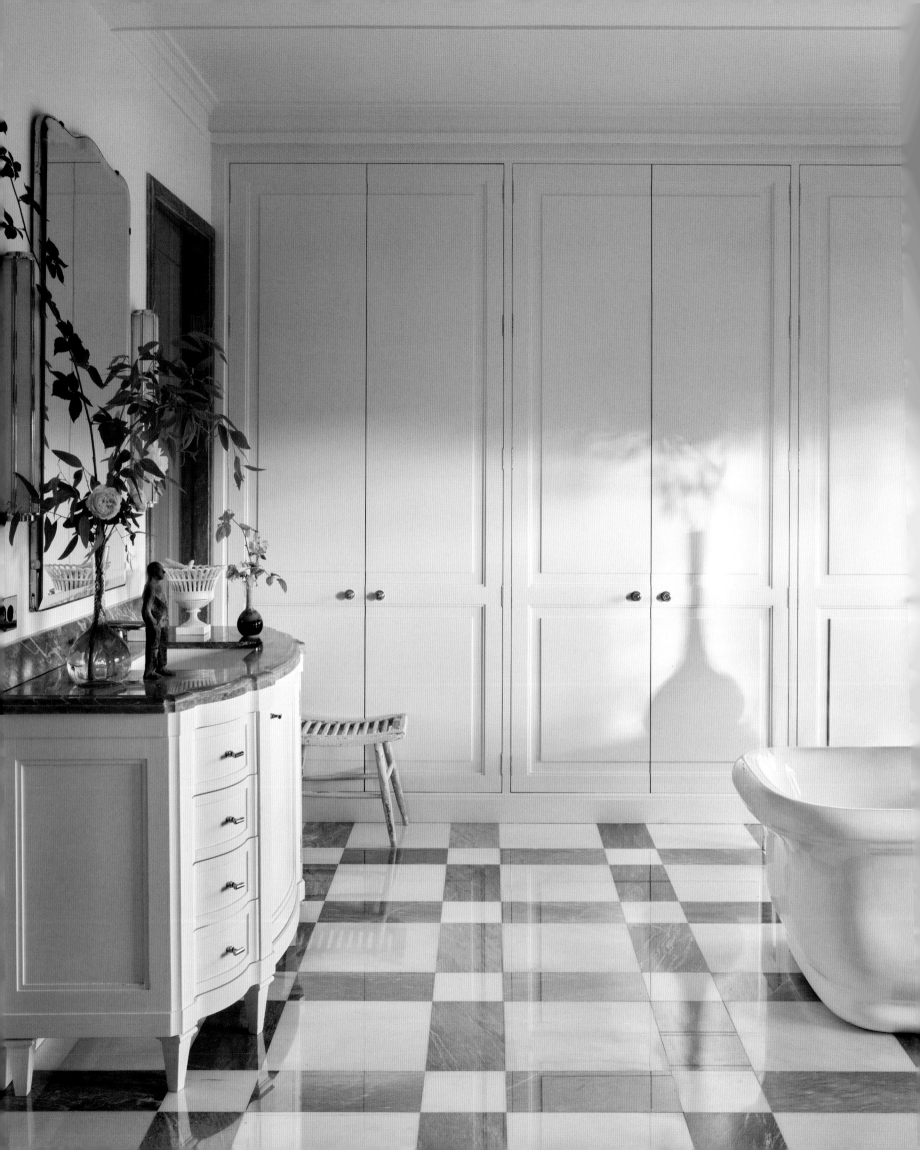

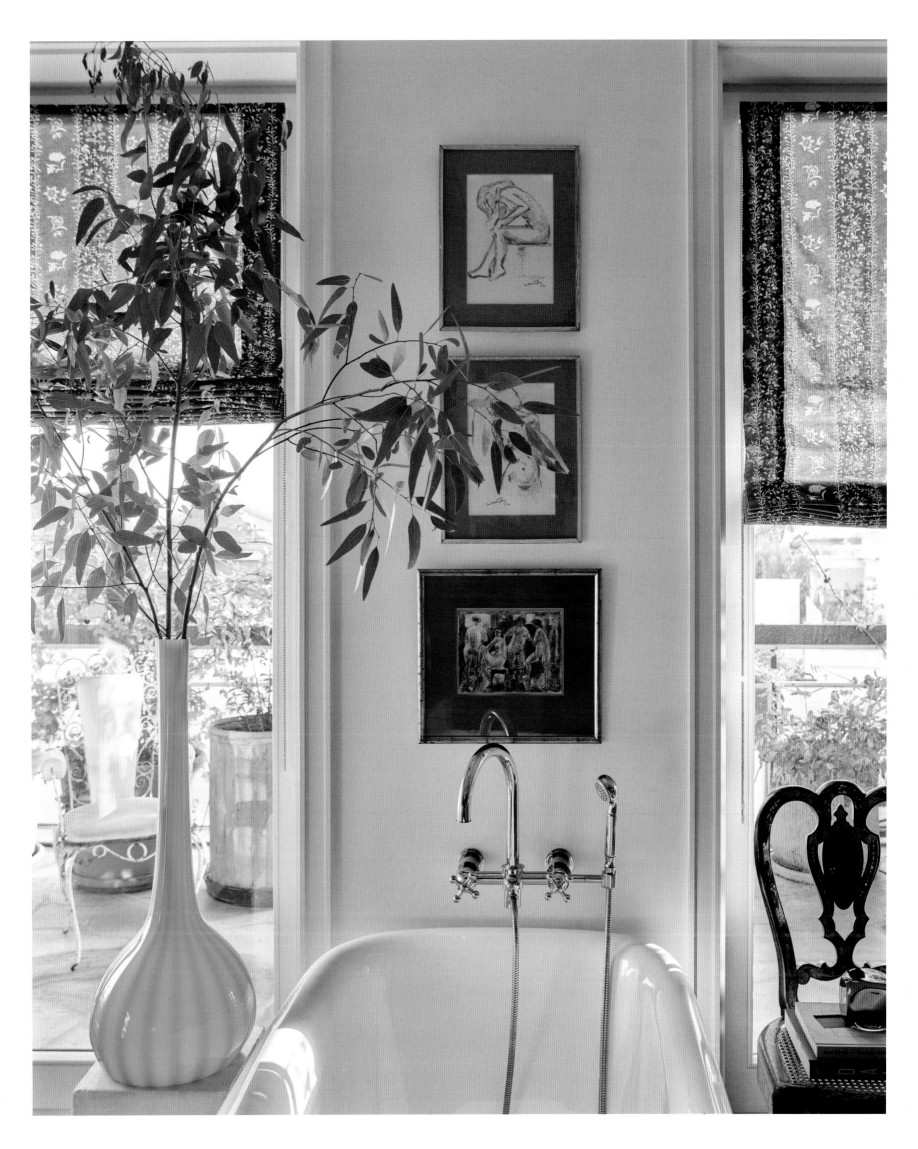

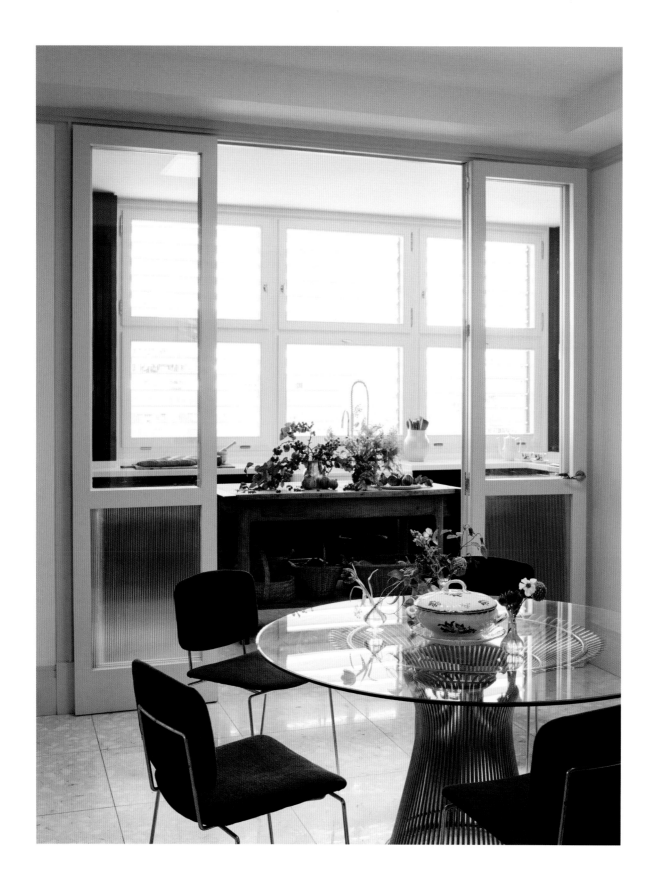

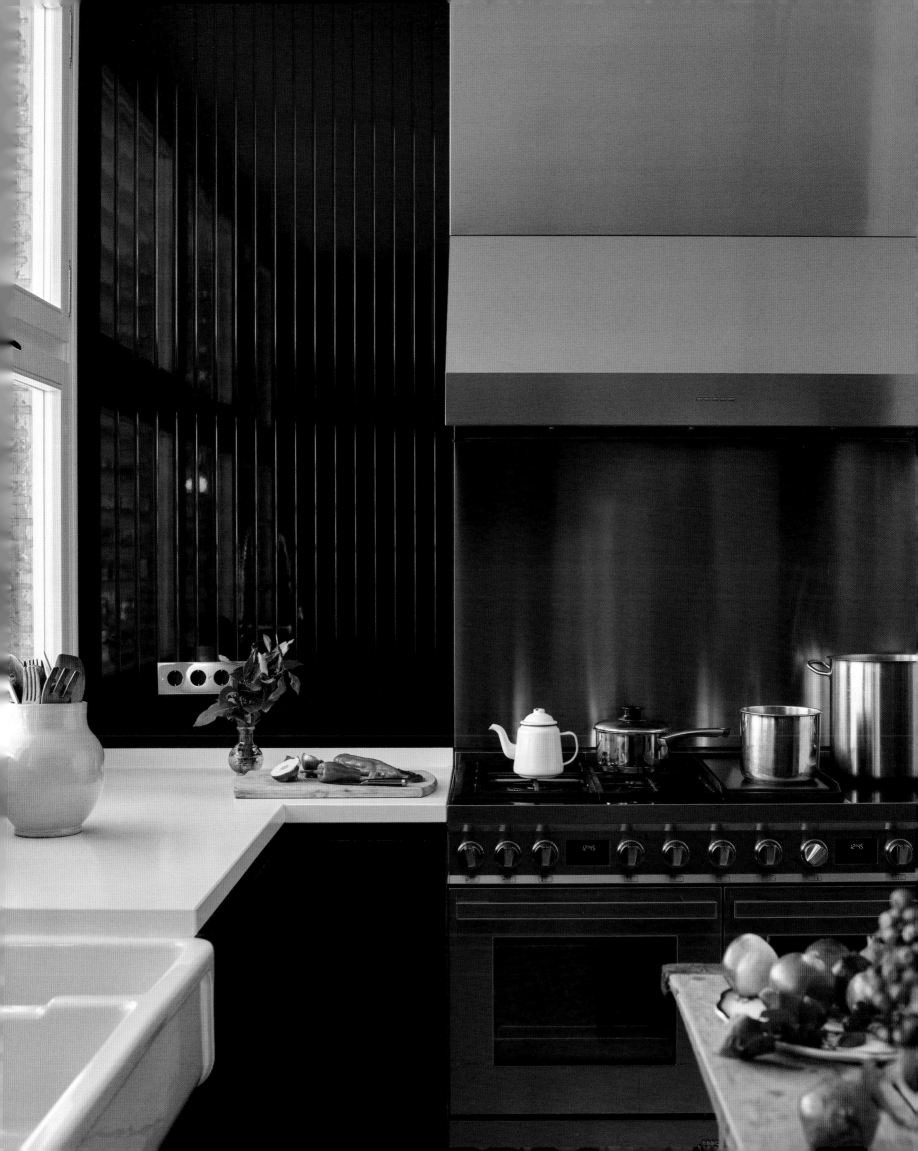

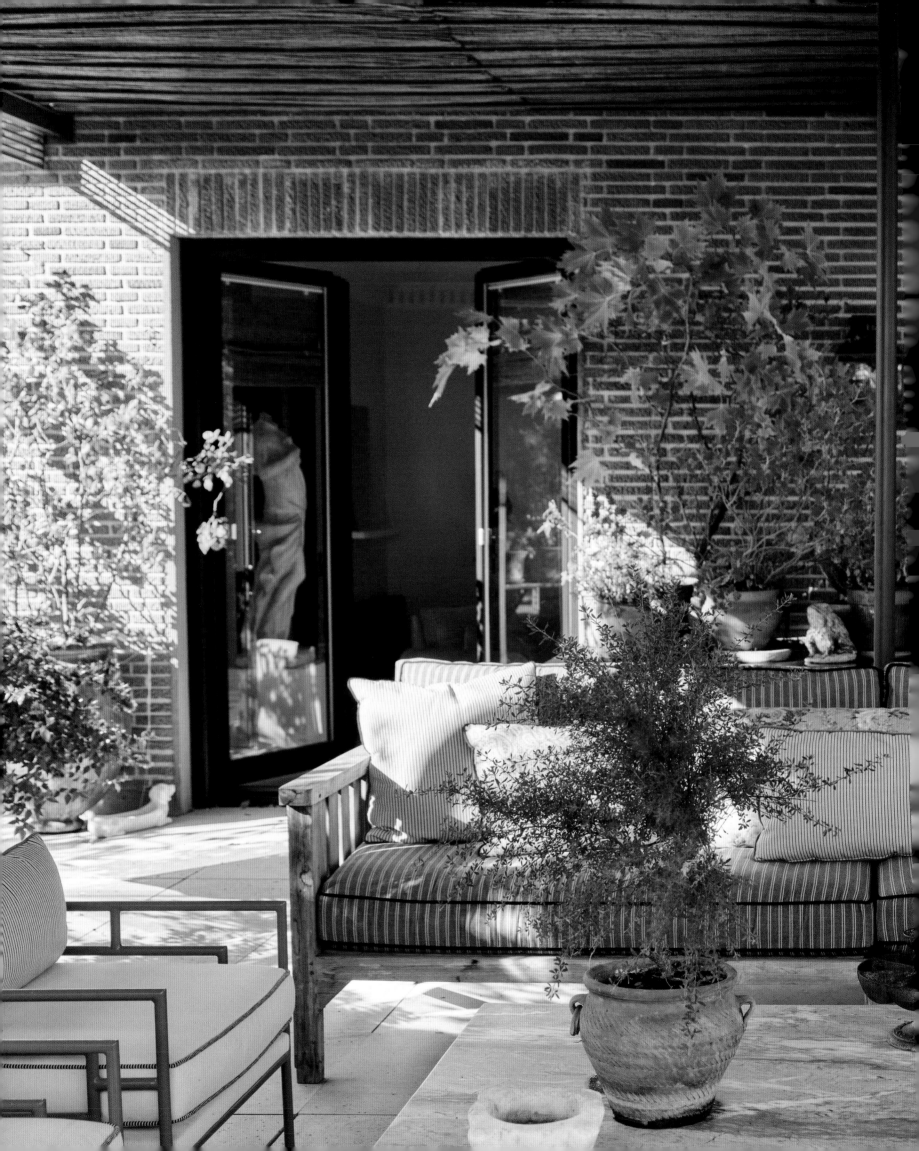

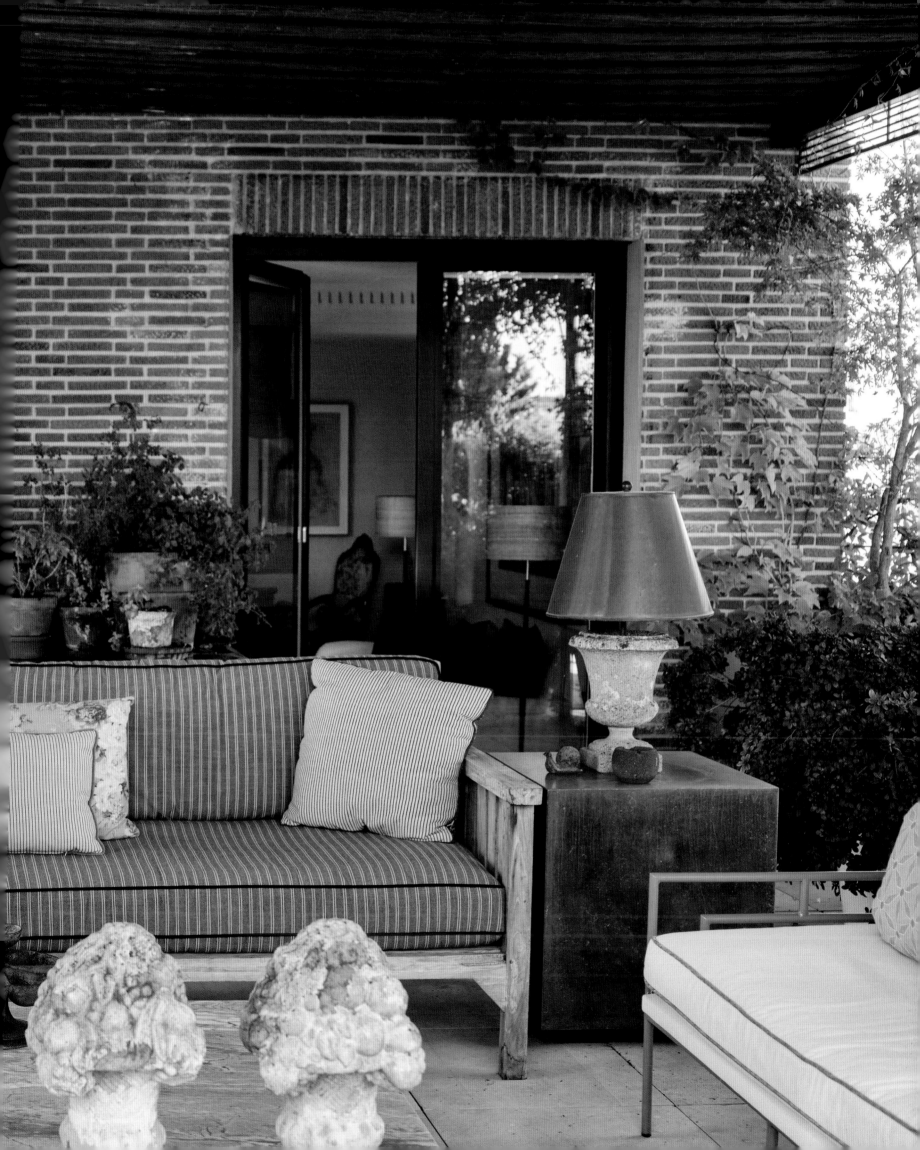

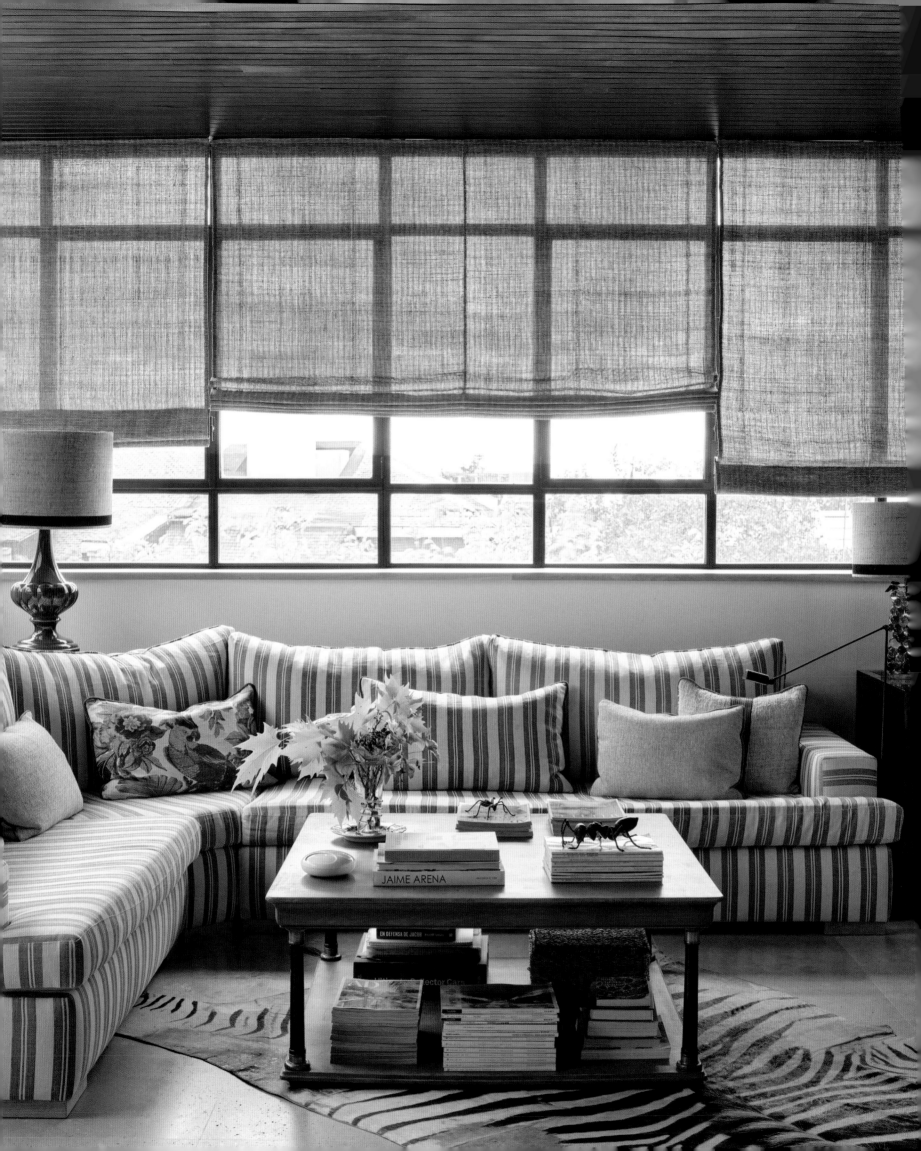

PAGE 47 In the lounge, a marble statue of Diana Cazadora (Diana the Huntress), gently washed in natural light from the courtyard, is magnificent next to the natural oak door that joins the lounge and the living room.

PAGES 48–49 A focal point of the lounge is a large 2015 photograph by Candida Höfer, entitled *Hospicio Cabañas Capilla Tolsá from Daniel Buren, work in situ Guadalajara I*, which hangs above the black velvet sofa. Two 1960s standing lamps and a coffee table, lounge chairs, and footstools from the same era sit on a large wool rug with a geometric pattern, all centered around the fireplace.

PAGE 50 On one side of the lounge is a Spanish Charles IV desk with two eighteenth-century Venetian chairs, all passed down through the family. A painting by Manuel Benedito completes the arrangement.

PAGE 51 A pair of 1970s Giancarlo Piretti for Castelli lounge chairs upholstered in natural wool sit flank the fireplace, over which hangs a painting by Spanish Impressionist Eliseu Meifrèn. Glazed doors on either side of the fireplace lead out to the courtyard.

PAGE 52 View of the library/dining room from the lounge. An extra-wide antique French table with 1960s black velvet chairs, surrounded by whitewashed pine bookcases, make this a wonderful space for eating, working, or reading. In the foreground, a faded pink velvet sofa with a mustard and turquoise footstool create a gorgeous color combination.

PAGE 53 A Lluís Hortalà artwork in the library/dining room.

PAGES 54–55 These bookcases have been part of the house since the 1950s. They were originally different colors, with gold flecks and marble effects, and were kept in the living room. During the renovation, they were dismantled, sanded down, restored to natural pine with just a hint of gold, and relocated to the library/dining room by the lounge.

PAGE 56 The primary bedroom is reached via a dressing room lined with woven Italian fabric —including the wardrobes. The bed is covered in Belgian brick-red linen and the carpet is a cinnamon color. A Christophe Dougier photograph hangs on the far wall.

PAGE 57 The dressing room, as seen from the primary bedroom, with the bathroom in the background. In the bedroom, a Jacinta Grondona sculpture stands on the bedside table; to the right of the doorway is a French desk passed down through the family. A chaise longue in the dressing room is upholstered in the same floral fabric as the bathroom blinds.

PAGE 58 Both the bathroom and primary bedroom have access to a long, narrow south-facing terrace, providing the suite with plenty of light and incredible views. The stunning flooring is created from white and gray Bardiglio marble. The washbasin unit was inspired by a similar one from the 1950s that was salvaged from the house.

PAGE 59 In the bathroom, an English tub is installed between the two patio doors for the best view. On the right is an antique French chair with mother-of-pearl detail, and on the left a tall blue vase catches the light and holds greenery.

PAGE 60 In the new house layout, the kitchen was installed under a large window and a glass screen was created to separate it from the everyday dining room and dinnerware storage. The kitchen table is antique French oak; the dining table by Warren Platner is topped with glass and accompanied by vintage chairs upholstered in maroon fabric.

PAGE 61 Glossy navy paneling in the kitchen, inspired by the 1950s period of the house, contrasts beautifully with the white sink and work surfaces, the steel appliances, and the French oak table.

PAGES 62–63 The lounge and the living room/sunroom exit onto a vast, square-shaped patio, tiled in Spanish limestone. An iron and rattan pergola shelters the seating area, and a teak couch with Belgian striped cushions and English iron chairs surround an enormous stone coffee table. Pots filled with plants are dotted all around.

PAGE 64 Between the two terraces, this space was created for use as a living room and media room/library. The corner sofa is upholstered with a striped American fabric, the roller blinds are Filipino raffia, and the 1970s lamps are ceramic and natural glass. This light-filled room opens onto the lounge and the terraces.

A HISTORIC TRIPLEX IN LISBON

Lisbon has always been a poorly kept secret. One of the prettiest cities in the world,
it's experienced a huge surge in tourism in recent years. Its picturesque streets and lovely
old houses have an eternal beauty when bathed in the light of the Atlantic and the Tagus.
The commission for this property in the historic Lapa district, one of the most elegant and
dignified in the Portuguese capital, came from a couple who love art and travel. They had
purchased the attic-duplex above their existing apartment and terrace, seizing the opportunity
to recreate their space as a triplex high above the city. The work was completed in 2013.

Two different stairways were chosen to connect the three floors: a stone staircase joins the
first and second floors, and an iron and wood spiral staircase in the center of the lounge
gives access to the third floor. López-Quesada decided to make this second staircase—which
connects the lounge and its adjoining terrace, the office, and the kitchen with the primary
bedroom, dressing room, and bathroom, and the library—a feature, rather than move it to the
rear of the property. The wooden floor in the lounge was painted black and left uncovered, and
the original windows were retained. The Belgian stone fire surround is also black, a response
to the property's restrained, pared-back style. Jeweled antique furniture emanates a sense of
both old and new.

One of the principal characteristics of this project was also its main challenge—the owners are
art collectors with a splendid selection of seventeenth-, eighteenth-, and nineteenth-century
furniture from Spain, Portugal, and Portuguese India. The collection includes chairs, tables,
desks, cabinets, and sideboards, with items made in palo santo and teak, decorated in some
instances with ebony and ivory. These stunning pieces feature throughout the property,
along with a collection of paintings and pictures that includes Andy Warhol, Alexander Calder,
Robert Rauschenberg, Joaquín Torres-García, and the Flemish school. The details of this three-
story property reveal a cosmopolitan, well-traveled life, woven with the tranquil and calm
atmosphere that is so characteristic of Lisbon, and particularly of the refined Lapa district.

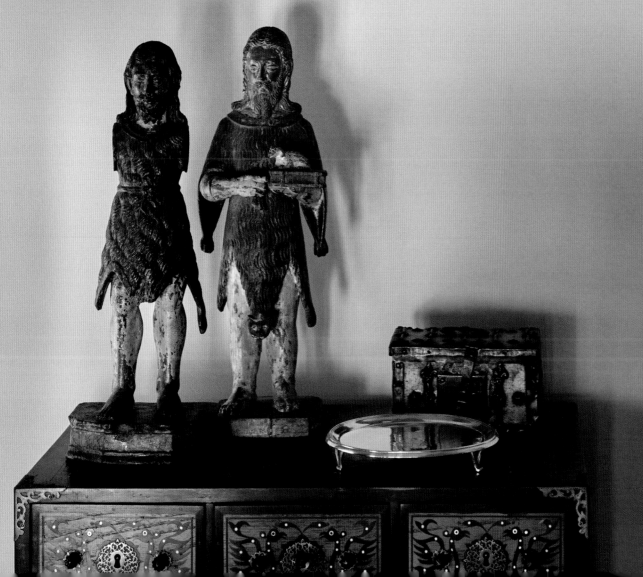

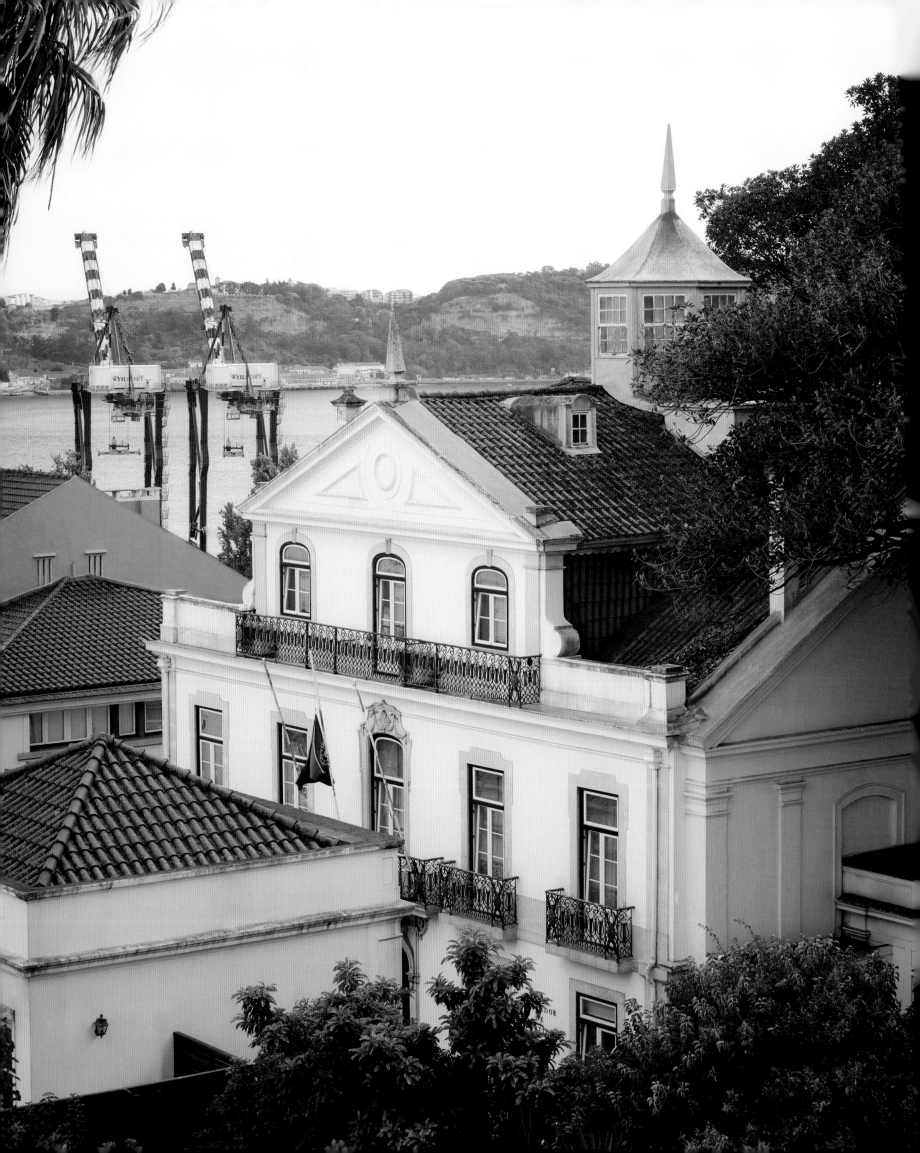

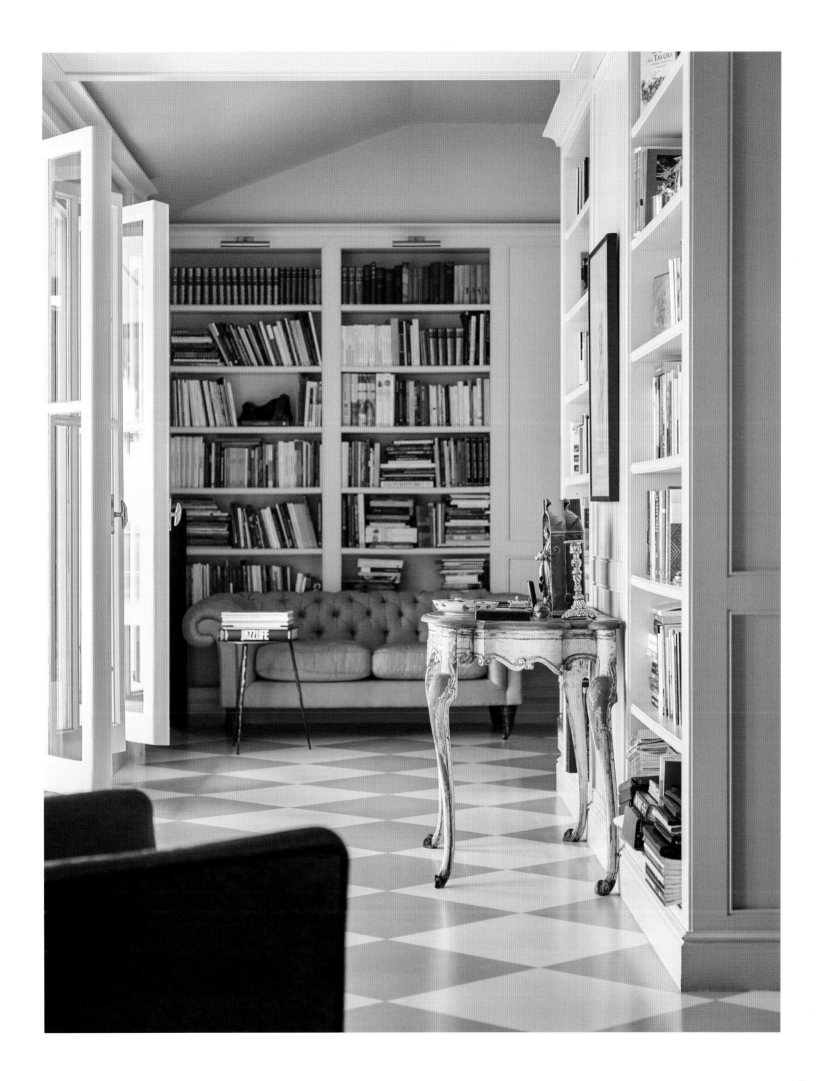

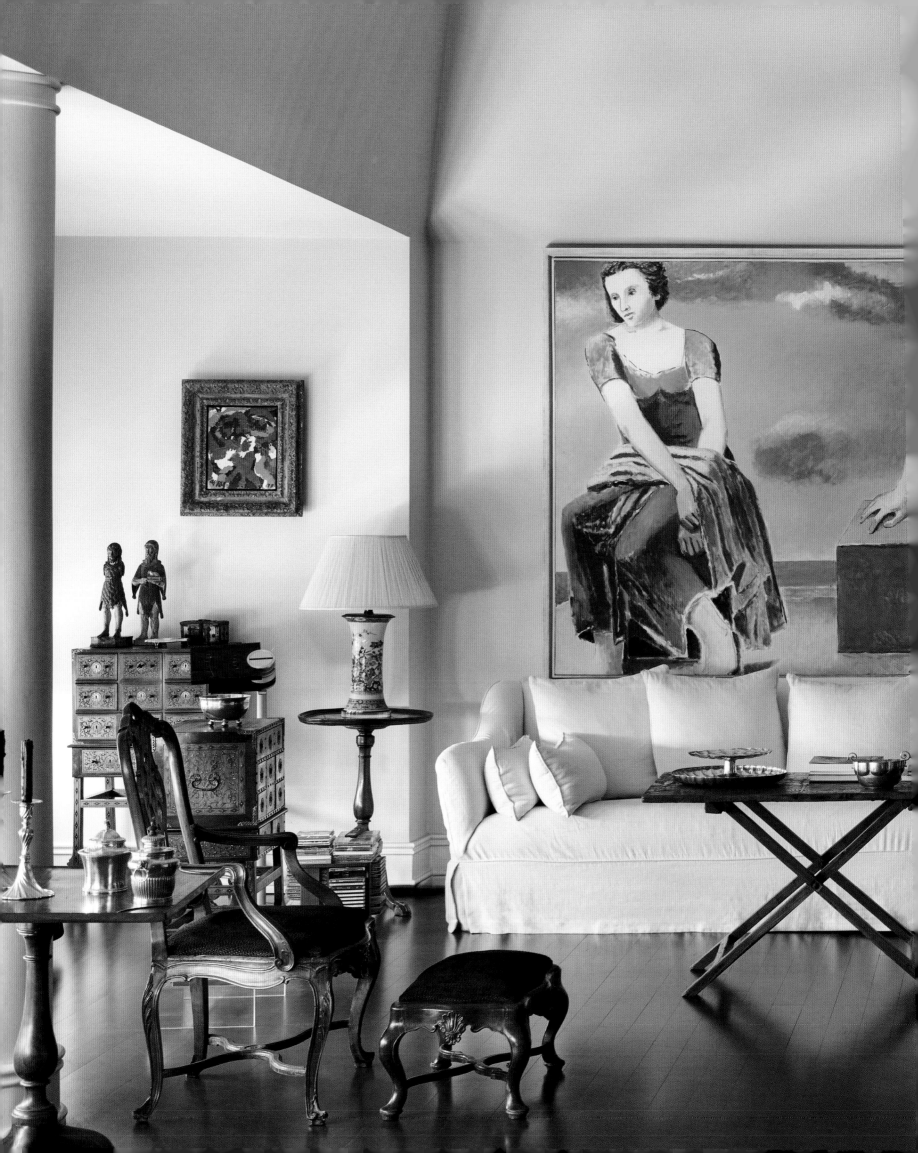

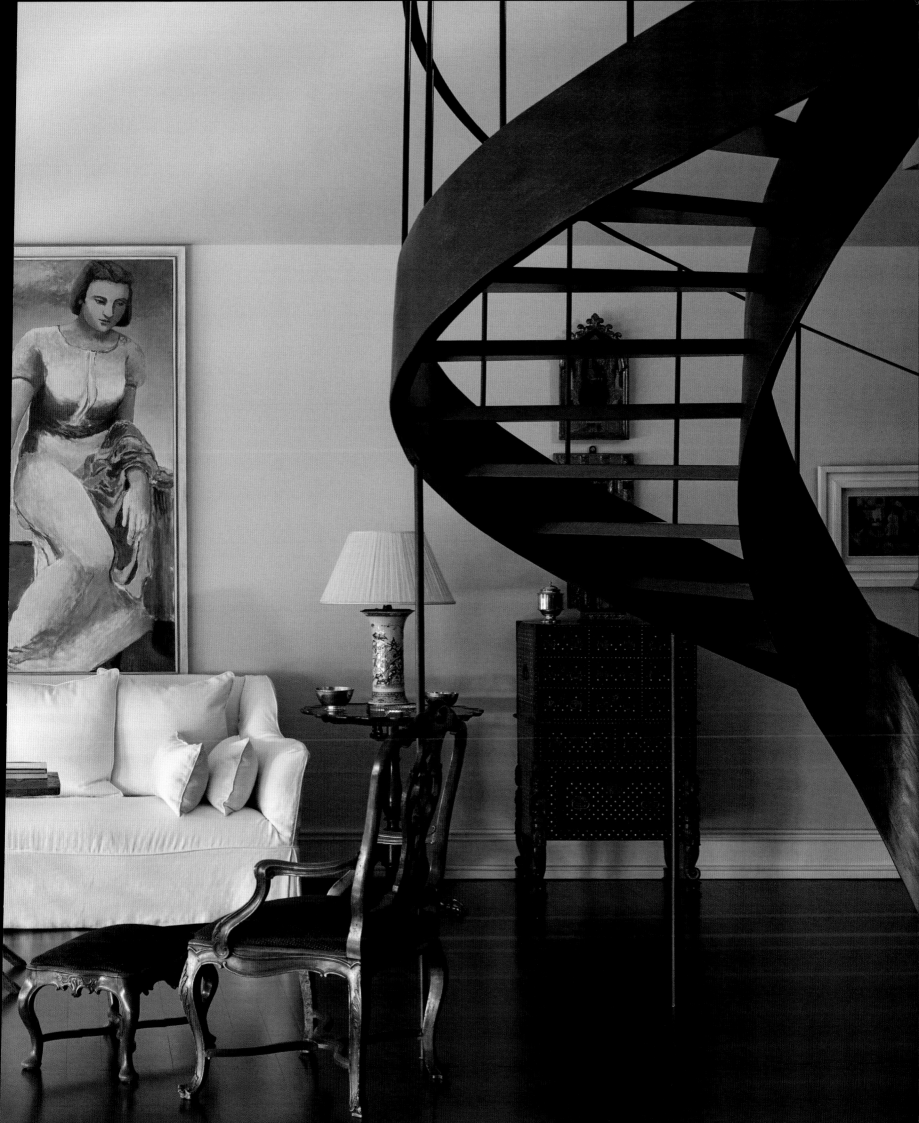

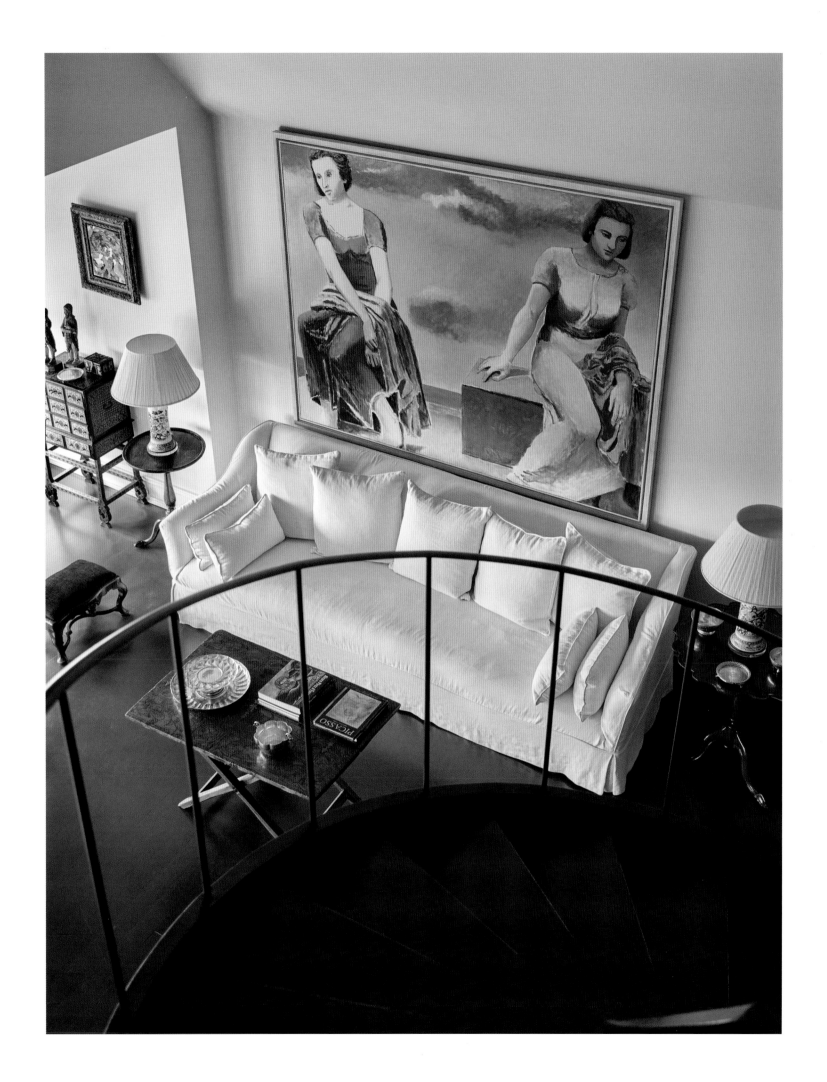

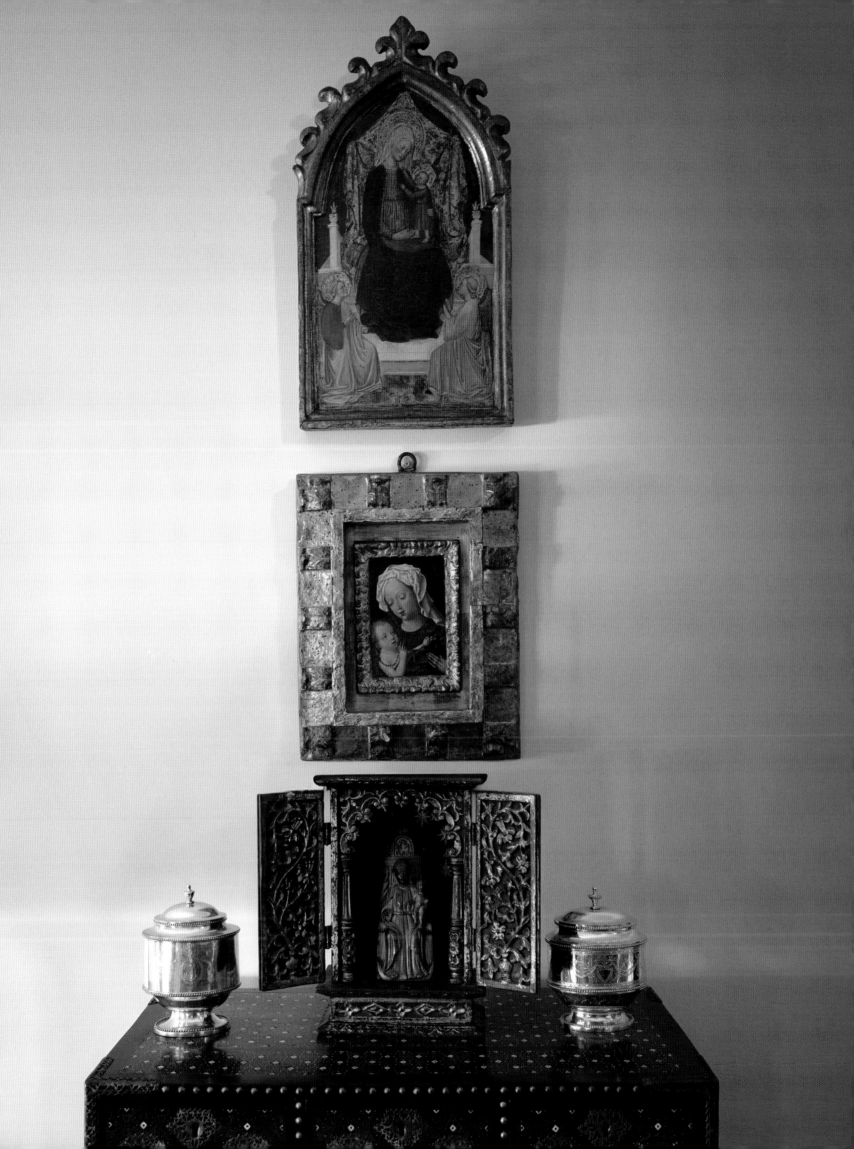

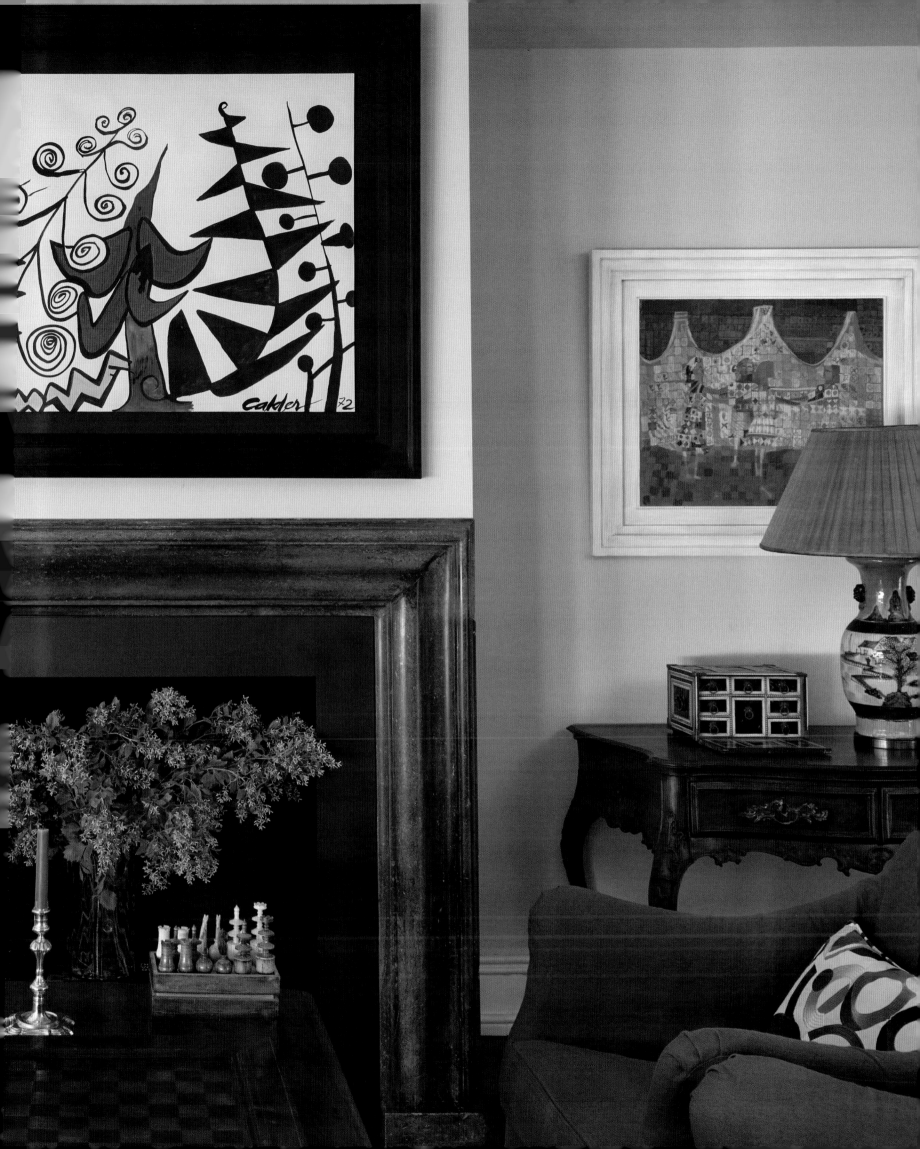

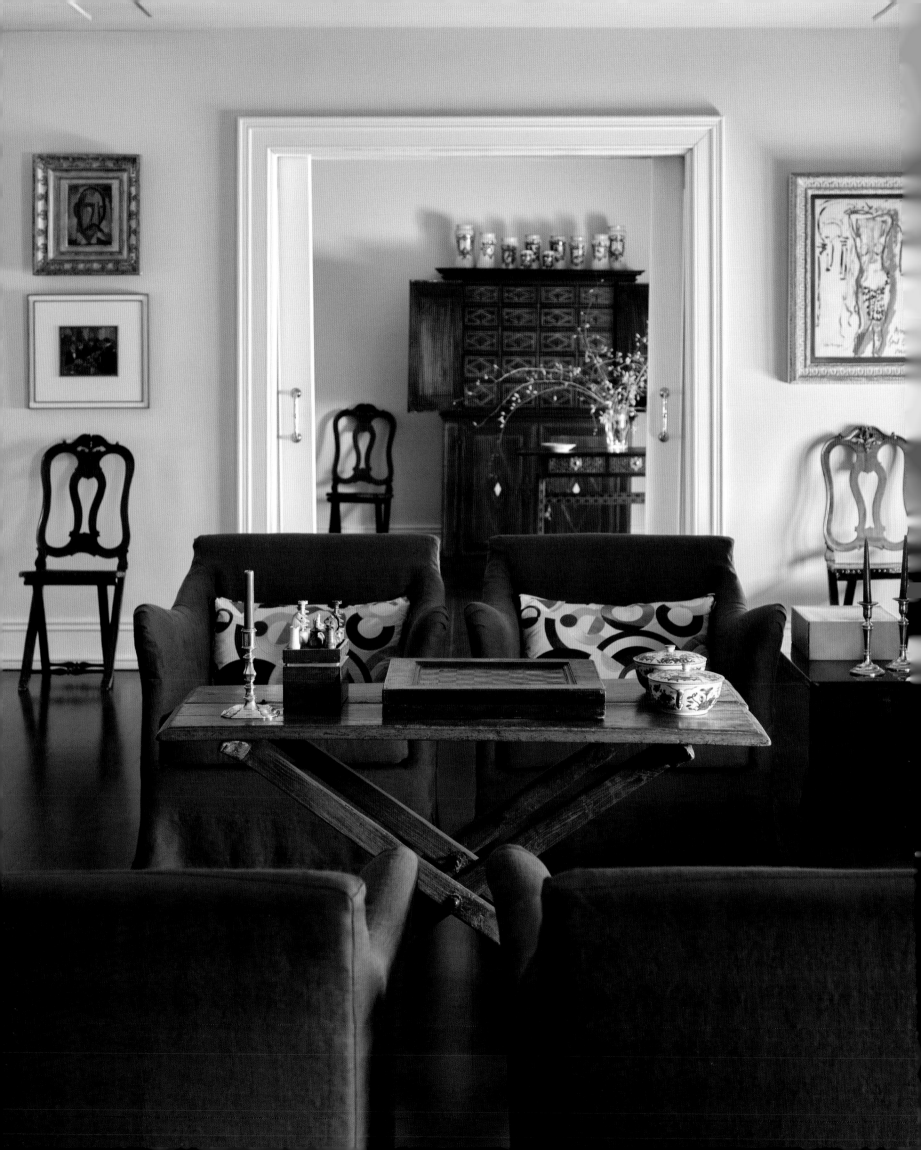

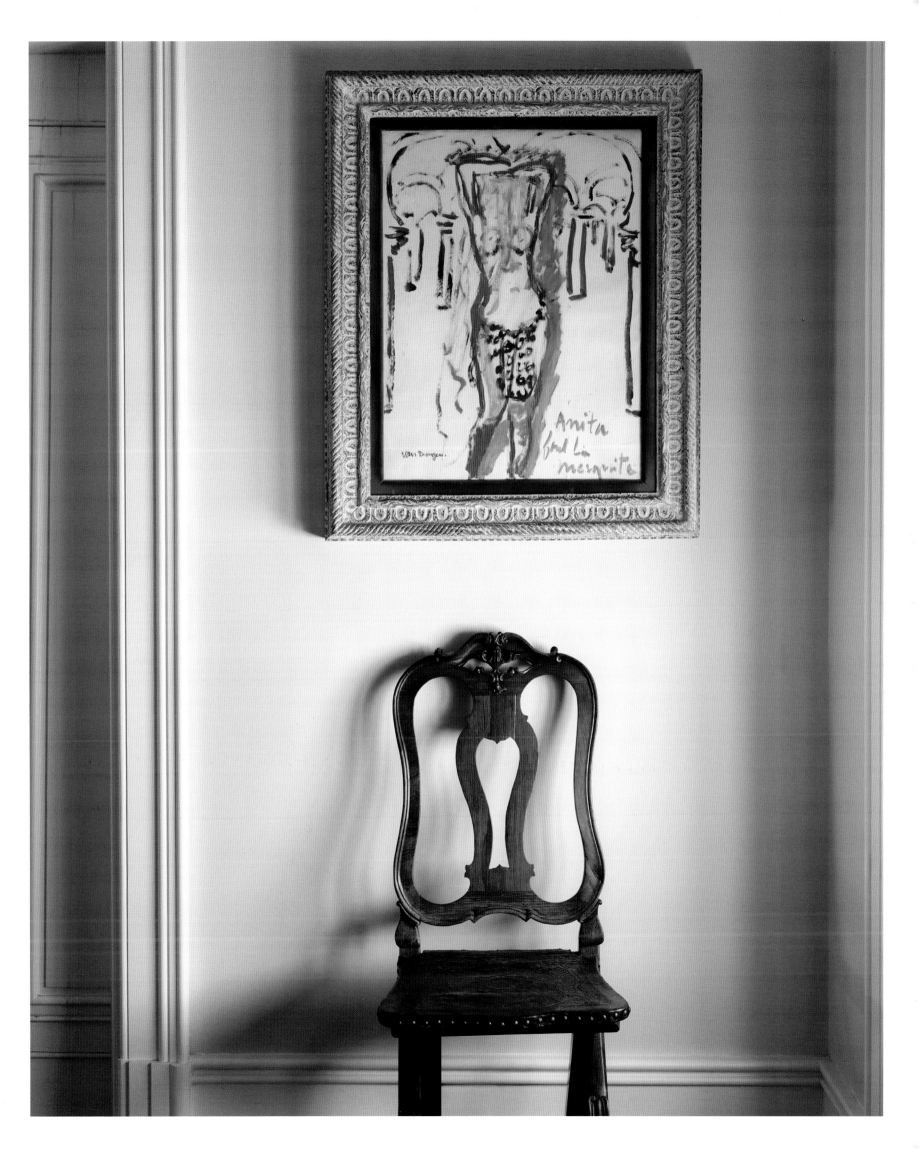

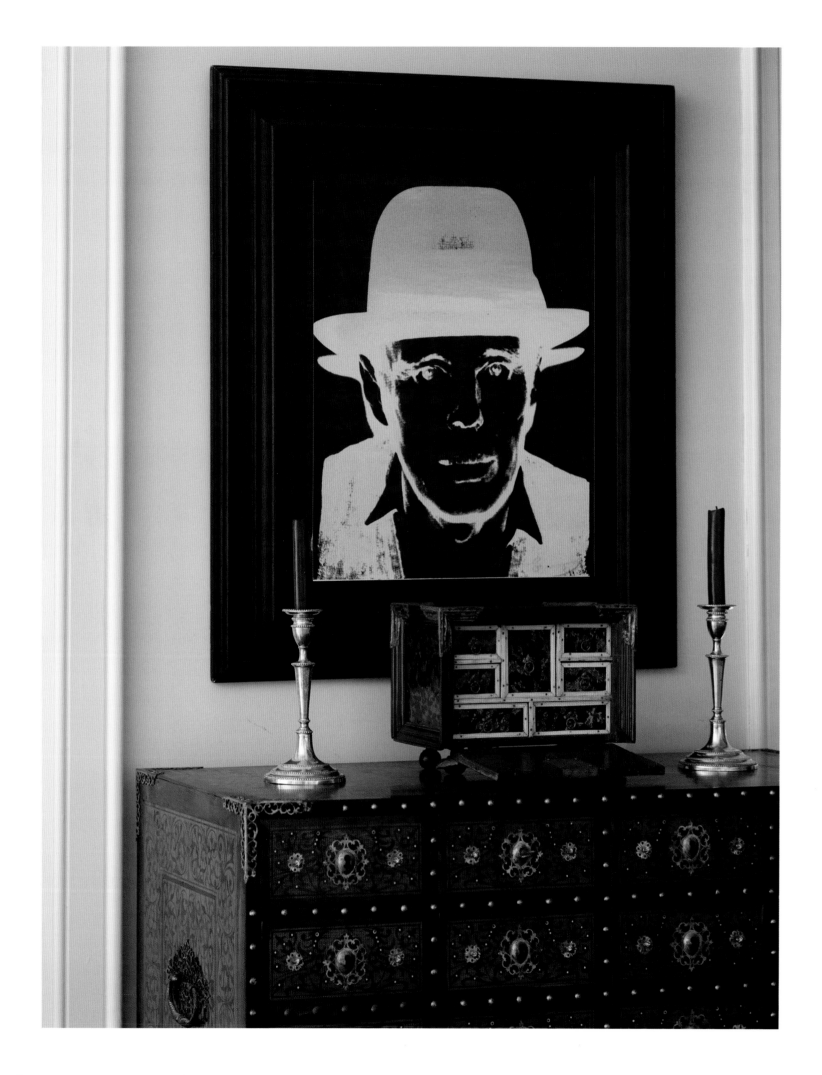

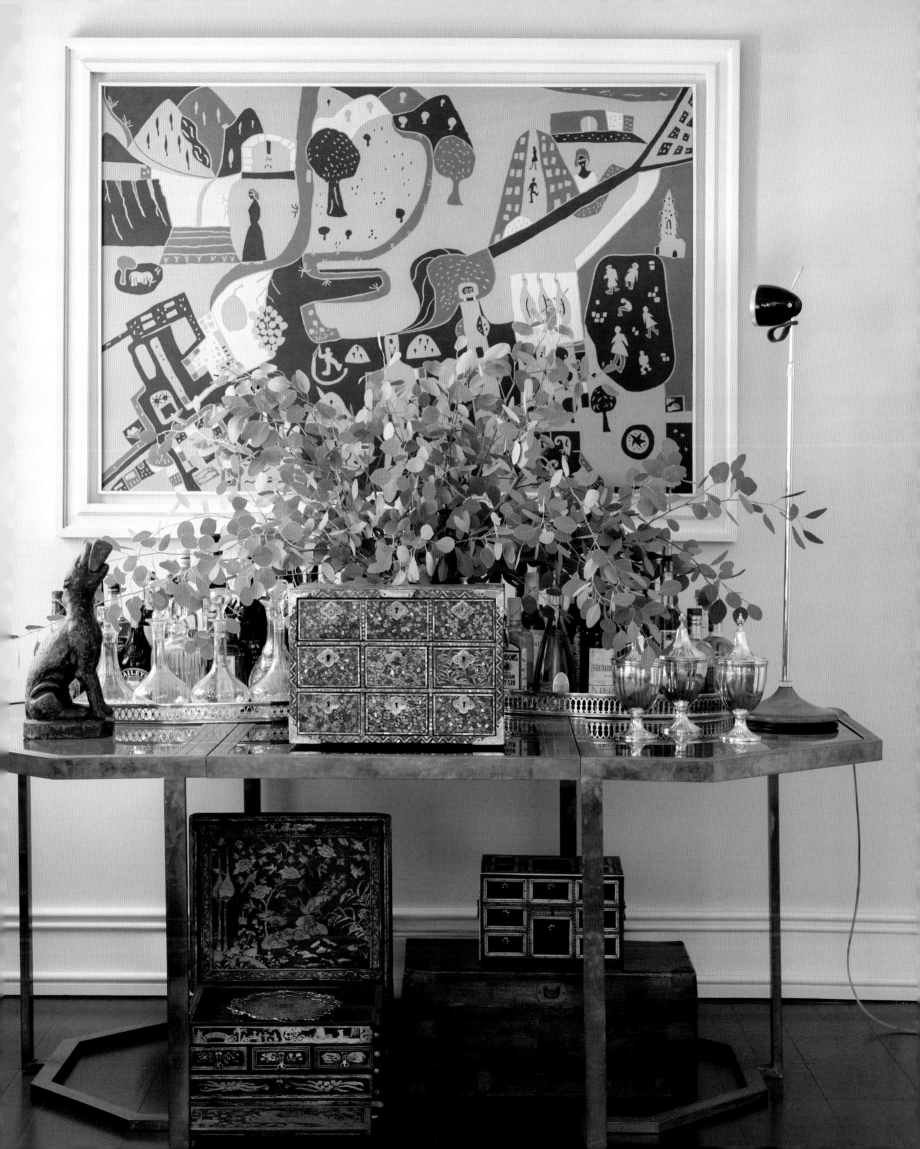

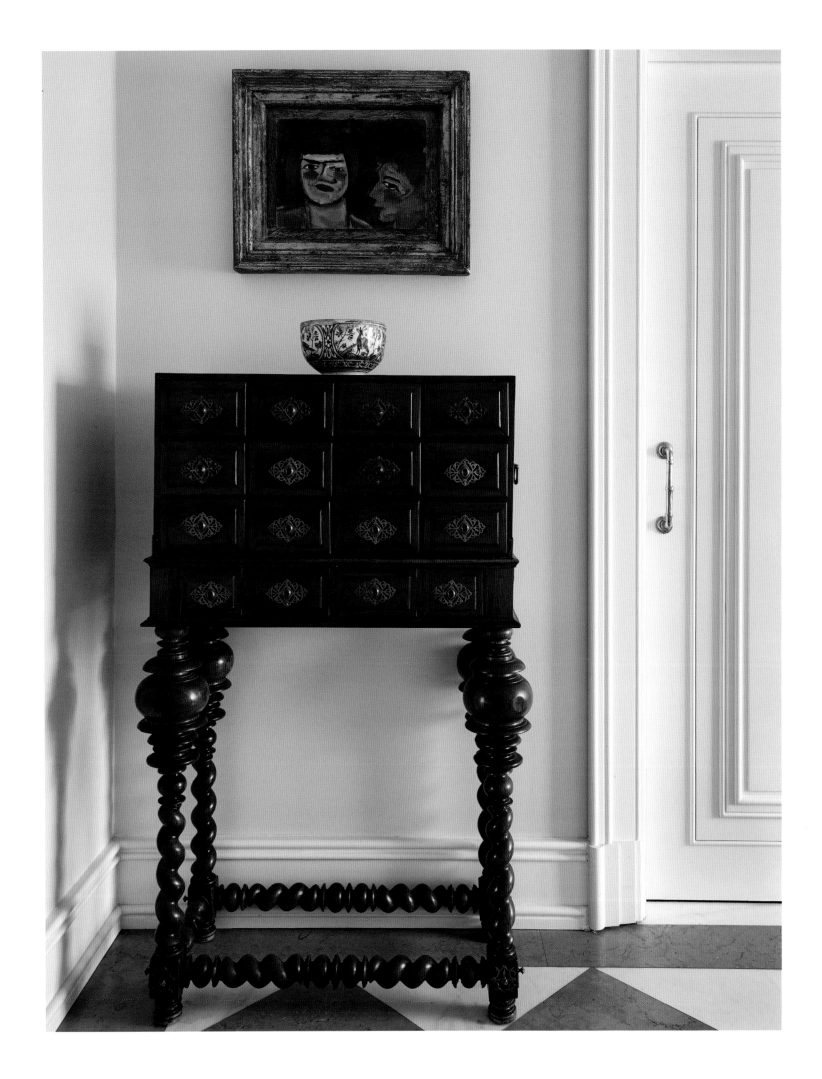

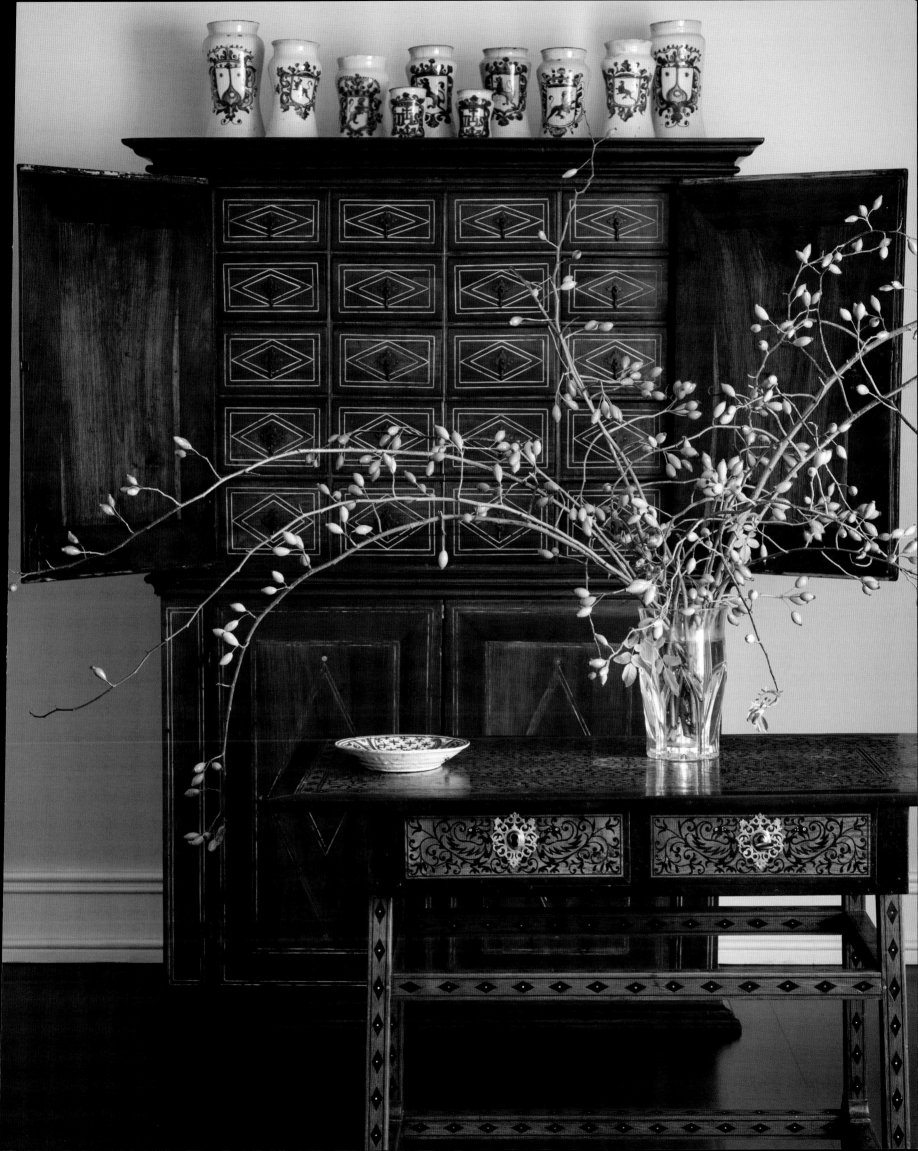

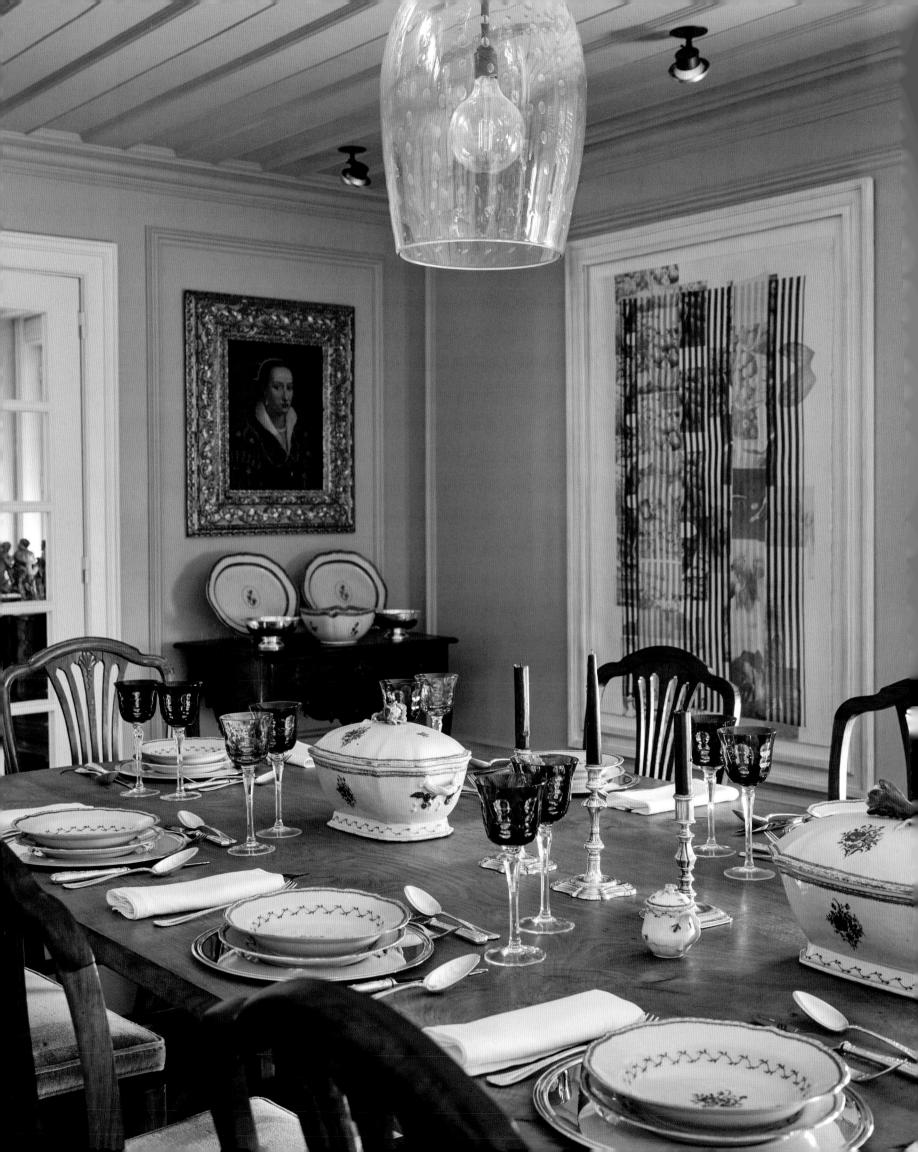

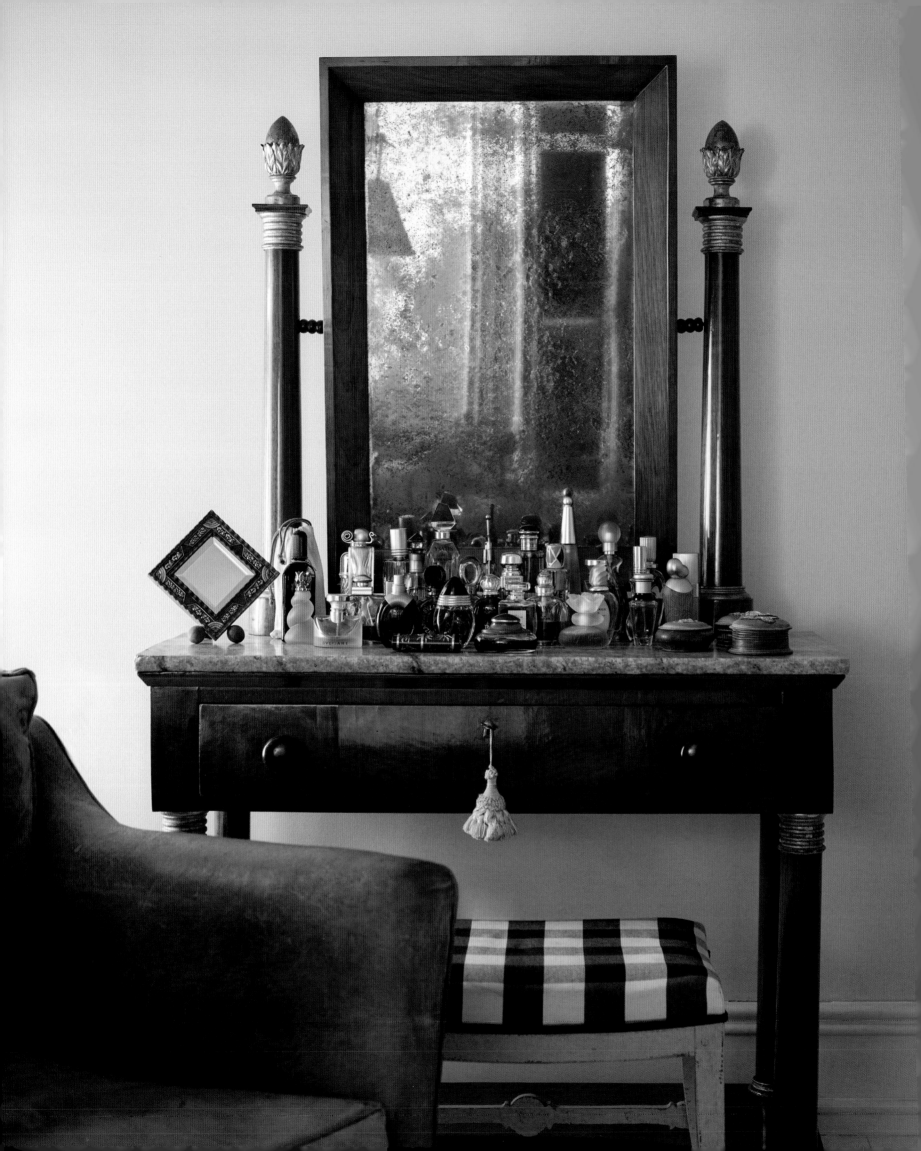

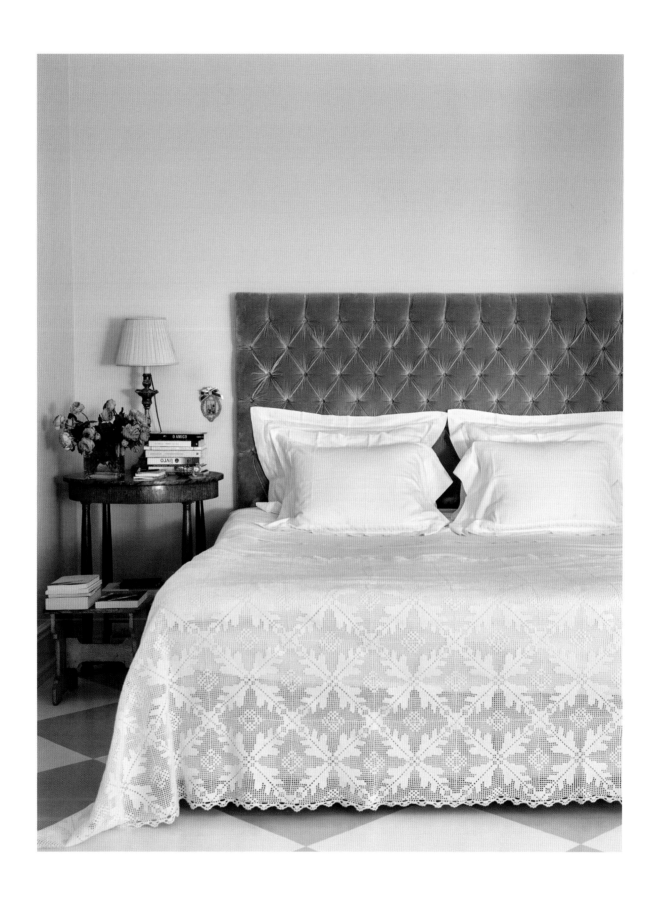

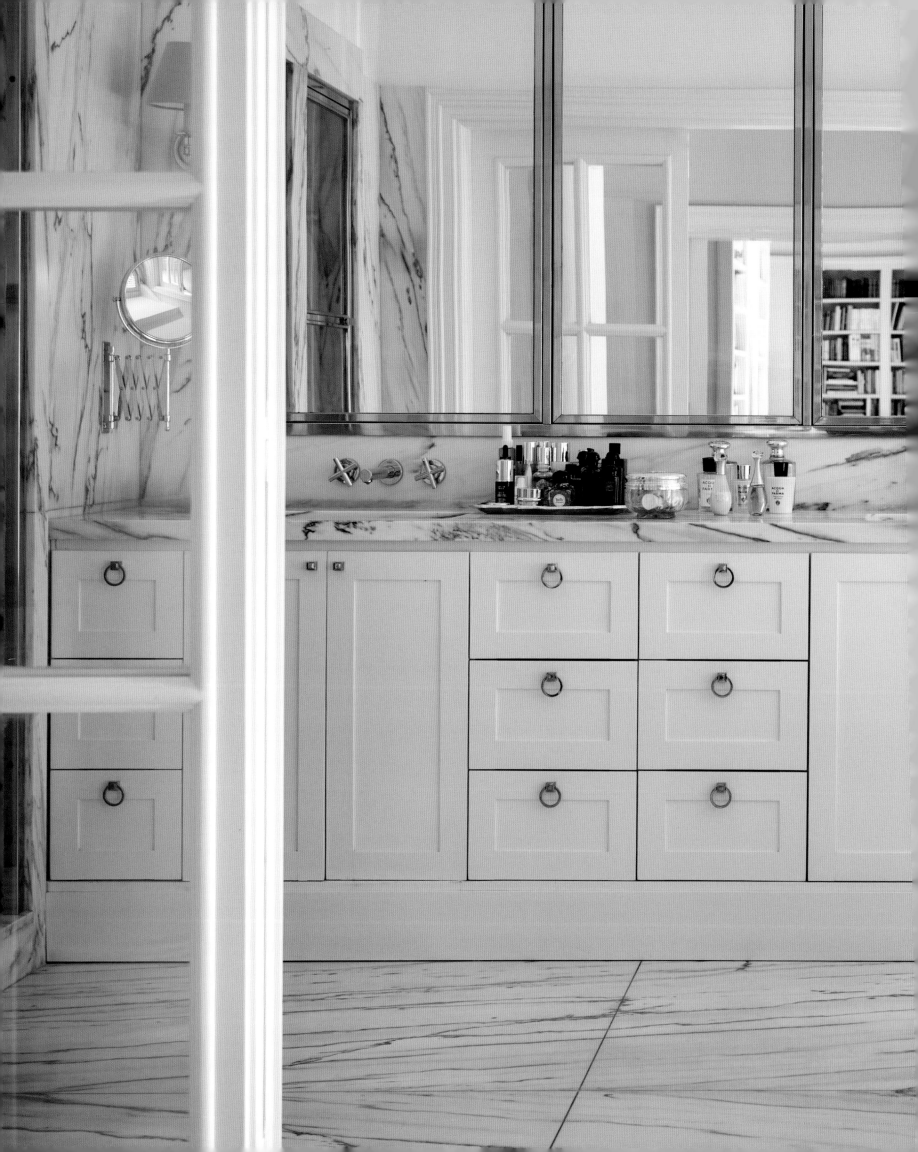

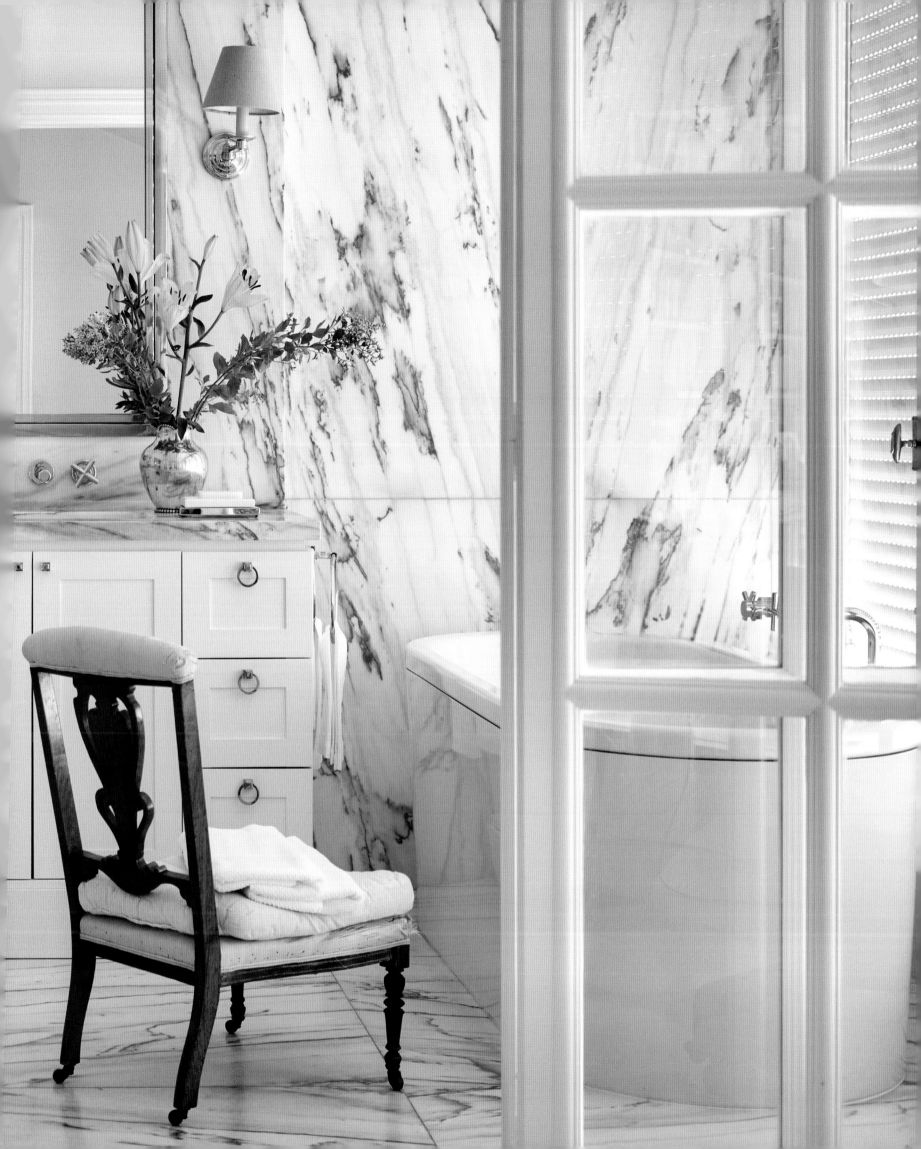

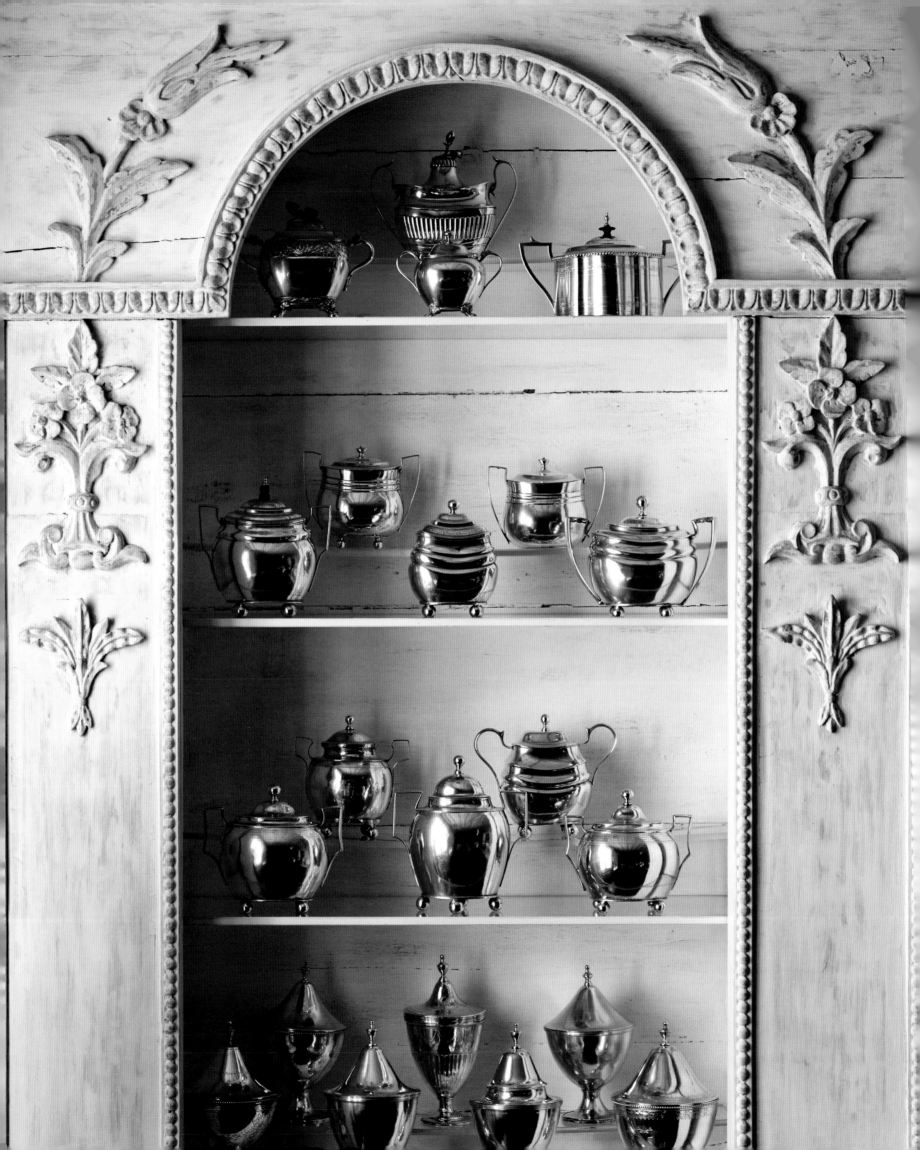

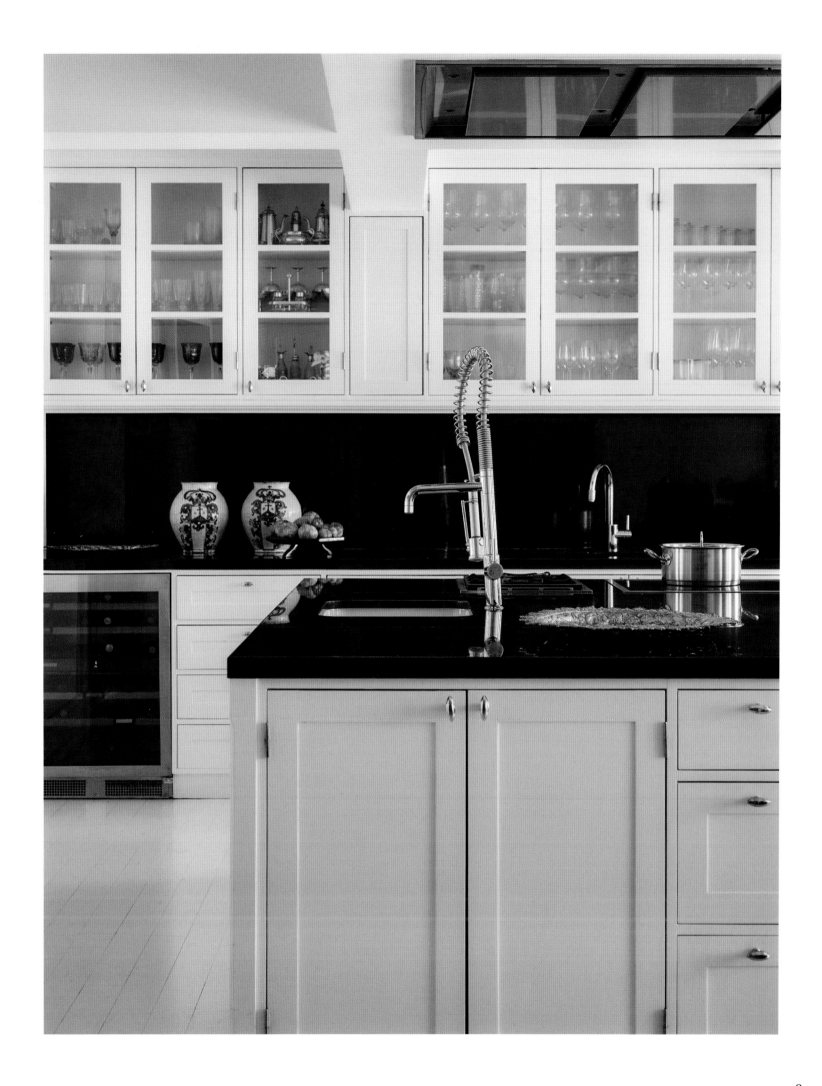

PAGE 67 A Karel Appel oil painting and two seventeenth-century Indo-Portuguese wooden sculptures of John the Baptist, next to a small fourteenth- or fifteenth-century French chest. The chest of drawers, made of ebony, teak, and marble, dates to the twelfth century and is from Portuguese India.

PAGE 68 View from the attic terrace of the house in the Lapa district of Lisbon, looking out over the Tagus River flowing out to sea.

PAGE 69 A library was created in the hallway that leads to the attic living room, primary bedroom, dressing rooms, and bathroom. The wooden flooring was painted gray and white to resemble a checkerboard. The colored wooden console table is Spanish, from the eighteenth century. The windows open onto a terrace with breathtaking views.

PAGES 70–71 In the lounge, a large white linen sofa sits on the black wooden floor alongside antique furniture, acquired over a lifetime of dedicated searching. The iron and wood staircase that winds its way to the attic is both light and voluptuous. Above the sofa hangs a 1989 acrylic painting on canvas by the Portuguese artist Menez. The rustic sixteenth-century juniper-wood table in front of the sofa is accompanied by a pair of eighteenth-century Portuguese palo santo chairs and footstools.

PAGE 72 The view looking down into the lounge from the top of the spiral staircase.

PAGE 73 Two silver sugar bowls sit on top of a seventeenth-century cabinet from Portuguese India, either side of a seventeenth-century Indo-Portuguese ivory religious sculpture. Above it hangs a fifteenth- or sixteenth-century painting of the Virgin and Child from the Flemish school, and crowning the ensemble is a painting on wood of the Virgin and Child by Álvaro Pires de Évora from the beginning of the fifteenth century.

PAGES 74–75 A black Belgian fire surround brought over from London is the focal point of this second living space in the lounge. Above it hangs a 1972 painting by Alexander Calder, on the right is a 1948 piece by Maria Helena Vieira da Silva, and on the left are works by Mário Eloy and Vieira da Silva. Below the pictures are a pair of eighteenth-century Portuguese palo santo console tables, which hold two teak, ivory, and tortoiseshell chests.

PAGE 76 Four armchairs upholstered in dark gray Belgian linen and a rustic seventeenth-century Portuguese teak table face the fireplace. Against the wall sit two eighteenth-century Portuguese teak chairs, beneath paintings by Portuguese artist Amadeo de Souza-Cardoso and Dutch artist Kees van Dongen. In the room beyond is a seventeenth-century Portuguese palo santo cabinet encrusted with ivory.

PAGE 77 A seventeenth-century Portuguese palo santo chair with a twentieth-century painting by Dutch artist Kees van Dongen.

PAGE 78 An Andy Warhol picture above an Indo-Portuguese teak, ebony, and ivory cabinet. A pair of nineteenth-century Portuguese silver candlesticks and an ivory and tortoiseshell chest sit on top.

PAGE 79 A Willy Rizzo brass and black glass table serves as a bar, accompanied by a wood, lacquer, mother-of-pearl, and gold Japanese tabletop writing chest from the Momoyama period (1568–1600), and two silver trays. Beneath the table is a seventeenth-century writing chest in painted exotic wood with gold-colored iron fittings.

PAGE 80 An eighteenth-century Portuguese palo santo cabinet with a seventeenth-century Portuguese earthenware bowl and a 1928 painting by Joaquín Torres-García.

PAGE 81 A seventeenth-century Portuguese India table with inlaid ivory and ebony stands in front of a seventeenth-century palo santo cabinet with inlaid ivory displaying blue and white earthenware pharmacy jars.

PAGE 82 In the dining room a Portuguese-style ceiling was created with painted wooden panels, and moldings were added to the walls for displaying artwork. The dining table and chairs are English antiques. The table is set with an East India Company dinner service, a tureen, and charger plates, and Portuguese silver candlesticks. On the right wall hangs a 1979 painting by Robert Rauschenberg, and above the console table is a sixteenth-century oil on canvas painting by Alessandro Allori.

PAGE 83 An eighteenth- or nineteenth-century Portuguese walnut dressing table displays a seventeenth-century Flemish painting on wood and two Portuguese cutlery chests, one from the eighteenth century and another from the nineteenth, as well as a nineteenth-century Portuguese silver egg coddler with handles and a lid.

PAGE 84 In the primary bedroom, a Portuguese walnut dressing table with a mirror holds a collection of perfumes. Beneath the table is a polychrome bench upholstered with large black and white checks. Two leather lounge chairs sit at the foot of the bed.

PAGE 85 The bedside table and handmade duvet cover in the primary bedroom are Portuguese. The color scheme here is gray and white.

PAGES 86–87 The bathroom, lined with gray and white Italian marble, looks out onto the terrace. The bathtub is placed by the doors to the terrace to take in the view, while the shower and toilet are hidden in cubicles. A glazed wooden screen opens to the primary bedroom.

PAGE 88 A nineteenth-century painted wood niche with a collection of eighteenth- and nineteenth-century Portuguese silver sugar bowls.

PAGE 89 All the kitchen cabinets are painted wood, and the worktops are Zimbabwe Black granite. The wooden floor is painted white to capture the light and the cooking area is extended by a large central island.

PAGE 90 On the landing, a twentieth-century photograph by Leonel Moura is juxtaposed with a fifteenth-century Flemish sculpture of the Virgin and Child.

BETWEEN THE PRADO AND THE BOTANICAL GARDENS

This corner apartment is located in one of the most beautiful and characteristic places in Madrid, with the Prado Museum to the west and the Royal Botanical Gardens to the south. Madrid's Botanical Gardens are almost three centuries old and have more than five thousand plant species from around the world. They are connected to the world-famous Prado, where the works of Velázquez can be seen in all their glory. The views from this magnificent apartment are spectacular.

This project, completed in 2017, is the fourth that López-Quesada has completed for close friends. The apartment, which was built in 1900, had previously been renovated in the 1970s and was in an extremely poor state. Isabel wanted to nurture the apartment's olden-day feel—recreating the old windows and balconies and keeping the yellow pine floor—but develop a new multilayered space in a classic, ultra-sophisticated, contemporary style that complemented the original features, with the old and the new in perfect balance.

The living room was enlarged by taking down partition walls. One of the challenges was bringing together the owners' contemporary art and their magnificent pieces of inherited furniture. Isabel looked to mid-century furniture to forge a link between the antique and contemporary pieces. The mix of gray, black, and dark green-blue sets the color tone of the house, which plays with light and with the golden tones reflected by features throughout the entire property. Two dark velvet sofas in the living room and the library enhance the gold in an antique landscape and a Chinese screen. The yellow pine floor meets Italian terrazzo in the kitchen. The dining room is anchored by a table that once belonged to Ava Gardner.

The colors of the main living spaces are carried through to the dressing room and bathroom, with a freestanding bath positioned against spectacular fabric filled with green, blue, and gold birds on a black background. In combination with the view over the Botanical Gardens' legendary greenery, the room produces an aesthetic reaction that surpasses the effect of many other luxuries.

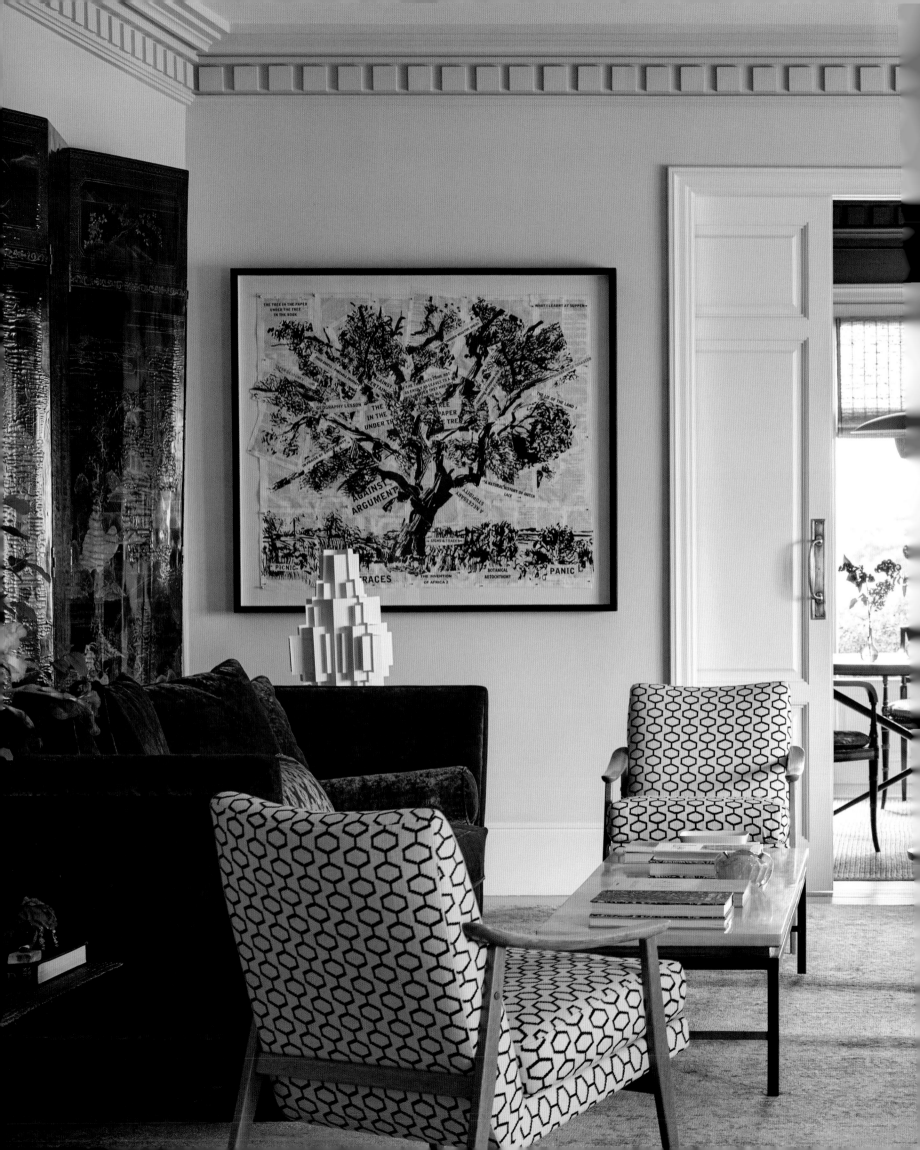

The artwork within the frame contains the following text:

THE TREE IN THE PAPER
UNDER THE TREE
IN THE BOOK

WHAT I LEARNT AT SUPPER

GEOGRAPHY LESSON

THE
IN THE
UNDER THE

TREE
PAPER
THE TREE

THE LIE OF THE LAND !

AGAINST
ARGUMENT

A NECESSARY
STUPIDITY

A NATURAL HISTORY OF DUTCH
LACE

PICNIC

PANIC

TRACES

THE INVENTION
OF AFRICA 2

BOTANICAL
AUTOCHTHONY

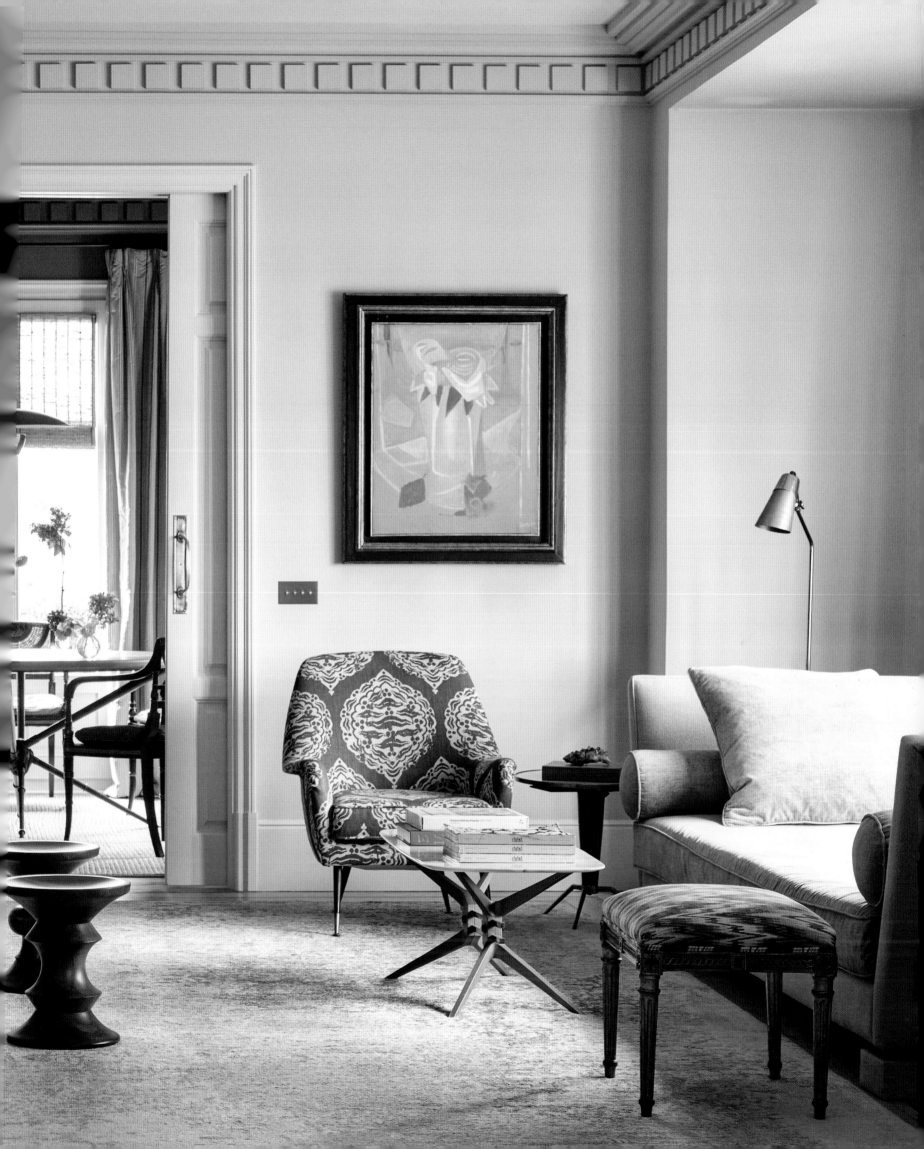

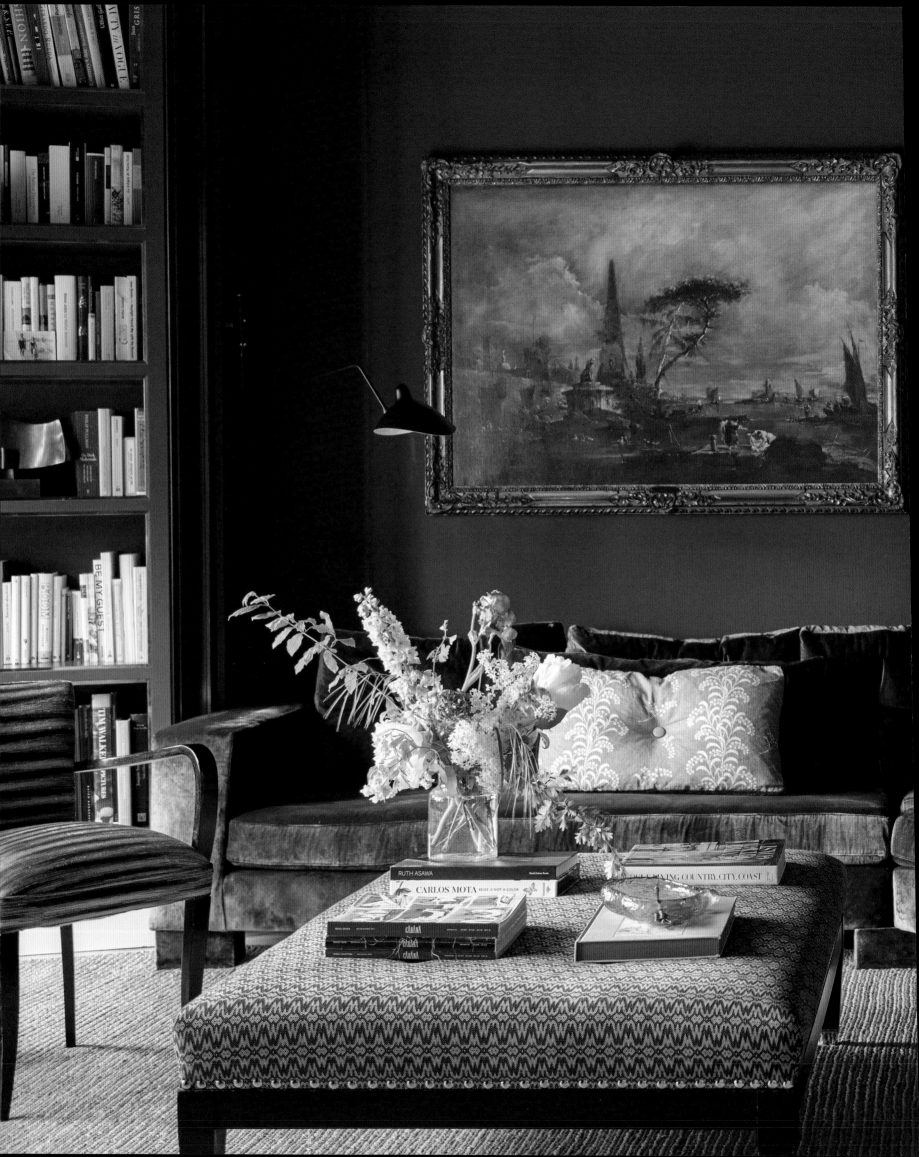

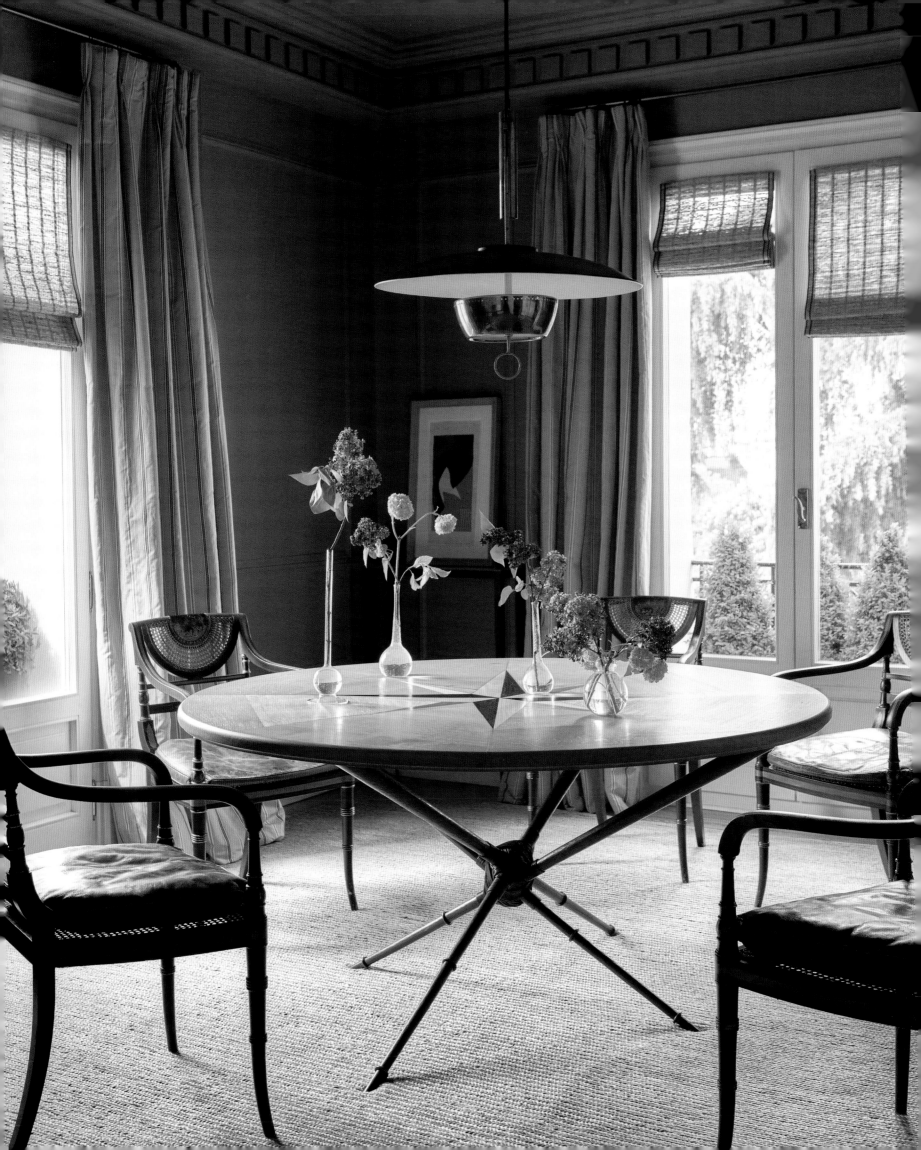

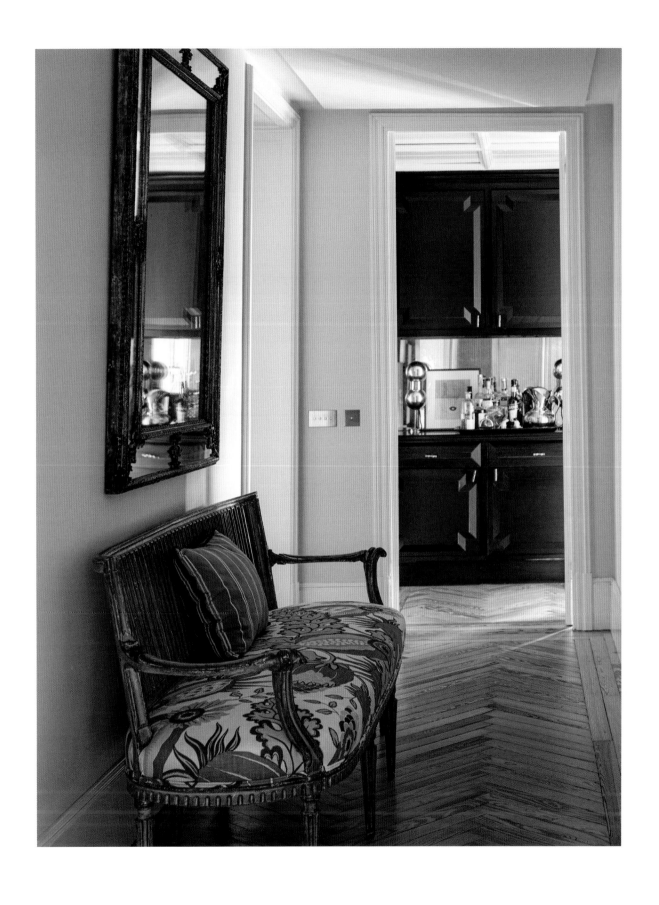

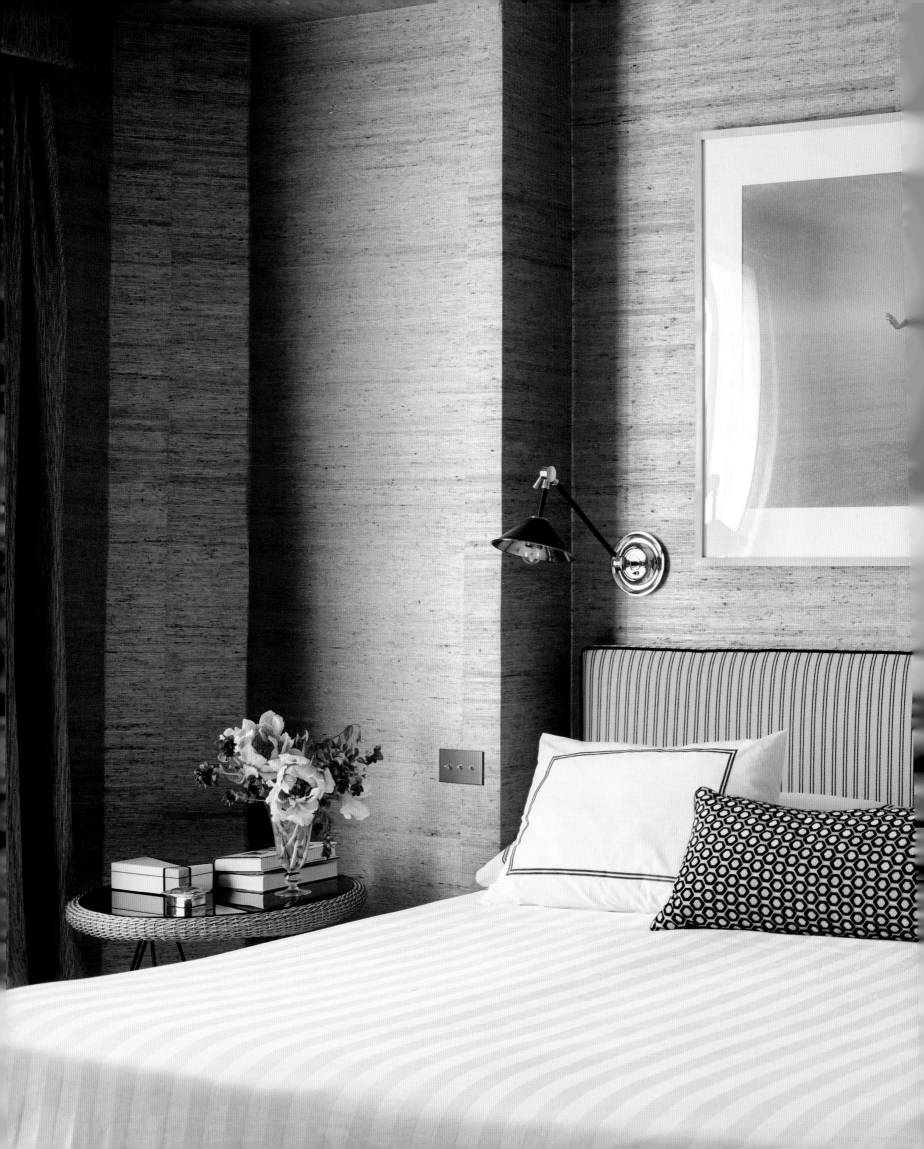

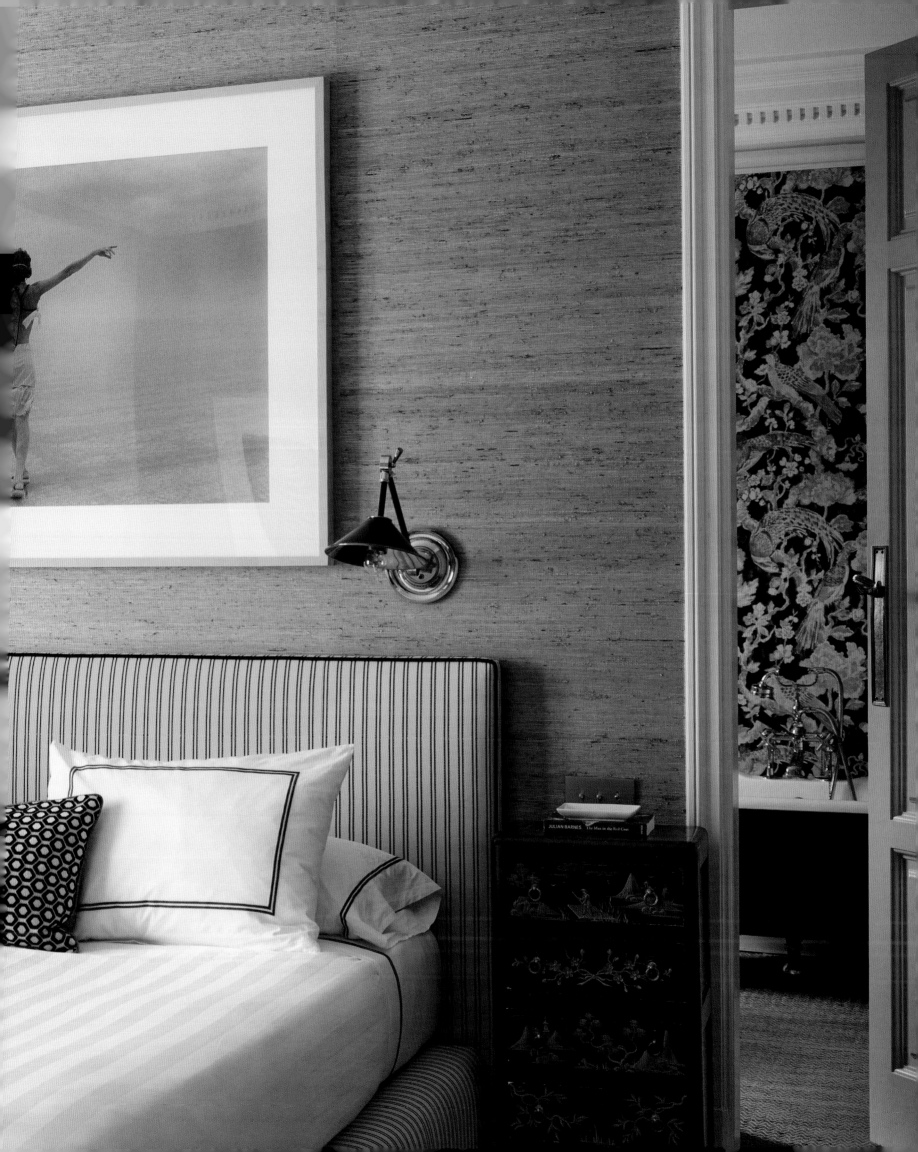

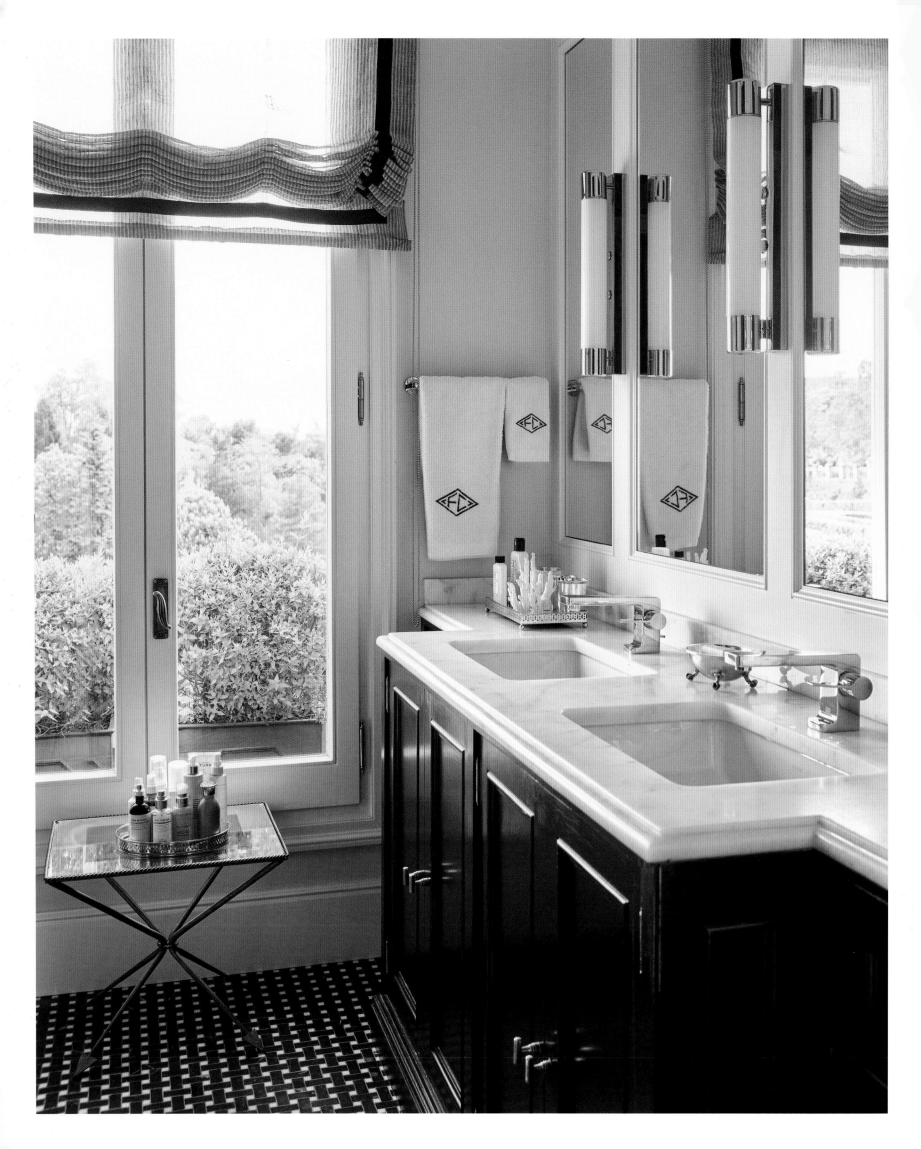

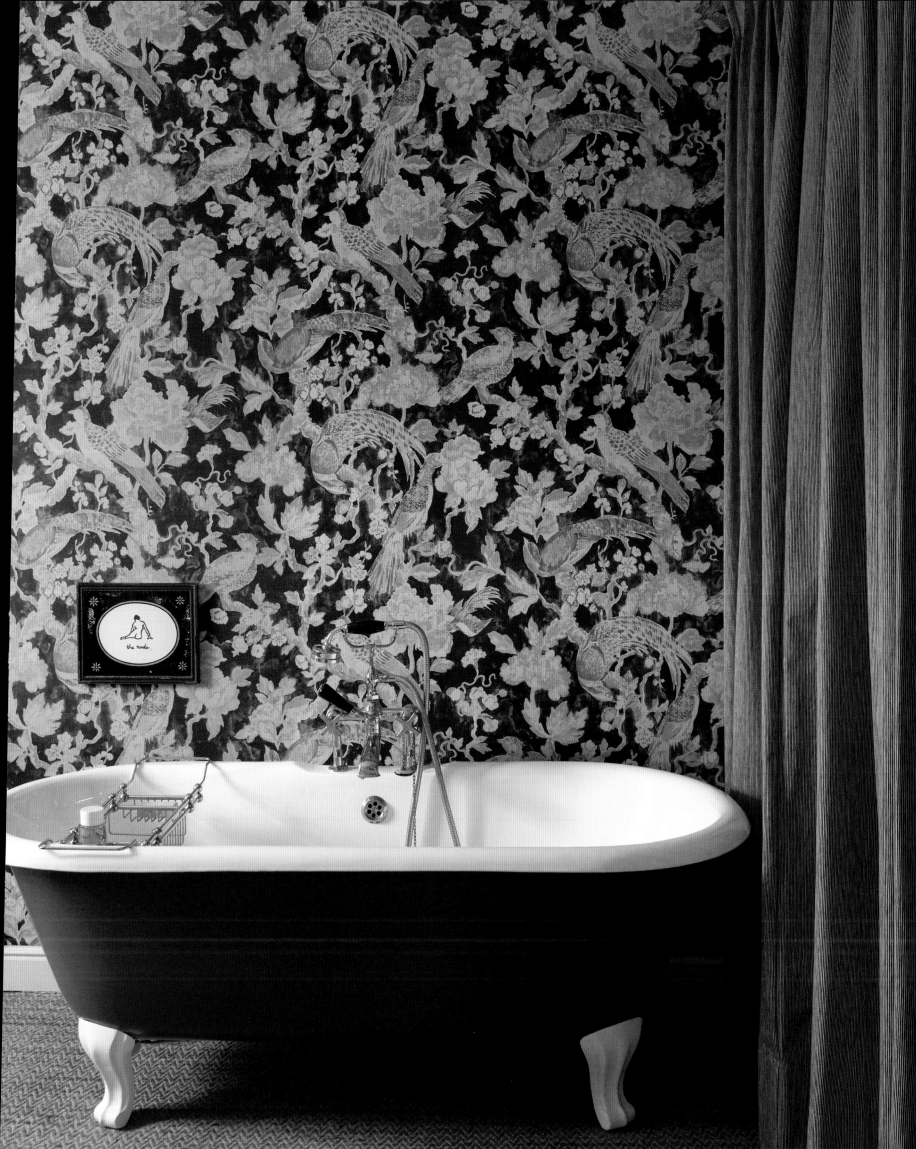

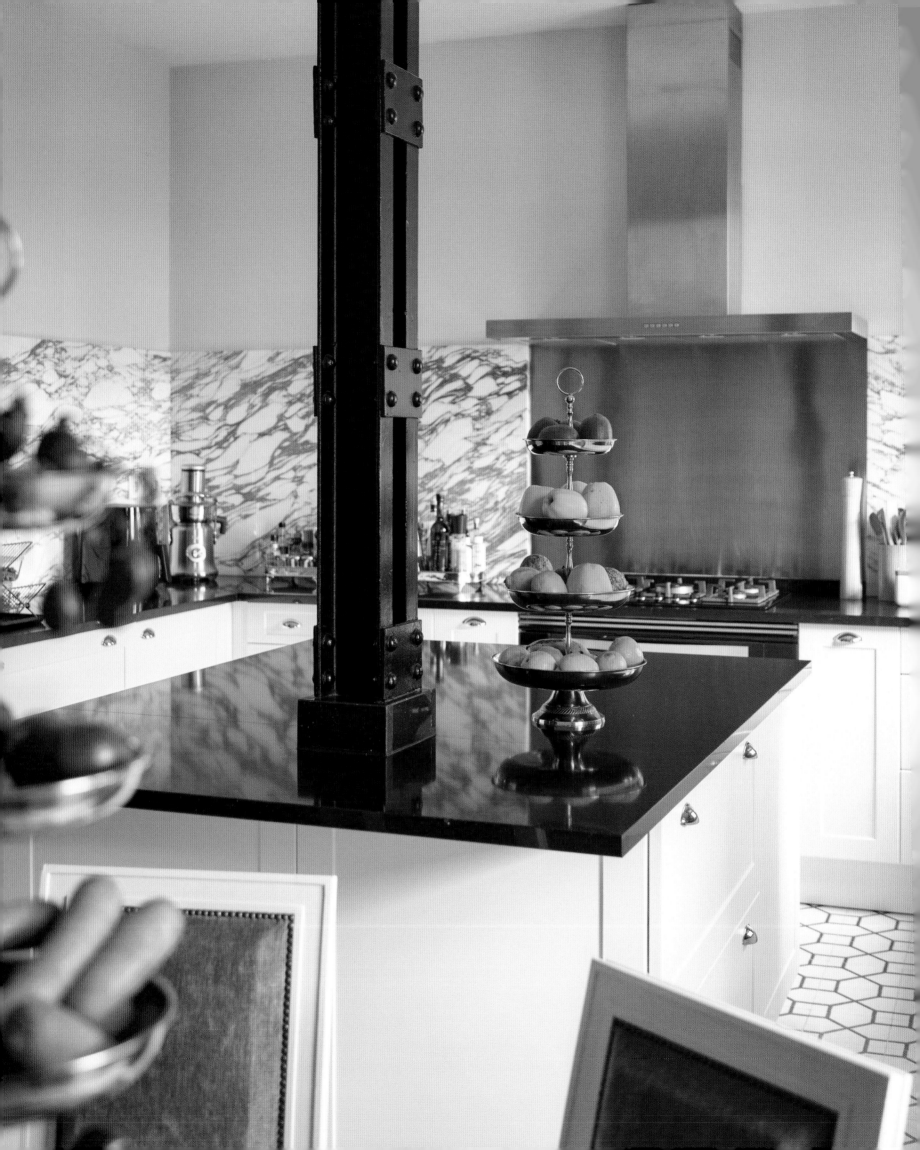

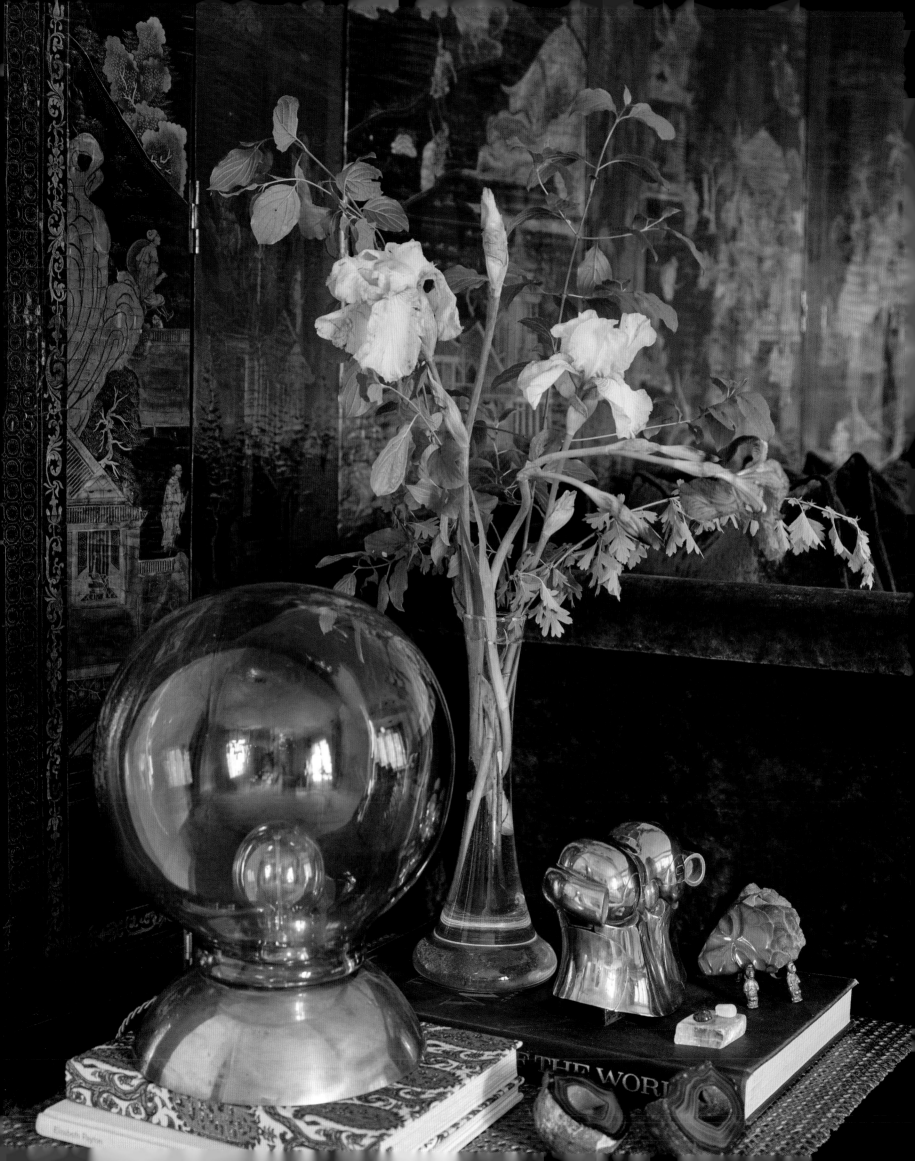

PAGE 93 In the dining room of this corner apartment in Madrid, a large collage by Antonis Donef complements the warm tones of English chairs and a Gaetano Sciolari for Stilnovo lamp.

PAGES 94–95 In the seating area of the lounge, a large sofa upholstered in navy velvet sits in front of an eight-panel, black-lacquered Chinese screen with gold edging. The screen dates from the late eighteenth century and features landscape scenes. Opposite, a backless daybed in the same style as the sofa reveals views over the Botanical Gardens and Prado Museum. Two low 1960s tables and chairs of the same period complete the arrangement. To the left of the sliding doors leading to the dining room hangs an artwork by William Kentridge, and to the right a painting by Francisco Bores. Madrid's Botanical Gardens are visible through the dining room windows.

PAGE 96 An eighteenth-century French console table in gray tones that has been passed down through the family stands in front of the window, dressed with two French iron urns and 1960s bottles holding lilac and greenery. To the left, a Louis XVI chair—another family heirloom— sits beneath an Elizabeth Peyton watercolor.

PAGE 97 The view from the living room into the lounge. Navy and green is a gorgeous combination used throughout the house. The sliding doors are from the original house and were relocated with the change of layout.

PAGES 98–99 The large living room window captures the afternoon light and looks out over the Prado Museum and Botanical Gardens. A painting by Francesco Guardi and a photograph by Wolfgang Tillmans hang above the corner sofa with bookcases opposite.

PAGE 100 The dining room accommodates eight to ten people without being overly large. French doors to the south and west provide incredible lighting for lunches. The round 1950s table with nested iron legs and an inlaid wooden marquetry star belonged to Ava Gardner when she lived in Madrid. The English chairs are inherited pieces. Natural fiber blinds were installed to temper the sunlight, with gray-blue striped curtains. A Gaetano Sciolari light adds a finishing touch.

PAGE 101 This hallway leads to the bar, which serves as an entrance to the dining room. The bench and mirror are both heirlooms. The bar was crafted from black-lacquered wood with mirrors set between the top and bottom cabinets and 1960s wall lamps. The pine parquet flooring is from the original house.

PAGES 102–3 The primary bedroom is lined with gray-green Japanese paper. On the right is the entrance to the woman's dressing room. One bedside table is chinoiserie, while the other is from the 1970s. The wall lamps and fabric headboard are American. Above the bed hangs a photograph by Cristina García Rodero.

PAGE 104 Opposite the bed is a desk with a bench upholstered in the same pattern as the wallpaper in the woman's dressing room—birds and flowers on a black background. A Hugo Guinness picture and a 1960s navy armchair complete the look.

PAGE 105 At the entrance to the primary suite stands a small French chest of drawers that belonged to the family with a Peter Zimmermann picture above.

PAGE 106 The bathroom, with views over the Botanical Gardens, was designed in black and white to be both elegant and luminous.

PAGE 107 A picture by Hugo Guinness hangs off-center above the bathtub in the woman's bathroom against a backdrop of colorful birds.

PAGE 108 The large kitchen enjoys a lot of light. White with wooden cabinetry is paired with Zimbabwe Black granite worktops combined and Italian Arabescato marble splash backs.

PAGE 109 In the everyday dining area in the kitchen, a table with chairs upholstered in mustard fabric stands in front of a large wall of cupboards. The flooring is Italian terrazzo laid in a vintage pattern.

PAGE 110 In the lounge, a golden lamp sits atop a bronze side table, both by Osanna Visconti. The table holds books, a small sculpture by Miguel Ortiz Berrocal, and semiprecious agate. Flowers in a simple clear vase stand out against the Chinese screen and navy velvet of the sofa.

BEAUTIFUL FLOORING IN LA JULIA

One of the hallmarks of López-Quesada's work is her choice of flooring and the way she integrates one type with another. The trick is finding high-quality pieces that can withstand use but that also offer personality and elegance to make a space feel special. This house, located in the residential neighborhood of La Julia in Santo Domingo, the capital of the Dominican Republic, has particularly beautiful flooring.

This new building, built on the former site of a small 1950s house, was designed by architect Marta Marín and Isabel López-Quesada and completed in 2018. The floor of the house is raised by three steps to prevent flooding. Its L-shaped design faces south and east, so the garden is opposite the living areas and the everyday dining area. The garden features the characteristic umbrella shape of the saman tree, also known as a rain tree. Orchids are traditionally planted in its trunk, as the humidity of the trees nourishes them. The saman brings an undeniably Caribbean feel to a house whose interior has an urban, sophisticated air generated by the juxtaposition of stone, wood, and tile flooring, old and new, with textile-covered, paneled, and papered walls, floral fabrics, and antique French furniture combined with bamboo pieces.

The small entrance hallway, with a Chinese lacquered cabinet that contrasts with a pretty albino turtle shell, introduces the main hall and the house's principal staircase. The staircase is made from beige stone with an imposing shape and height, accentuated by the paneled walls, which continue in the hallway and foyer. Upstairs is the primary bedroom, the children's bedrooms, and a family living room, connected to the downstairs and service area by a second staircase in gray stone. The floor of the service area is laid with tiles from a local factory that makes perfect reproductions of Santo Domingo originals; the other floors feature limestone, Pietra sandstone, and Belgian black limestone in white and gray tones, arranged in a chain of geometric shapes.

The main dining room and its library are downstairs, along with the everyday dining room, the lounge, the living room with its raffia wall coverings, the cooking area, the food preparation area, and finally the guest bathroom, which features white and black toile de Jouy wallpaper and Maison Jansen palm-tree wall lamps, reminding us that this is a Caribbean house at heart.

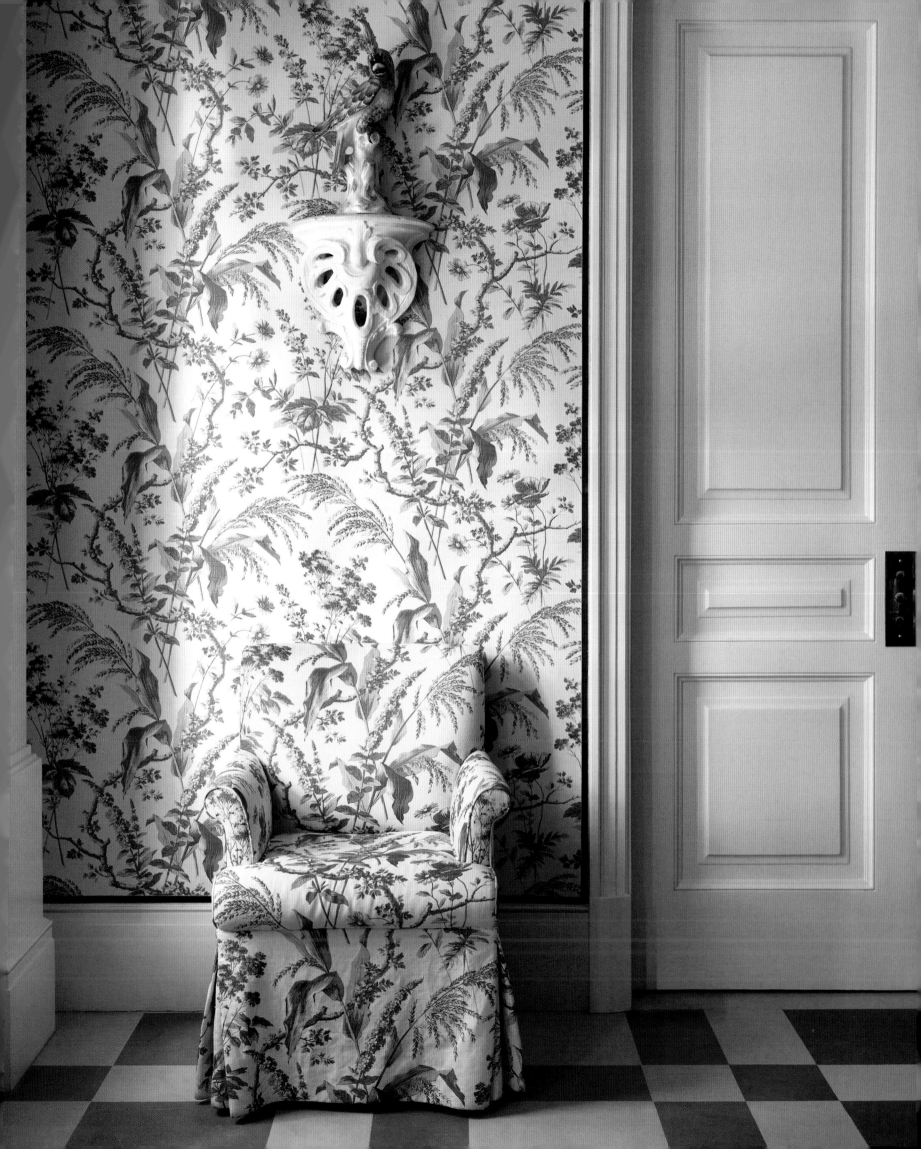

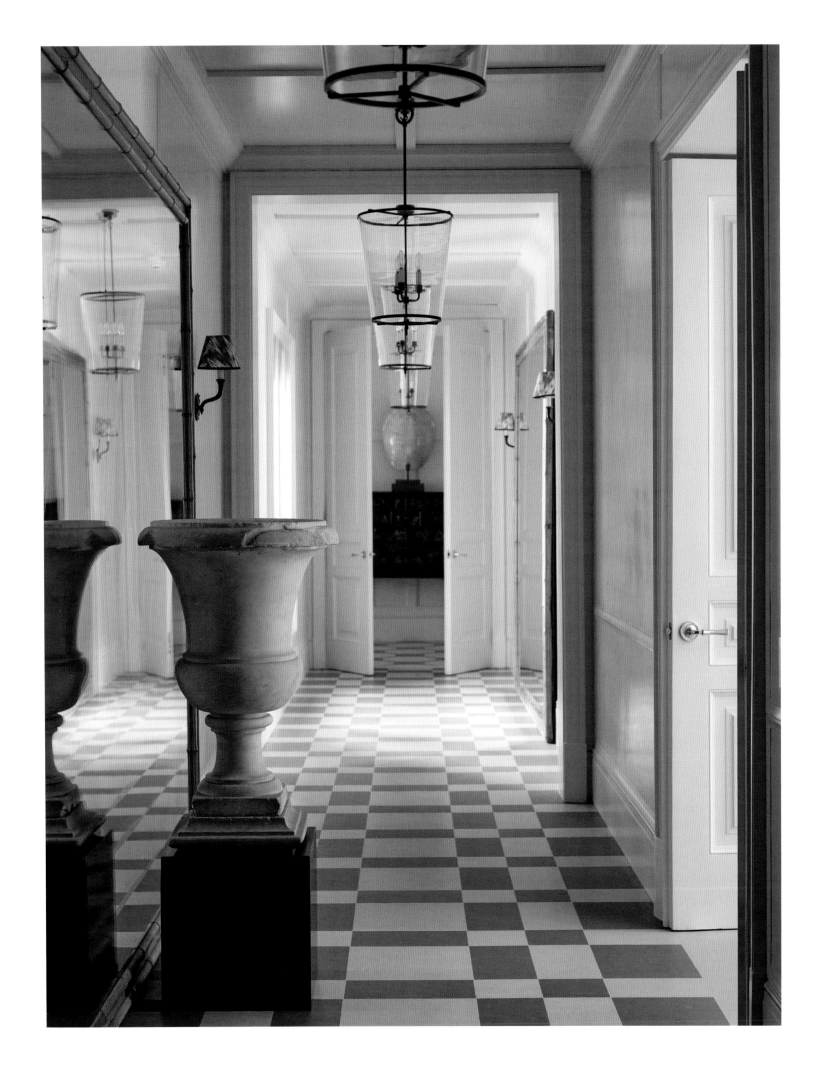

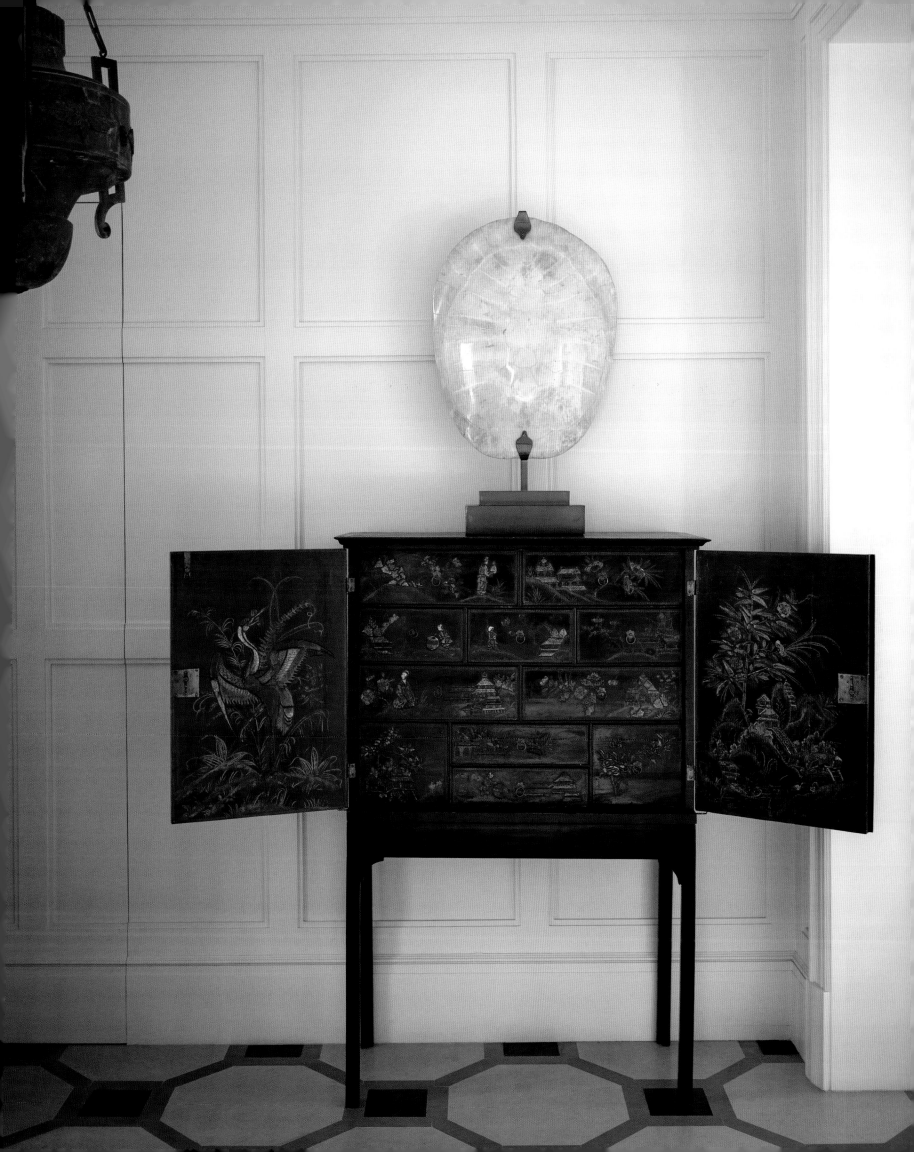

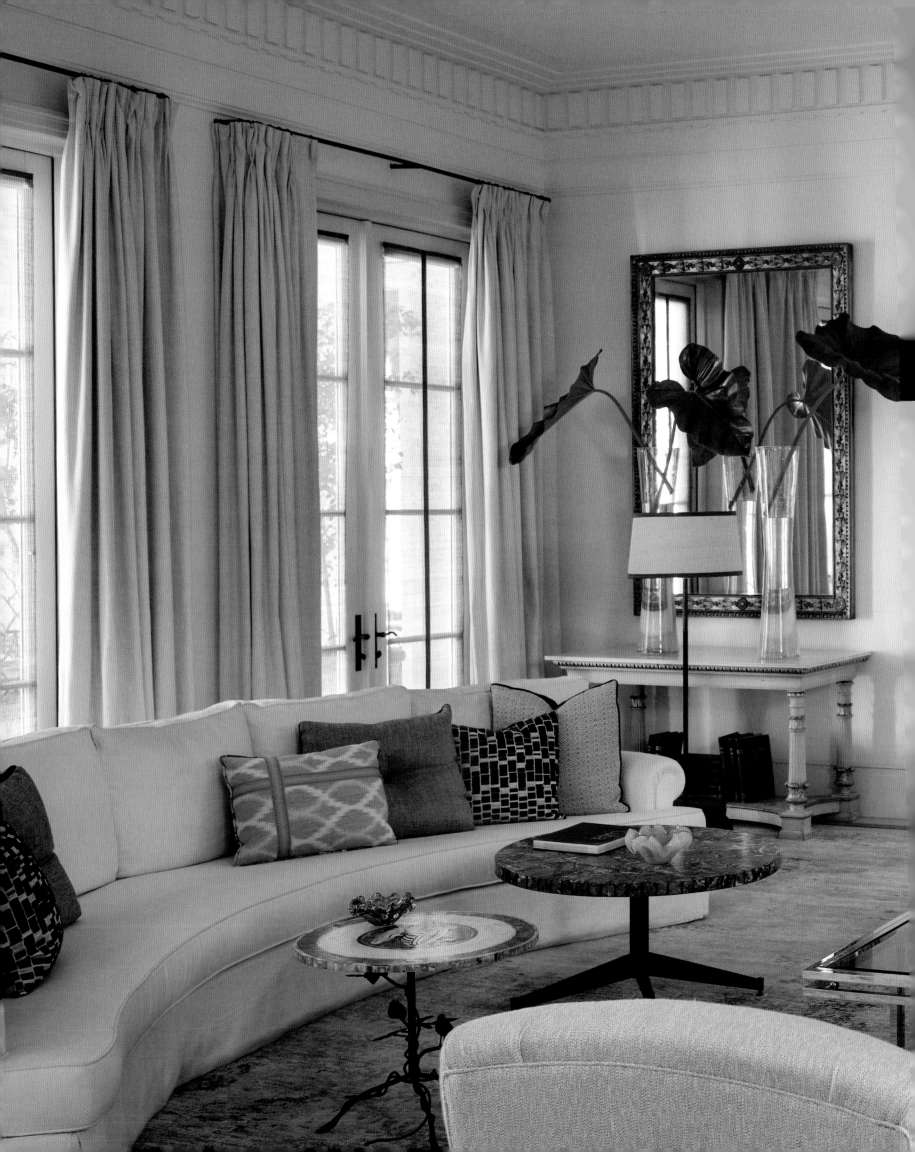

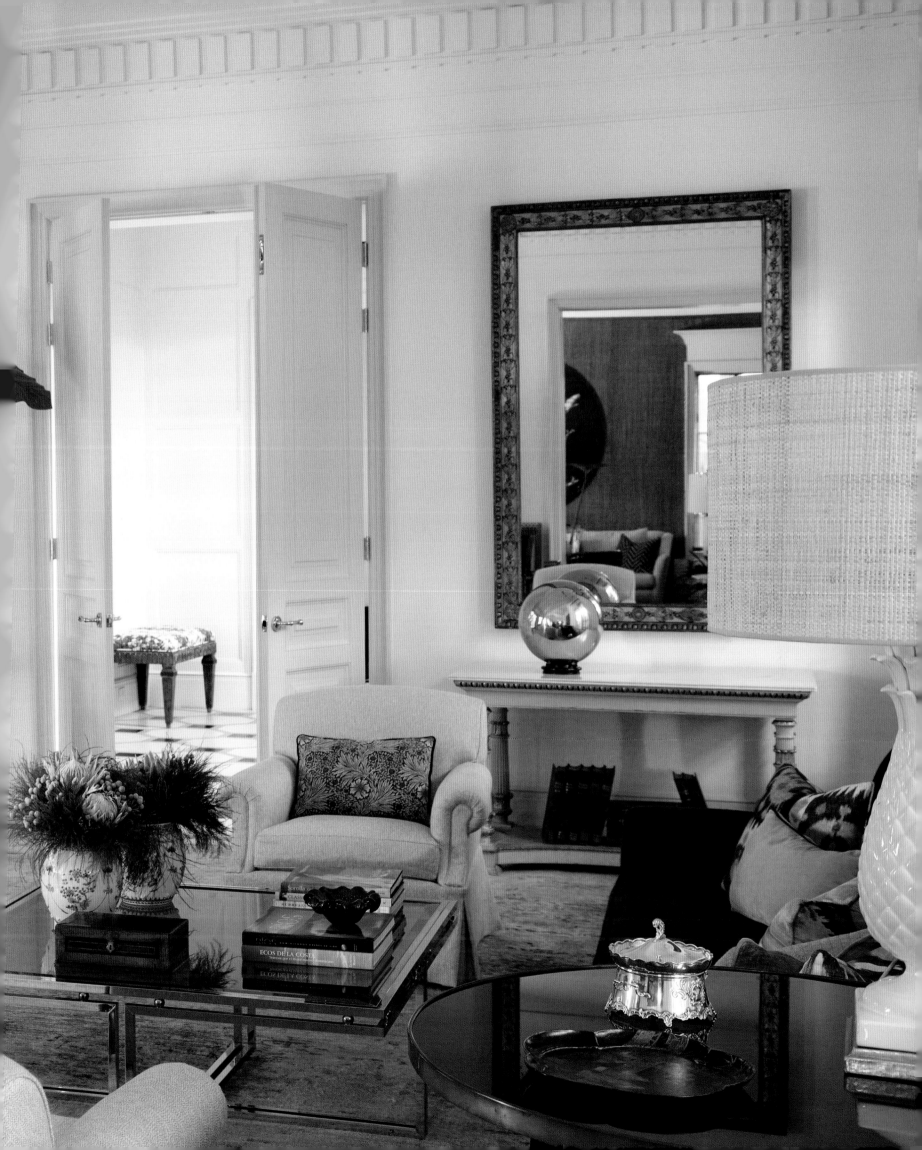

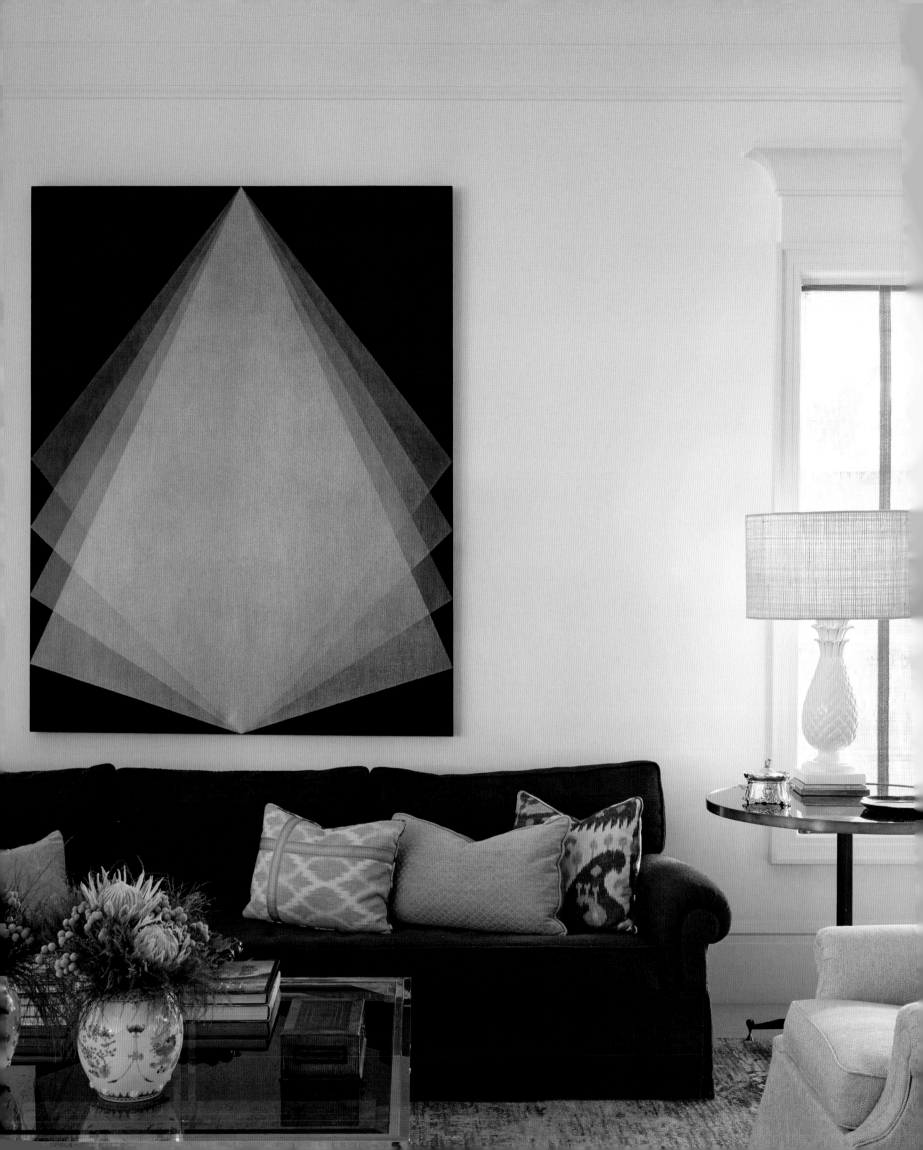

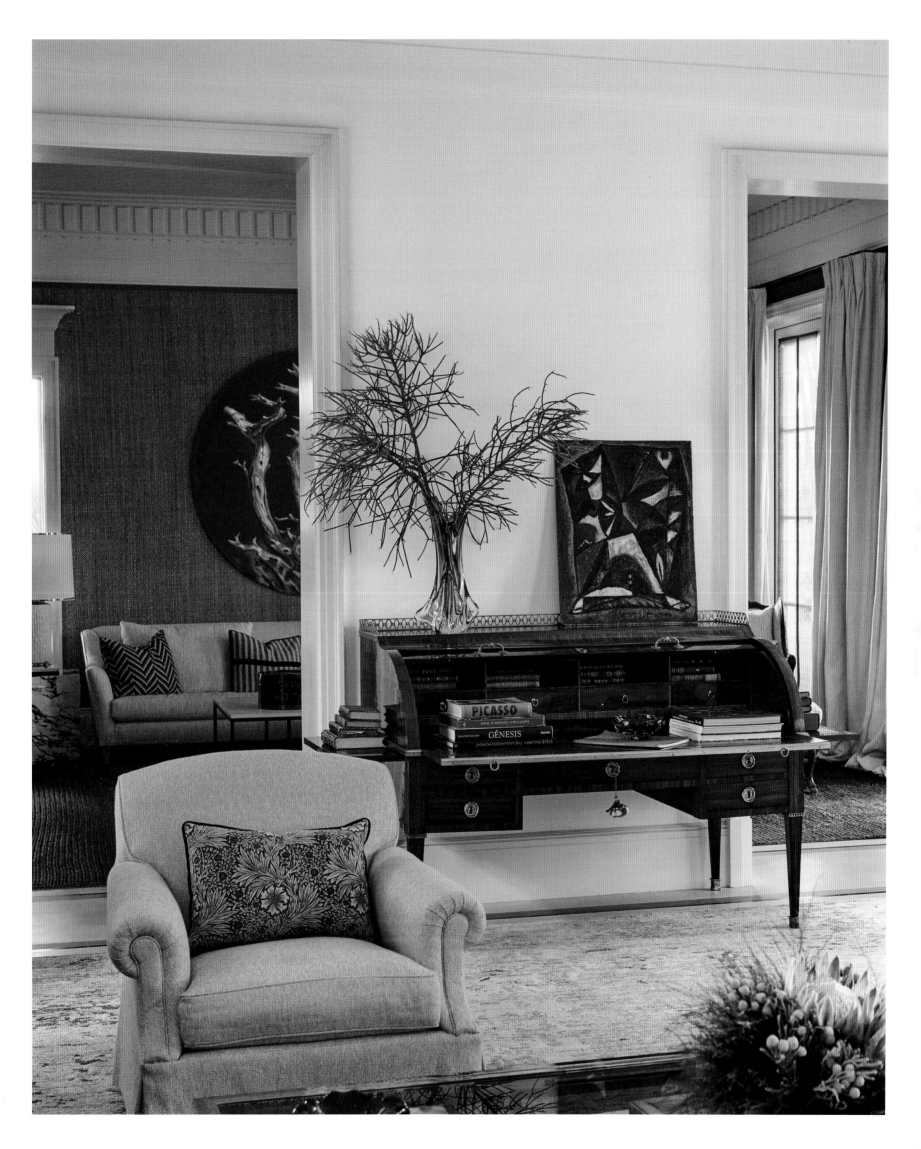

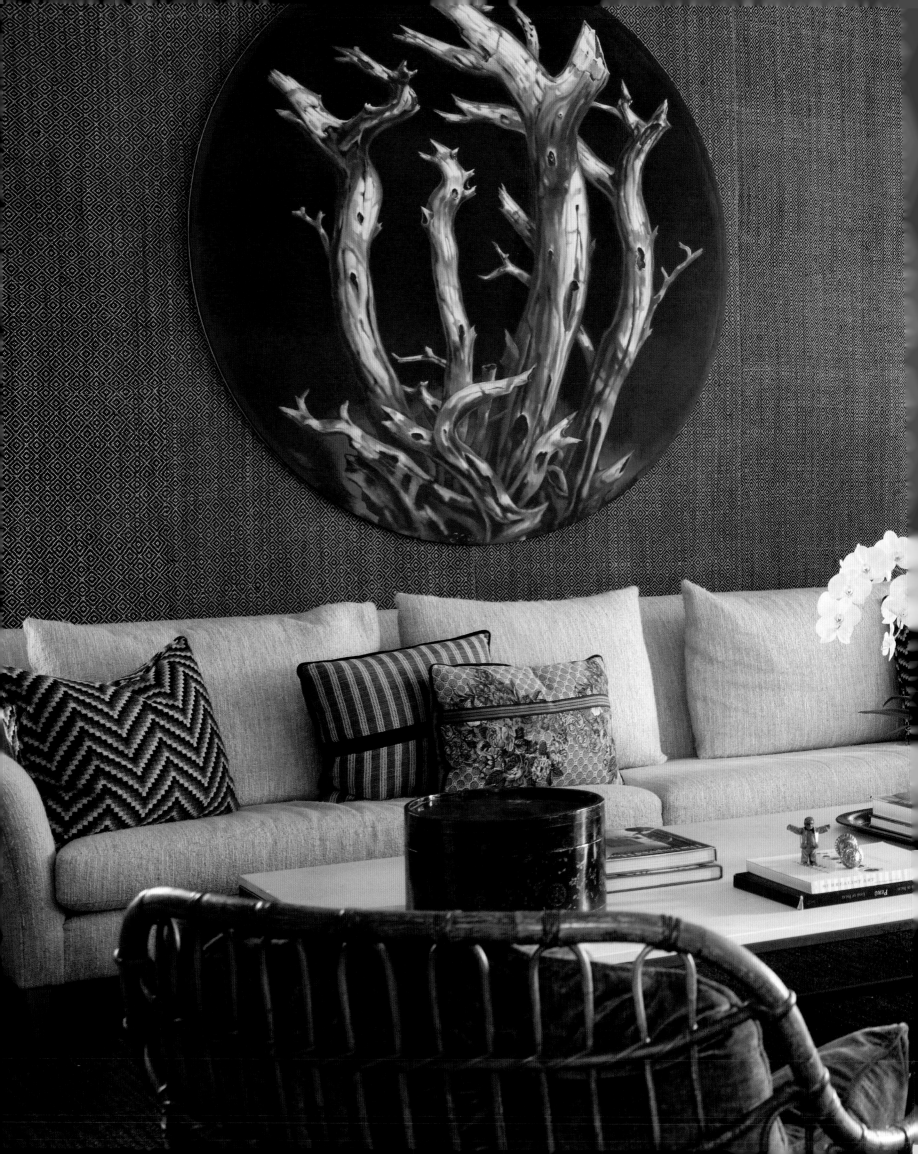

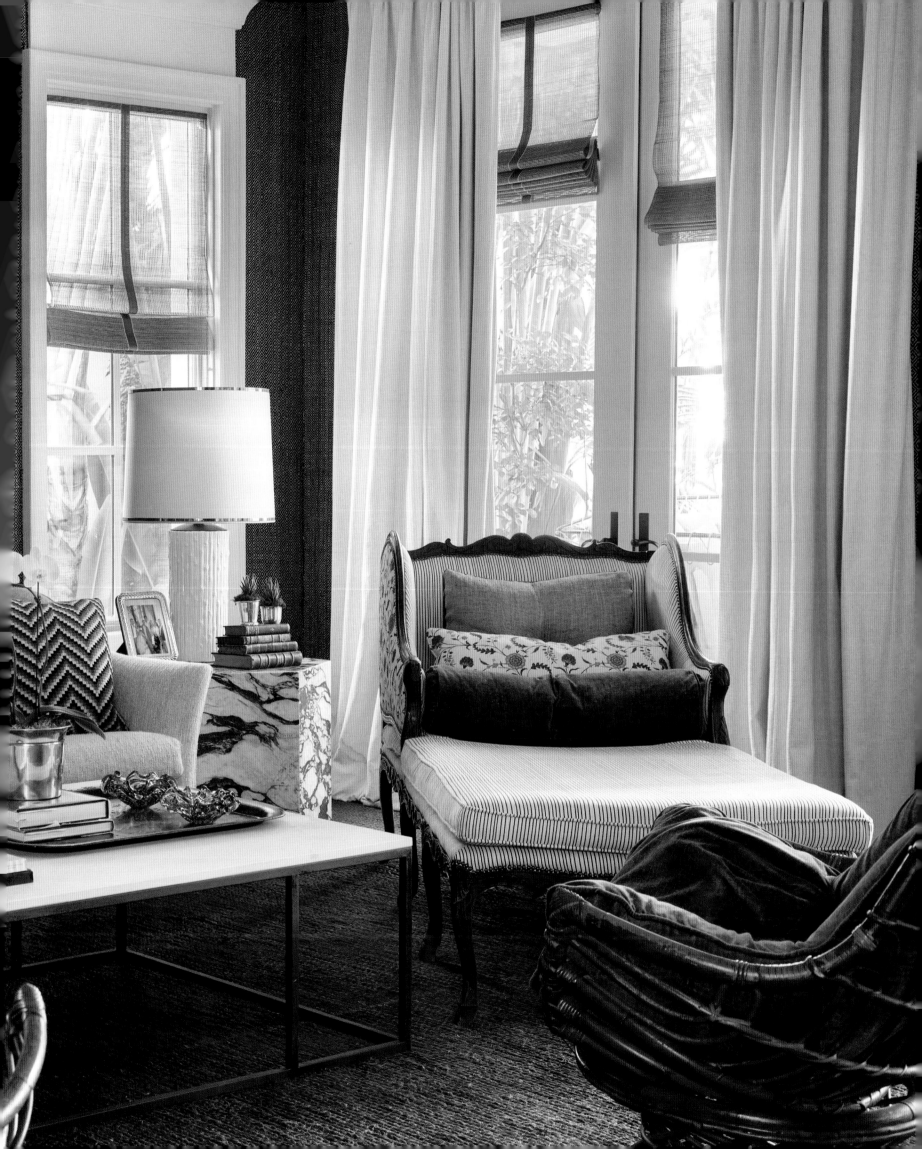

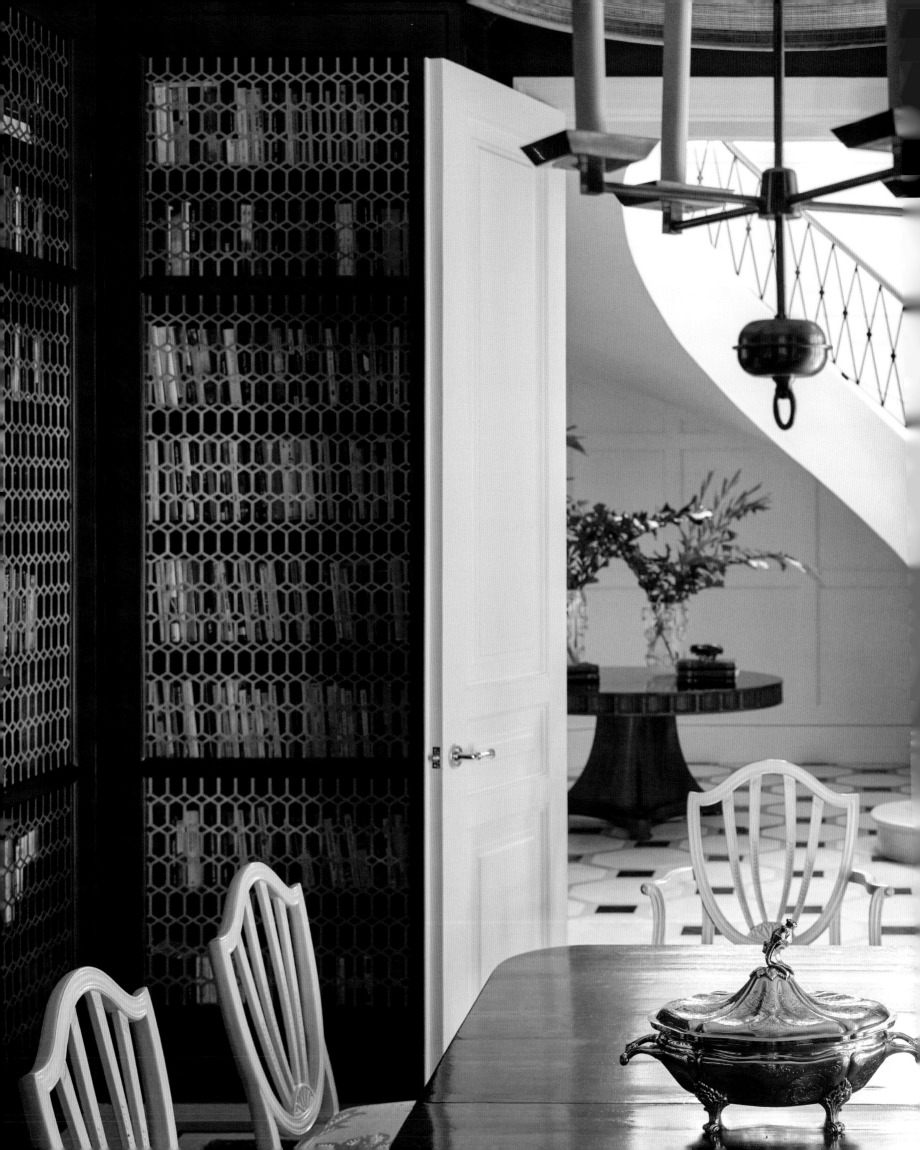

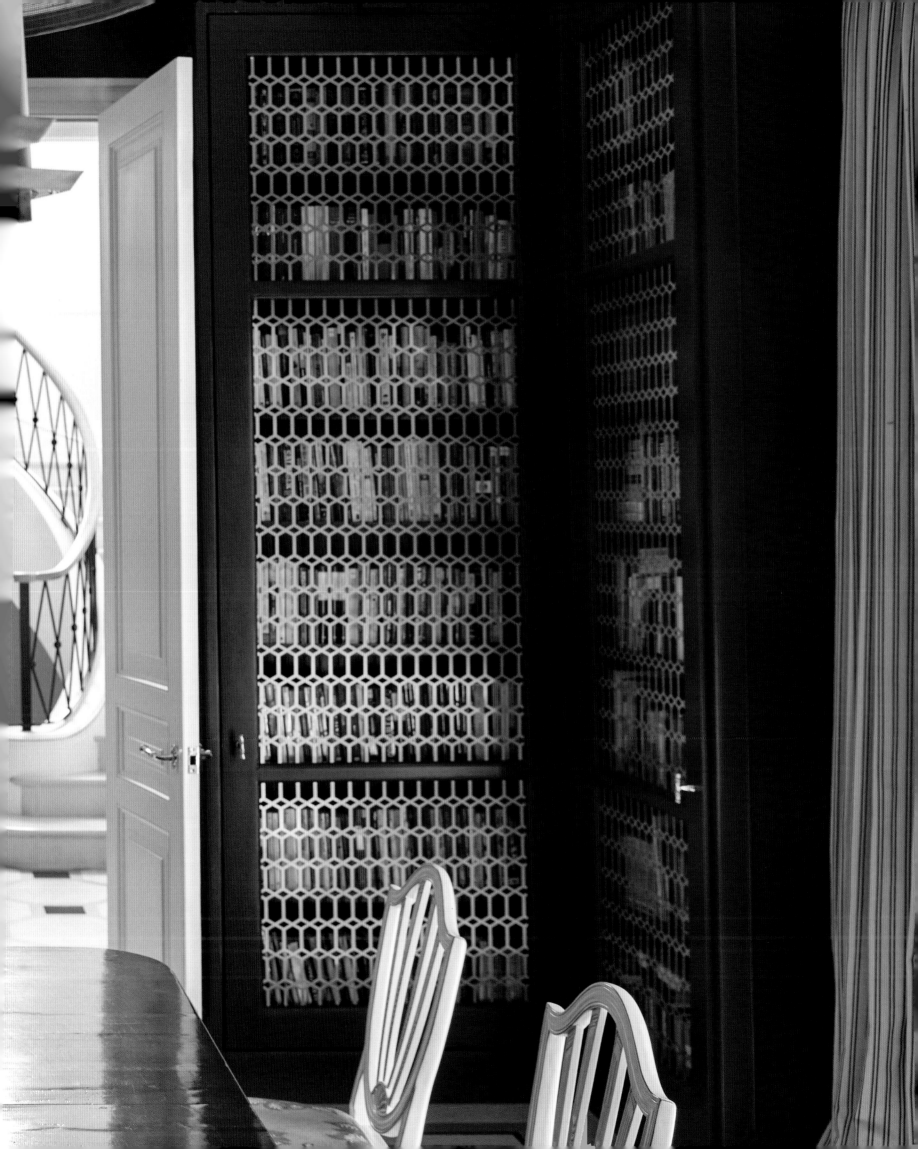

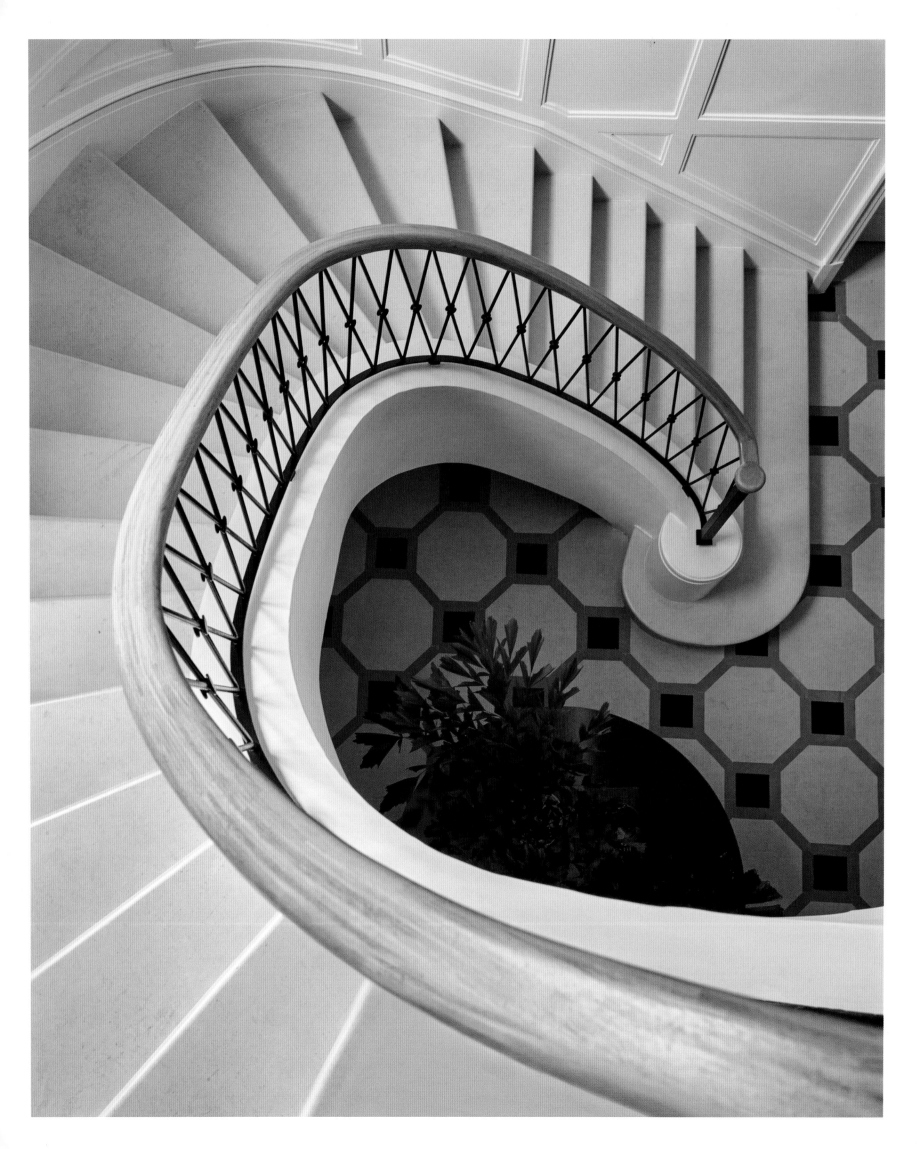

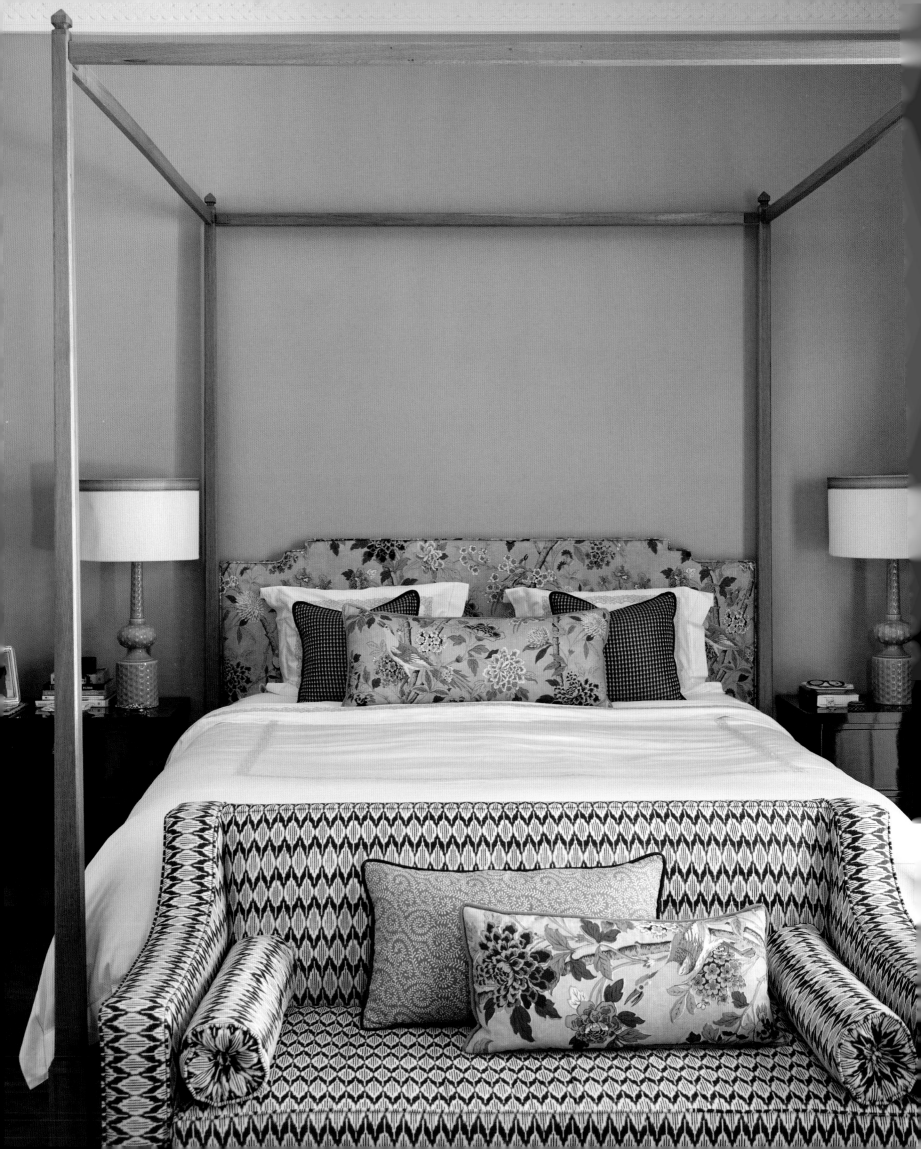

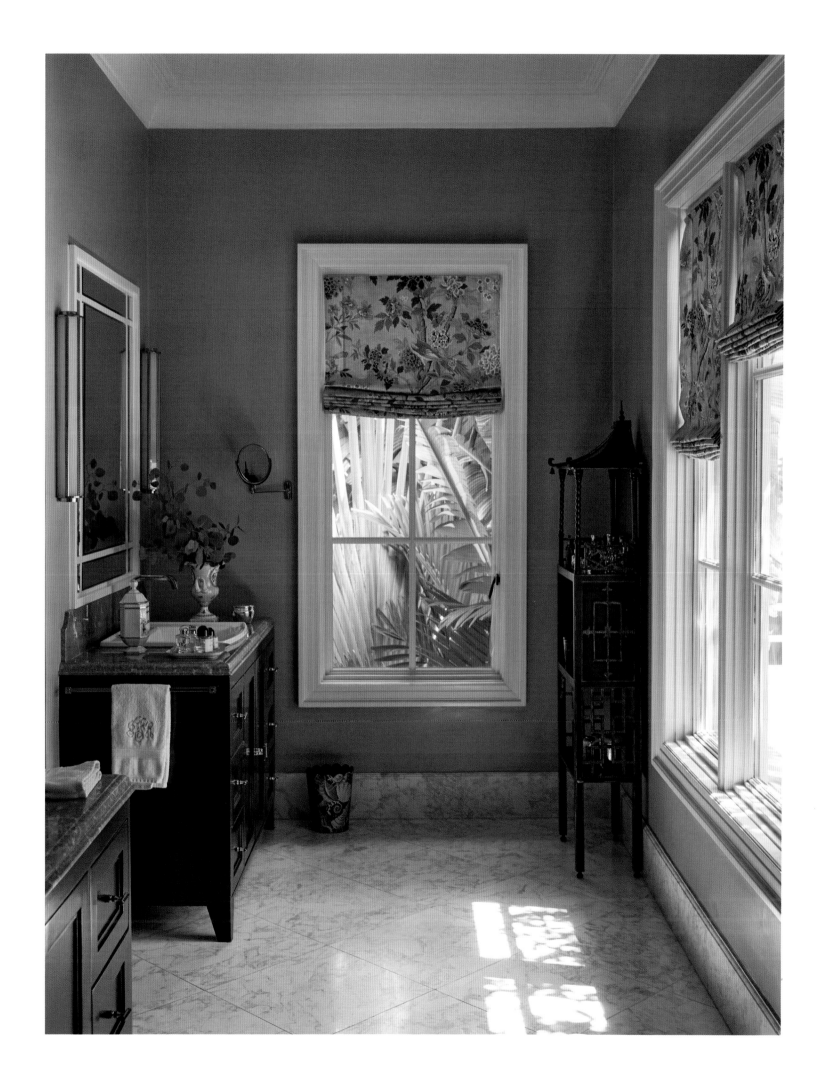

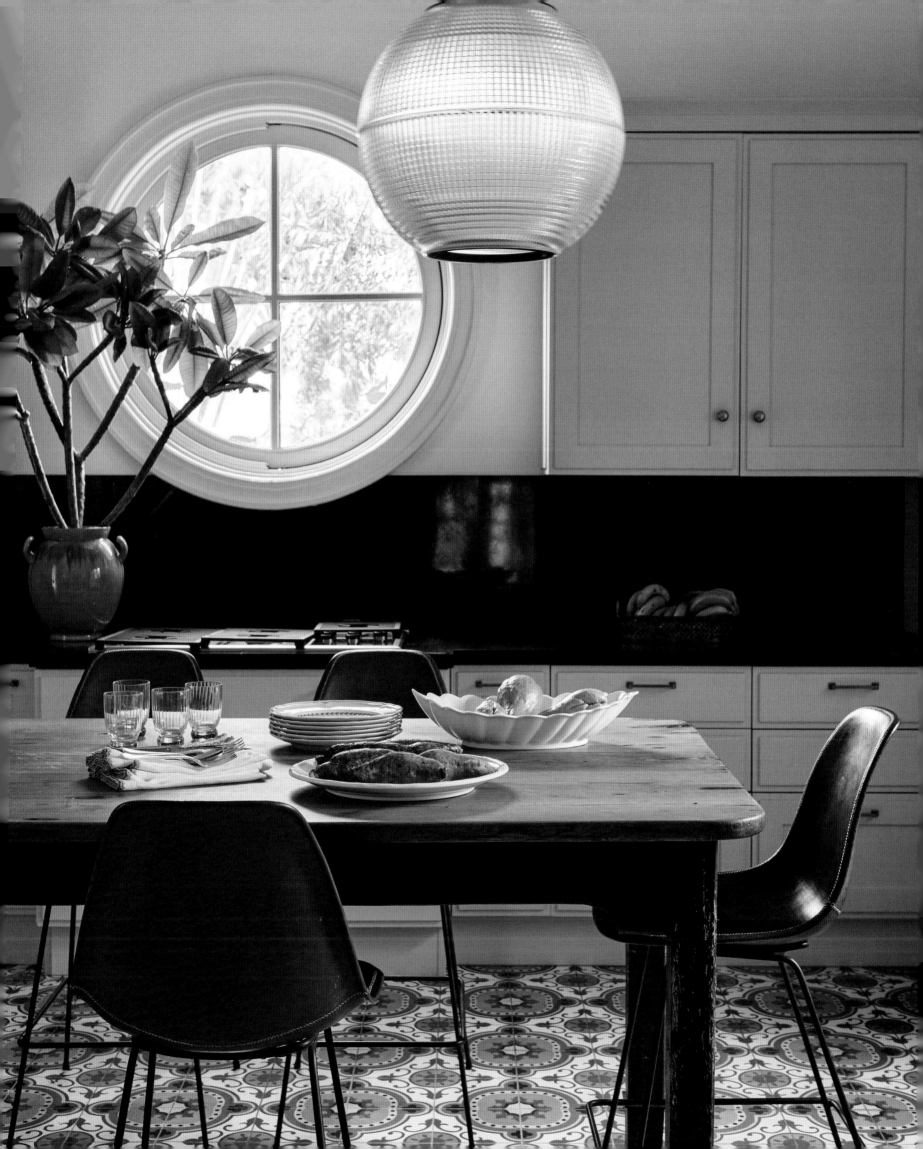

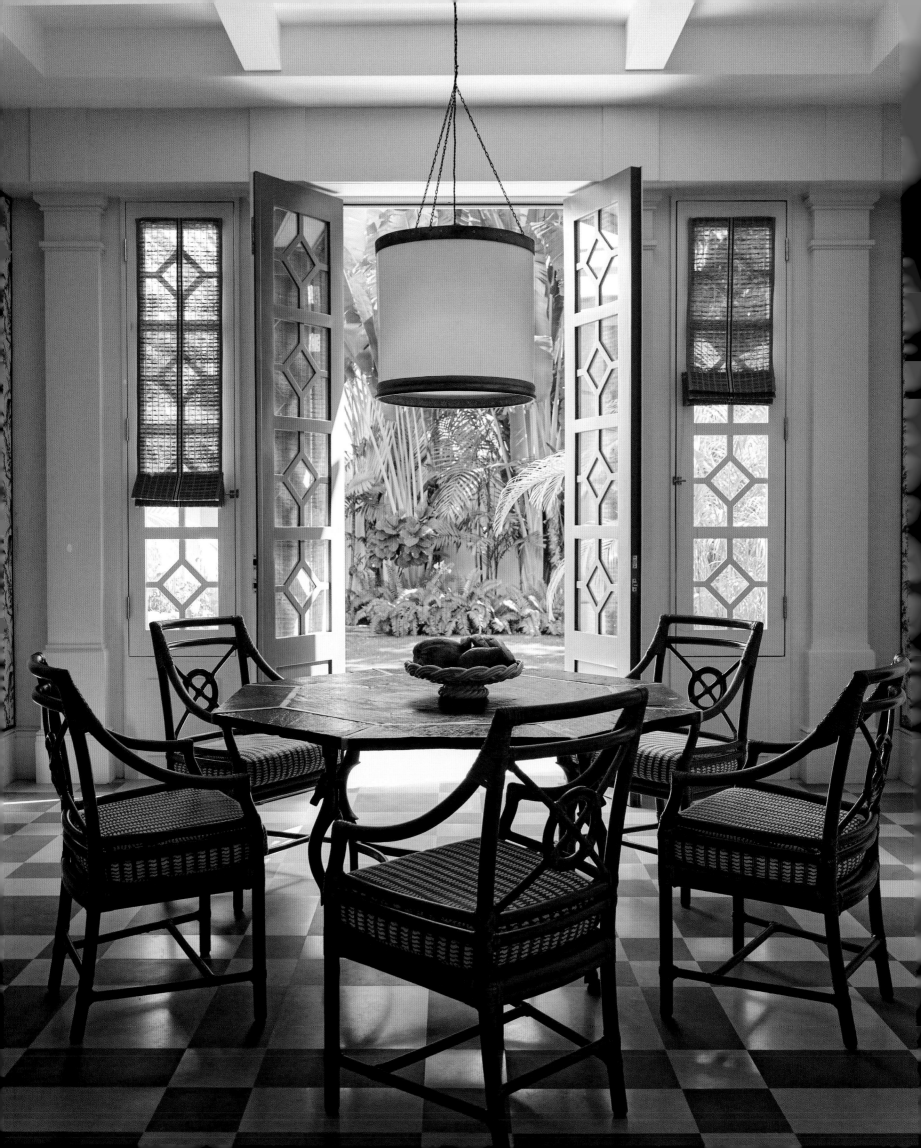

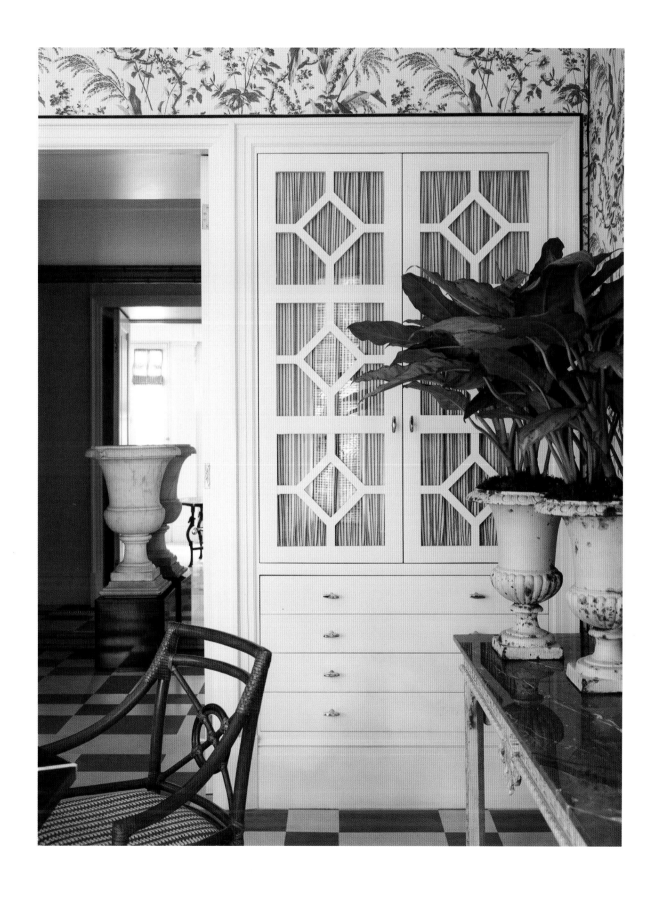

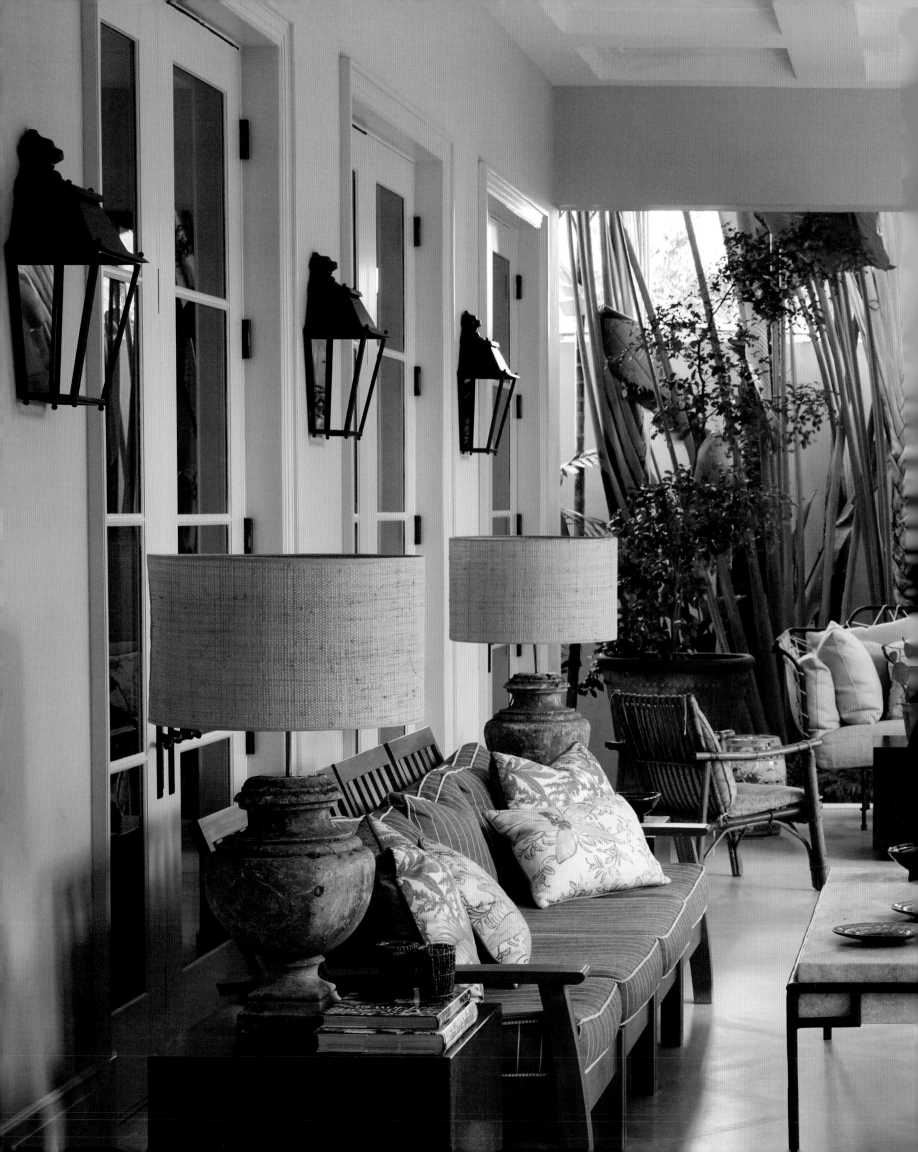

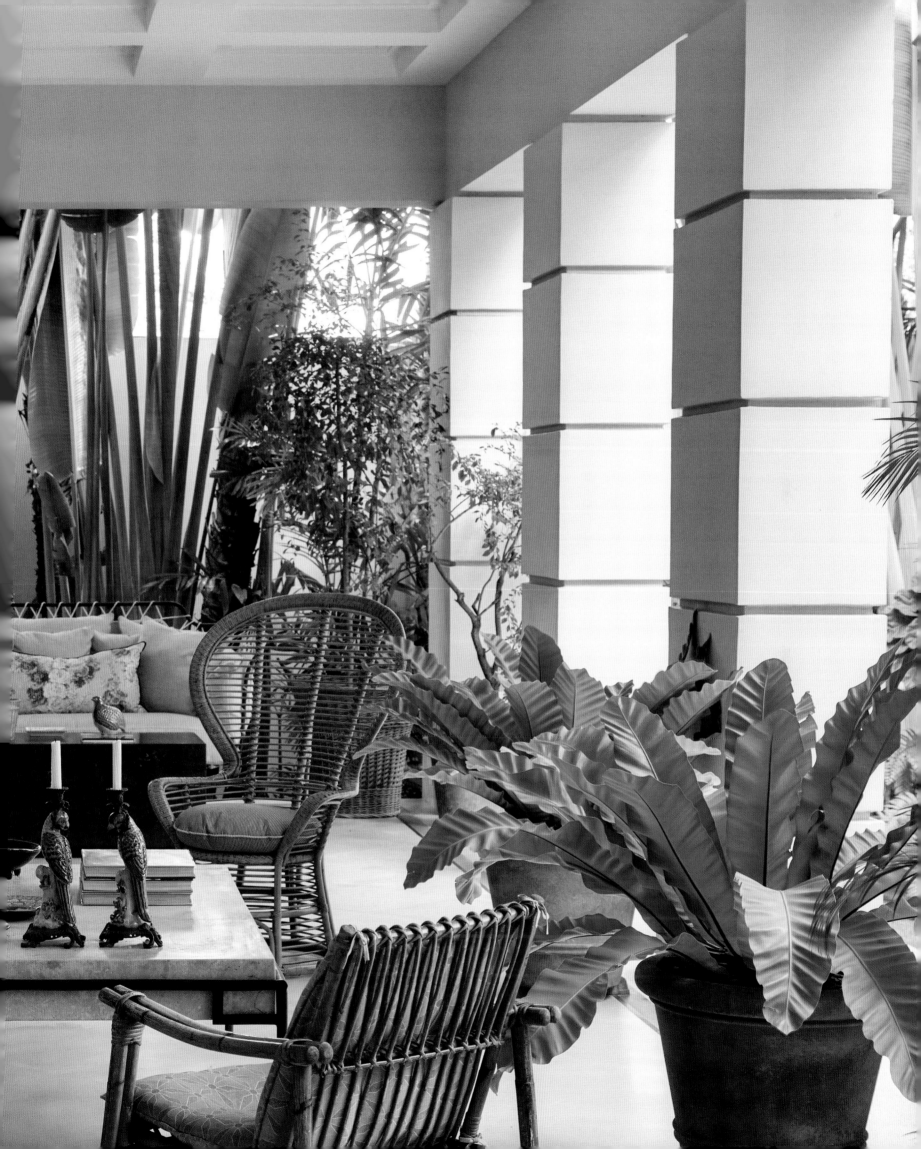

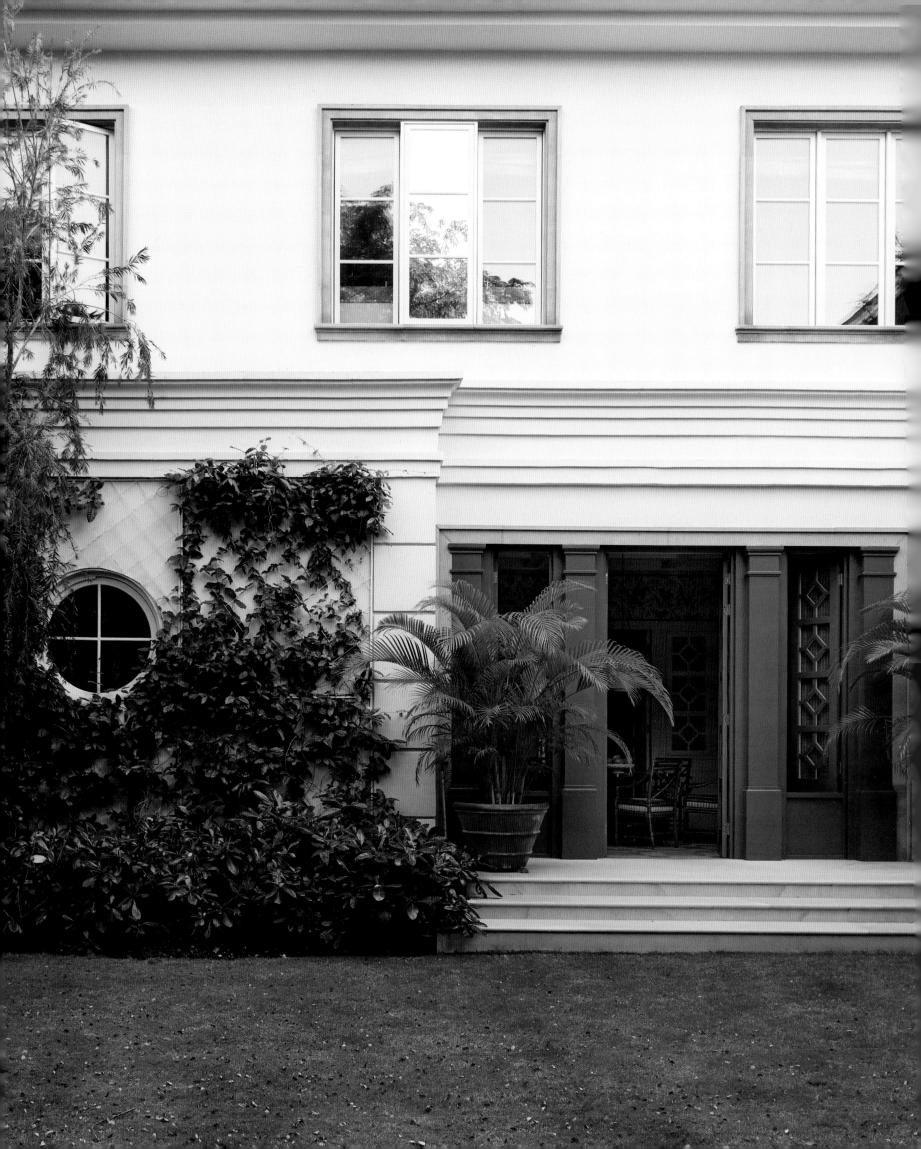

PAGE 113 In the everyday dining room in La Julia, the walls and armchairs are covered with floral fabric and porcelain birds stand on top of decorative wall sconces. Double doors lead to the cold kitchen.

PAGES 114–15 The staircase—stunning yet simple in form—takes center stage in this large hallway. Large square paneling covers the walls. A round walnut table and a painting by Paul Giudicelli occupy the space under the stairs. The three-color stone floor was designed especially for this house, and the wall lamps were made in Isabel López-Quesada's studio. Natural light streams in from a north-facing window.

PAGE 116 A hallway, floored in gray and beige, was created to join the entrance hall with the everyday dining room and the kitchen areas. A marble vase creates a focal point, and two large bamboo mirrors reflect the light from a succession of lamps.

PAGE 117 The paneled entrance hall has a hidden door that leads to the guest bathroom. A chinoiserie lacquered cabinet displaying an albino tortoiseshell piece from the 1970s and a bronze thurible hanging from the ceiling are the only decorative items, contrasting with the white wall panels.

PAGES 118–19 The lounge has three sets of French doors leading to the porch and garden. A large seating area is defined by a straight sofa, a curved sofa, and armchairs. A pair of nineteenth-century Italian console tables coupled with large eighteenth-century gold-framed mirrors flank the doorway to the hall. Mid-century square and round coffee tables offer surface space.

PAGE 120 A deep-blue velvet straight sofa in the lounge sits between two north-facing windows. Above it hangs a picture by Mexican artist Gonzalo Lebrija.

PAGE 121 An eighteenth-century French Louis XVI desk is positioned between the two openings to the living room, creating a focal point in the lounge. The picture resting on top is by Clara Ledesma.

PAGES 122–23 The living room walls are lined with beige and black raffia. This second large seating area in front of the TV contains a French chaise longue with 1970s bamboo lounge chairs and a blend of fabrics and fibers. The circular artwork above the sofa is by José García Cordero. Two French doors lead out to the porch.

PAGES 124–25 The dining room also has doors to the porch. Four large bookcases painted in a Coca-Cola color were custom-made and installed in its four corners. The table is English mahogany, with white-painted chairs that stand out and add a fresh touch. The main staircase can be seen at the back.

PAGE 126 The view from the top of the main staircase offers a stunning snapshot of the flooring below, the beige limestone stairs, the oak handrail, and the slender iron spindles.

PAGE 127 The upstairs landing leads to the primary suite and the children's area. The three-color flooring used downstairs is repeated here, dressed with a large French iron and oak table, and two lounge chairs upholstered in a fabric with a pattern of pineapples and leaves.

PAGE 128 The beige tone of the primary bedroom walls is mirrored in the oak four-poster bed and the fabric of the blinds.

PAGE 129 The primary bathroom features black bespoke cabinets. Both the bathroom and the primary bedroom enjoy access to a large terrace filled with plants.

PAGES 130–31 The cold kitchen is a family space. The hydraulic tile flooring was created in a workshop that employs traditional methods. The colors, chosen specifically for this room, complement the whitewashed cabinetry and Zimbabwe Black granite worktops. Two vintage pendant lights hang above the central French table, mirroring the ox-eye window looking out onto the garden.

PAGE 132 Located between the formal dining room and the cold kitchen, the everyday dining room opens onto the garden and receives the morning light. Painted wooden doors and windows work beautifully with floral fabric and the stunning gray and white floor. Bamboo chairs surround a slate and iron table.

PAGE 133 Cupboards used for storing dinnerware, glassware, and cutlery flank the doors leading from the everyday room to the hallway.

PAGES 134–35 The porch, facing south, is reached via French doors from the living room, lounge, and dining room. A large teak sofa is framed by bamboo chairs, and an iron bench sits at the back. An abundance of lush plant life surrounds the space.

PAGE 136 A view of the cold kitchen's ox-eye window and the blue colonial-style doorway to the garden, which was created to provide an exit from the everyday dining room. The rooms for the younger members of the household are above. The windows are outlined in gray stone, and linear moldings run around the whole facade.

CLASSICISM IN MADRID'S SALAMANCA DISTRICT

This early twentieth-century apartment is found in one of the most legendary buildings in Madrid's Salamanca district. This part of the Spanish capital is renowned for its high-end shops and is home to some of the city's best bars and restaurants. But beyond its commercial attractions, the Salamanca neighborhood has always been a special place because of its cheerful streets, grand homes, and proximity to El Retiro.

This project, completed in 2014, involved a total renovation that flipped the layout and changed the materials used in the original apartment. The kitchen was moved to the front of the apartment, while the rear was reserved for the bedrooms. The only things that remain from the original apartment are two leaded glass windows in the hallway and the library. The wide, understated main entrance hall delivers visual impact through its stone floor in gray, beige, and white—colors used frequently throughout the property—and a large painting by the Catalan artist Antoni Tàpies, a dominant figure in twentieth-century Spanish art.

This magnificent entrance leads to the office/library, the dining room, the lounge, and the living room, which overlook Calle de Claudio Coello. An everyday dining room, with walls hung with mirrors that give it a sense of breadth, acts as an entrance way and leads to the owners' daughters' rooms, the guest rooms, and service rooms. The primary bedroom and bathroom are situated at the back of the house, with walls covered in patterned American raffia and a bath of Italian Arabescato marble. A long row of closets lines the corridor.

The clients wanted the lounge to be an exceptional living area. The room has three windows looking onto the street and two soft, curved beige sofas. At the rear, in front of a stunning large Chinese screen, sits a Willy Rizzo table for serving nibbles or for working in the natural light from the windows. Completing the space are two eighteenth-century Italian sideboards and a triptych by the British artist Francis Bacon. Beiges and grays connect the living area and the dining room, which is lined with a Zuber grisaille scenic wallpaper, giving perspective and a sense of depth. This area is presided over by a large metal table designed in López-Quesada's studio. The pair of mid-century sideboards in the dining room connect with the drawers from the same era in the office, made from palo santo wood and bordered by a large black and gold bookcase.

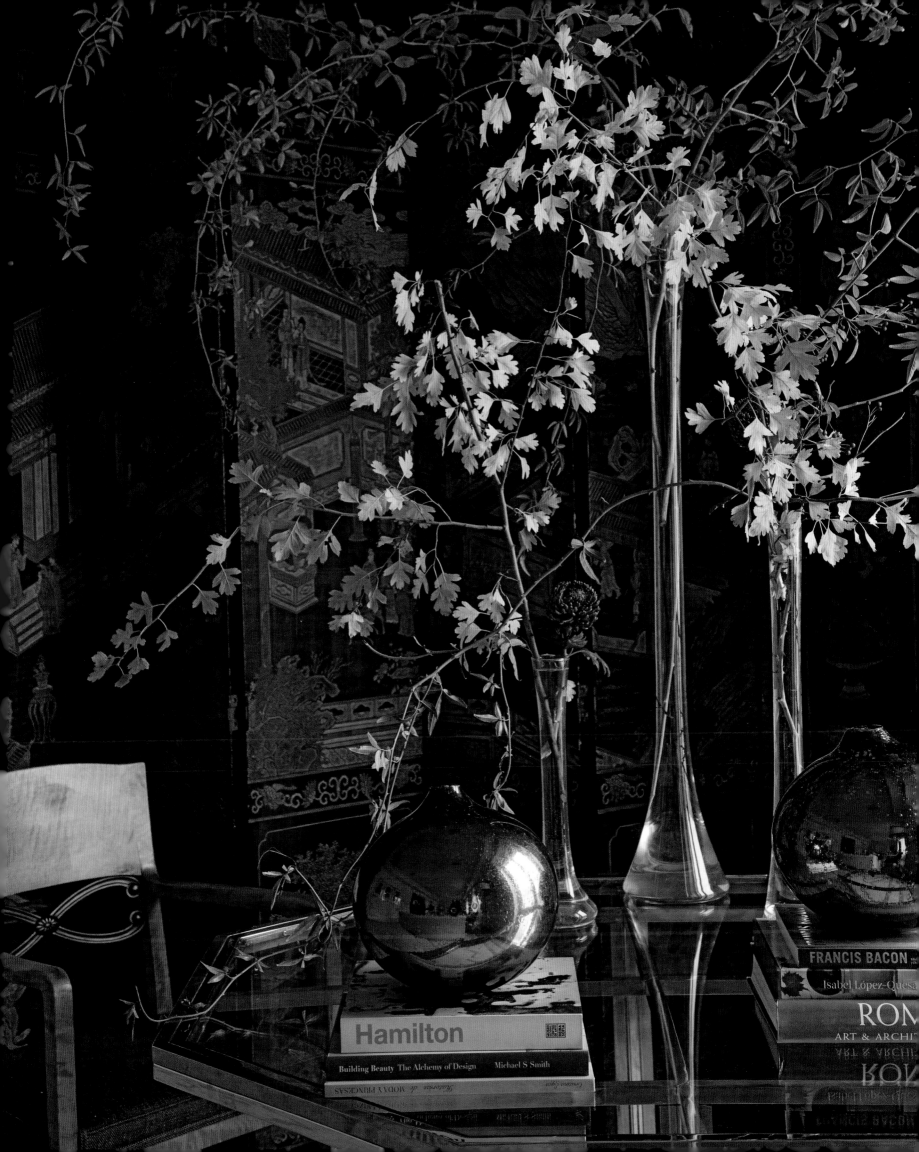

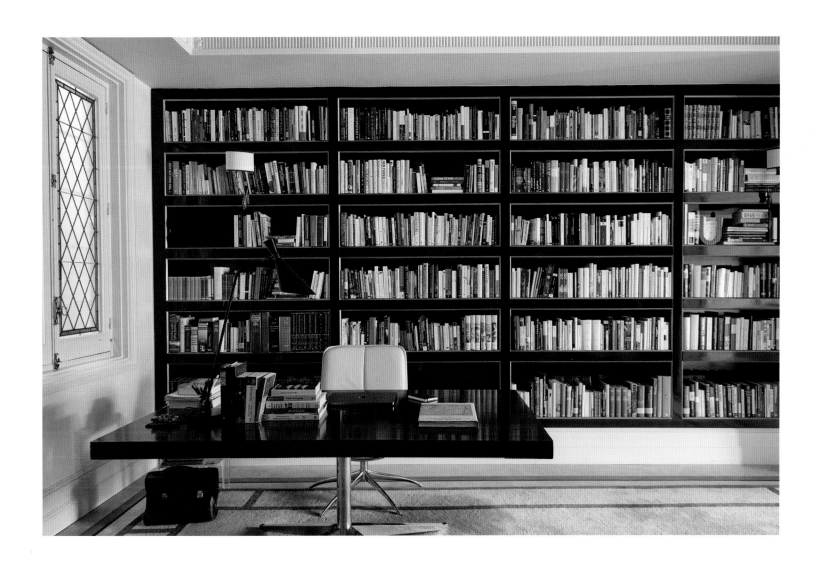

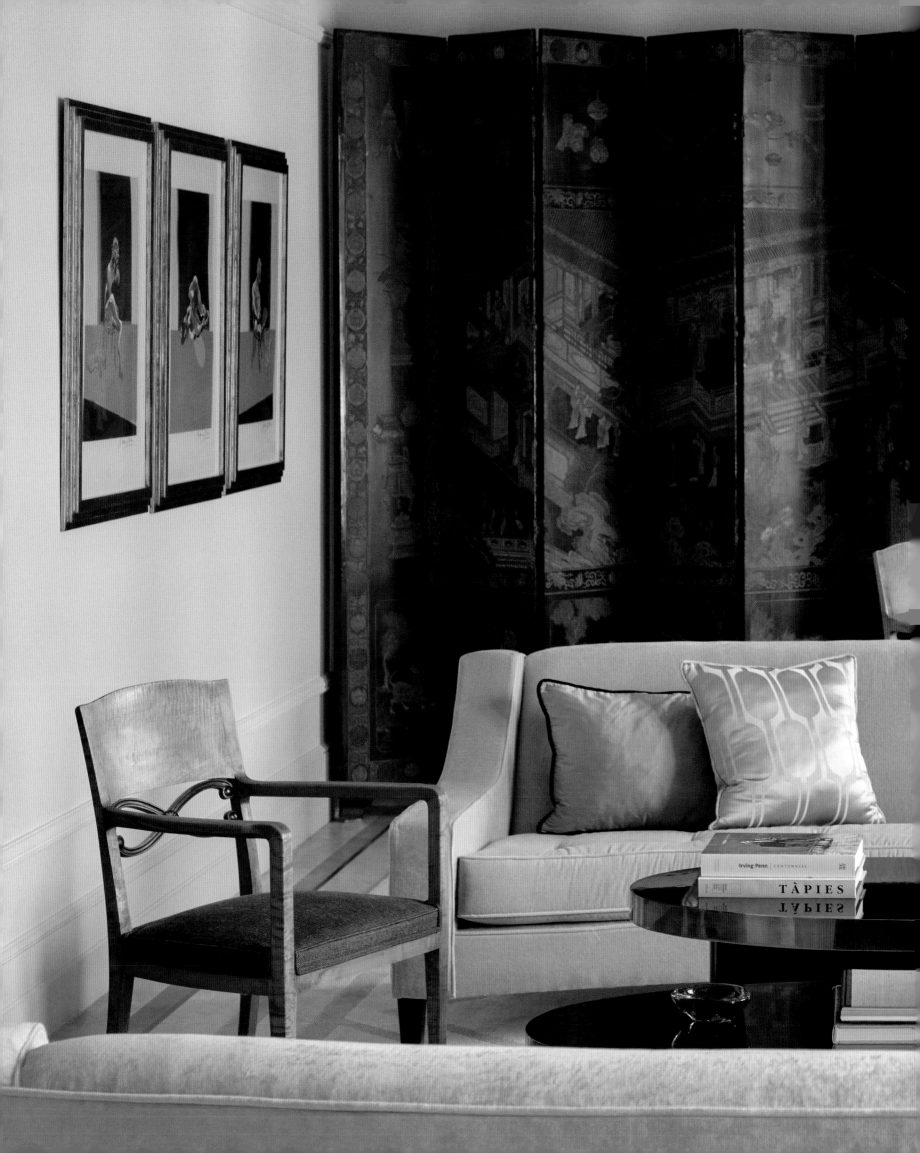

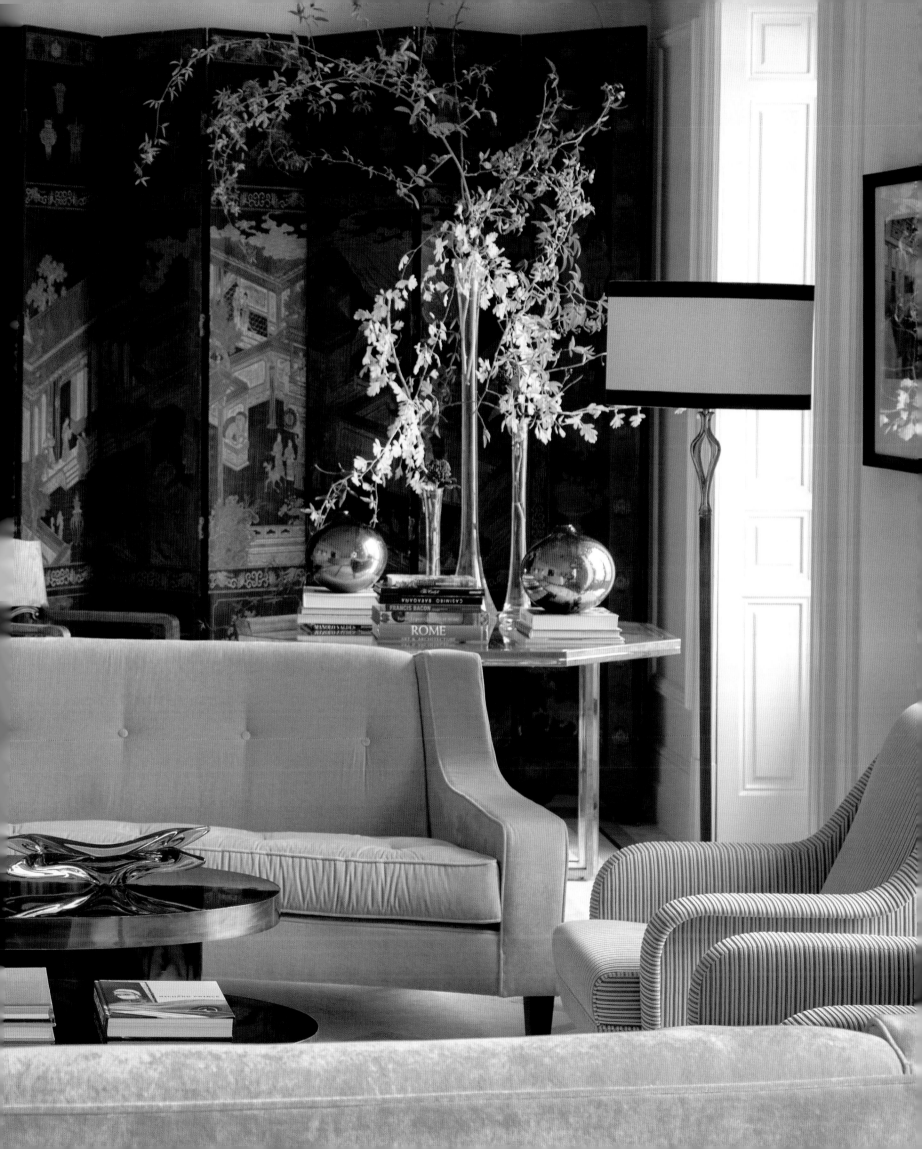

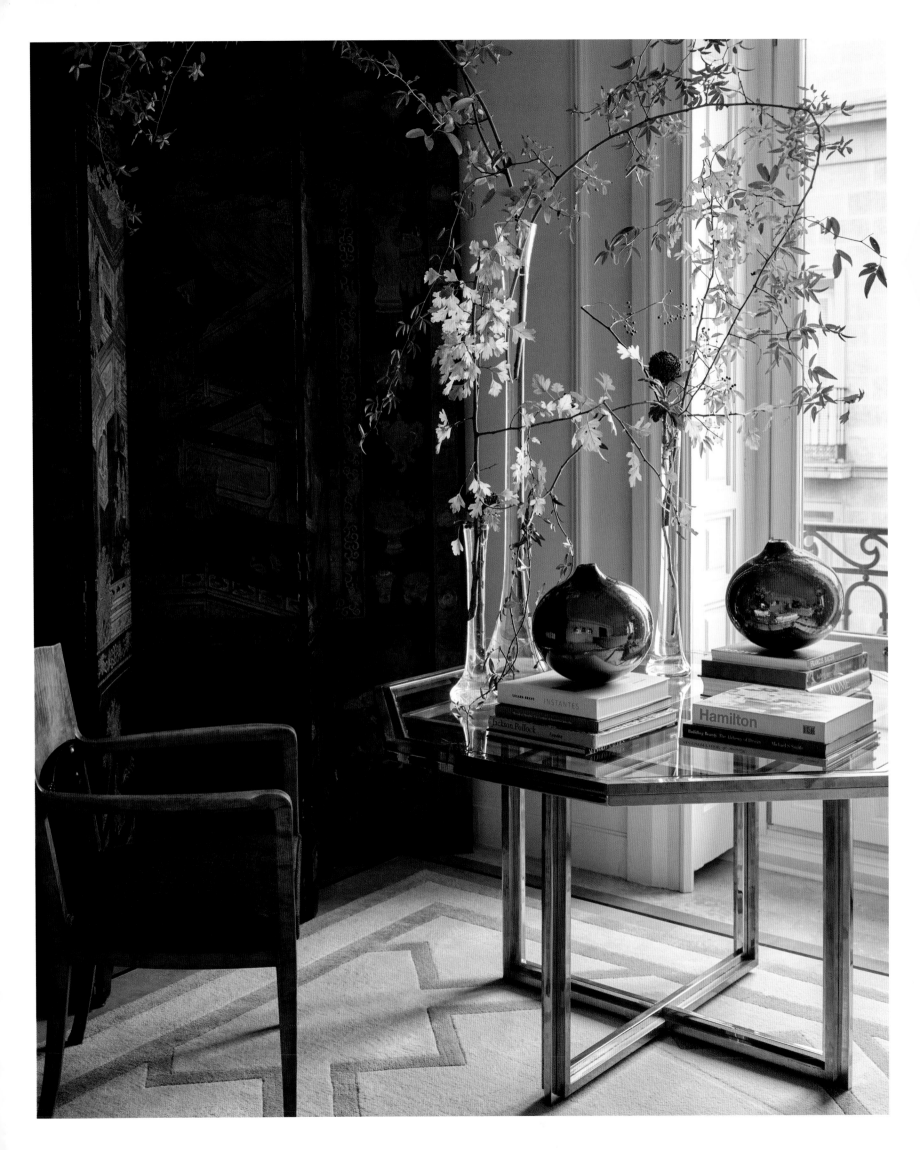

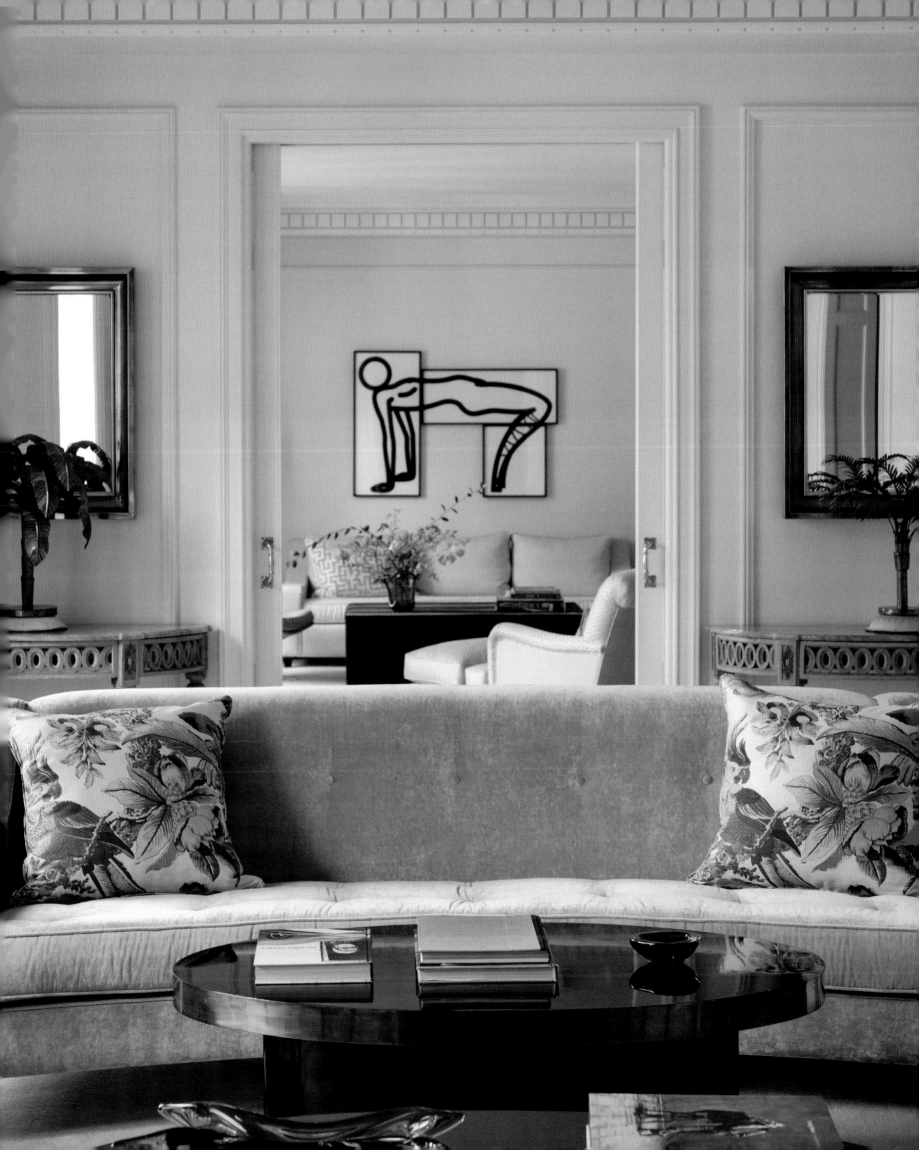

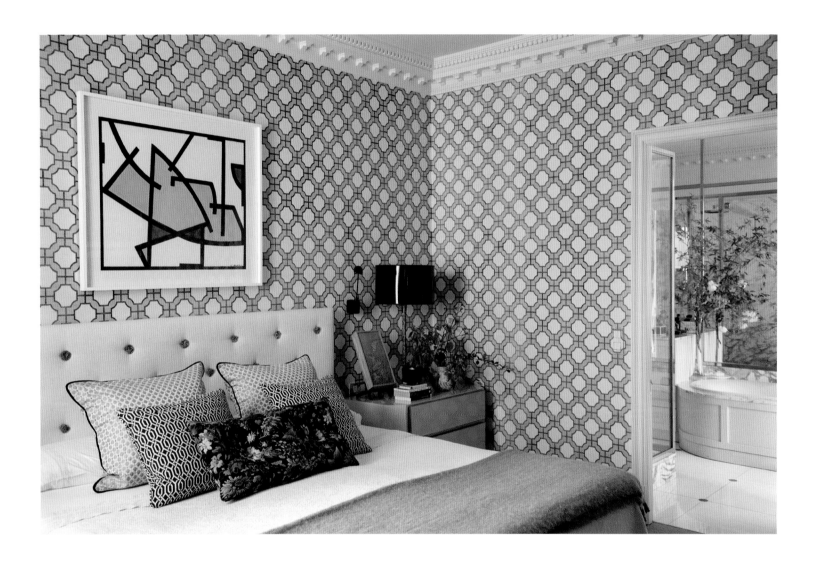

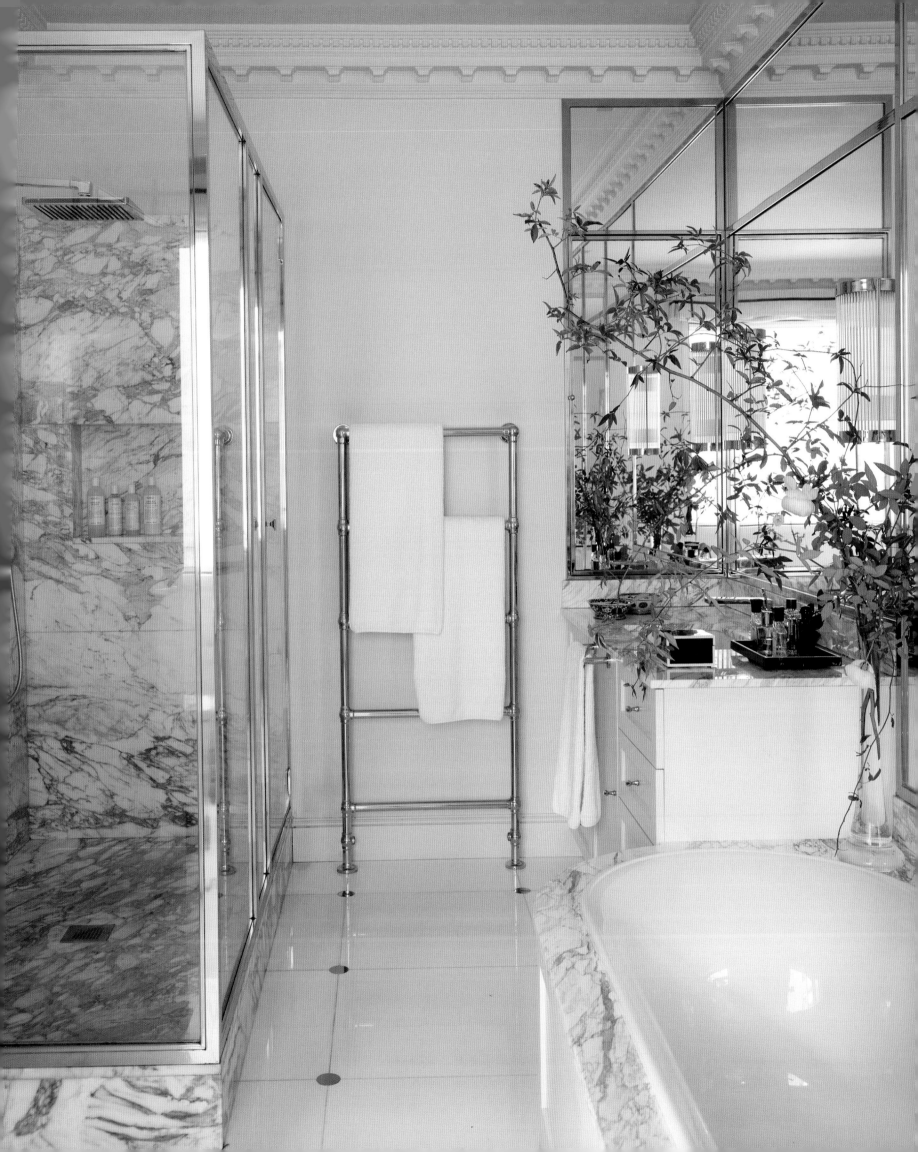

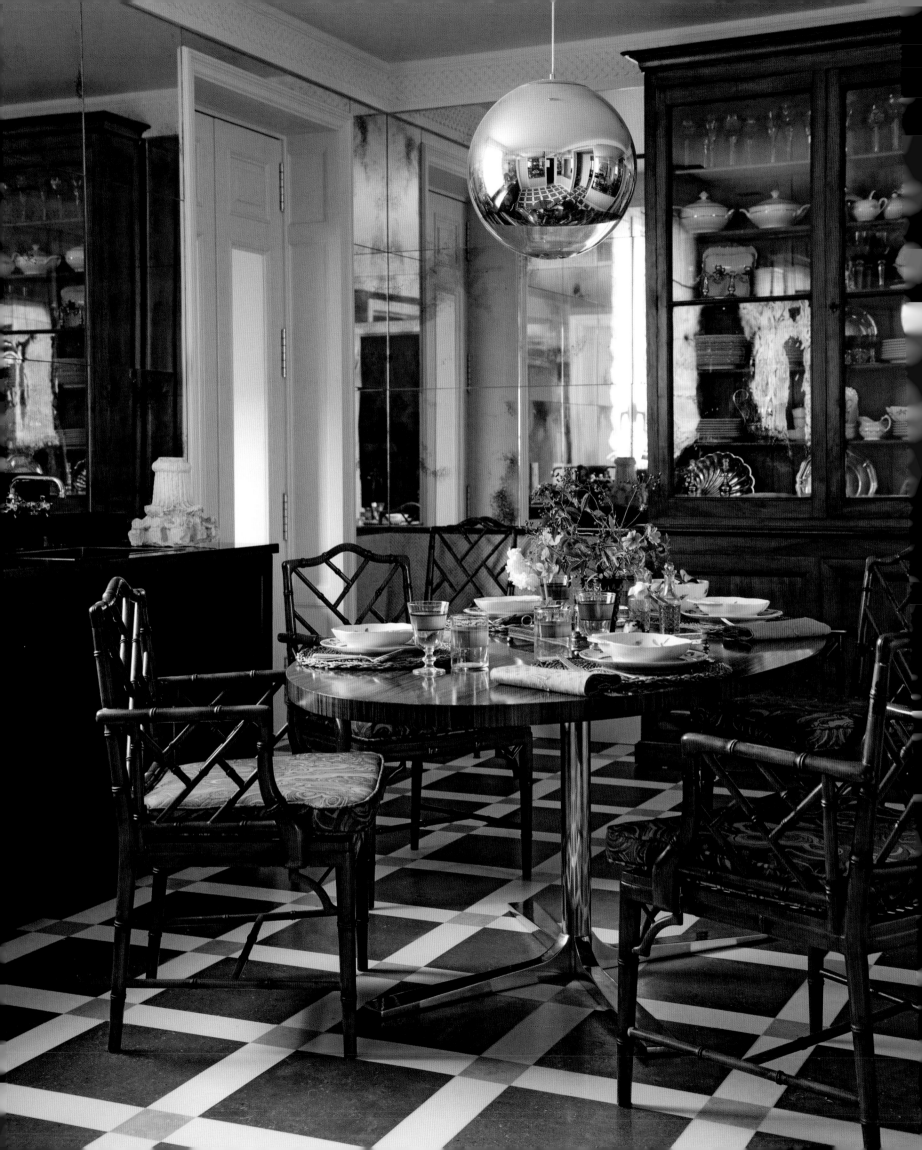

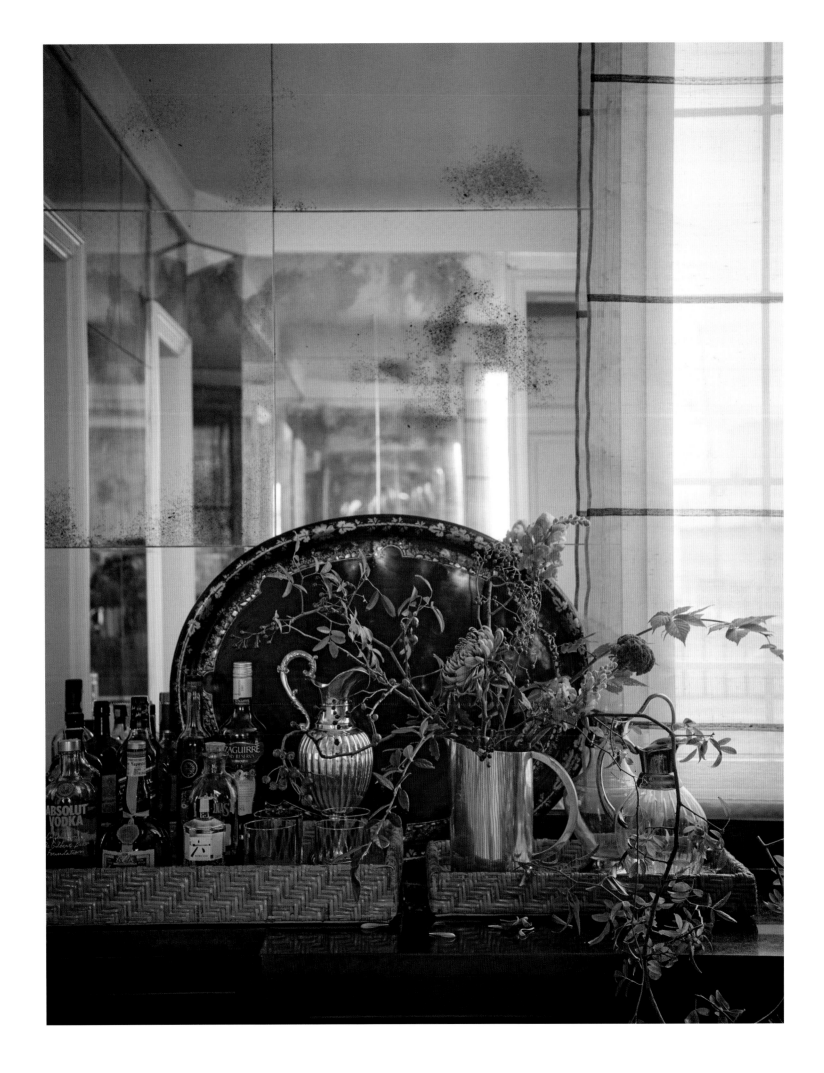

PAGE 139 In the lounge of the Salamanca apartment, a table by Willy Rizzo holds books and glass balls, contrasting with the screen behind. The greenery is from florist Inés Urquijo.

PAGE 140 A large work by Antoni Tàpies is the star of the hallway, paying homage to the artist's centenary. The flooring is designed in gray, beige, and white stone.

PAGE 141 In the office/library, one whole wall is lined with books. A mid-century Florence Knoll palo santo table serves as a workspace. The carpet is two-tone gray wool and the bookcase is painted black with gilded edges. A restored leaded window lets in the light.

PAGES 142–43 The dining room transitions from black to white through various shades of gray, augmented by beautiful Zuber grisaille scenic wallpaper. A white metal table with chairs upholstered in gray wool sit in front of a white English marble fire surround.

PAGES 144–45 A wonderful Chinese screen anchors the long lounge. Its twelve Coromandel lacquered leaves depict a view of the countryside from the air, and its border is decorated with ritual objects from the nineteenth century. On the left are three pictures by Bacon. In the center of the room, a living space is created by two soft, curved sofas surrounded by chairs.

PAGE 146 A Willy Rizzo gold and chrome table at the end of the lounge is a place for taking tea, working, or simply reading. A striking geometric-patterned wool rug echoes the lines of the table and the Chinese screen behind it.

PAGE 147 A view of the lounge looking toward the living room. The black and brass coffee tables in the lounge were designed to match the sofas. On either side of the doors to the living room, a pair of polychrome Italian console tables hold mid-century brass palm trees. The pinks and browns of the living room, with a Julian Opie artwork above the sofa, can be seen through the open doors.

PAGE 148 Hicks-inspired raffia covers the wall of the primary bedroom. The two bedside tables are painted gray, and pillows on the bed in three different fabrics add a touch of color. A connecting door leads to the bathroom.

PAGE 149 In the bathroom, the white marble flooring with steel "coins" blends with Italian marble of the shower, basins, and countertops. The cabinets, fronted with mirrors outlined in steel, enhance the feeling of space and light in this long, narrow room.

PAGE 150 The everyday dining room features the same stunning flooring as the hallway. An oval table and faux-bamboo chairs occupy the center of the space. The walls are lined with vintage mirrors, and a black desk serves as an island. A large mahogany cabinet is filled with dinnerware and glassware, with tablecloths stored below.

PAGE 151 Detail of the bar in the pantry, with Philippine trays to hold the bottles, the jugs, and the whiskey glasses, which are by Los Vasos de Agua Clara.

PAGE 152 A pair of black glass chests of drawers with gold detailing stand out against the Zuber grisaille wallpaper in the dining room. Vieux Paris porcelain and gold vases are placed on top.

A NEST ATOP MANHATTAN

The hustle and bustle of a city like New York can overstimulate, generating never-ending ideas and thoughts—after all, it's the city that never sleeps. So, when López-Quesada received a commission for an apartment in the Four Seasons Private Residences in New York's Tribeca district, it was clear that it needed to be ultra cozy. The plan was to create a homely nest as a counterpoint to the intensity of the amazing views of the city from the apartment.

The Spanish and Greek couple who own this property were connected to López-Quesada through a previous project—she had designed a house for the husband's parents on the island of Spetses that also features in this book (see page 298). Initially, the couple had taken an apartment on the forty-second floor of the building, which had been completely remodeled, but part-way through that project their family grew, and they moved to the sixty-third floor, which gave them more room and even more spectacular views over New York. The project was completed in 2019.

Most of the pieces were sourced from Spain, with the clients' involvement. The stunning lounge is a highlight of the apartment, with walls clad in gray herringbone and enormous windows looking north and east over Manhattan. A mixture of mid-century furniture and antiques was chosen for this clean-lined, broad space, crowned with a large golden ceiling lamp. A daybed placed next to one of the windows allows one to enjoy the views or peacefully read; two velvet sofas, one blue and the other green, add other options for sitting and relaxing. Two spectacular 1960s floor-to-ceiling oak columns placed next to the sliding door contrast with the elegant gray on the walls and nod to classical culture and the husband's Greek origins.

A sliding door connects the lounge to a combined everyday dining room, library, and kitchen, where raffia decorations and moldings give the space a sense of warmth. The main dining room features an abundance of birds and palm trees in its tropical landscape wallpaper, patterned china, and, above all, a large porcelain centerpiece of brightly colored birds reflecting the bird's-eye view of the big city from the sixty-third floor.

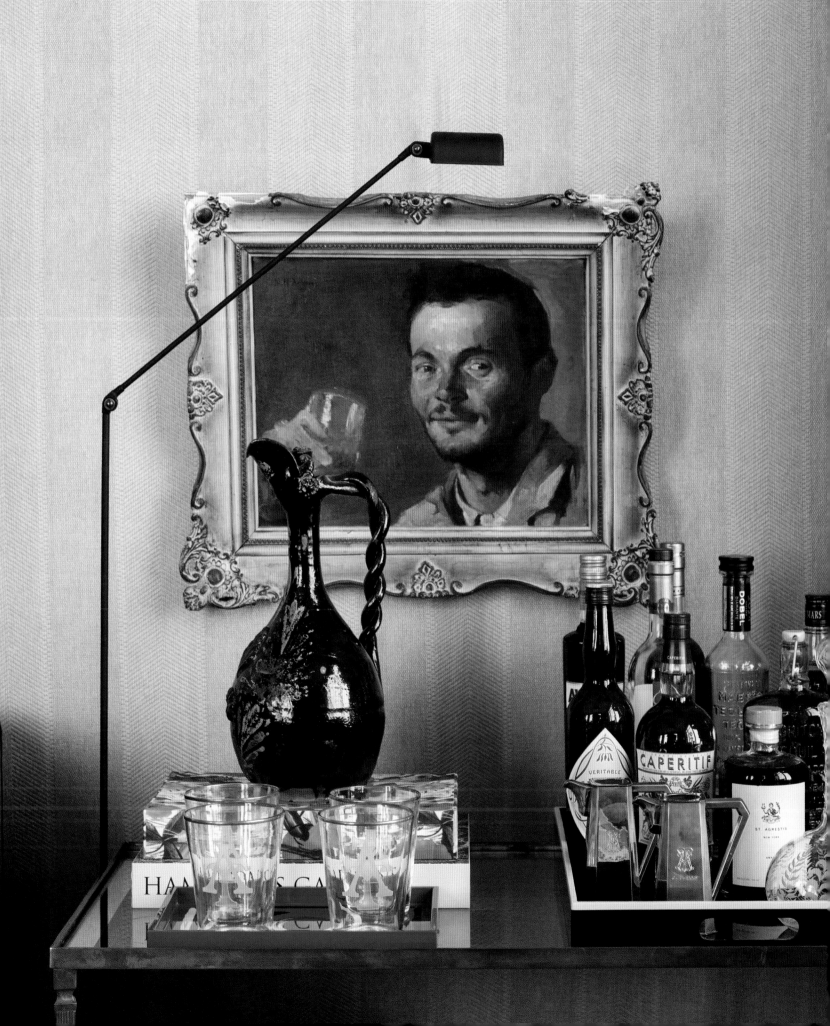

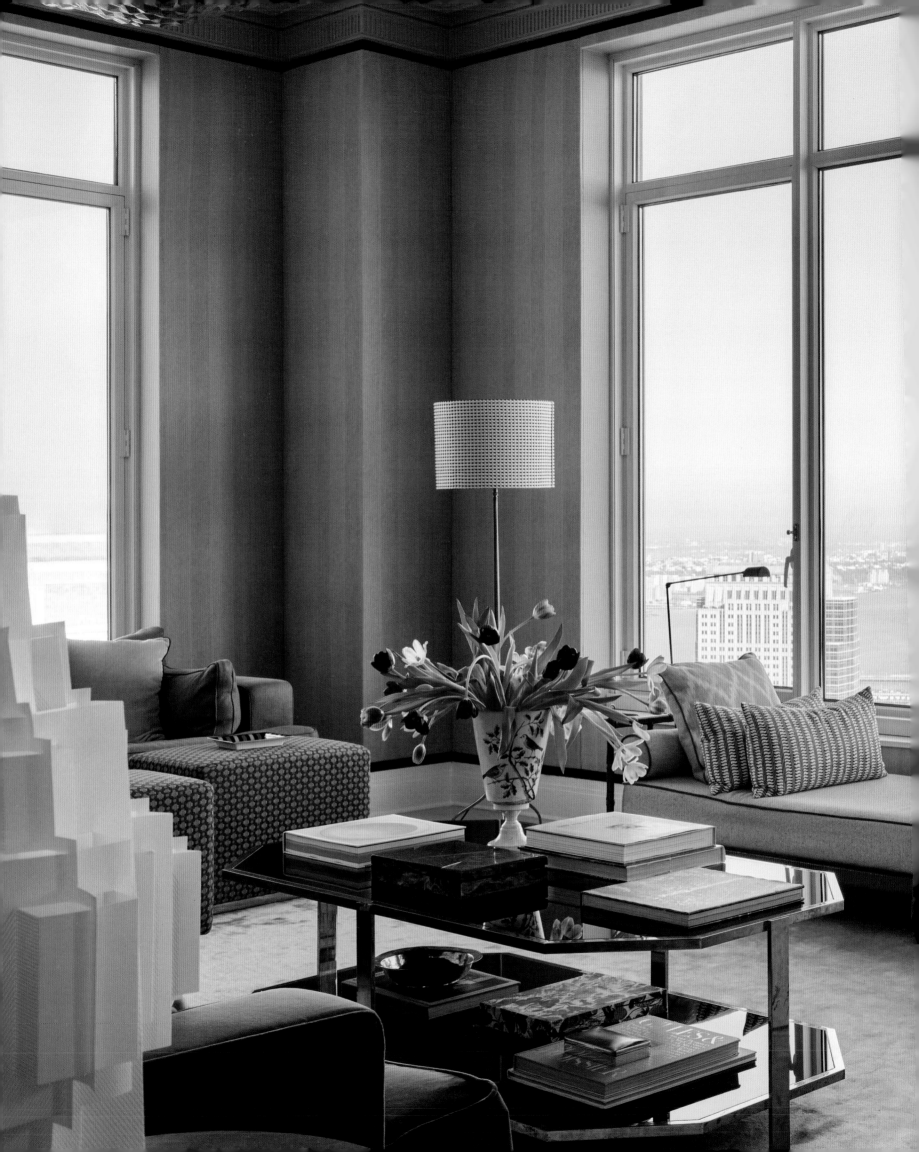

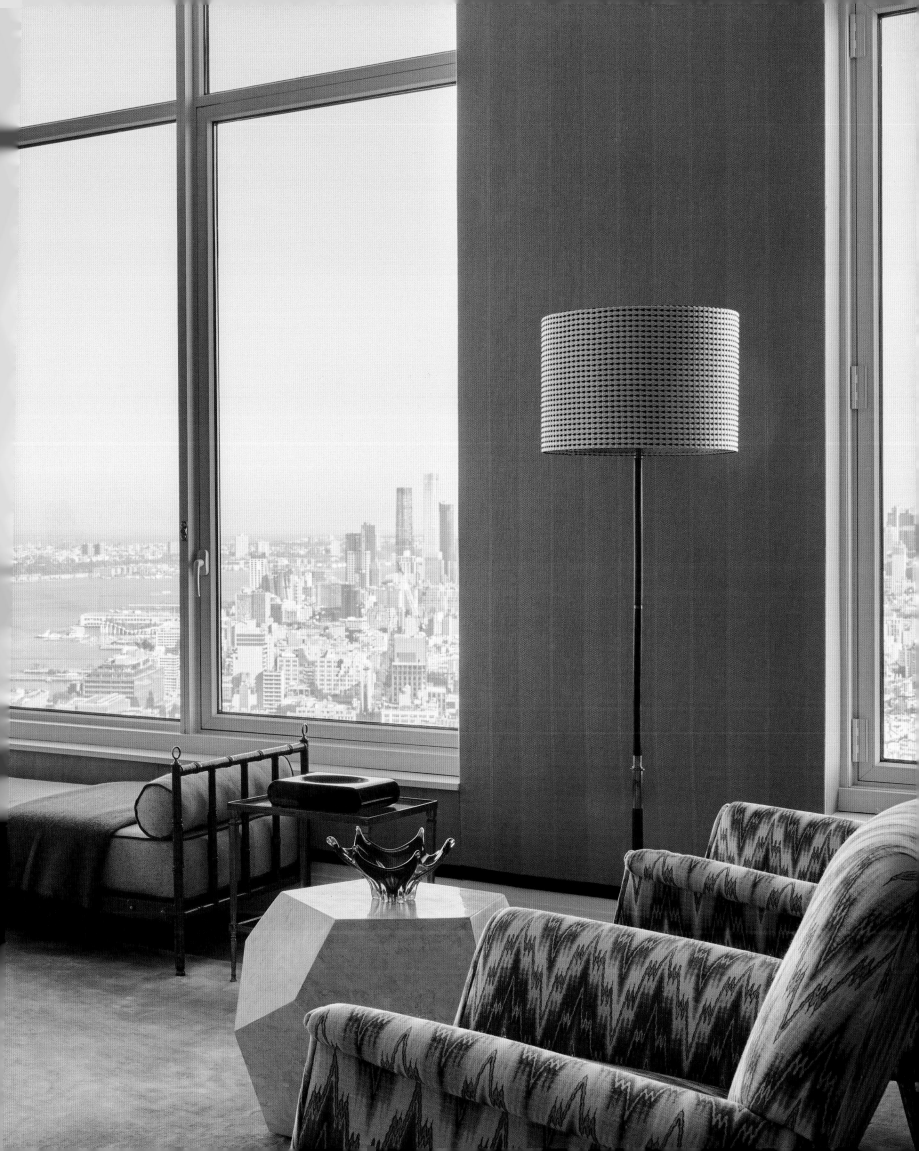

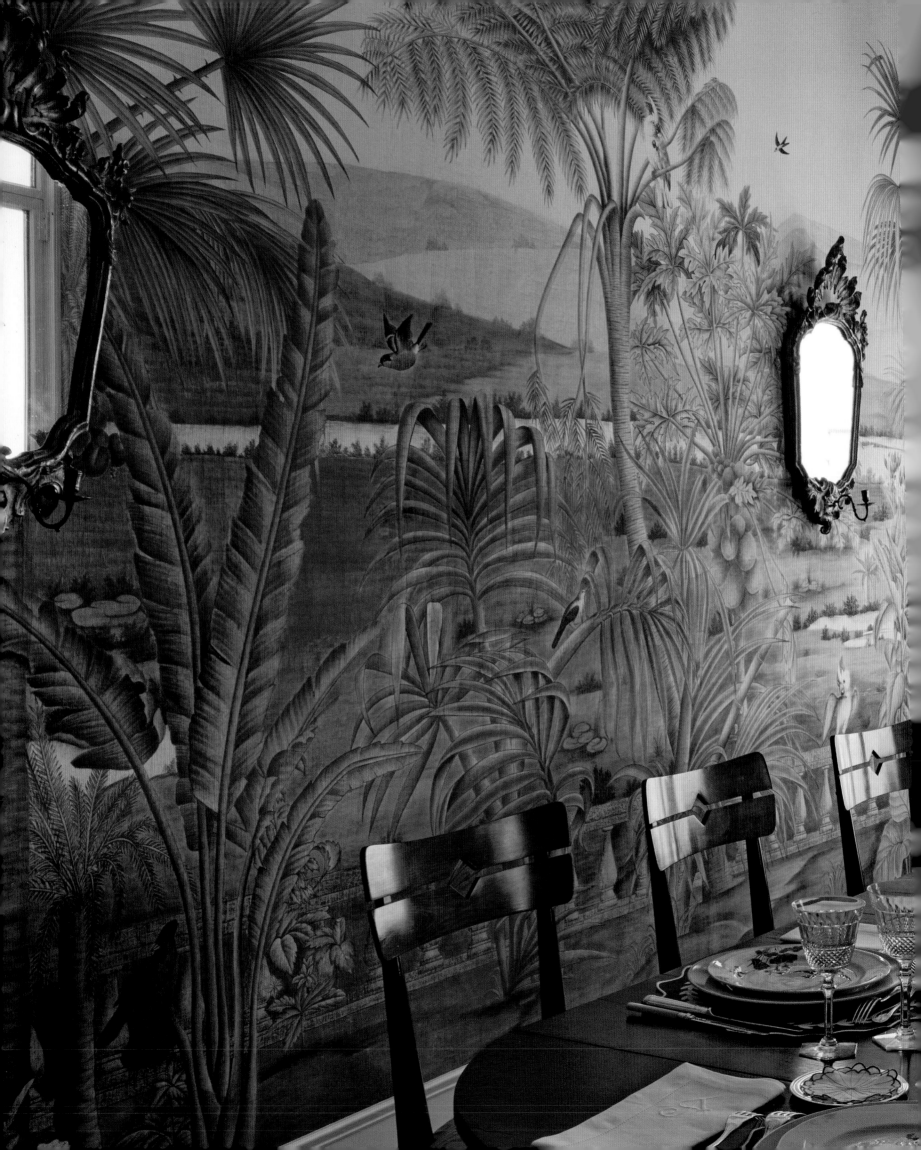

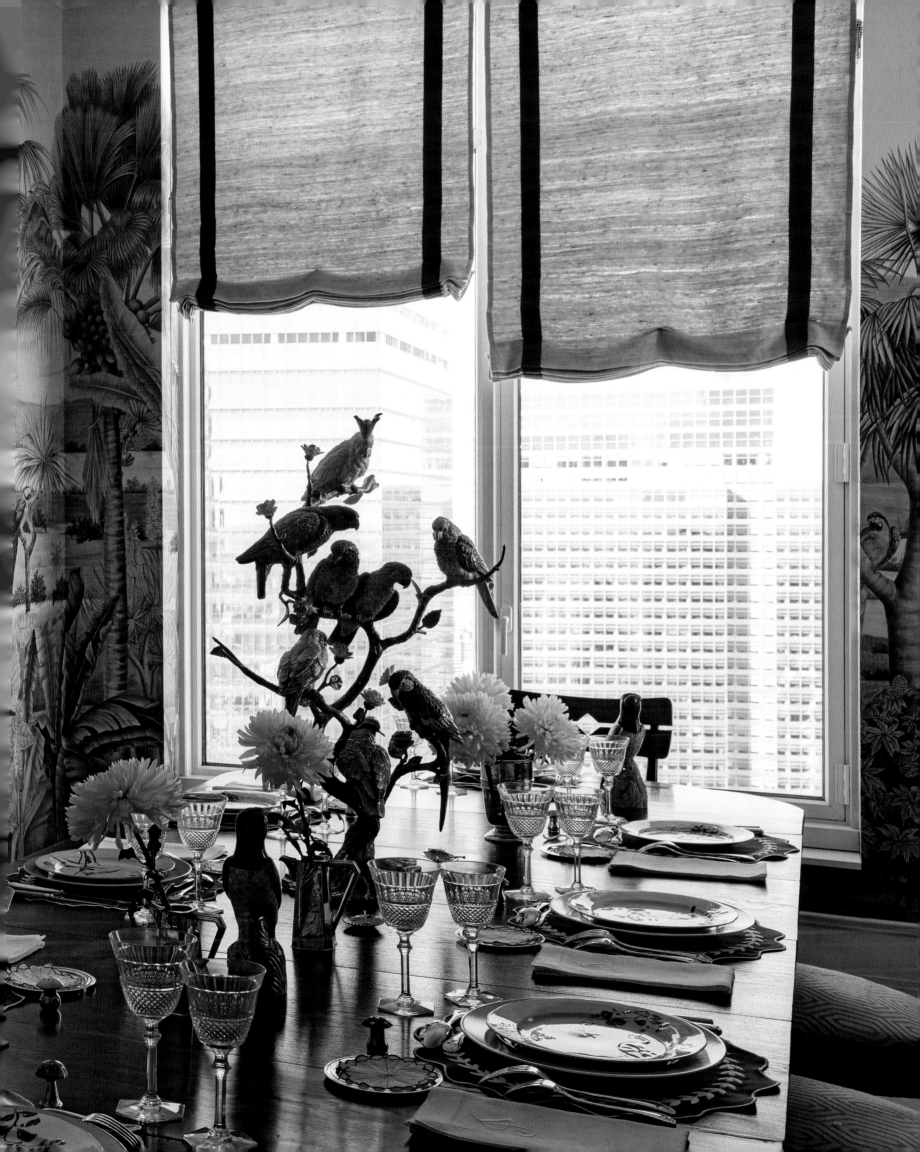

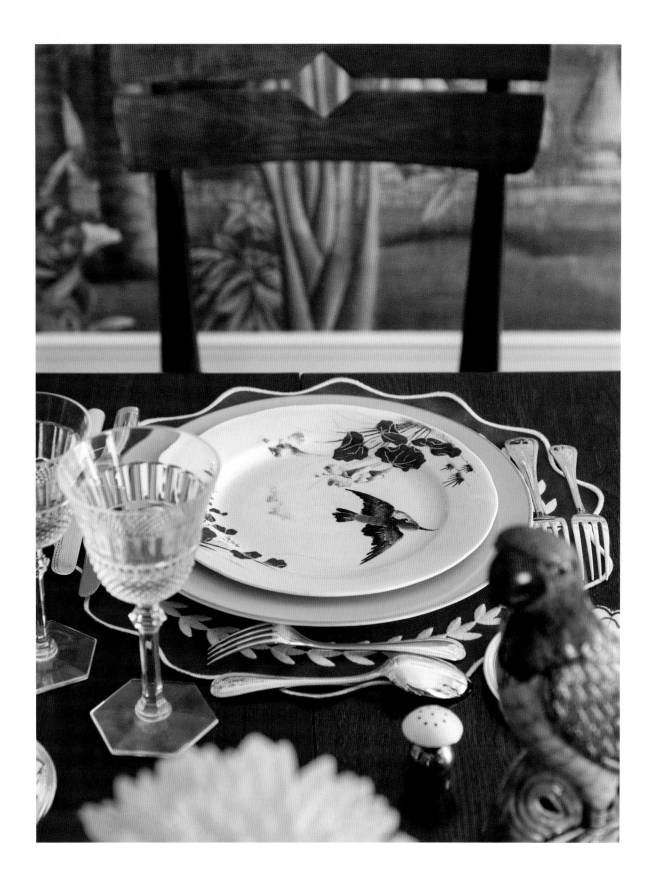

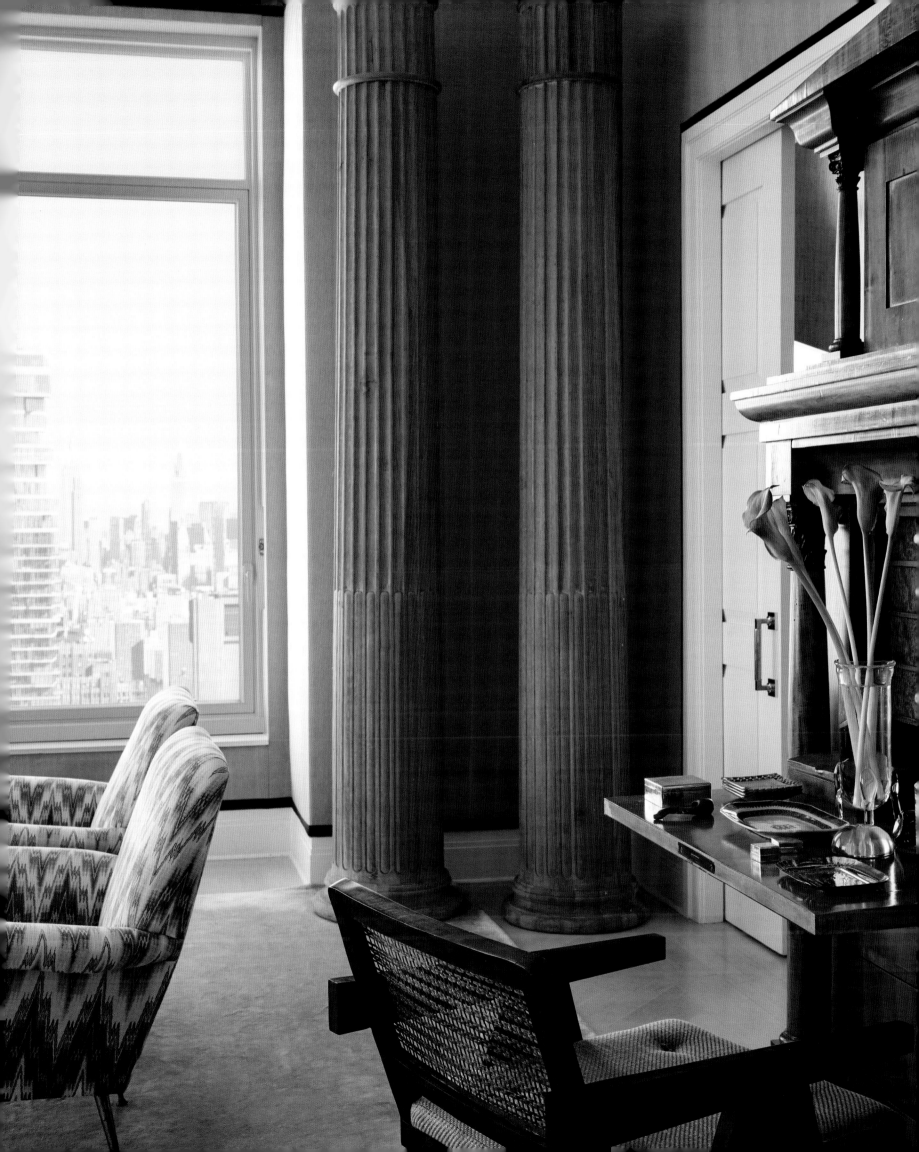

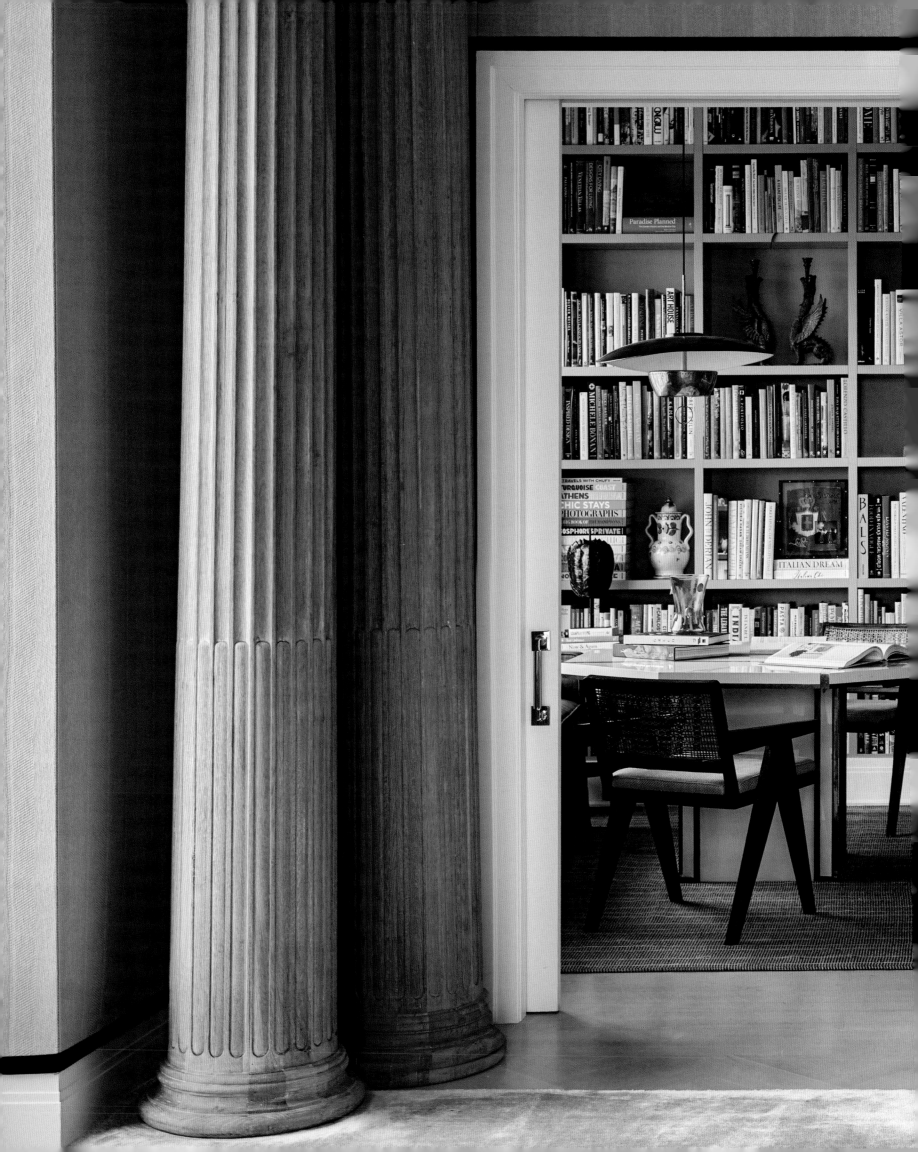

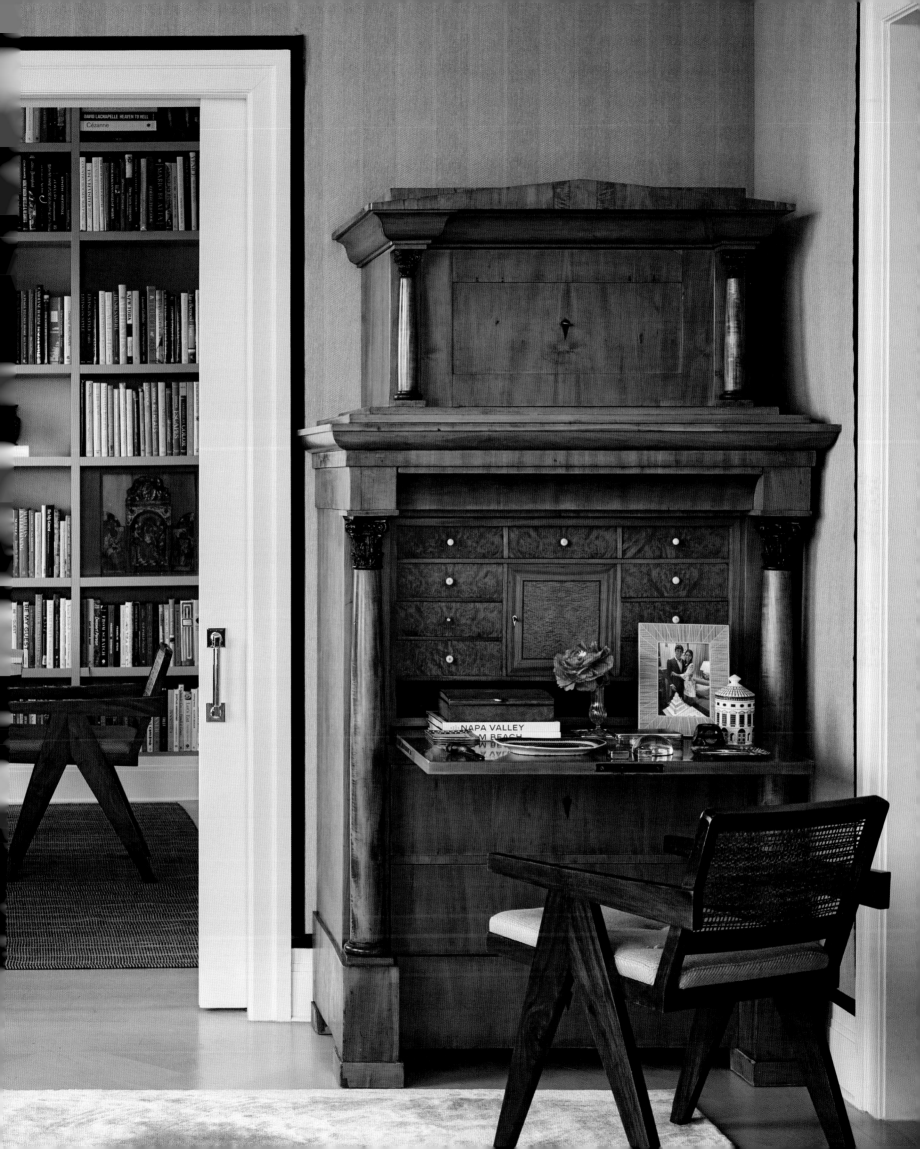

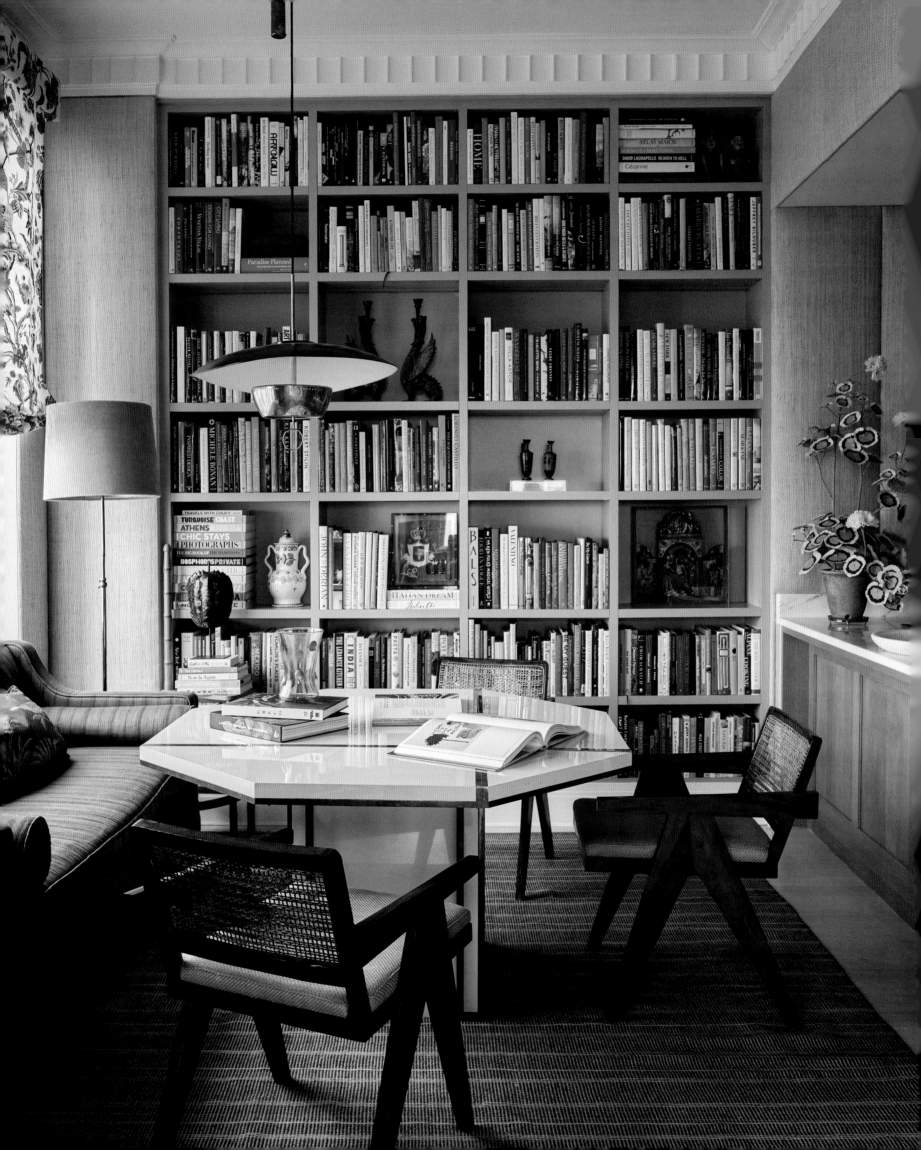

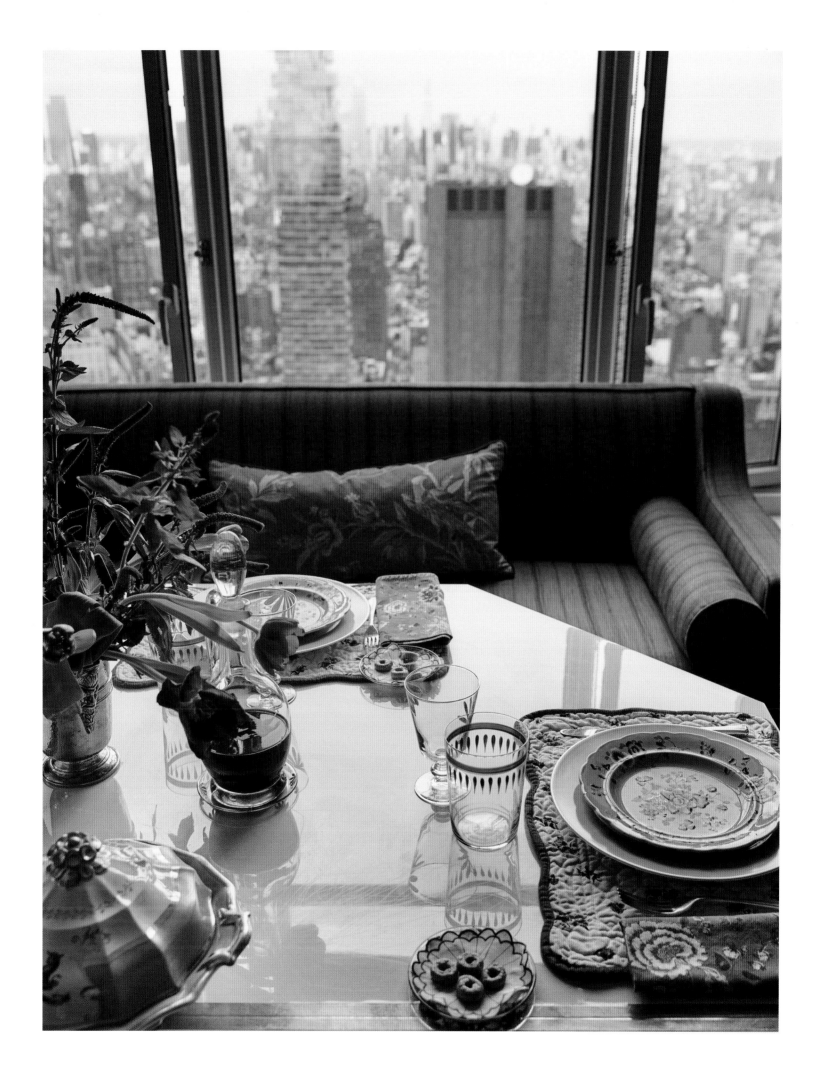

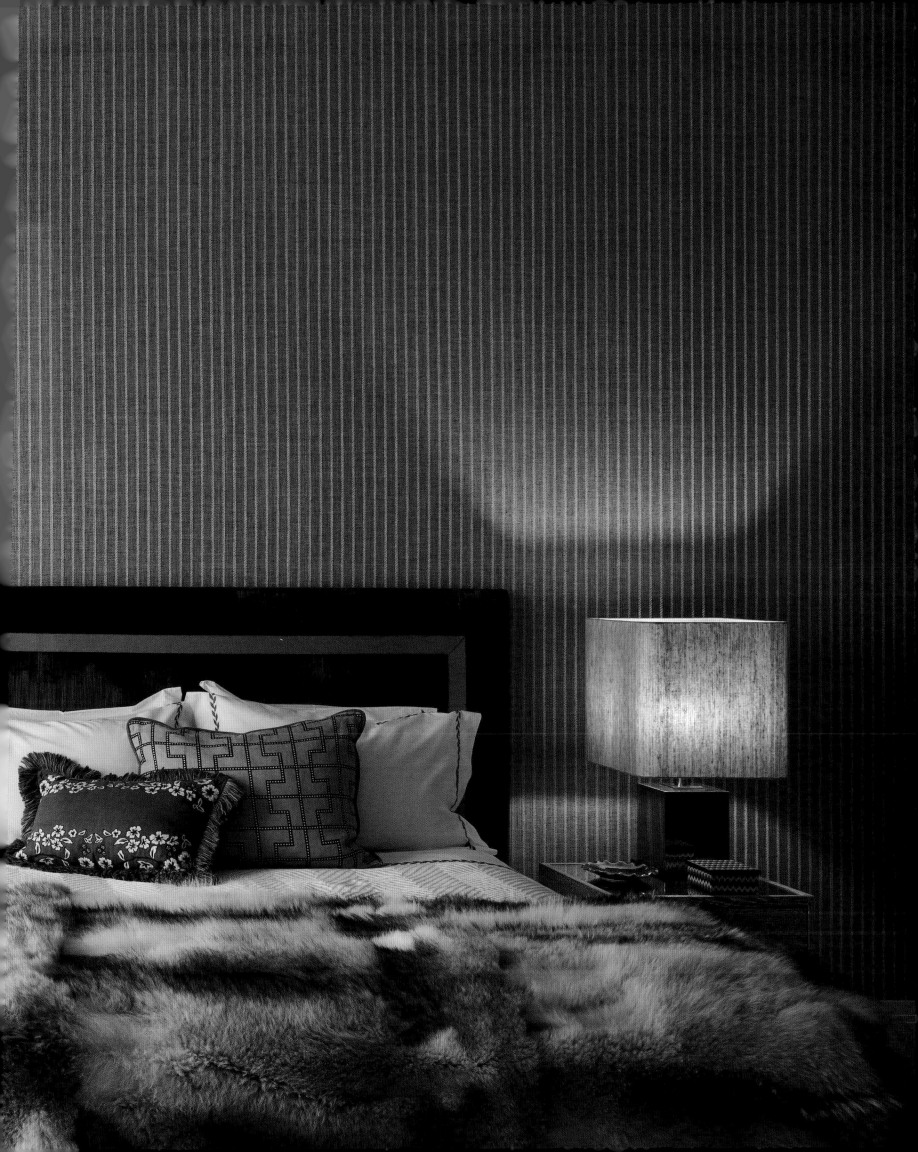

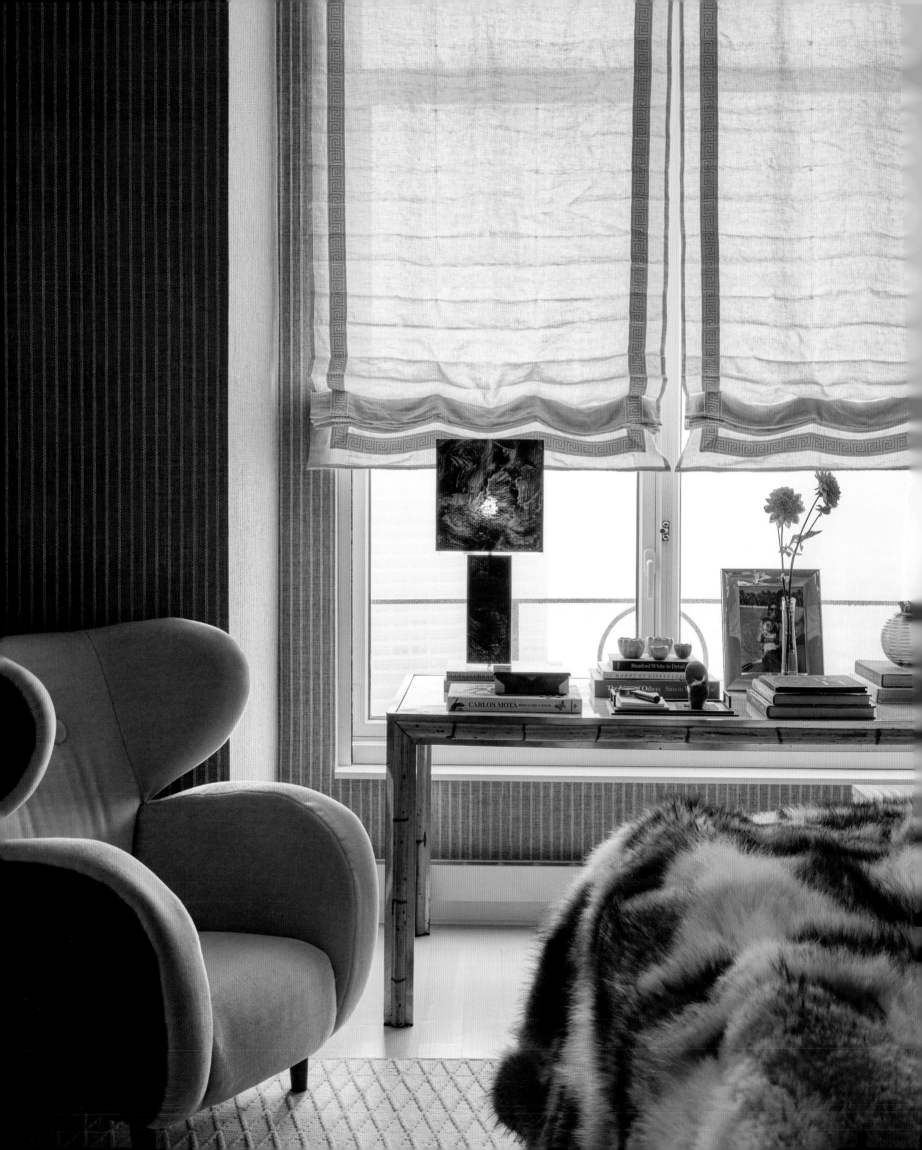

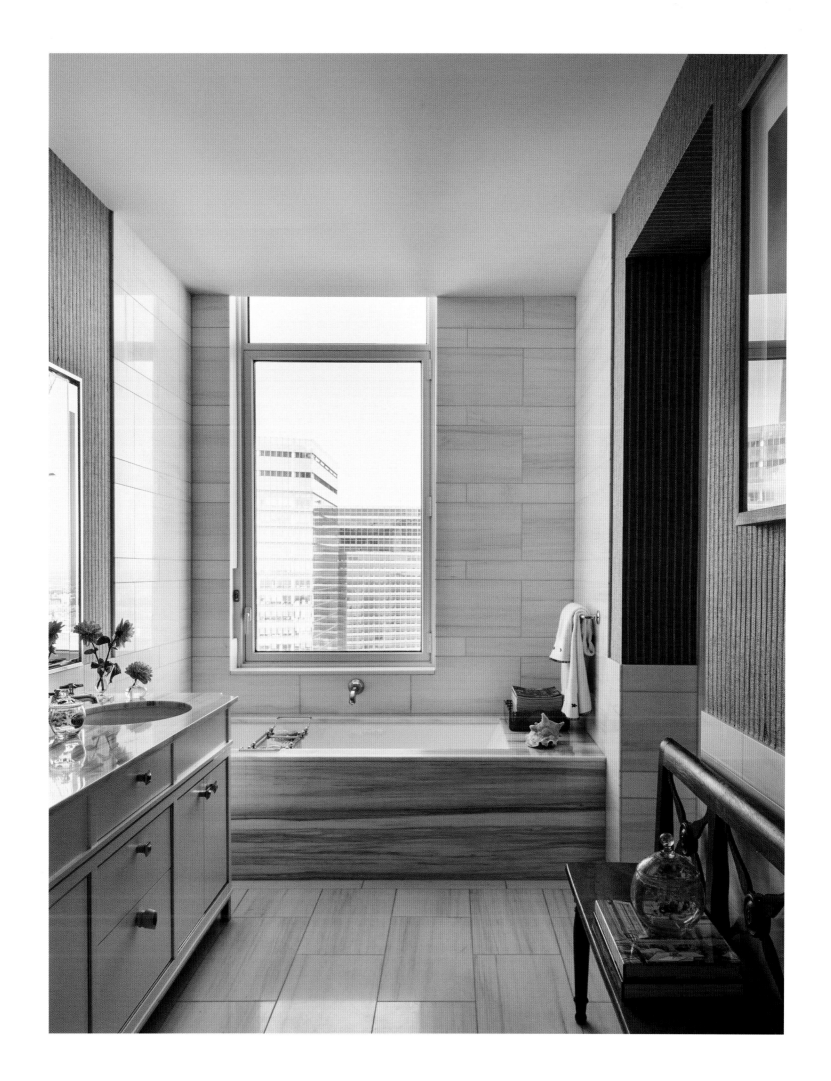

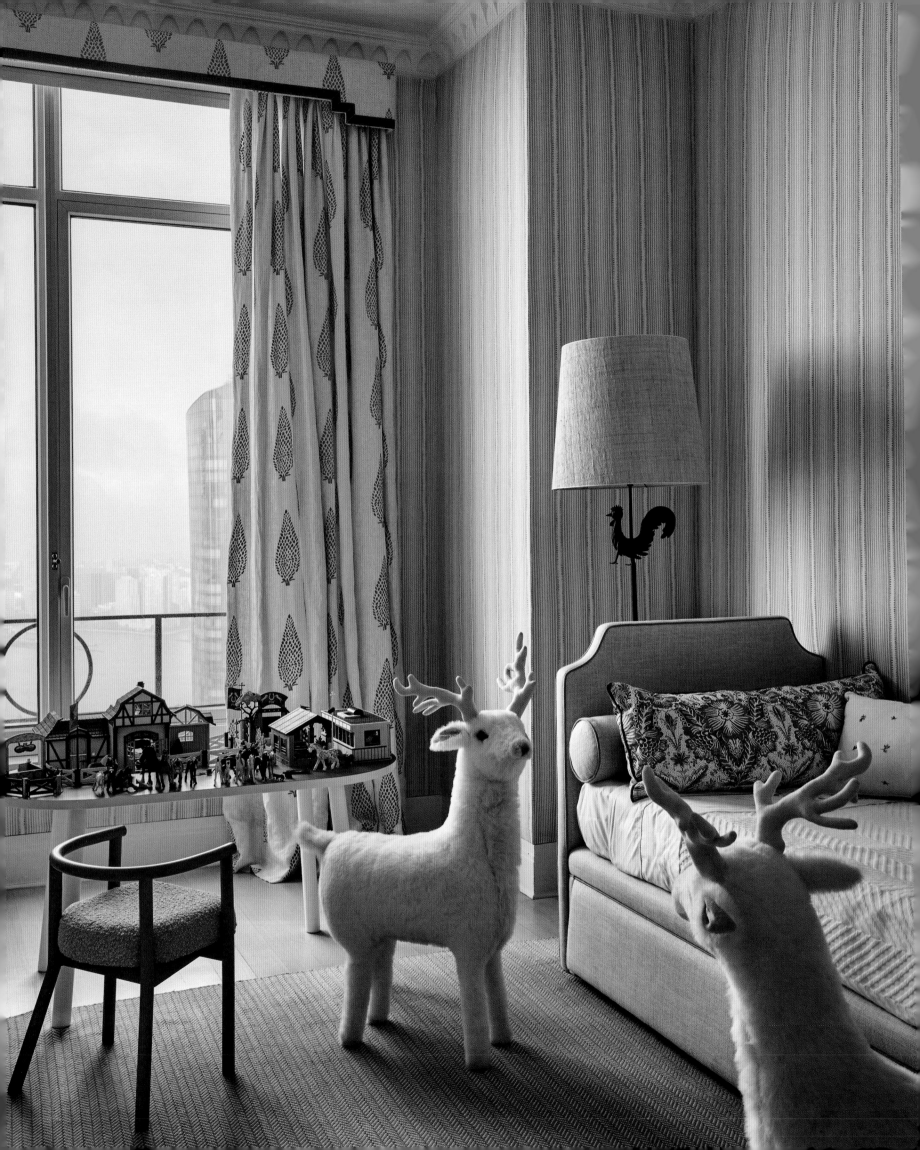

PAGE 155 In the lounge of the Manhattan apartment, an antique Greek painting of a man drinking complements the bar.

PAGES 156–57 Sofas made in Isabel López-Quesada's studio are arranged in front of the large windows in the lounge, alongside 1970s lounge chairs and a Jacques Adnet daybed, to take advantage of the spectacular view. The walls are lined with gray tweed with a black velvet band, set against a wooden floor with a wool and silk rug. A pair of 1960s lamps add a finishing touch.

PAGES 158–59 The dining room features tropical wallpaper and blinds made of natural fibers. Two French mirrors with candlesticks reflect light back into the room. The 1960s table is walnut and the chairs are walnut and black lacquer. The magnificent porcelain parrots of the table centerpiece look like they've escaped from the jungle scene on the walls.

PAGE 160 Table settings are composed of nineteenth-century French dinnerware on a light green charger plate and a khaki linen placemat, accompanied by Baccarat glassware.

PAGE 161 An imposing pair of oak columns made in the 1970s occupy a corner of the lounge.

PAGES 162–63 The view from the lounge into the combined everyday dining room/kitchen. To the left of the door are two imposing oak columns, and to the right is a Biedermeier cabinet. The dining area is furnished with a Willy Rizzo painted metal table with Pierre Jeanneret chairs, an upholstered seat, and a Gaetano Sciolari light. One wall has been transformed with floor-to-ceiling bookshelves. An English rug covers the floor.

PAGE 164 This closer view of the everyday dining room shows the cornices that outline the ceiling, the raffia wall covering, and the seat beneath the window. Greek pieces are displayed among books in the bookcase.

PAGE 165 An impressive view of Manhattan from the window in the everyday dining room. The set table creates a bold, elegant effect with blue floral plates, Provençal placemats, and Los Vasos de Agua Clara glassware.

PAGE 166–67 The primary suite is lined with American raffia featuring natural stripes on a taupe background. The bedside tables are made from reclaimed wood and hold 1960s Senda lamps. A navy headboard with a gray grosgrain ribbon stripe and a wolfskin throw give the bed a striking look.

PAGE 168 In front of the bedroom window is a 1970s bamboo and brass desk with a faux tortoiseshell lamp from the same period. An Italian lounge chair sits alongside.

PAGE 169 Like the bedrooms, the bathroom has views. An antique walnut bench warms the marble of the floors, shower, bathtub, and walls. Some of the walls are decorated in the same raffia as the primary bedroom.

PAGE 170 In the girls' bedroom, the cornice features little arches, and the walls are lined with natural and pink French linen. The sofa bed and the embroidered curtains are both light gray. A 1970s lamp featuring a cockerel adds an original touch.

AVA'S SPIRIT

This duplex in Madrid's historic El Viso neighborhood was built in the fifties and purchased by actress Ava Gardner when she moved to Madrid in the same decade. There are many tales associated with this apartment and the arguments between night-owl Ava and her downstairs neighbor, the exiled Juan Domingo Perón, over the Hollywood star's endless parties.

The actress sold the apartment to López-Quesada's husband's grandfather when she left Madrid at the end of the 1960s. The duplex remained with López-Quesada's in-laws until the beginning of the century. When it was finally put up for sale, Isabel—who had secret dreams of renovating it one day—mentioned the duplex to a friend who was looking for an apartment to live in with her husband and three young children. Isabel's dream came true.

Although the layout of the duplex was outdated, its "bones" were magnificent. Isabel threw herself into the huge task of assessing and reinforcing its structure, renewing the drainpipes, and altering the layout and roof. The living room had a small west-facing terrace that caught the afternoon light beautifully. To open up the view, three large floor-to-ceiling windows were installed, bringing the terrace and the living room together. The rebuild, completed in 2016, included work by landscape architect Fernando Martos, who designed the lush double terrace featuring wooden planters, mature pear trees, a pergola, and a large wisteria.

Next to the living room is a formal dining room/library, its dual function preventing the space from feeling too serious. The everyday dining room has a picture wall on one side and a cabinet for crockery and glassware on the other. Downstairs are the kitchen, office, ironing room, and primary bedroom, each space floored in stone arranged in a different pattern. A sculptural wooden staircase joins the two floors. A dumb waiter was also installed, a traditional feature in these types of apartments. The family living room with a large terrace and the children's bedrooms and bathrooms are upstairs.

The owner of the apartment believes that the renovation work didn't erase Ava from the space and that her spirit continues to linger. Every time they have people over for dinner or host a party, the event goes on into the early hours and no one ever wants to leave.

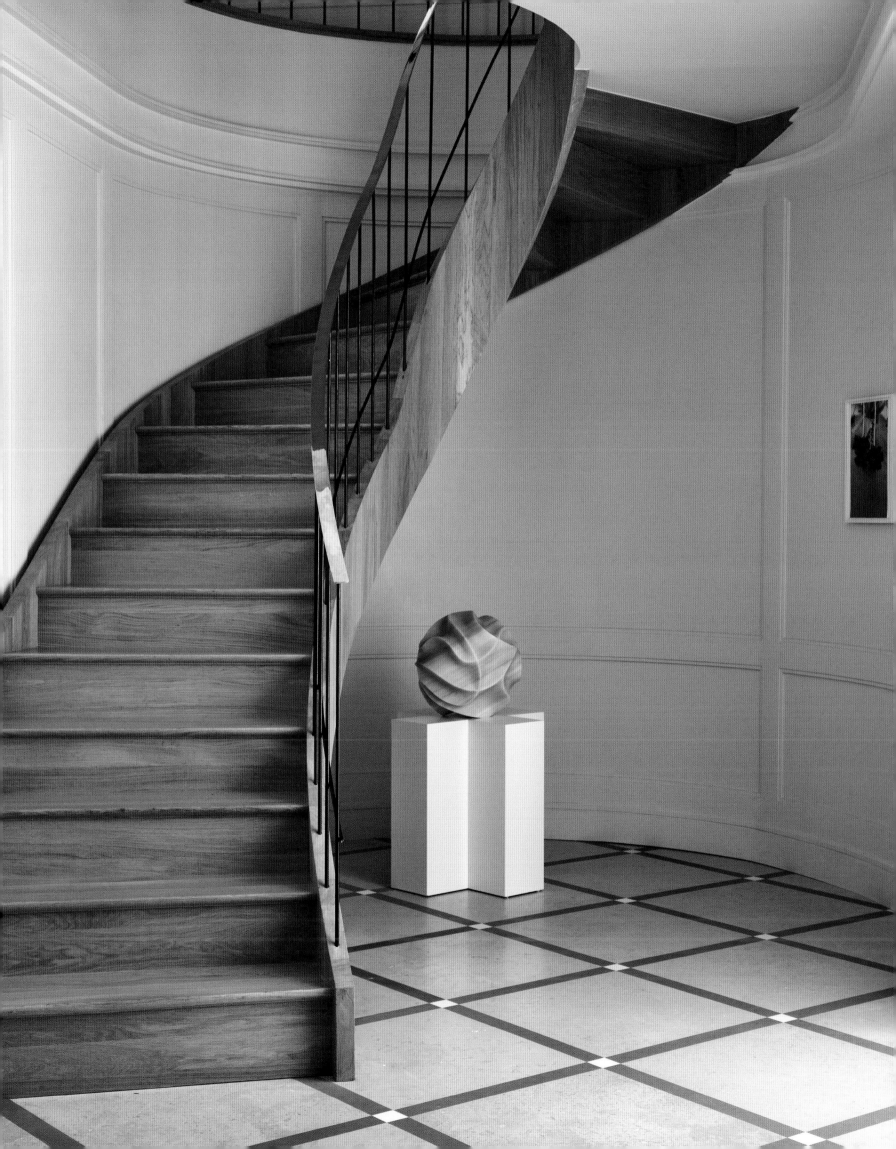

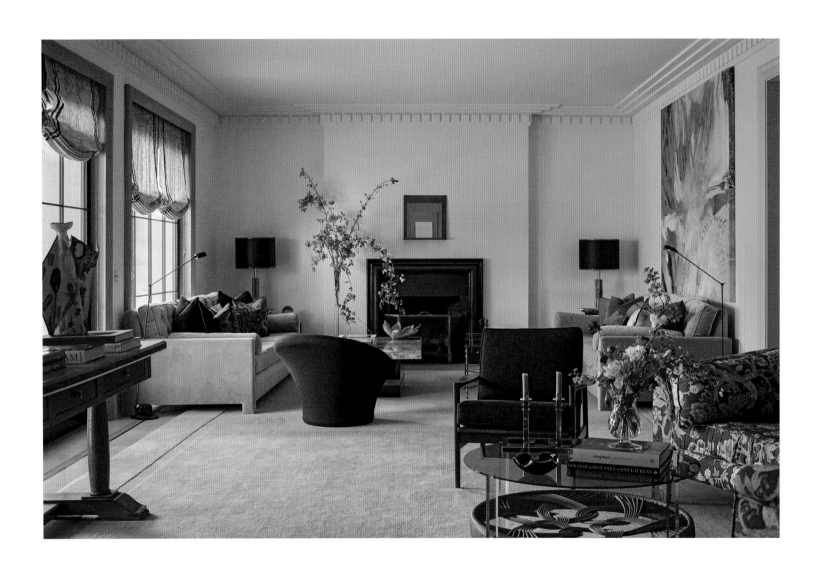

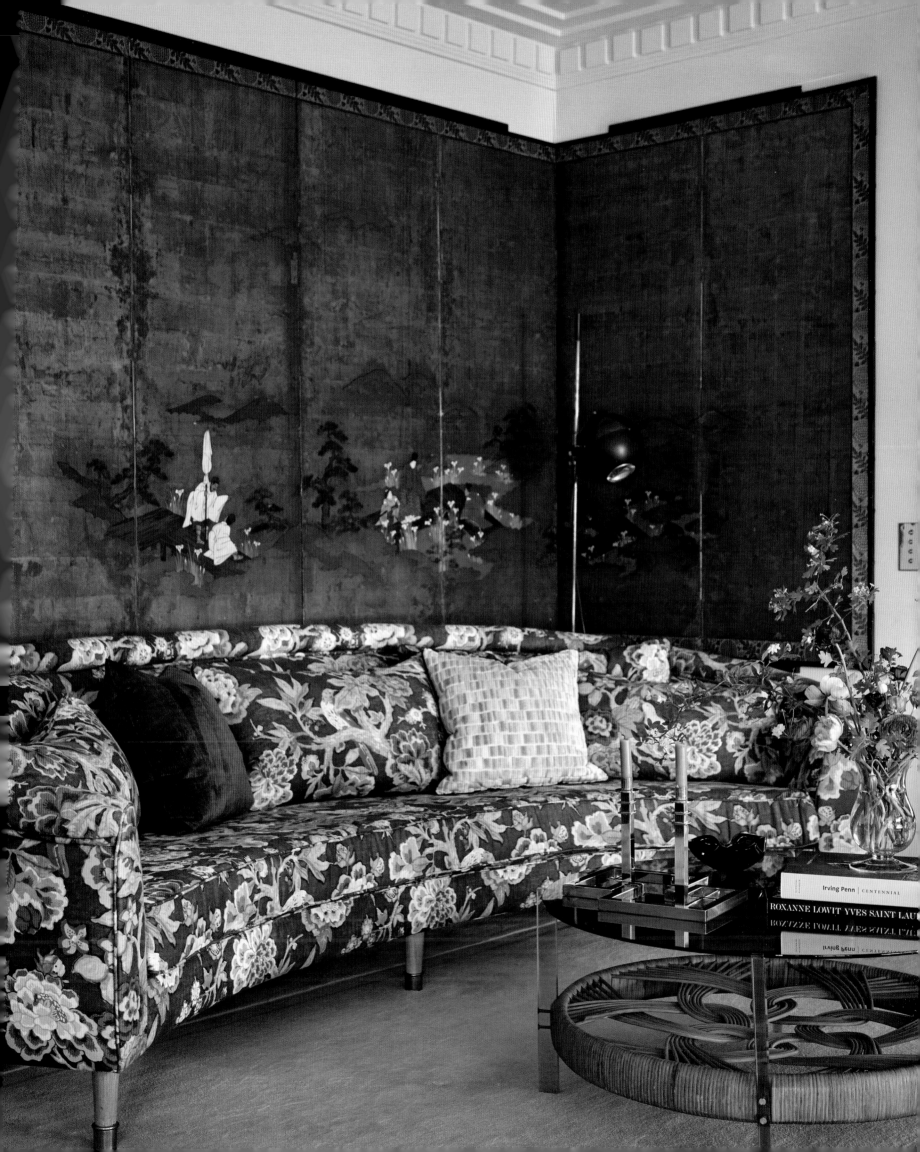

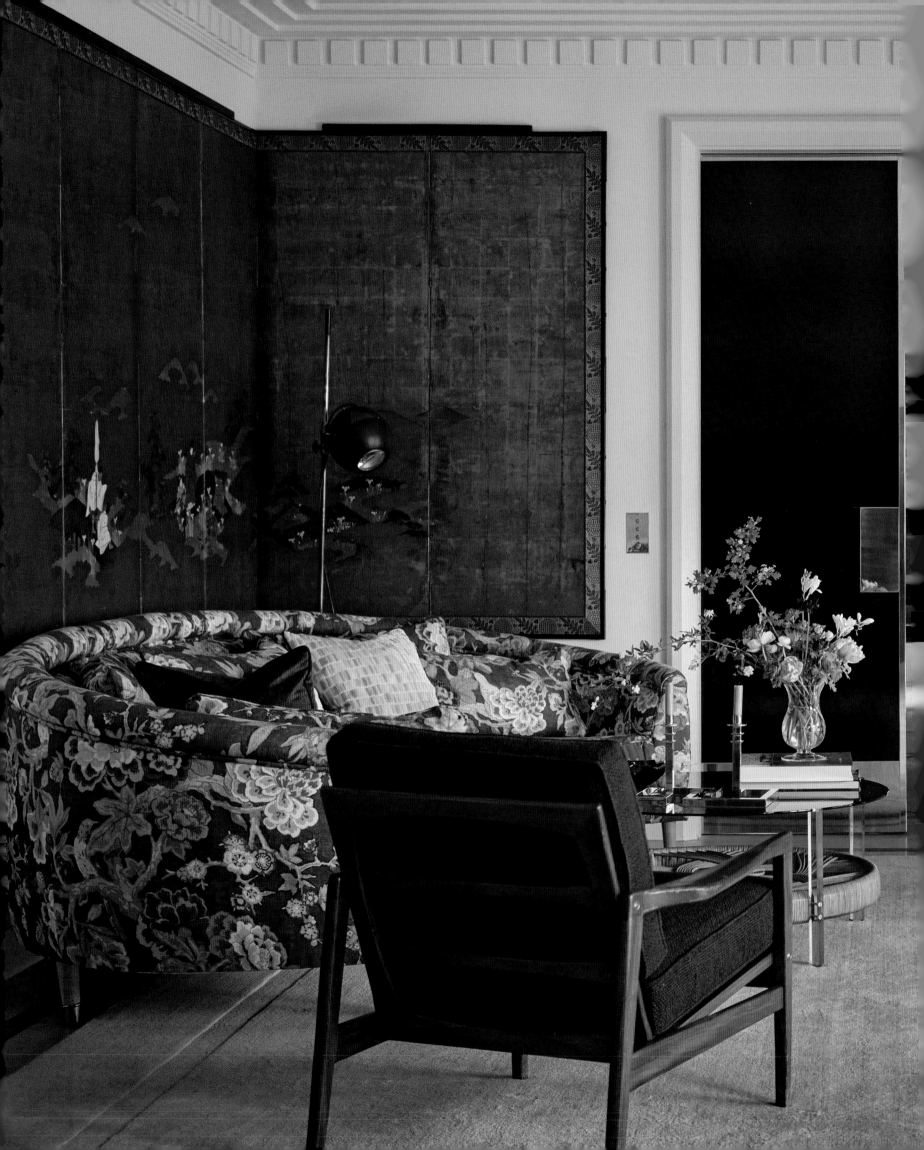

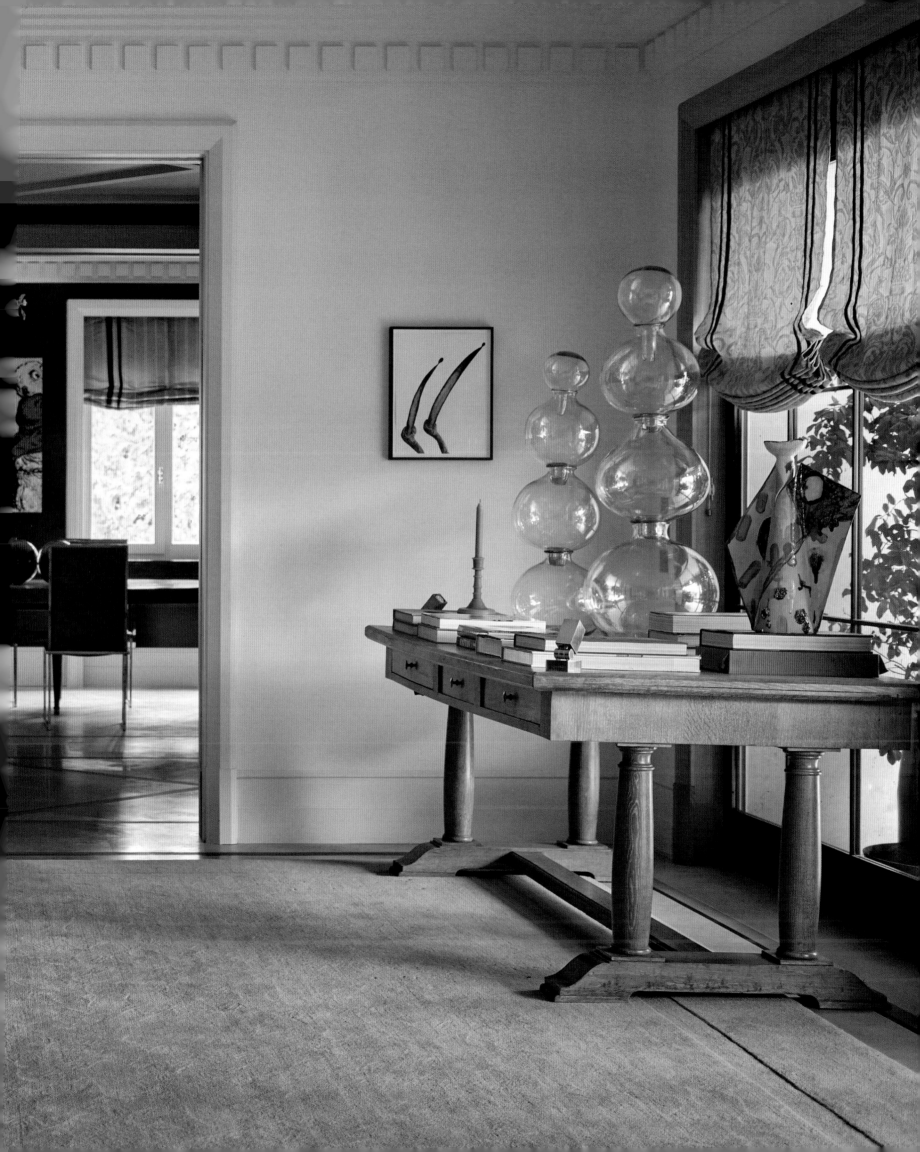

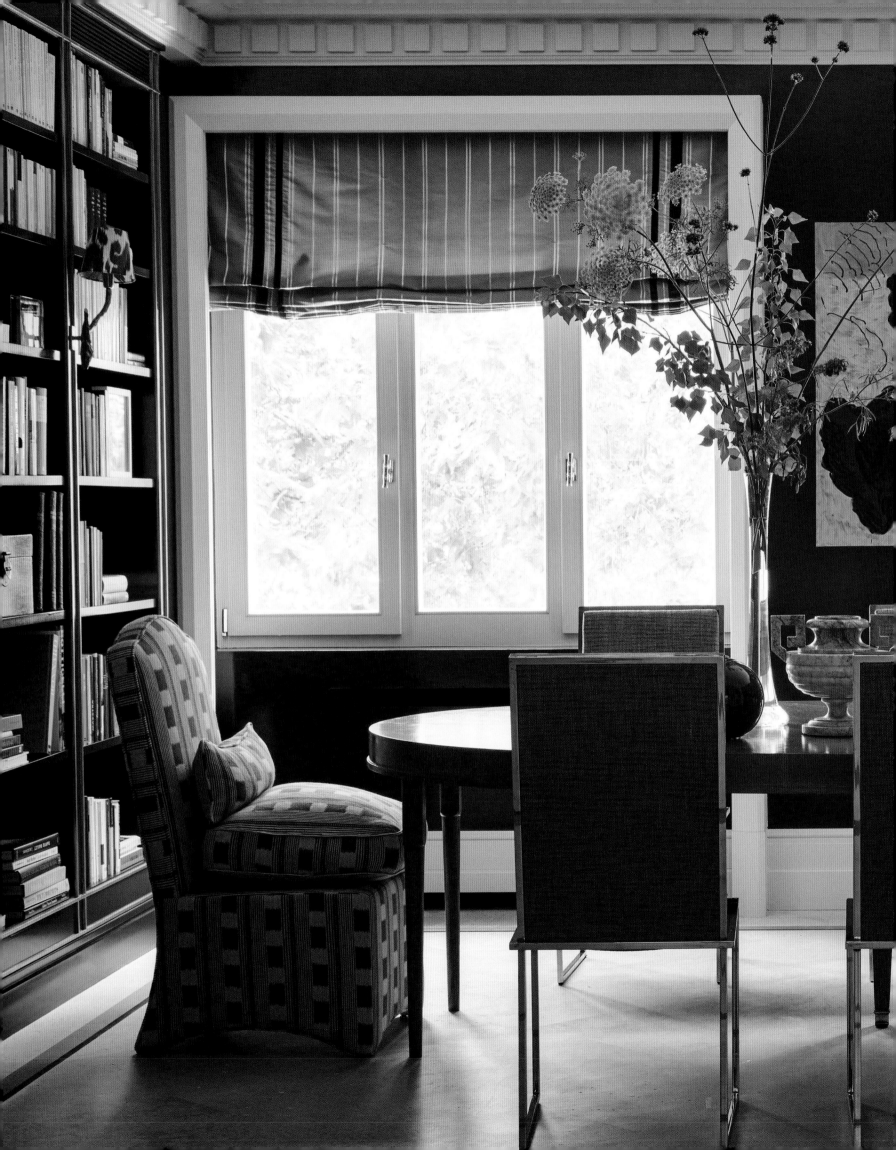

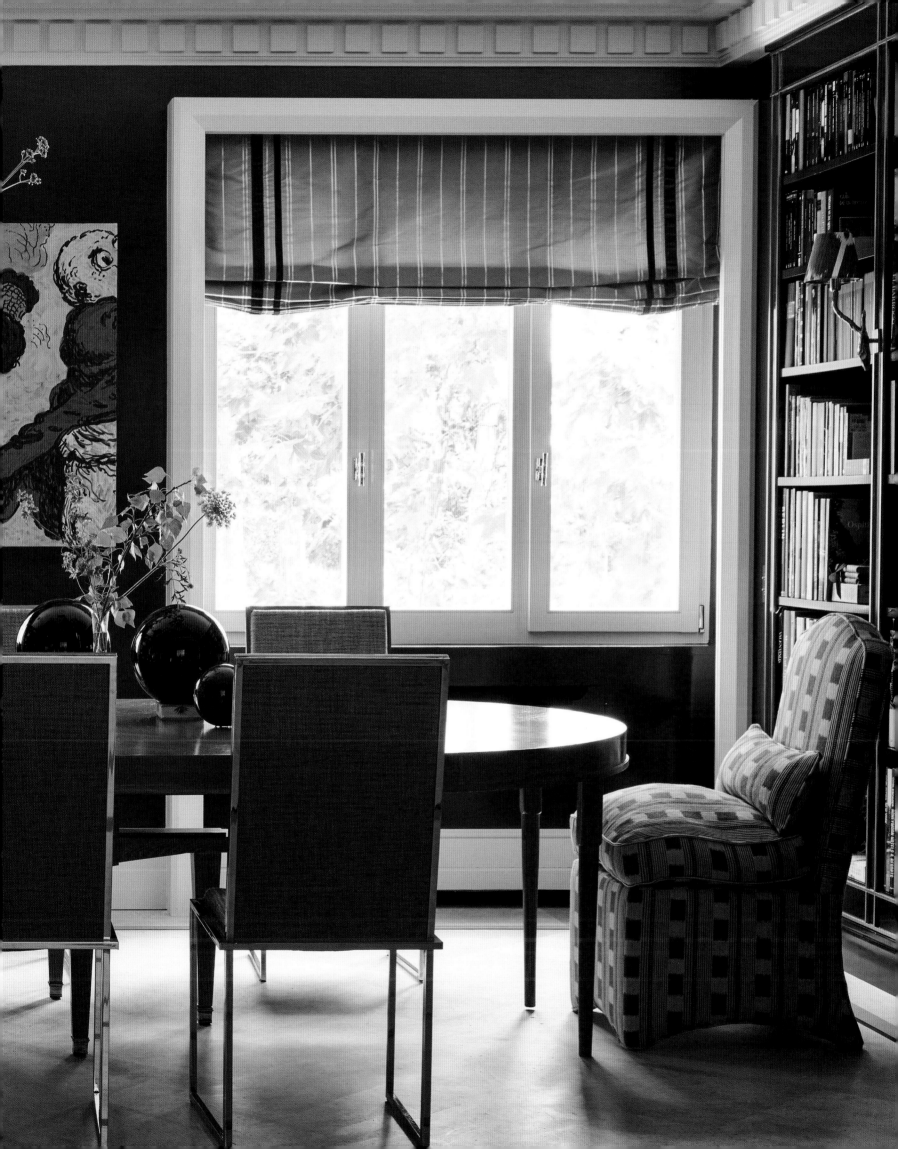

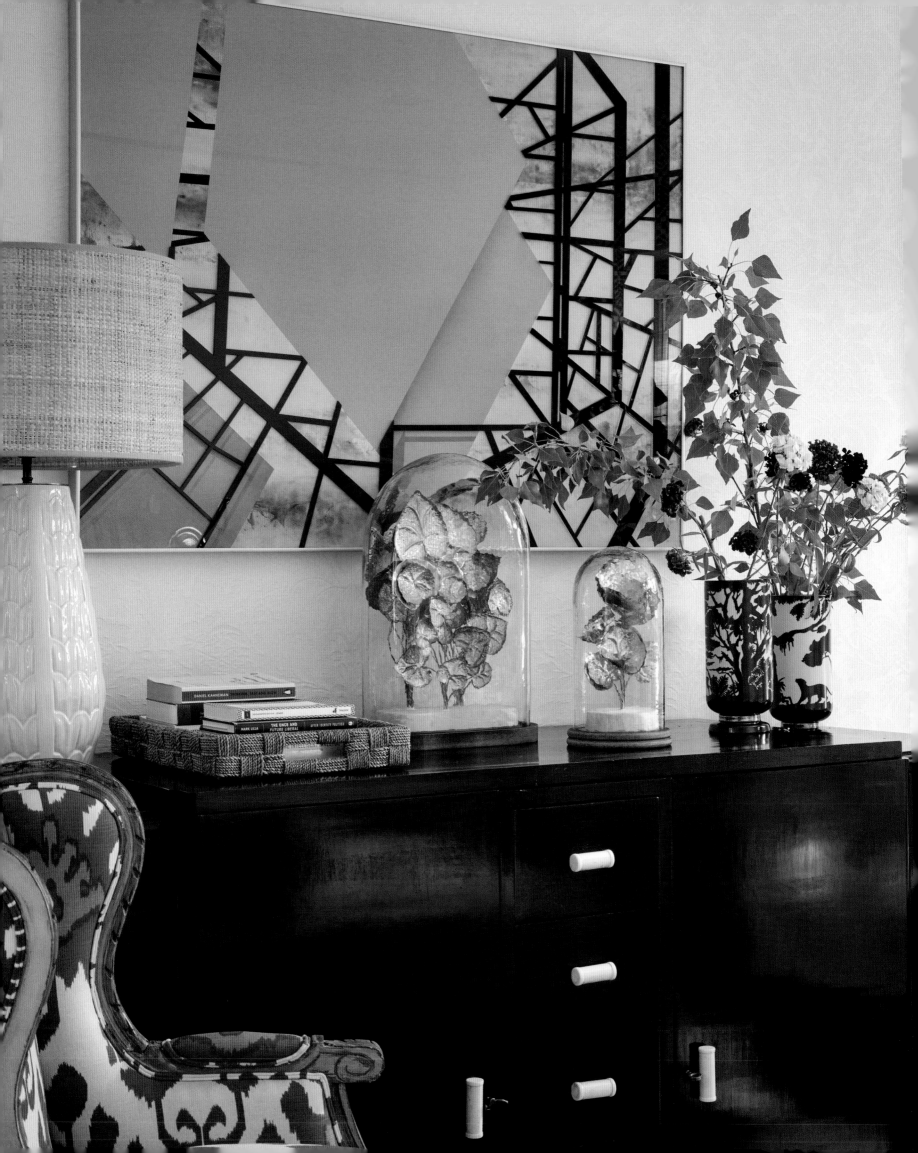

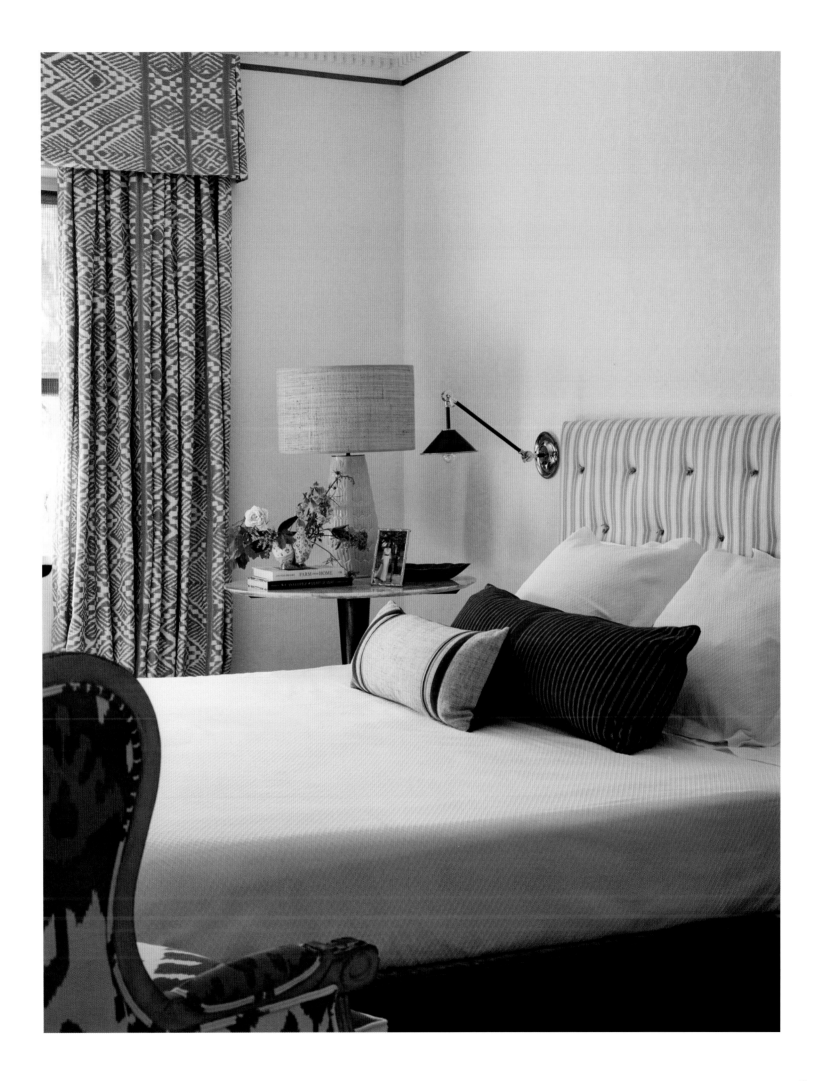

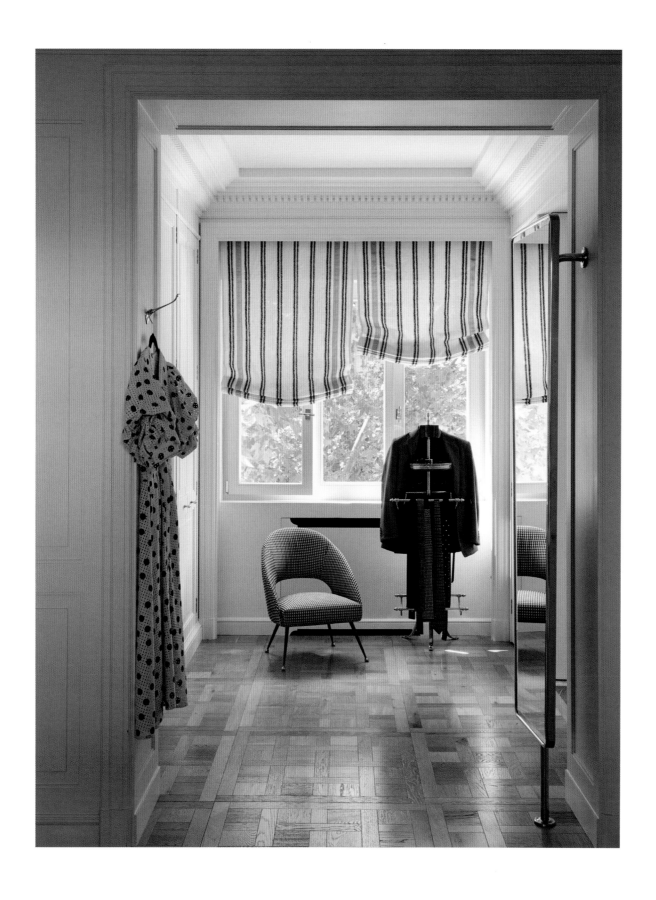

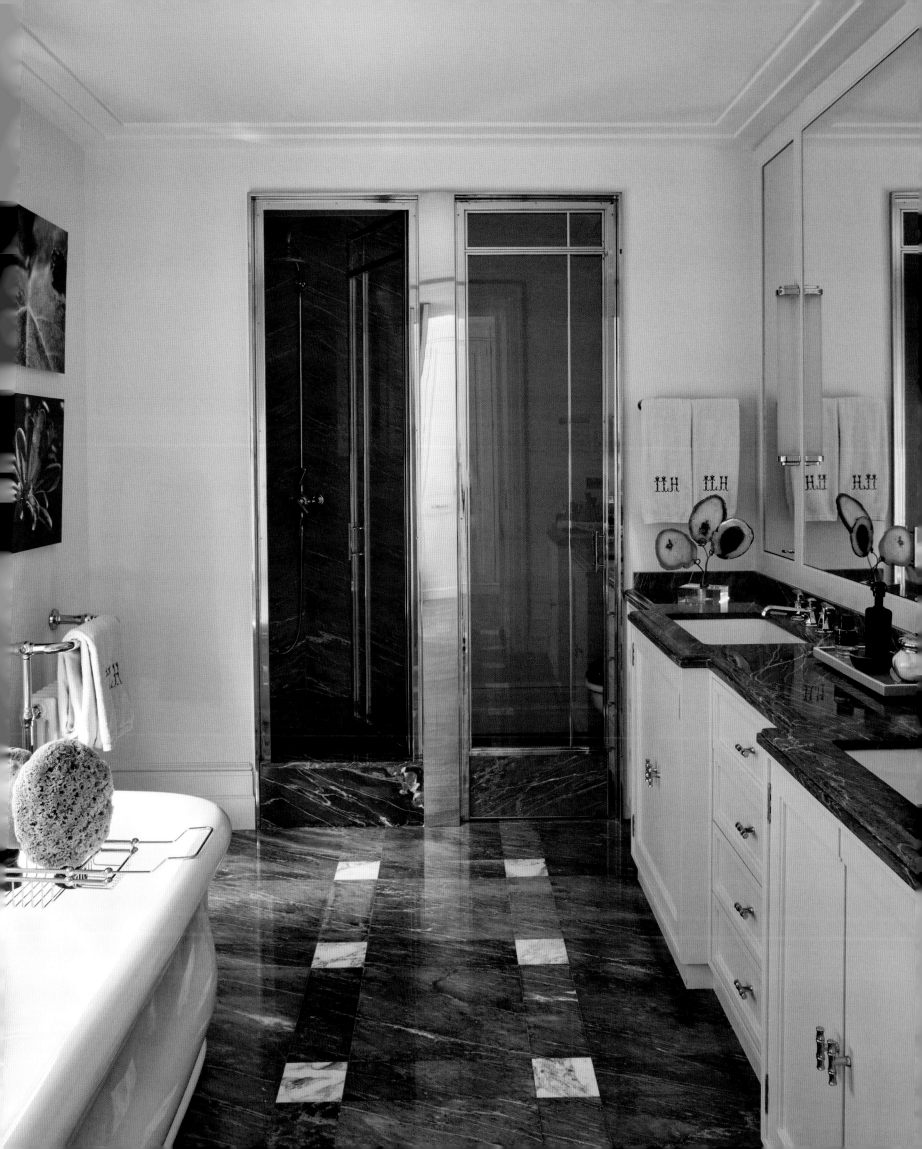

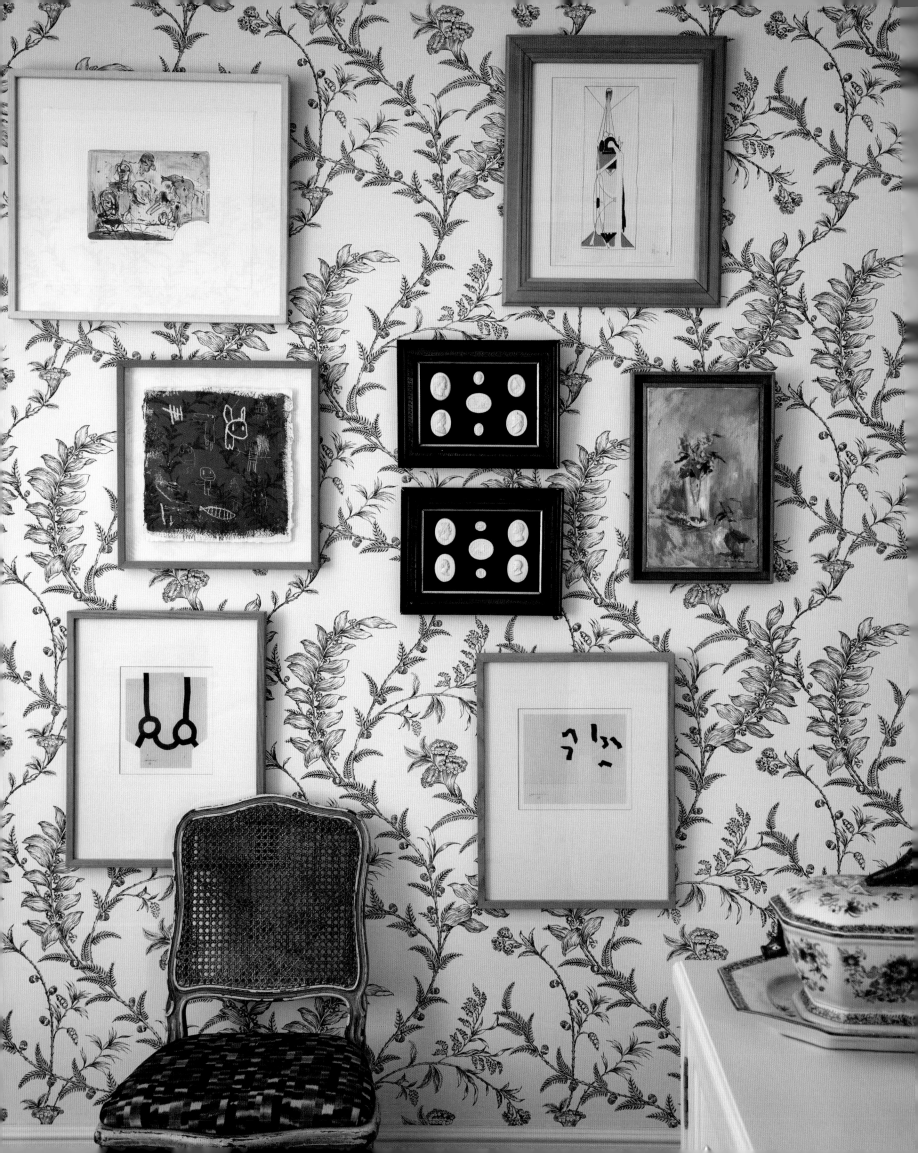

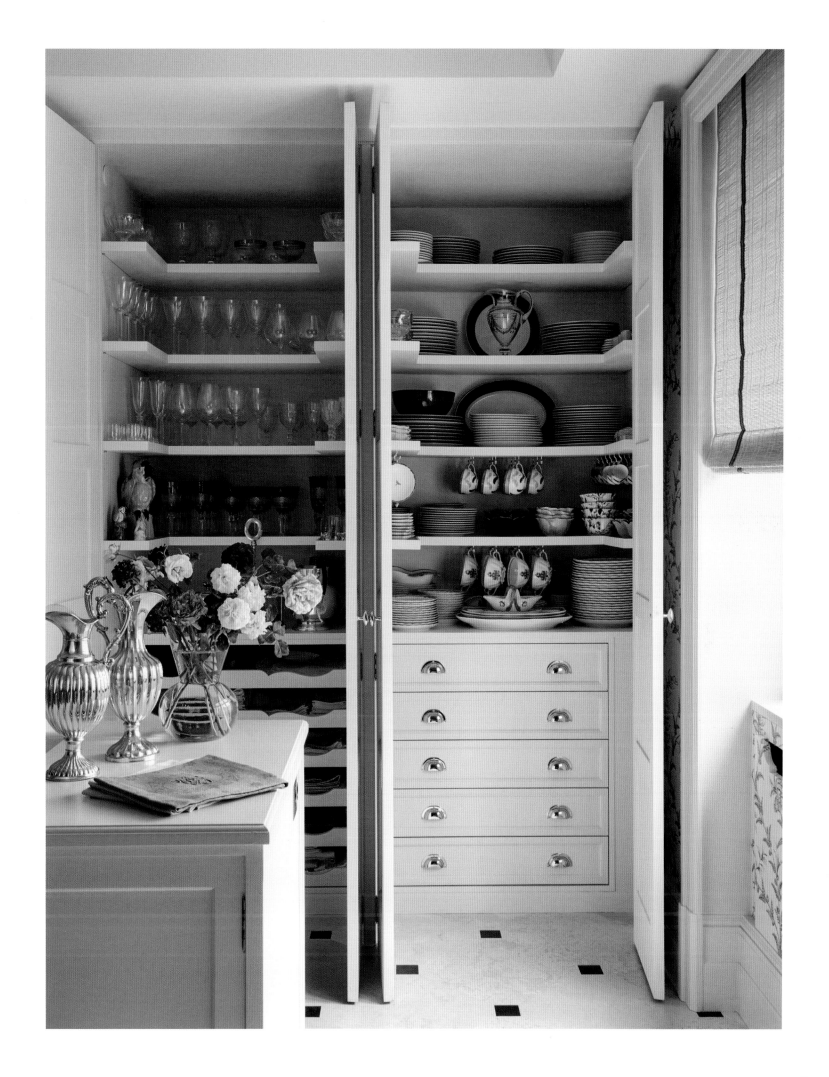

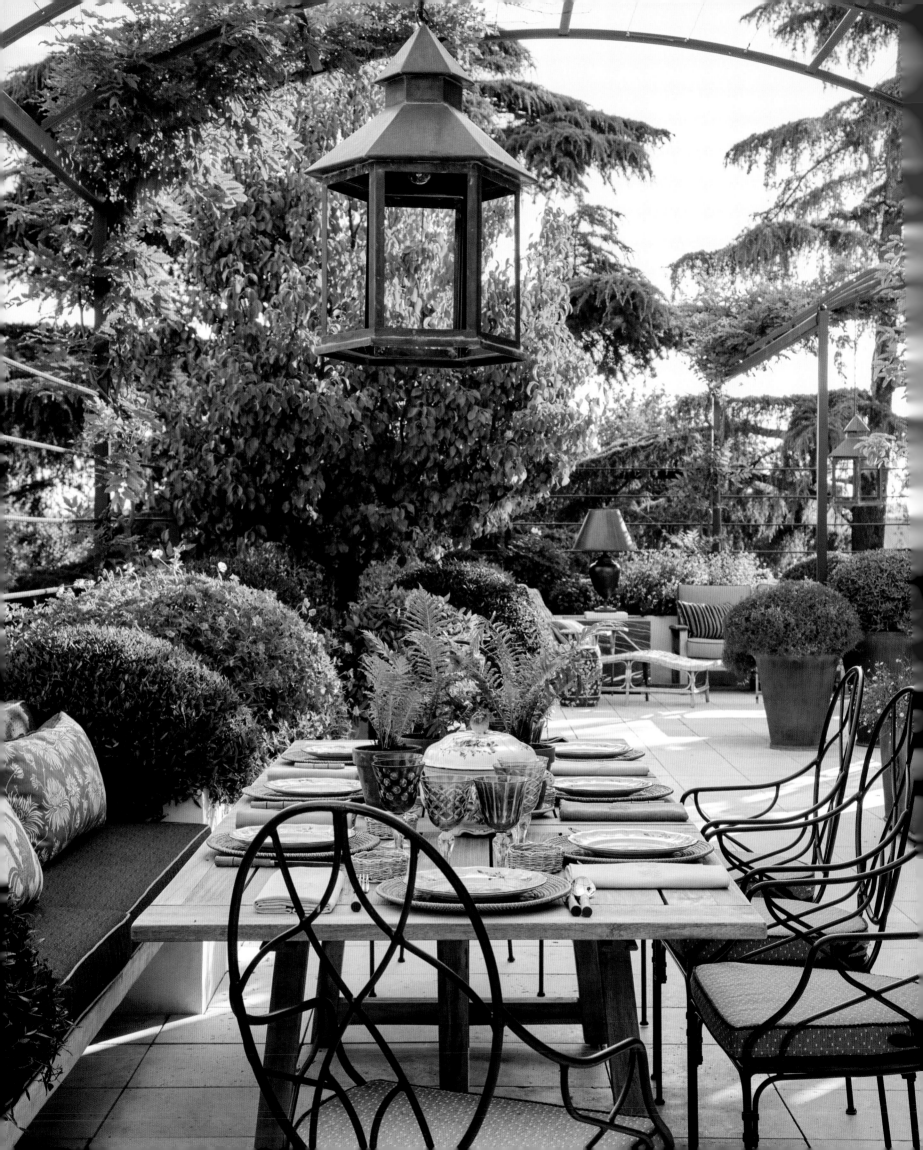

PAGE 173 The rounded entrance hall of the El Viso duplex hugs the staircase created to access the property's upper level. The stone floor in a pattern of gray, beige, and white contrasts with the oak of the staircase and the white enveloping walls. A marble sculpture by Tadanori Yamaguchi echoes the circular shape of the hall and a photograph by Wolfgang Tillmans adds a splash of color.

PAGE 174 The lounge is divided into two separate areas, with a central path leading out to the terrace. Two light camel velvet sofas and Pierre Paulin Mushroom chairs in anthracite-gray wool create a large space for socializing. A wonderful oil painting by Donna Huanca and a ceramic by Jose Dávila above the fireplace add a robust finishing touch.

PAGE 175 On the other side of the lounge, an antique Japanese screen was installed. Its wonderful browns, blues, and greens tone in with the curved sofa upholstered in American floral fabric. The round glass and rattan coffee table and the chocolate ball lamp are both from the 1970s.

PAGES 176–77 In the lounge, three large sets of French doors open onto the terrace. In front of one is a large French reclaimed oak table from the 1950s, piled with books and artworks, including a Mexican blown-glass piece entitled *The Virgin's Tears*, and a vase by Milena Muzquiz. The black and brass sliding door leads through to the dining room. Hanging to the right of the door is a drawing by Teresa Solar.

PAGES 178–79 The dining room/library faces south and has two large windows to capture the light and treetop views. Its two bookcases are outlined in brass. The 1950s French oak table is accompanied by Romeo Rega chairs, with an upholstered chair at each end. A Charlie Billingham painting from his exhibition at Travesía Cuatro gallery presides over this incredible living space painted in dark English green.

PAGE 180 In the primary bedroom, a 1950s stained black cabinet with drawers and doors sits opposite the bed, alongside nineteenth-century French lounge chairs upholstered in American fabric. The photograph is by Daniel Nave.

PAGE 181 The walls of the primary bedroom are lined with white fabric, enhanced with a ribbon beneath the cornice. Gray stripes on the headboard and pillows, geometric-patterned gray and white fabric curtains, and a pelmet with touches of black complete the look.

PAGE 182 The flooring in the dressing room is 1950s-style oak parquet, matching the period of the property. A large window lets in light, which can be diffused by striped linen blinds. A small 1960s lounge chair, a 1960s Ritz clothes butler, and a pivot mirror are the only items of furniture.

PAGE 183 The main bathroom is painted white with a gorgeous gray Bardiglio and white Arabescato marble floor. An English bathtub sits beneath the window. Lightweight steel and glass doors enclose the shower units and the toilet.

PAGE 184 The everyday dining room is wallpapered in a toile with a black and white foliage pattern. A French mesh chair and an antique soup tureen sitting on the office island give this room a sophisticated, feminine touch. Works by Óscar Domínguez, Edgar Plans, Hermen Anglada Camarasa and Bonifacio adorn the wall.

PAGE 185 Cupboards for storing dinnerware, glassware, table linen, and cutlery.

PAGES 186–87 The large roof terrace, designed by landscape artist Fernando Martos, is divided into different spaces. The square section features a seating area surrounded by gardens and a fountain. Cedar trees from the garden below reach up majestically, offering shade in the afternoons when the sun starts to dip.

PAGE 188 In the long section of the terrace, a dining area has been created, with a handmade bench set between planters, a teak table, and iron chairs. Both terrace spaces are covered by curved pergolas with wisteria growing over the top. Mature pear trees sit among topiary balls, evergreens, and flowering plants.

COUNTRY

The seven country houses featured here—predominantly projects that Isabel López-Quesada has completed in the last fifteen years—are located in Spain, the United States, the Dominican Republic, and across the Mediterranean, in a variety of landscapes, from mountains to meadowlands to coast. These are spaces almost exclusively designed for vacations and weekends, for hosting friends, relaxing in nature, and enjoying time with family. What makes them truly unique is their focus on reusing materials, their commitment to vernacular crafts, and their dedication to creating a dialogue between interior and exterior, aesthetics and comfort.

A SENSE OF HISTORY IN SEGOVIA

Located in the Spanish province of Segovia, this estate is something of a milestone in López-Quesada's career. Largely considered the project that launched her work onto the international stage, it has graced the pages of such prestigious magazines as *House & Garden* and *Milieu.* The commission was completed with the owners' involvement—Isabel had worked for them several times previously—as well as in close collaboration with architect Pablo Carvajal and landscape architect Fernando Caruncho. The professional trio successfully infused both the house and the garden with a distinctly historical feel, weaving together landscape, materials, and decor. The house may have been completed in 2008, but it feels as though it's always been there.

The house and garden are surrounded by a large Castilian estate, created as a haven for weekends and vacations. Fernando Caruncho's garden design acts as a bridge between the landscape of the southern Sierra de Guadarrama and the house itself. The garden includes a swimming pool disguised as a fountain, lined in granite and with water gushing at its center, but the U-shaped pergola, supported by pillars of granite and covered in wisteria, is a standout feature. The large central courtyard provides a wonderful approach to a building inspired by the traditional Spanish country home.

The building spans two floors, and the double-height living room takes advantage of this to capture more light and space. With views onto the garden, this expansive space leads to the library and dining room. The kitchen, office, ironing room, and two guest bedrooms are also on this floor, with the main family bedrooms upstairs. The second floor is accessed via a robust oak staircase that retains a sense of lightness thanks to its thin metal handrail. The staircase leads down onto a checkerboard floor that features in several of the downstairs areas.

The main flooring in the house is walnut and oak; this runs through the living room and adjacent rooms as well as the main bedrooms. The antiques are a particular highlight of the house, as are the doors and fireplaces brought in from Belgium and France. English furniture mixes with Moroccan carpets. Upstairs, the walls of the bedrooms, as well as the dressing room and main bathroom with its iconic freestanding rattan-covered bath, are lined in Transylvania linen, a fabric that brings warmth to these intimate spaces.

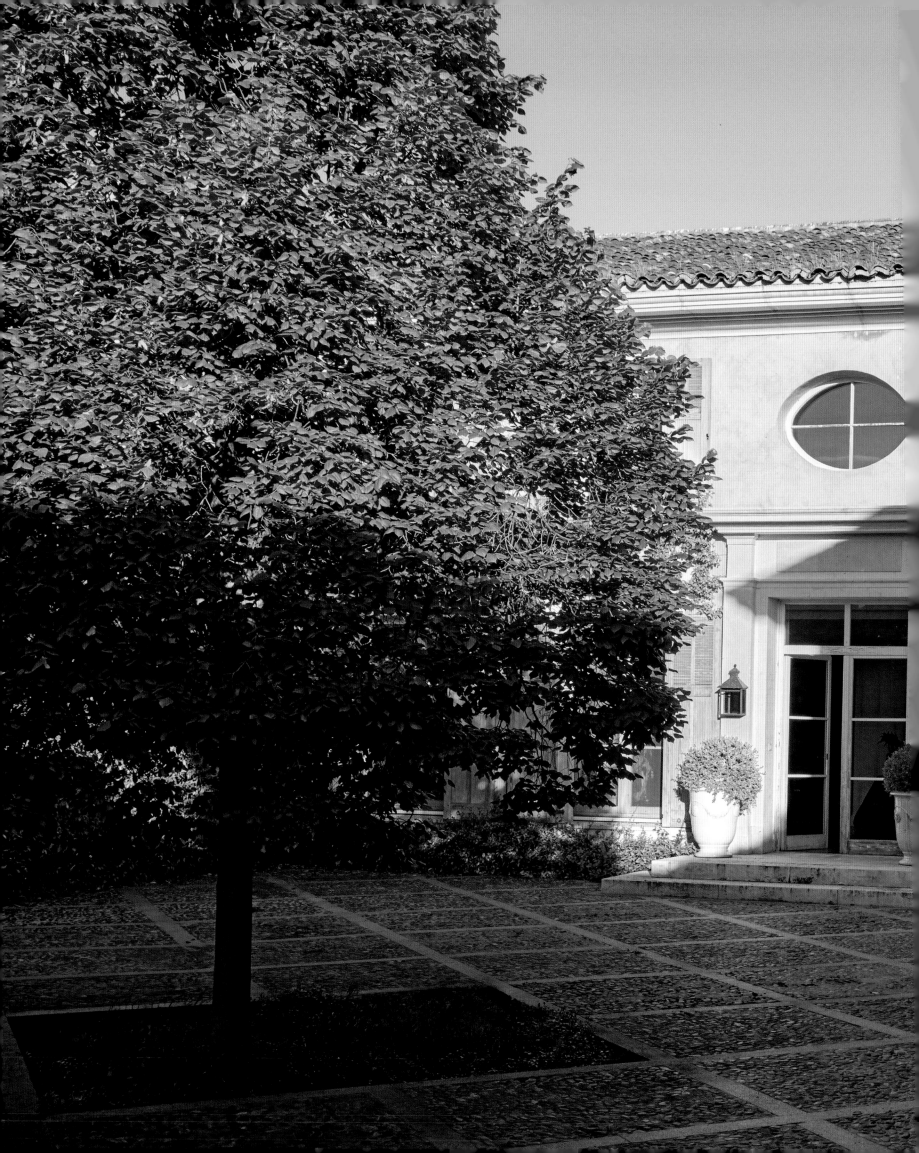

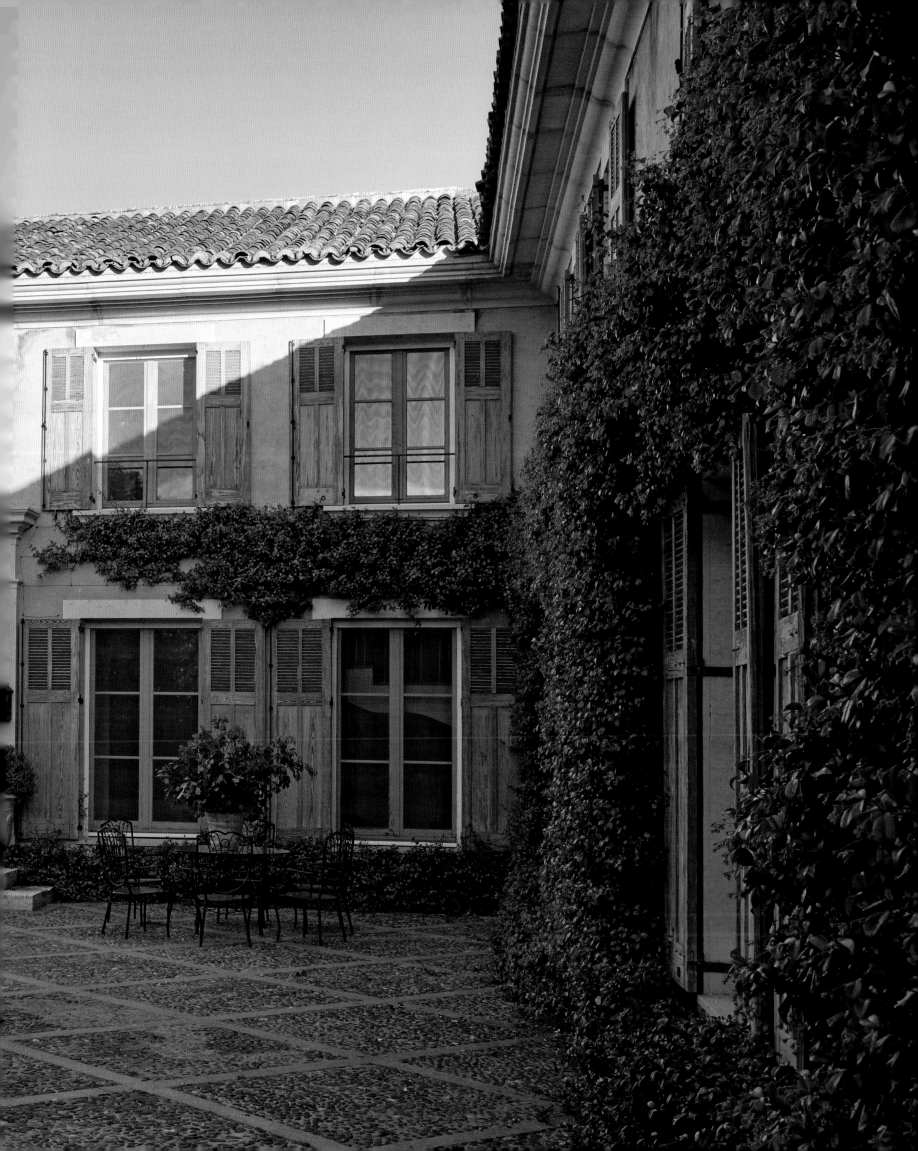

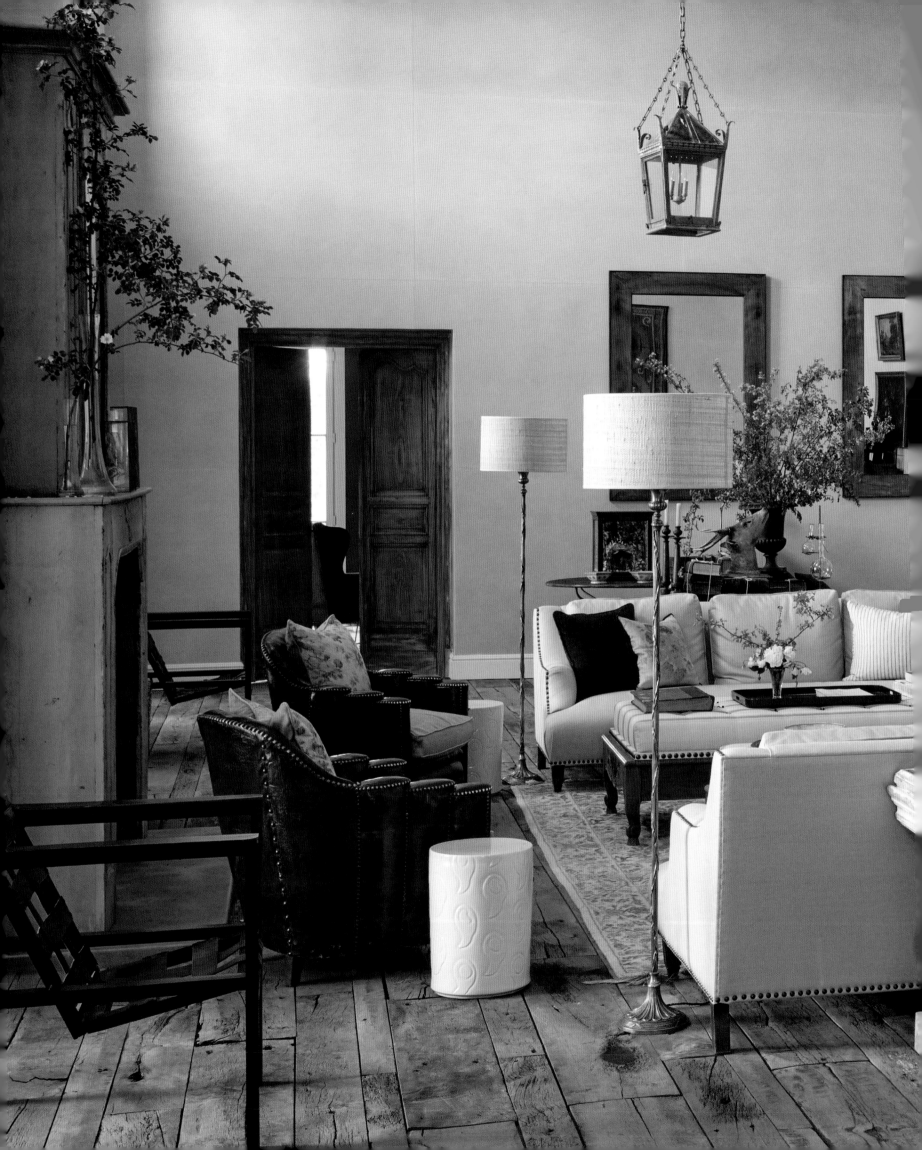

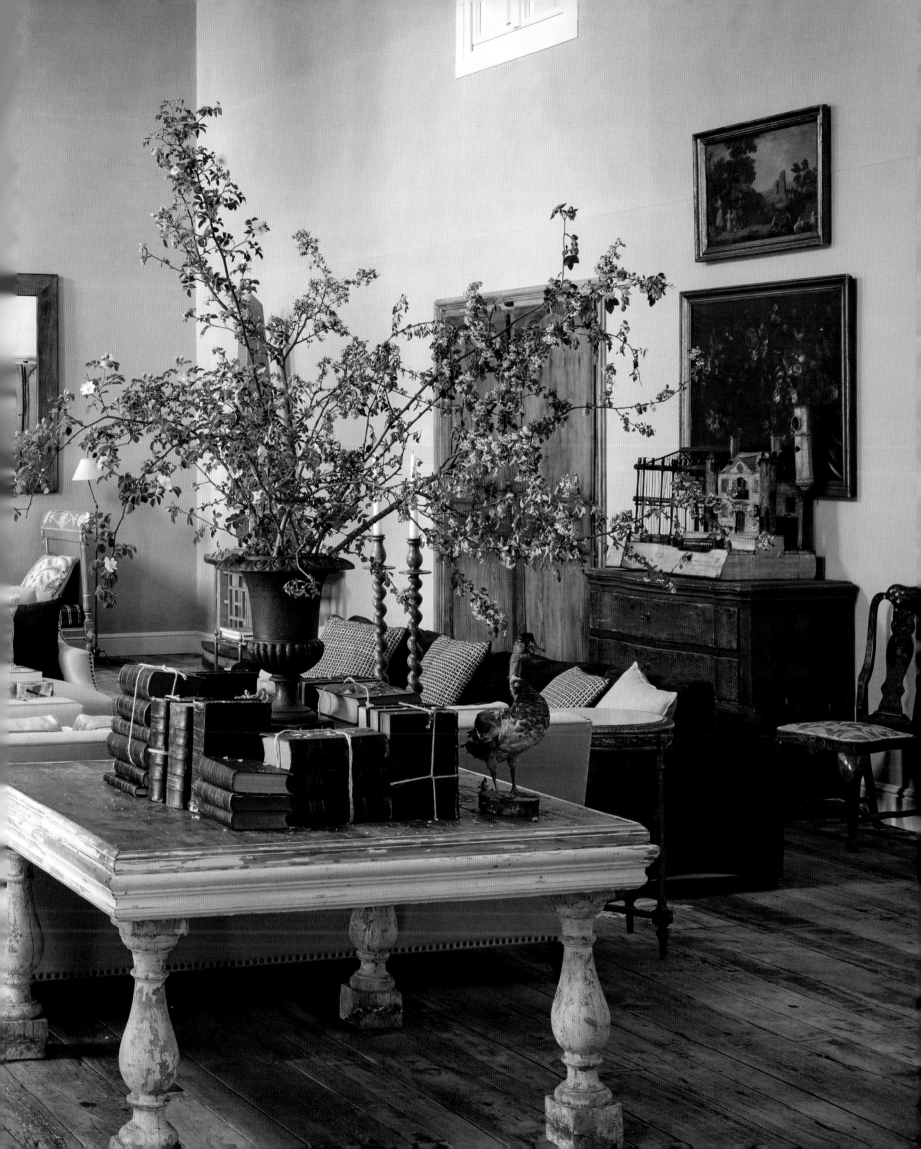

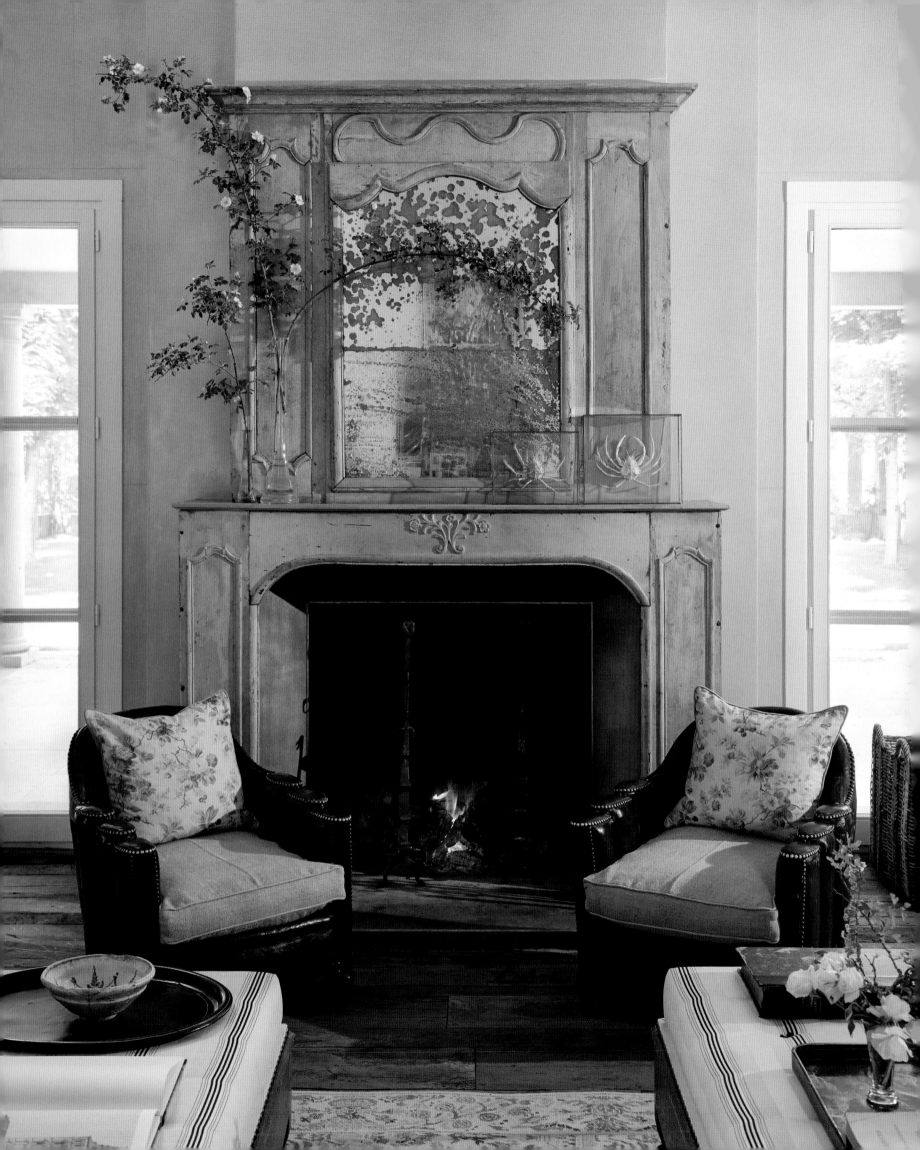

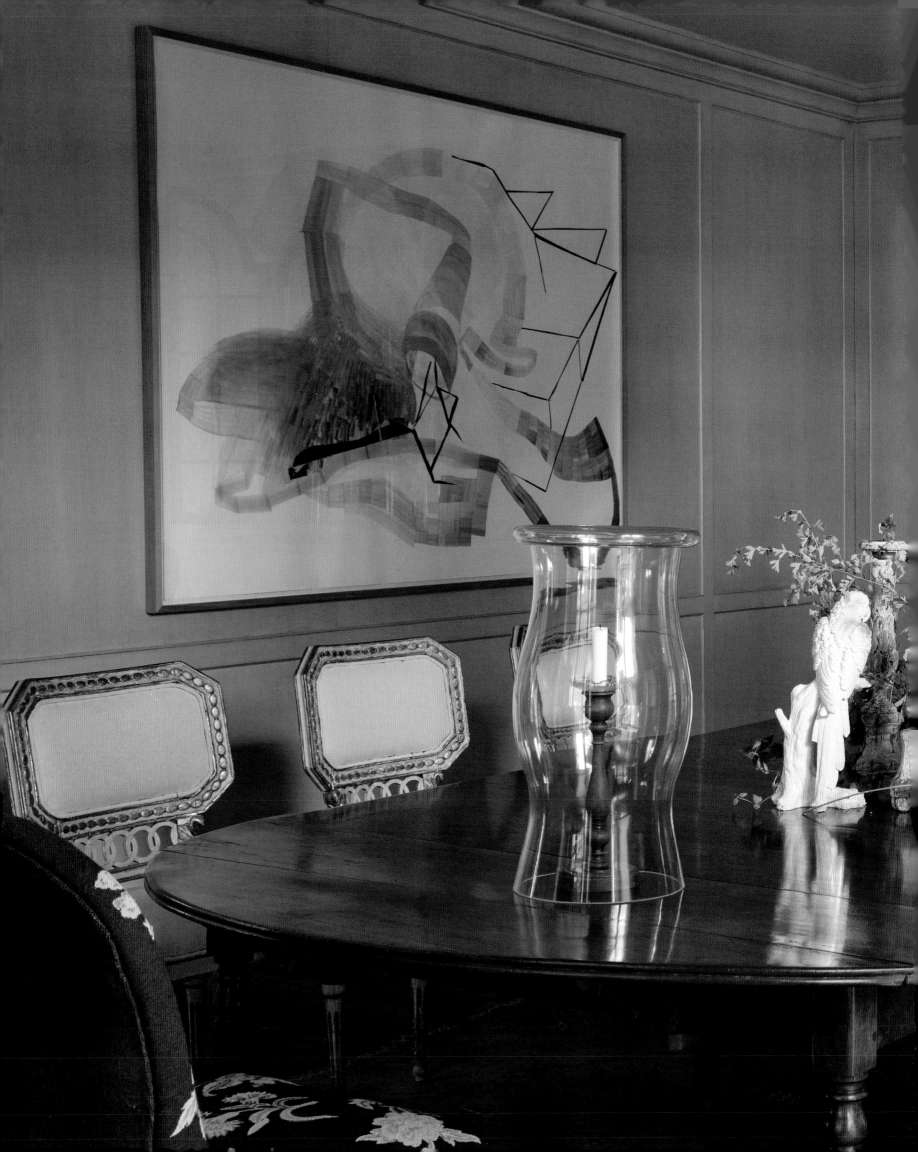

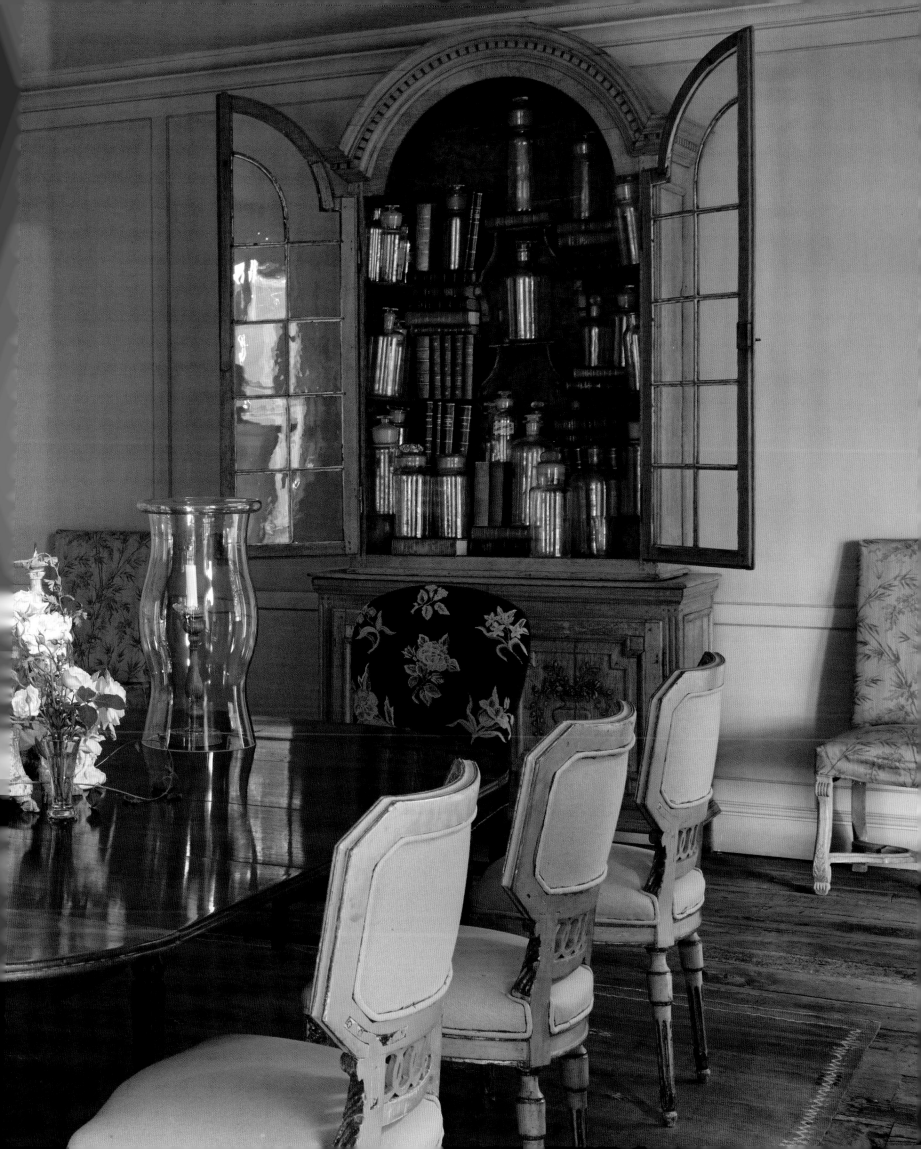

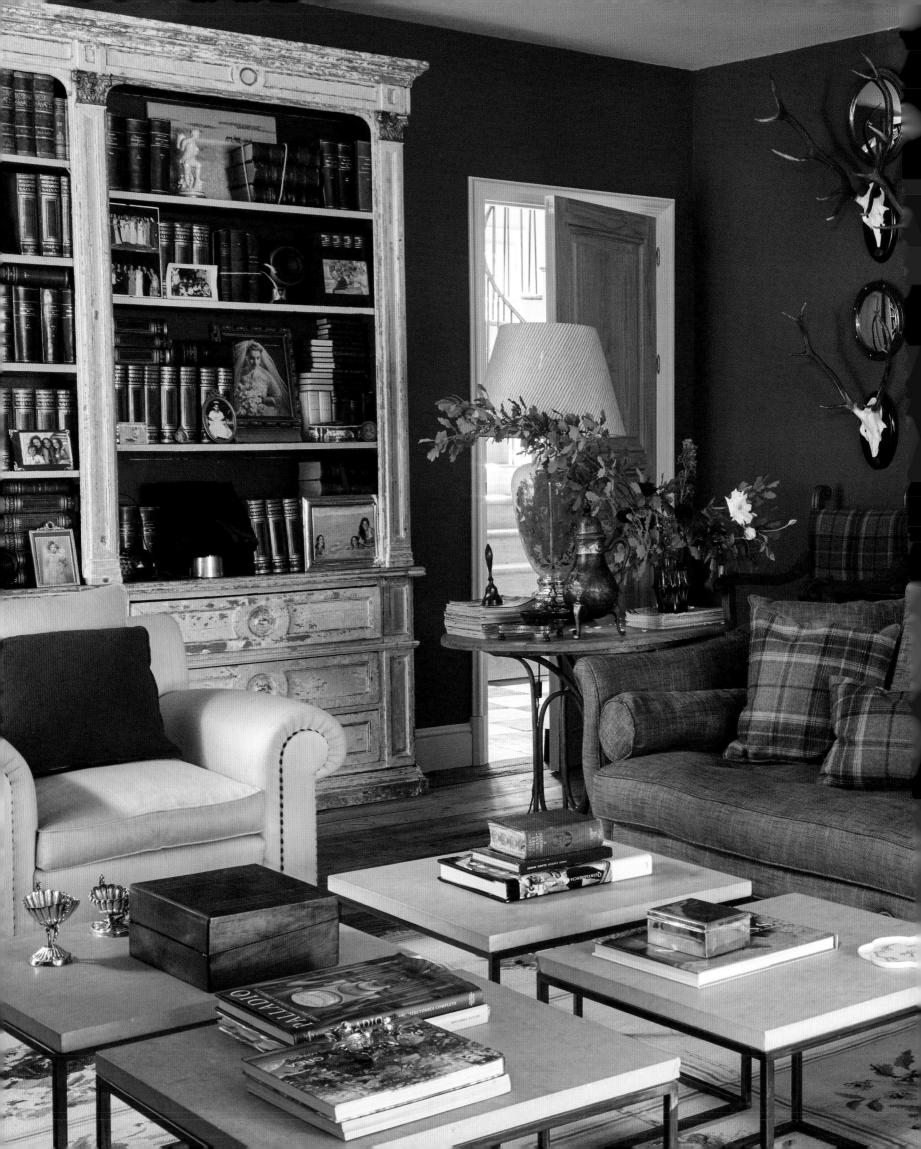

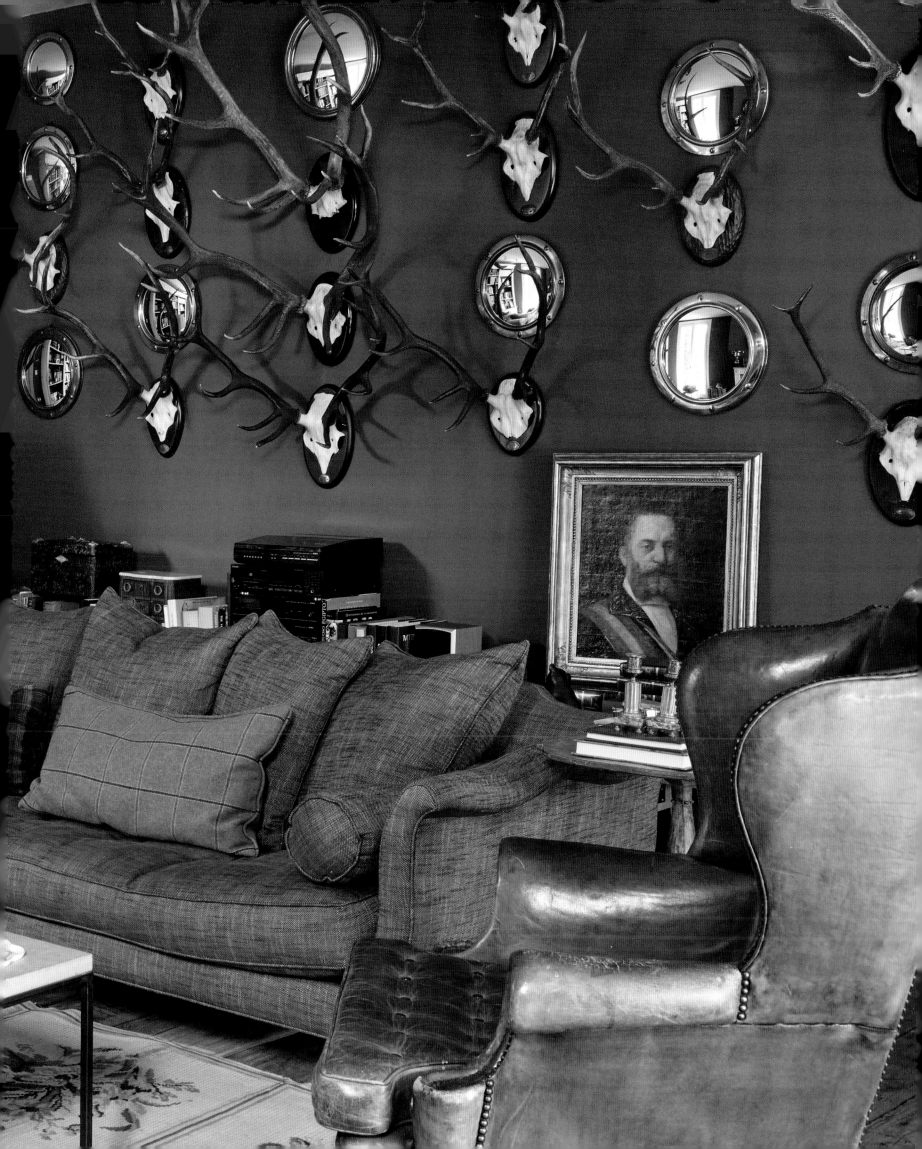

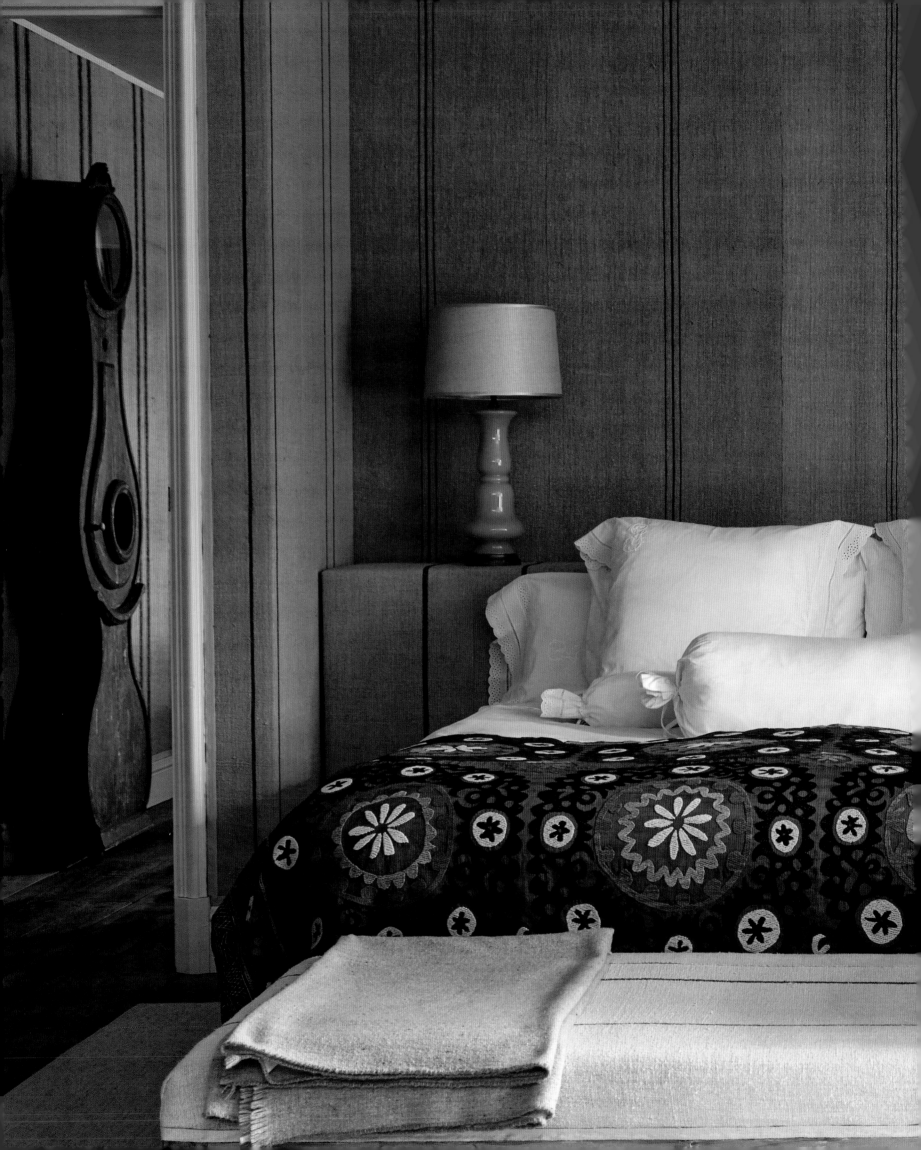

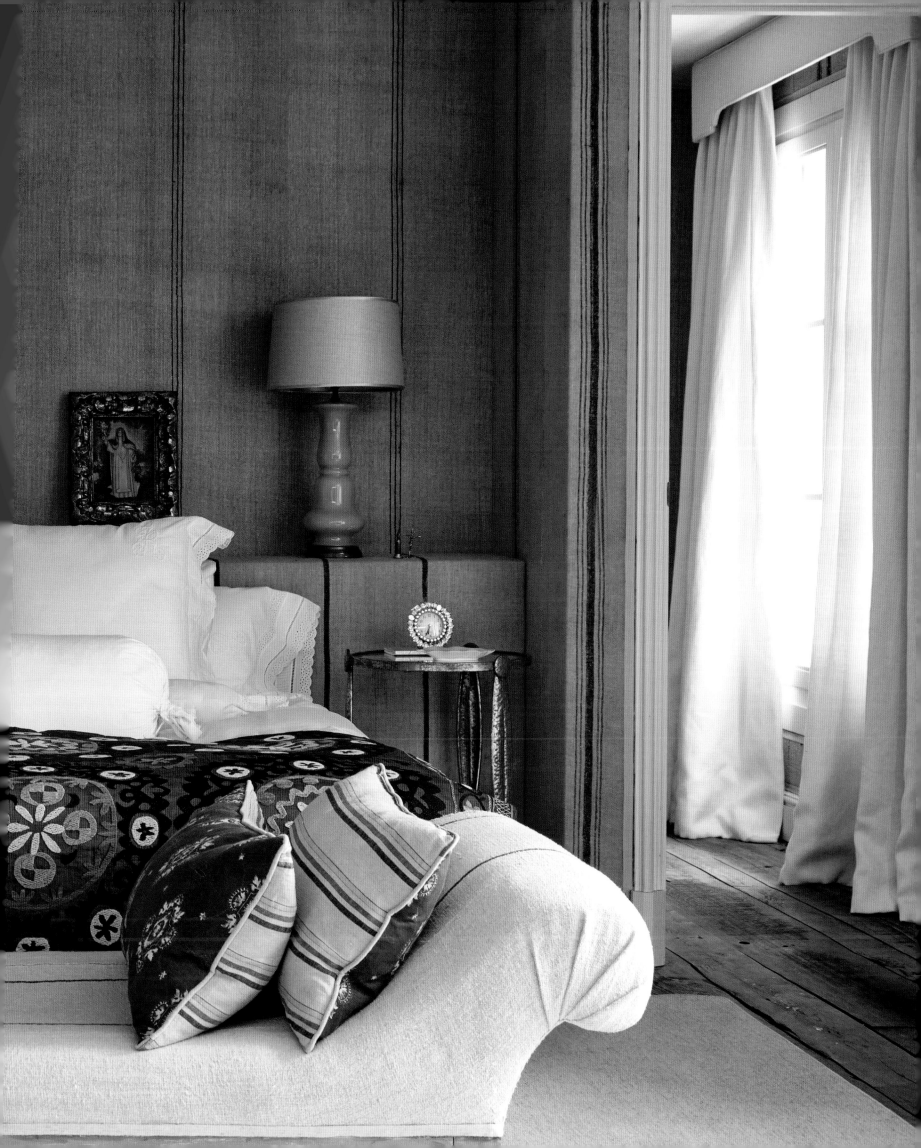

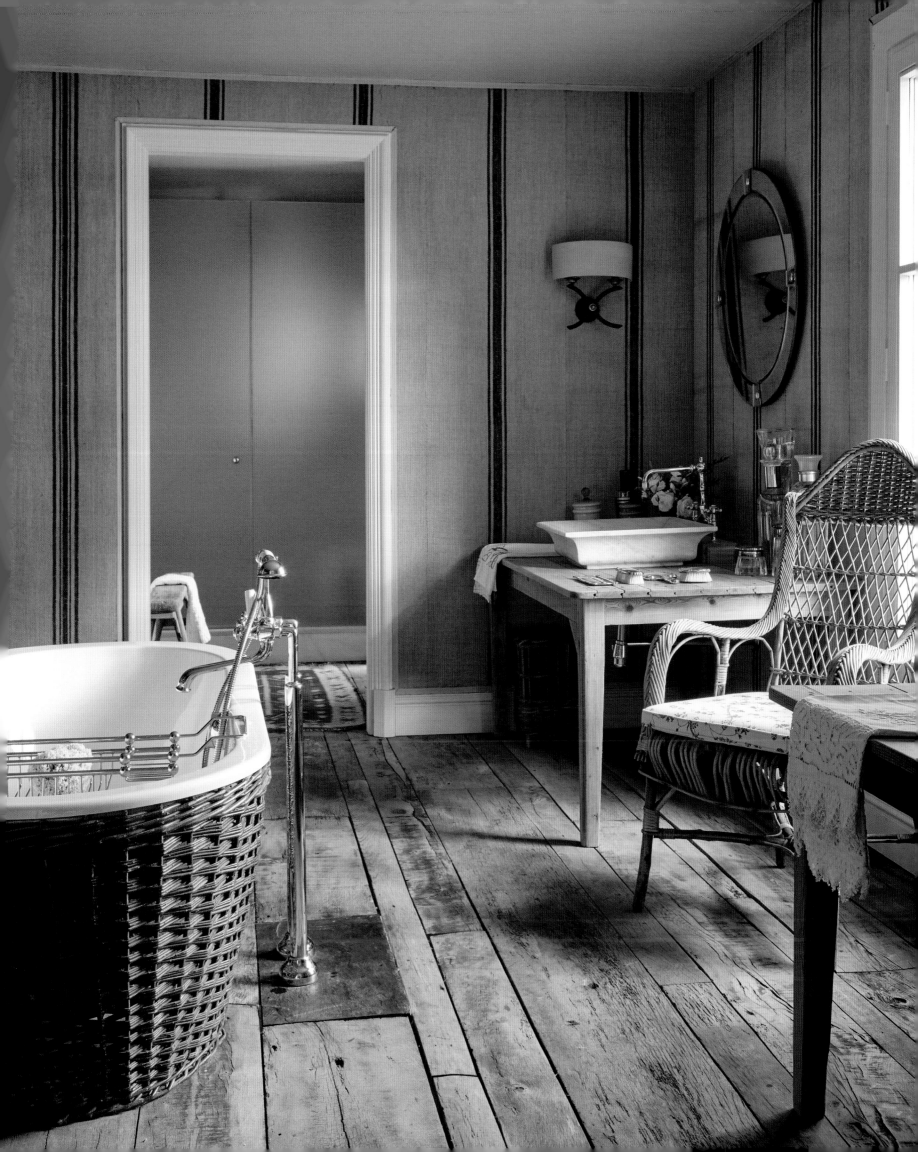

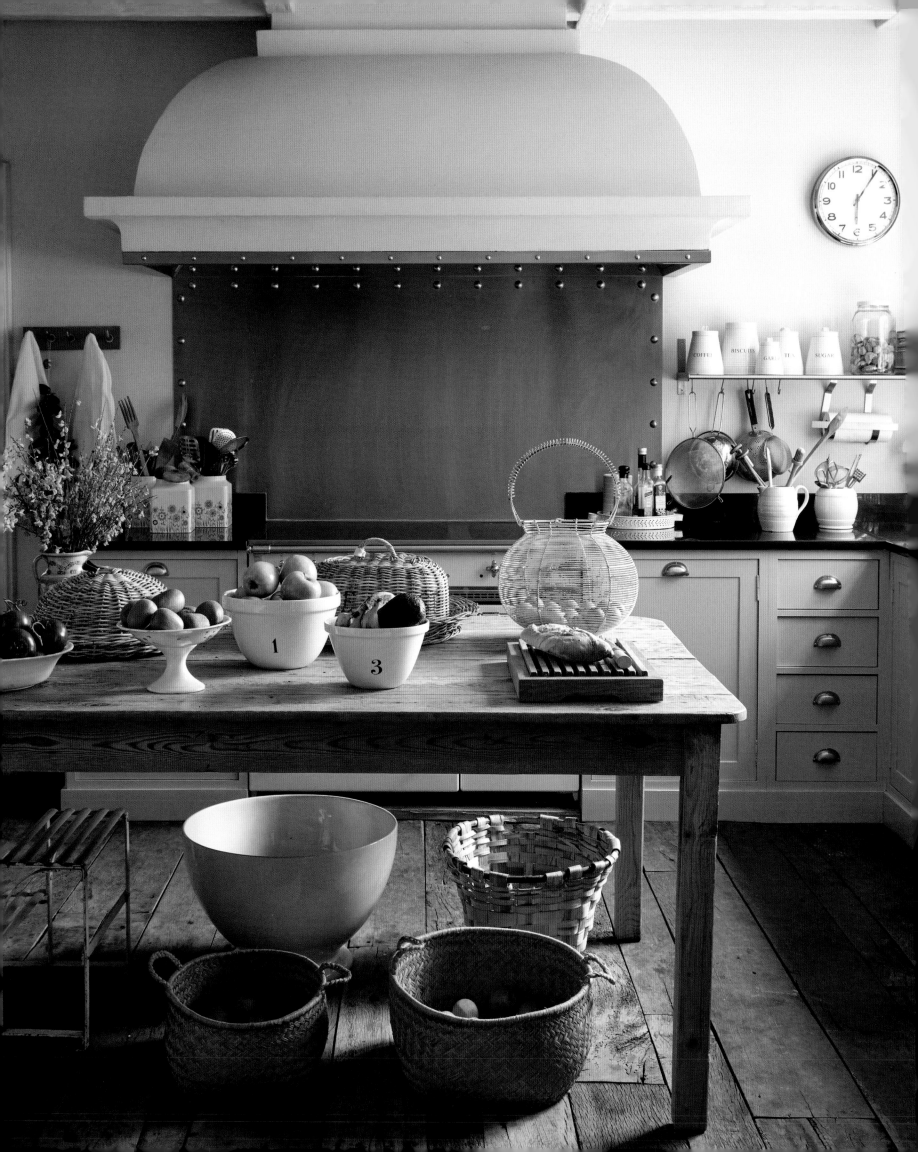

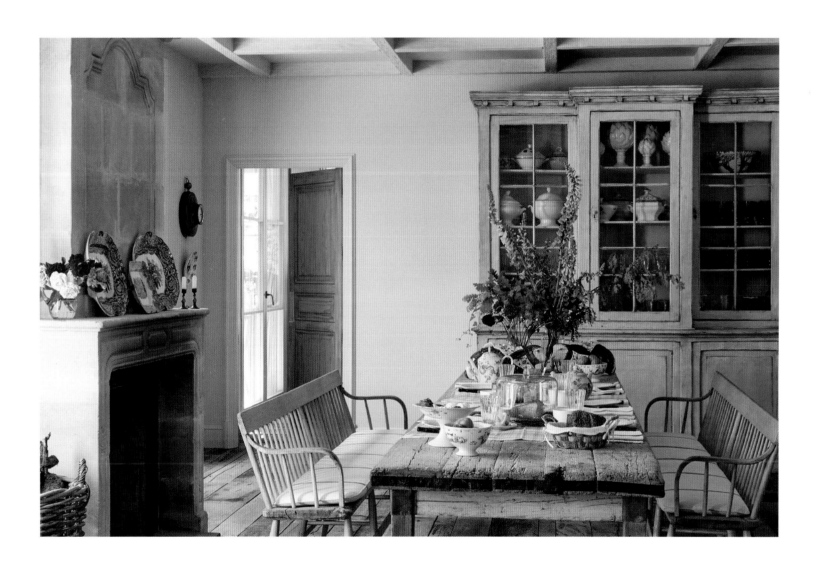

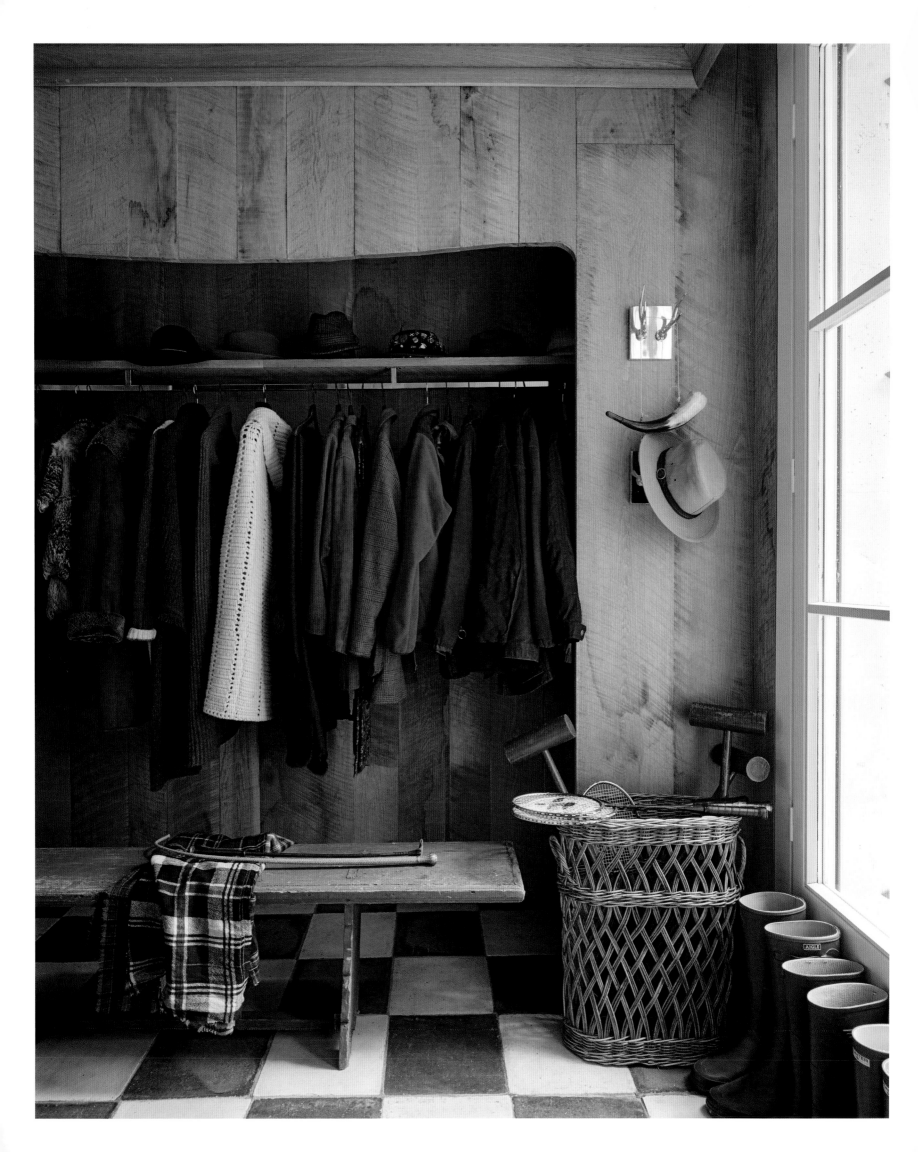

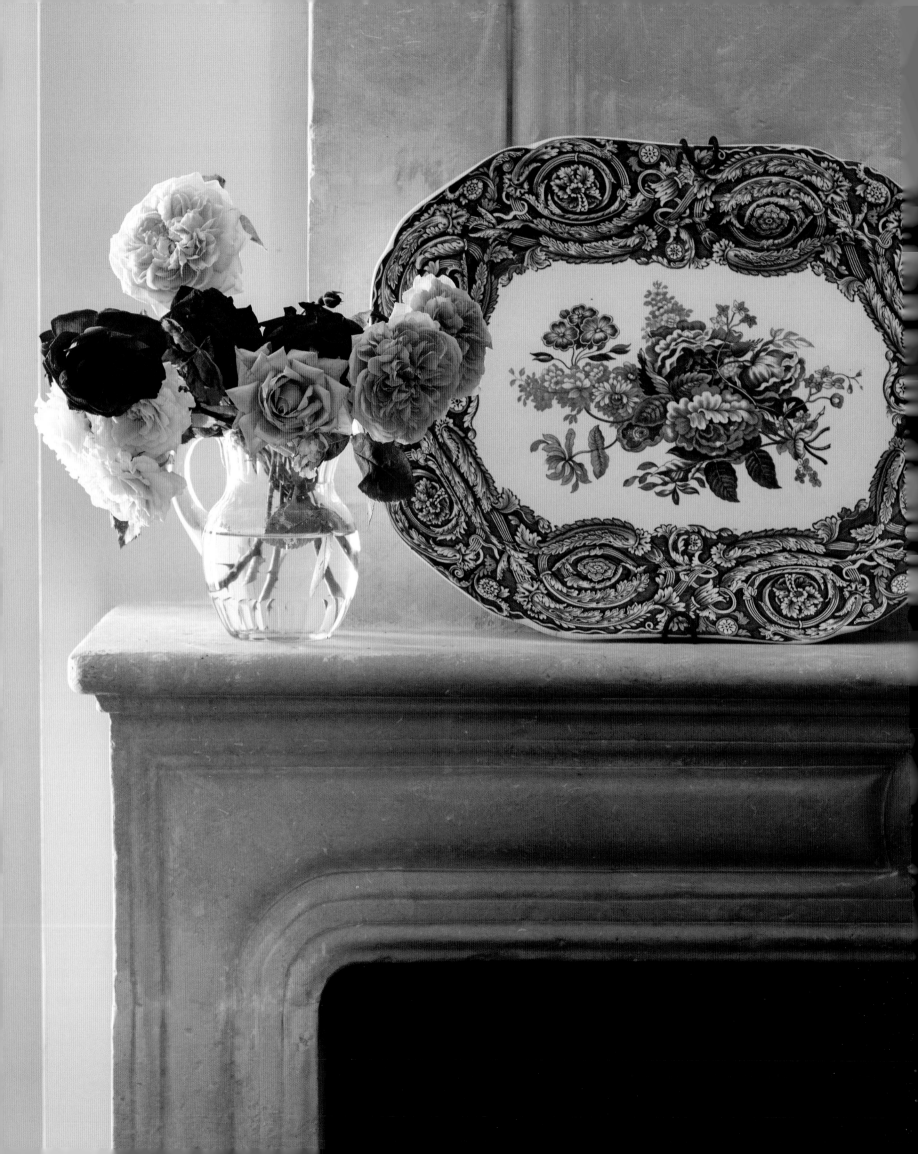

PAGE 195 The double-height entrance hall of the Segovia estate is laid with large eighteenth-century Belgian floor tiles, and the walls are painted to give the appearance of faded striped wallpaper. Stone urns and antlers arranged on a table covered by an antique tapestry create a stunning feature.

PAGES 196–97 The entrance courtyard, designed by Fernando Caruncho and architect Pablo Carvajal, is laid with pebbles in large diamond shapes and edged in granite. A majestic lime tree sits at the center of the courtyard, and jasmine-covered facades adorn the entrance. The front door is surrounded by Campaspero stone. Along with the glass panels in the door, a distinctive ox-eye and large windows flood the hallway with light.

PAGES 198–99 The double-height lounge has a substantial living space arranged around an eighteenth-century wooden fire surround topped with eighteenth-century French mirrors. Tables set behind each sofa display antique books and iron urns filled with sprigs and branches. Opposite the fireplace, a red Swedish chest of drawers holds a cage, with old family paintings hanging above. The lounge walls are ashlar plaster in the form of large blocks. Two eighteenth-century English lamps hang from the ceiling.

PAGE 200 Set between the windows of the lounge, the eighteenth-century wooden fire surround and mirrors are the focal point of the large seating area.

PAGE 201 On either side of the French pine double doors is an English sideboard—sourced from an old glasshouse—each topped by a polychrome obelisk.

PAGES 202–3 The dining room is accessed from the lounge and the everyday dining area. The nineteenth-century walnut table is surrounded by Swedish chairs, with an English upholstered chair at each end. Gray-green wood paneling is complemented by a Vicky Uslé painting. The space houses two eighteenth-century French oak cabinets; the interior of one is painted a stunning blue and displays books and old pharmacy bottles.

PAGE 204 An English chocolate-colored upholstered chair with embroidered flowers sits on a tomato-colored Moroccan rug.

PAGE 205 An oak chest of drawers holds decorative iron urns and glass bell jars. A picture from the Goya school hangs on the wall above.

PAGES 206–7 The living room is painted khaki green. Against one wall, large pharmacy shelves are stacked with books; the other is covered in a display of antlers and brass-framed mirrors. A tobacco-colored Belgian sofa and various armchairs rest on an Arraiolos rug from Portugal, opposite a nineteenth-century white marble fireplace. An English leather armchair is the perfect finishing touch.

PAGES 208–9 In the primary bedroom, a strawberry-colored suzani adds a splash of color. The bed is arranged in front of the doors leading onto the terrace, while two symmetrical doors connect the bedroom with the living room. The chaise longue at the foot of the bed is upholstered in blue striped fabric.

PAGE 210 The flooring in the upstairs gallery is restored antique walnut and oak. Two antique floristry tables containing vases filled with horns sit at either side of the windows above the lounge.

PAGE 211 In the bathroom, two antique pine tables support basins and round English mirrors hang above. A freestanding rattan-covered bath is the focal point in the middle of the space.

PAGE 212 The kitchen features a curved extraction hood and bespoke wooden furniture. An old pine table in the middle of the room is useful for storing baskets and utensils.

PAGE 213 The breakfast room is located between the dining room and the kitchen. Its pretty French stone fireplace sits between the windows, decorated with English porcelain pieces and rose-filled vases. The ceiling beams are arranged in a grid pattern. A French cabinet filled with dinnerware and glassware sits against a wall at the end of the long table lined with blonde English benches.

PAGE 214 Accessed from the gallery, the mudroom and guest powder room are clad in oak planks from floor to ceiling. The black-and-white checkerboard floor contrasts with the light wood.

PAGE 215 Fernando Caruncho designed the garden, which is encircled by a wisteria-covered pergola on stone pillars that marks the transition between the upper and lower levels.

PAGE 216 Roses and an English porcelain platter rest on the French mantelpiece in the everyday dining room.

THE FUTURE HIDING
IN AN OLD BARN

Located on an extensive estate in Chadds Ford, forty-five minutes outside Philadelphia, this 1869 Swedish-style barn, set in a landscape that changes constantly with the seasons, faced the main farmhouse. The new owners—a couple from New York—initially moved into the farmhouse with their three children, with no idea they were living directly opposite their future home. A couple of years went by before it became apparent that the old barn, with its three floors and imposing adjacent silo, used for animals and grain, would make a wonderful home with plenty of space for the whole family.

Pietro Cicognani's architecture firm was commissioned to undertake the renovation and rebuild, and in 2011 the owners stumbled upon López-Quesada's work in the New York blog *Habitually Chic* and immediately fell in love. The Madrid-based studio seemed a long way away, but Isabel and architect Marta Marín quickly began to envisage the future of La Granja.

Reclaiming this nineteenth-century barn and converting it into a year-round home was a complex two-year renovation that was completed in 2015. The project involved working with the vernacular styles of the local area, particularly traditional ways of working with wood and stone. López-Quesada often says that researching the crafts and trades of other countries is what makes her work outside Spain so satisfying. It may not have been easy, but the project brought forth new and powerful ideas. The work of carpenters from the local Amish community and their profound understanding of wood was a key element of the project.

A metal staircase connecting all the floors was installed in the old silo, linking the ground floor with the children's bedrooms, kitchen, dining room, study, and the floor above with the living room and the primary bedroom. A large terrace on the southern side of the barn and a glazed sunroom to the west allow the landscape to be enjoyed all year round. English landscape architect Jonathan Anderson designed the garden.

The triple height of the barn was maintained thanks to a decision not to close off the ceilings of the study and the dining room. A wooden staircase provides passage between the upstairs lounge and the downstairs sunroom. Hydraulic tiles, originally from a house belonging to the owner's grandmother in Santo Domingo, line the floor in this area, which is decorated with mirrors and antique engravings. The decor is eclectic—mid-century lamps, brass furnishings, and two bookcases and a bar created from two imposing eighteenth-century Spanish doors.

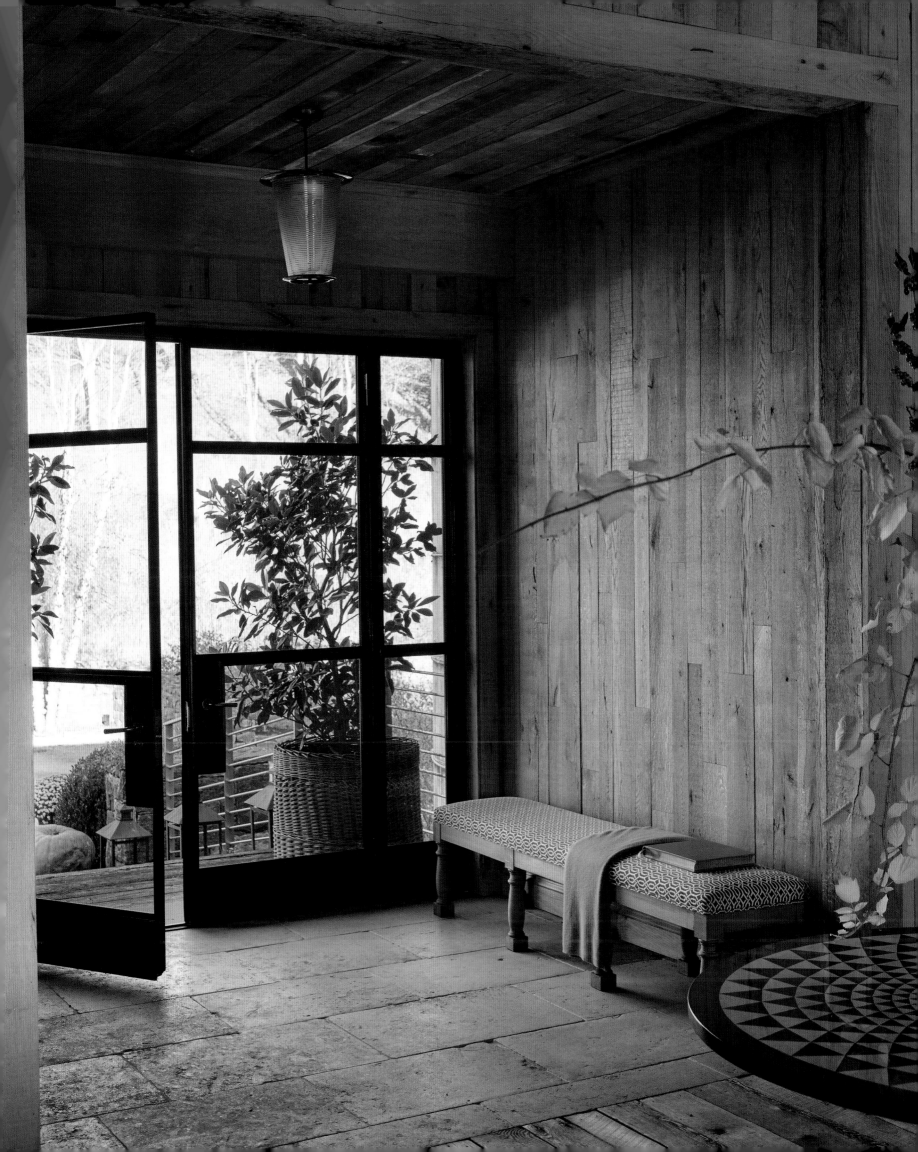

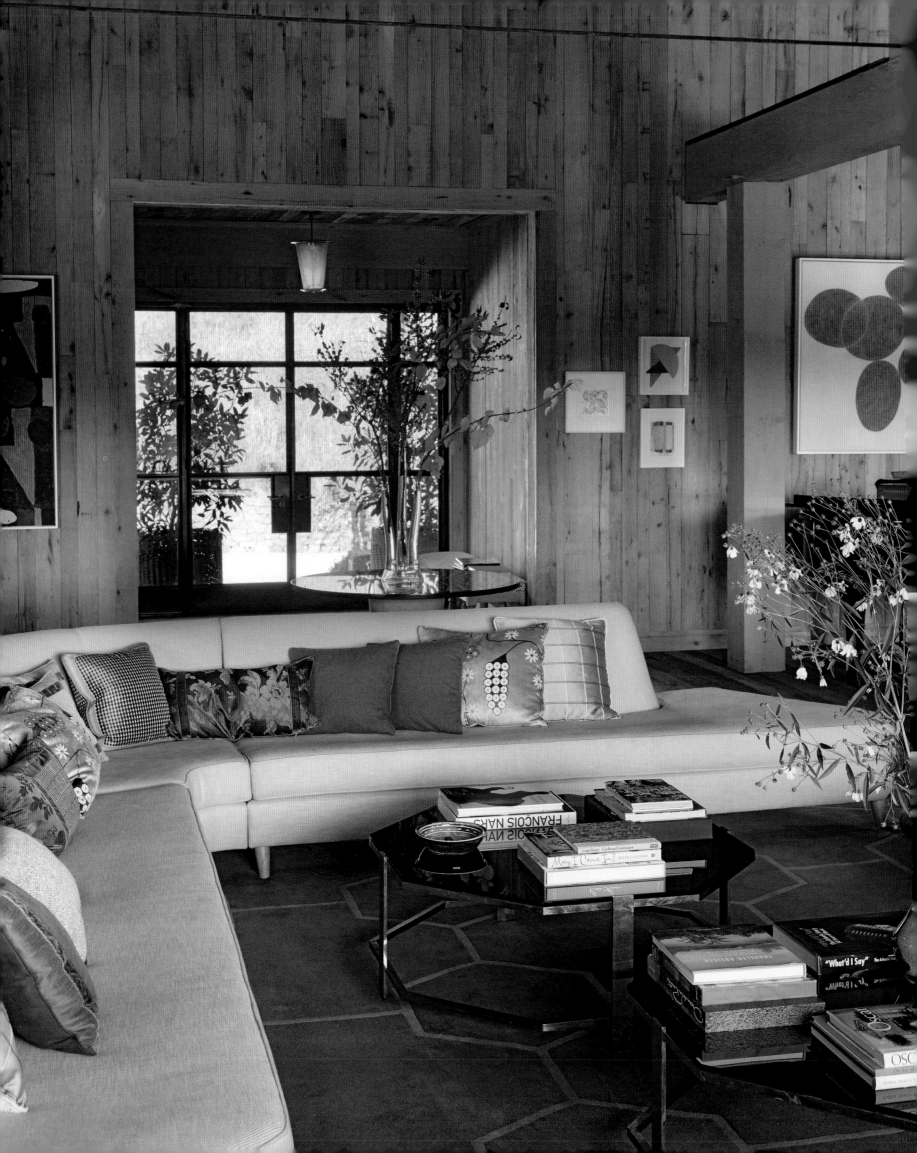

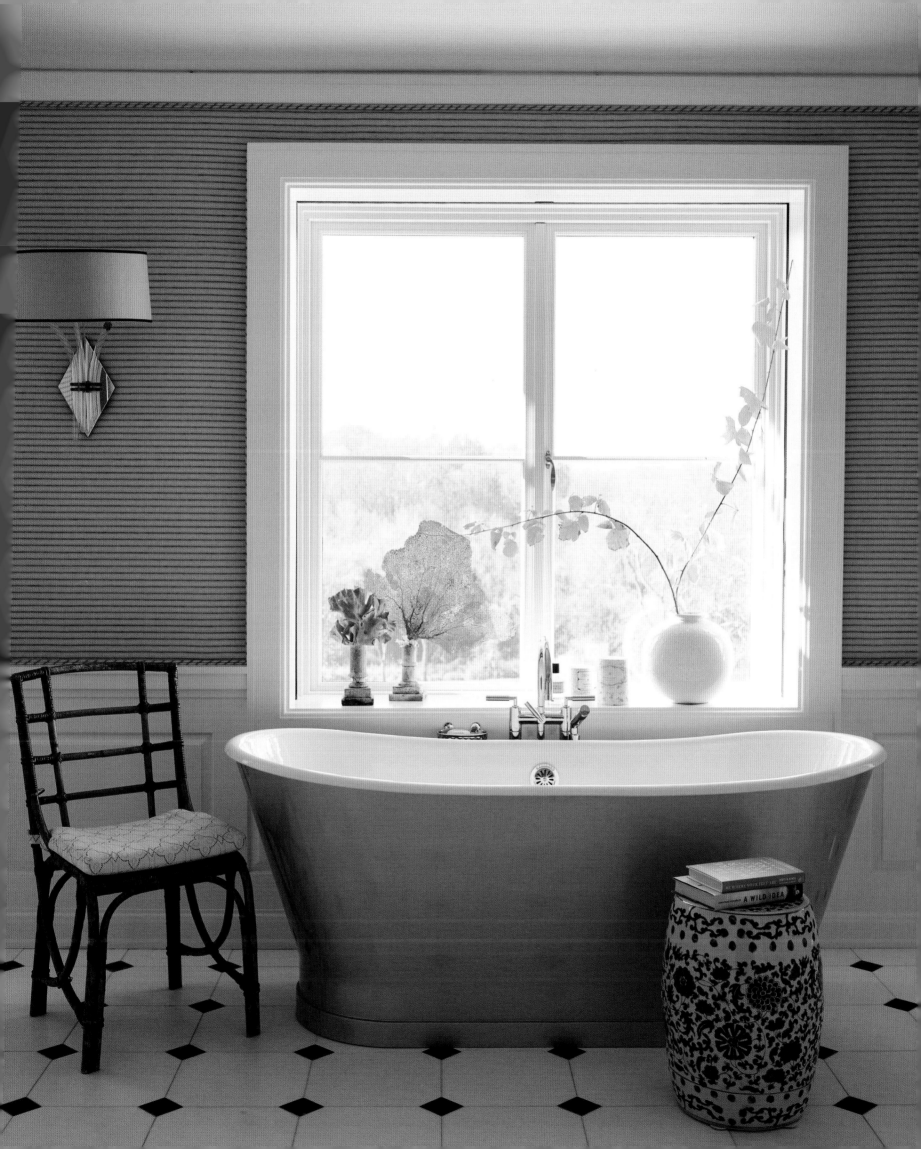

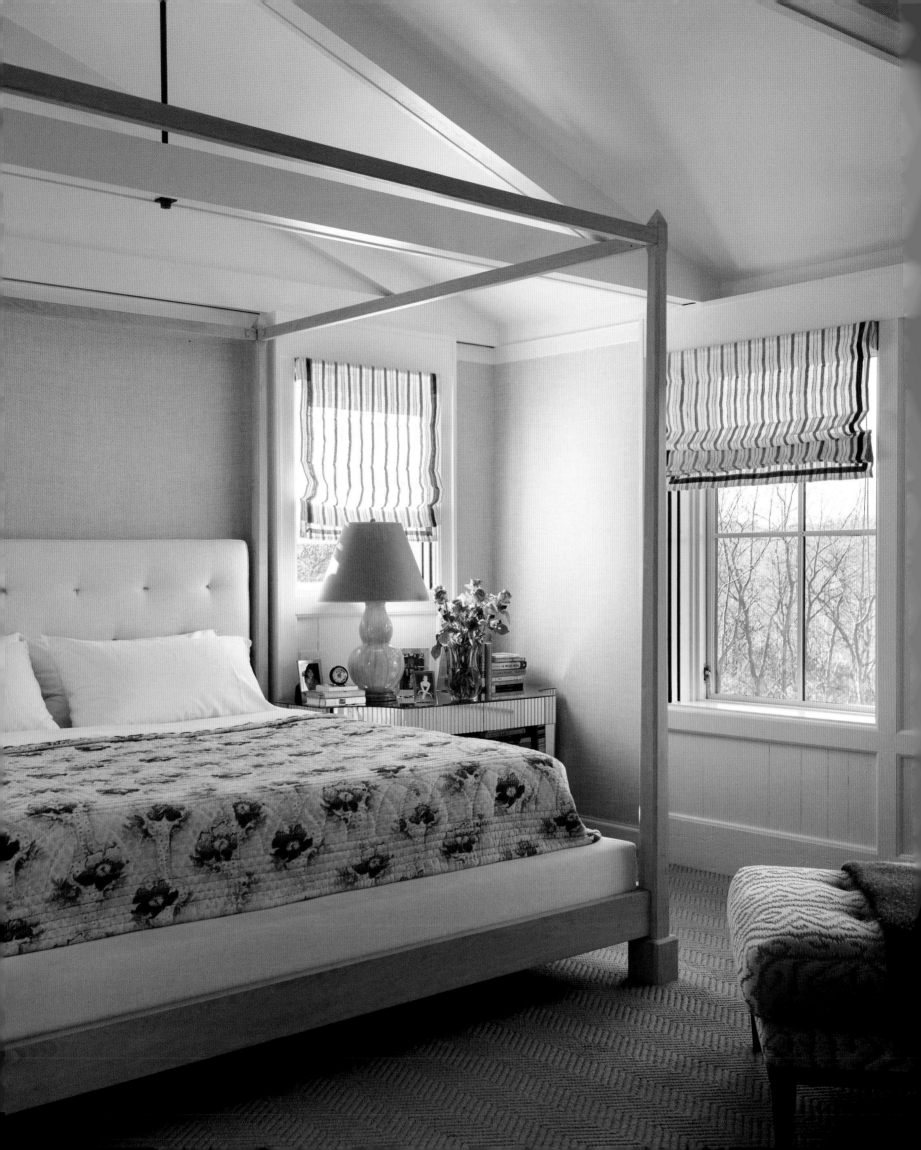

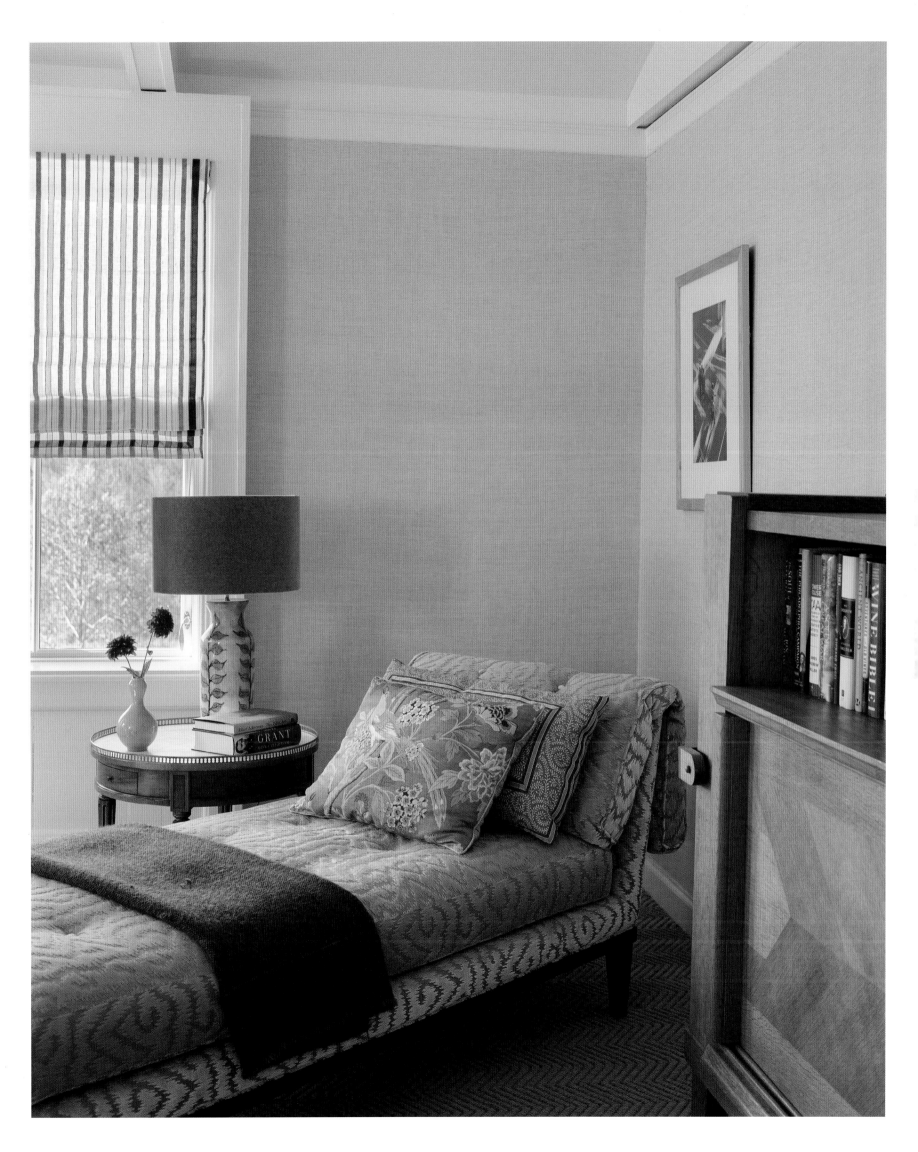

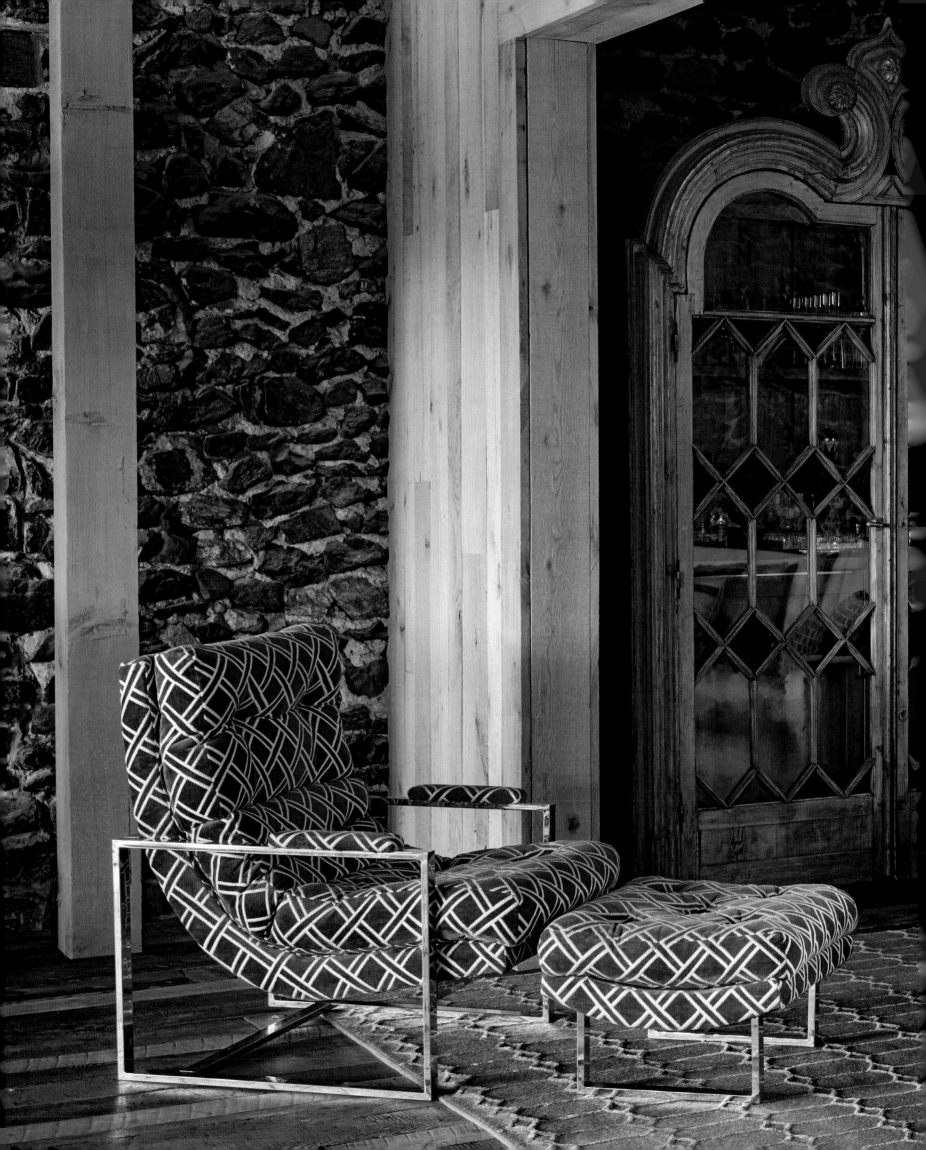

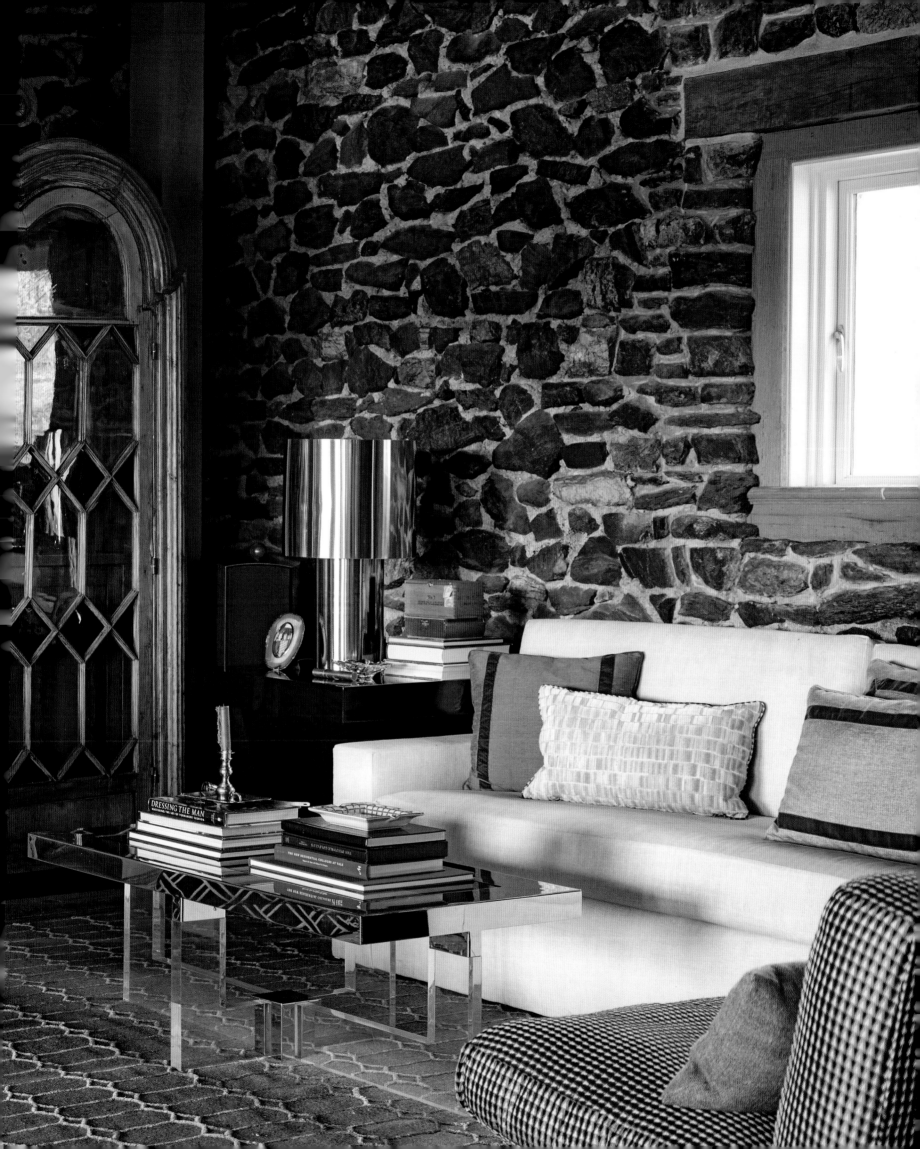

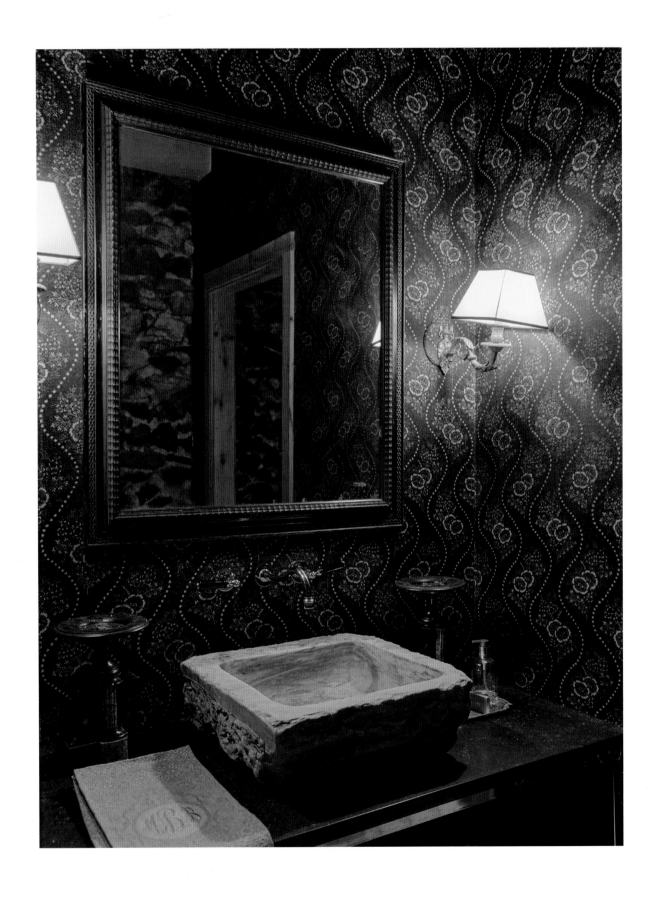

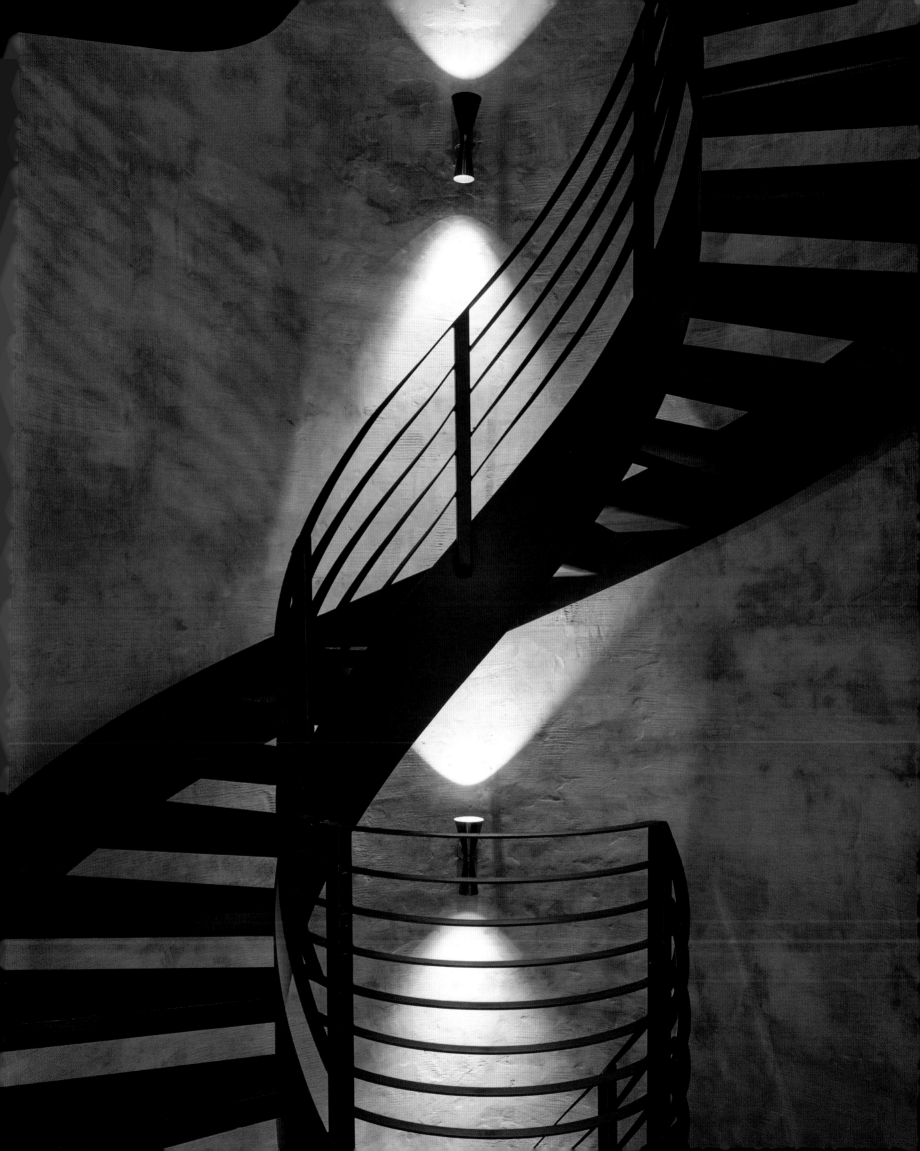

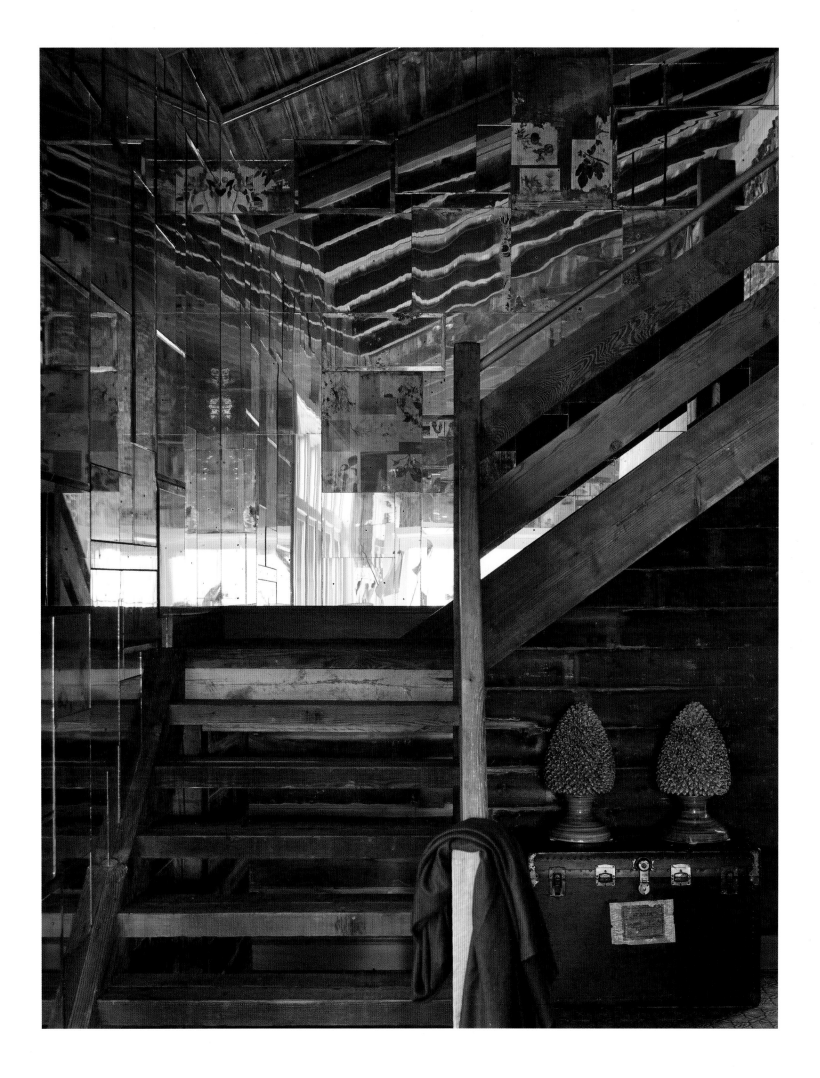

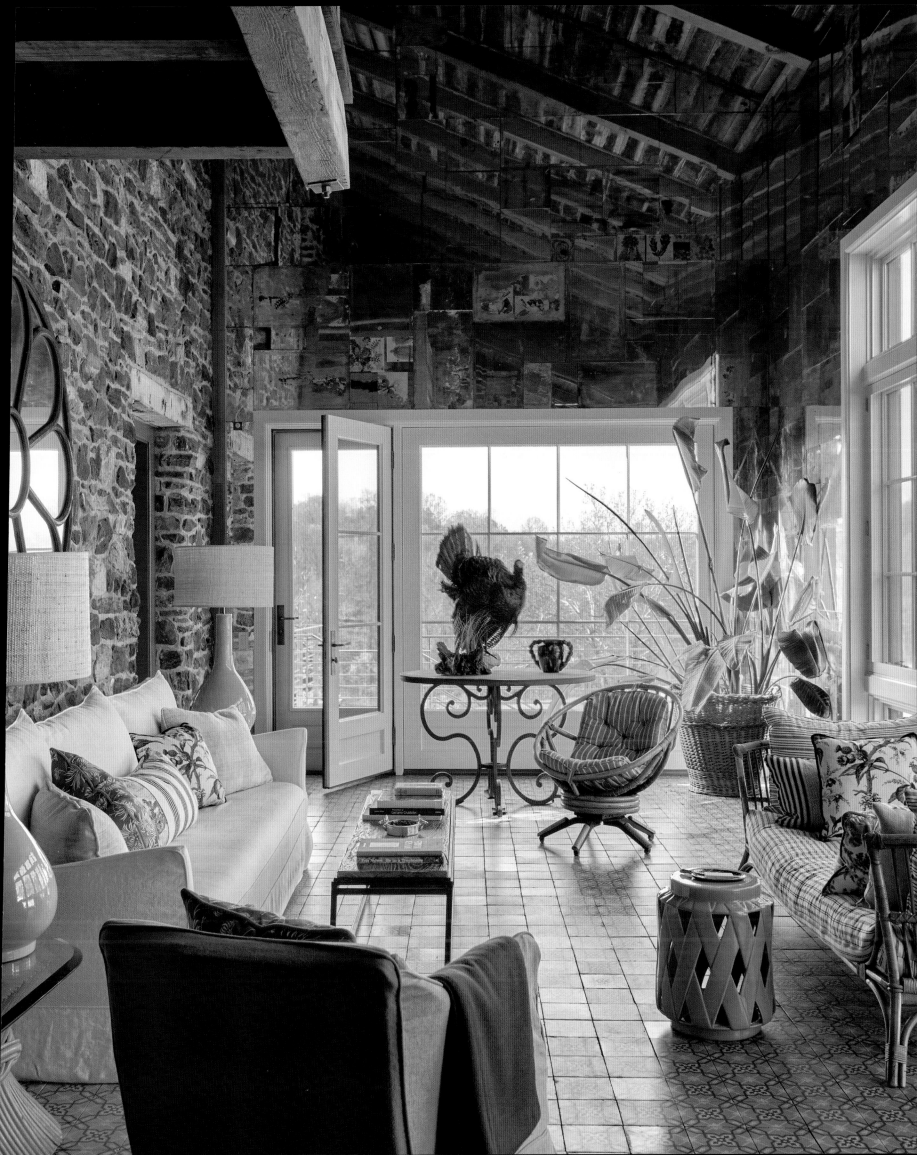

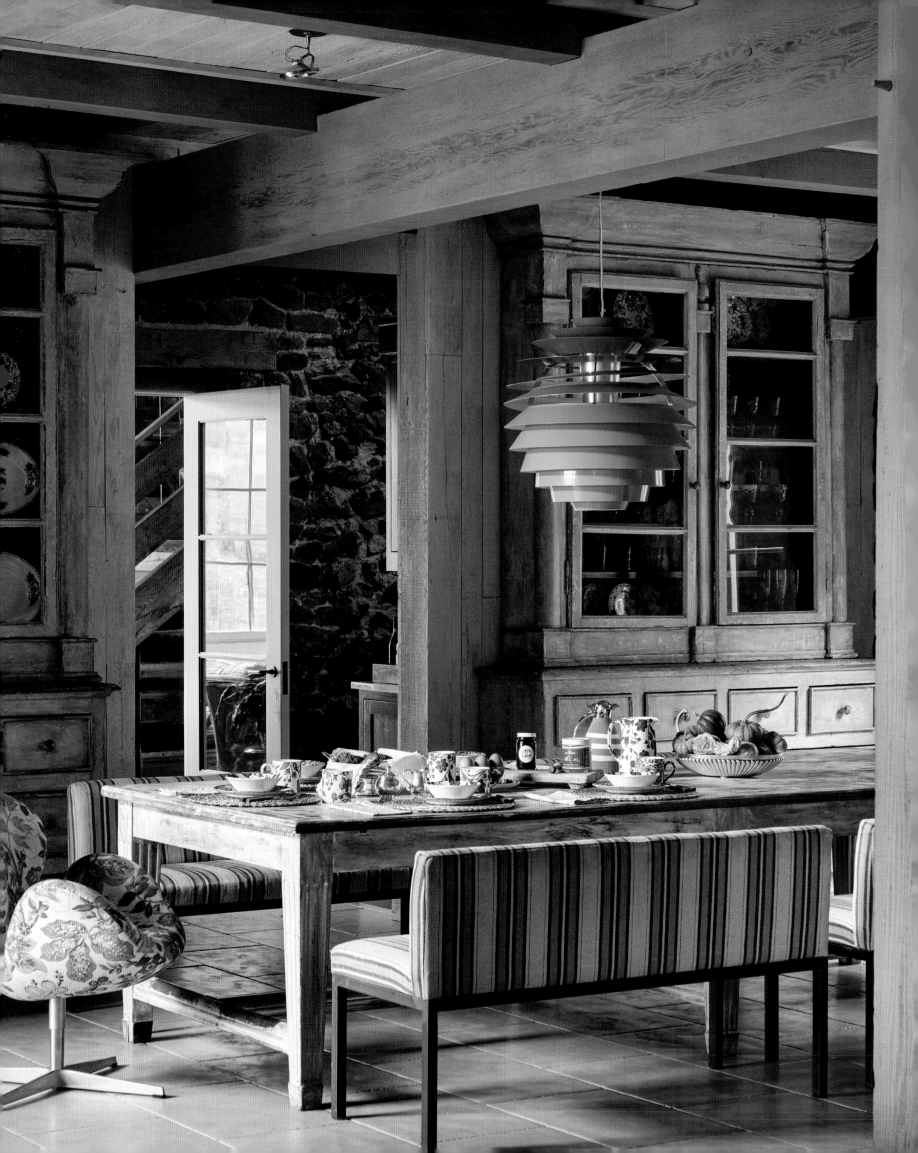

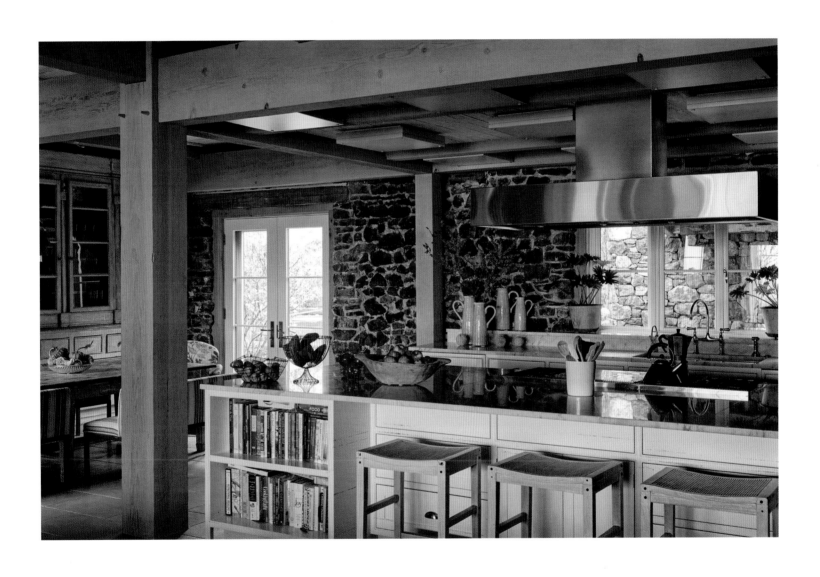

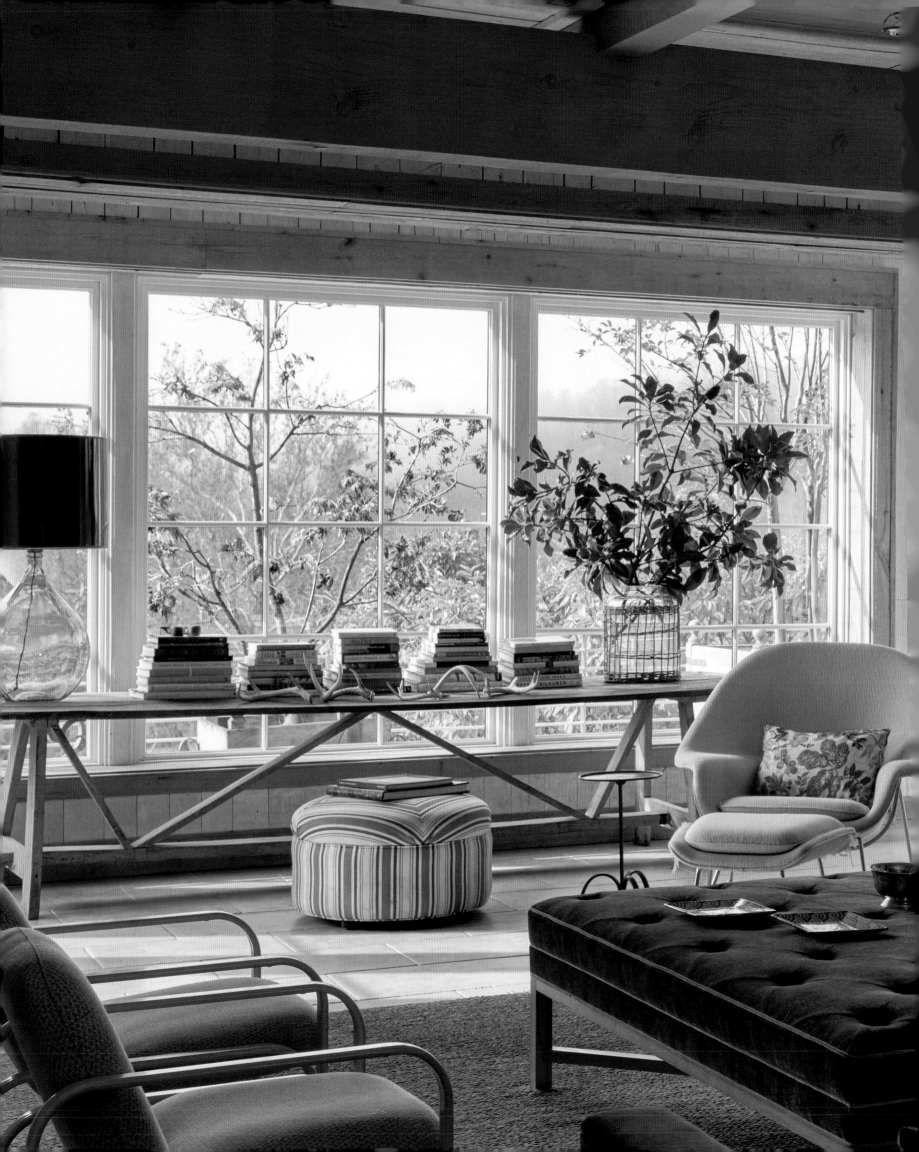

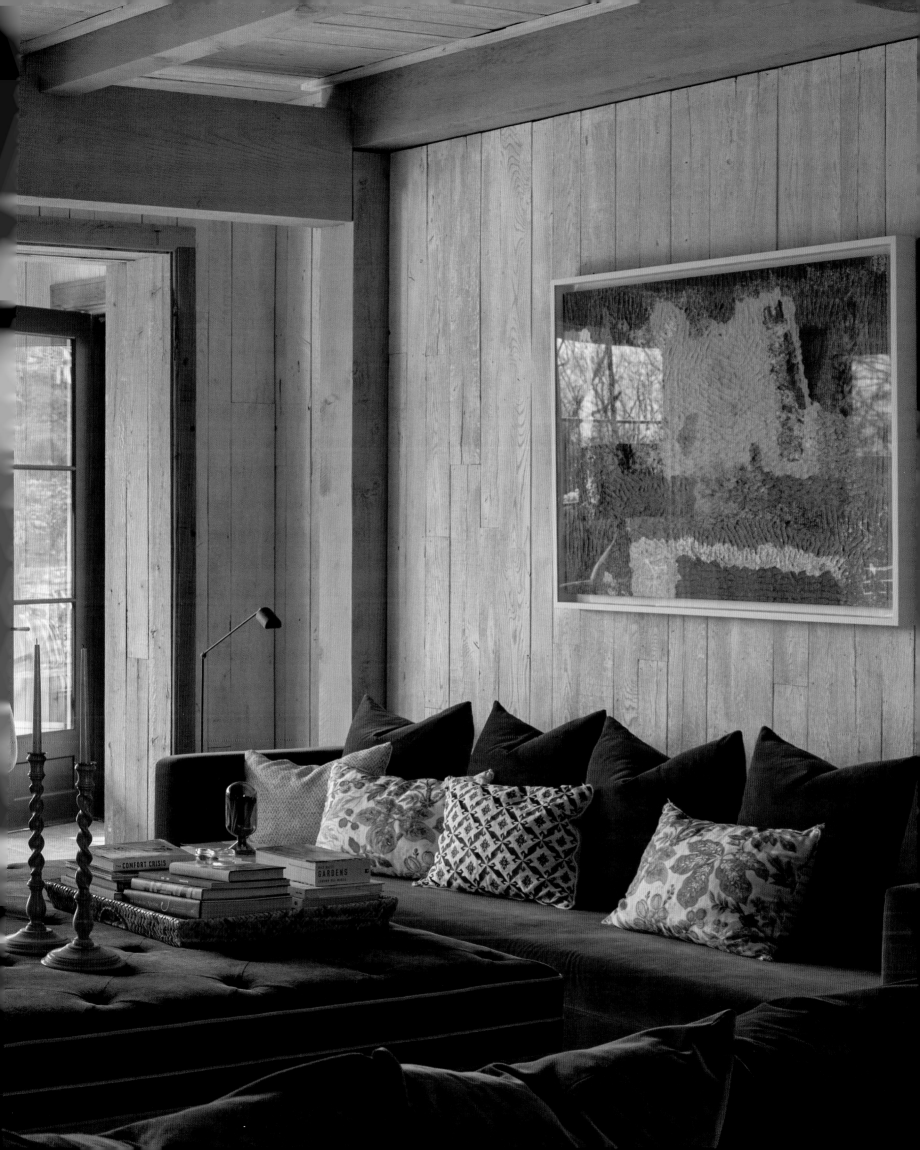

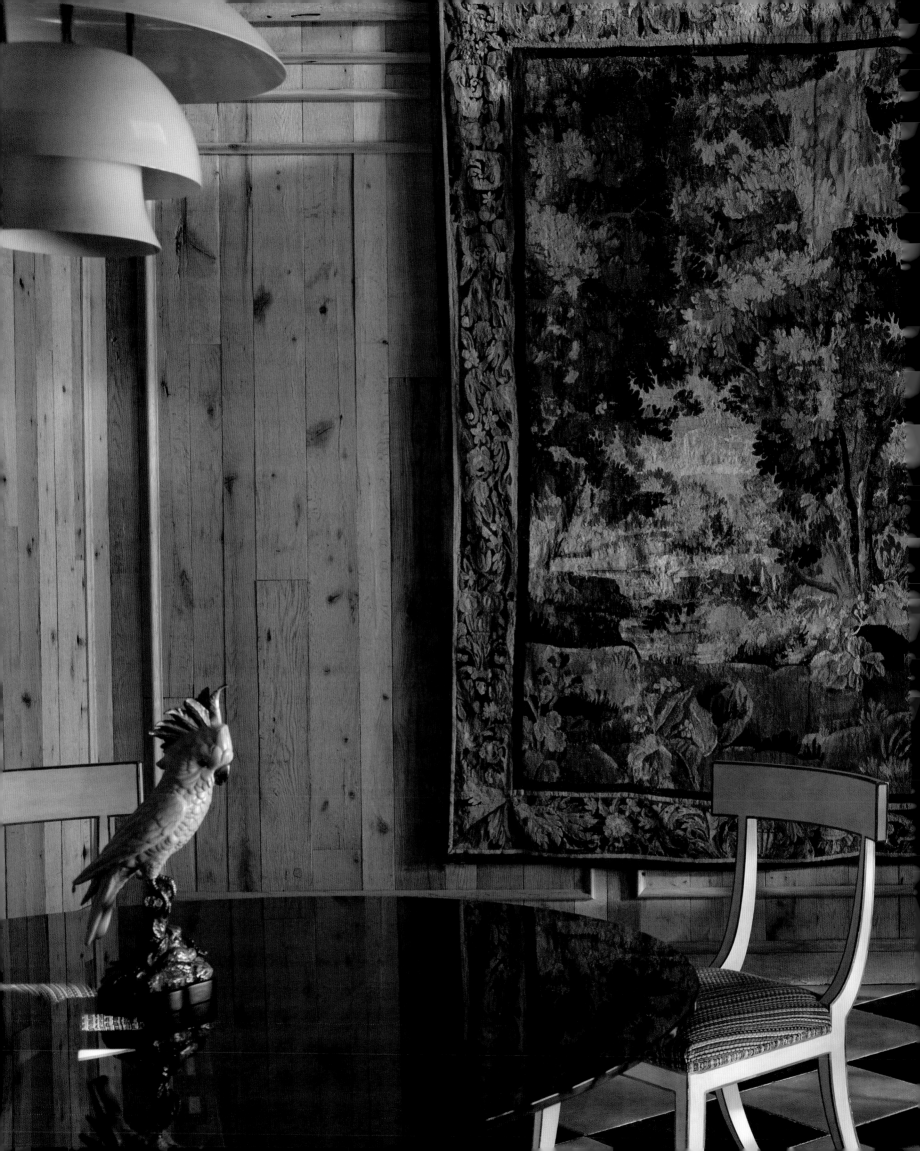

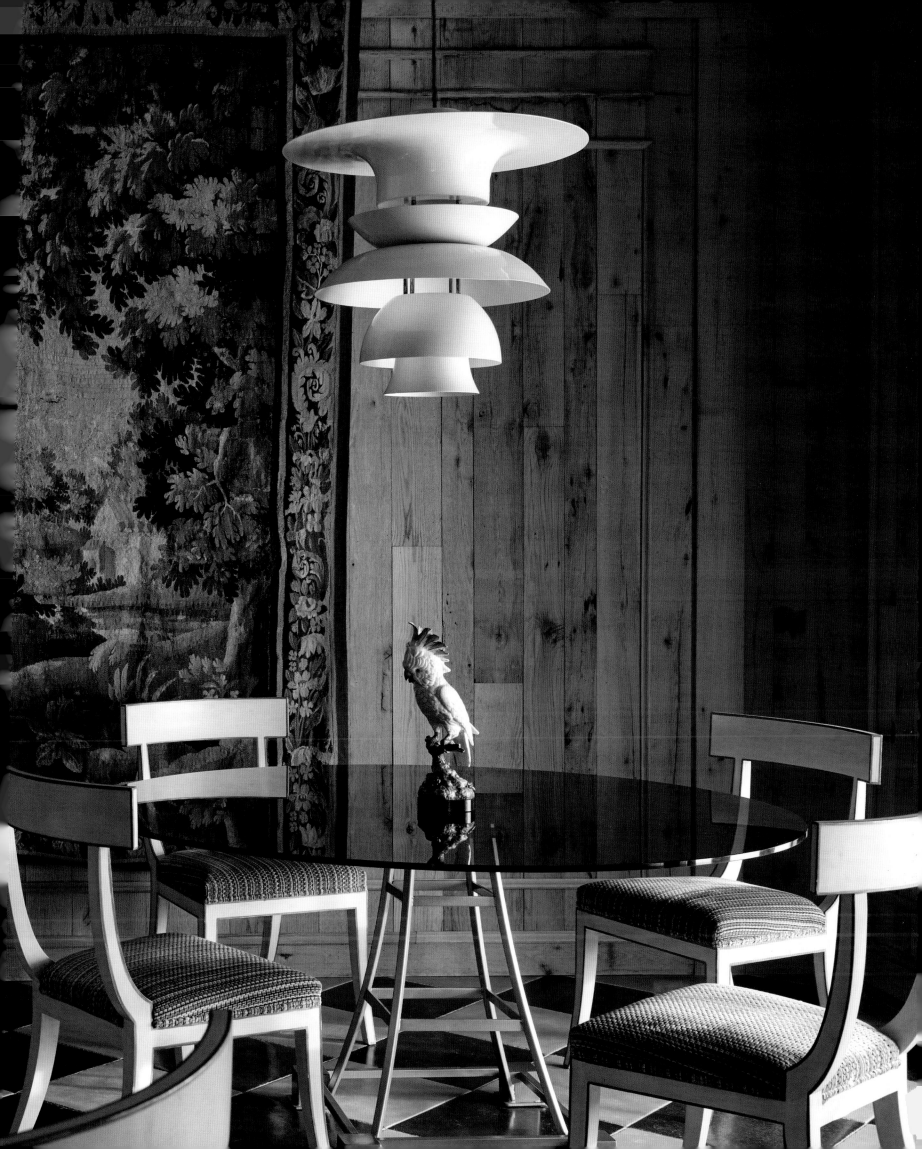

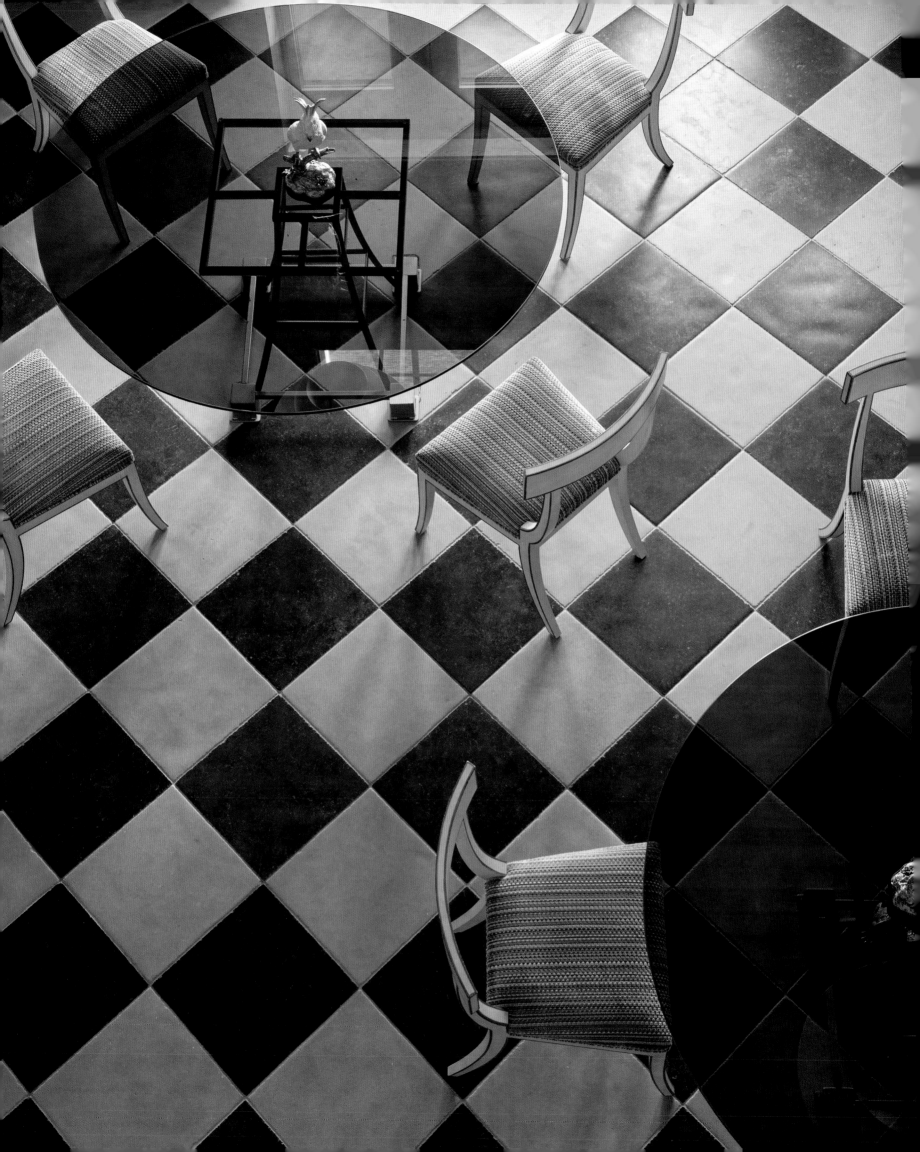

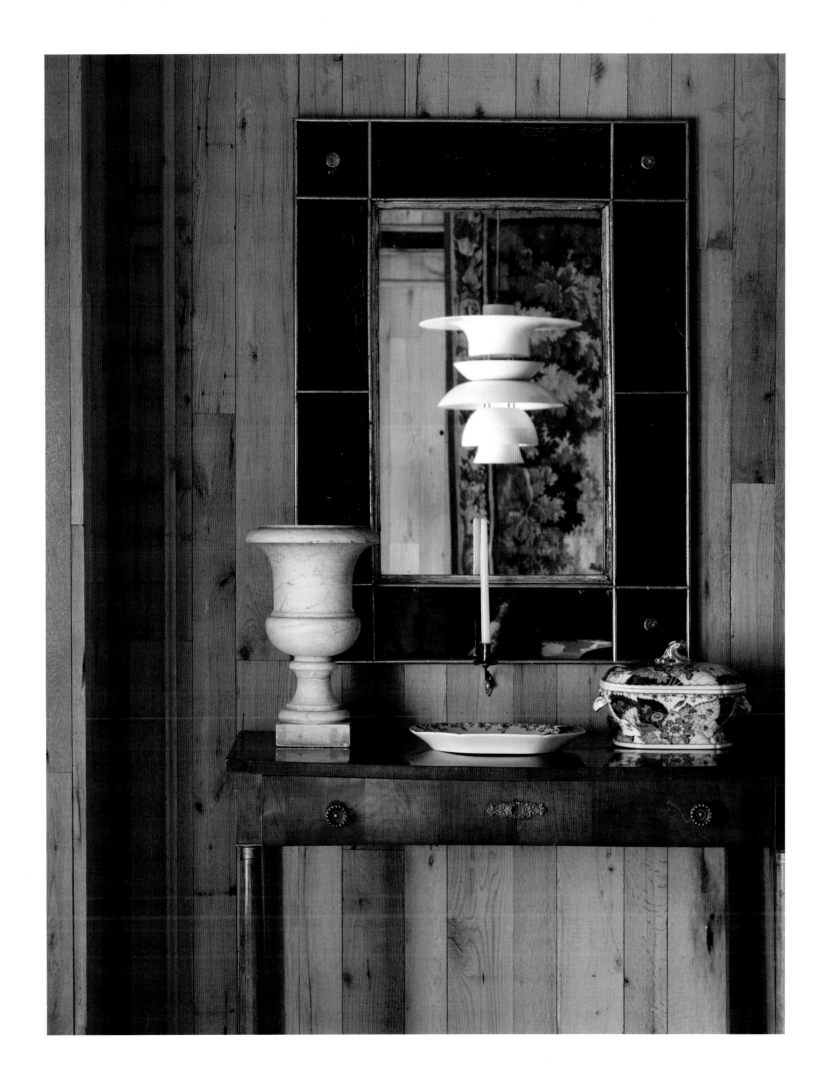

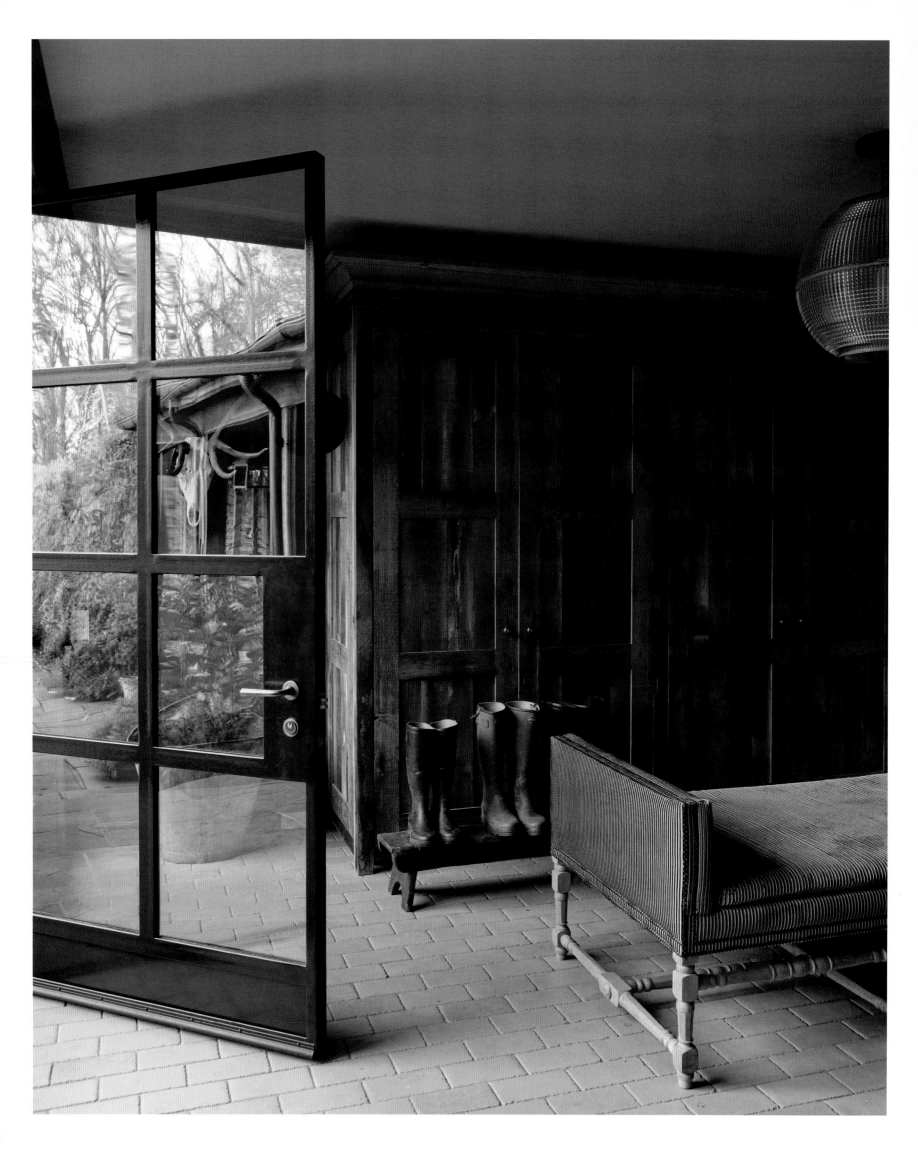

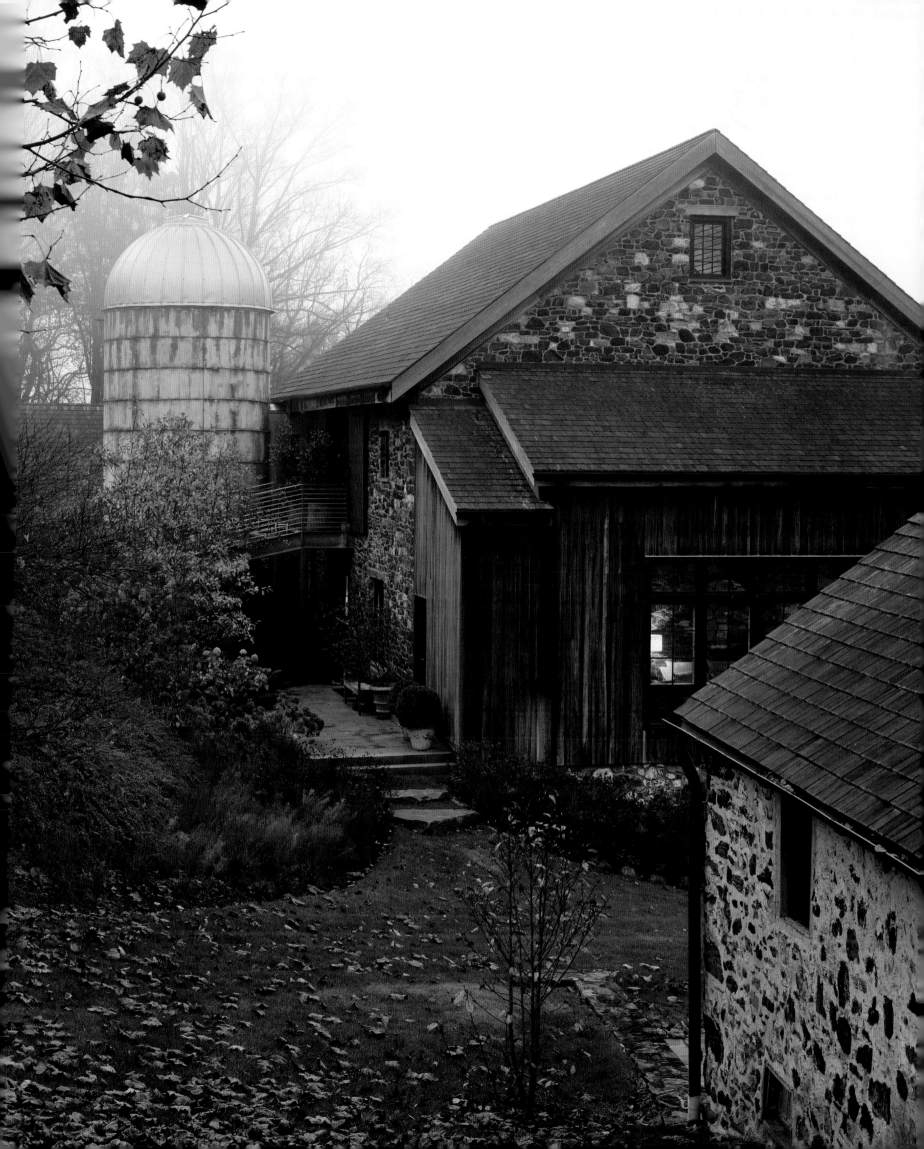

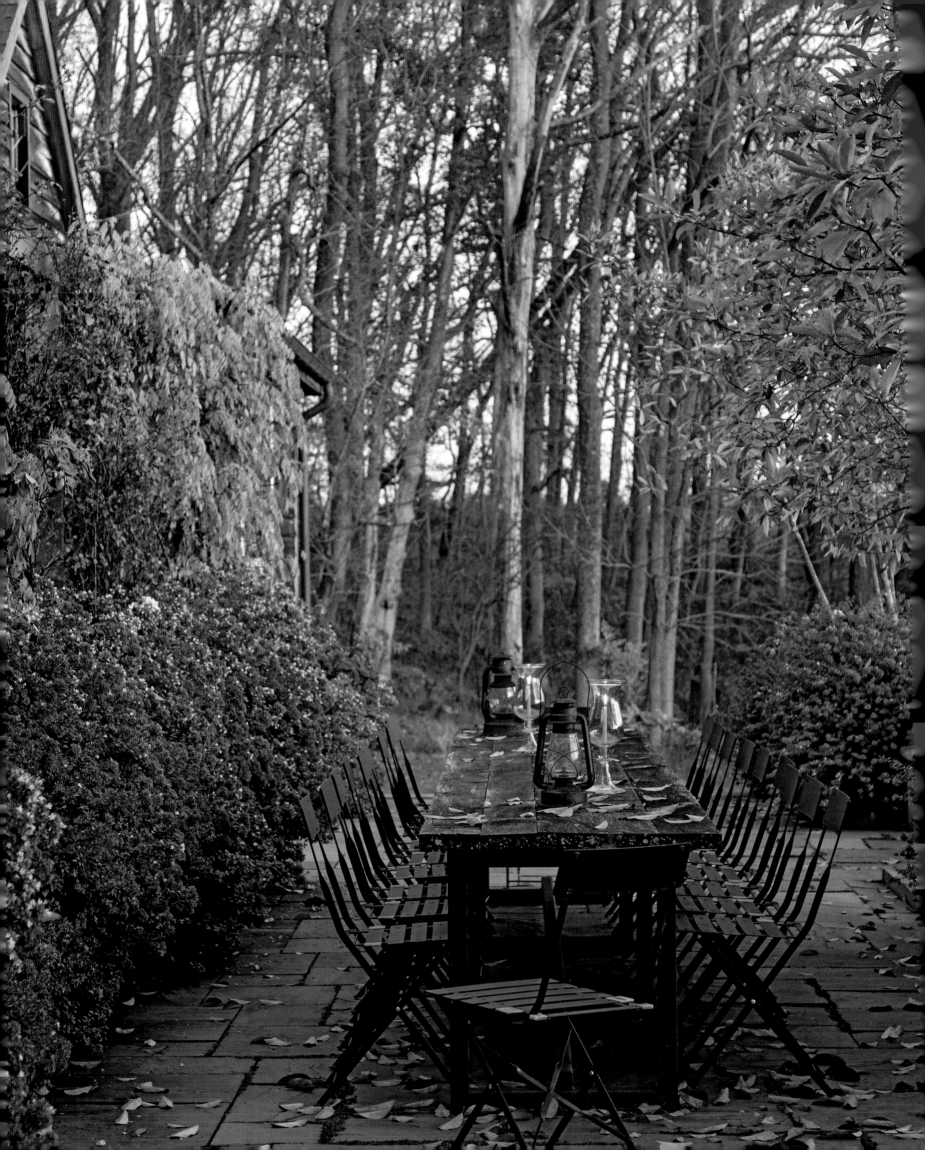

PAGE 219 An iron-framed front door allows northern light to enter the barn. Beyond, the original blue sliding doors have been recreated. The flooring is antique stone, and the walls and ceiling are clad in wood.

PAGES 220–21 The lounge takes up the whole of the upper floor, apart from the study and the dining room. The texture of the old wood in the ceilings and floors, combined with the oak on the walls and the stone of the old walls, creates a warm light. A Jonathan McCree painting on the chimney breast complements 1970s orange leather lounge seats.

PAGE 222 The large living area is shaped by a substantial L-shaped sofa in front of the fireplace, two 1960s brass tables, and four armchairs.

PAGE 223 A 1920s table with a substantial walnut-veneer base topped with Portoro marble sits next to the windows at the back of the living room.

PAGE 224 The original stone walls were restored and left visible. This wall marks the starting point of the barn's extension, leading to the primary suite comprising a hallway, closets, a dressing room, a bathroom, and the primary bedroom.

PAGE 225 The bathroom floor is tiled in white and black marble, with Arabescato shower cubicles and toilet. The walls are decorated from mid-height with wool, above painted wood panels. The bathtub sits directly under the window, between a shower cubicle and vanity unit. The views from the bathtub are hard to beat.

PAGE 226 Vintage lamps, striped roller blinds on the sash windows, and a flowery French bedspread give the primary bedroom a rustic yet bright look.

PAGE 227 The bedroom's light gray wool wallpaper, antique French Chambron chest of drawers, and furniture give the space warmth. The chaise longue came from New York and was reupholstered in gray velvet.

PAGES 228–29 A small lounge area was created in the entrance space, featuring two cabinets made from antique Spanish doors. One of them was made into a bar and the other into a bookcase. The 1970s American lounge chair with footrest is by Milo Baughman, and the Perspex table came from the owners' New York apartment—a striking contrast to the barn and the old cabinets. The dark stone walls highlight 1960s chrome lamps, which wink mischievously.

PAGE 230 Next to the elevator, the guest powder room is decorated with painted American raffia. An antique stone sink sits on a steel table while a black ebonized mirror flanked by piano sconces provides the finishing touch to this dramatic space.

PAGE 231 An iron staircase was created within the silo, connecting the three floors of the barn. Natural light enters from above. Earth-colored plaster covers the walls.

PAGE 232 A wooden staircase leads from the main lounge to the sunroom. One wall is original stone; the three others are lined with antique engraved mirrors. The sunlight bounces off the mirrors, creating a magical effect. The old wooden beams and planks of the ceiling have been left exposed.

PAGE 233 The sunroom was created in a space at the side of the main house, typical of Pennsylvania barns. The blue-toned hydraulic floor tiles were rescued from the homeowner's grandmother's house in the Dominican Republic. Bamboo and cane furniture, and other soft furnishings, give the room a light and airy feel.

PAGE 234 The everyday dining area comprises a large French table with four benches, two spectacular dressers to the left and right of the approach to the bar and sunroom, and an exquisite turquoise Louis Poulsen lamp.

PAGE 235 The kitchen, which is set in an open space with the everyday dining room and the living room, has a large central island and characteristic stone walls.

PAGE 236–37 Together with the kitchen and everyday dining room, the living room completes this space. Large windows capture southern light, and doors lead onto the terrace.

PAGES 238–39 The study and the dining room are open, double-height spaces. Both are clad in antique oak and laid with a limestone and Belgian black stone checkerboard floor. The dining room features two round tables on glass and gold metal bases with sixteen consular-style chairs placed around them. Two 1950s beige metal pendants by Danish designer Poul Henningsen hang from the ceiling. An eighteenth-century tapestry decorates the main wall.

PAGE 240 View of the dining room with its spectacular limestone and Belgian black stone checkerboard floor from the upstairs lounge.

PAGE 241 Opposite the wall displaying the tapestry, two French Imperial console tables adorned with marble urns, tureens, and Mottahedeh Vista Alegre porcelain sit underneath large 1950s gold-painted wood and black opaline glass mirrors.

PAGE 242 The mudroom—on the middle floor—is approached from the back garden or the garage area. Closets clad in old wood store raincoats and boots. Iron-framed glazed doors maximize the light entering the room. The floor is laid with light gray stone pavers. A central bench under a vintage glass light is ideal for putting on and taking off shoes.

PAGE 243 View of the barn from the west. The original silo is visible in the background, with the walkway leading to the main door and the light sunroom.

PAGE 244 Outside the mudroom door, a long dining table for al fresco lunches and dinners is conveniently close to the kitchen, which is also on the middle floor. Everything nestles within the forest and surrounding greenery.

DREAMING OF A MAGNIFICENT LIBRARY

The owners of this house decided to quit New York and retire to a Mediterranean island and live there year round. They wanted a modest house in a pretty village, and a simple yet sophisticated design full of understated luxury that would fit in with the surrounding architecture. A house that would be tricky to pin down at first—a house with some mystery.

The biggest secret of this house—and its beating heart—is the library. This temple to the art of reading is located in the highest part of the upper floor. It houses a collection of eight thousand books built up over a lifetime, offering a practical but beautiful space to preserve and enjoy them, lit by a large window. The old roof beams are visible, and the blue-green bookshelves match the walls. This blast of color is confined to this intimate space; the rest of the house features neutrals and whites. A central large antique French cabinet breaks the rhythm of the shelves. This is where the oldest and most fragile items are kept.

The extensive work, completed in 2019, involved two houses and a garage. The houses, in ruins, were rebuilt in the traditional limestone of the area and connected by the garage, which was converted into a large living space with five arches and a sizeable wood-paneled area that hides the house's technical systems and can be used for storage. An English pine floor was laid upstairs, with Burgundy stone in various patterns downstairs.

The doors are another celebrated feature. In the dining room downstairs, an old door rescued from the debris of the ruined houses was restored and is now framed by two tables. The primary bedroom on the upper floor has wooden paneling and antique pine doors that lead to more than just wardrobe space—they occupy two facing walls of the room. On one side, the doors lead to the dressing room and a bathroom; on the other, they open on a closet and a secret entrance to the library, nurturing the sense of intimacy and mystery.

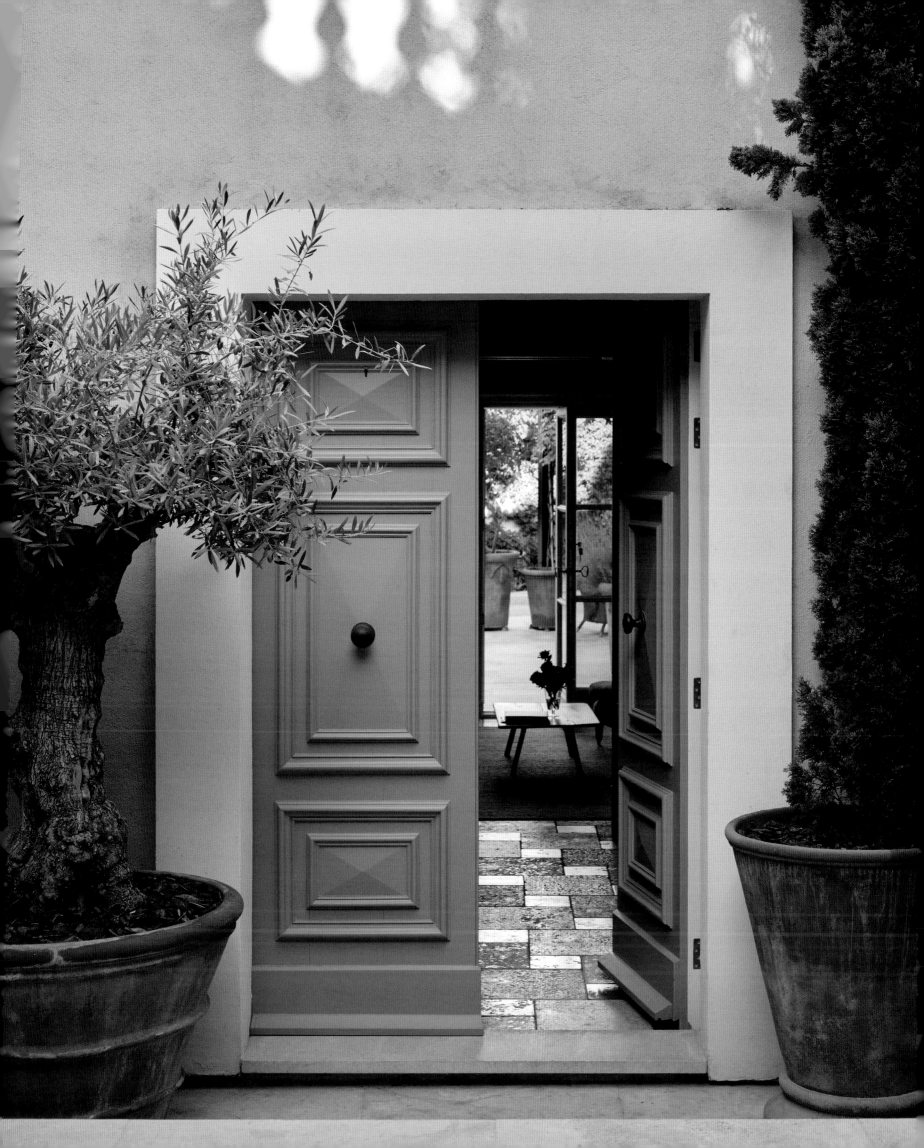

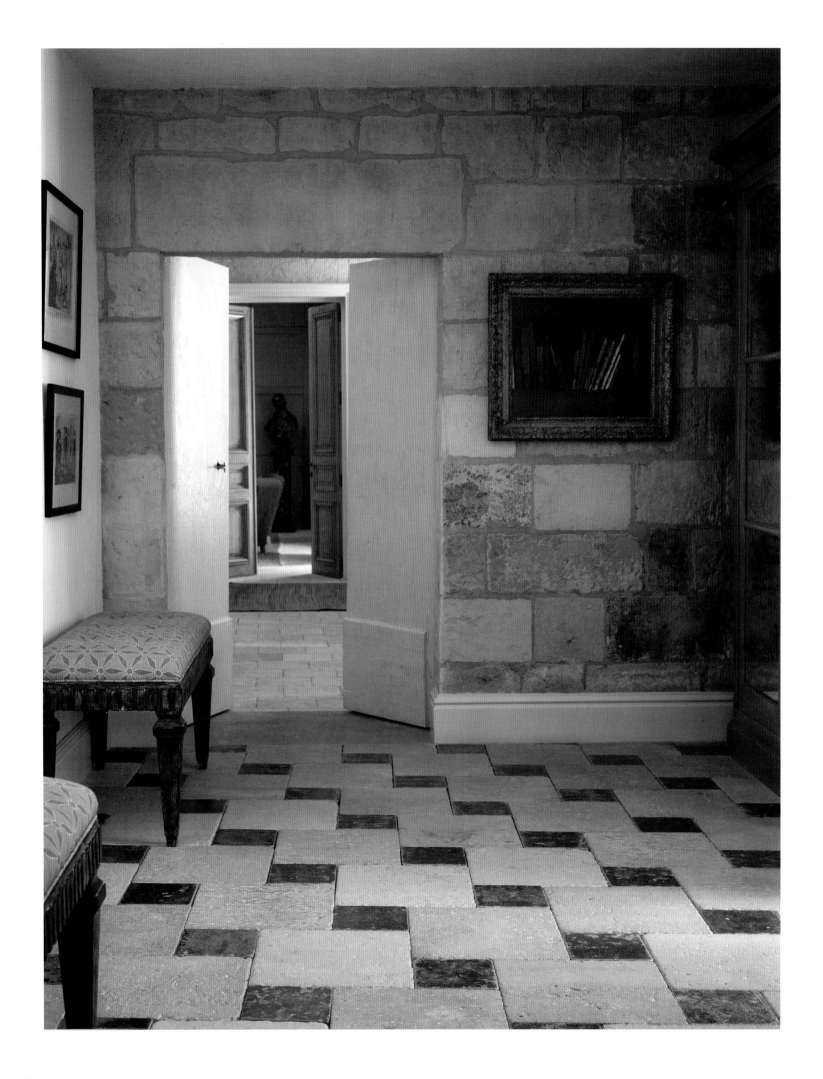

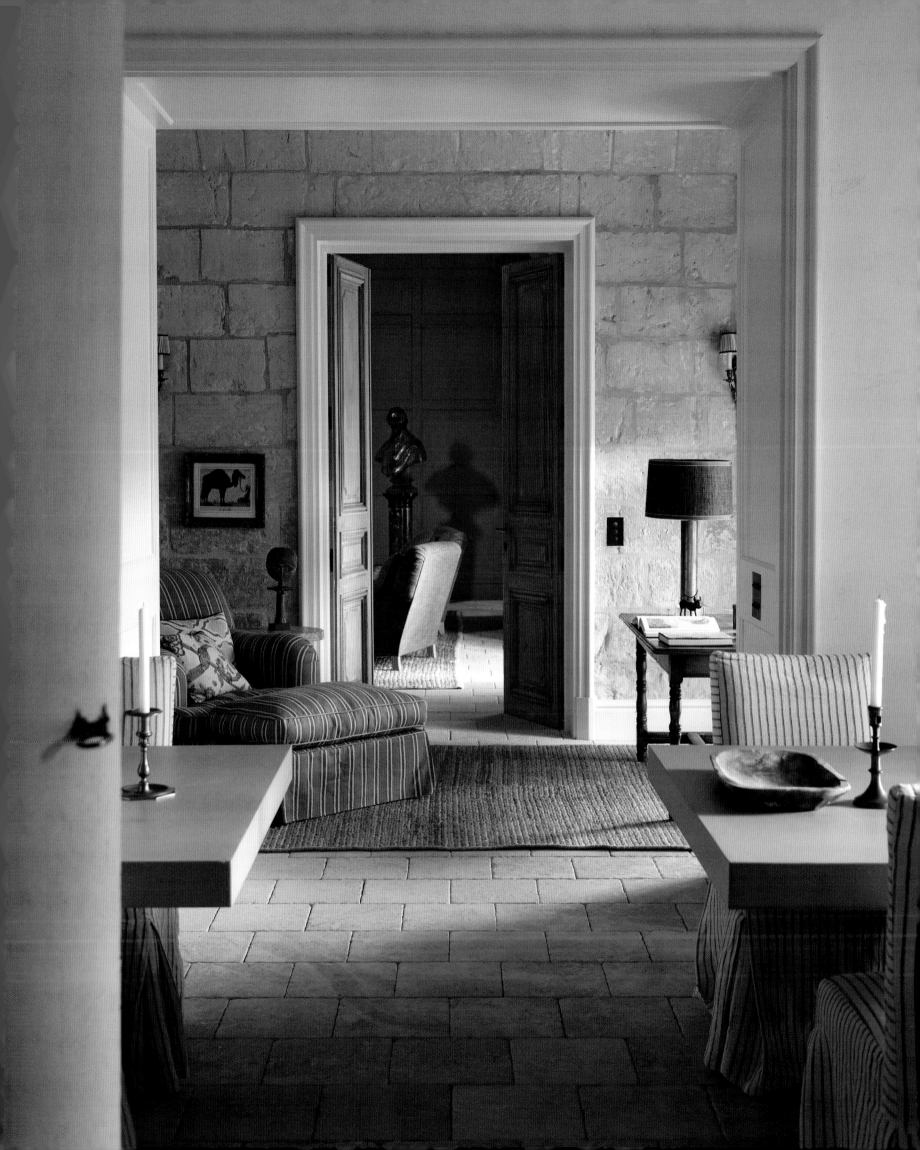

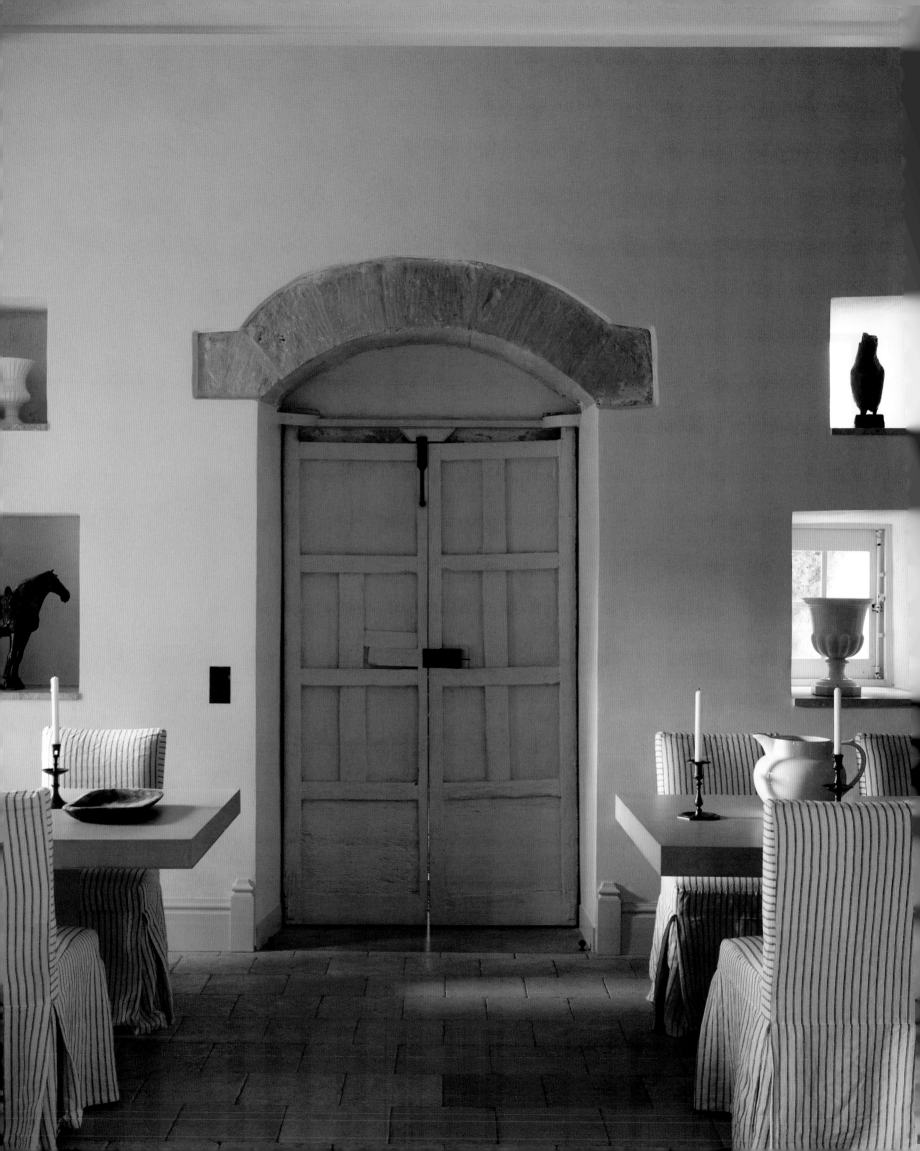

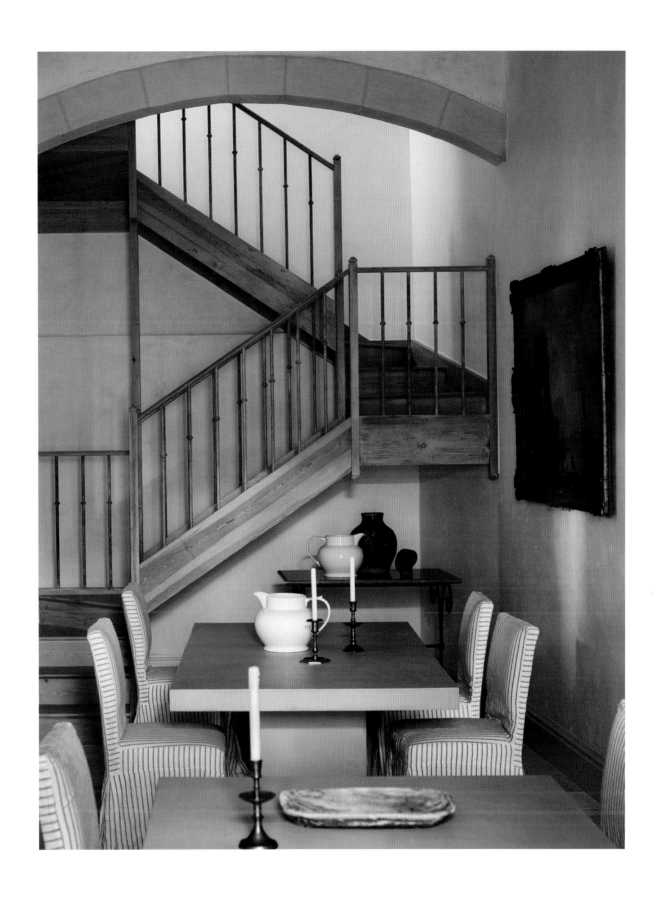

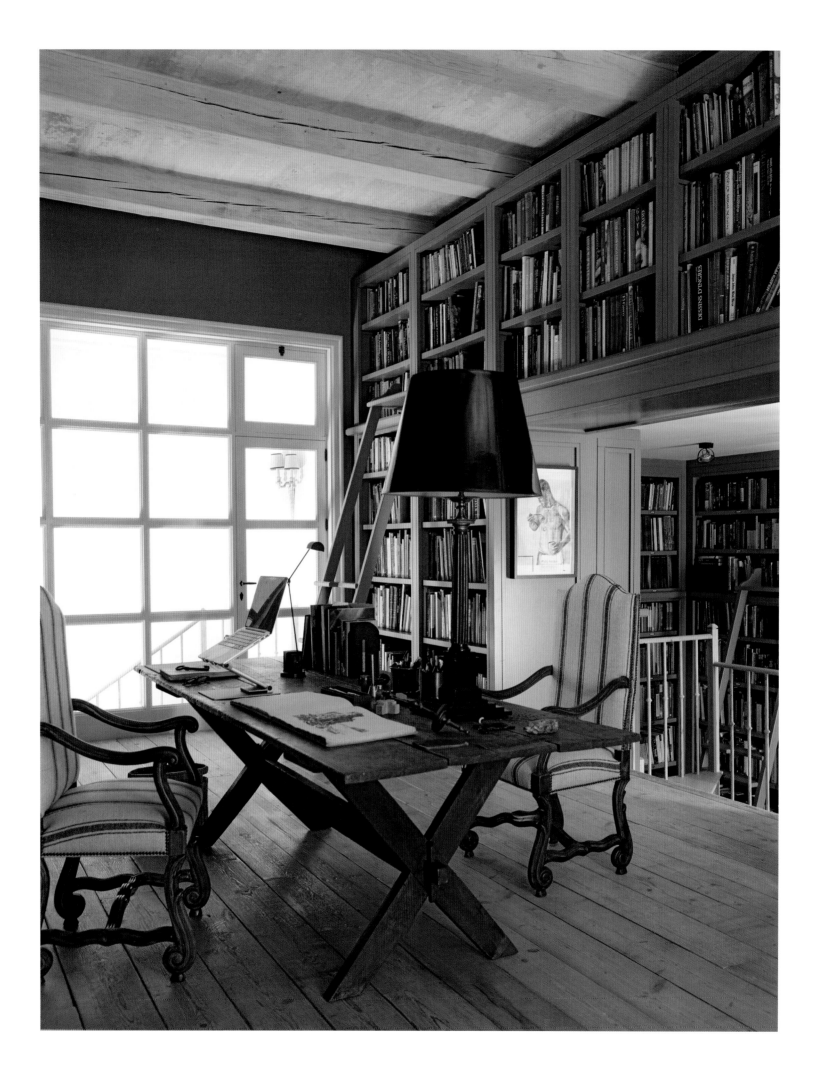

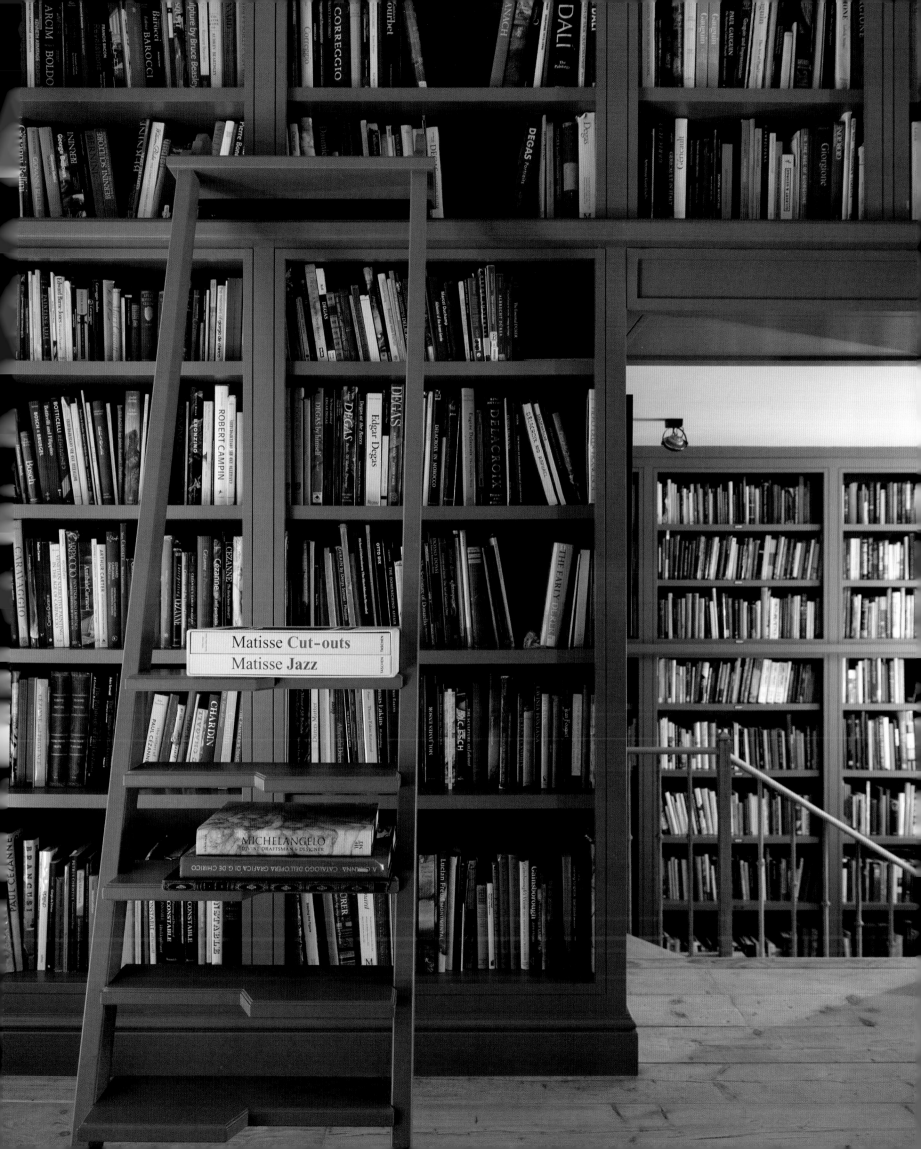

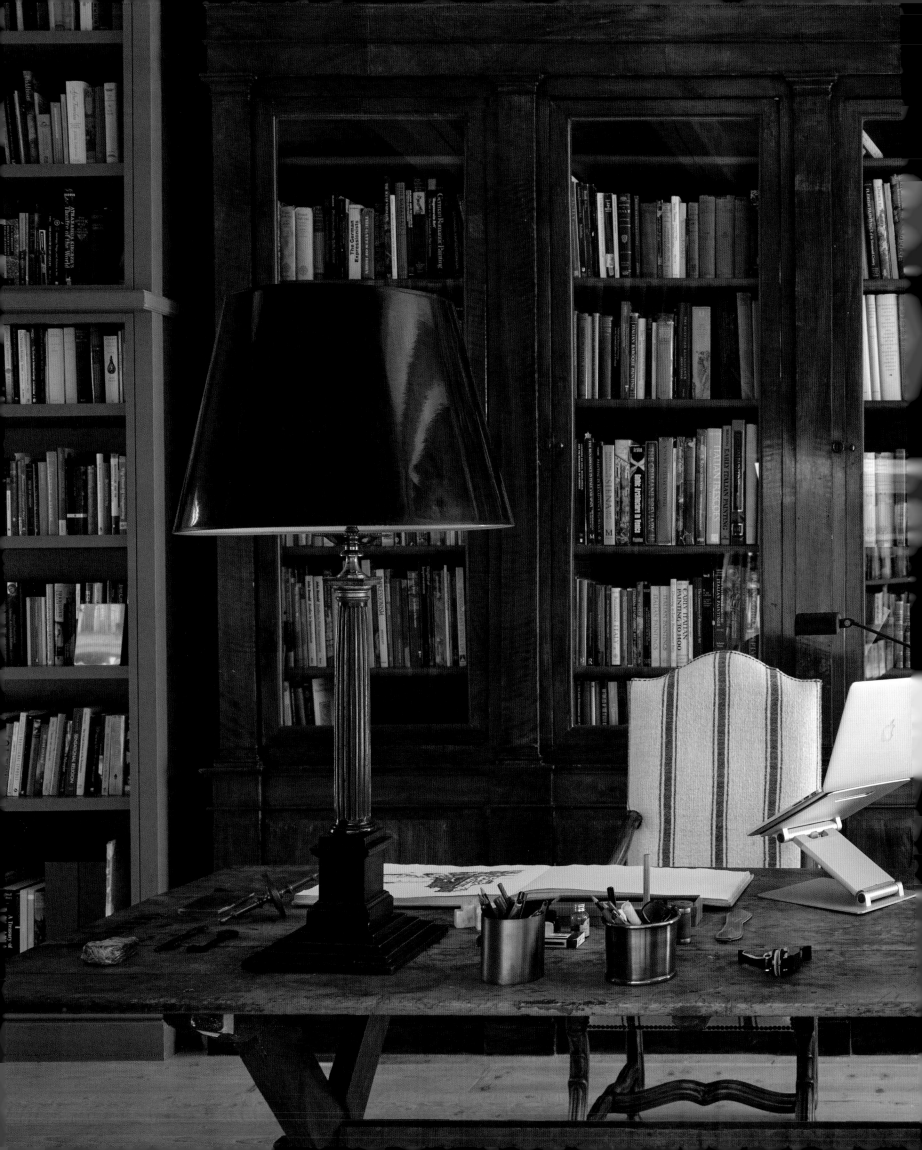

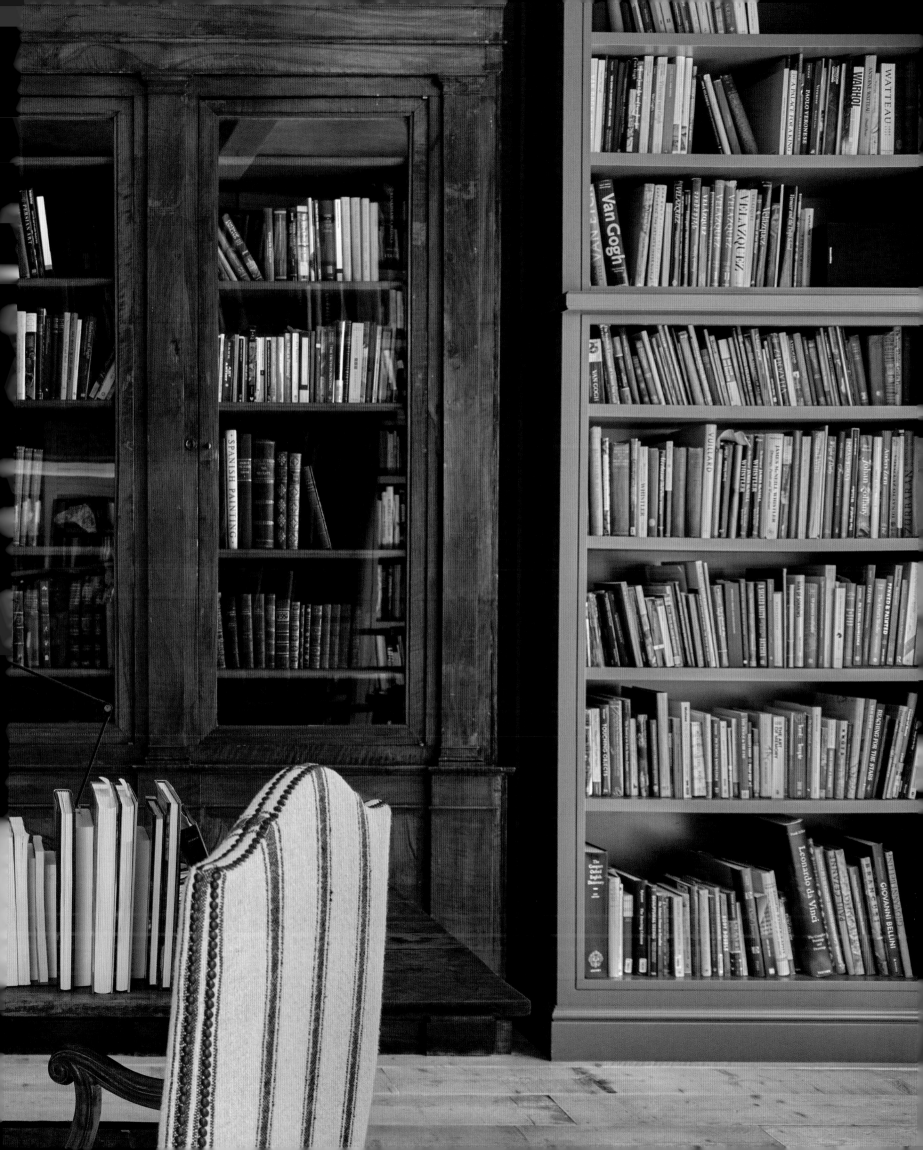

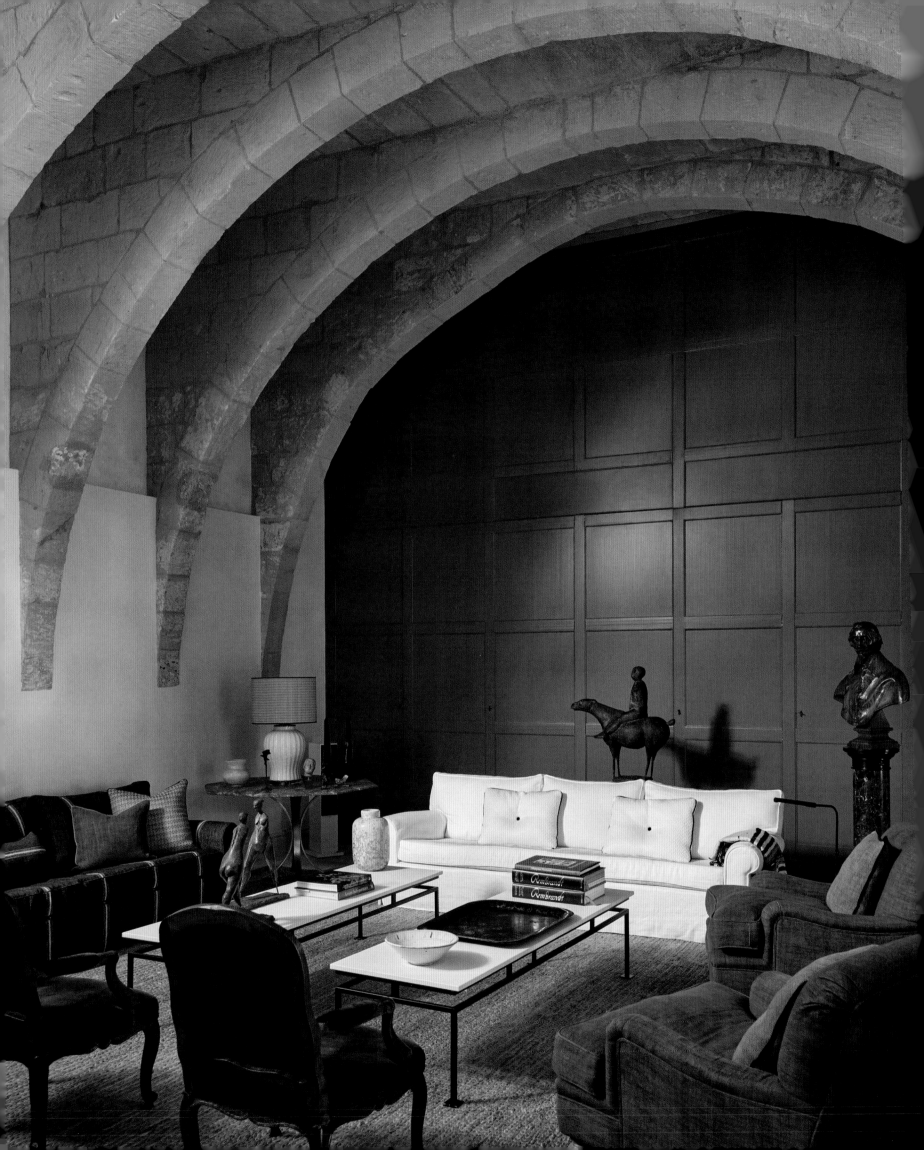

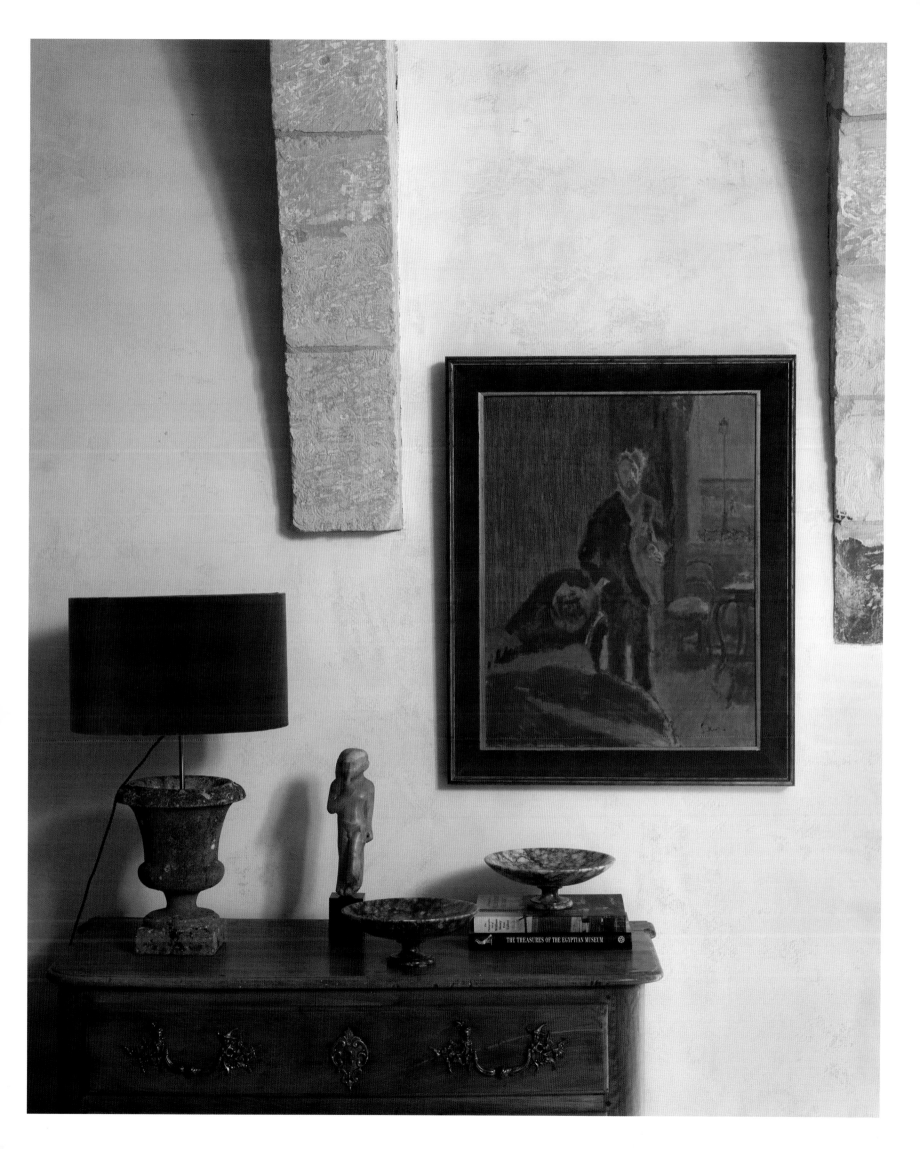

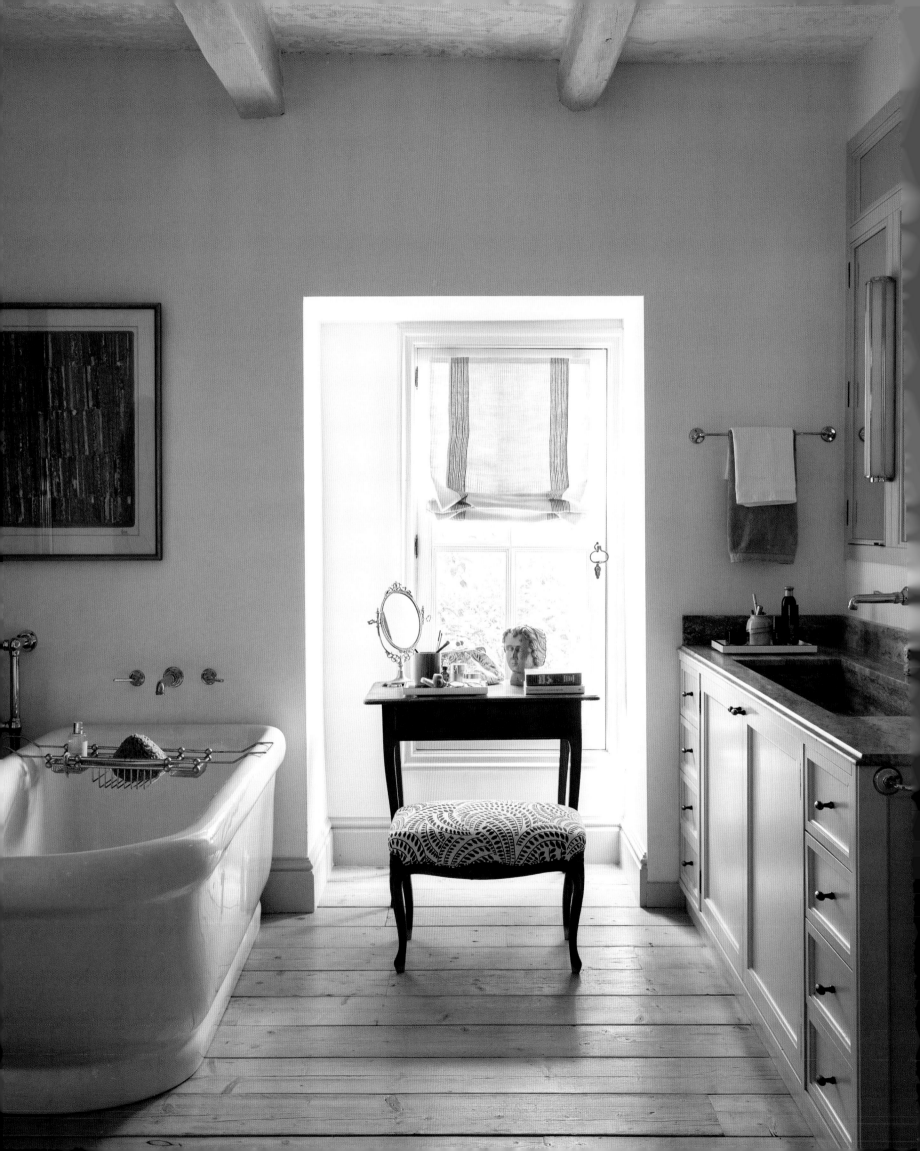

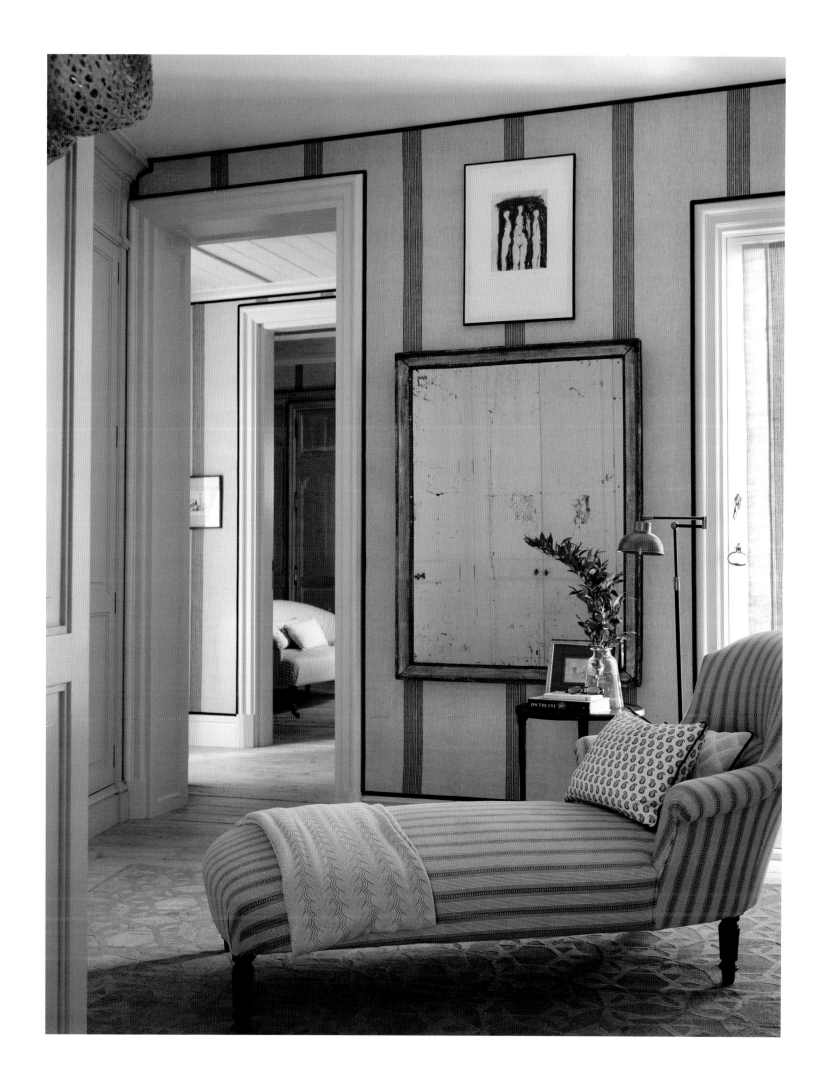

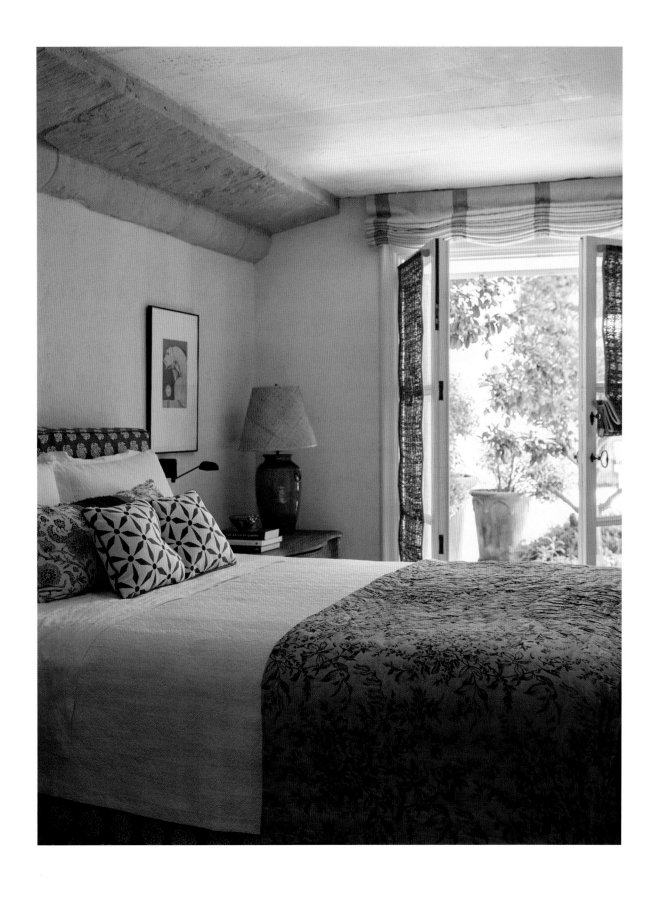

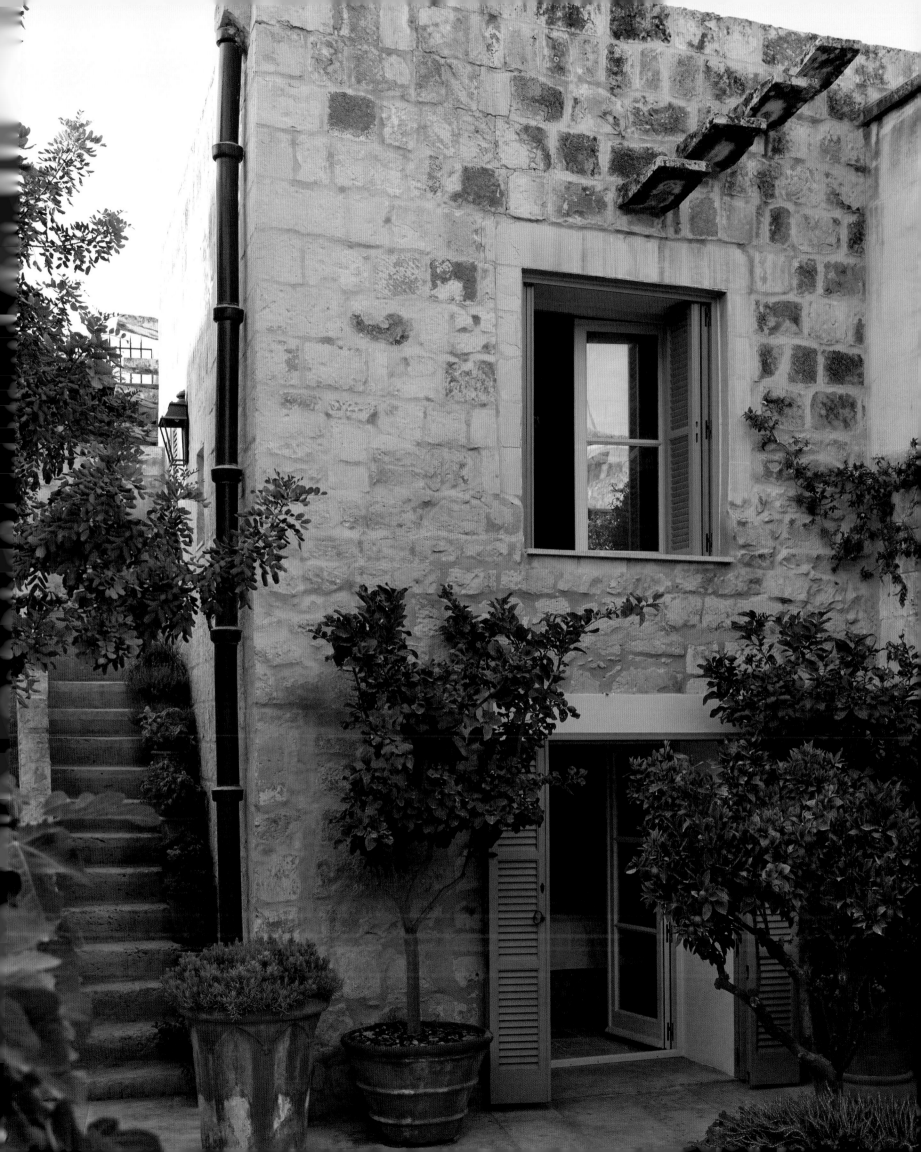

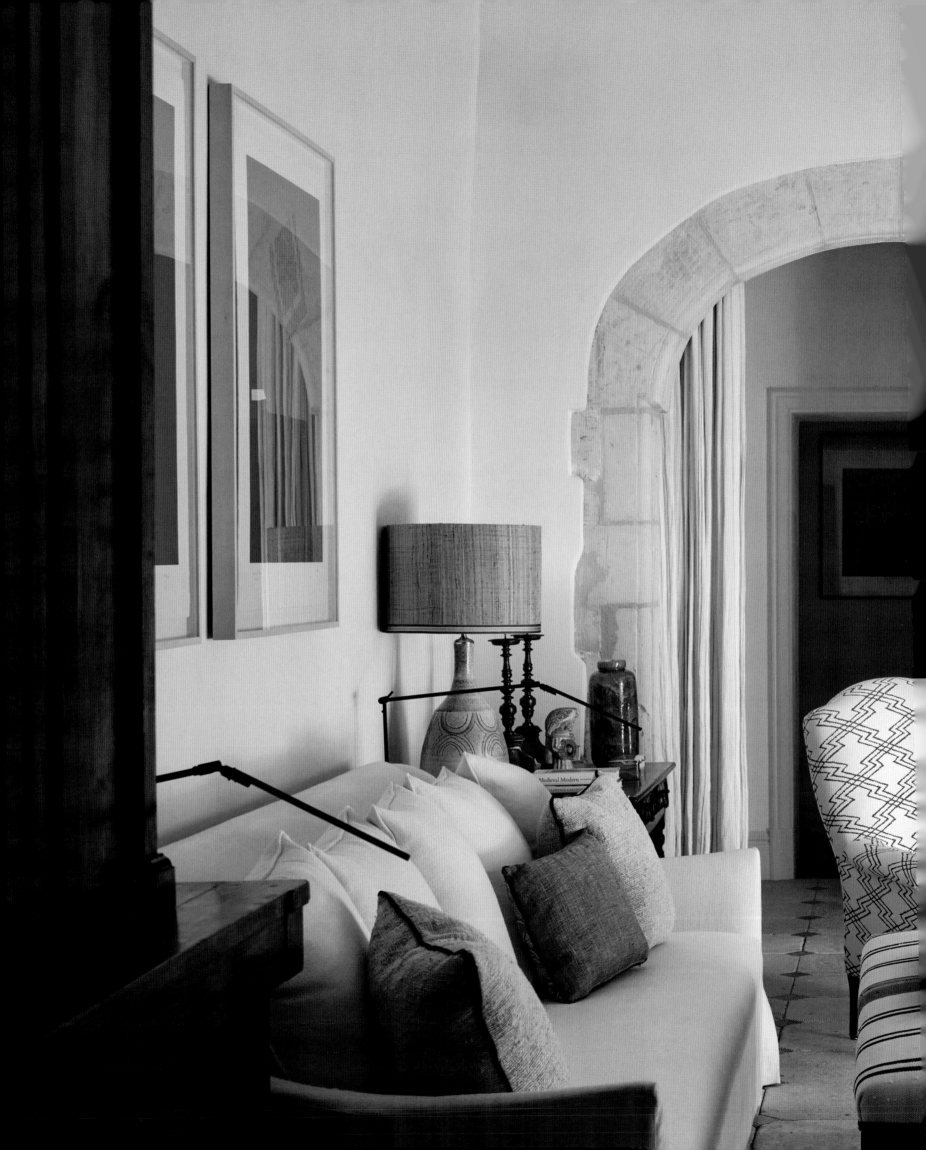

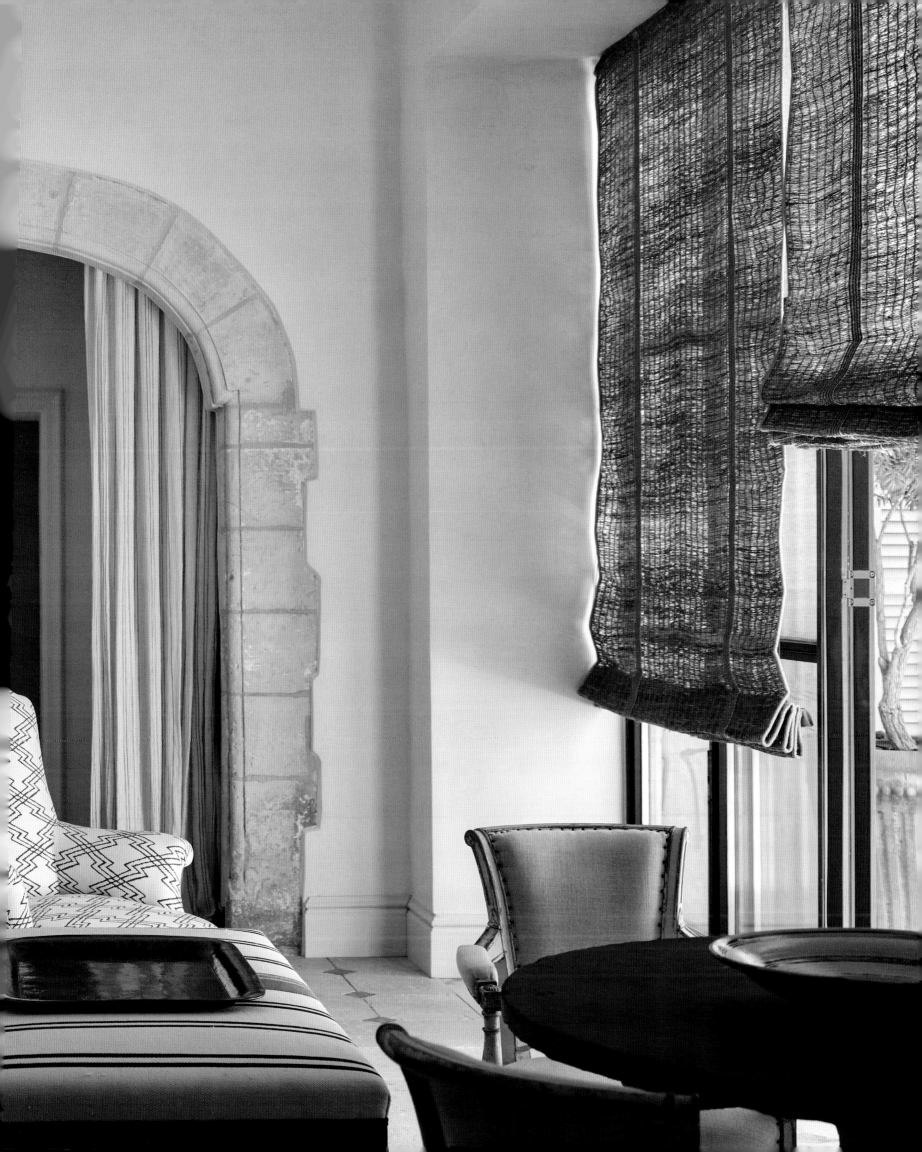

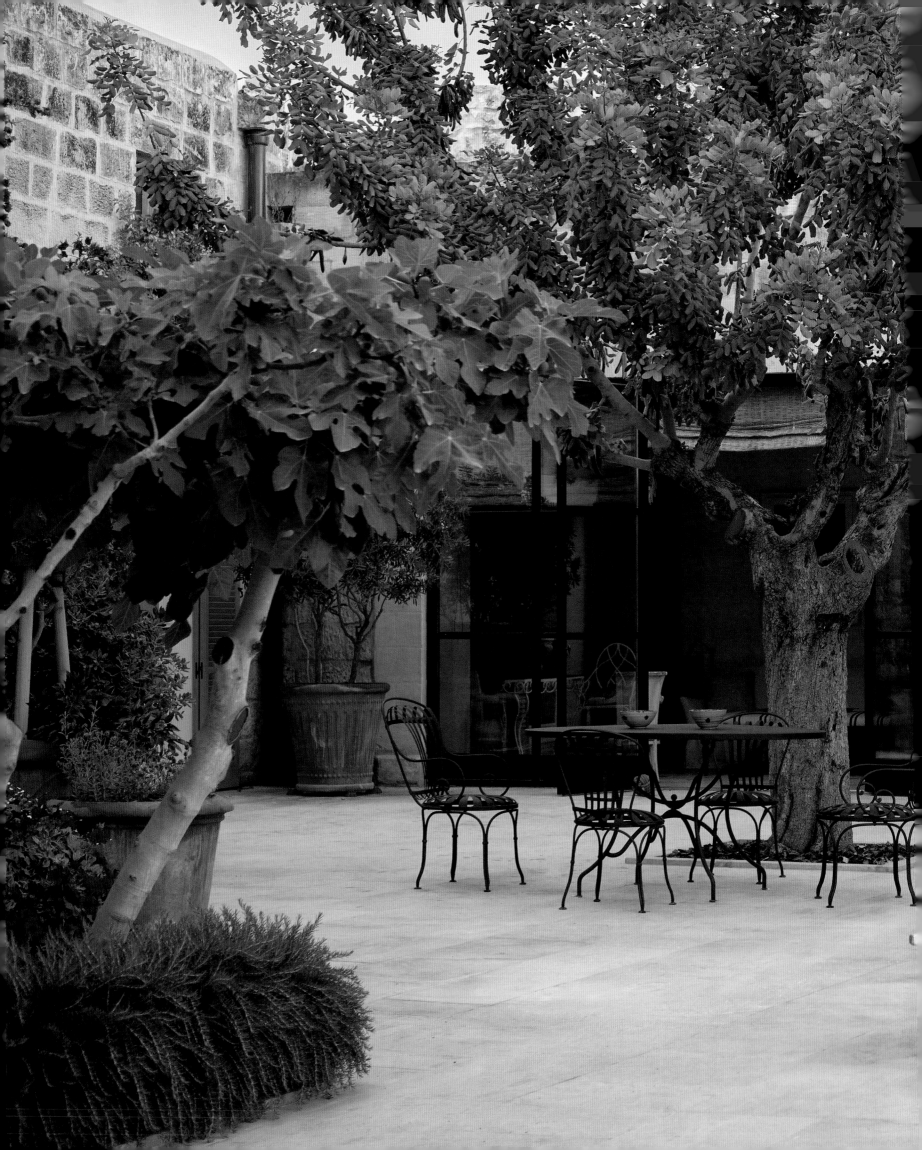

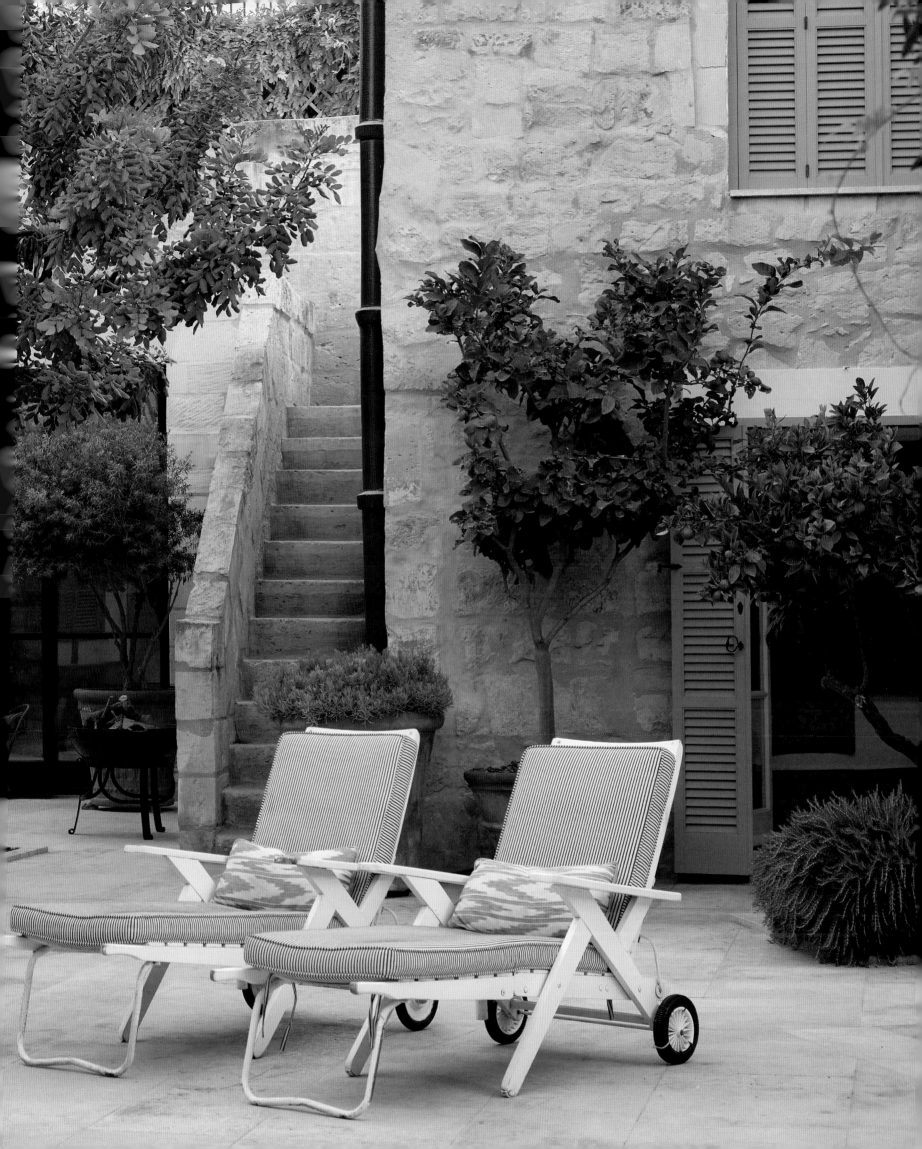

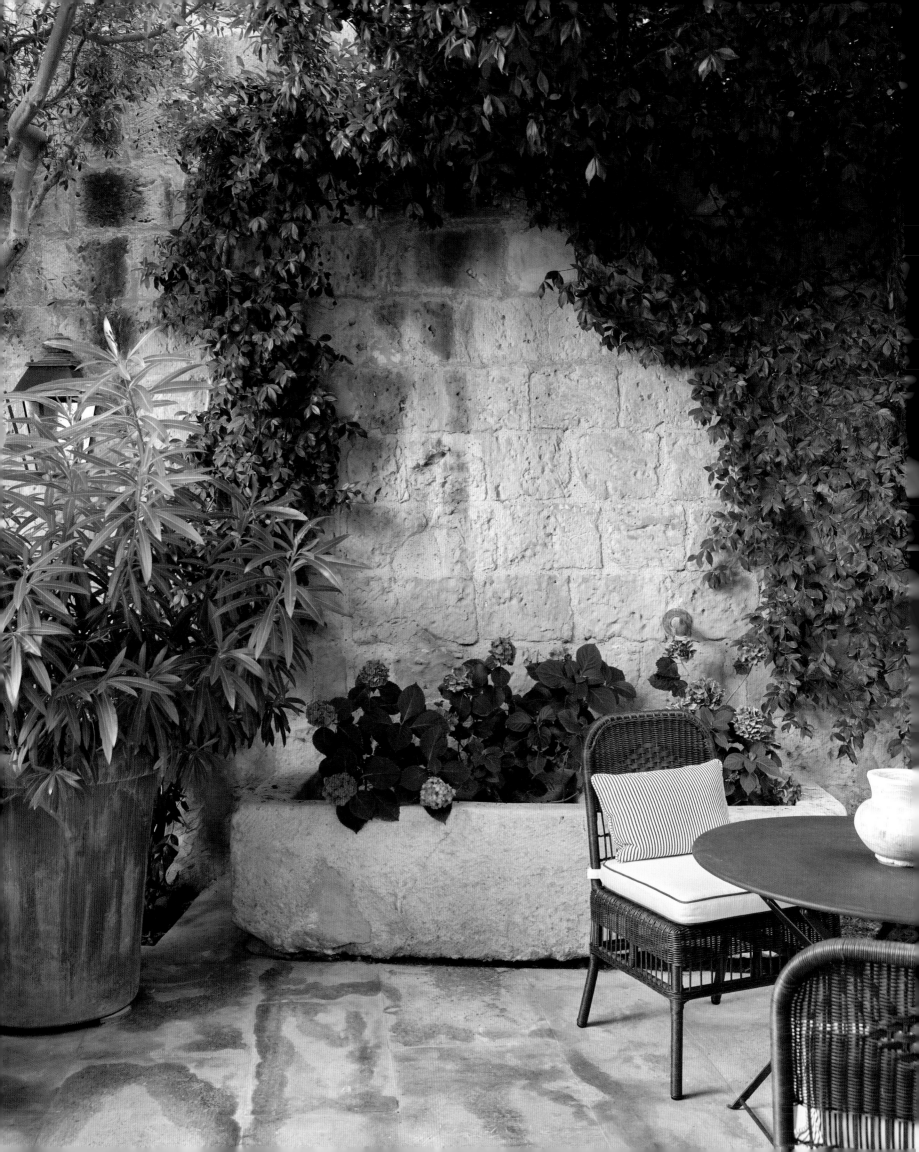

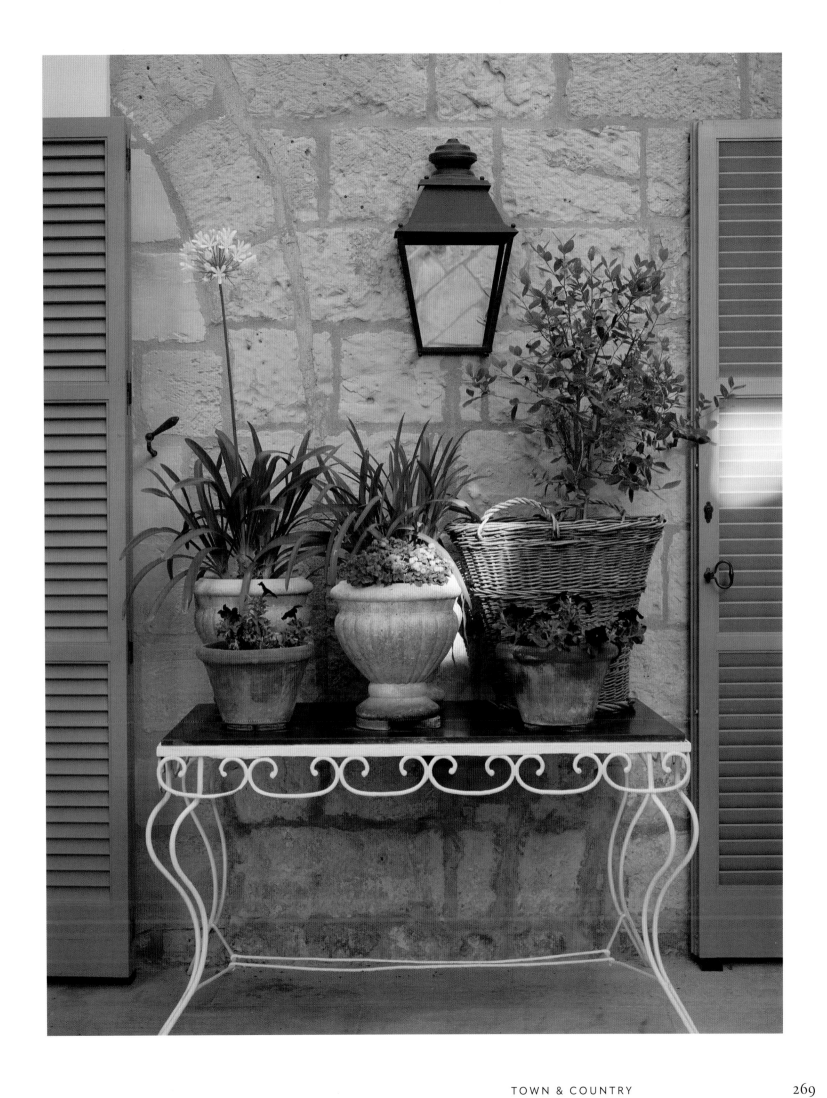

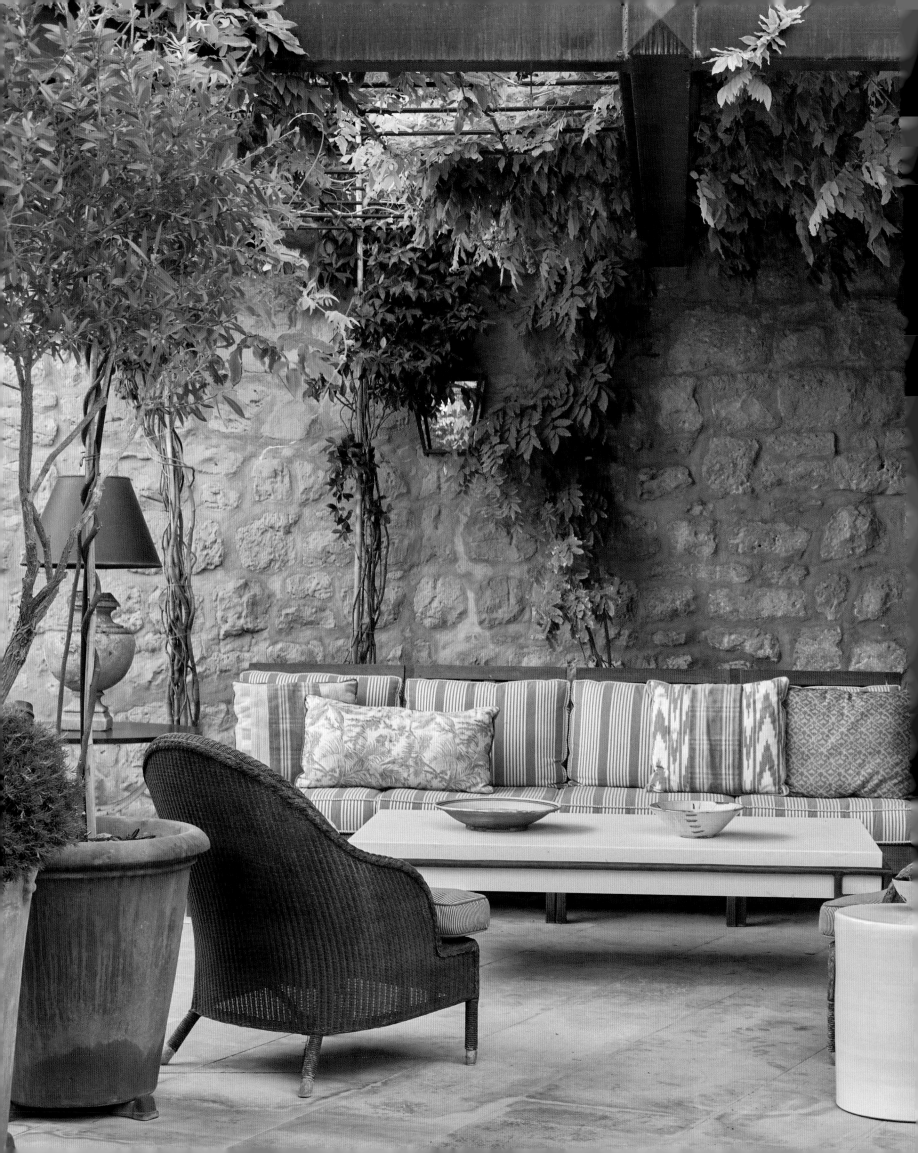

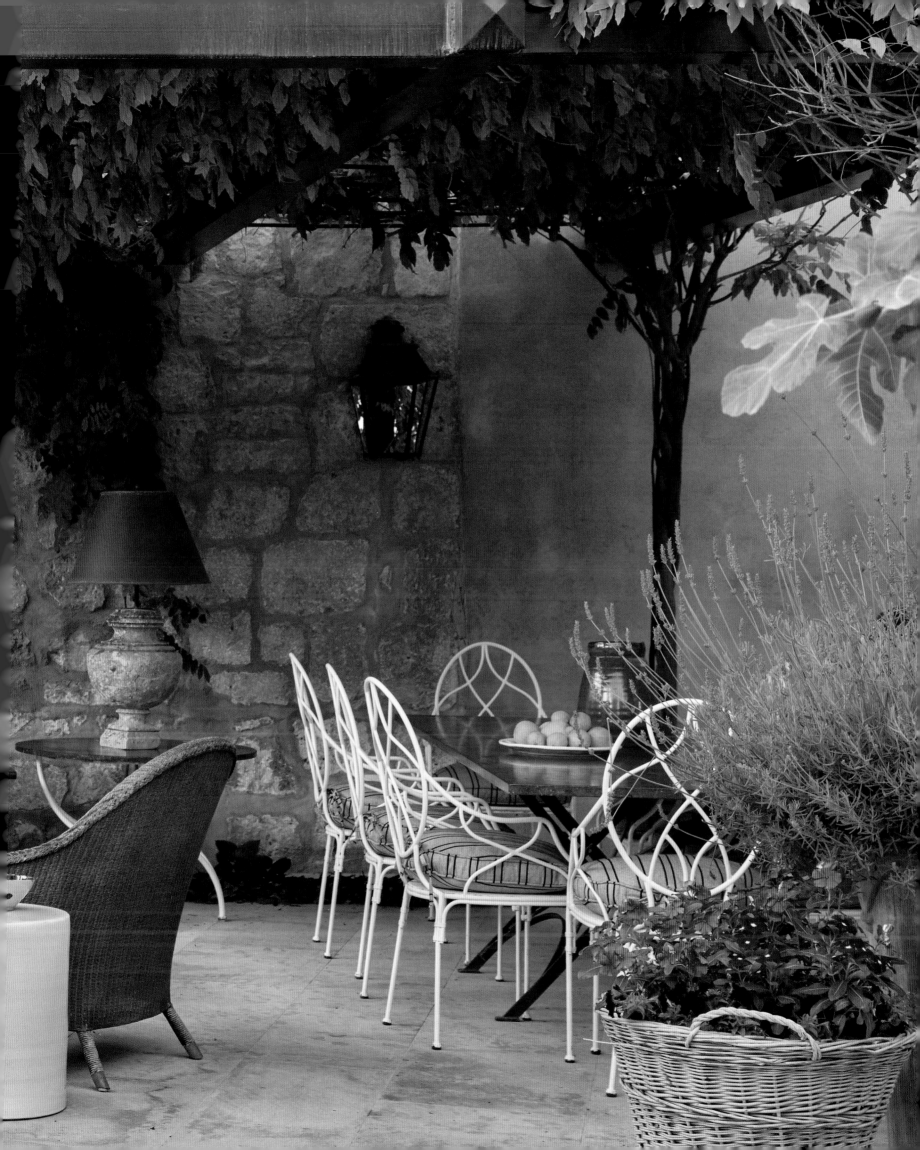

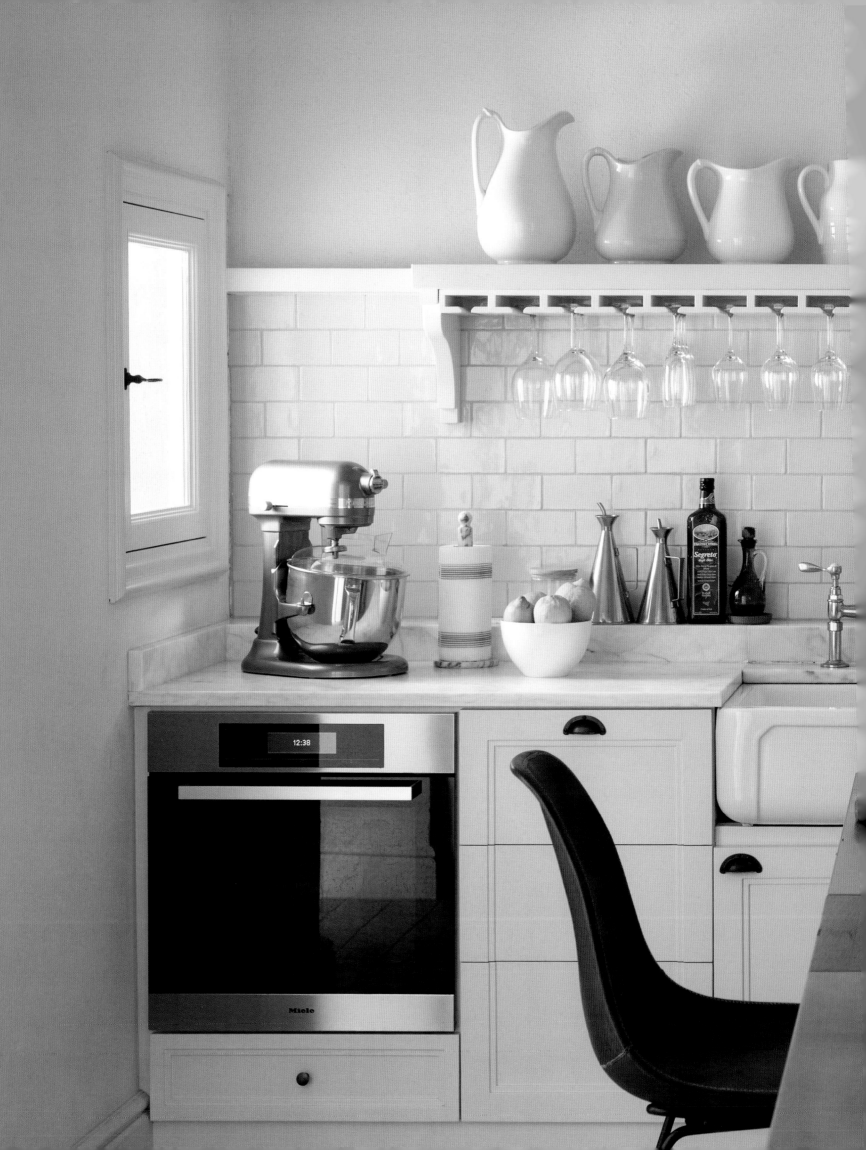

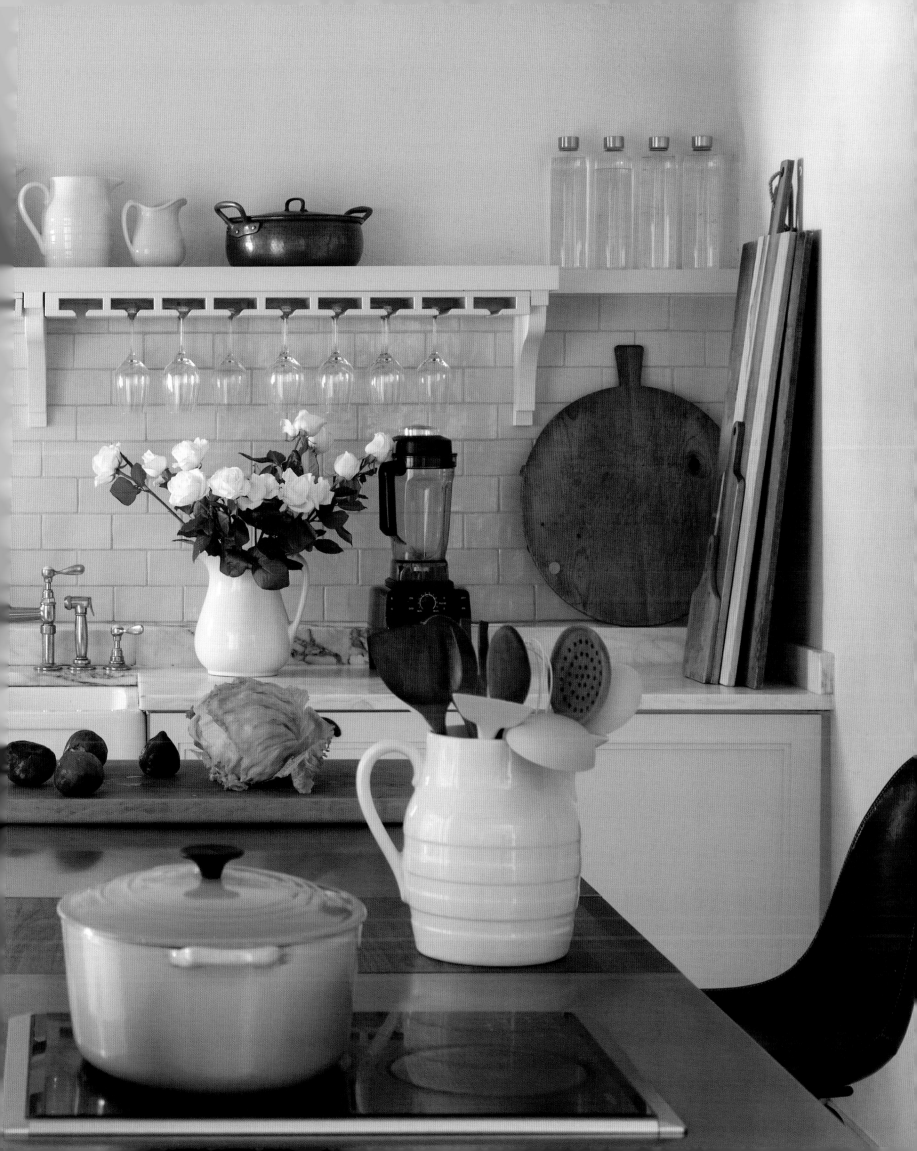

PAGE 247 A blue-painted double front door leads from the front courtyard into an entrance hall, floored in Burgundy stone with gray accents.

PAGE 248 The old stone walls in the hall were restored. The white wooden double door is from the original house; it was removed and reused in the doorway to the dining room.

PAGE 249 The dining room, in the foreground, leads onto a study with a fireplace, followed by the lounge at the back.

PAGE 250 Another view of the dining room. The original double door and stone lintel is characteristic of this island.

PAGE 251 Two separate dining tables allow passage through the center of the space. A door to the right opens to the garden, while on the left an oak staircase leads to the library.

PAGE 252 The library is a standout feature of the house, yet the space retains its privacy, with access via a staircase from the dining room and a secret door in the primary bedroom.

PAGE 253 Ranging over two floors and lit by several windows, the library houses more than eight thousand books.

PAGES 254–55 A large antique French walnut cabinet occupies a central wall space; the bookshelves were built around it.

PAGE 256 The lounge was created in a space that had previously been used as a stable and a garage. The mezzanine was demolished and the stone arches restored or remade where needed. Lime plaster was used on the walls and beige stone on the floor. The large central seating space is perfect for socializing. Fabrics are plain and simple in gray and white with lots of texture.

PAGE 257 A lamp made out of a stone urn sits on top of an antique French chest of drawers.

PAGES 258–59 In the primary bedroom, wood paneling on two walls conceal a closet on one side, and on the other a secret door to the library; the other walls are covered in beige linen striped with black. Two antique bedside tables in different styles sit at either side of the black-and-white toile de Jouy headboard. The room was given an east-facing terrace.

PAGE 260 The bathroom is floored in wood, with a dainty dressing table in the window, a spacious bath, two shower cubicles, and a toilet. The light from a south-facing window, which looks onto another courtyard, makes this a bright, cheery space.

PAGE 261 The dressing room is lined with the same wall covering as the bedroom, with a large gilded dressing mirror. One door leads to the terrace and the other to the bathroom.

PAGE 262 The guest bedroom, in enchanting red and blue decor, opens to the garden and pool. The restored stone cornice is a unique feature of this architectural style.

PAGE 263 The guest room is reached from the sunroom and the courtyard. A painting studio on the floor above enjoys its own entrance. The Italian-style garden is planted with citrus trees.

PAGES 264–65 The lounge leads into the sunroom—a living area with giant glazed iron doors that can be opened wide to merge with the courtyard. The fabrics used here are natural and light, with raffia blinds to soften the light. The stone arch was restored and closed slightly. Beyond, a small kitchen was created for preparing breakfast and snacks.

PAGES 266–67 A view of the sunroom and guest room from the courtyard. A carob tree and a fig tree provide some shade.

PAGE 268 A stone trough in a corner of the entrance courtyard is planted with flowers.

PAGE 269 Pots and baskets decorate a 1960s ironwork table between the doors of the lounge and the study.

PAGES 270–71 An iron pergola was installed between the swimming pool and the house to provide shade for the outdoor living and eating area closest to the kitchen. A teak sofa and woven rattan chairs are dressed in blue and green French and English fabrics and flanked by stone lamps.

PAGES 272–73 The kitchen, bathed in light from the courtyards, has painted units and a porcelain Belfast sink. A steel workbench occupies the central space.

PAGE 274 The project plans, showing a cross-section of the house, hang on the kitchen wall.

THE OAK-FILLED *DEHESA*

With its unique flora and fauna, the Extremaduran *dehesa* is one of the most beautiful and well-conserved ecosystems in Europe. The crops and seasonal movement of livestock—mostly cattle and pigs—are integral to an imposing landscape made up of different species of oak and cork trees. The colors and richness of the land make for an extraordinary natural environment.

This house, a new build completed in 2013, was a collaboration between architect Pablo Carvajal, landscape architect Luis González Camino, and Isabel López-Quesada. It's a rural holiday home, created for enjoying large family gatherings with lots of children, nieces, nephews, and friends.

The intention was to create a typically Spanish house, with a tree-filled entrance courtyard around a fountain, and a central double-height structure with two additional buildings, one on the left and one on the right, each with its own hallway. The walls of the hallways are covered in a wide-striped fabric, and ox-eye windows on each side visually connect both entrances. One of these leads to the mudroom, essential in any country home, for which López-Quesada sourced carved wooden paneling and eighteenth-century French doors. This hallway leads to a guest bathroom, the office, and the kitchen. The other hallway leads to the guest quarters and is decorated with a selection of plants and Swedish furniture.

The ground floor features striking antique French stone flooring, inset with large squares of herringbone, complemented by two imposing stone fireplaces. Beautiful wooden floors feature in the rest of the house, with matting to protect them and soften footsteps. In the main family areas—the lounge, study, living room, and library—the decor is a mix of fine antique furniture and pictures in the main areas. Simple, rustic elements are scattered throughout, including willow baskets, antique marble basins, and large pine tables in the kitchen and office, with contemporary details like the oxidized industrial lamps in the office and kitchen. The entire house is delicately balanced between traditional and modern.

The owner is a lover of trees and books, and the library—lined with wooden planks—has a secret door connecting it with the living room. The house opens to the spectacular *dehesa* landscape and its pathways through two south-facing porches and a terrace that catches the shade of the albizias.

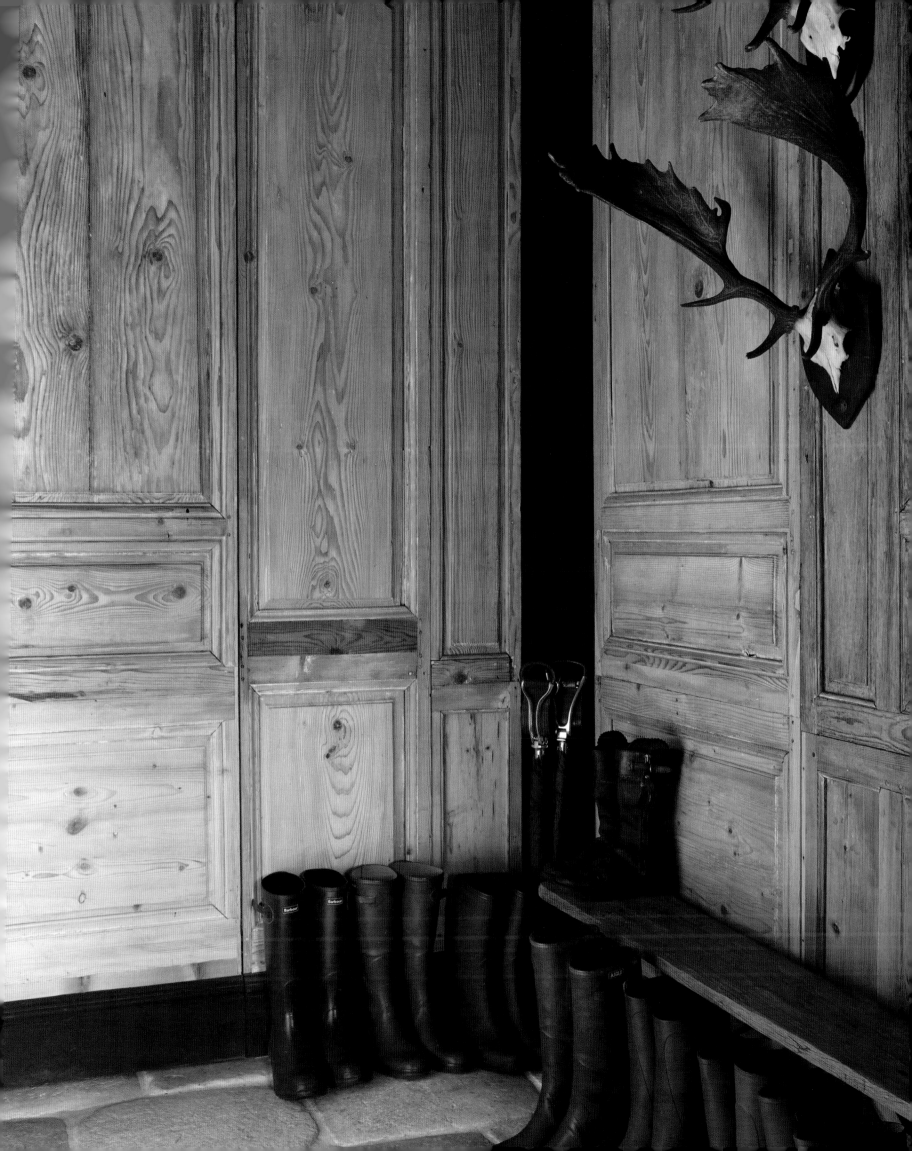

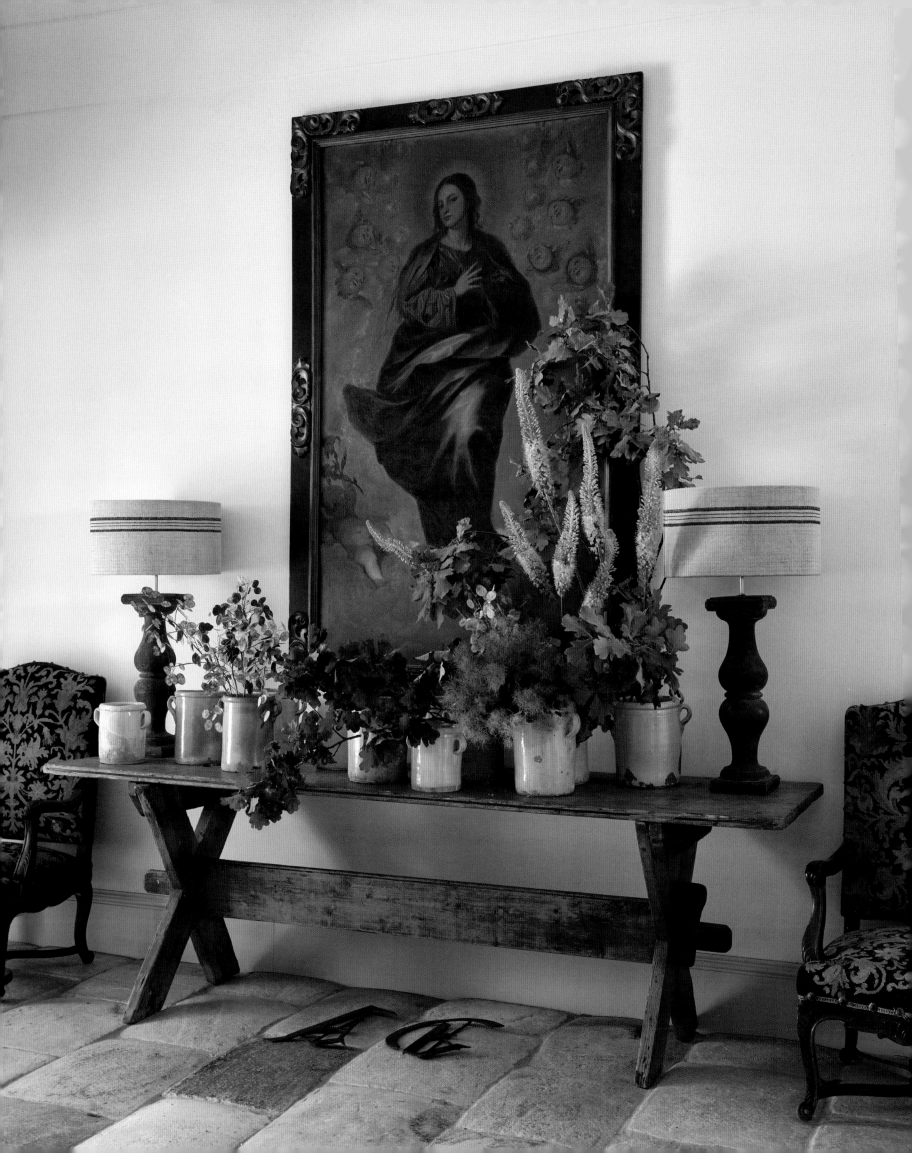

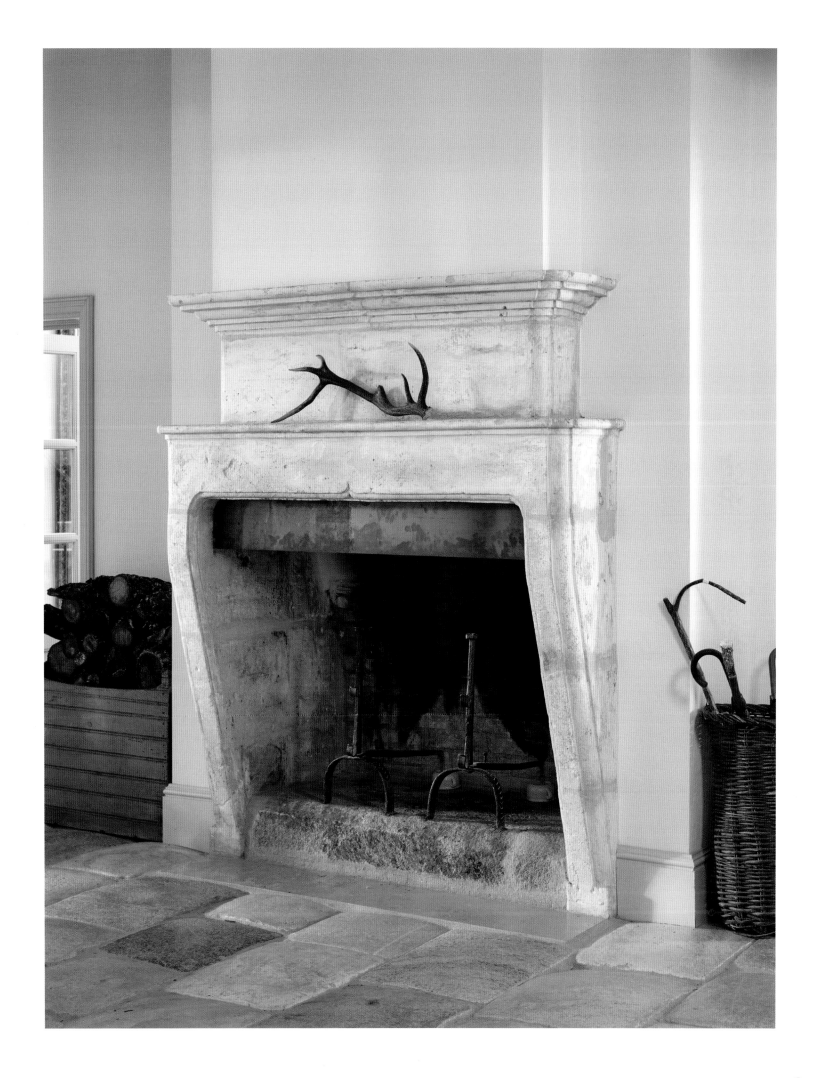

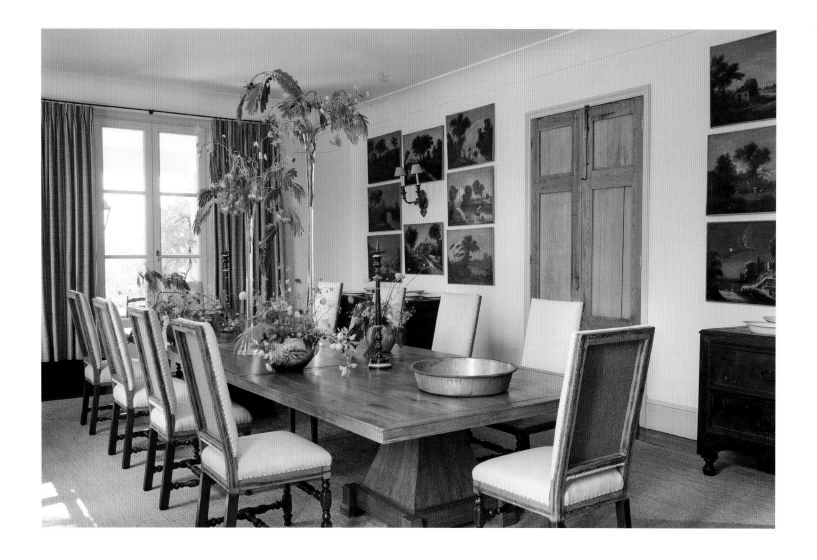

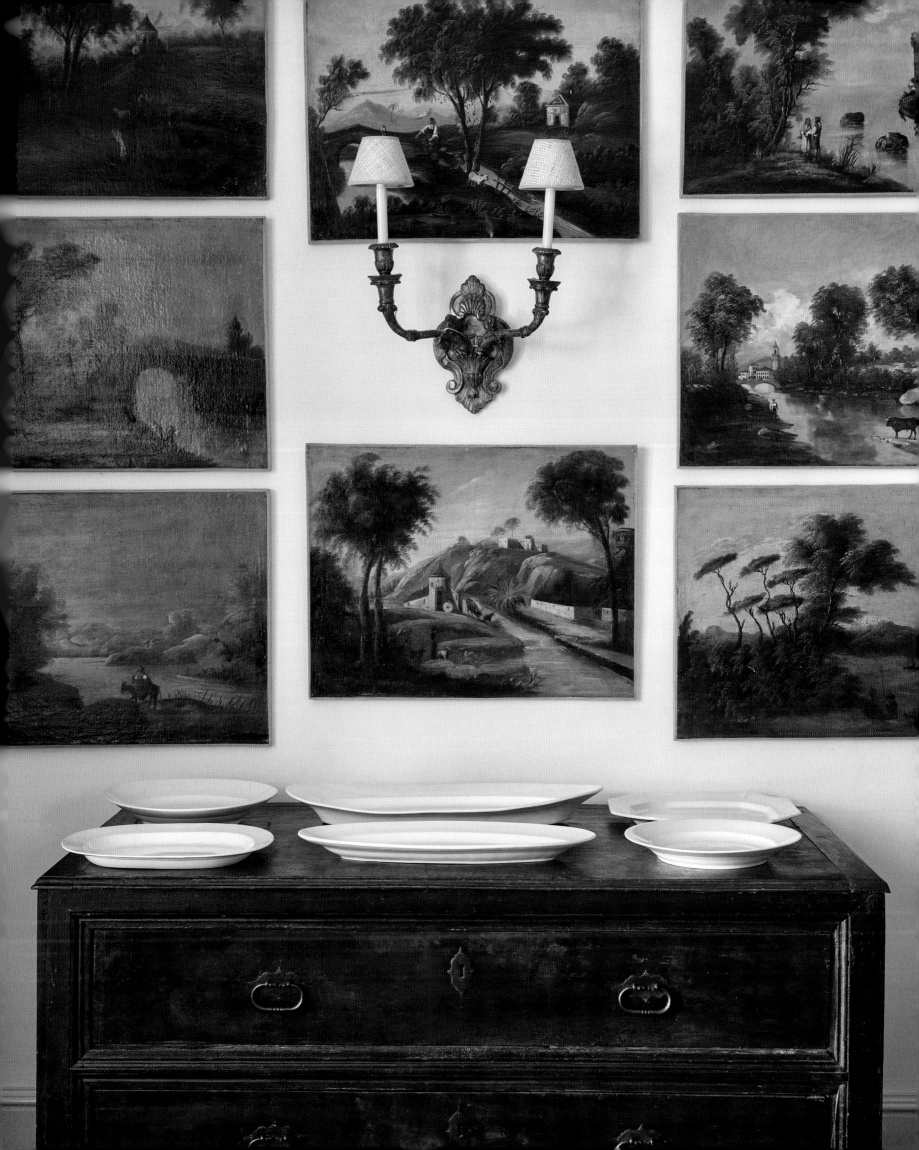

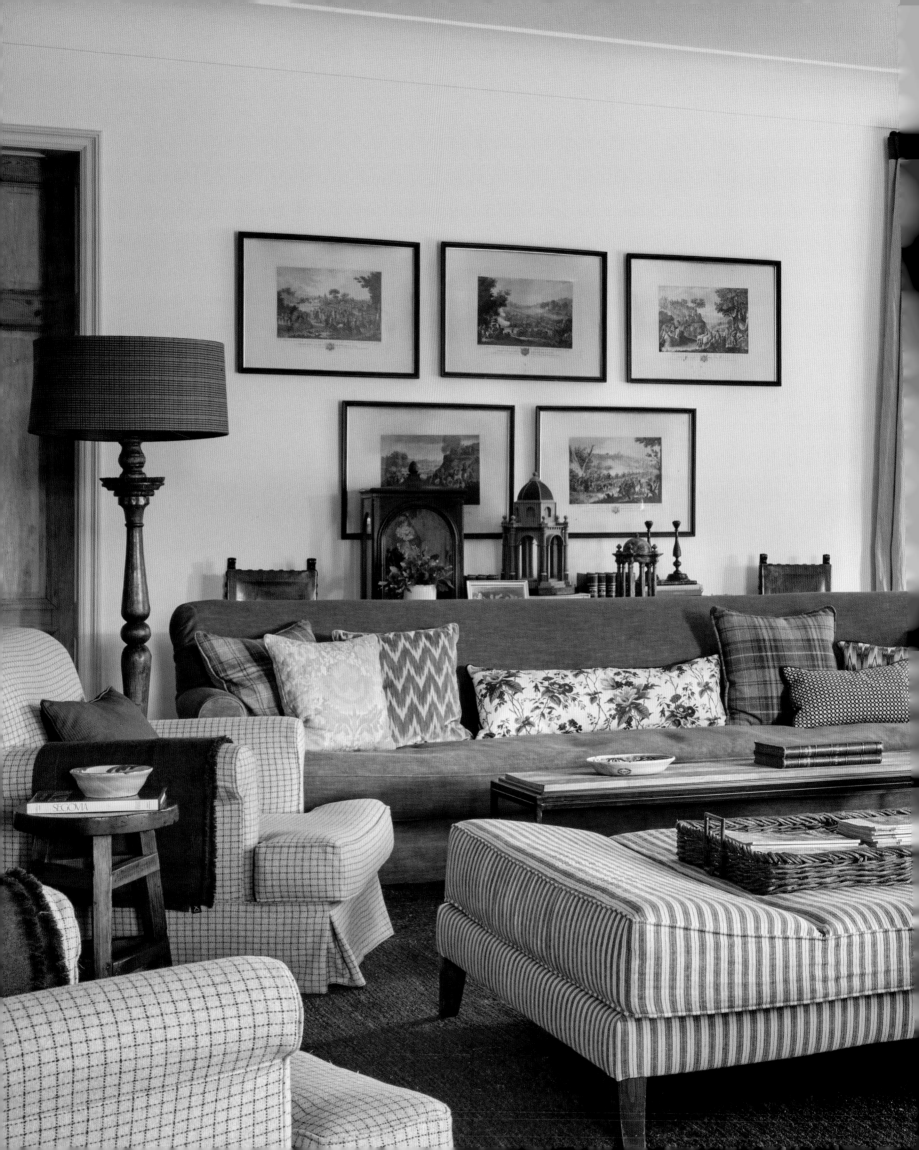

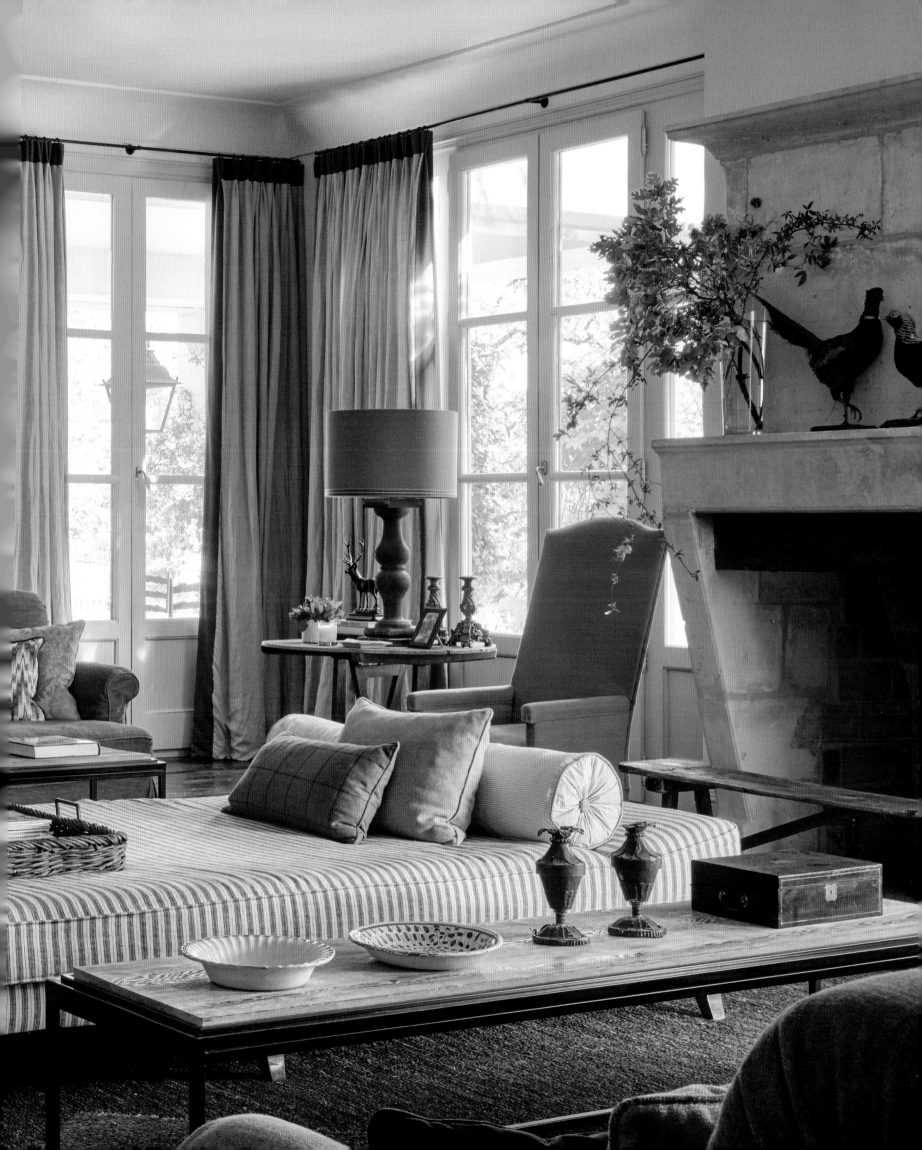

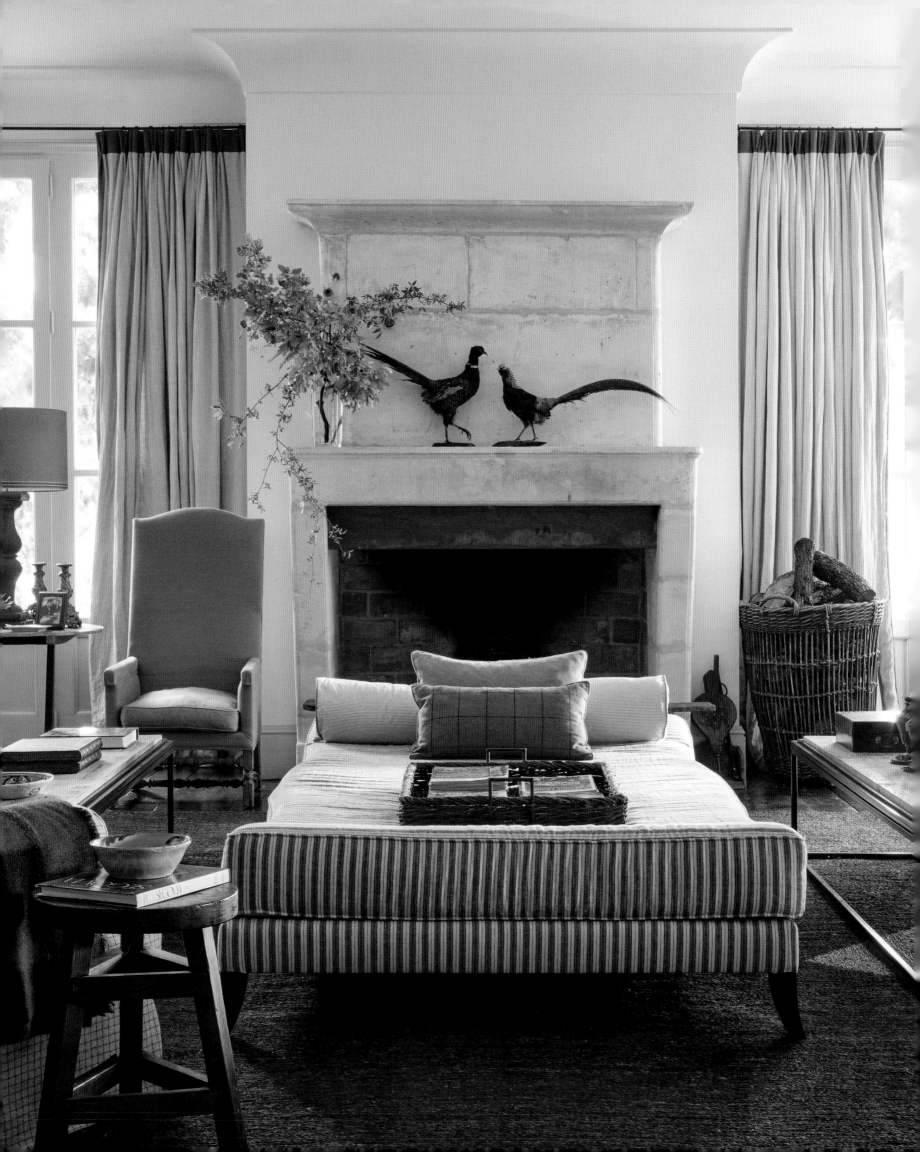

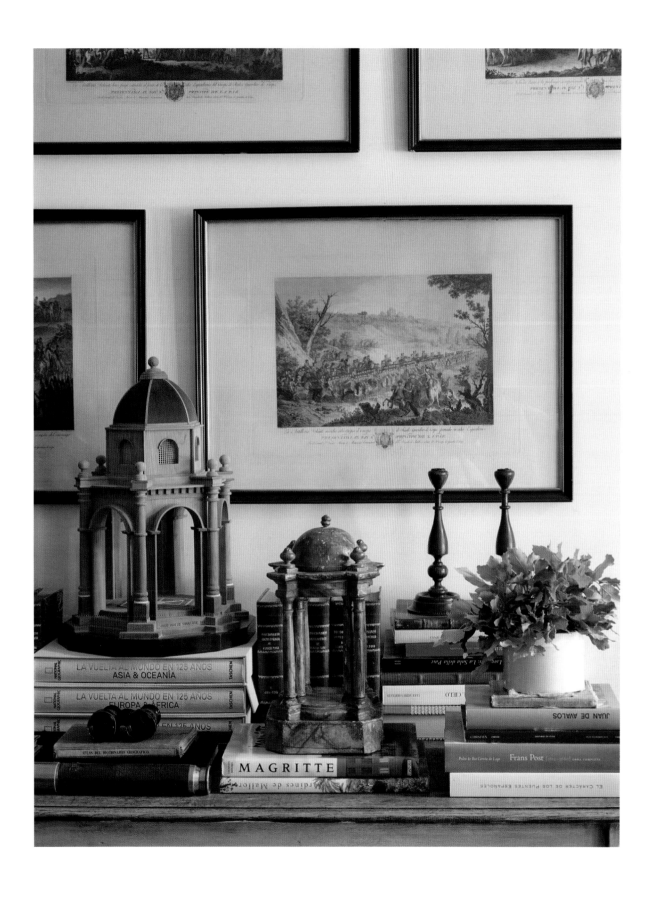

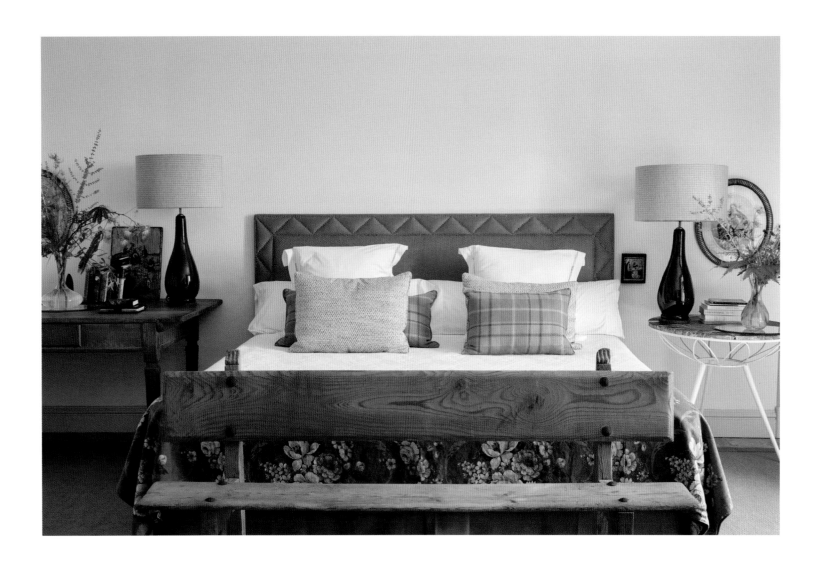

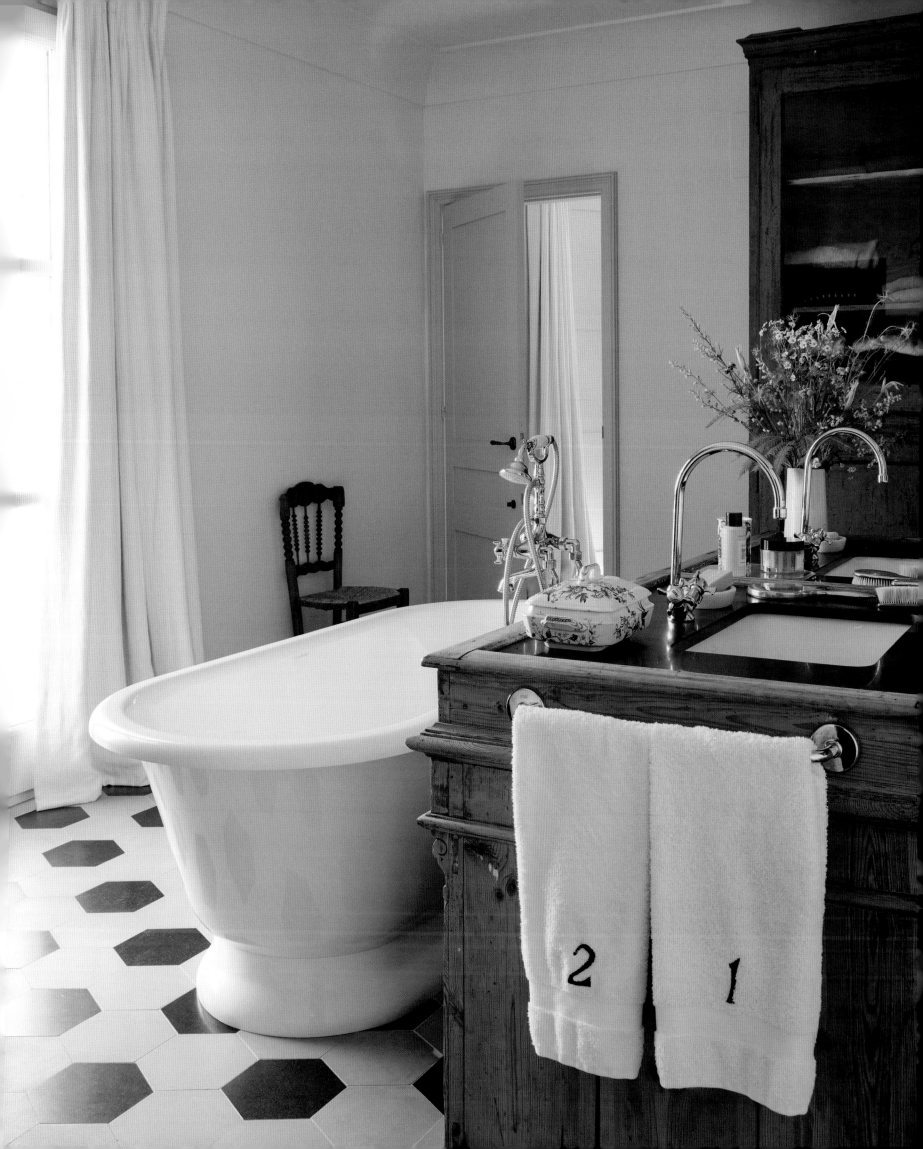

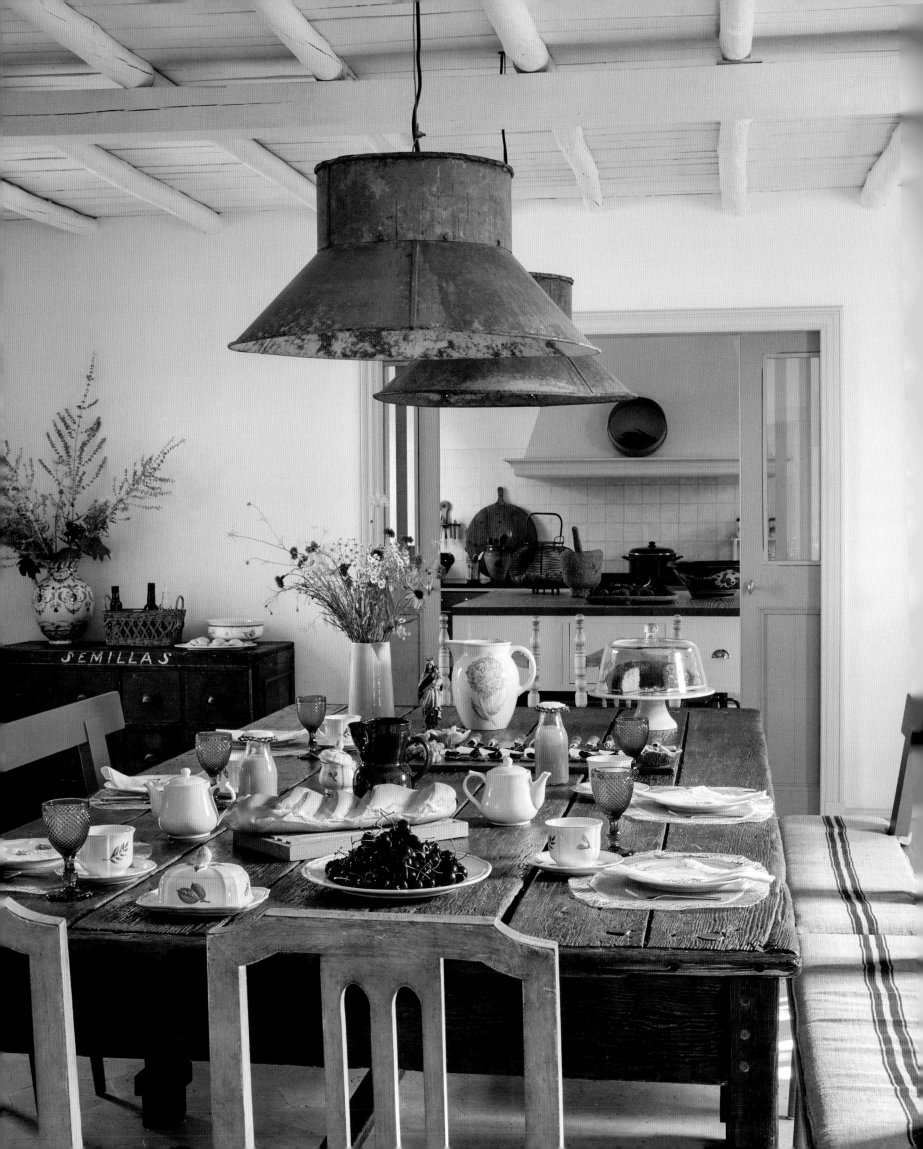

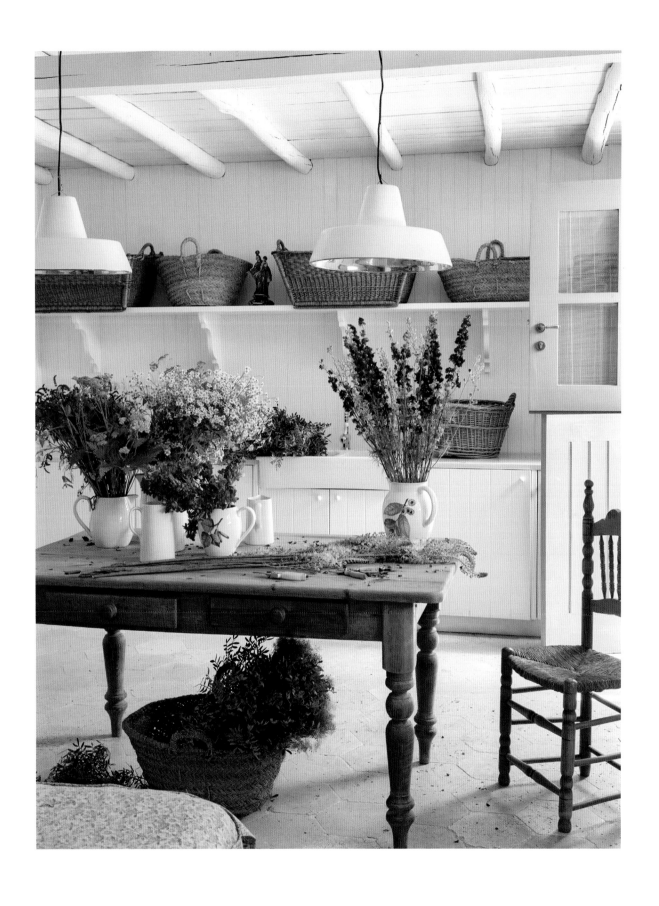

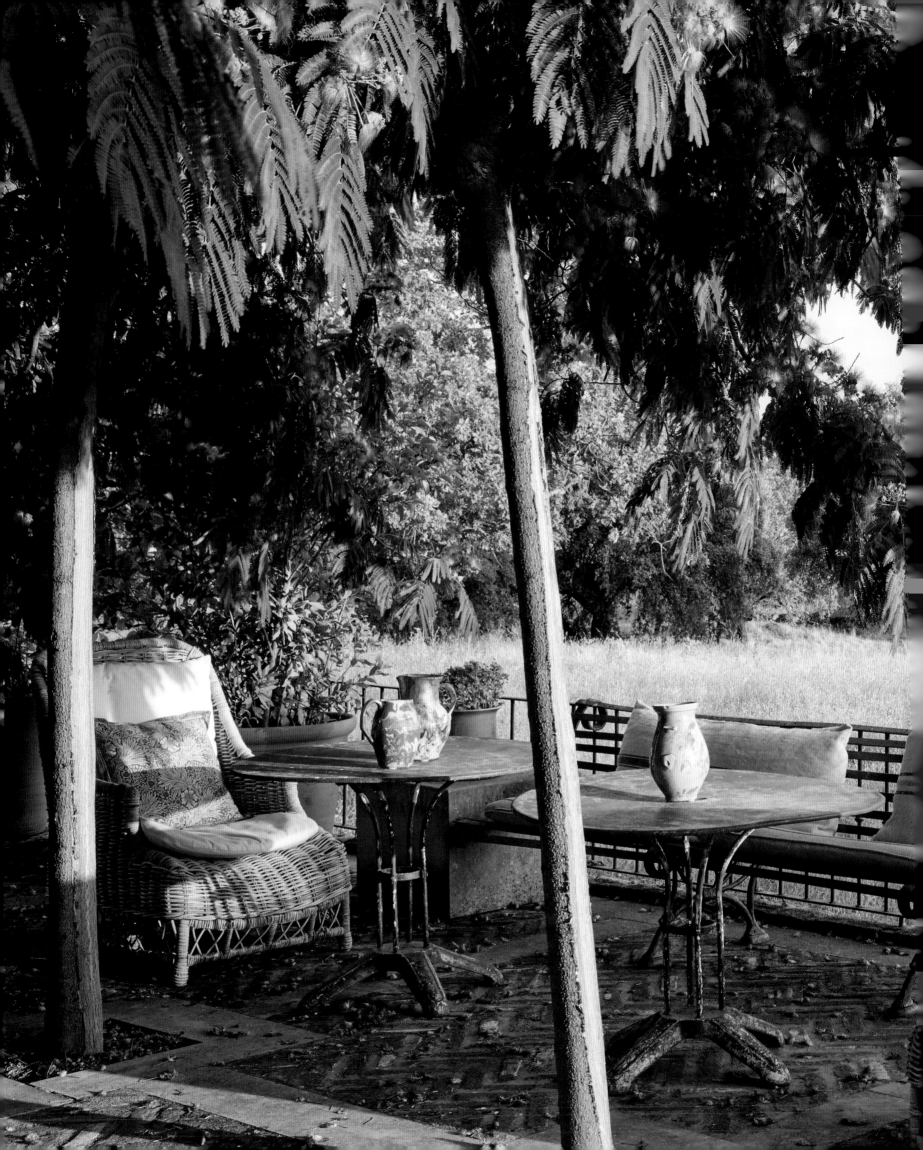

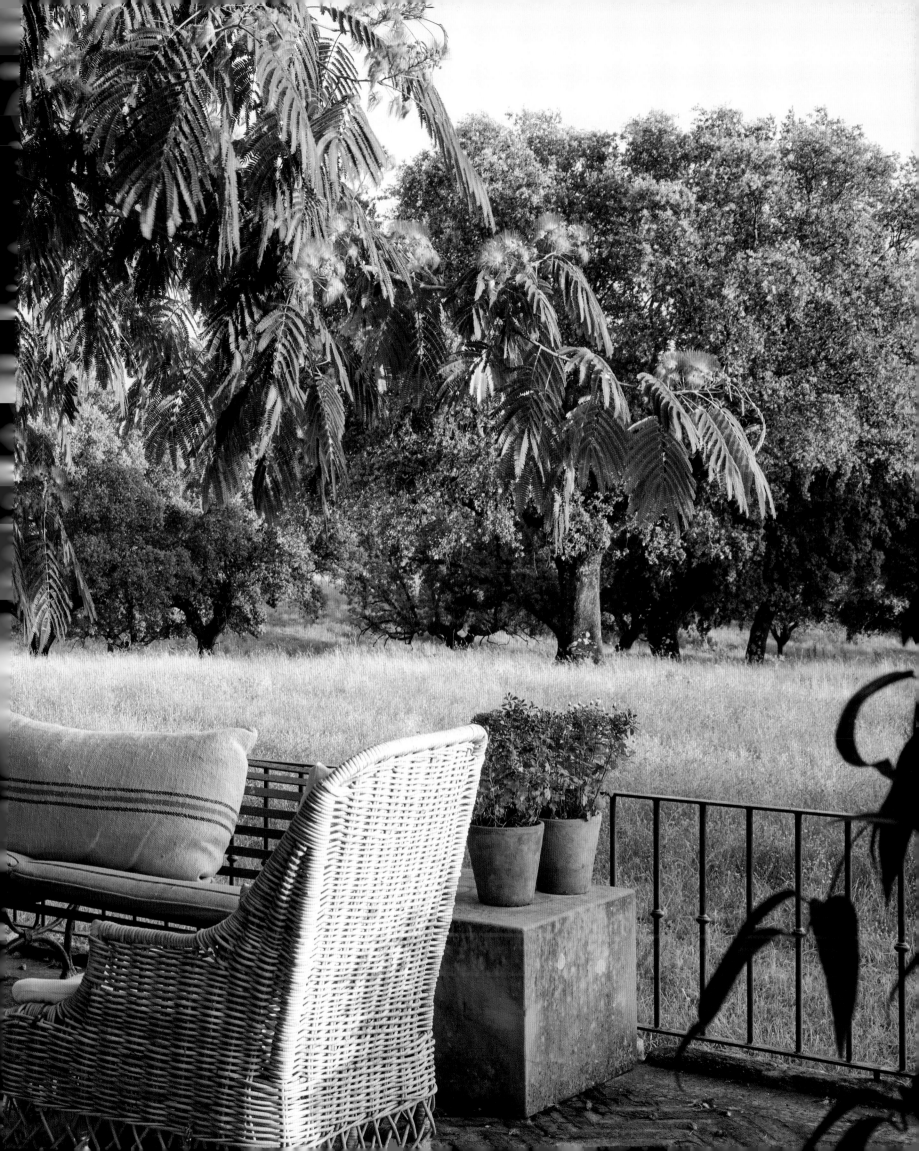

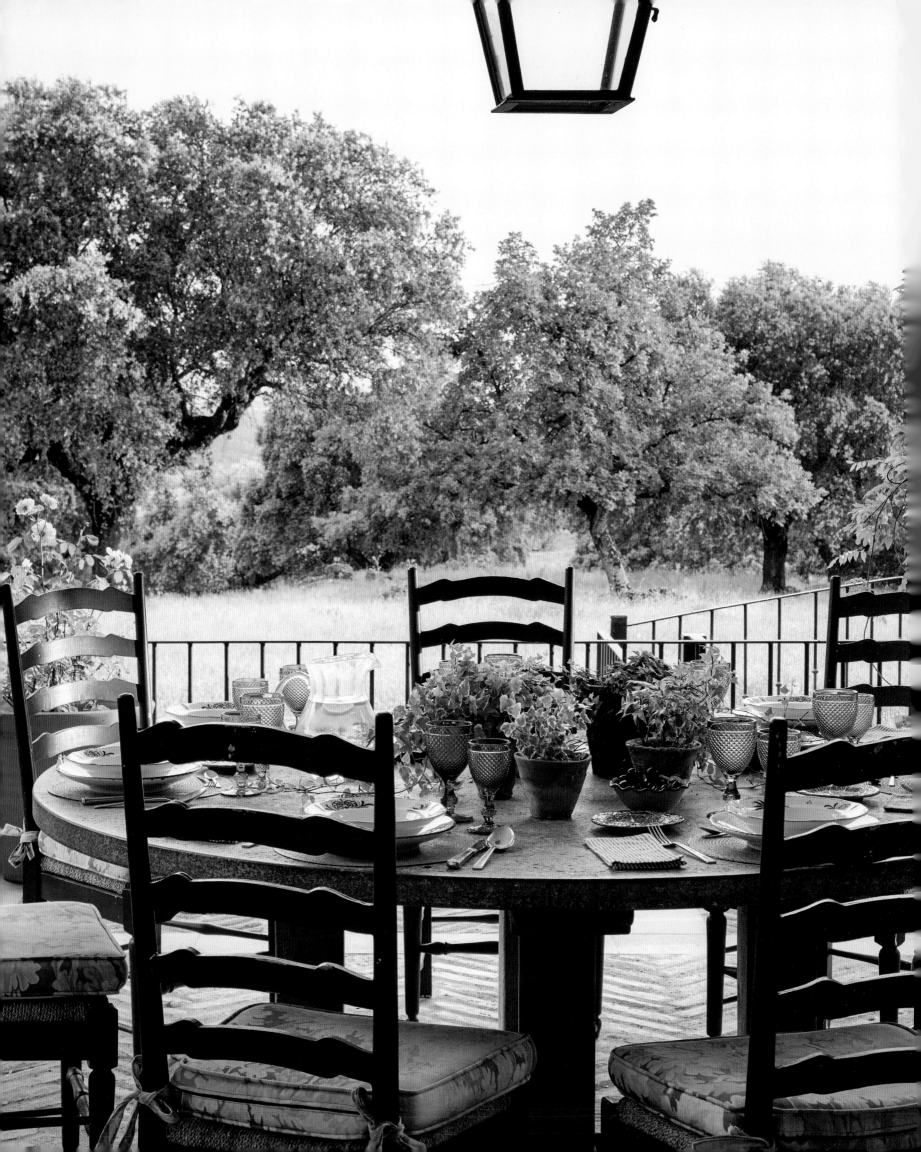

PAGE 277 The mudroom of the house is clad in French antique pine panels, with upper wall sections covered in the same striped wallpaper as the hallways. Hunting trophies cover one wall.

PAGES 278–79 A large granite fountain surrounded by eight hornbeam trees sits at the center of the entrance courtyard. The water feature was designed by landscape architect Luis González Camino and the house's architect, Pablo Carvajal.

PAGE 280 In the hall, a rustic French table displaying flower-filled Italian clay pots sits beneath an old religious painting. Doors to the right open onto the lounge.

PAGE 281 On the opposite wall of the hall, an eighteenth-century fire surround complements the delightful soft-edged antique stone floor.

PAGES 282–83 The hall continues to the left and the right. The hallway to the right leads to the guest rooms and features a polychrome Swedish sideboard with a collection of plants.

PAGE 284 The large dining room faces south-east. Its two oak tables can be joined together to provide seating for up to eighteen people. The chairs are a classic Belgian design in beige linen; a display of flowers from the albizias in the garden covers the table. A collection of nineteenth-century antique landscapes hangs above two chests of church drawers flanking the door to the lounge.

PAGE 285 One of the chests of church drawers with an eighteenth-century wall lamp and a collection of landscapes above. White porcelain platters contrast with the dark wood.

PAGES 286–87 The lounge has four doors that open onto the terrace with country views. Two side doors lead out onto porches. A large central French stone fire surround sits squarely against the chimney breast. Opposite, a daybed with sofas and armchairs on either side connects the two living areas.

PAGE 288 The eighteenth-century fire surround and daybed in the lounge.

PAGE 289 A side table in the lounge holds model temples, books, and candlesticks, with engravings on the wall above.

PAGE 290 The primary suite is upstairs, along with four children's bedrooms and two living rooms. The suite comprises a bedroom, a living area, and a bathroom. The antique flower-patterned fabric at the foot of the bed provided inspiration for this room and can also be glimpsed in the living room. Both rooms have large windows to the south with views of the countryside.

PAGE 291 The hexagonal beige and black Belgian stone bathroom floor. An island with two sinks sits in the middle of the space in front of the bath, which faces the window.

PAGE 292 Generous breakfasts are served on a large antique French table in the everyday dining room, which overlooks an orchard at the rear. The room is located in the east wing, along with the kitchen and laundry. The kitchen can be glimpsed at the back of the space.

PAGE 293 The laundry room leads out to the orchard garden. The ceilings of the office, kitchen, and laundry are in the traditional style, made from logs and wooden planks. The wooden cupboards are painted in customary white.

PAGES 294–95 The lounge terrace, shaded by four pink-flowering albizias, is raised by a few steps and closed off to prevent animals from entering. The stone floor is laid in large geometric shapes, infilled with bricks laid on edge. A long antique iron bench with a stone block at either end, colonial-style willow armchairs, and coral-colored iron tables from France make a comfortable outdoor area for entertaining or relaxing.

PAGE 296 The dining-room porch is covered to provide shade at mealtimes. Stunning country views can be enjoyed from the round table and rustic chairs.

BETWIXT THE SEA AND THE OLIVE GROVES

The elegant southern Greek island of Spetses is one of those places that embodies every part of its Mediterranean soul—its fascinating nautical history, its sea caves, and its architecture. With a landscape laden with olives, jasmine, and bougainvillea, Spetses is a favorite of Athenians. Houses run down to the edge of the sea, characterized by their high walls—a reminder of times when the island's inhabitants needed to protect themselves from attacks by Turkish ships.

When the Athenian owners of this property commissioned López-Quesada, the Greek architect Nikos Moustroufis had finalized the plans and almost finished the build. Everything else needed to be done: floors, colors, lighting, baths, furniture, closets, and more. The house was imagined as a small village centered around a pebbled entrance courtyard. It comprises several buildings, all with surrounding pergolas and terraces.

The core concept involved creating a refreshing, simple ambience with plenty of light and breezy currents of air, while respecting the characteristics of the local architecture. The owner of the house planted the abundant garden, which is surrounded by an olive grove. She was also involved in buying furniture and other objects with López-Quesada, including a beautiful collection of antique ceramics.

The importance of respecting the local style is evident in every design choice. One example is the traditional *mesana* in the guest bedroom—a library and closet unit that would have contained a hidden entrance to secret passageways that allowed residents to escape from the house. It's also seen in the range of blues—indigo, navy, pale blue—that link the woodwork on the roofs with the windows, floors, and kitchen units. Blue tones, against a white background as always, are also found on an old dresser and in the softly striped fabric of a four-poster bed.

Hydraulic tiles echo the tones of the fabrics used in the living room and bedrooms, as well as the ceramic detailing in the bathrooms, whose old marble basins were sourced from a local antiques dealer. Two French dressers and two antique English mirrors preside over the living room space along with a collection of enchanting conch shells. The house, completed in 2012, weaves together items from the interior of the island, the ocean, and the Mediterranean landscape.

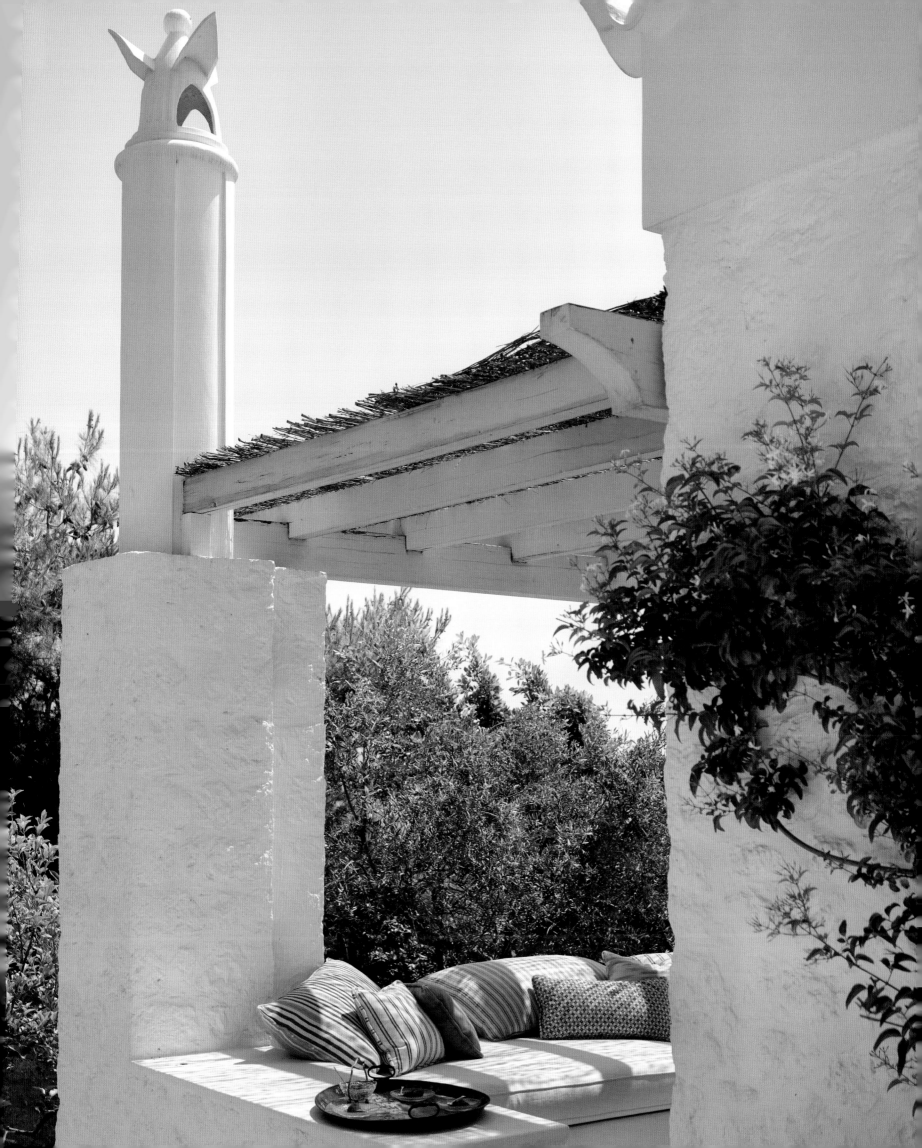

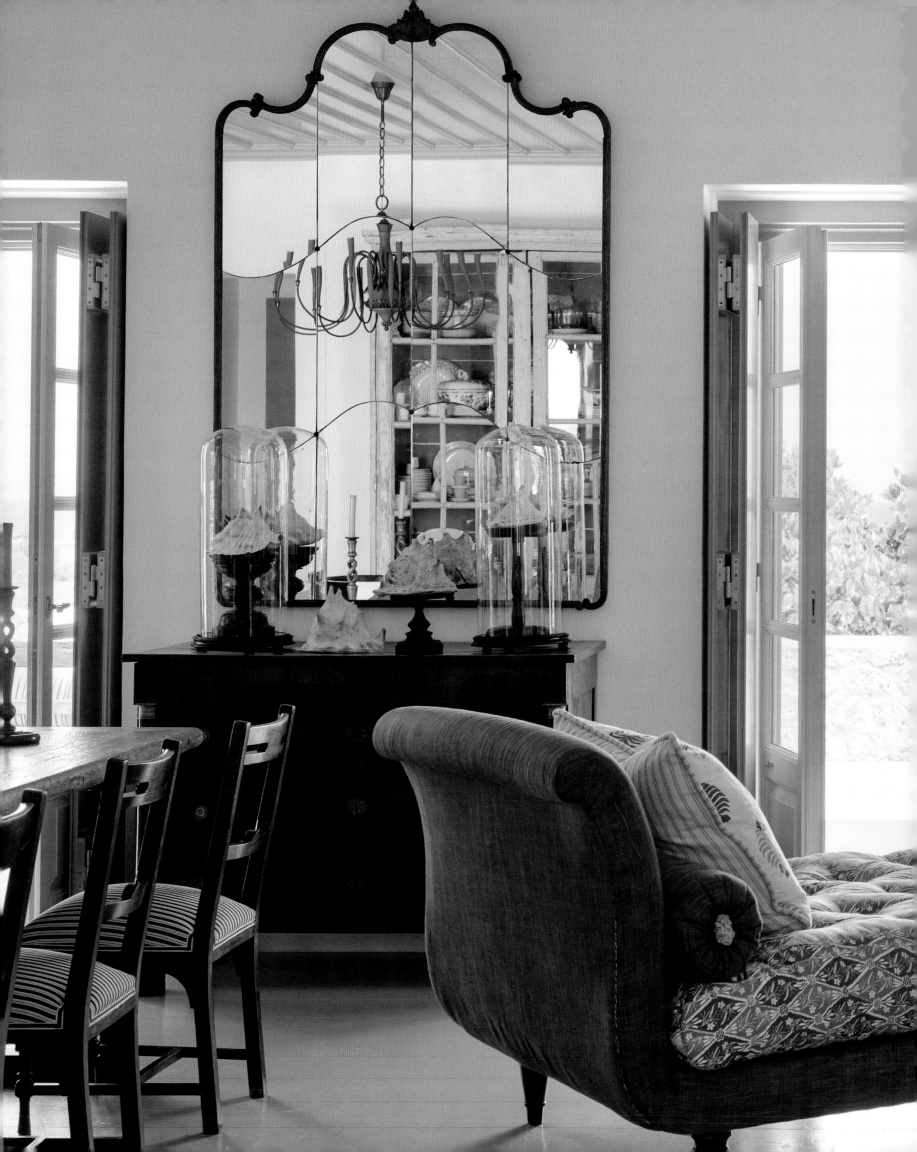

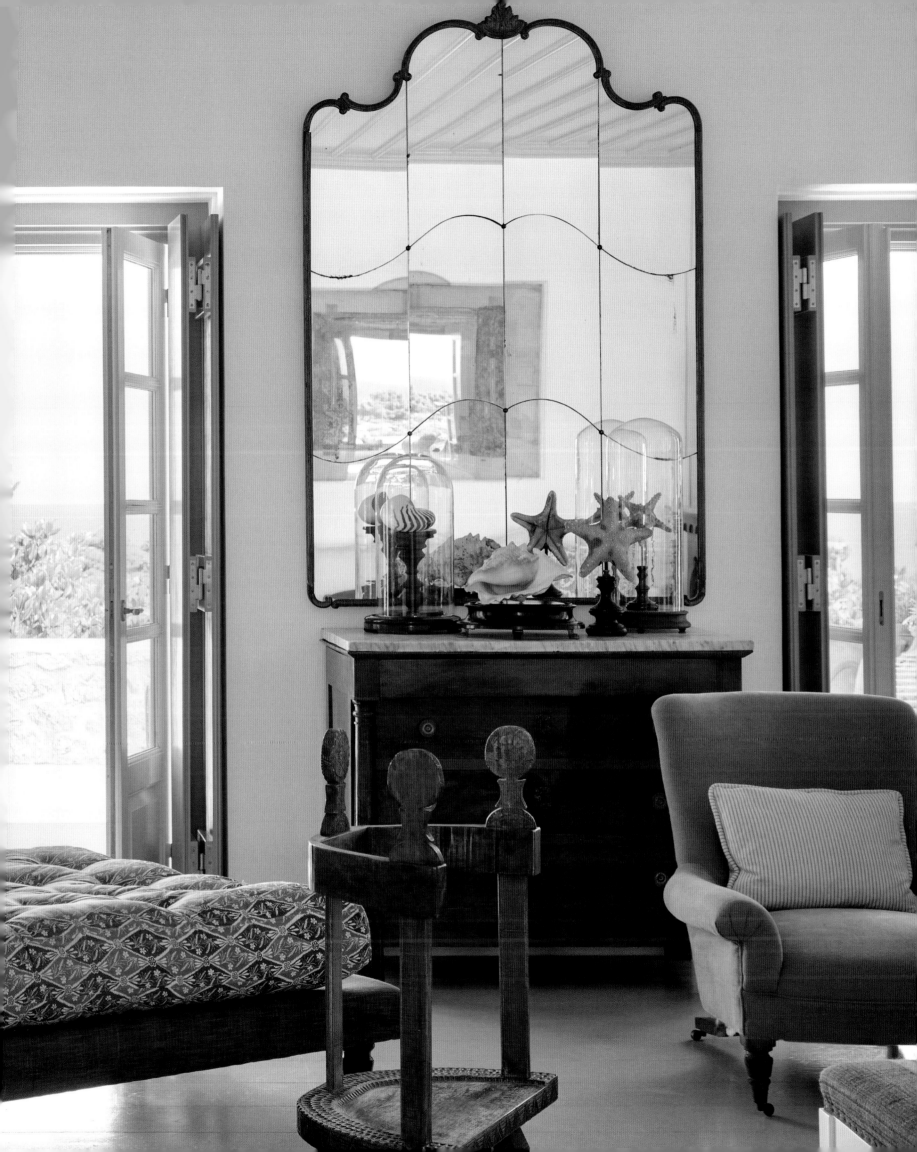

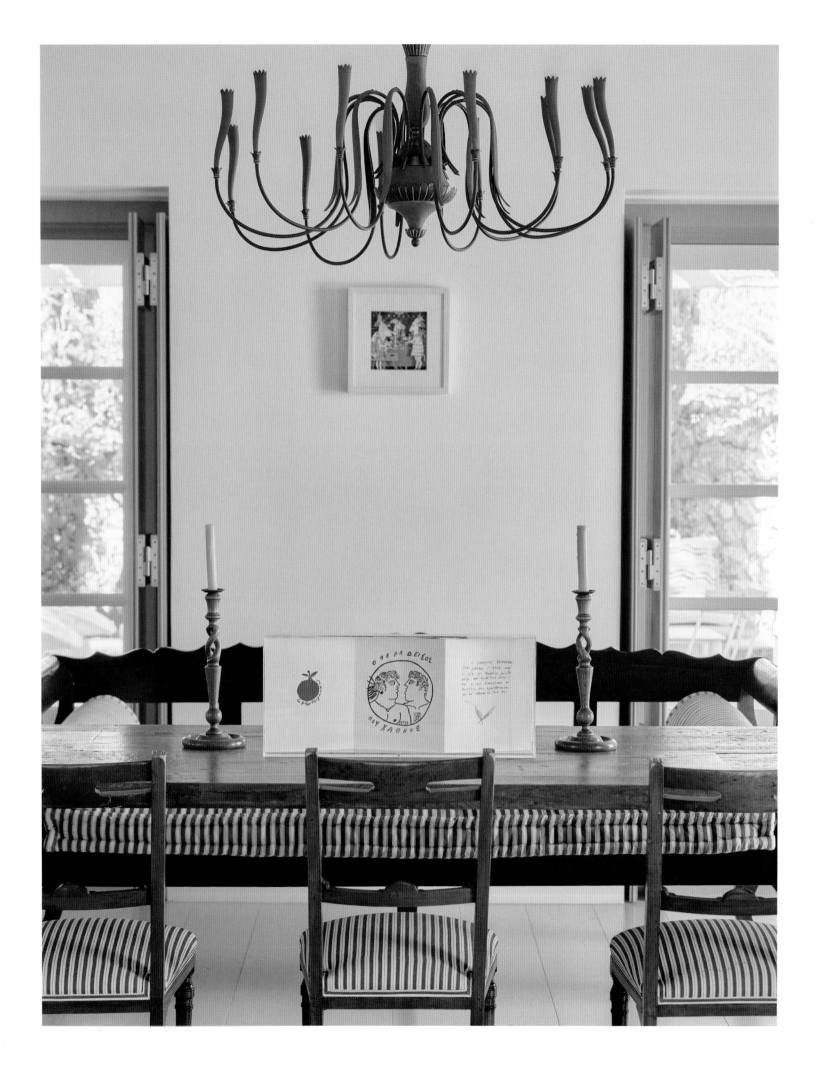

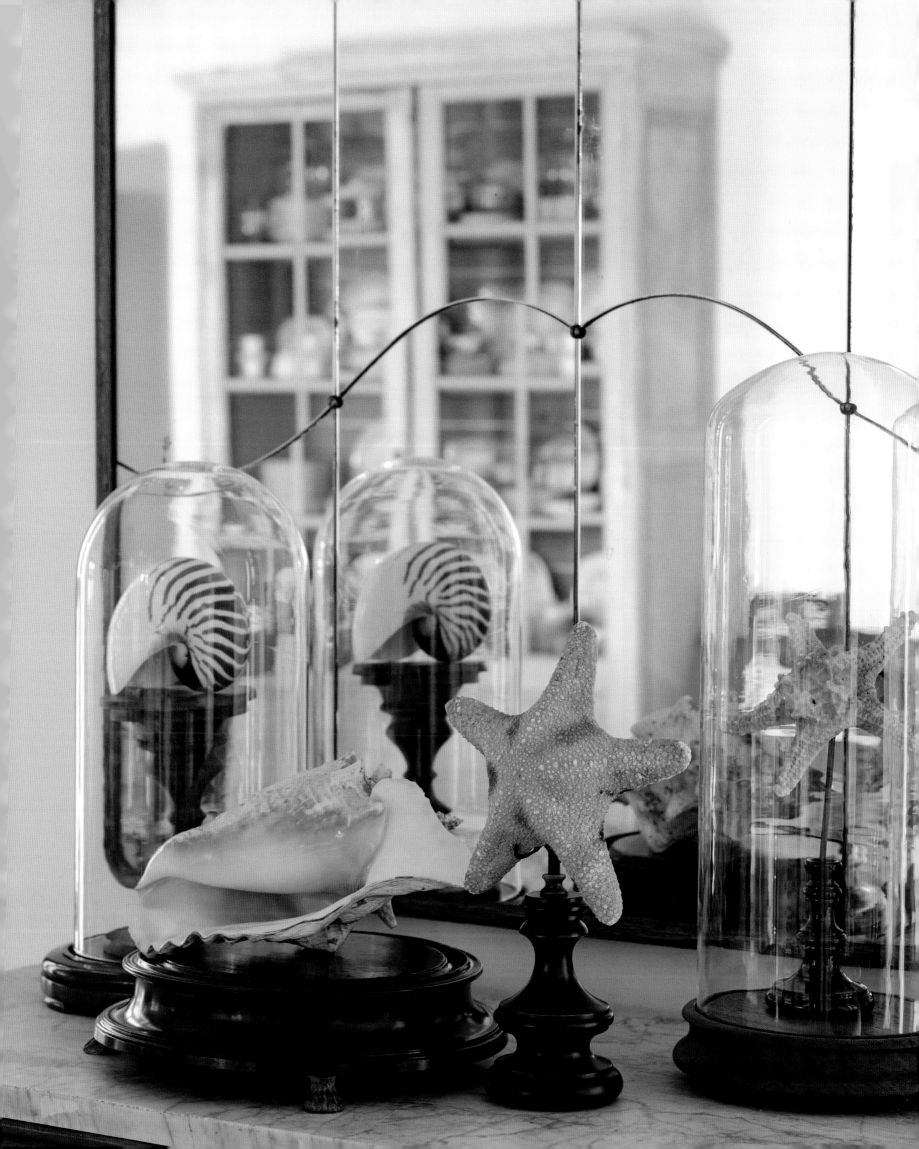

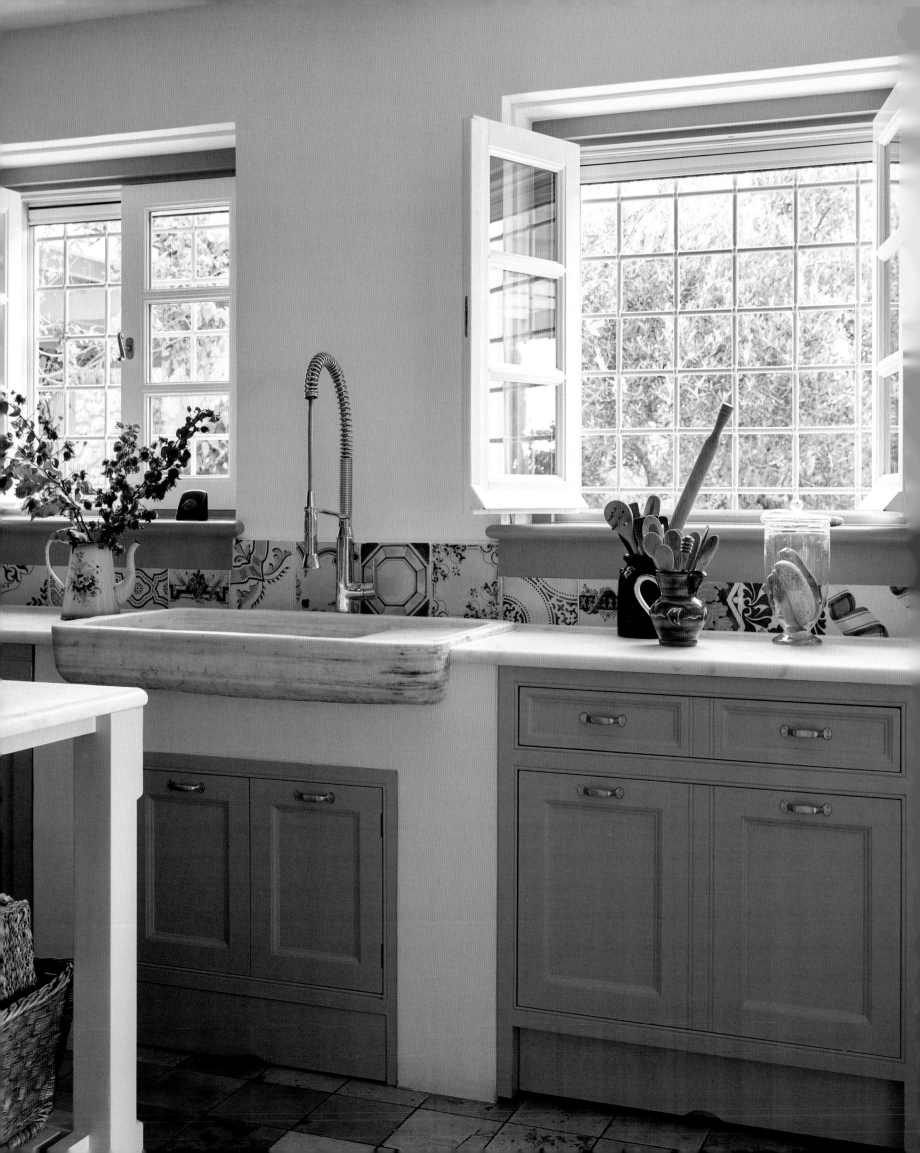

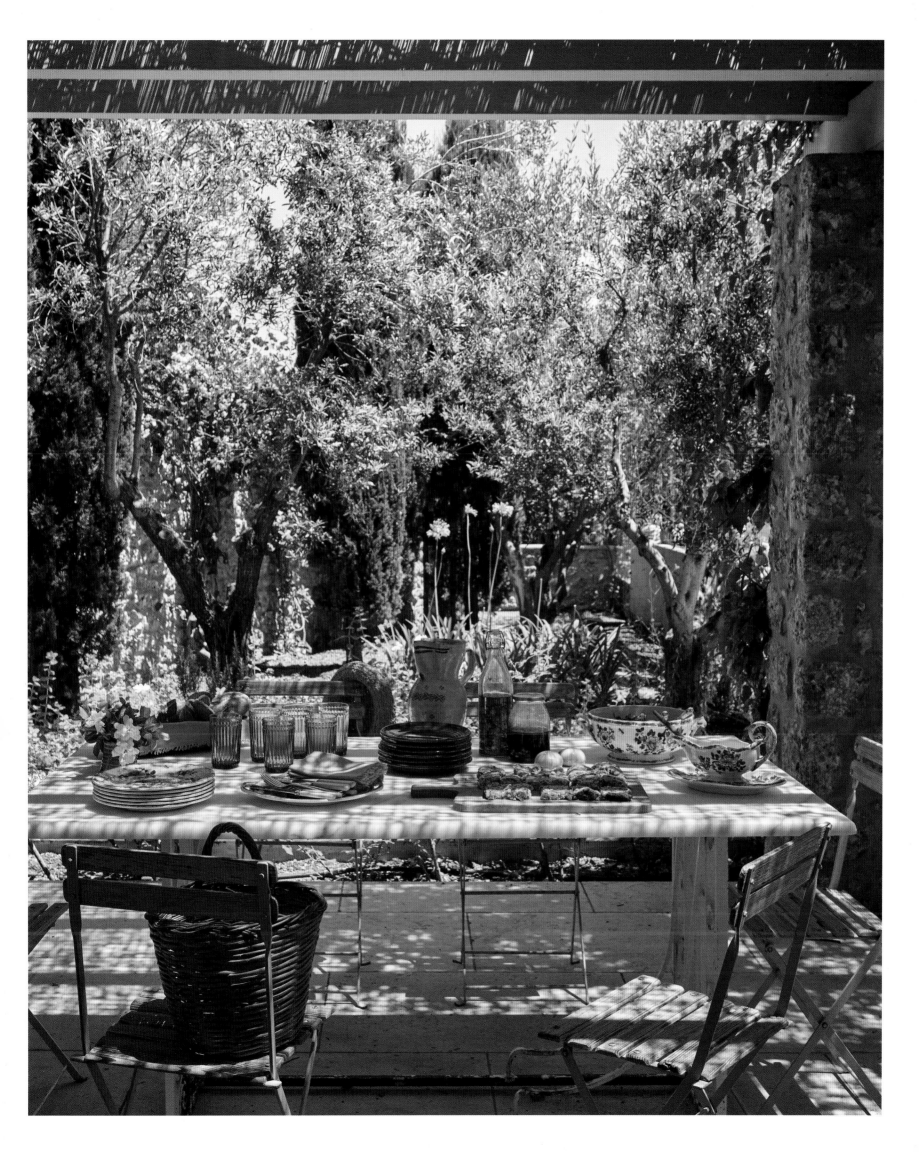

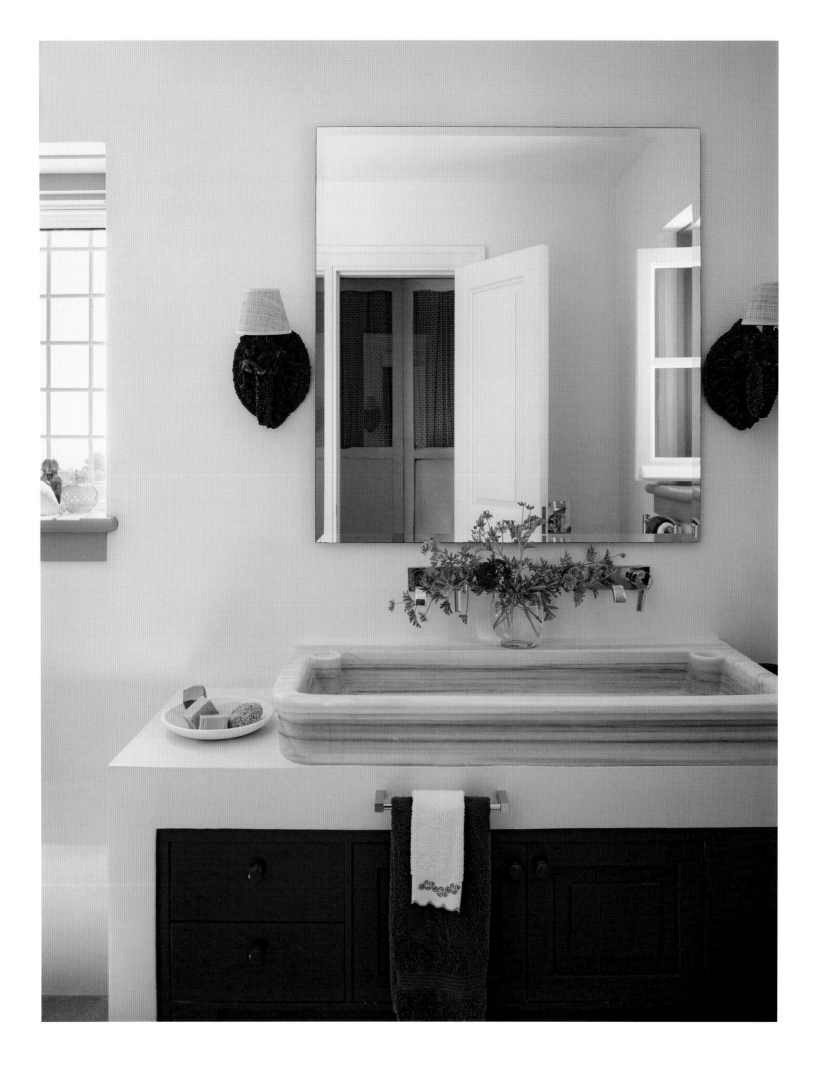

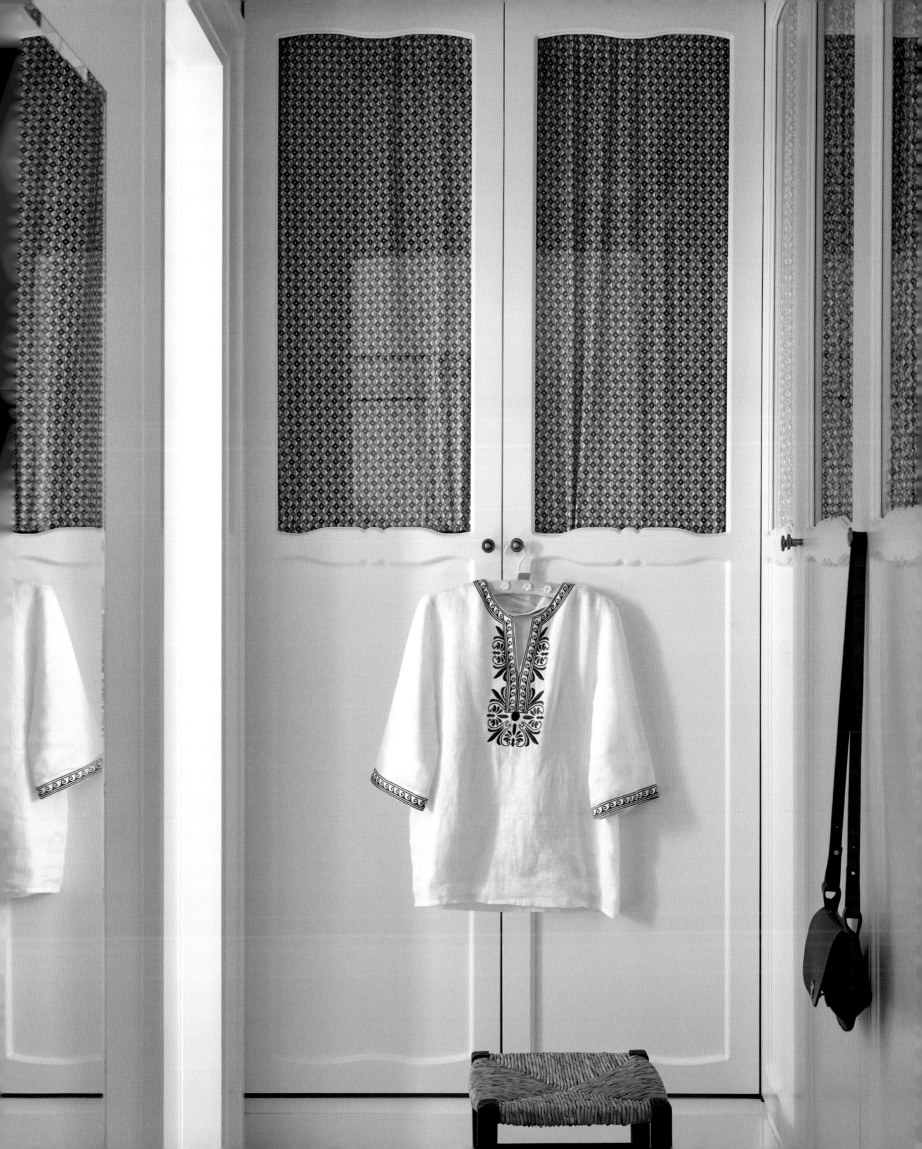

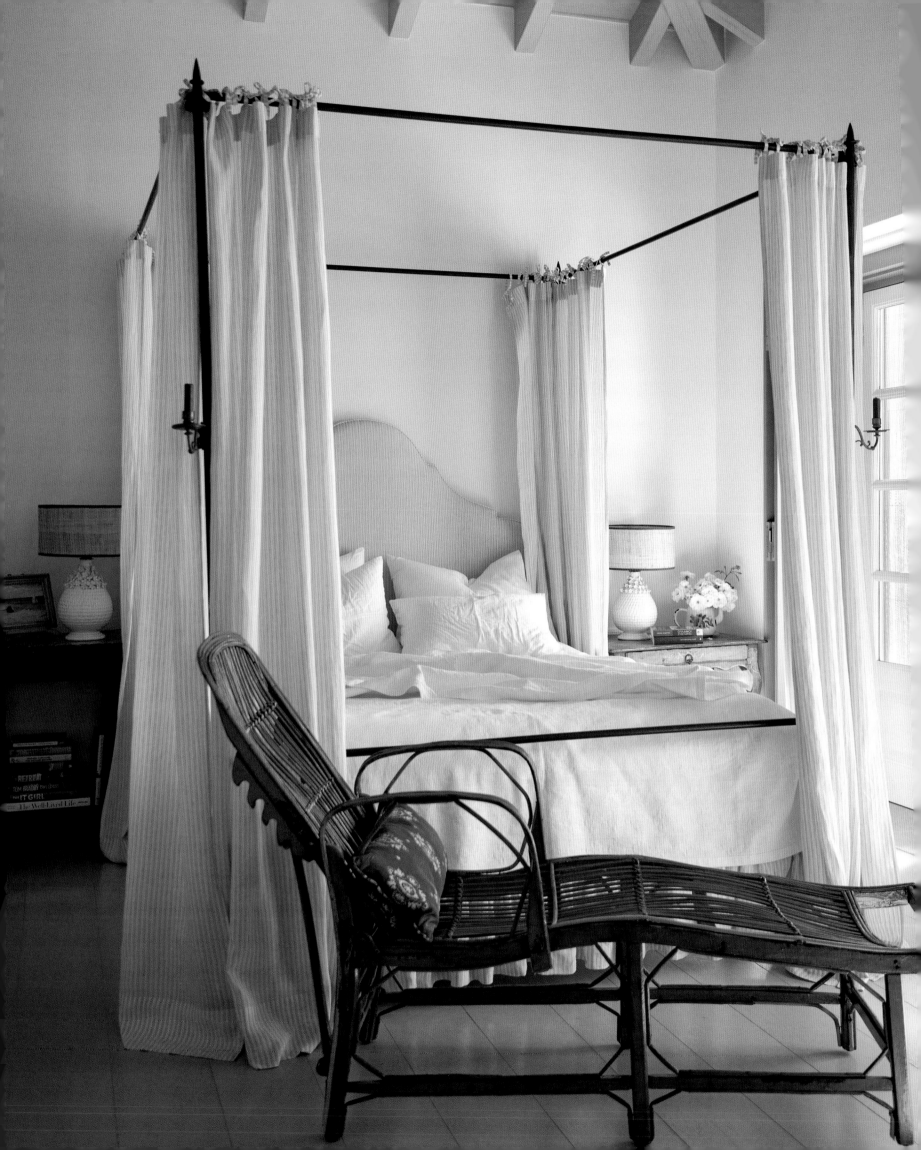

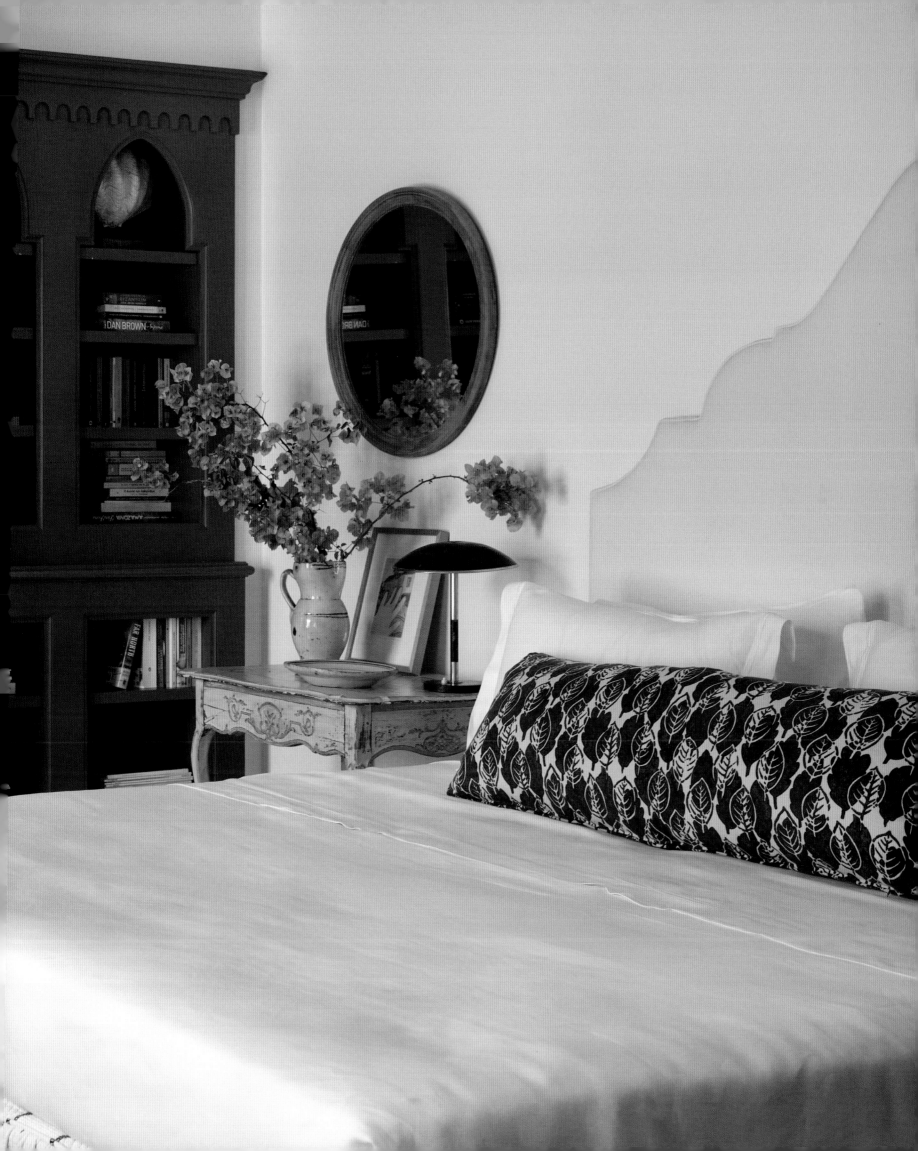

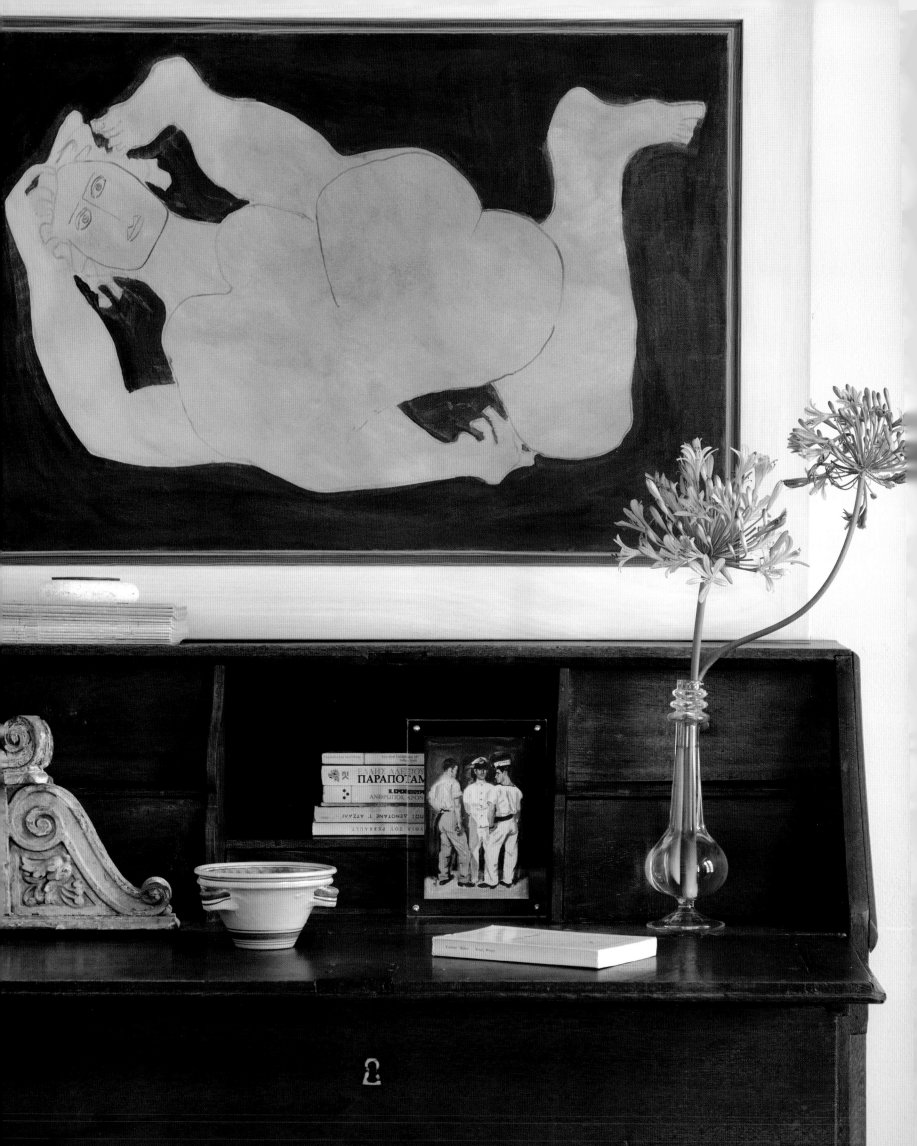

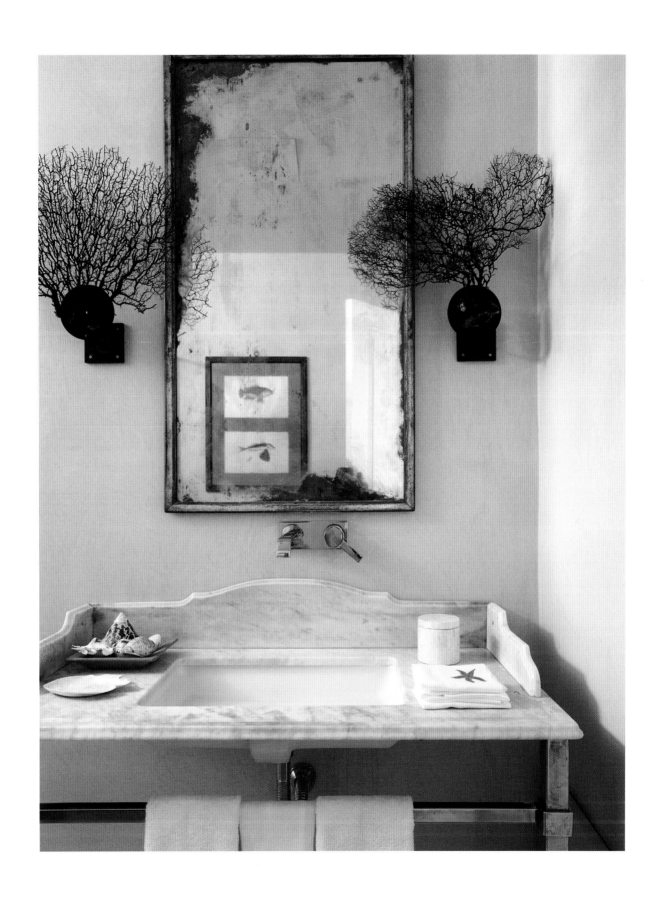

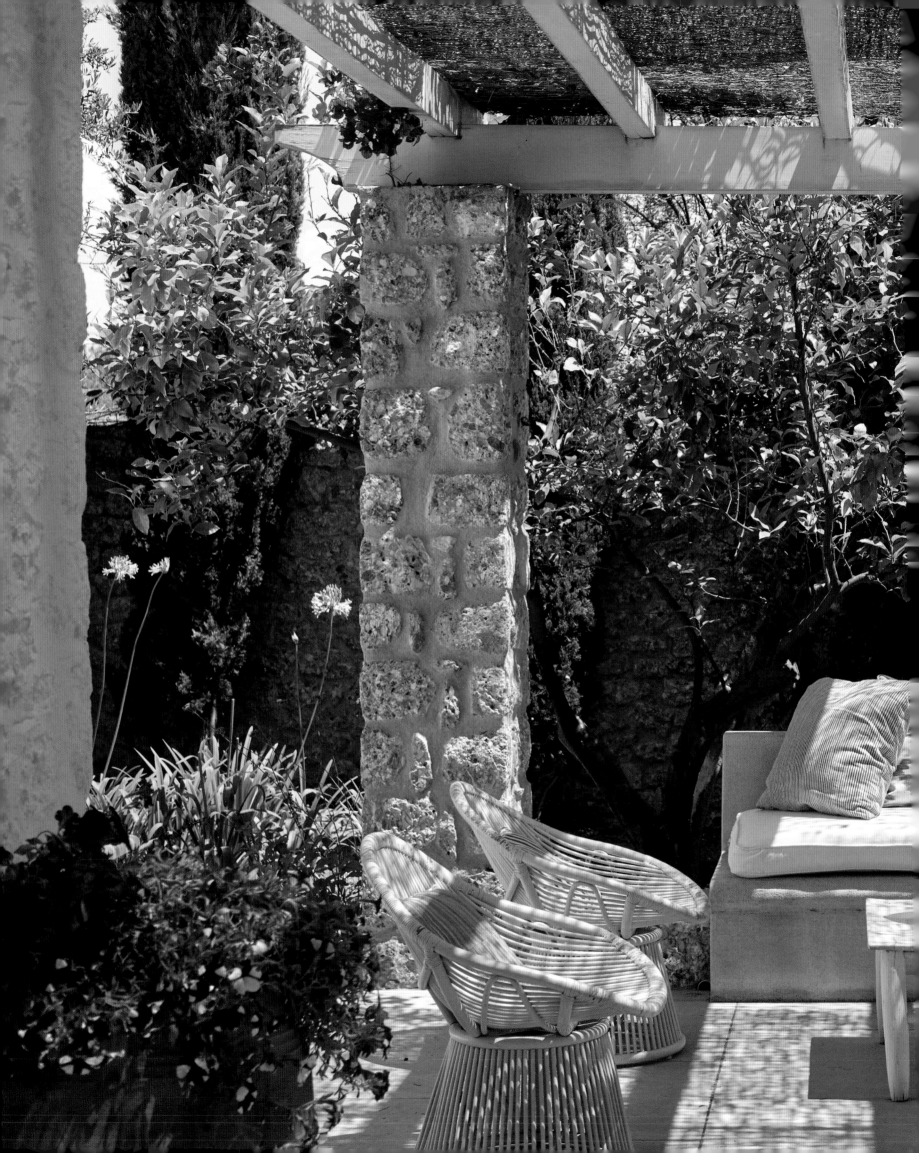

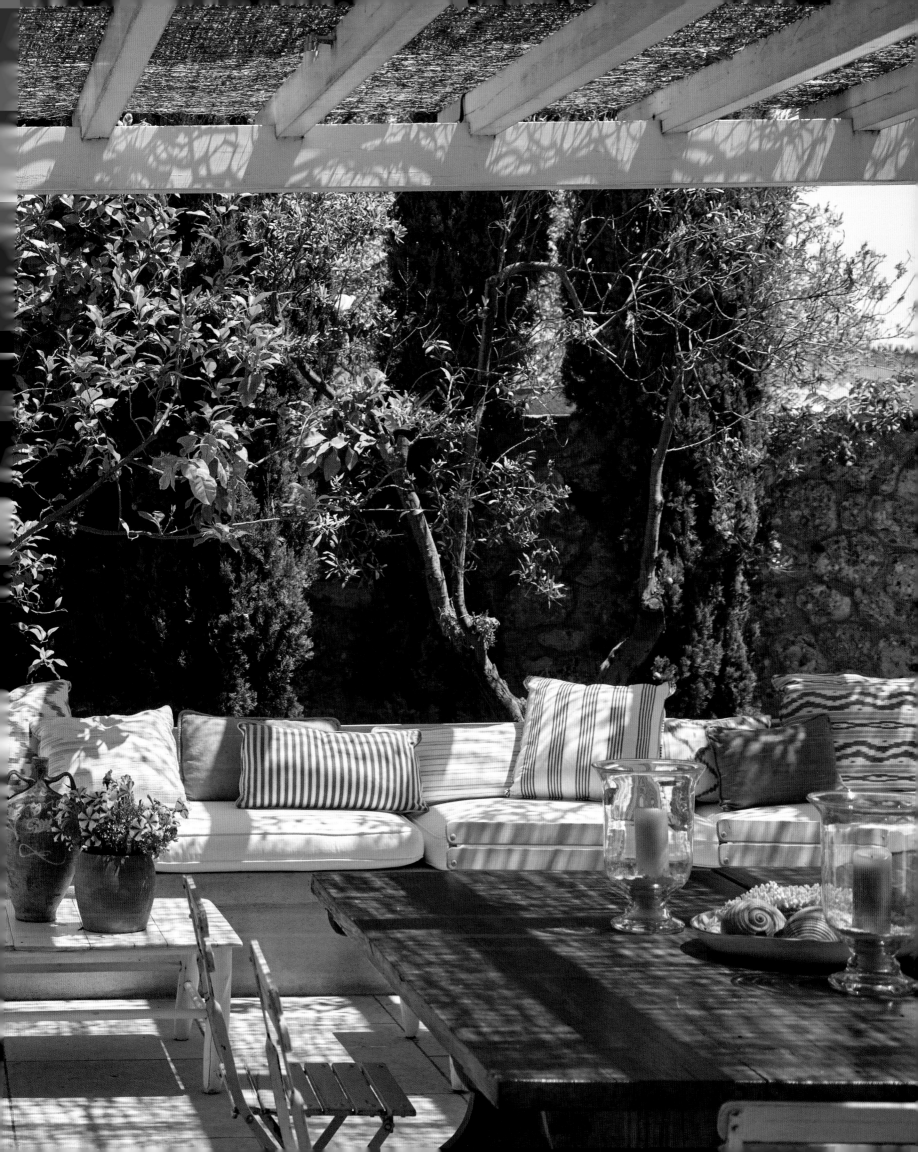

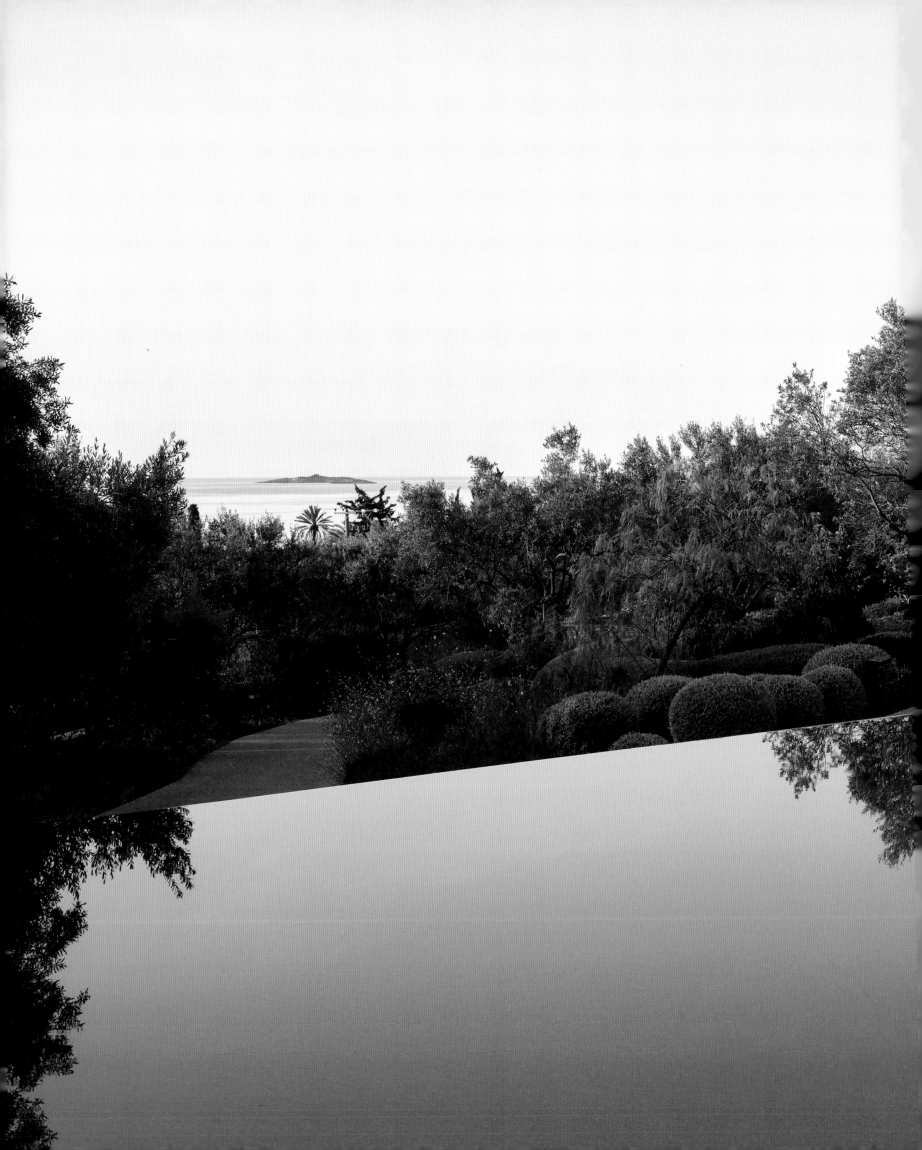

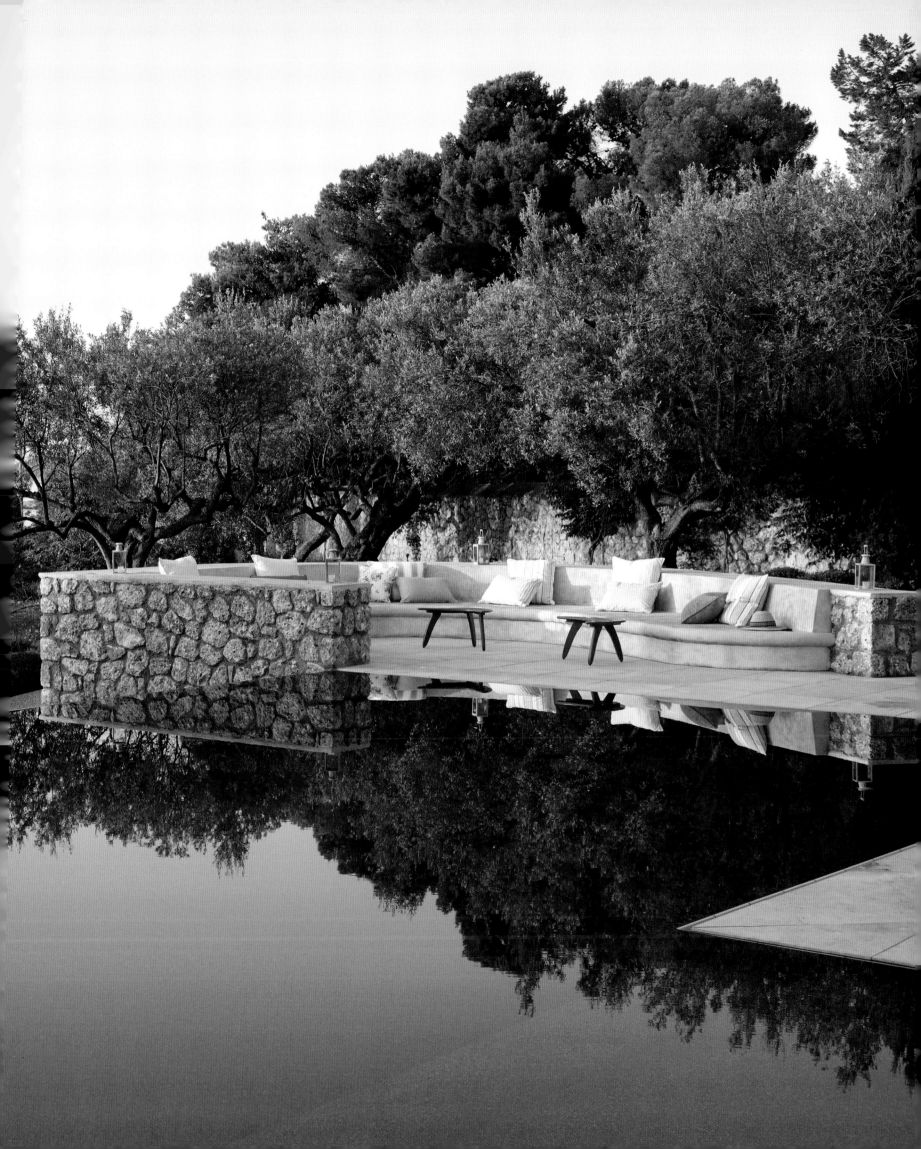

PAGE 299 A perfect terrace topped by a blue pergola. From this vantage point, traditional Spetses chimney tiles and roofs can be appreciated, along with the climbing jasmine. Pillows and cushions are decorated in a mixture of stripes, blues, and greens. Delicacies are served on an antique tray, hand-painted with a view of the village.

PAGES 300–301 The three double doors of the lounge in the main house open onto a terrace with sea views. Between these sit French chests of drawers topped by English mirrors and a collection of seashells in glass bell jars. A chaise longue separates the living space and fireplace from the dining area. The blues of the ceiling, floors, and woodwork blend perfectly with the whites, blues, and brick red of the fabrics and upholstery.

PAGE 302 Chairs and an antique bench line the wooden table in the dining area. A 1950s green Greek chandelier hangs above it.

PAGE 303 A French cabinet with a blue interior filled with dinnerware is reflected in a mirror behind the seashell display.

PAGE 304 The kitchen is in the left wing of the house—it's long and thin with two west-facing windows and a glazed door looking out to sea. The antique marble counter sits on blue fitted units. Old patterned tiles are used in a full-length splash back.

PAGE 305 An antique marble table with iron legs is laid with an assortment of French dinnerware beneath the pergola next to the kitchen. The Mediterranean garden is full of olive trees and cypresses; bougainvillea and agapanthus can be seen in the background.

PAGE 306 Two people can use the wide marble bathroom basin at once. It rests on a fitted wooden vanity unit painted a deep blue. Red coral wall lights add a touch of color at either side of the mirror.

PAGE 307 The antique-style doors in the dressing room are reproductions, with white and blue fabric panels fitted behind the panes of glass. From here, the bathroom can be accessed on the left.

PAGE 308 The floor and ceiling of the primary bedroom are both painted a soft blue. The bed is made from slender wrought iron, with drapes in English ticking and antique piano candlesticks fitted to the uprights. At the foot of the bed, a green antique lounge chair looks onto the terrace. A bedside table sits on either side of the headboard—one is wooden and in the imperial style, the other is Swedish in a range of blues; both are topped with white porcelain lamps.

PAGE 309 A large French chest of drawers with original blue paintwork sits against the wall of the dressing room; a white lamp, stones, and keepsakes, and a green glass vase filled with agapanthus and lavender from the garden are arranged on top.

PAGES 310–11 The guest suite is reached from the central entrance courtyard. It comprises a large bedroom, a bathroom, and office. In the bedroom, a *mesana*, painted a wonderful dark gray, was created; this library and closet unit used to feature in all Spetses houses, concealing access to a network of tunnels used for escaping from Turkish invasions in years gone by. A large bed with a scalloped headboard faces an imperial daybed with striped upholstery. The flooring in the whole of this area is black and white marble in a checkerboard pattern.

PAGE 312 A painting by Greek artist Nikos Nikolaou hangs above a French writing desk in the guest bedroom, opposite the bed. A smaller picture of sailors by Yiannis Tsarouchis sits on the desk.

PAGE 313 The antique marble countertop in the guest bathroom was fitted with iron legs. An antique mirror with gorgonian coral wall lights on either side reflects the fish etchings on the opposite wall.

PAGES 314–15 Pergolas cover the space between the main house and the house where the younger members of the household live. Gently enveloped by cypresses, olive trees, and climbing plants, they're the perfect spot for al fresco dining. Resting on stone pillars, light blue beams are fitted with rattan panels to provide respite from the Greek sunshine. A built-in bench loaded with cushions in a mixture of blue, green, and tomato-red fabrics makes an ideal seating area.

PAGES 316–17 The sea can be seen from the huge pool surrounded by trees. A stone bench allows evenings to be spent out in the open.

PAGE 318 Fitted shelves in the living room house a pretty collection of folk pottery, behind two vintage lattice chairs.

MEET ME UNDER THE OMBÚ TREE

Every house has a story, and the tale of this one on Menorca in the Balearic Islands is inextricably bound to eight ombú trees. People who settled here in the nineteenth century planted these Argentinian trees and everything flows from their imposing presence. It's the trees that make this house a home.

The whole garden is enchanting. It was designed by landscape architect Fernando Caruncho, who, as always, demonstrates great respect and knowledge of the environment. This is seen in details like the traditional walled walkways created in island stone and the reuse of an old balustrade. He also worked in a fountain and two stone benches that are perfect for relaxing on in the shade of the ombú trees. Twenty-five years on, the house and its wonderfully timeworn garden are still beautiful.

The owner wanted to restore the old colonial style of the house. Characteristically classic Mediterranean furnishings were mixed with English and European pieces to capture the historical influences on Menorca. With this sense of history in mind, older pieces of furniture were restored. A series of beautiful seascapes conjure the island's naval past. White sash windows were fitted and the man's dressing room was decorated with striped fabric, along with a nineteenth-century English chair and a twentieth-century Mila lamp.

Natural materials like raffia and willow were used throughout the house in various styles and functions—for example, in wardrobe doors, allowing clothes to stay fresh and breathe in the humid environment. The materials are also used in lampshades, as matting, and on the walls of the main bedroom and dressing room.

The house is connected with the lush garden via a large porch laid with a black and white colonial-style floor. The patterns on cushions and bolsters inside the house also feature on those on the garden benches, extending the connection between house and garden and adding beauty and comfort. Sitting in the shade of an ombú tree in this wonderful corner of Menorca is a unique joy that never grows old.

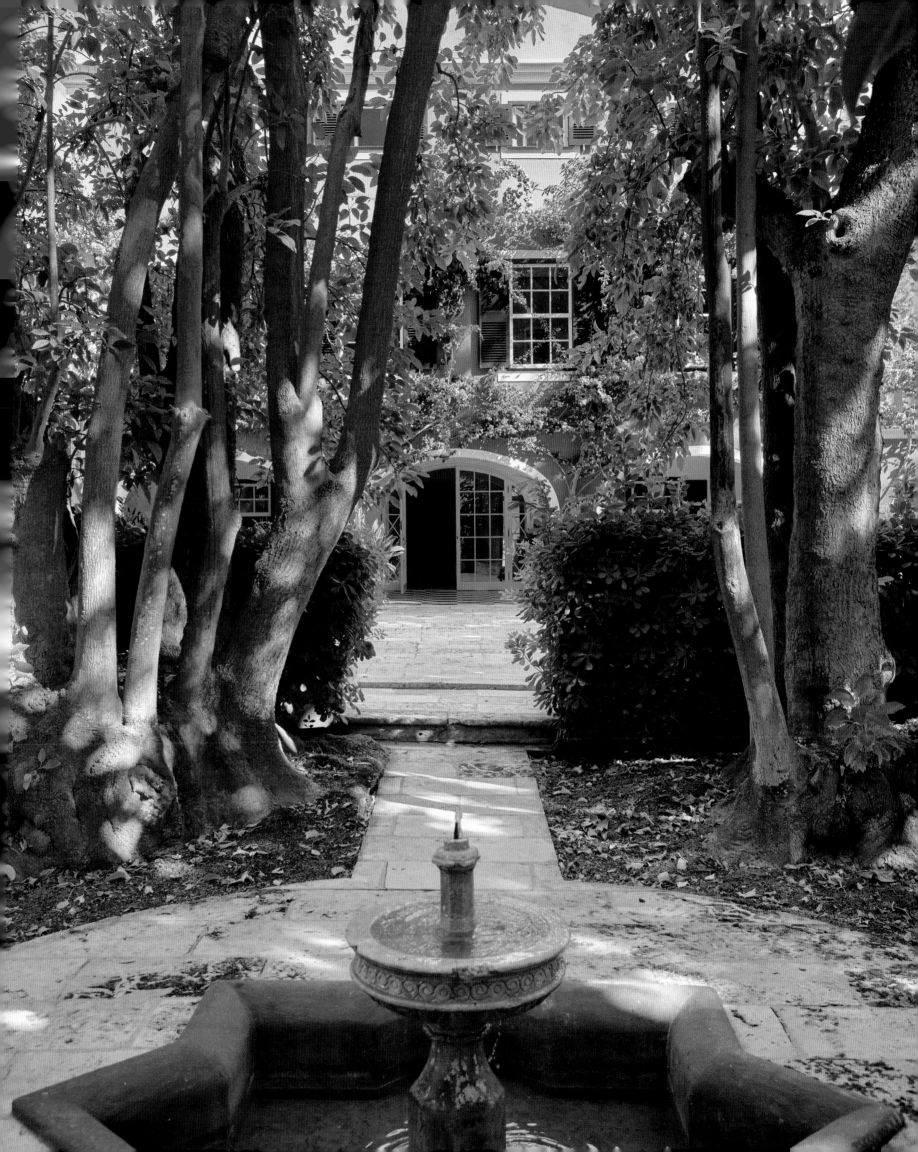

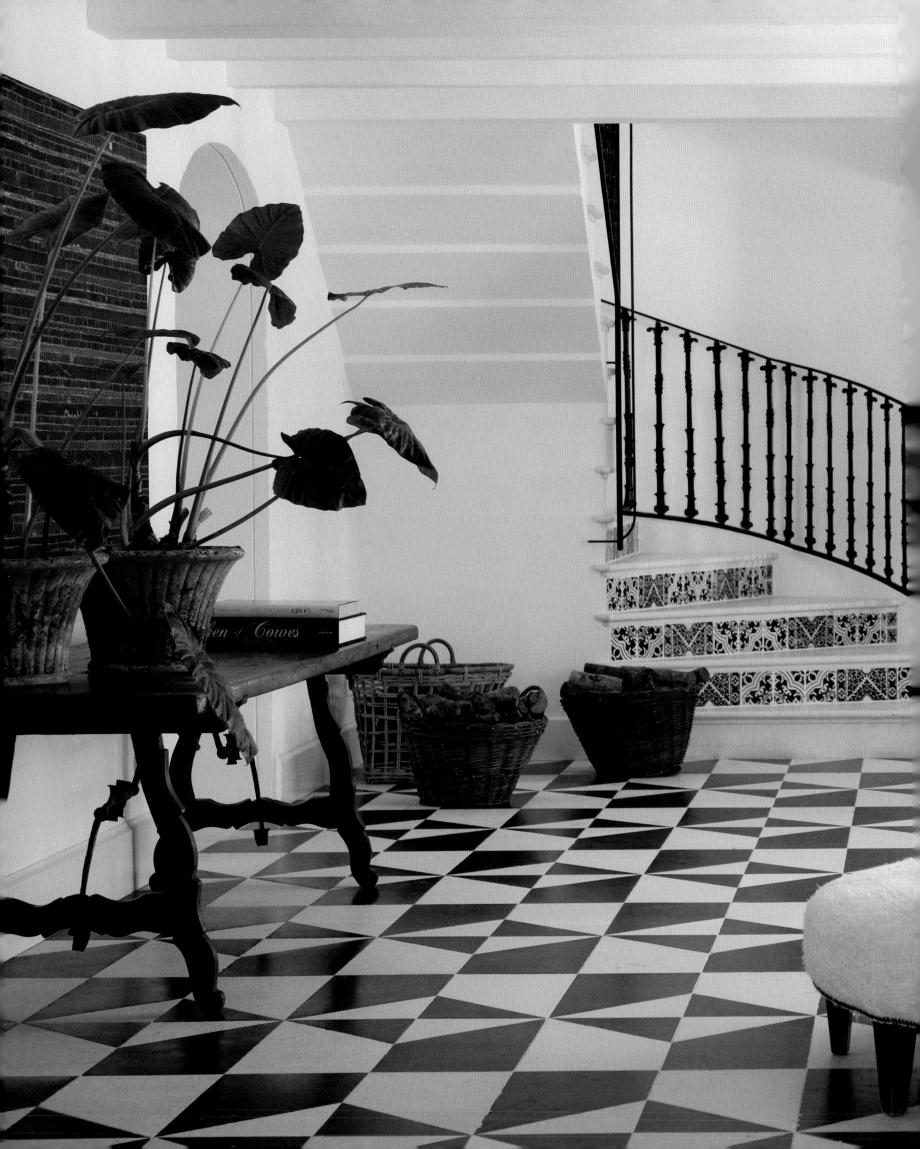

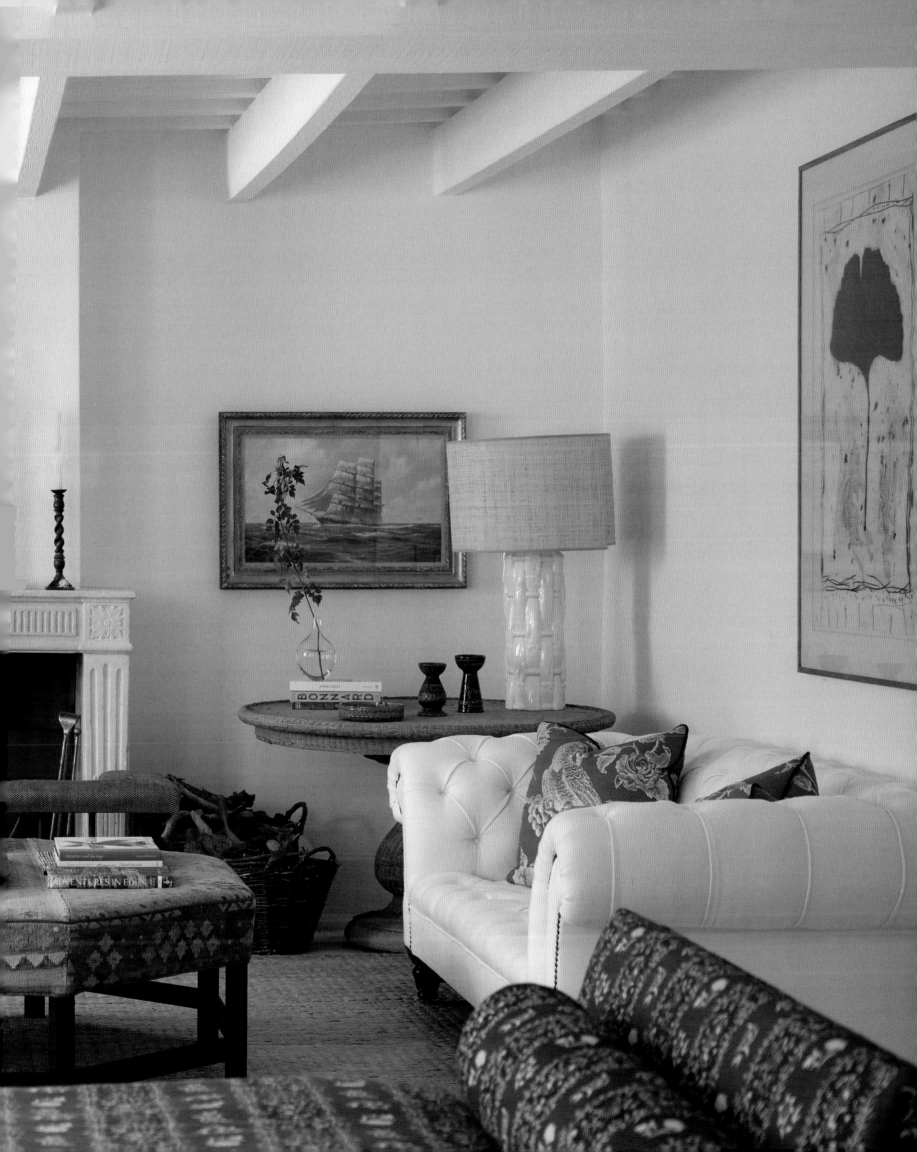

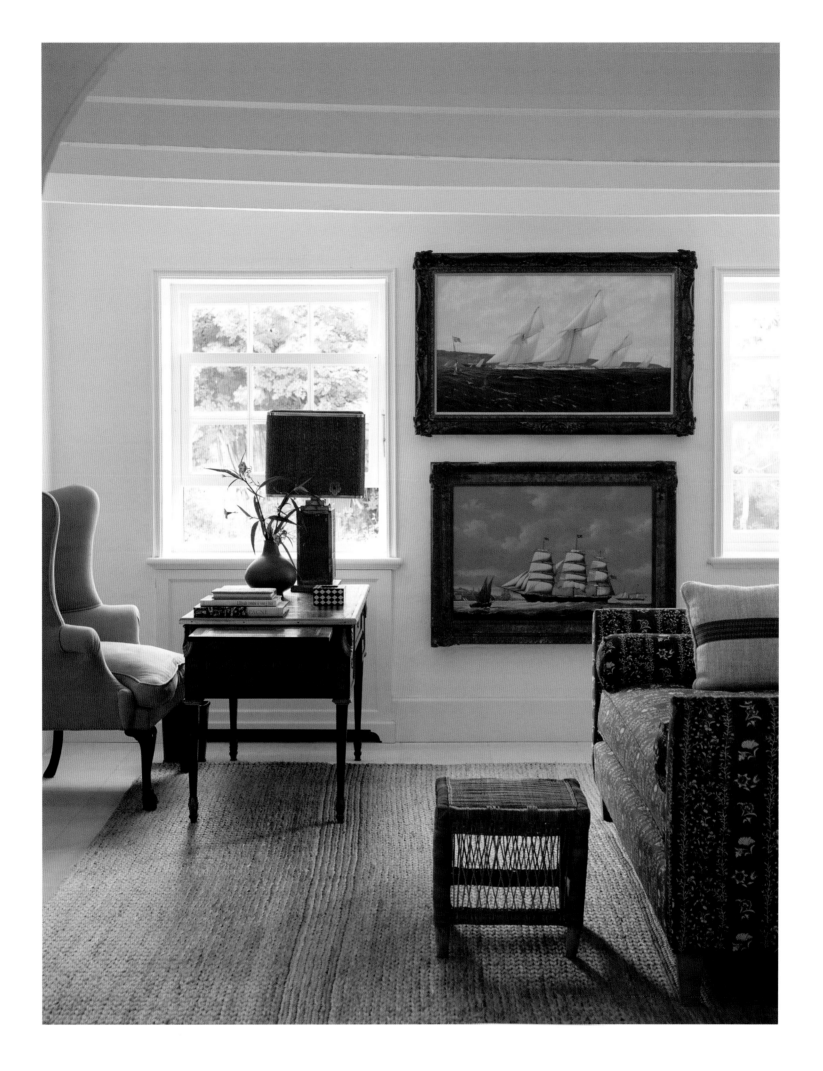

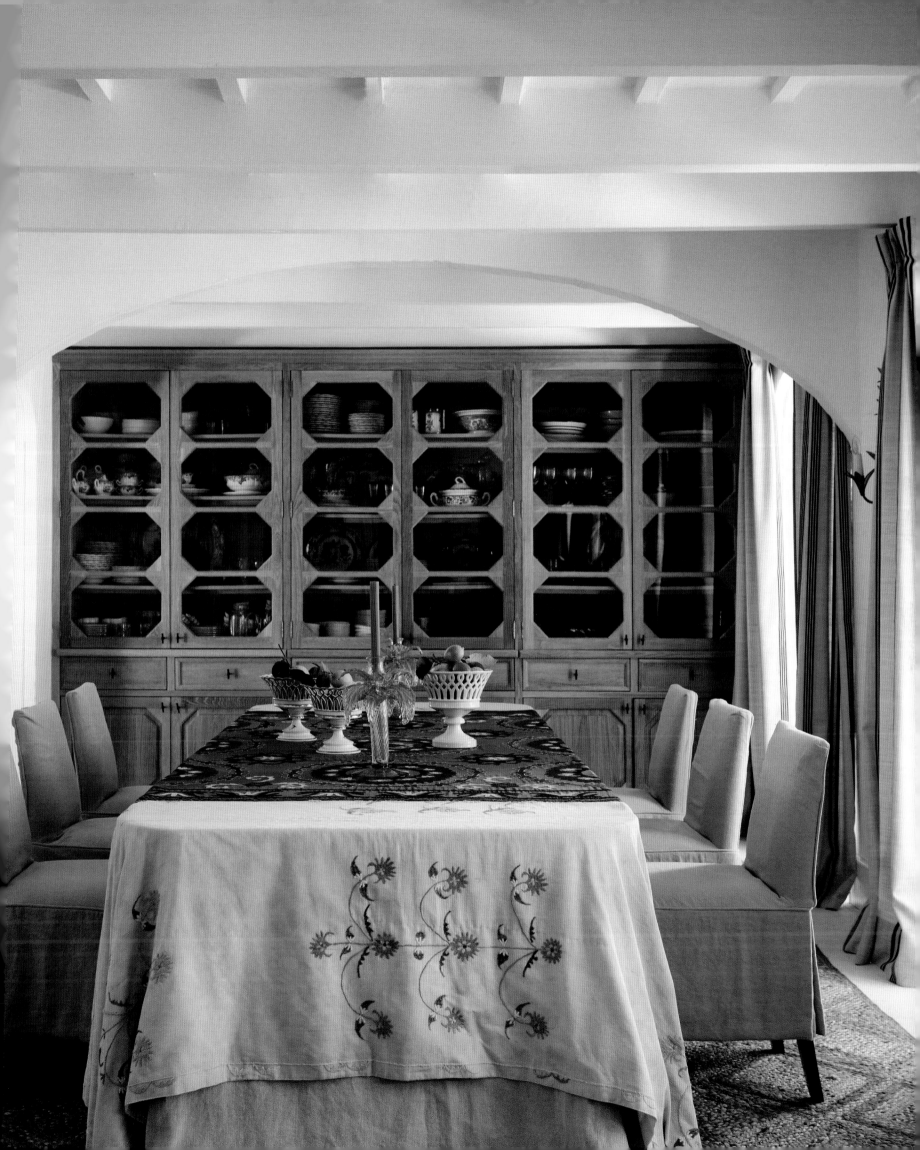

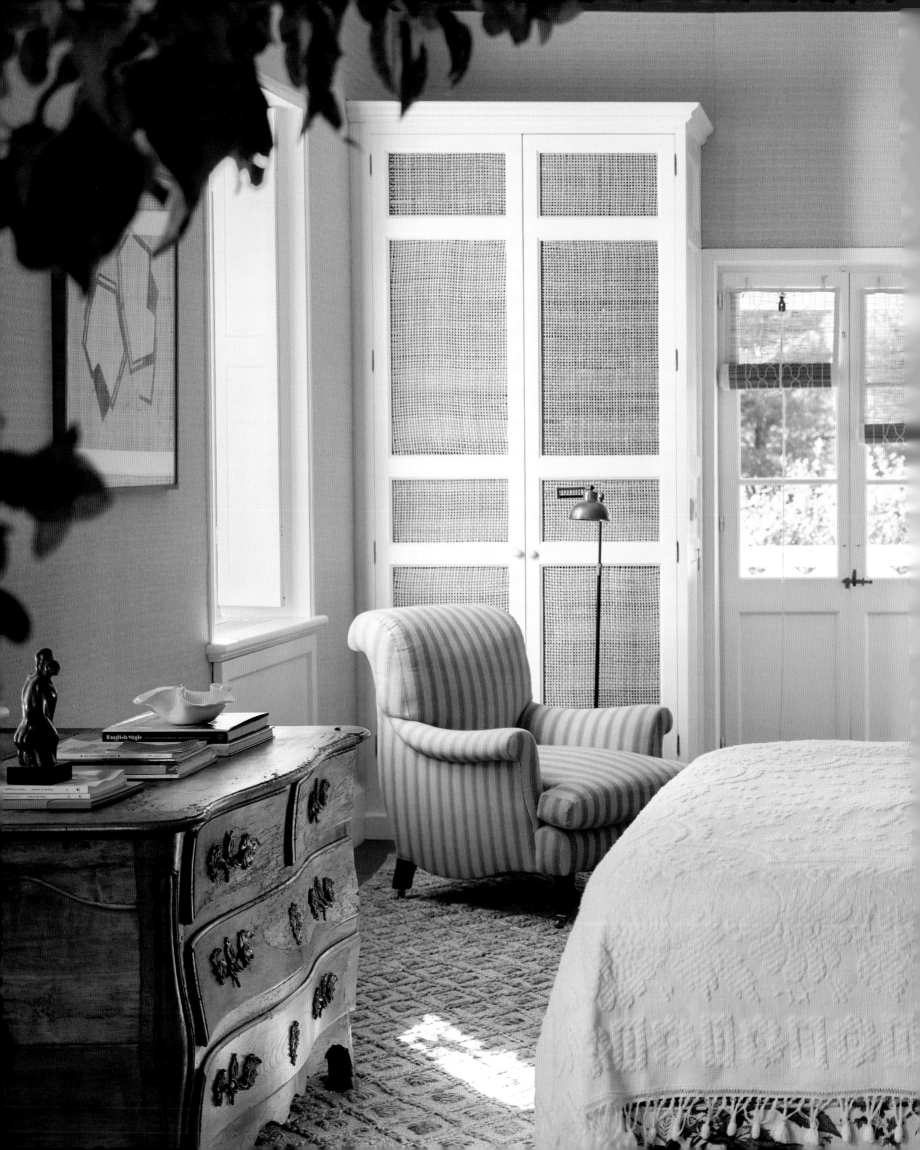

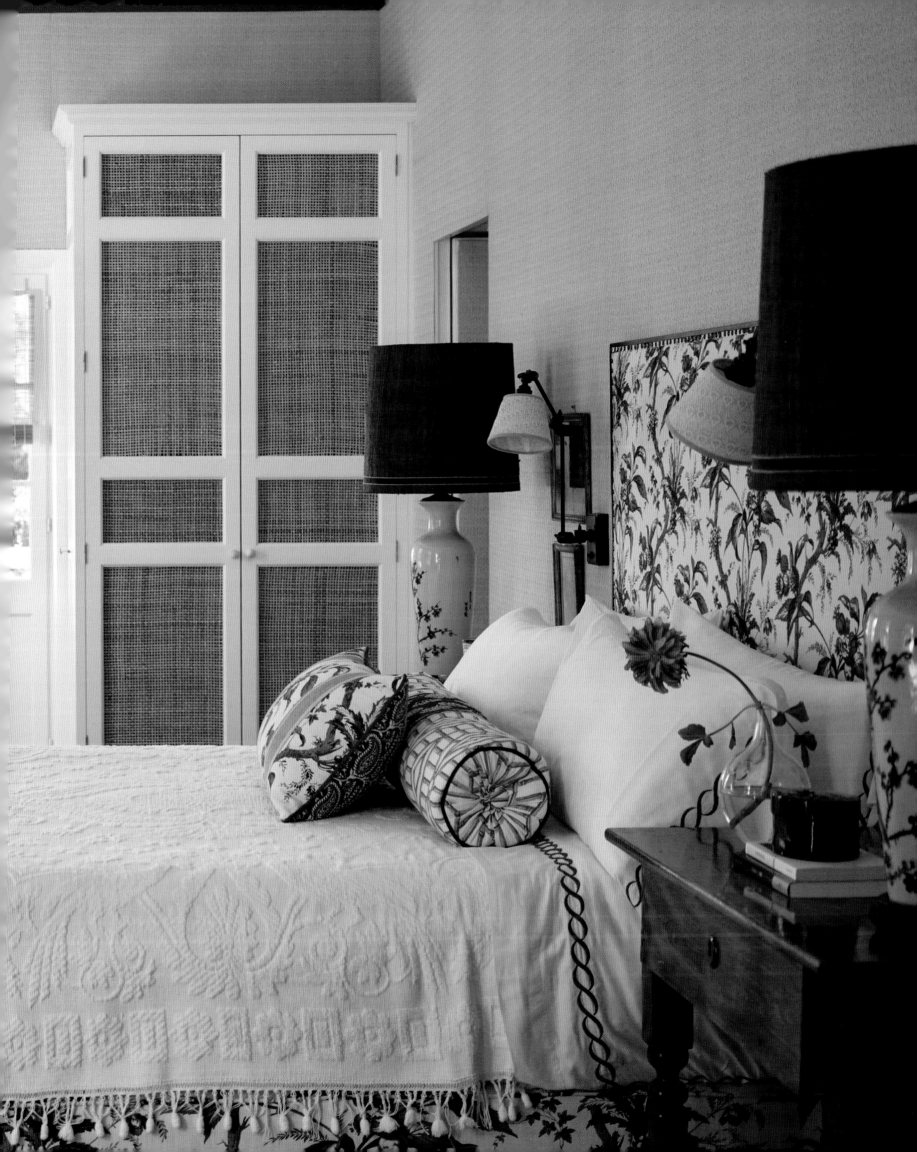

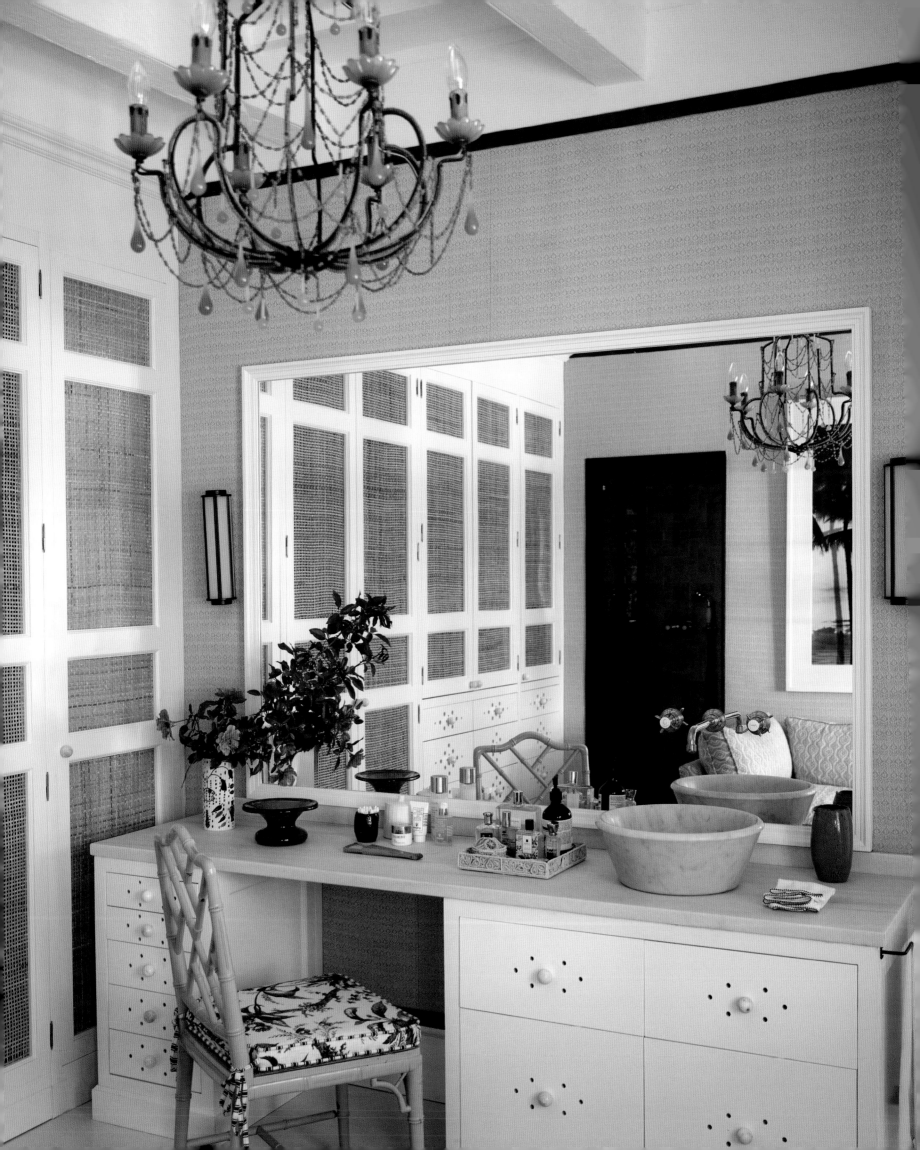

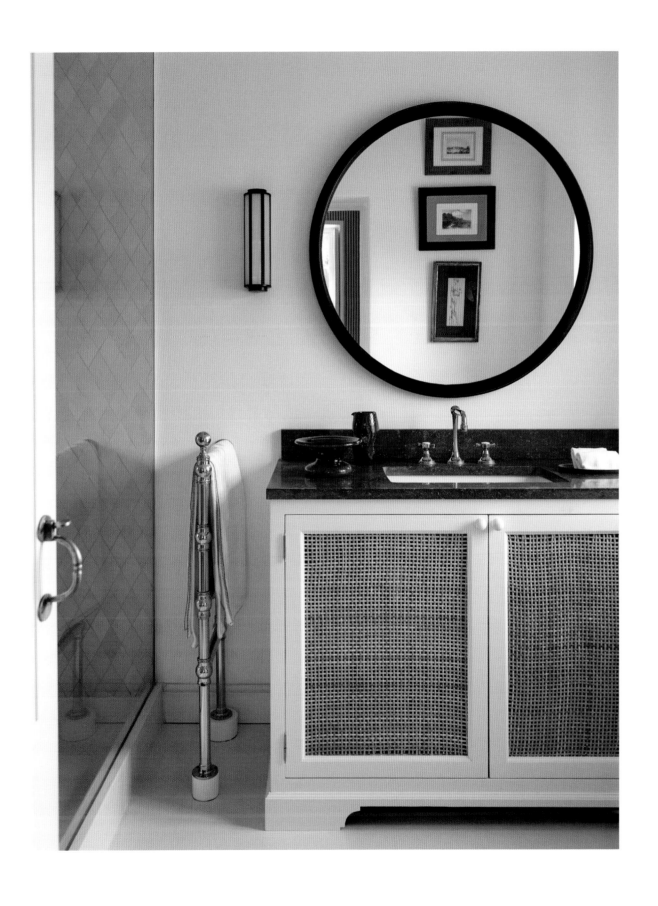

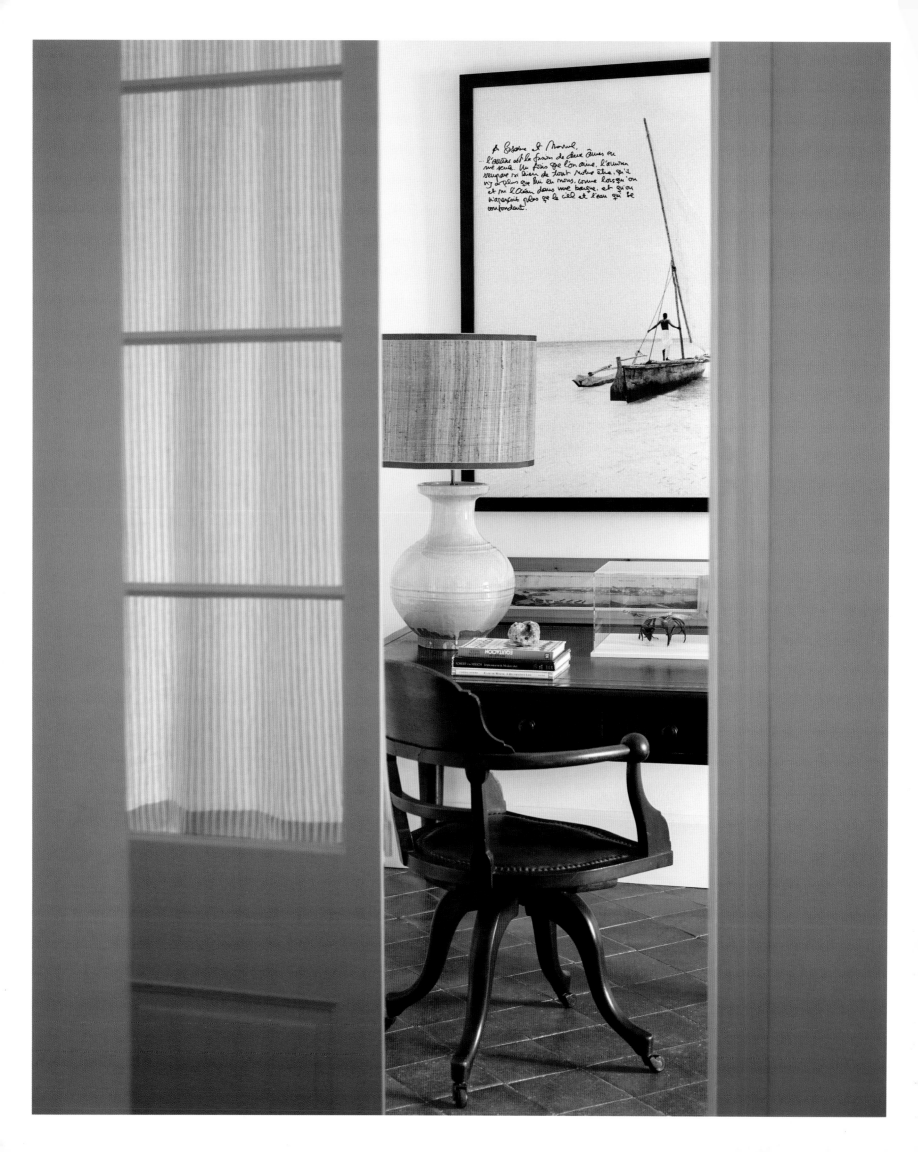

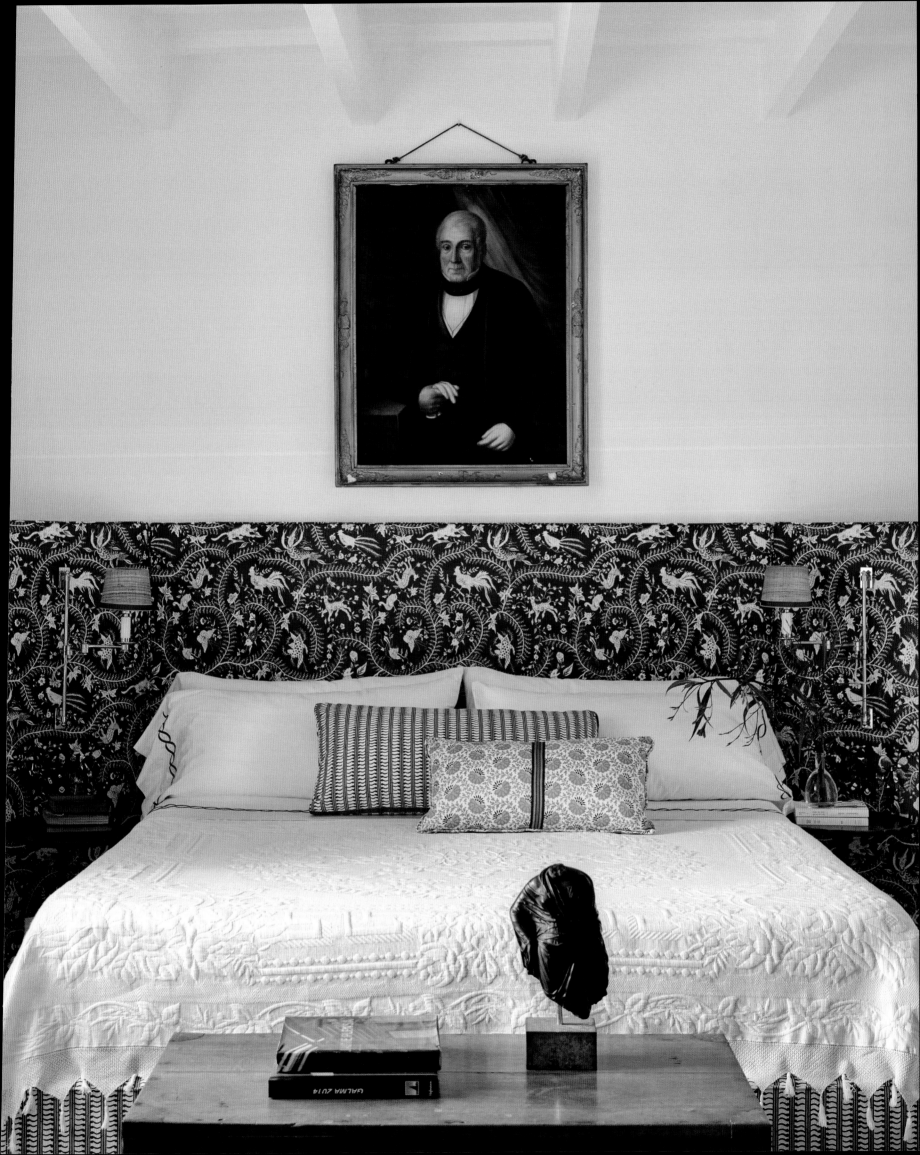

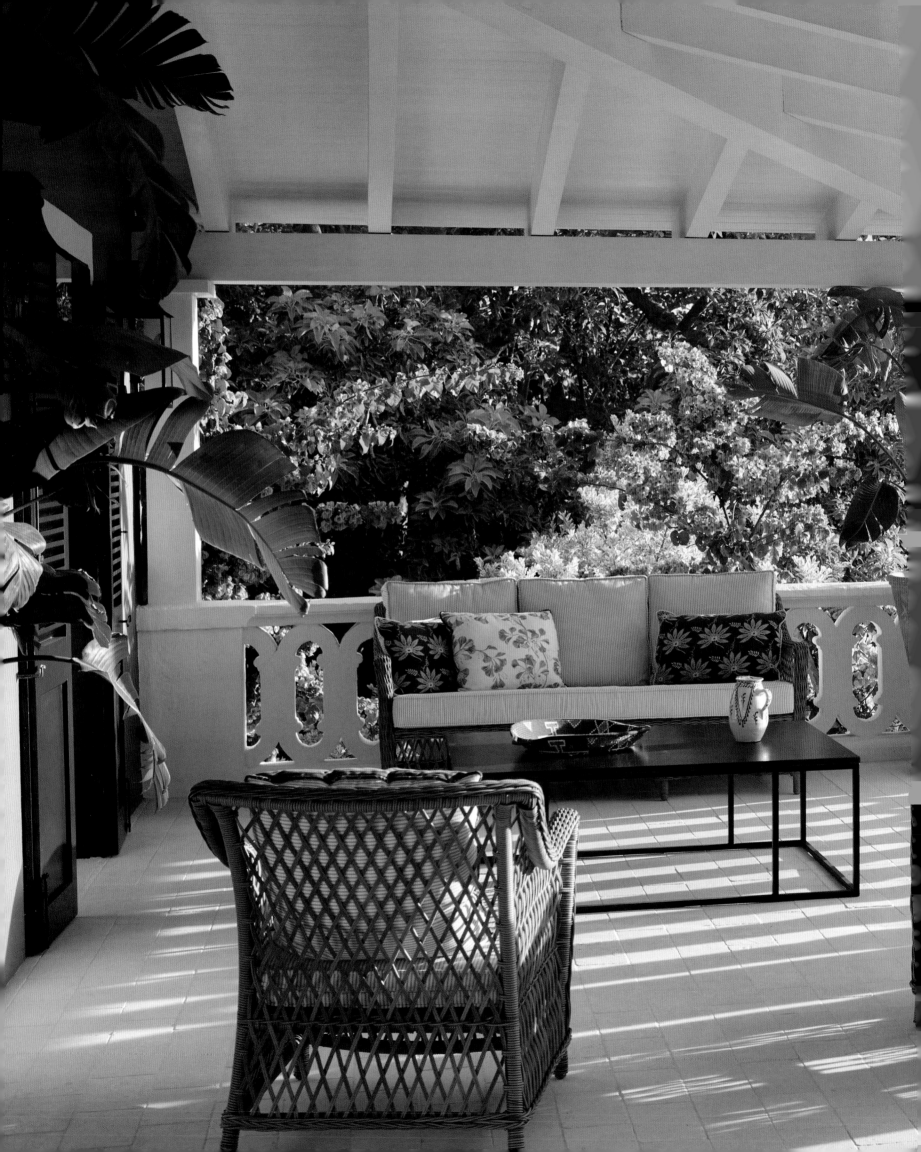

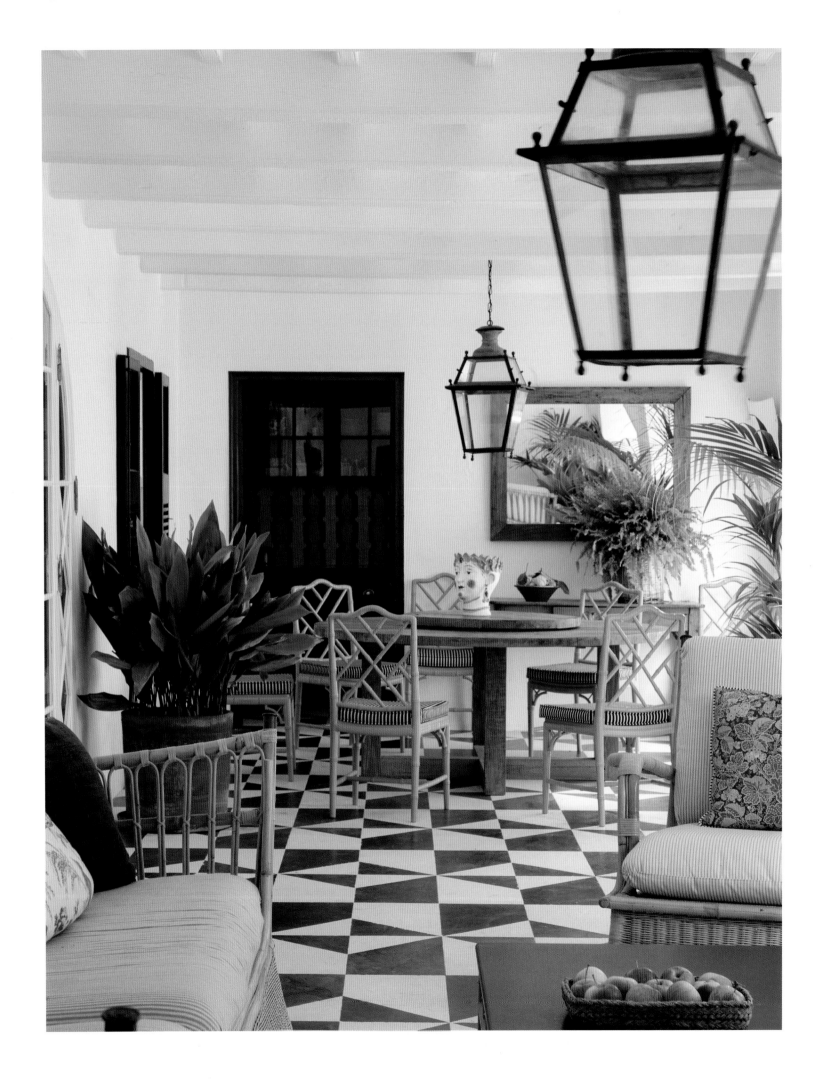

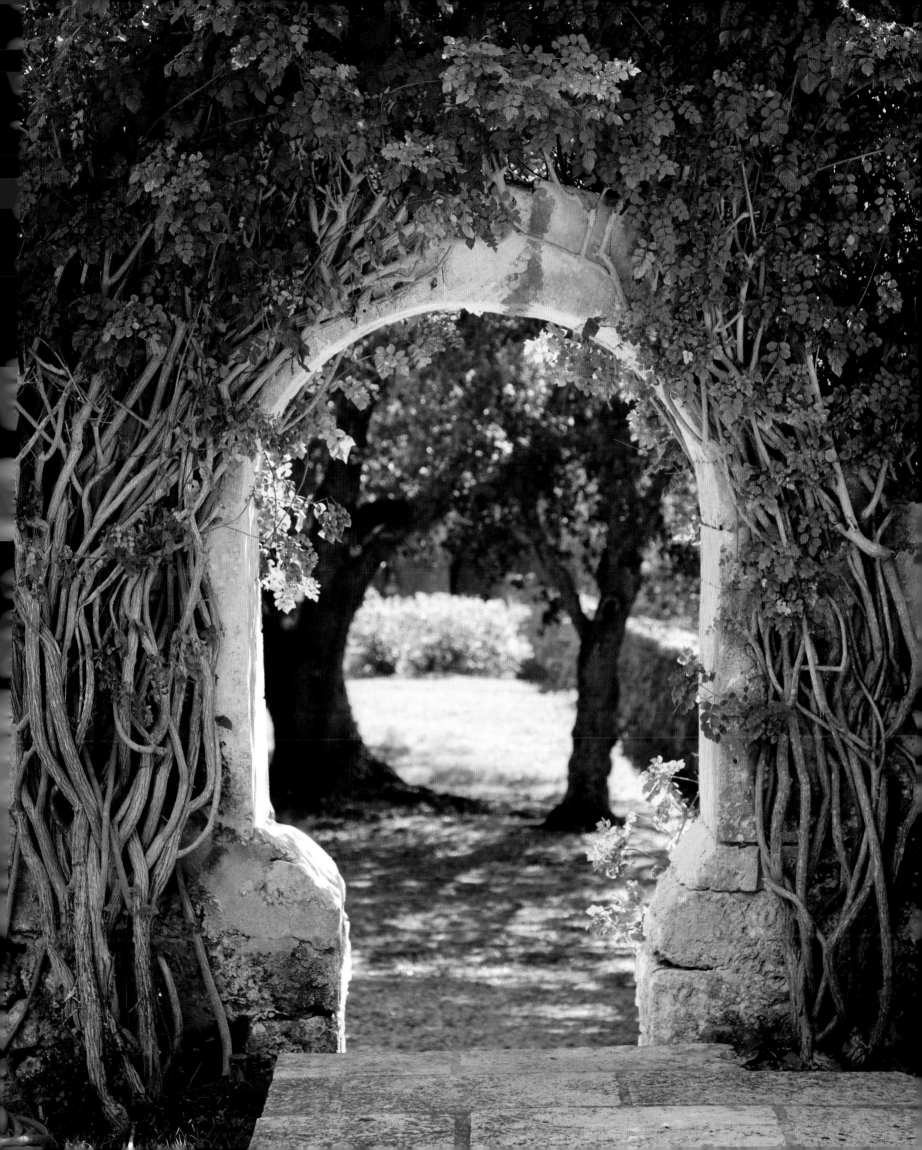

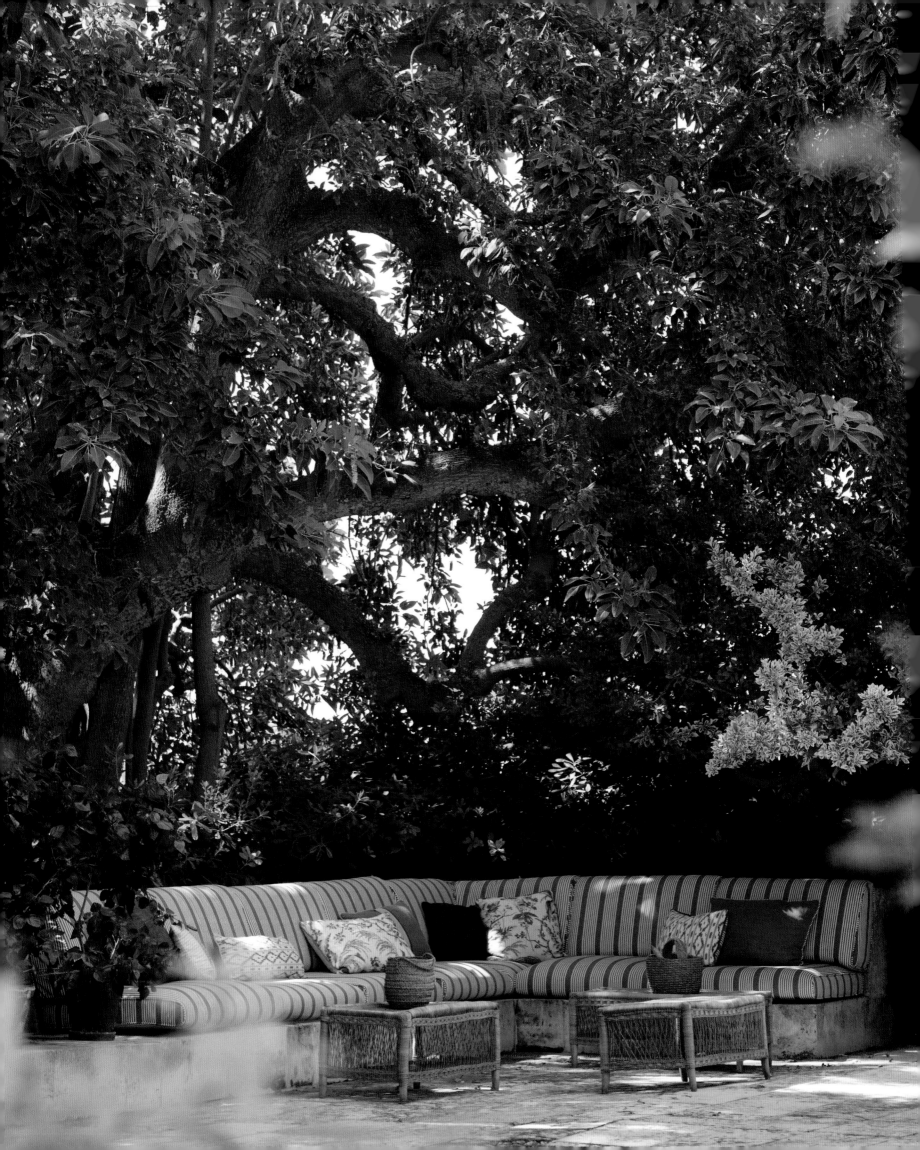

PAGE 321 This Menorcan estate sits in the countryside but is very close to the sea. The house dates from the middle of the nineteenth century and is in the English colonial style, with sash windows and green shutters. Fernando Caruncho's garden design twenty-five years ago respected eight Argentinian ombú trees. He reconstructed walls and entrances to create walkways that give views of the sea and installed benches in front of the house. The garden design gently embraces and enhances the house. In the foreground, a fountain burbles under the ombú trees.

PAGES 322–23 In the large, illuminated hall, a Spanish table takes pride of place opposite the entrance archway. The colonial-style floor is beige and black. On the staircase, risers are tiled in black and white.

PAGES 324–25 The lounge has three English-style sash windows and a central French stone fire surround. The large living area is arranged around the fireplace, with a daybed marking off the space. On the left of the fireplace is a French book cabinet; a naval painting hangs to the right. The roof beams and walls are painted white. A large mat covers almost the entire floor, which is laid with *marés* stone from the island.

PAGE 326 Two antique naval paintings hang beside a French writing desk in the lounge.

PAGE 327 The large, light-filled dining room opens onto the back porch. A cabinet for storing crockery, glassware, and table linen sits at the back of the room. The table is covered by antique suzanis and decorated with an arrangement of Gordiola glass from Mallorca and porcelain bowls.

PAGES 328–29 The generous primary bedroom looks to the south, over the ombú trees. A door at the back of the room leads onto an extensive, beautiful terrace with views of the country and the sea. Sash windows reveal glimpses of pink bougainvillea. The walls are covered in beige raffia, the closet doors have rattan panels to help deal with the humidity, and matting covers the floor. A French chest of drawers conceals the TV.

PAGE 330 The woman's bathroom and dressing room, reached from the right of the bedroom, has a feminine style with a countertop dressing table and vanity, a chaise longue placed between two aquamarine cupboards, and a pink glass chandelier from Paris. The decor features raffia, as in the bedroom. This bathroom also leads onto the magnificent terrace.

PAGE 331 The man's bathroom and dressing room is to the left of the main bedroom and is decorated in brown and beige stripes with raffia furnishings.

PAGE 332 The second guest bedroom is reached via a writing space featuring an English desk and a mahogany chair. The large, framed black-and-white photograph was a wedding present. The lovely classic red Catalan floor is typical of these houses.

PAGE 333 In the second guest bedroom, the headboard wraps around the wall, encompassing small bedside tables. The bed is made up with vintage French bedding. An old portrait adds a touch of solemnity.

PAGES 334–35 Adjoining the primary bedroom and bathroom is a large terrace with an original balustrade in *marés* stone from the island offering views over the countryside to the sea. Iron and wicker furniture and Italian planters complete the space.

PAGE 336 The porch and hall share a black and beige floor, with separate living and dining areas. The furniture is bamboo in natural and green shades, as are the fabrics used here.

PAGE 337 An archway leads from one garden area to another.

PAGE 338 Landscape architect Fernando Caruncho designed these large stone benches in front of the house and beneath the ombú trees, creating a shady seating area, cushioned in striped and floral fabrics in greens and blues.

THE SIMPLE BEAUTY OF MONTE SAN FRANCISCO

Monte San Francisco ranch is located on a tropical estate in the municipality of Jarabacoa, in the mountains of the Dominican Republic's Central Range. Dedicated to breeding Brangus cattle and Peruvian paso horses—a breed descended from a mixture of purebred Spanish and Barb horses—Monte San Francisco emanates a feeling of calm. This was its owner's dream: to create a simple place where feelings and emotions can be experienced without the need for excessive decoration or superfluous posturing. The estate is named for Saint Francis of Assisi, to whom the Nicaraguan poet Rubén Darío dedicated his famous poem "Los motivos del lobo" (The motives of the wolf)—"The man who has the heart of the lily, the soul of a cherub, the heavenly tongue..."—and whose love of animals is felt here.

In this pursuit of purity and connection with nature, two neglected barns were brought back to life rather than being constructed from scratch. These simple architectural structures were originally used for animals and storing crops. The main barn at Monte San Francisco is in the English style, similar to those seen in the eastern United States, and was built in 1904, at the start of the twentieth century. The smaller barn in the Dutch style dates from 1891, the end of the nineteenth century. The project was completed in 2021.

Jeffrey Dungan's architectural studio was commissioned for the initial project, but the baton was passed to Isabel López-Quesada and architect Marta Marín. Maintaining the visually austere aesthetic requested by the client, they created a space that embraces a sense of the fundamental. The imposing thirty-foot-high (nine-meter-high) entrance of the main barn perfectly expresses the beauty of the structure's old pine. The facade's original design was changed, as well as the layout, and the space became a large living area with sofas, an old iron daybed, a large table, and a dining room at the rear. On the mezzanine above, a guest bedroom was created, and two further guest bedrooms were built beneath the barn, along with a cinema, an ironing room, service rooms, a kitchen, and an office. The small barn, about 330 feet (100 meters) away, houses the main bedroom. The garden and the swimming-pool area owe their mix of dynamism and subtlety to landscape architect Fernando Martos.

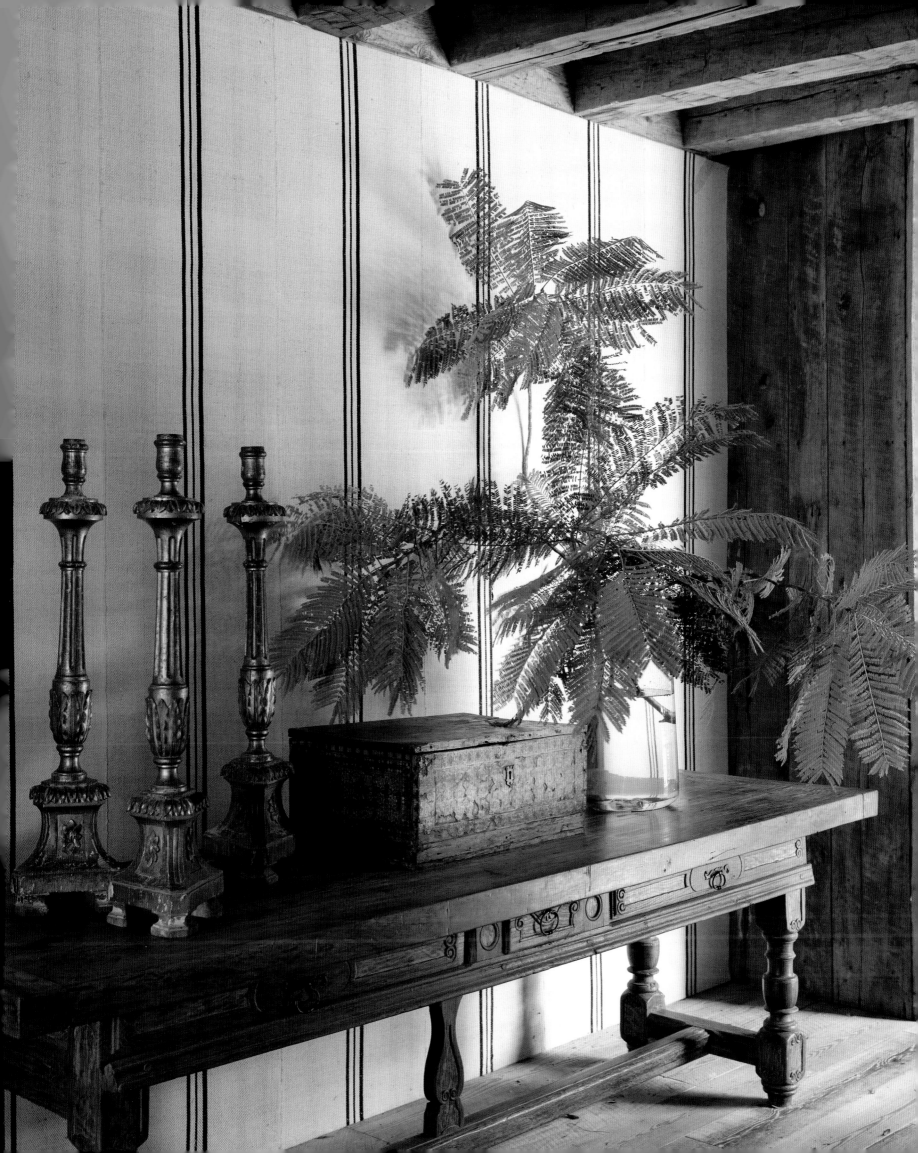

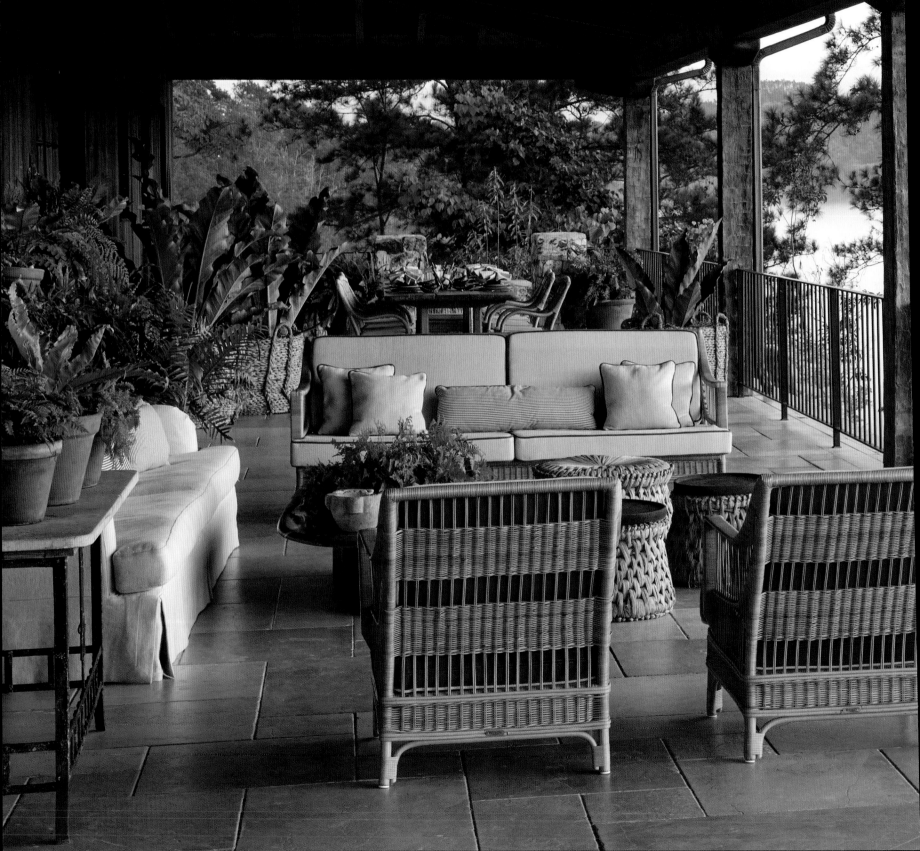

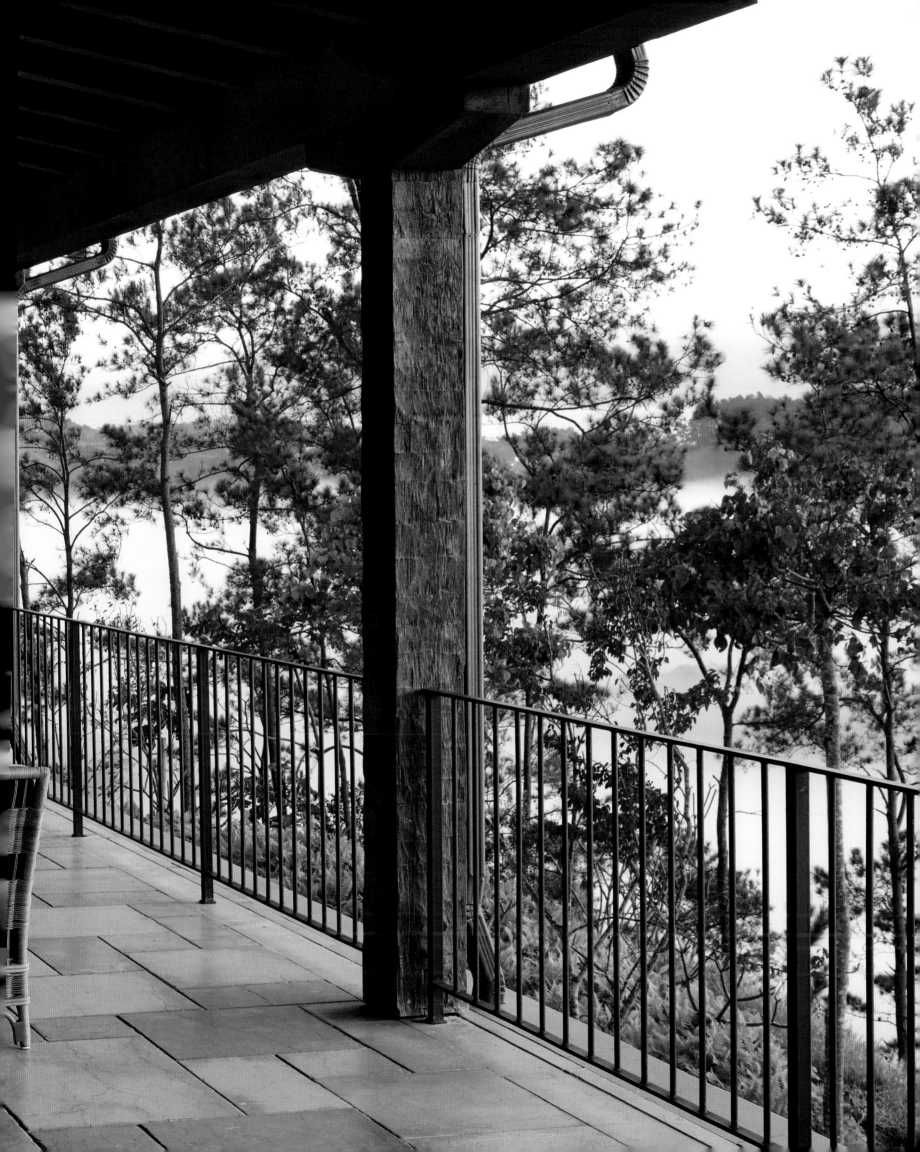

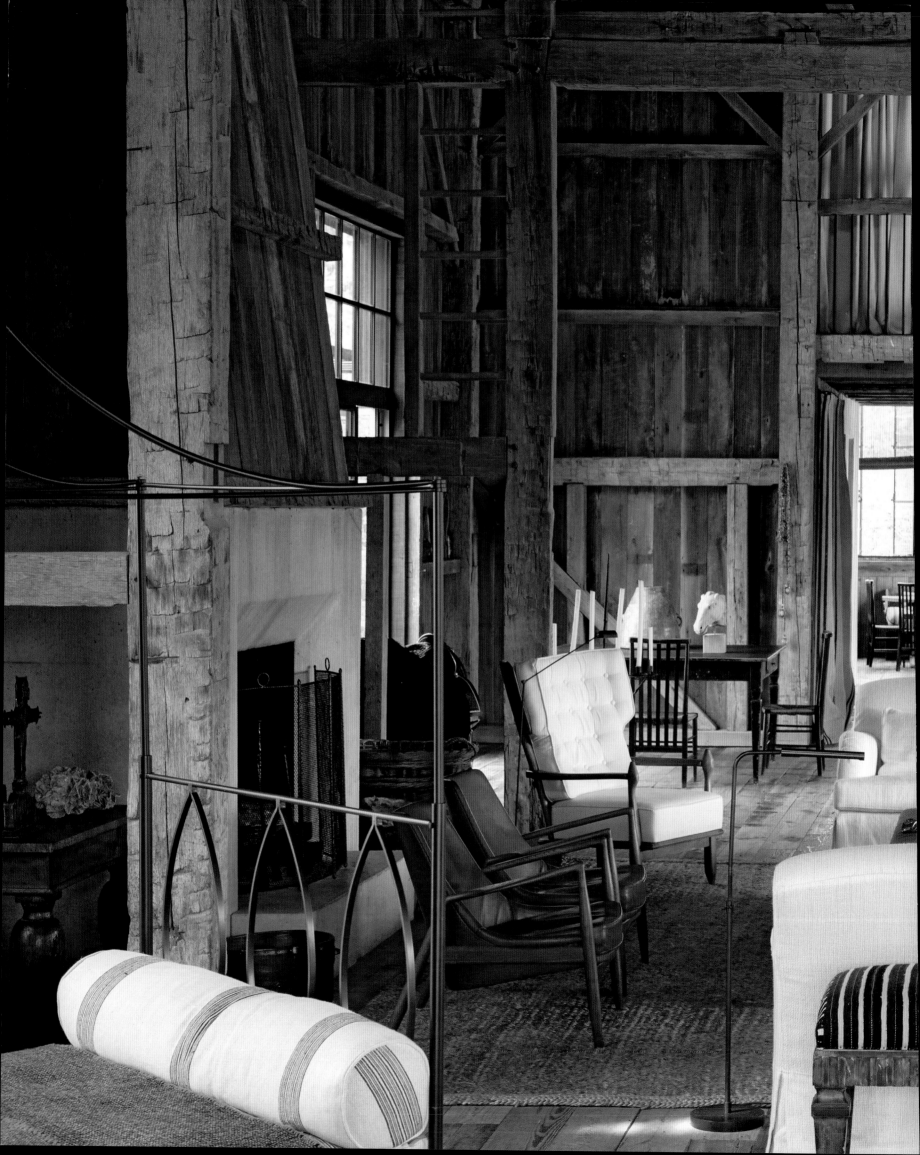

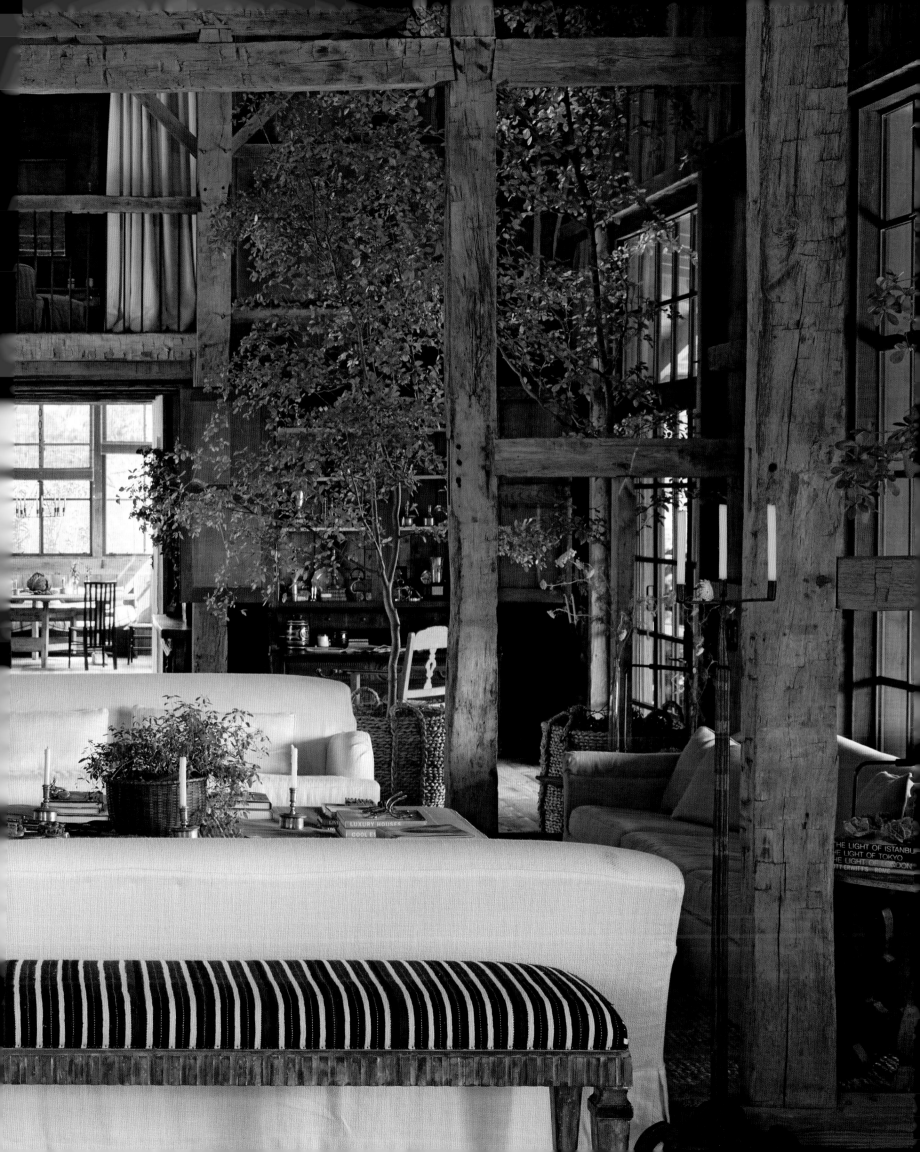

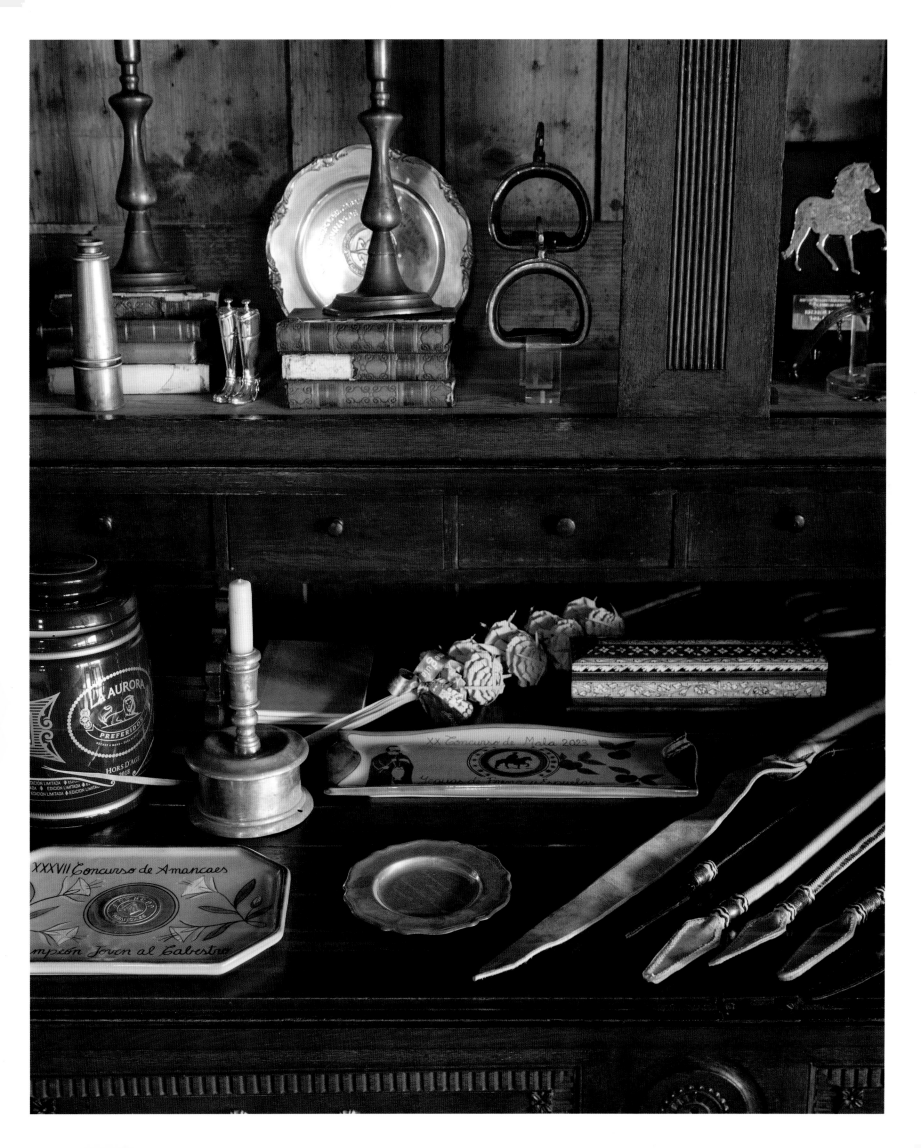

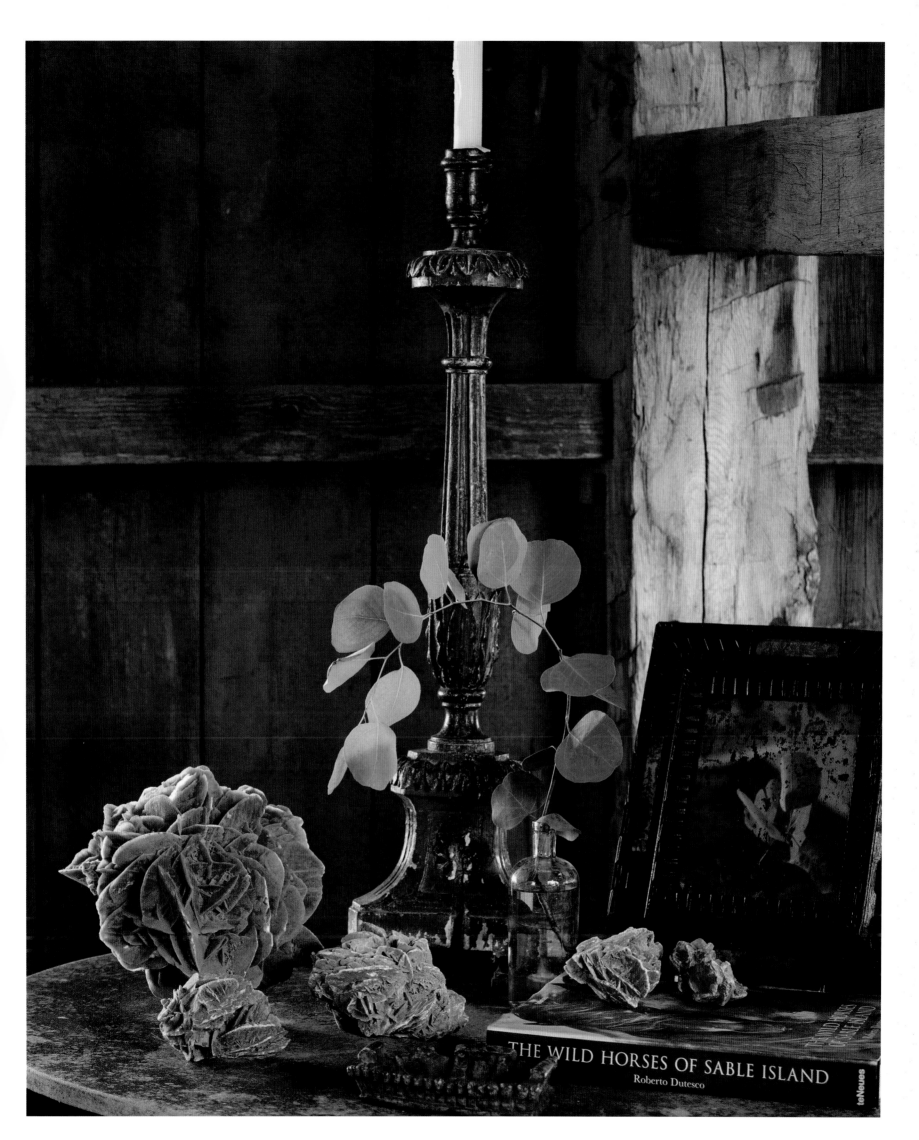

THE WILD HORSES OF SABLE ISLAND

Roberto Dutesco

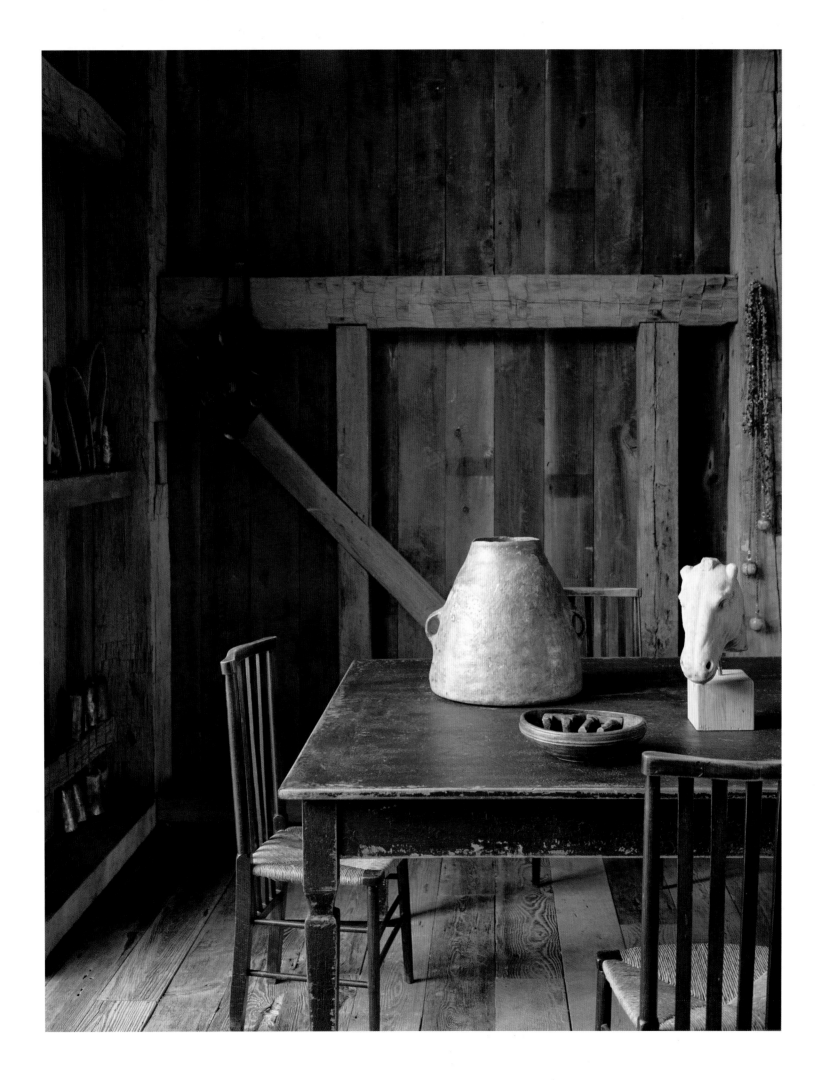

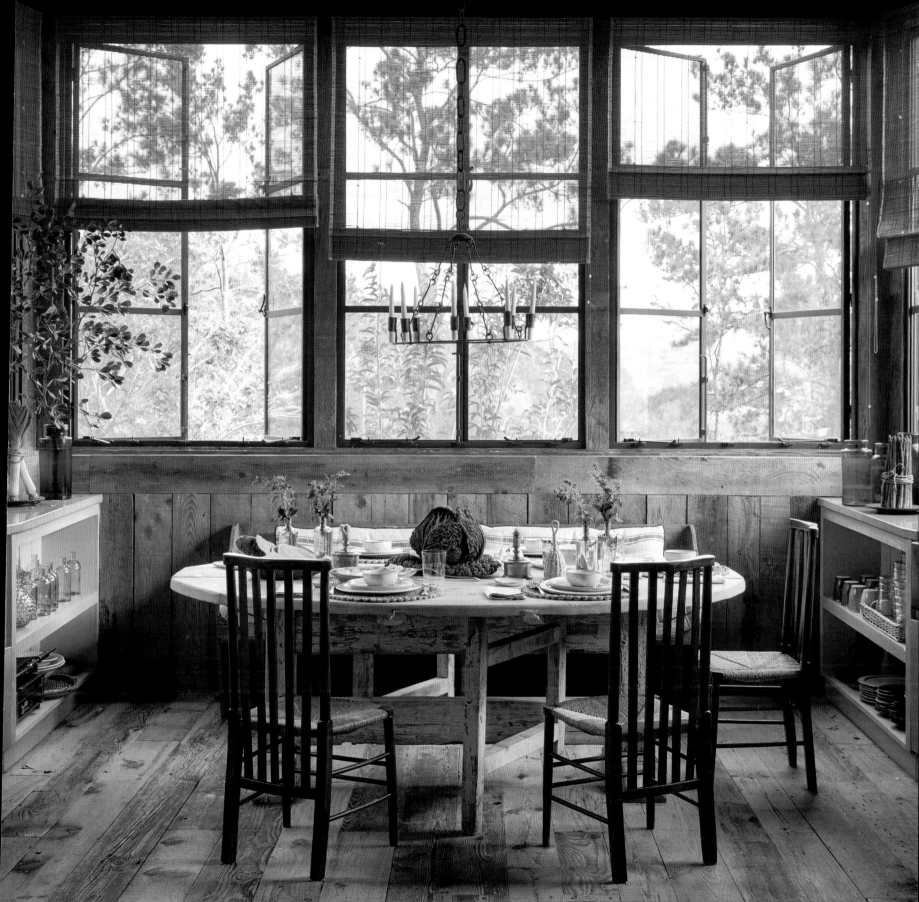

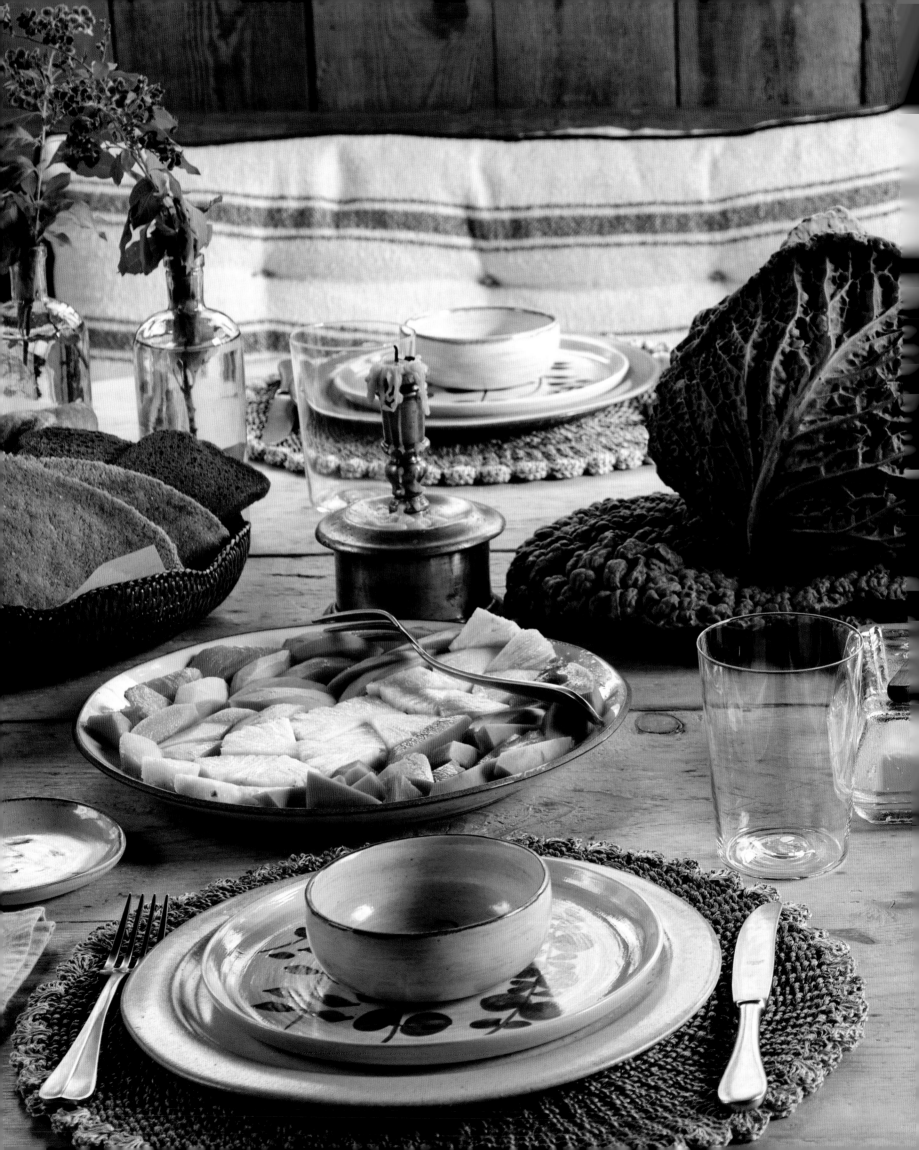

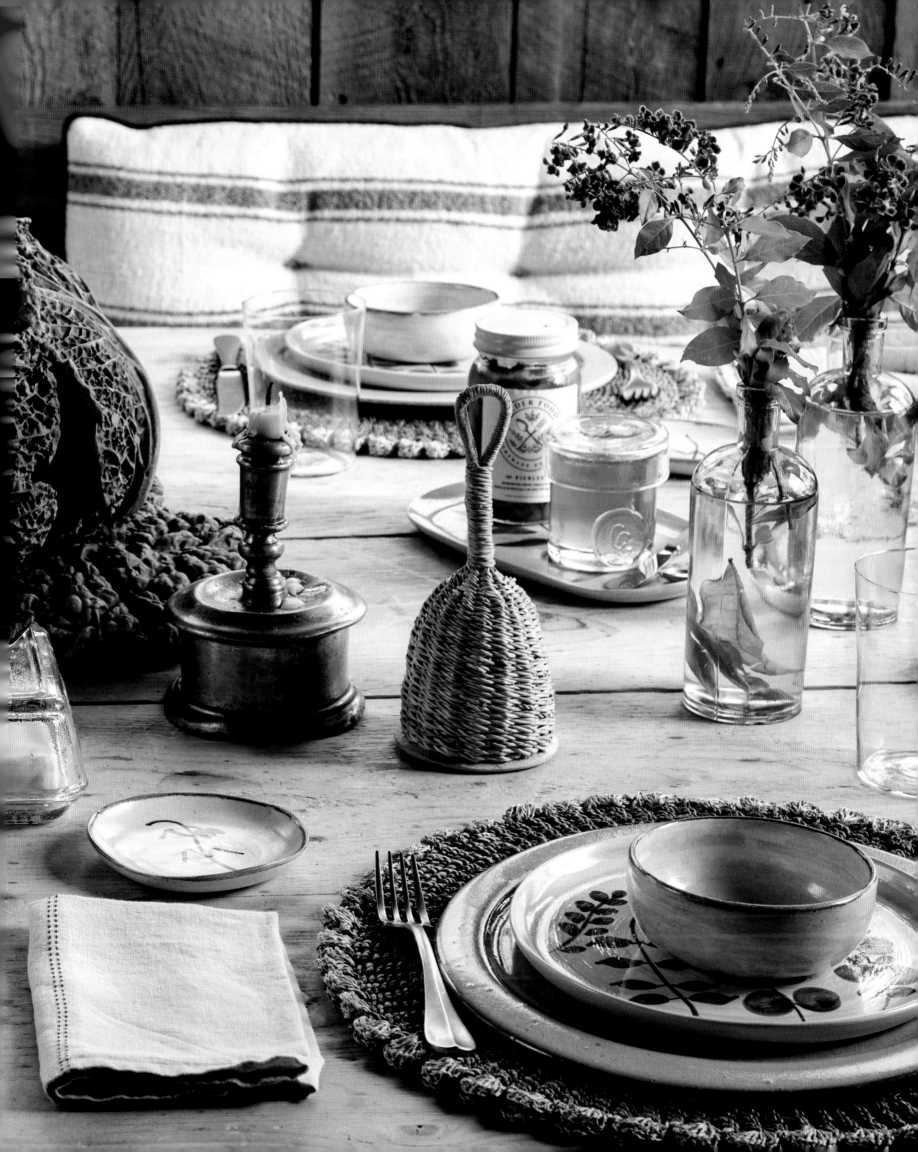

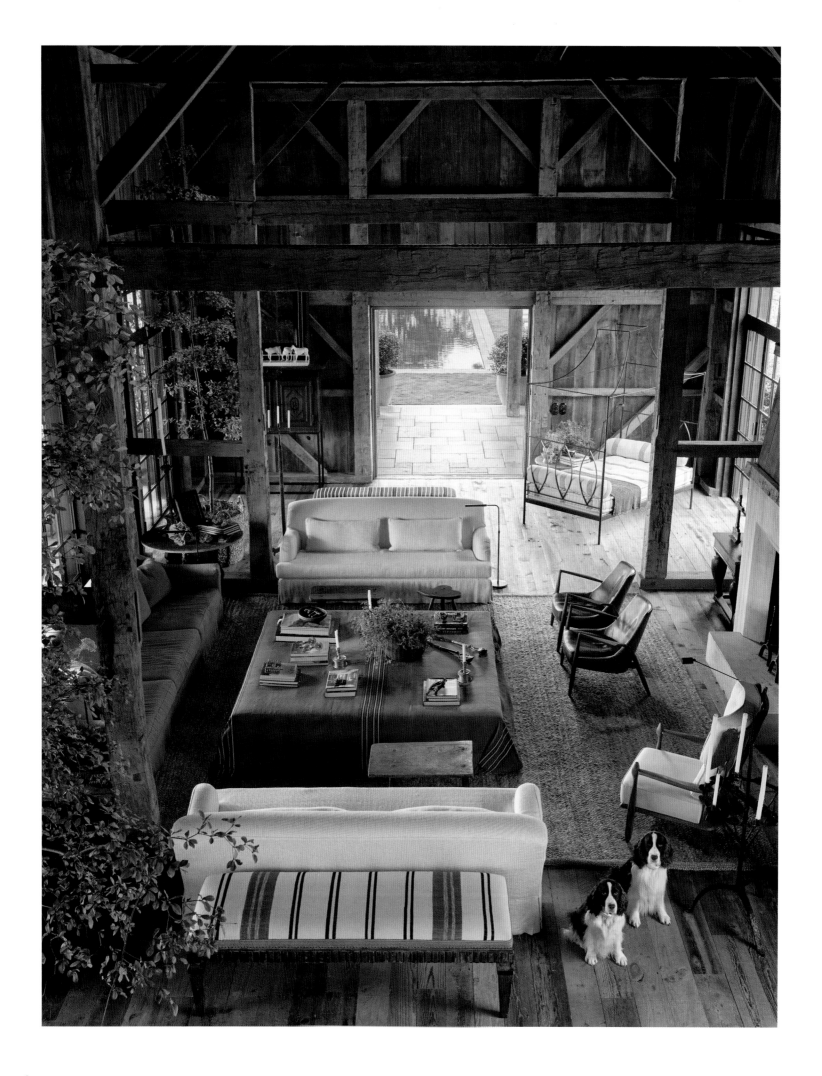

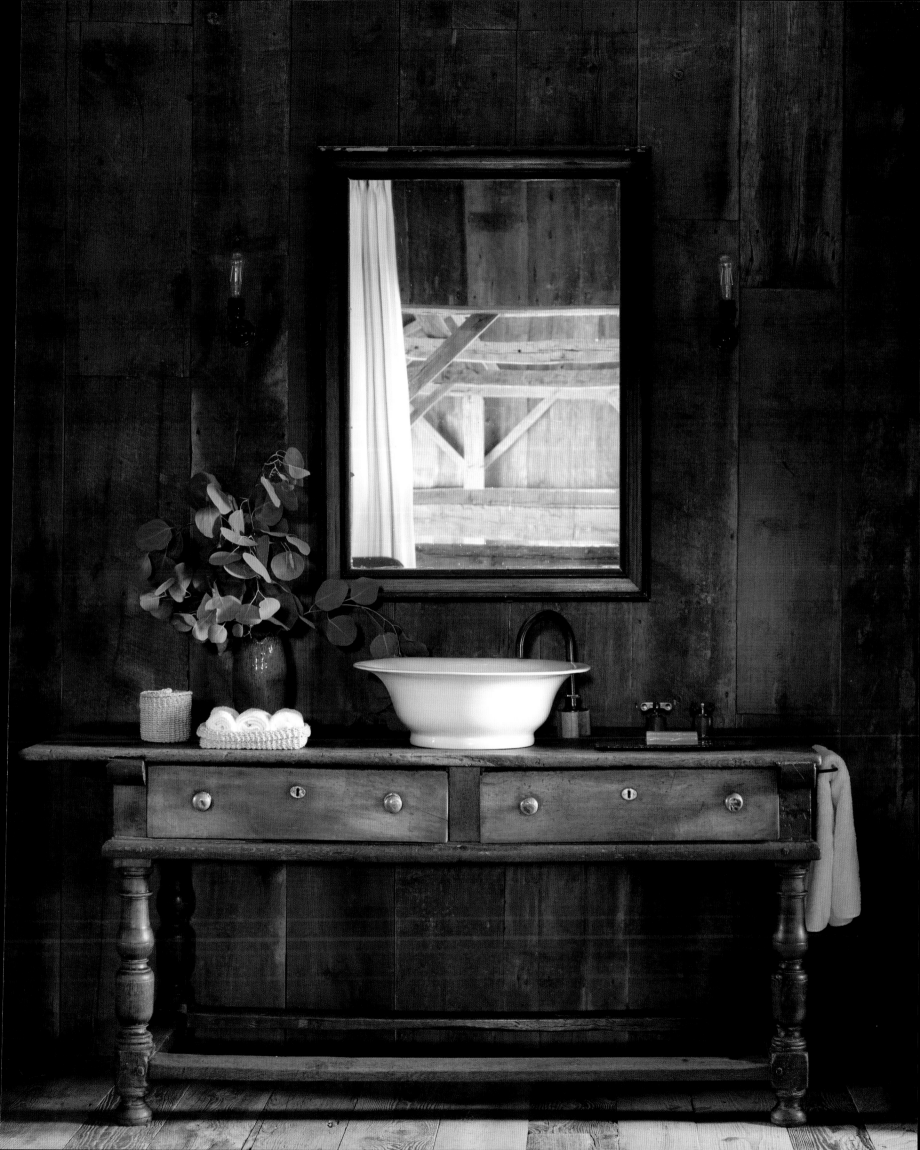

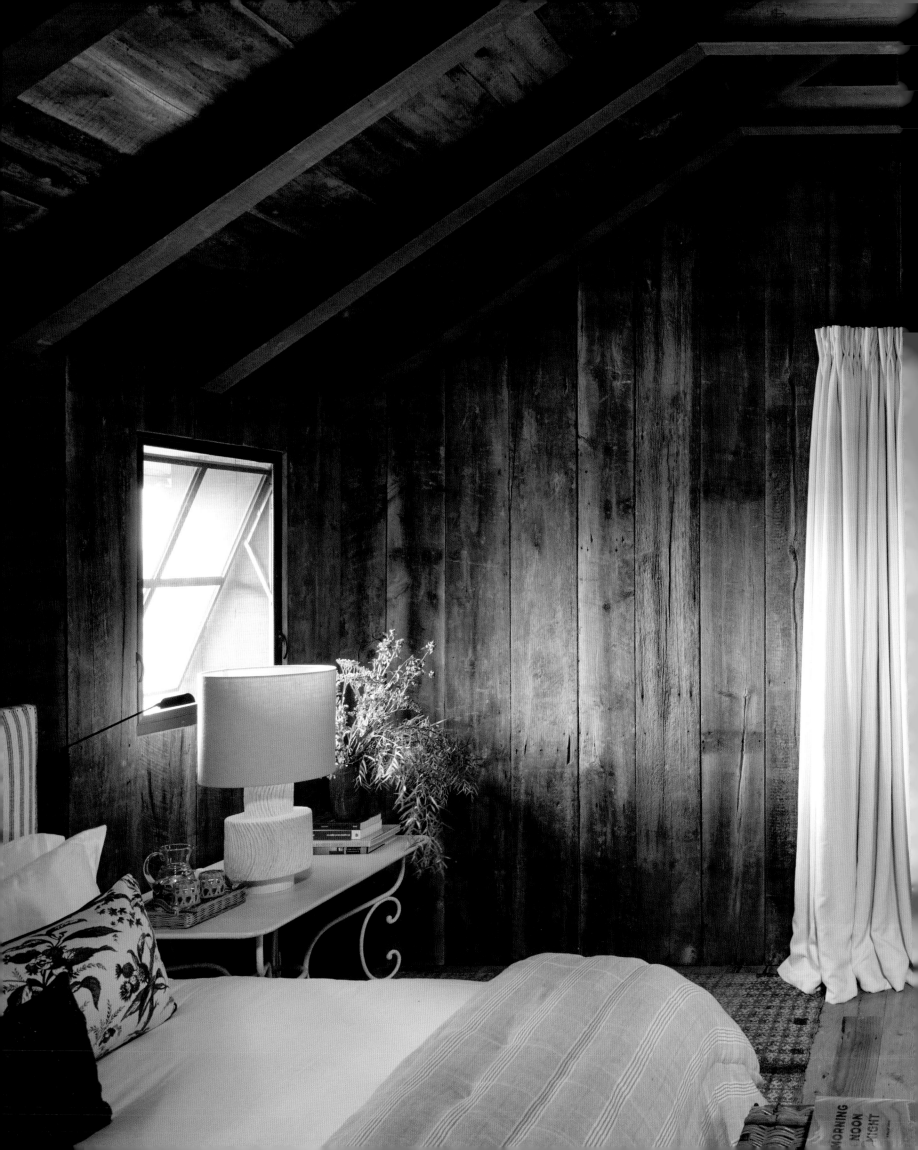

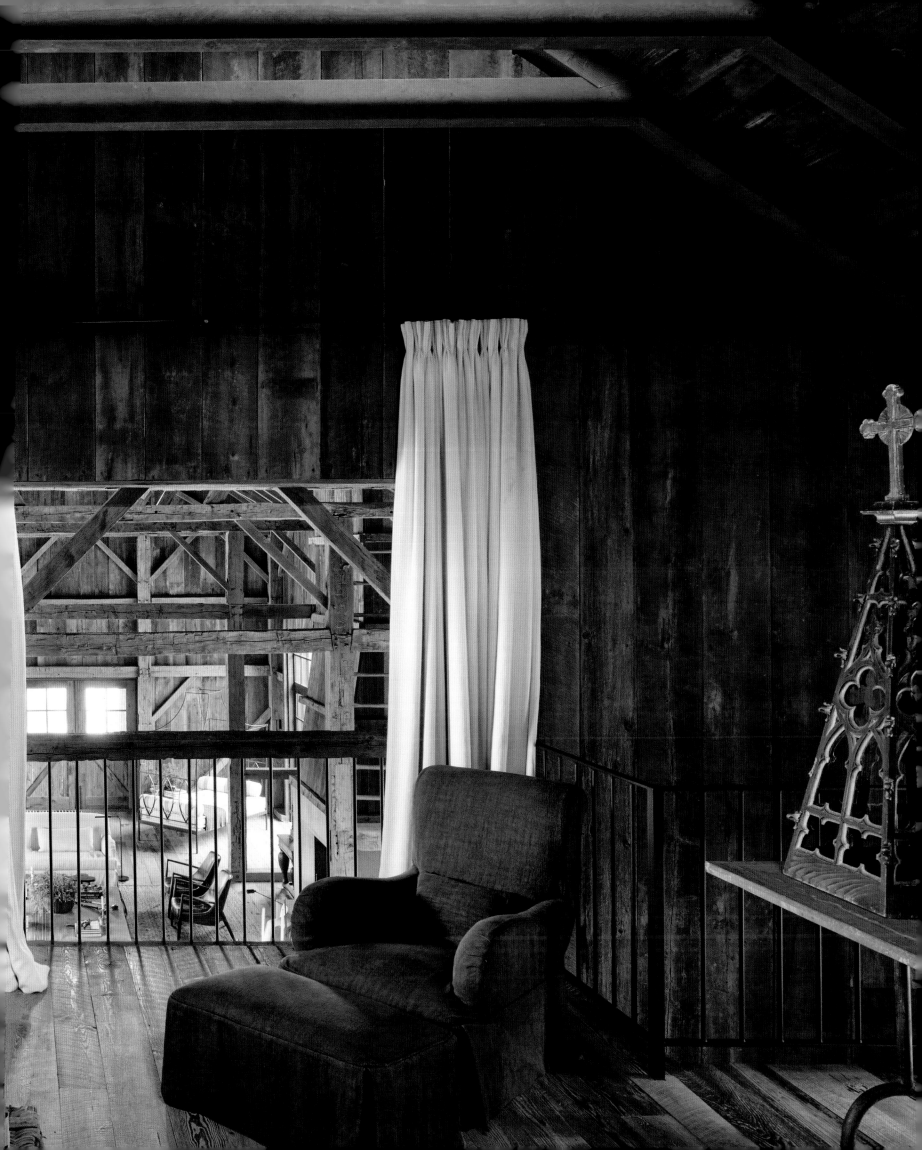

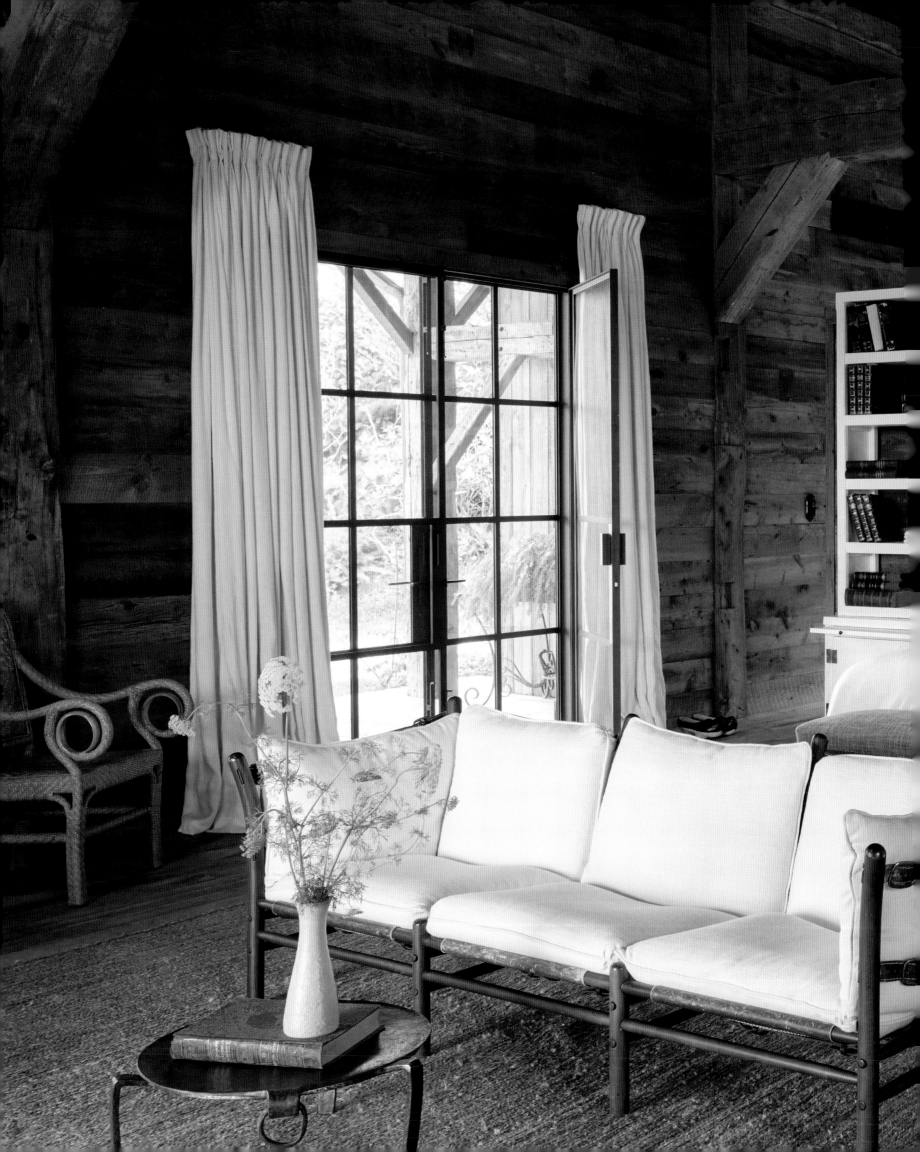

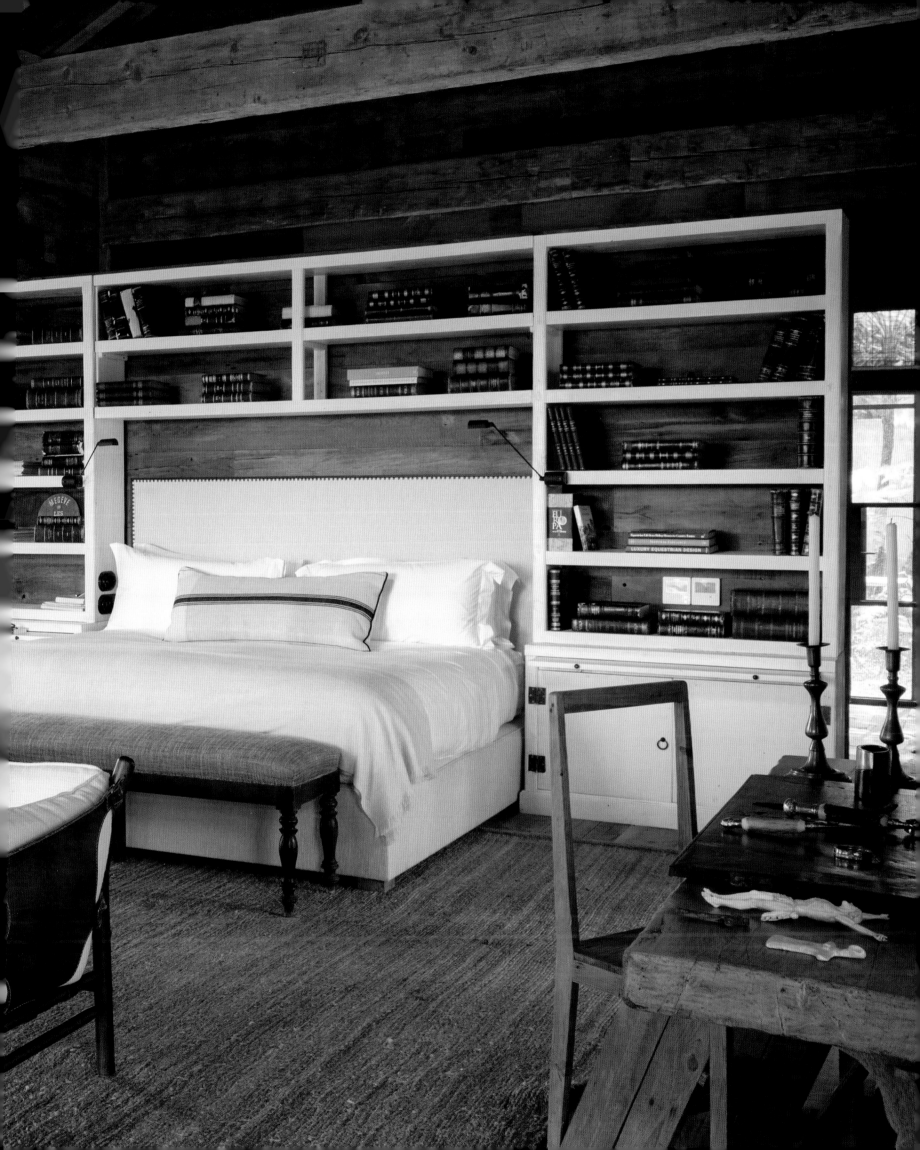

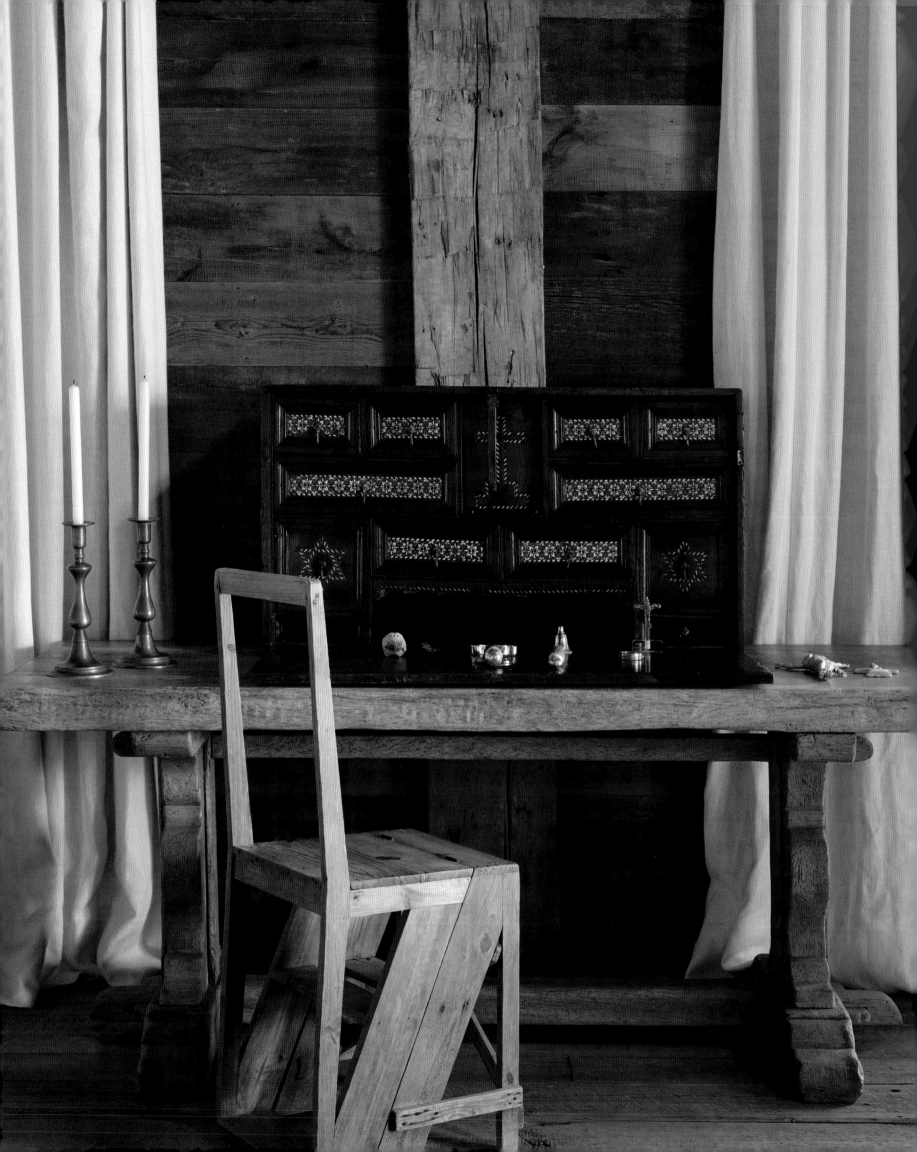

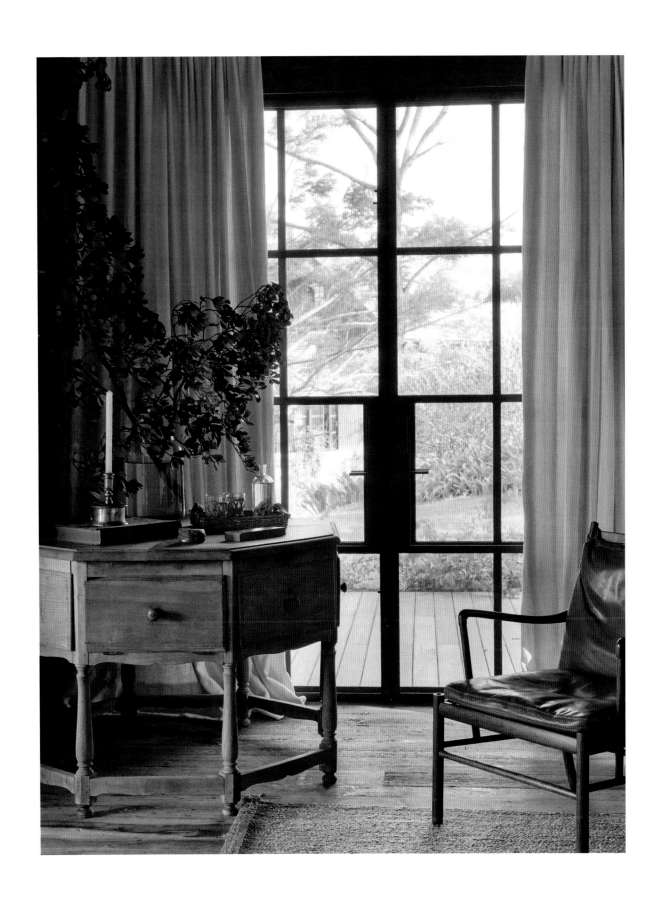

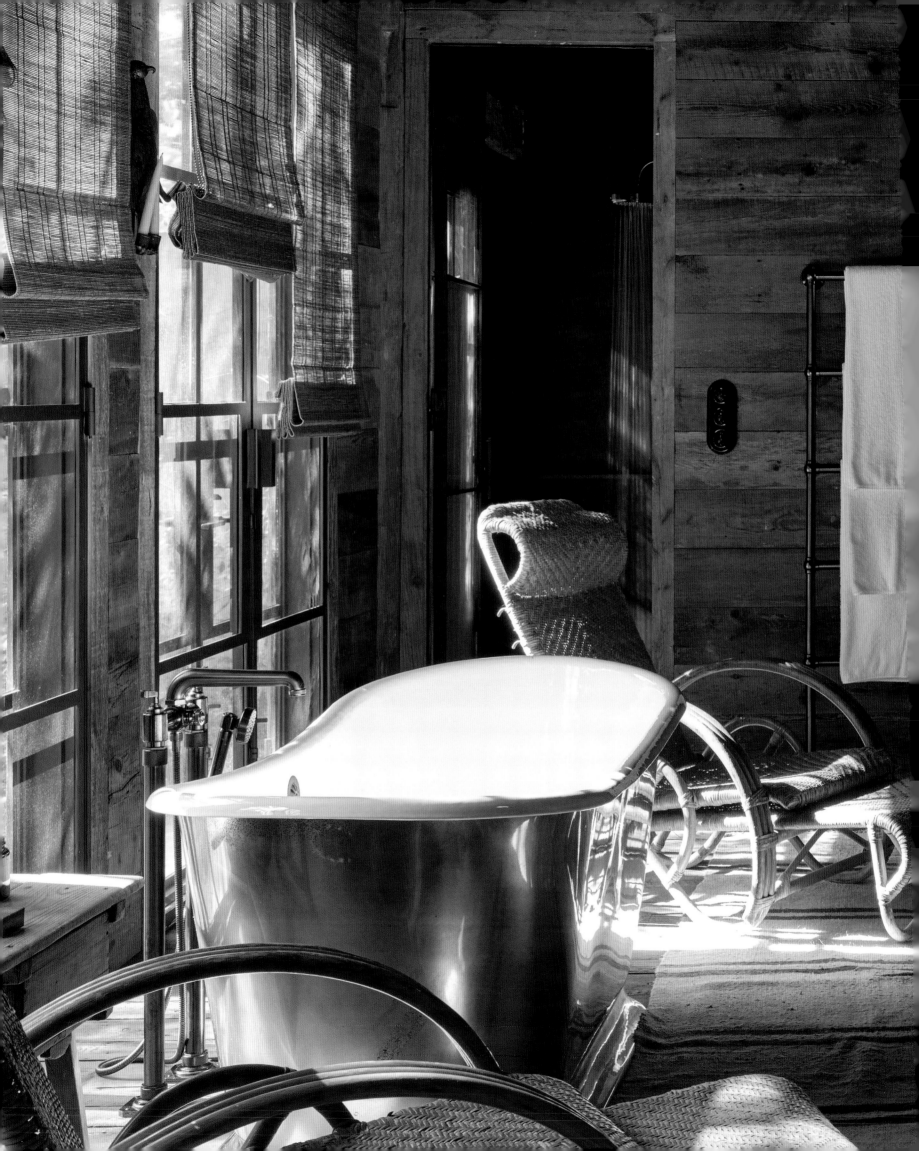

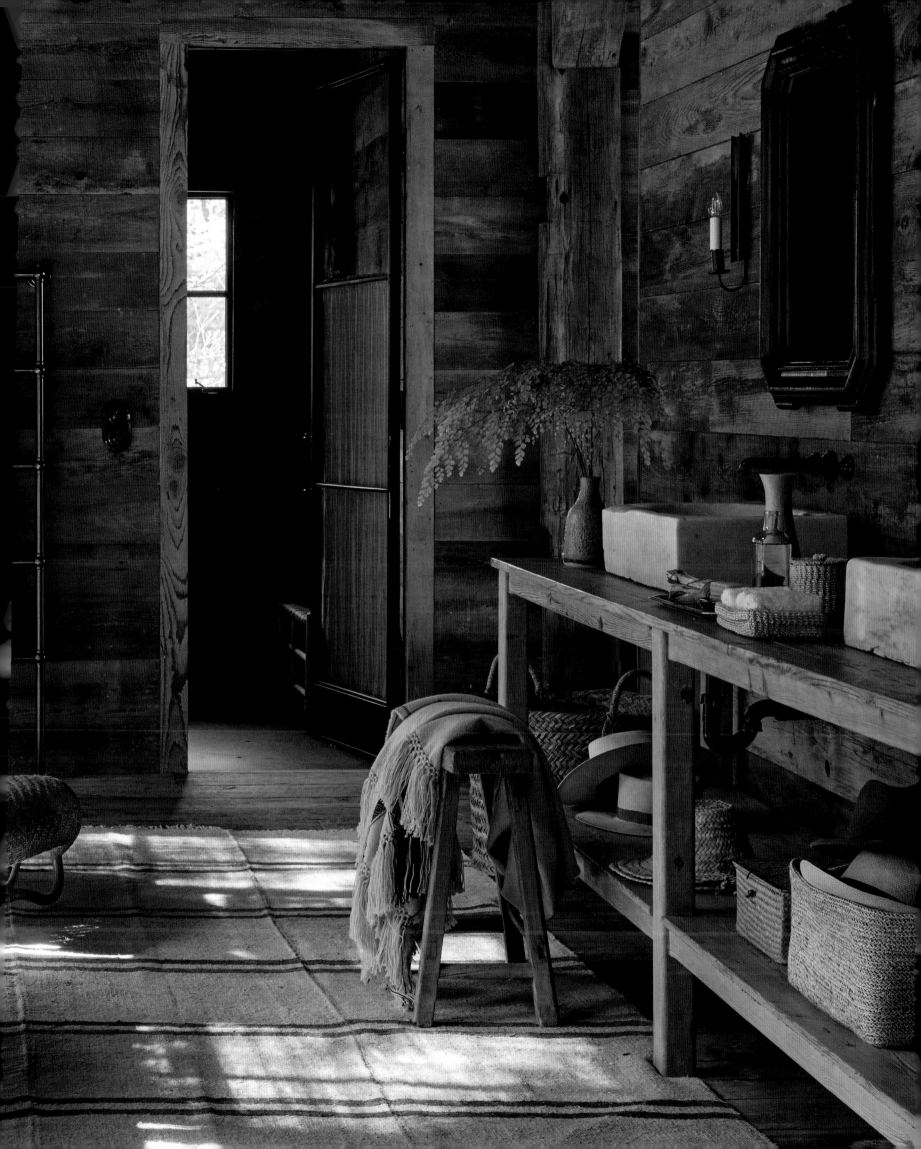

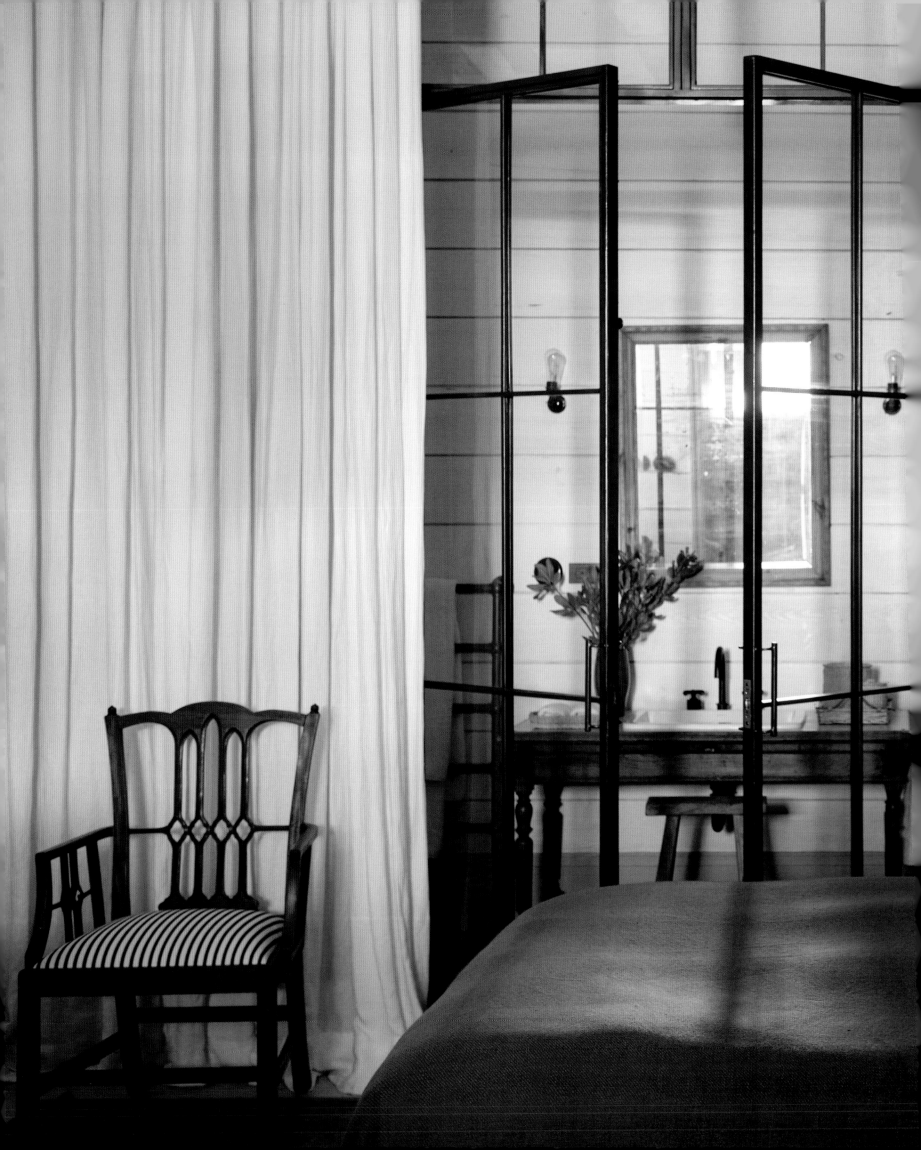

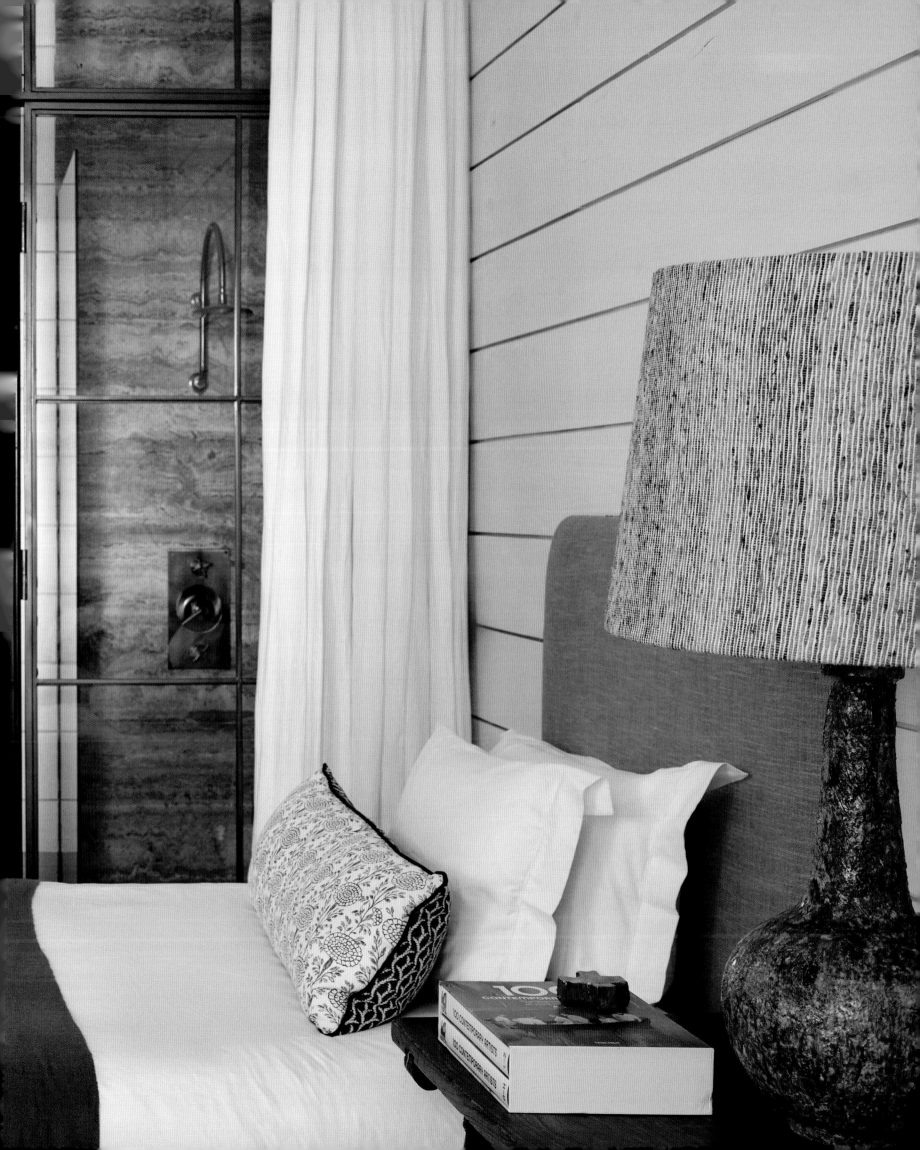

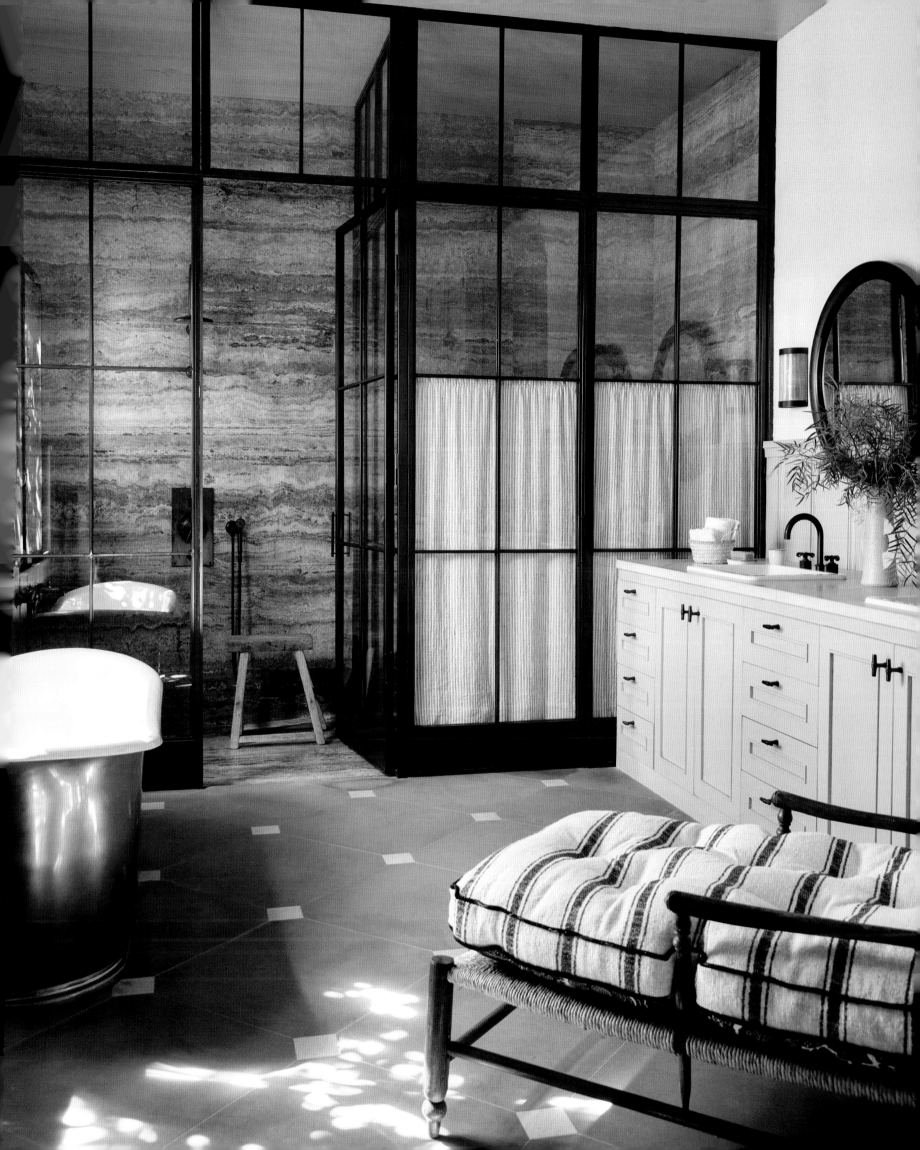

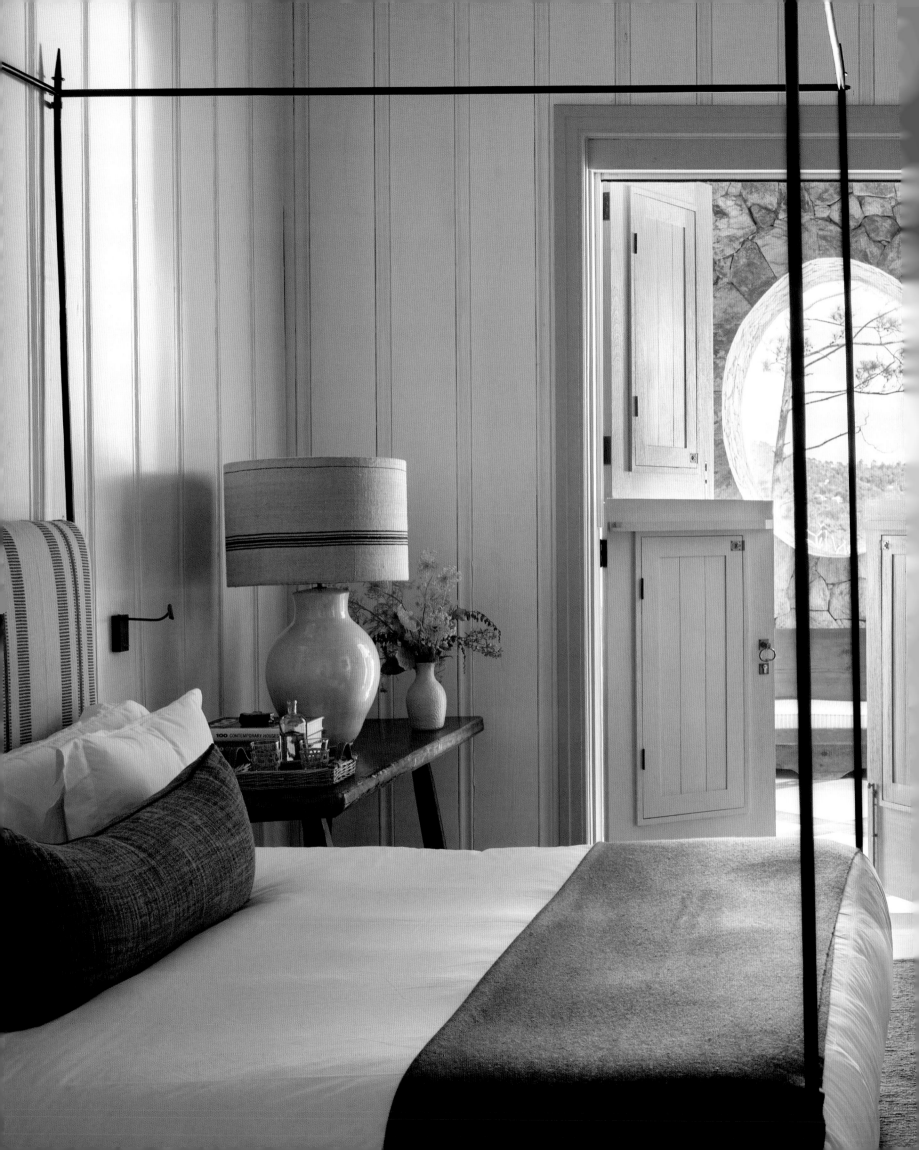

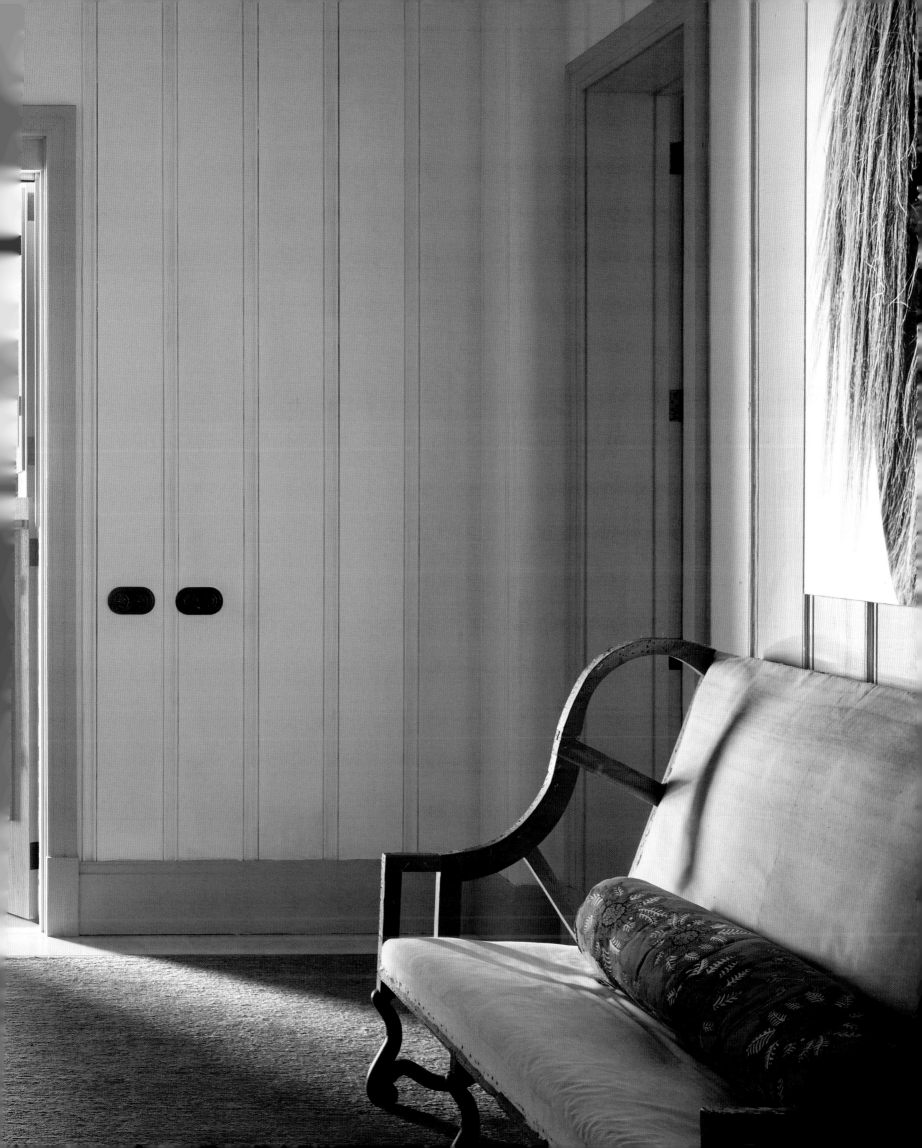

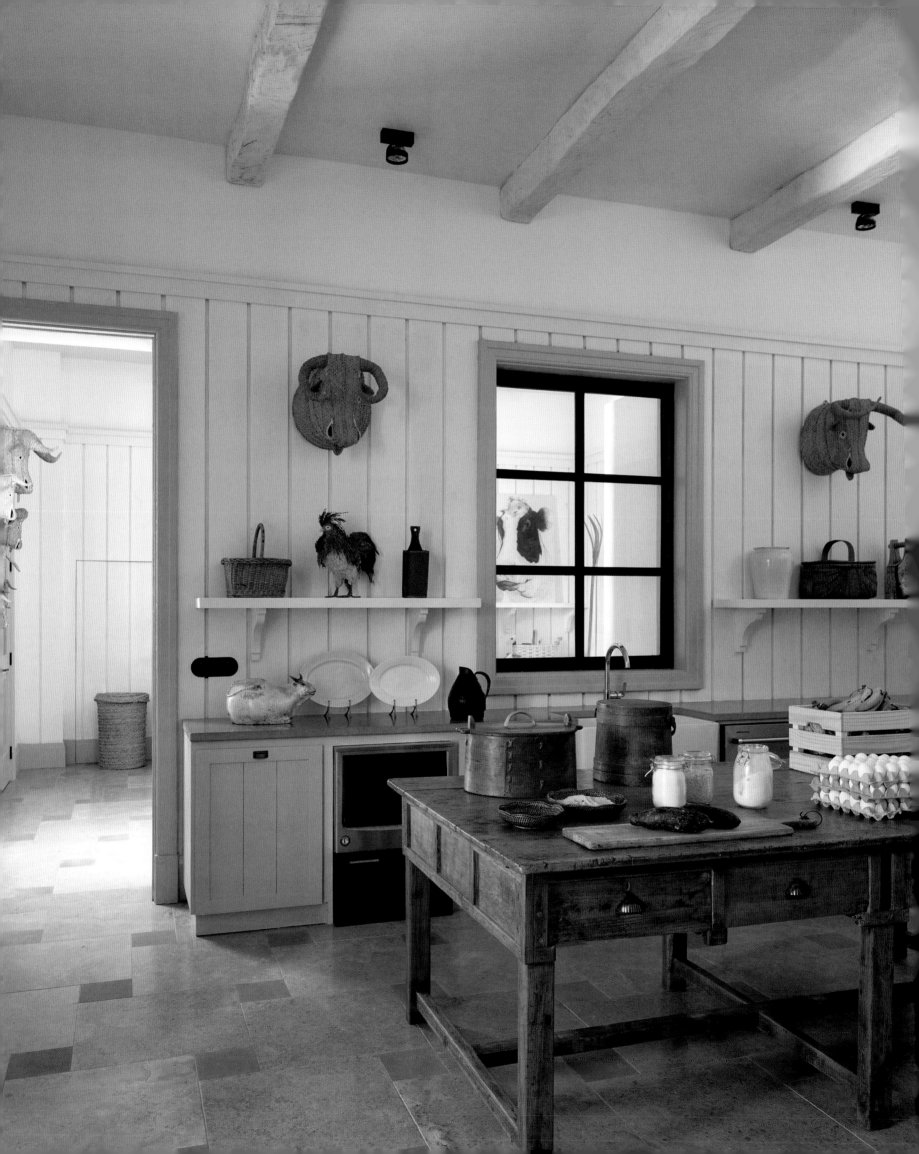

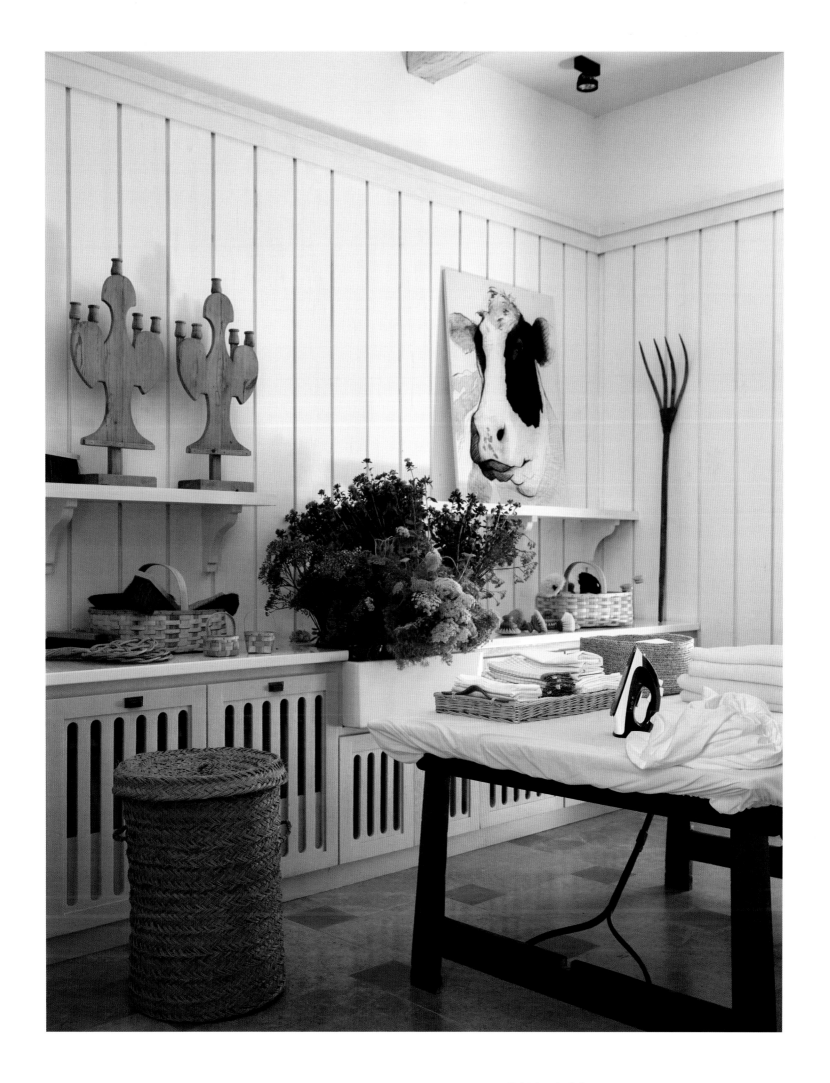

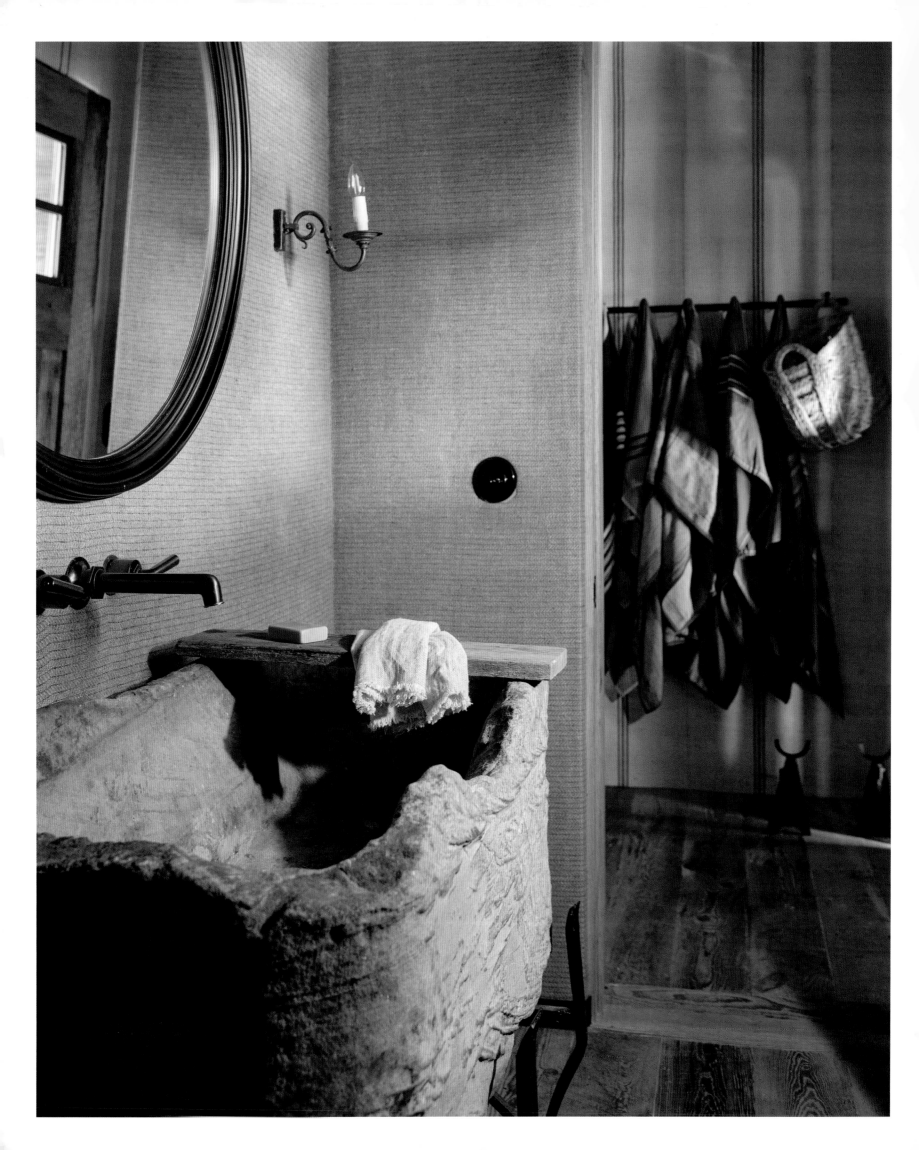

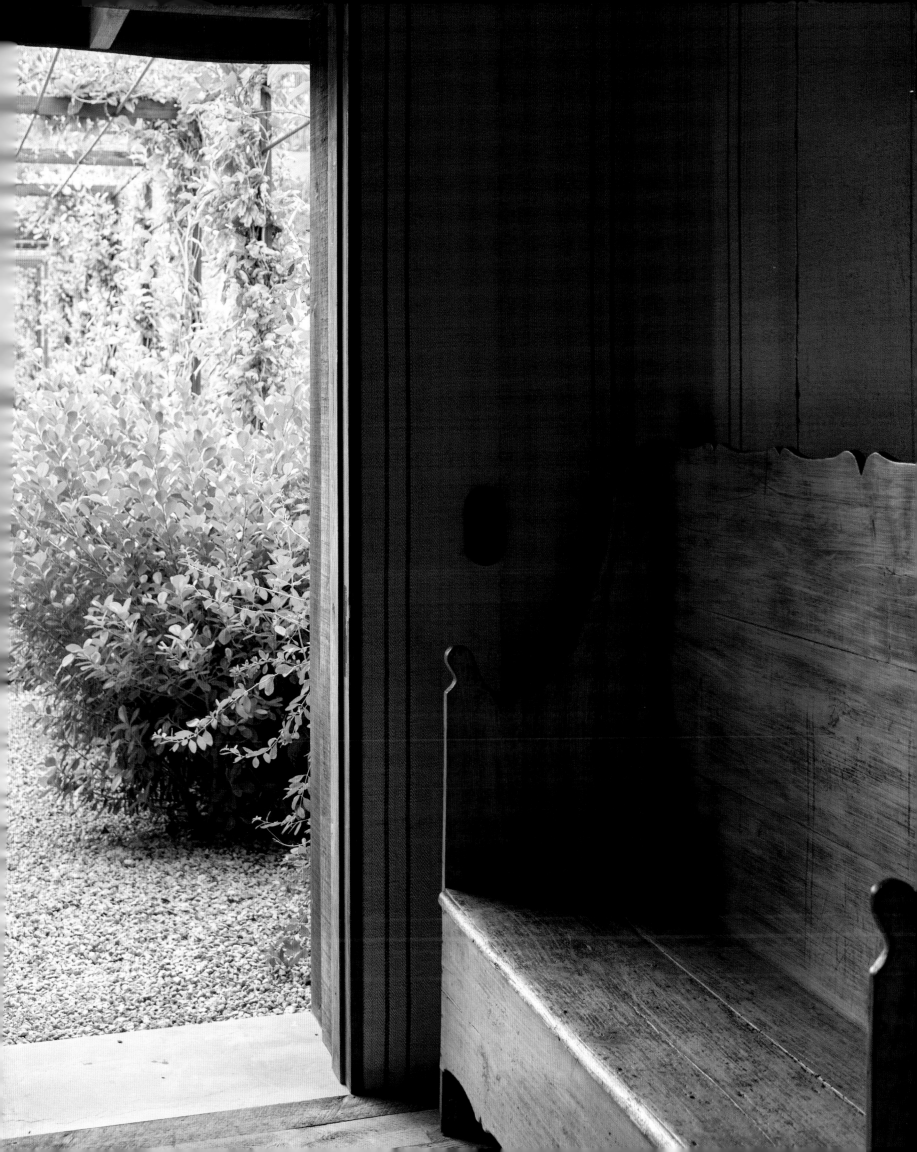

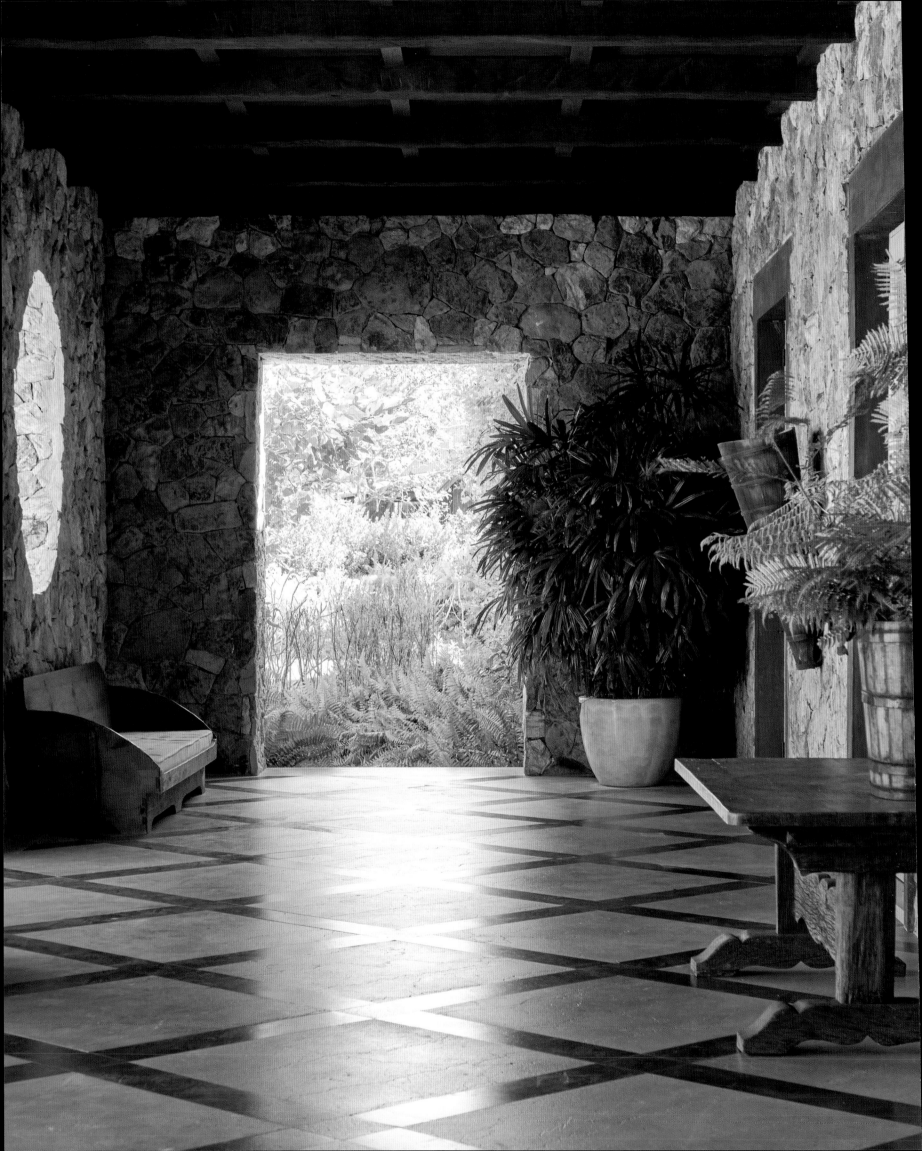

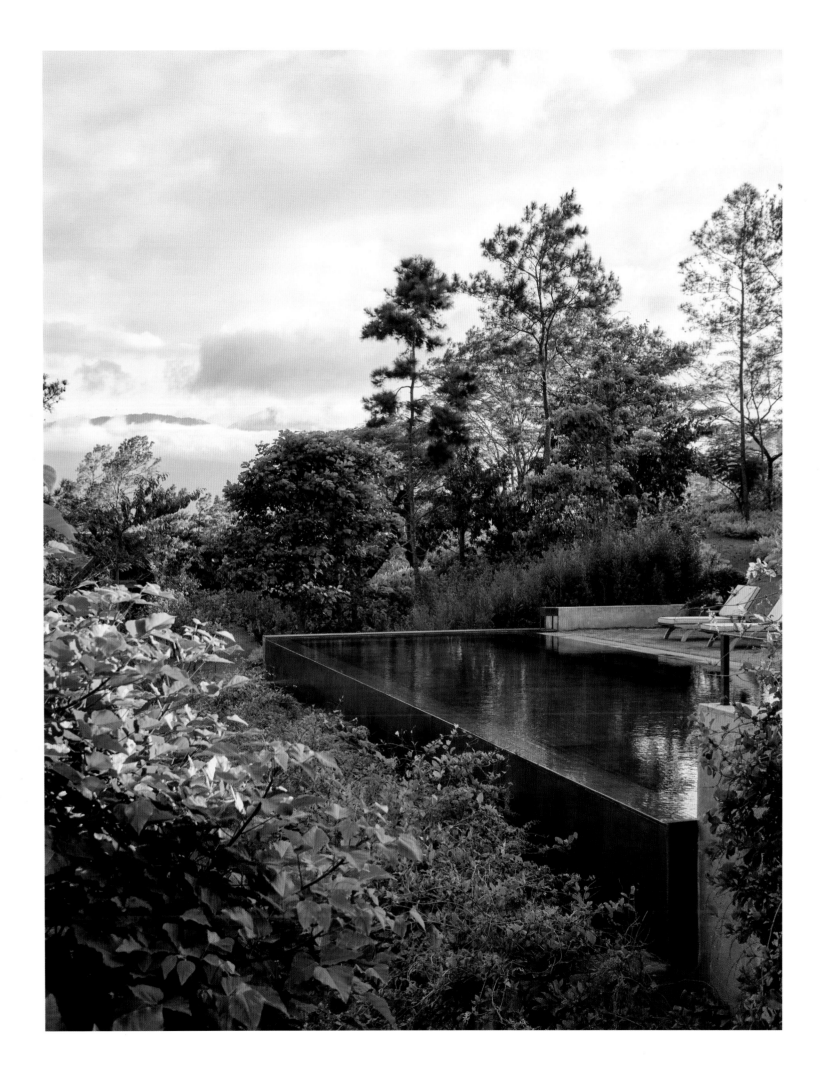

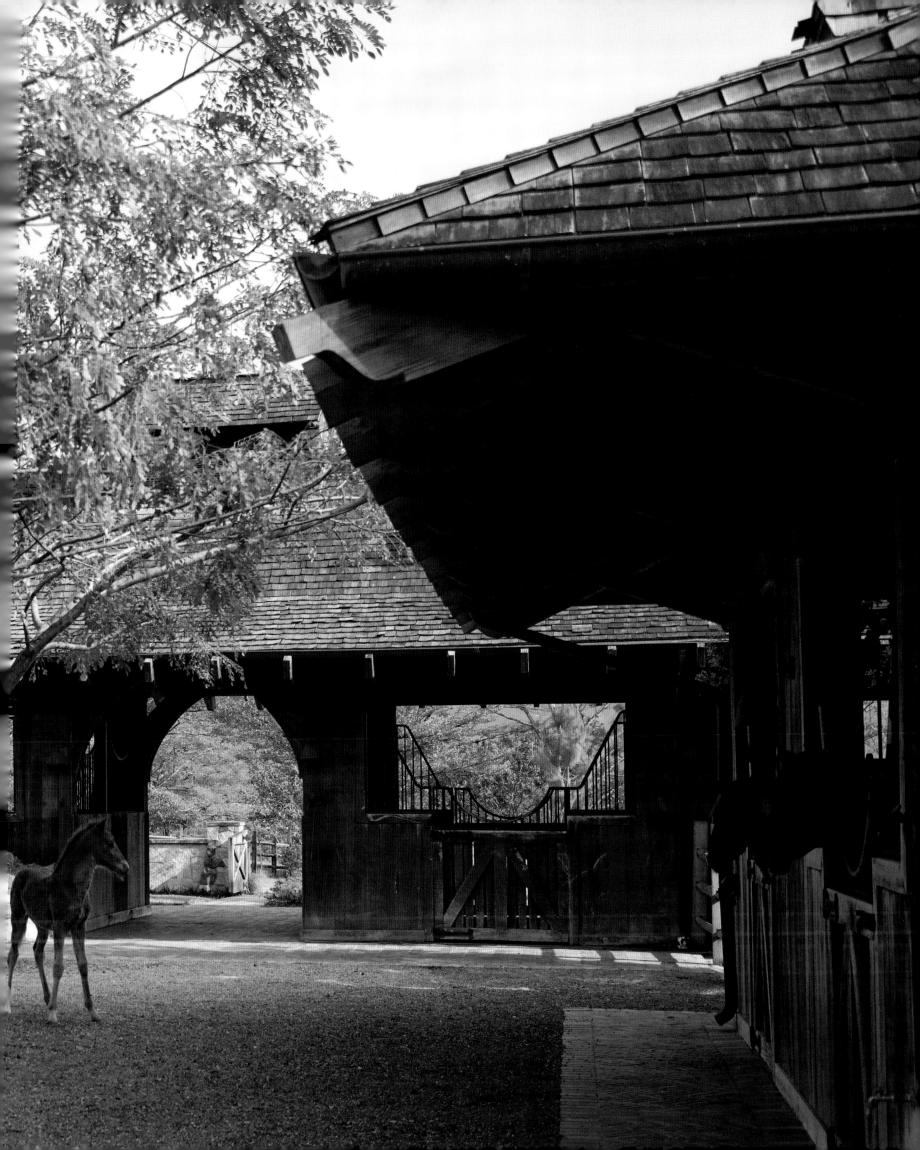

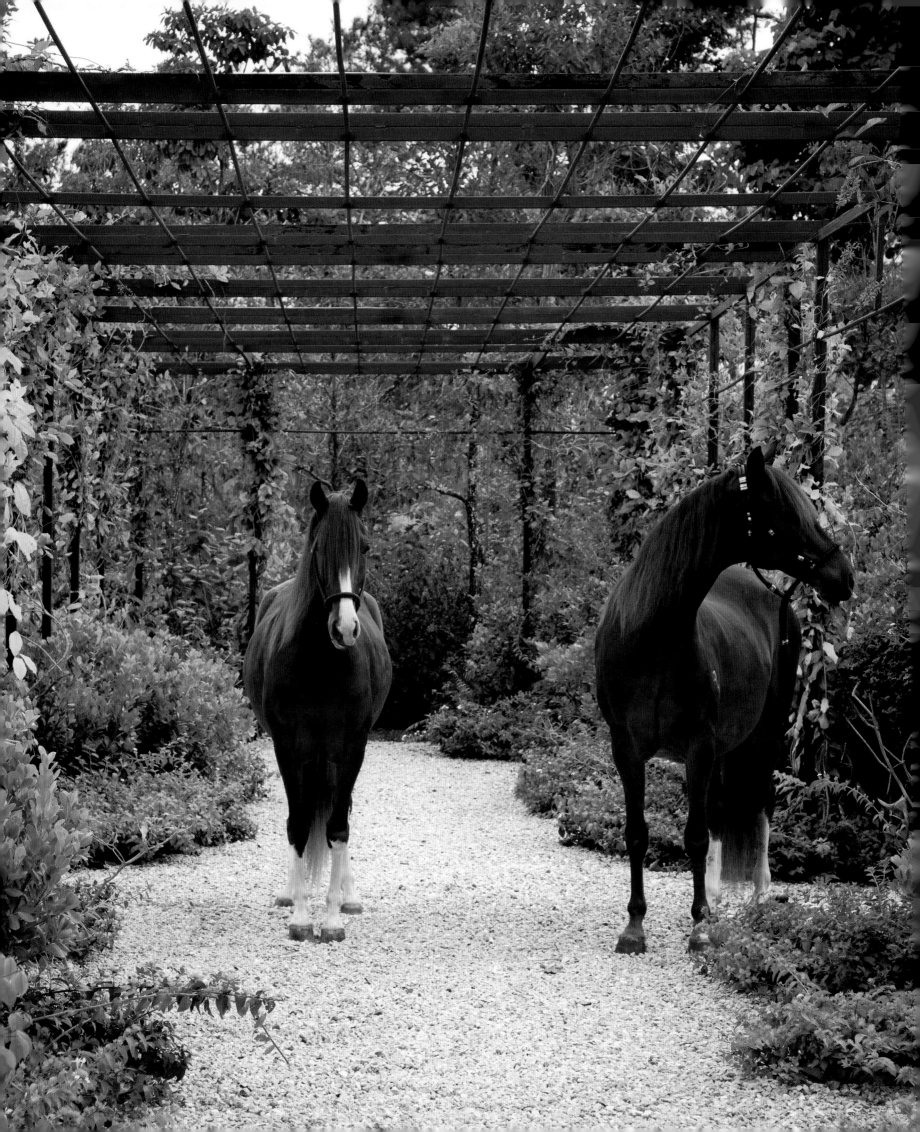

PAGE 341 The walls of the gallery between the lounge and the dining room of the Monte San Francisco ranch are covered in striped Transylvania linen and wood. Reused antique beams adorn the ceiling. A sturdy French walnut table displays a beautiful arrangement of three church candles, a sixteenth-century Spanish chest, and a spray of greenery.

PAGES 342–43 The porch off the lounge has a large seating area with a dining area at the back that enjoys incredible views of the mountains and valley. The floor is beige Jerusalem stone.

PAGES 344–45 Around the fireplace in the living room a large seating area was created with three Belgian linen sofas, Scandinavian armchairs, and a Chambron lounge chair, all resting on an enormous rug. Standing candelabras and old wood on the walls, floors, and ceiling, enhance the ambience. A French bench seat upholstered in striped fabric can be seen in the foreground.

PAGE 346 A Belgian oak sideboard from the late eighteenth century is loaded with mementos, candlesticks, and trophies and is also used as a desk. A Spanish chair provides a beautiful splash of green.

PAGE 347 Mementos and special objects on the Belgian oak sideboard.

PAGE 348 On another Belgian table, seventeenth-century Spanish processional crucifixes in silver and a large desert rose contrast elegantly with the wood of the wall.

PAGE 349 The immense concrete fireplace with a Chambron lounge chair to the right and a Scandinavian leather armchair to the left.

PAGE 350 A seventeenth-century Louis XIII cabinet conceals a bar and is topped by a sculpture of horses and an eighteenth-century Dutch mirror.

PAGE 351 A tablescape in the lounge includes a nineteenth-century wooden church candlestick, a Louis XIV mirror from 1700, and a collection of desert roses.

PAGE 352 An ebonized Italian table with English chairs. The table is decorated with an antique Peruvian jug and a Neoclassical horse's head in marble.

PAGE 353 An informal dining area on the other side of the lounge, with a Swedish table and English chairs, and a Spanish iron pendant light with candles. The walls and ceiling are clad in wood.

PAGES 354–55 An ornamental metal cabbage by Rafael Mayor makes a naturalistic table centerpiece, alongside pewter candlestick holders from Pedraza in Spain.

PAGE 356 The view from the mezzanine, where the guest room is located. Charlie and Braun, the family dogs, look up quizzically. French benches in different striped fabrics balance the white sofas. A Peruvian tablecloth covers the central table. A metal daybed to the right provides a relaxing reading spot. Doors lead out to the swimming-pool garden.

PAGE 357 The antique wood vanity in the guest bedroom. A vintage basin stands out against recycled wood.

PAGES 358–59 The guest bedroom on the mezzanine looks out over the lounge, with curtains to close off the space. The main colors here are white, brown, and blue. A 1970s red travertine table displays a church pinnacle.

PAGES 360–61 The smaller, Dutch-style barn was built about 330 feet (100 meters) from the main building to house the primary suite. Clad entirely in antique wood inside and out, it faces north toward the mountains and the flowing river. The bed sits within a white antique wooden bookcase placed against the wall that separates the room from the bathroom. The fabrics here are Belgian cotton and linen in pale colors. A 1960s leather sling sofa looks out to the valley.

PAGE 362 A large Belgian table displaying a sixteenth-century cabinet and a ladder chair sit between two large windows.

PAGE 363 A hexagonal English library table sits in a corner of the room, accompanied by a Scandinavian leather chair.

PAGES 364–65 The primary bathroom is located behind the library. The closet, shower, and toilet are concealed in cubicles. Three large glazed iron doors open onto a private courtyard with an abundance of palms and ferns. The English freestanding bath sits in front of the central window, flanked by two 1950s willow lounge chairs. The eagle wall lights between the doors are from the same decade. Antique Macael marble basins, each with an octagonal ebonized mirror above, rest on a simple pine table. Reed roller blinds diffuse the light, and a striped Moroccan rug covers the floor.

PAGES 366–67 The bathroom in the green guest bedroom is at the back, behind an iron and glass partition with a curtain for privacy. The sink sits on an antique table and the shower is green travertine.

PAGE 368 A Swedish closet for clothes storage and two English chairs are placed at the foot of the bed in the green guest bedroom.

PAGE 369 The maroon guest bathroom has a gray Pietra Serena stone floor with beige accents. The shower and toilet are housed behind an iron and glass screen. The bath sits beneath the window beside a French chaise longue providing a lovely space for contemplation.

PAGES 370–71 The maroon guest bedroom features vertical paneling, an iron bed, and an antique French bench upholstered in natural-colored fabric. An antique French walnut table sits beside the bed. Stable-style doors open to reveal an oval window.

PAGE 372 The sloping site meant that there was room for an entire floor—with magnificent high ceilings—under the barn. The laundry room, cold kitchen, and hot kitchen are found here, along with the guest rooms and the cinema.

PAGE 373 The laundry room and kitchen have antique tables, ceilings with exposed beams, and bespoke painted wooden furniture. These practical rooms are cheerful and full of life, with plenty of storage for dinnerware, ornaments, and pantry items. All these rooms are laid with stone floors with square accents.

PAGE 374 The guest powder room is decorated in raffia and contains a giant stone sink with a length of wood as a rustic vanity. Past this room is the mudroom with its display of Peruvian fabrics.

PAGE 375 A seventeenth-century Spanish bench in the second mudroom, which is entered from the pergola or the porch.

PAGE 376 The two guest bedrooms and the cinema can be accessed from the outside gallery with its diamond-patterned floor. A bench sits under the circular opening in the stone wall of the porch.

PAGE 377 The porch, the pergola, and the barn all lead to the swimming-pool garden. The dark gray stone of the pool perfectly mirrors the sky, and the garden overflows with lush and abundant greenery planted by Fernando Martos.

PAGES 378–79 The stables, designed by architect Jeffrey Dungan, were the beginning of the ranch.

PAGE 380 Peruvian horses by the trough under the pergola designed by Fernando Martos as an approach to the barn.

ACKNOWLEDGMENTS

Gracias otra vez.

I write these lines from Shanghai, China, where we've come to see a project and explore this wonderful city. I've spent forty years as an interior decorator, and I thank God every day for having this vocation and the gift to pursue it. I am incredibly happy doing what I do.

This book would not be possible without my clients and friends. Thank you for calling me and trusting me, for having fun with me and enjoying our projects together.

Thanks also to Mark Magowan and Beatrice Vincenzini at Vendome for always being there with their expertise. To Miguel Flores-Vianna, thank you for your professionalism and savoir-faire.

Thanks to my architect and landscaper friends for working together in such incredible teams. I've mentioned them by name in each project so you can recognize them.

Thanks to the antiques dealers from whom we buy pieces that make homes so meaningful: Ramón Portuondo, Horacio Portuondo, Alfonso Icaza, Jon Urgoiti, Christine Reiff, Berenis, Le Secret, and others. Thanks in particular to JF Garabieta, my friend, who passed away in January of this year as I was finishing writing, leaving us completely orphaned. My homes and projects are filled with his special things. This book is dedicated to him.

To all the craftsmen who build our dreams—builders, workers, cabinetmakers, metalworkers, electricians, plumbers, parquet layers, glaziers, upholsterers, and others—thank you. The list is endless, but I've been working with some of you for forty years.

Thanks to the skilled and dedicated people in my studio, who help to make each project possible, against all odds.

Thanks to a few women who are always there: to Loreto López-Quesada, the great stylist of this book, for her patience; to Marta Marín, architect in the studio, for her insight—*we have done wonderful work together, some of it in this book*; to Natalia Cabeza De Vaca, for her great taste and energy; to Elsa Fernández-Santos for beautifully shaping my words; to Inés Urquijo for her delightful flowers—I can't live without them. To all the great women around me, thank you.

And, finally, thanks to my dear husband Álvaro, who after forty years in the profession has decided that I am his "rock star," and to my beloved children, who can now join me on trips and enjoy them together. I hope they learn a lot while having fun.

Isabel López-Quesada

TOWN & COUNTRY
First published in 2024 by The Vendome Press
Vendome is a registered trademark of The Vendome Press LLC

VENDOME PRESS US
PO Box 566
Palm Beach, FL 33480

VENDOME PRESS UK
Worlds End Studio
132–134 Lots Road
London, SW10 0RJ

www.vendomepress.com

Distributed by Abrams Books

Every effort has been made to identify and contact all copyright holders and to obtain
their permission for the use of any copyrighted material. The publisher apologizes for
any errors or omissions and would be grateful if notified of any corrections that should
be incorporated in future reprints or editions of this book.

ISBN 978-0-86565-449-5

Publishers: Beatrice Vincenzini, Mark Magowan, and Francesco Venturi
Editor: Jodi Simpson
Translator: Rhiannon Egerton
Production Manager: Amanda Mackie

Designer: Peter Dawson, www.gradedesign.com

Library of Congress Cataloging-in-Publication Data available upon request

Printed and bound in China by 1010 Printing International Ltd.

PAGES 2–3 View of the courtyard from the lounge in Isabel López-Quesada's home in Madrid. A large traditional wood-glazed door floods the room with southern light, while Italian palo santo wood and steel lounge chairs take center stage. The courtyard was designed by Fernando Caruncho.

PAGES 4–5 View of the office from the dining room of the house in Salamanca, Madrid. A Zuber grisaille covers the walls in the foreground, with a black and gold bookcase behind. Placed in the dining room are a pair of twentieth-century commodes and a pair of nineteenth-century white and gold Porcelaine de Paris urns.

PAGES 6–7 The primary suite of the property in Segovia, Spain, comprises a living room with its own fireplace, a bedroom, a bathroom, and a dressing room. All three rooms are lined with striped Transylvania linen. A work by Deva Sand hangs above an old French table that is used as a desk. A love seat with footrest provides a comfortable spot for relaxing.

PAGE 8 In Madrid, a deep blue velvet sofa with a Balinese silk cushion sits in front of a late-eighteenth-century gold-edged screen with eight black lacquered panels featuring Chinese landscapes.

PAGE 11 Louis Vuitton suitcases stacked on a bench and antique etchings on the wall create a feature between two pine doors in the Segovia house.

PAGES 16–17 View from the Manhattan apartment on the sixty-third floor of the Four Seasons Private Residences in Tribeca.

PAGE 19 The hallway of the Santo Domingo house in the Dominican Republic. A pair of oversized bamboo mirrors reflect the light from the window and door. A nineteenth-century marble urn rests on a floor of limestone and Pietra Serena sandstone.

PAGES 190–91 The Jarabacoa barn enjoys fabulous views over the coursing river, meadows, and mountains. It's like stepping into a painting!

PAGE 193 Mountain and treetop views from the porch of the Jarabacoa barn.